MODERN CONTEMPORARY

MODERN CONTEMPORARY

ART AT MoMA SINCE 1980

EDITED BY

KIRK VARNEDOE • PAOLA ANTONELLI • JOSHUA SIEGEL

THE MUSEUM OF MODERN ART, NEW YORK

This book is published in conjunction with the exhibition *Open Ends* at The Museum of Modern Art, New York, September 28, 2000–January 30, 2001, organized by Kirk Varnedoe, Chief Curator, Department of Painting and Sculpture; Paola Antonelli, Curator, Department of Architecture and Design; and Joshua Siegel, Associate Curator, Department of Film and Video. *Open Ends* is the third and final cycle in the series of exhibitions titled *MoMA2000*. • *MoMA2000* is made possible by the Starr Foundation. • Generous support is provided by Agnes Gund and Daniel Shapiro in memory of Louise Reinhardt Smith. • The Museum gratefully acknowledges the assistance of the Contemporary Exhibition Fund of The Museum of Modern Art established with gifts from Lily Auchincloss, Agnes Gund and Daniel Shapiro, and Jo Carole and Ronald S. Lauder. • Additional funding is provided by the National Endowment for the Arts, Anna Marie and Robert F. Shapiro, NEC Technologies, Inc., and by The Contemporary Arts Council and The Junior Associates of The Museum of Modern Art. • Education programs accompanying *MoMA2000* are made possible by BNP Paribas. • The publication *Modern Contemporary: Art at MoMA Since 1980* is made possible by The International Council of The Museum of Modern Art. • The interactive environment of *Open Ends* is supported by the Rockefeller Brothers Fund. • Film programs during *Open Ends* are supported by The New York Times Company Foundation. • Web/kiosk content management software is provided by SohoNet. • Produced by the Department of Publications, The Museum of Modern Art, New York • Edited by Harriet Schoenholz Bee • Designed by Steven Schoenfelder • Production by Marc Sapir • Color separation by Barry Siddall, MR Reproduktionen, Munich • Printed and bound by Passavia Druckservice, Passau • Set in Officina and Bell Gothic, this book is printed on 135 gsm Galeria Art Silk. • Printed in Germany • ©2000 by The Museum of Modern Art, New York. • Certain illustrations are covered by claims to copyright cited in the Photograph Credits. All rights reserved. • Library of Congress Catalogue Card Number: 00-108144 • ISBN 0-87070-021-9 (hardbound, MoMA, Thames & Hudson) • ISBN 0-8109-6214-4 (hardbound, Abrams) • ISBN 0-87070-022-7 (paperbound, MoMA) • Published by The Museum of Modern Art, 11 West 53 Street, New York, New York 10019. www.moma.org • Hardbound edition distributed in the United States and Canada by Harry N. Abrams, Inc., New York. www.abramsbooks.com • Hardbound edition distributed outside the United States and Canada by Thames & Hudson, Ltd., London.

MODERN CONTEMPORARY ART AT MoMA SINCE 1980

Contents

John Barnard
Gary Hill
General Idea
Lari Pittman
Akira Kurosawa
Brice Marden
Thomas Struth
Arata Isozaki
David Hammons
Richard Prince
Joel Sternfeld
Yvonne Rainer
Kiki Smith
Elizabeth Murray
Mike Kelley
John Cage
Bruce Conner
Office for Metropolitan
 Architecture
Felix Gonzalez-Torres
Agnieszka Holland
Zhang Yimou
Yang Fengliang
Jim Nutt
Stephen Frears
Neil Winokur
Chris Killip
Francis Ford Coppola
Martin Scorsese

1991 | 291
Toshiyuki Kita
Annette Messager
Peter Eisenman
John O'Reilly
Boris Mihailov
Shimon Attie
Julie Dash
Toyo Ito
Warren Sonbert
Ernie Gehr
Annette Lemieux
Oliver Stone
Tom Dixon
Dieter Appelt
Jean-Michel Othoniel
Vito Acconci
Felix Gonzalez-Torres
Tejo Remy
Enzo Mari
Abelardo Morell
Zaha M. Hadid
Glenn Ligon
David Wojnarowicz
Allen Ruppersberg
Raymond Pettibon
Christopher Wool

Frank Gehry
Brice Marden
Robert Gober
Cindy Sherman
Janine Antoni

1992 | 320
Paul McCarthy
Mike Kelley
Roy Lichtenstein
Christopher Connell
Ben Faydherbe
Ingo Maurer
Guillermo Kuitca
Willie Cole
Arata Isozaki
Richard Serra
Peter Campus
Rudolf Bonvie
Santiago Calatrava
José Leonilson
Louise Bourgeois
Rody Graumans
Christopher Bucklow
Terence Davies
Sigmar Polke
Philip-Lorca diCorcia
Juan Sánchez
Raymond Pettibon
Rosemarie Trockel
Mark Steinmetz
Gabriel Orozco
Donald T. Chadwick
William Stumpf
Neil M. Denari
Simon Patterson
Chris Burden
Clint Eastwood

1993 | 344
Clint Eastwood
Reiko Sudo
Helen Chadwick
Chris Marker
Zacharias Kunuk
Anselm Kiefer
Glenn Ligon
Rosemarie Trockel
Brice Marden
Herzog & de Meuron
 Architects
Ellsworth Kelly
Roni Horn
Robert Therrien
Derek Jarman
Fernando Campana
Humberto Campana

Antonio Citterio
Glen Oliver Löw
Jean Nouvel
Rachel Whiteread
Ian Hamilton Finlay
Martin Scorsese
Ximena Cuevas
Charles Ray
Rirkrit Tiravanija
Cheryl Donegan
Jos van der Meulen
Nam June Paik

1994 | 367
Hal Hartley
Quentin Tarrantino
Lorna Simpson
Renzo Piano
Takeshi Ishiguro
Kim Jones
Andreas Gursky
Mona Hatoum
Teiji Furuhashi
Bill Viola
Jenny Holzer
Robert Gober
Ann Hamilton
Ross Bleckner
Michael Schmidt
Thomas Roma
Richard Artschwager
Uta Barth
Cy Twombly
Philippe Starck
Rineke Dijkstra
Marlene Dumas
Hella Jongerius
James Turrell
Jeff Scher
Barbara Kruger
Louise Bourgeois
Bob Evans
Roni Horn
Jean Nouvel
Alberto Meda
Glenn Ligon

1995 | 399
Carrie Mae Weems
Louise Bourgeois
Marcel Wanders
Tom Friedman
Peter Halley
Toba Khedoori
Ellen Gallagher
Toyo Ito
KCHO (Alexis Leyva
 Machado)

Doris Salcedo
Laurie Anderson
Joel Sanders
Herzog & de Meuron
 Architects
Sigmar Polke
Chuck Close
Matthew Barney
cyan
Sheron Rupp
Stan Douglas
Jasper Johns
Inoue Pleats Co., Ltd.
Luc Tuymans

1996 | 421
Luc Tuymans
Joel Coen
John Sayles
José María Sicilia
Flex Development B.V.
Mona Hatoum
John Armleder
David Hammons
KCHO (Alexis Leyva
 Machado)
Gary Simmons
Gabriel Orozco
Chris Ofili
Jeanne Dunning
Thomas Demand
Andrea Zittel
Werner Aisslinger
Franz West
Al Pacino
Toray Industries, Inc.
Ken Jacobs
Igor Moukhin
Kiki Smith
Raymond Pettibon
Kara Walker
Arthur Omar
Kristin Lucas
Vik Muniz

1997 | 442
Fred Tomaselli
Chuck Close
Arnulf Rainer
Martin Puryear
Stan Brakhage
Reiko Sudo
Daniel Libeskind
Willie Cole
Kiki Smith
William Kentridge
John Baldessari

Rachel Whiteread
Franz West
Lewis Klahr
Sue Williams
Yukinori Yanagi
Zhang Peili
David Williams
Pipilotti Rist

1998 | 462
Fiona Banner
Konstantin Greic
Julia Loktev
Paul Winkler
Charles Long
Aleksei German
Richard Serra
Anish Kapoor
Terry Winters
Gerhard Richter
Gabriel Orozco
Christian Boltanski
Jia Zhang Ke
Matthew Barney
Kara Walker
Luc Tuymans
John Madden
Robert Rauschenberg
Chris Ofili
Enrique Chagoya
Lisa Yuskavage
Elizabeth Peyton
Philippe Starck
Ralph Schmerberg
Mariko Mori
Cai Guo-Qiang
Rachel Whiteread
William Kentridge

1999 | 486
William Kentridge
Phil Solomon
Julian Opie
Andreas Gursky
Barbara Bloom
Jean-Marie Straub
Danièle Huillet
Carroll Dunham
Damien Hirst
E. V. Day
Chris Ofili
Richard Serra
Shahzia Sikander

2000 | 499
Jean-Luc Godard
Faith Hubley
Matthew Barney

Foreword

Open Ends is the third and final of three cycles of exhibitions organized by The Museum of Modern Art under the banner *MoMA2000* to mark the millennium. Selected entirely from the Museum's extensive collection and presented over a seventeen-month period, these cycles of exhibitions have been conceived to explore issues and themes in modern art through the filter of the Museum's holdings. Modern*Starts,* which focused on the period 1880 to 1920, was followed by *Making Choices,* which dealt with the years 1920 to 1960. This concluding cycle, *Open Ends*, examines the art of 1960 to the present. All three cycles take a multidisciplinary approach and include works of art from all of the Museum's curatorial departments: Architecture and Design, Drawings, Film and Video, Painting and Sculpture, Photography, and Prints and Illustrated Books, presented in a series of synthetically organized exhibitions.

The chronological framework of the cycles is intended only as a convenient means of loosely organizing a considerable body of material into a coherent group of exhibitions. Over the last seventy years, The Museum of Modern Art has argued for an understanding of modern art through a carefully articulated history of this still-evolving tradition. By establishing a reading of modern art based on critical dates, styles, schools, and key artists, the Museum sought to make sense of the often competing and contradictory forces of this tradition. Modern*Starts, Making Choices,* and *Open Ends* build on this work but endeavor to provide a more interdisciplinary approach to the material. Each cycle explores relationships and shared themes as well as divergent movements and conflicting points of view by juxtaposing works of art in new and challenging ways. Individual exhibitions within each cycle concentrate on issues germane to the period under consideration, but the works of art chosen for these exhibitions often span the century in order to reveal how themes from one movement either respond to earlier questions or affect later decisions.

Taken together Modern*Starts, Making Choices,* and *Open Ends* are meant to provoke new responses and new ideas about modern art. They are not meant to be overarching or definitive statements about modern art or even about the nature of The Museum of Modern Art's collection but, rather, interrogatory ones that can help shape future issues and concerns to be dealt with as the new century unfolds. The ability of The Museum of Modern Art to embark on this initiative is the result of several generations of collecting that have allowed the Museum to acquire holdings of unparalleled richness and complexity. Indeed, many of the most important historical developments in modern art that have emerged over the last one hundred years are represented in the Museum's collection.

Alfred H. Barr, Jr., The Museum of Modern Art's founding director, spoke of the Museum's collection as being metabolic and self-renewing. While he meant this in terms of the Museum's ability to constantly acquire new works of art through selective de-accessioning of its more historical holdings, the idea of an institution capable of considering and reconsidering itself in response to the ongoing and continuous inquiry about modern art is central to any understanding of the Museum. There is within the Museum a lively debate about which artists to collect, which works of art to display, and which exhibitions to mount. At the heart of these discussions is always the question of how to display our collection, what issues and themes to focus on, and what juxtapositions and relationships to highlight or emphasize. Given the cost and complexity of making significant architectural changes to the Museum's galleries in order to create spaces that allow for different kinds of presentations of the collection, the changes effected by these debates can take years to be realized.

ModernStarts, *Making Choices*, and *Open Ends* are thus unique opportunities for the Museum to literally reconfigure many of its galleries and explore its collection in a way that is almost impossible to do on an ordinary basis. Each cycle should be seen as an experiment designed to offer a different reading or understanding of modern art while providing a more thorough investigation of the depth and breadth of the collection. In doing so we hope we will have turned the Museum into a laboratory where arguments and counter-arguments, issues, and ideas of modern art can meet and be explored in a way that allows for the emergence of new approaches to our history, and by extension, the history of modern art. This becomes especially important as the Museum prepares for a major architectural reconstruction, scheduled to begin when *MoMA2000* closes.

The idea for this series of exhibitions began more than four years ago when a retreat was held with seven chief curators of the Museum to consider what might be done in recognition of the closing of the century that saw the birth of modern art as well as the founding of The Museum of Modern Art in 1929. After extensive discussion we felt that for an extended period of time we should concentrate on our own collection, devoting to it the attention we would normally give to the development of a major loan show. We were attracted to this idea because it afforded us the opportunity to reconsider the way we present our collection to the public as well as the chance to look back, from the vantage point of the end of the century, over one hundred years of modern art while posing questions that would guide our thinking about modern art into the next century. We quickly realized that despite the synthetic nature of The Museum of Modern Art's collection, no exhibition or series of exhibitions could ever hope to provide a genuinely comprehensive account of a tradition of that is still very much alive and evolving. This led to the recognition that the greatest contribution that we could make at this time would be to show as much of the collection as possible, including both familiar and unfamiliar works of art, in new and imaginative ways that open up possibilities for us, and our public, to examine the future.

Given the magnitude of this task, the entire curatorial staff embarked on an extended review of the collection and worked together to create a comprehensive overview of what the Museum had acquired over the last seventy years. Subsequently, smaller working groups were asked to study specific aspects of the collection and report back to the full staff on their findings. Other research departments of the Museum, including conservation, education, the library, and the archives, were also invited to participate in these discussions. Eventually we decided that to examine the collection to the extent we wished, we needed to use all of the Museum's galleries for this project and to divide the project into three separate cycles of exhibitions, each anchored around a chronological moment equal to roughly a third of the period covered by our holdings.

The organization of each cycle was entrusted to an interdepartmental team. Each of the teams was encouraged to pursue its own interests and ideas and to articulate them in unique and different voices. Taken together ModernStarts, *Making Choices*, and *Open Ends* are not meant to be read as a continuum, as if each were a part of a larger, seamless whole; rather, they are meant to provide three separate and distinct "takes" on modern art as represented by the collection.

As noted above, *MoMA2000* evolved out of lengthy discussions with the Museum's seven chief curators, all of whom—Mary Lea Bandy, John Elderfield, Peter Galassi, Terence Riley, Margit Rowell, Kirk Varnedoe, and Deborah Wye—made important contributions to the form it took. Its overall coordination was provided by John Elderfield (from 1996 to 1998) and Mary Lea Bandy (since 1999) in the capacity of Deputy Director for Curatorial Affairs, and by Beatrice Kernan, Assistant Deputy Director for Curatorial Affairs, assisted by Sharon Dec and Amy Romesburg, and working closely with Jennifer Russell, Deputy Director for Exhibitions and Collections Support, Michael Maegraith, Publisher, and Jerome Neuner, Director of Exhibition Design and Production. *Open Ends* has been skillfully and insightfully directed by Kirk Varnedoe, Chief Curator, Department of Painting and Sculpture; Paola Antonelli, Curator, Department of Architecture and Design; and Joshua Siegel, Associate Curator, Department of Film and Video, assisted by Judith Hecker and Amy Horshak.

Glenn D. Lowry
Director
The Museum of Modern Art

Introduction | Kirk Varnedoe

This volume presents a selection of artworks made after 1980, drawn from the collection of The Museum of Modern Art. The works, in diverse mediums, come from each of six curatorial departments in the Museum: Painting and Sculpture, Drawings, Prints and Illustrated Books, Architecture and Design, Photography, and Film and Video. The dominant purpose of the volume is visual information; but its eleven thematic essays suggest particular concerns that unite works of different dates, styles, or mediums.

The book was conceived during the planning of the exhibition *Open Ends*, the third and concluding cycle in the Museum's series of *MoMA2000* exhibitions. This series, held at The Museum of Modern Art from autumn 1999 through spring 2001, has been drawn entirely from the holdings of the Museum, and has been presented as a re-examination of the history of modern art and of the Museum's collection. It has sought to integrate works from all curatorial departments and across traditional historical categories in ways that could provide a testing-lab for fresh consideration of what the Museum has done in the past—and might do in the future—with its incomparable collection.

Modern Contemporary was organized in a parallel spirit. From the outset, it was meant to accompany *Open Ends*, but not to serve as its catalogue. It was intended to be an independent publication, whose contents were selected separately from the exhibition lists and structures. Of course, the contents of book and exhibition often overlap: both draw from the same collection, and many of the same highlights are featured. Similarly, some of the essays address themes taken up by individual exhibitions within *Open Ends*, although the texts are not descriptions of those thematic displays.

Still, many of the works in the exhibition are not in the book, and vice versa. A principal difference involves the period covered. *Open Ends* focuses on works in the collection dating from 1960 to 2000, and initially this book was to have covered a similar scope. However, it soon became clear that it would be impossible, in one volume, to feature the better-known works of the 1960s and 1970s—including, for example, the masterworks of Pop and Minimalism—and also to showcase the richness of the Museum's acquisitions of recent art of the 1980s and 1990s. Acutely aware of how little chance the public has had to see the scope and variety of the Museum's contemporary acquisitions, we decided to focus in the publication exclusively on the period after 1980. The book thus allows maximum exposure for the least-known part of the Museum's collection, and underlines the institution's continuing engagement with contemporary art. Even with the expanded focus, however, it should be recognized that the illustrations gathered here represent only a relatively narrow selection of the far larger and more comprehensive acquisitions of post-1980 works. While preliminary lists were solicited from the various curatorial departments, the final selections were ultimately the responsibility of the book's editors.

Modern and Contemporary Art at MoMA

The Museum of Modern Art was founded as, and has always been, an institution committed to contemporary art. From the inauguration in 1929, and for many years after, it was thought that the "permanent" collection would have relatively constant dimensions, but ever-changing elements. The

founding director, Alfred H. Barr, Jr., proposed the notion of a torpedo through time, conjuring the image of a forward-moving collection that would always have its "nose" in the present and immediate past, and a "tail" in the receding past about fifty years distant. The metaphor implied that, as a balance to its ongoing acquisitions of new art, the Museum would steadily divest itself of the older art in its possession, as that older art became more "classic" than "modern." This practice was designed to keep the Museum forever fresh and free from the burdens of an extended history, and also indicated pragmatic concerns for limiting the size of the collection and for providing, by the occasional sale of the older artworks, a renewable source of funding for future purchases.[1]

Had the notion of the torpedo been followed literally, the earliest works in the Museum's collection would now be those of the early 1950s. Instead, the early 1950s were precisely the point at which the Museum began to accept—tentatively and piecemeal at first, then as a matter of general principle—that it would retain its collection of Post-Impressionist masterworks (such as Cézanne's *Bather* and van Gogh's *The Starry Night*) as the starting point of its painting and sculpture collection. (Other curatorial departments had different points of departure for their collecting: Photography and Film, for example, include the beginnings of their mediums, around 1840 and 1890, respectively). This change meant that the tail of Barr's torpedo would become permanently pinned to around 1880, while the nose would continue to advance. The resultant tensions and stretches—between the ever-more-certified treasures of the historical collection and the seemingly ever-more-perilous adventures of collecting the art of the present—defined the character of The Museum of Modern Art in the last half of the twentieth century.

Those who have worked at the Museum in recent years, and those who have supported it, have felt that its built-in duality—the simultaneity of its commitments to what might be called classic modern art and to the creativity of the immediate present—not only makes sense, but creates the special quality of the institution. There is an argument to be made that the revolutions that originally produced modern art, in the late nineteenth and early twentieth centuries, have not been con-cluded or superseded—and thus that contemporary art today can be understood as the ongoing extension and revision of those founding innovations and debates. The collection of The Museum of Modern Art is, in a very real sense, that argument. Contemporary art is collected and presented at this Museum as a part of modern art—as belonging within, responding to, and expanding upon the framework of initiatives and challenges established by the earlier history of progressive art since the dawn of the twentieth century.

The historical collection provides a special implicit framework, illuminating and demanding, within which to present the art of today. And, conversely, a continued engagement with today's art constantly challenges the curatorial staff to reexamine and reinterpret the history of innovations that preceded it. Without the dialogue between these twin aspects, The Museum of Modern Art would be a far less rewarding place for viewers to visit, for the staff to work, and for artists to show their work. The trick is, of course, to find the proper balance, in institutional time and resources, between the care and elucidation of the classic modern collection and the everyday-renewed need for growth and change. The works shown in this book are an important part of that process of growth—of the constant amendment, revision, and expansion of the collection that, in sum, constitutes an evolving definition of what the institution is.

Past Bedrocks and Present Risks

The German Expressionist painter Franz Marc once said, "Traditions are wonderful things—to create." The presence of a great historical collection at The Museum of Modern Art is a source of pride and incentive to those who acquire new art for the Museum. But, contrary to the suspicions of some critics of MoMA, the historical collection does not provide a monolithic canon against which potential new acquisitions can be universally measured, nor any sharply defined template for the institution's future. In this respect, Alfred Barr—the son of a preacher, and often described as a missionary—may have left his best legacy to subsequent curators, not in the form of a theological orthodoxy but in the form of an existential injunction to act and to take chances. He always insisted that

if, two decades later, even a tenth of the works acquired in a given year were deemed worthy of showing on a long-term basis, it would be a positive accomplishment. And he insisted that, in the eyes of history, sins of omission look worse than sins of commission: that is, the curator is more often damned for what he or she failed to acquire, than for the things brought in that, over time, do not pan out.

A corollary of Barr's pragmatic outlook—humbling but encouraging at the same time—is that the quality of the collection is as much a matter of retrospective refinement as of on-the-spot discernment. It is easy to presume, given the many masterworks of early modern art in the collection, that the Museum had, early on, a "hot hand" for identifying and obtaining superior pieces of then-contemporary art. A closer look will show, however, that the institution began conservatively, and got more "progressive" as it aged. In the mid-1930s The Museum of Modern Art looked more like a museum of Kolbe, Maillol, and Pascin; it became the Museum of Picasso, Matisse, Malevich, and Duchamp only gradually—often by key purchases made with the benefit of considerable hindsight. The purchase of Picasso's 1907 *Les Demoiselles d'Avignon* in 1937 is one example, the acquisition of key Abstract Expressionist works in the 1970s another; and several key works of the late 1950s and 1960s—by artists such as Rauschenberg, Warhol, and Judd—were only brought into the collection in the 1990s. In this respect as well as others, it would be mistaken to see the Museum's view of earlier modern art as frozen, in opposition to its changing assessments of the present. Instead, these two aspects—the revision and refinement of a view of history, and an openness to the lessons of contemporary creators—are often closely connected, and evolve in dialogue.

However, one premise of the "torpedo," involving the relationship between the older and newer parts of the collection, has become virtually inverted. It was originally thought that older modern art from the collection would be sold to buy more up-to-date works. In more recent years, while de-accessioning artworks has continued to be an important means of raising money for acquisitions, an unwritten policy has evolved with regard to works whose worth has been validated by history.

The policy holds that such works should not be sold in order to fund the speculative field of contemporary art but only to acquire what are deemed better works of the same kind or, alternatively, to acquire works that have over the years become desirable additions to the historical collection.

A Changed Context

For many years after its founding, The Museum of Modern Art enjoyed a global pre-eminence owing at least in part to the uniqueness of its mission. But one measure of success is emulation, and, beginning in the 1960s, numerous institutions in the United States and abroad, either newly founded or reinvigorated, began to take up a parallel commitment to modern—and especially to contemporary—art. At the start of the twenty-first century, this competitive element has become ever more intense, as the status of contemporary art—among both private and state-supported institutions, and among the wealthiest private collectors—has ascended dramatically. The bar has been (and continues to be) raised, financially and in many other respects, for institutions like this one that aim for primacy on this hotly contested terrain. The depth and variety of the Museum's collection of early modern art, still unrivaled, only adds to its future challenges—to build its collection in a way that will both maintain the high levels of quality established by its past, and also redefine its singular character within a now crowded and intensely competitive field. One of the demands the altered situation places upon the Museum is that of carefully examining the mechanisms by which the institution has thus far acquired art, and of assessing their viability for the years to come. And in this regard, the impression this book presents—of a continuous, multimedia collection—actually belies the more complex and often fragmented procedures that brought these works to MoMA.

How Art Enters the Collection

While the works in this book are presented as a continuum of various mediums, they entered the collection by different routes, determined by the six different curatorial departments (divided

according to medium) within the Museum. Each department has its own budget and its separate acquisition committee, made up of Trustees and other invited patrons of the Museum. The basic mechanism of acquisition is everywhere the same: curators propose, and committees dispose. Works proposed for acquisition (including gifts offered) are presented at committee meetings by curators, who argue for the addition of the works to the collection. The committee (whose members contribute most of the funds that make up the acquisition budget) then votes to accept or reject the proposed work.

Beyond that, however, departmental philosophies of collection-building may differ widely. Some departments have specific exclusions built into the representation of their respective fields. While the Department of Film and Video might eagerly amass a collection of films related to war, for example, the Department of Architecture and Design has always refused to collect weapons. Yet while the design collection has been formed within a generally very broad, non-restrictive consideration of functional and commercial objects, the collection of film (while it includes such diverse fields as feature films, animation, documentary, and experimental works) has specifically avoided collecting within the area of commissioned work, which constitutes one of the largest areas of film production—thereby specifically excluding industrial, religious, and pornographic films. The collecting of photography, film, and design objects at the Museum, meanwhile, proceeds in certain areas without regard for original artistic intention (acquiring, for example, items such as propellers, ball bearings, documentary photographs, family snapshots, instructional film, or home movies), while the departments of painting and sculpture, drawings, and prints only collect works defined and intended as art by their creators. No department aspires to anything like a reportorial or archival inclusiveness in dealing with its respective field, though the Department of Prints and Illustrated Books has made arrangements for the acquisition of every work issued by certain publishers who have had particular significance for their area.

Perhaps most crucially, the collection is built by six separate staffs of curators, whose outlooks and strategies may vary widely. This produces a diverse range of approaches pursued simultaneously at any given moment in the Museum's history. It also means that each department's collection accumulates a particular set of idiosyncratic strengths and weaknesses—pockets of concentration and broad patterns of representation—that reflect different generations of leadership. Each new set of "builders" must in turn choose how to build further upon, or compensate for, the particular structures left by their predecessors. For example, when the photographer Edward Steichen was the head of the Department of Photography, his collecting reflected ideas of a universal language of photography (as embodied most evidently in his well-known 1955 exhibition *The Family of Man*); but his successor John Szarkowski focused his collecting and exhibitions program on the work of particular artists. From Barr's early exhibitions on Cubism and Surrealism to more recent shows devoted to Cy Twombly or Japanese textiles, curatorial programs of loan exhibitions have also opened special opportunities for acquisition, and left their mark on the permanent holdings of the Museum. Particular artists and schools have come in and out of favor, and the collection records these fluctuations. Barr did not share, for example, James Thrall Soby's early enthusiasm for Jackson Pollock, and it was not until William Rubin's efforts in the late 1960s and 1970s that the Museum's exceptional holdings of this artist were finally formed. Soby's affection for the work of Pavel Tchelitchew in the late 1930s and early 1940s, on the other hand, now seems a closed chapter in collecting, without any subsequent reinforcement. Examples of similar shifts and stops and starts, corrections and revisions, mark every phase of the Museum's holdings in virtually every medium.

In sum, while the collection of the Museum may seem to many outside observers to represent a monolithic structure, built according to some uniform consensus, those inside the institution are most acutely aware of how its holdings are actually a rich patchwork, formed—from the beginning and still today—within a shifting constellation of contingencies, including the changing practices of separate departments, the divergent tastes of particular donors, and the shifting concerns of individual curators.

The Particular Challenges of Recent Art

The collecting of contemporary art has, in the past few decades, challenged the Museum's structures, both physical and organizational, in several ways. Most evidently, the scale of many important works in painting and sculpture has increased beyond the ability of the institution's building to contain them, and the sprawling space requirements of other works—especially in the area of installation art, but also in photography, drawing, and print-making—have imposed sharp limitations on what can be on view at any given time. We hope to address these challenges by the dramatic increase in open, high-ceilinged galleries for contemporary art within the new Museum building designed by Yoshio Taniguchi. There are no such direct, physi-cal solutions, however, for other, parallel conun-drums. A number of impulses within new art since the 1960s—including Happenings or Performance Art, Conceptual Art, and Earthworks—have been explicitly opposed to the idea of the collectible object, and hence to a fundamental premise of the traditional museum. And even within the domains traditionally covered by the Museum's various departments, there has been an important upsurge of hybridization, intentionally and effectively transgressing the boundaries between, say, video and sculptural installation, or photography and painting. Many important artists since the 1960s have conceived of their art as one program ex-pressed through diverse mediums, including not only painting, sculpture, drawing, and printmak-ing, but also often photography, film, and video. While it was Barr's genius to propose that all the diverse modern mediums—painting, film, photog-raphy, design, etc.—belonged together under one roof, the idea of separate languages of expression, and separate historical traditions, still shaped the formation of the individual curatorial depart-ments. Now, when artists frequently work simul-taneously and interchangeably within several different mediums, and criss-cross the traditional lines between fine and applied arts as well, these curatorial divisions can frequently seem constrain-ing and arbitrary.

This intellectual challenge is linked, paradoxi-cally, with a shift in economic structures. Much of contemporary art has moved away from the basic model of the unique, handmade object, preferring instead mechanical means of production and mov-ing more comfortably in the zone of photography, prints, film, and video where infinite replication is implied. But, at the same time, that art has, regardless of medium, often been pressed into conformity with models of marketing and sales associated with the traditional trade in paintings. Large-format, limited-edition works are now a staple of artists working in photography, film, and video, and the prices being asked are dra-matically, by quantum leaps, larger than those observed within these mediums prior to the 1990s. In these circumstances, more collective planning and cooperation between the various departments of the institution seems a priority for any reasoned program of acquisitions. Accomplishing that coor-dination, while honoring and accommodating the pluralism and curatorial autonomy that has thus far enriched the Museum's holdings, will be a key goal of the present and future staff.

note

1. Kirk Varnedoe, "The Evolving Torpedo: Changing Ideas of the Collection of Paint-ing and Sculpture of The Museum of Mod-ern Art," in *The Museum of Modern Art at Mid-Century: Continuity and Change.* Stud-ies in Modern Art, No. 5 (New York: The Museum of Modern Art, 1995): 12–72.

Note to the Plates

The following plates are arranged chronologically, beginning in 1980. All are works of art in the collection of The Museum of Modern Art and represent acquisitions of contemporary work in the Museum's six curatorial departments: Painting and Sculpture, Drawings, Prints and Illustrated Books, Architecture and Design, Photography, and Film and Video.

• The year in which a work was made or completed is referenced at the bottom of the page next to the page number. The illustrations are accompanied by brief captions for purposes of identification; these give a plate number, the name of the artist, title and date of the work, and an abbreviated medium to indicate at a glance (and sometimes only in a general way) whether a work is a photograph or a film, a drawing or a painting, a print or a multiple, a sculpture or an installation, etc.

• The actual, complete medium of each work is given in the fuller caption in the Checklist of Illustrations on page 541, along with other information. The checklist is organized sequentially according to the disposition of the plates. There the reader will find for each illustrated work the plate number, the full title, series (if applicable), date, medium, and dimensions (in feet and inches, and in centimeters or meters, height before width before depth). For prints, dimensions are given both for plate or composition (comp.) size and sheet size, and the publisher, printer, and edition size are given where relevant. For architecture, inclusive dates represent the period from commission or design to completion; single dates may represent the point at which a drawing or model was made; and "project" indicates that a work is unbuilt. For film and video, a work is represented either by a still, or frame, from the work or a promotional image; and for these the country of origin, type of film, and running length are given. For design objects and multiples, the manufacturer may be given. For series in all mediums, a representative sample of the whole work may be shown; the size of the whole will be indicated in the checklist entry. The final part of most entries is the credit line, which indicates how the work entered the Museum's collection.

• To locate works by particular artists, the reader may consult the Index of Illustrations, on page 555, which lists the works alphabetically by artist and keys them by plate number.

Art at MoMA Since 1980

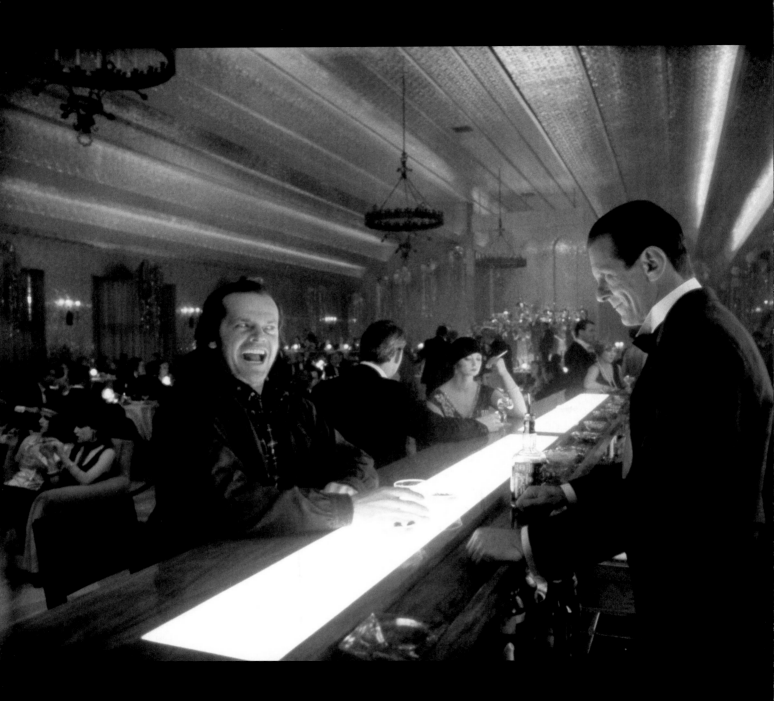

1. **Stanley Kubrick.** The Shining.
1980. Film

opposite:
2. **Cindy Sherman.** Untitled Film
Still #59. 1980. Photograph

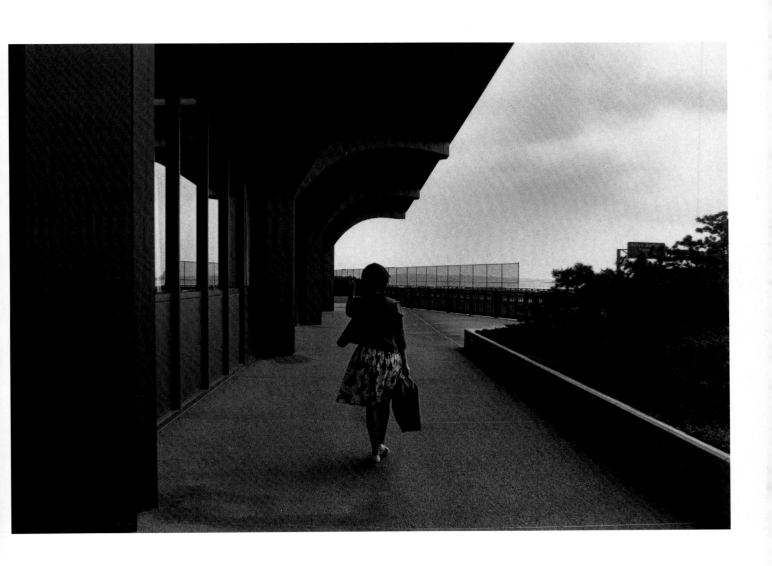

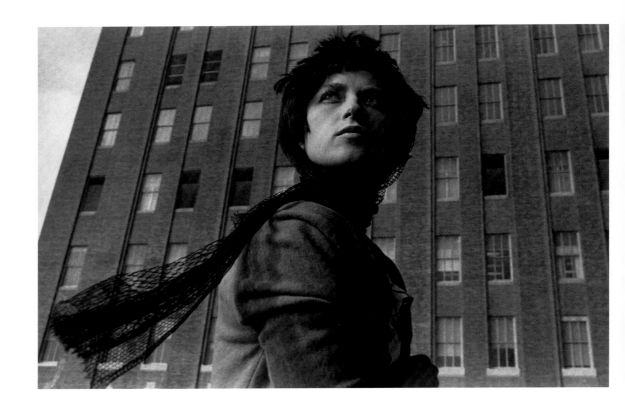

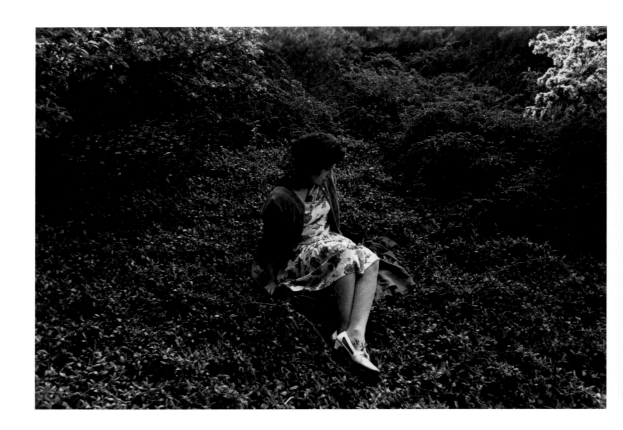

3. Cindy Sherman.
Untitled Film Still #58.
1980. Photograph

4. Cindy Sherman.
Untitled Film Still #57.
1980. Photograph

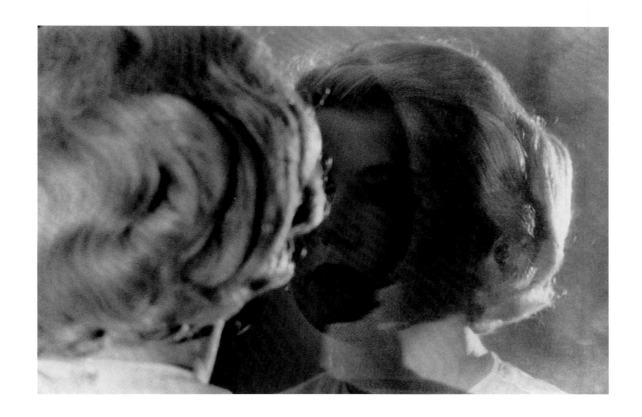

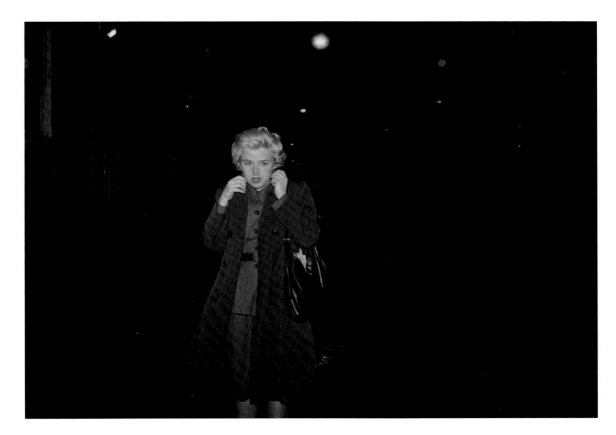

5. Cindy Sherman.
Untitled Film Still #56.
1980. Photograph

6. Cindy Sherman.
Untitled Film Still #54.
1980. Photograph

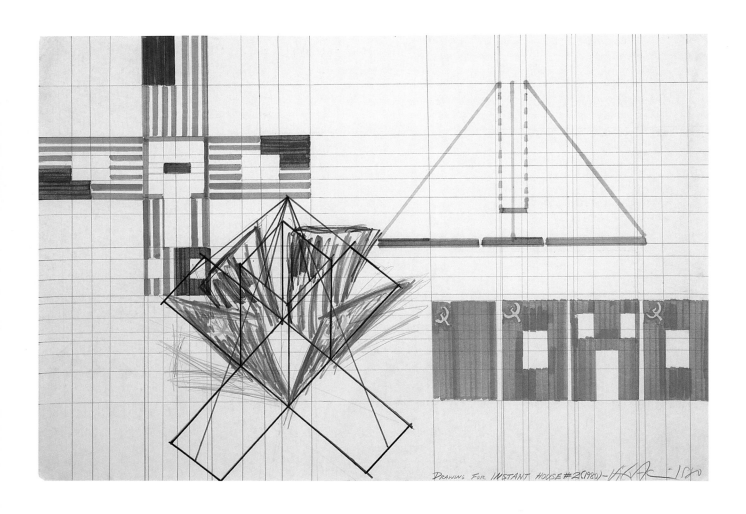

Drawing For INSTANT HOUSE #2(1980)—VACANCI—1980

7. Vito Acconci.
Instant House #2, Drawing.
1980. Drawing

opposite:
8. Vito Acconci.
20 Foot Ladder
for Any Size Wall.
1979–80. Print

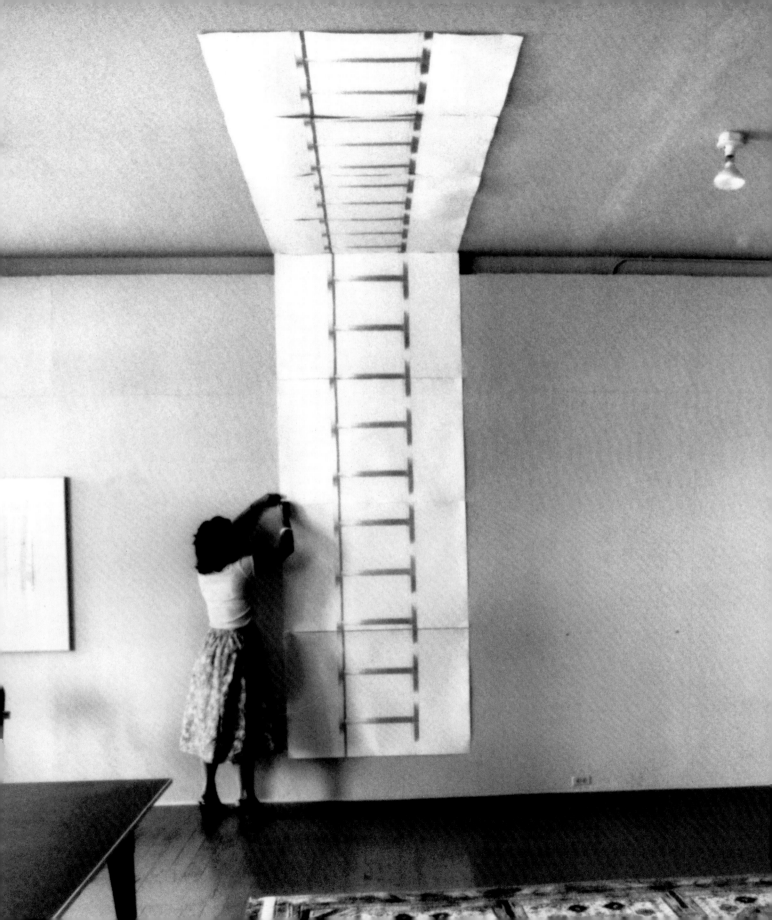

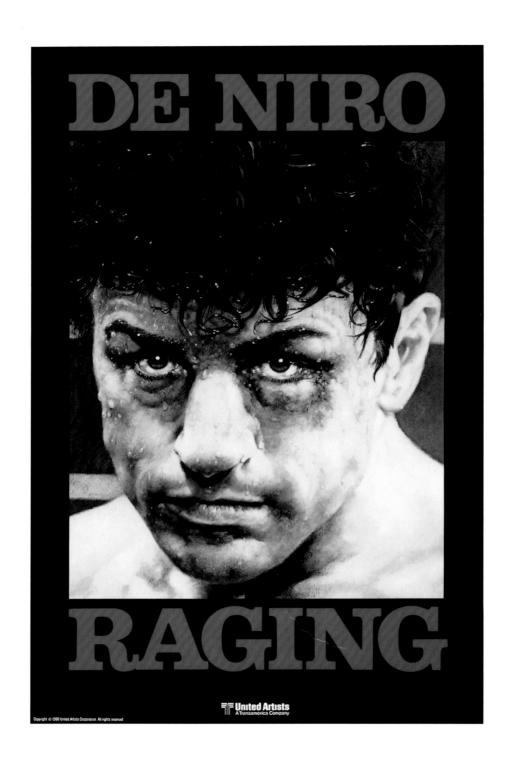

9. Martin Scorsese.
Raging Bull. 1980. Film

opposite:
10. Niklaus Troxler.
McCoy/Tyner/Sextet.
1980. Poster

11. Jean-Luc Godard.
Sauve qui peut (la vie).
1980. Film

12. **Rainer Werner Fassbinder.** Berlin Alexanderplatz. 1980. Film

13. **Lino Brocka.** Bona. 1980. Film

opposite:
14. **John Hejduk.** A.E. Bye House, Ridgefield, Connecticut. Project, 1968–80. Architectural drawing

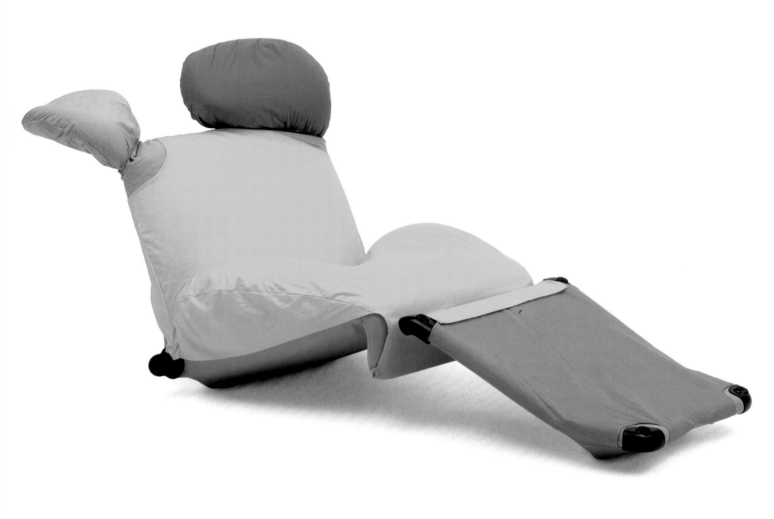

15. Toshiyuki Kita.
Wink Lounge Chair. 1980.
Design

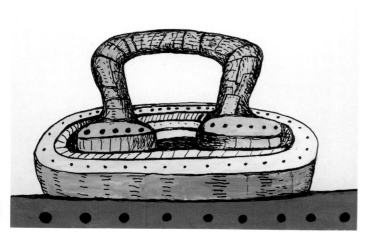

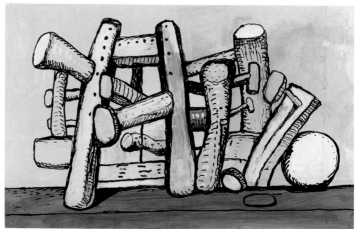

16. Philip Guston.
Untitled. 1980. Drawing

17. Philip Guston.
Untitled. 1980. Drawing

18. Philip Guston.
Untitled. 1980. Drawing

19. Philip Guston.
Untitled. 1980. Drawing

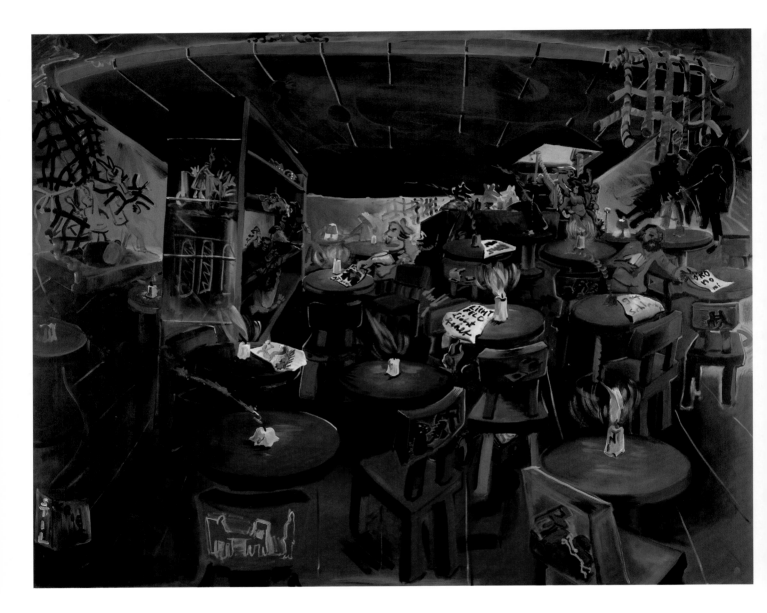

20. Jörg Immendorff.
Cafe Deutschland (Style War).
1980. Painting

opposite:
21. Louis Malle. Atlantic City.
1980. Film

22. Shohei Imamura.
Vengeance Is Mine.
1980. Film

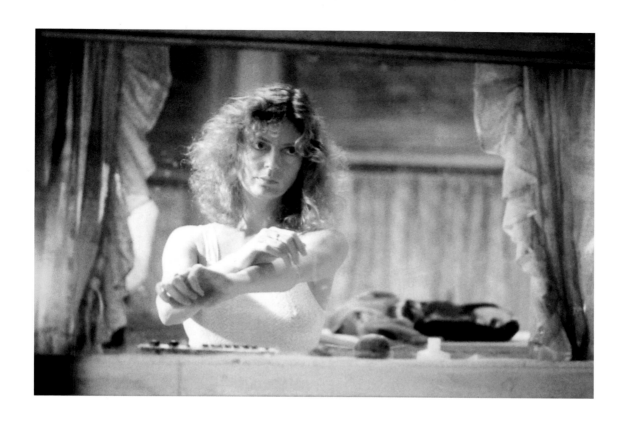

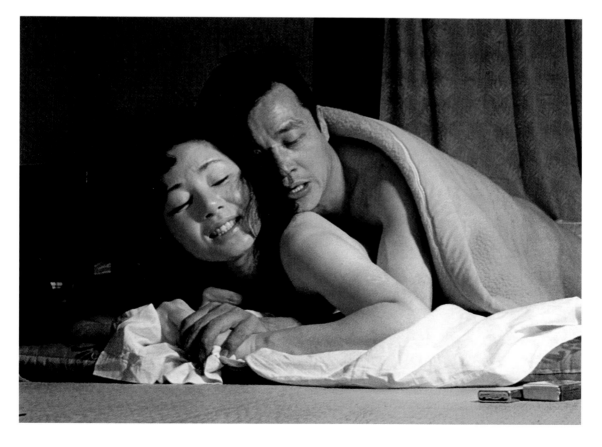

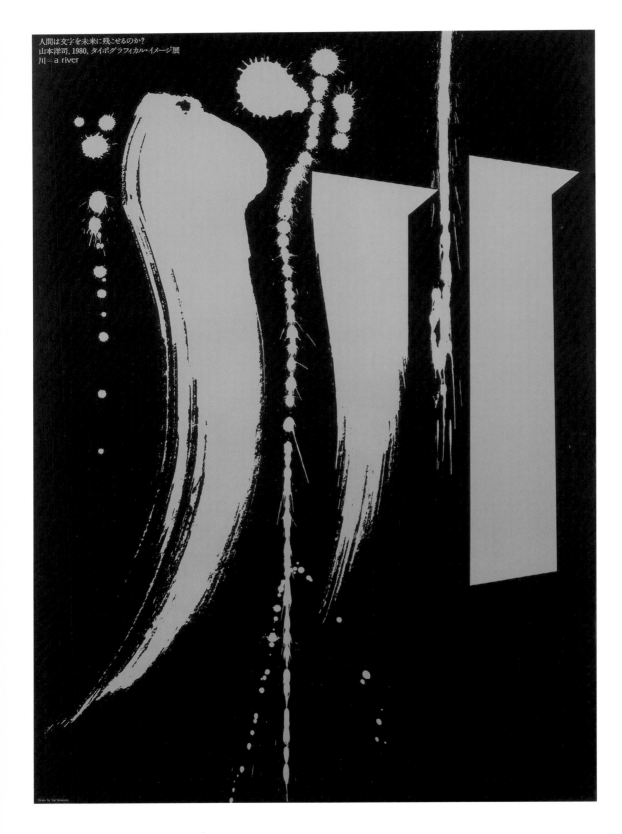

人間は文字を未来に残こせるのか？
山本洋司, 1980、タイポグラフィカル・イメージ展
川＝a river

23. **Yoji Yamamoto.**
A River. 1980. Poster

opposite:
24. **Carlos Diegues.**
Bye Bye Brazil. 1980. Film

25. **Leon Hirszman.**
They Don't Wear Black Tie.
1981. Film

26. **Héctor Babenco.**
Pixote. 1980. Film

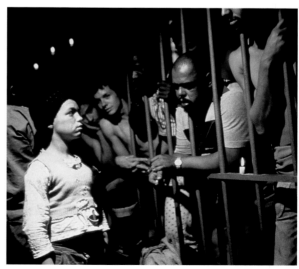

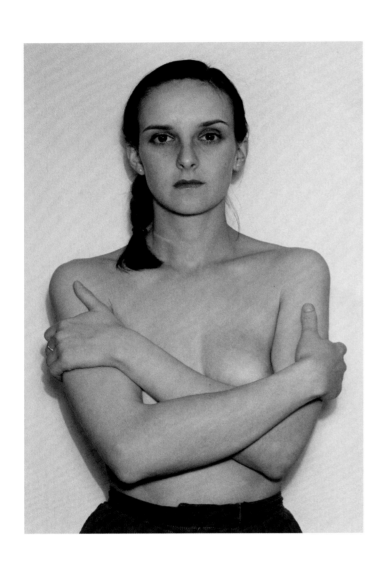

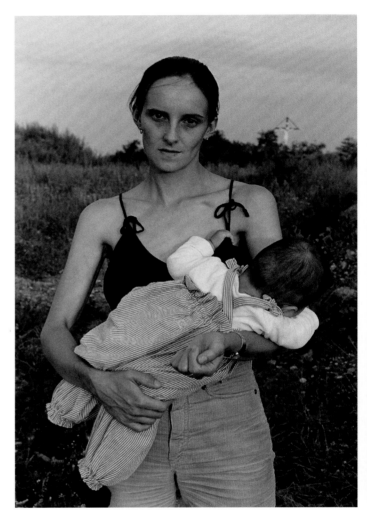

27. Seiichi Furuya.
Graz. 1980. Photograph

28. Seiichi Furuya.
Schattendorf. 1981.
Photograph

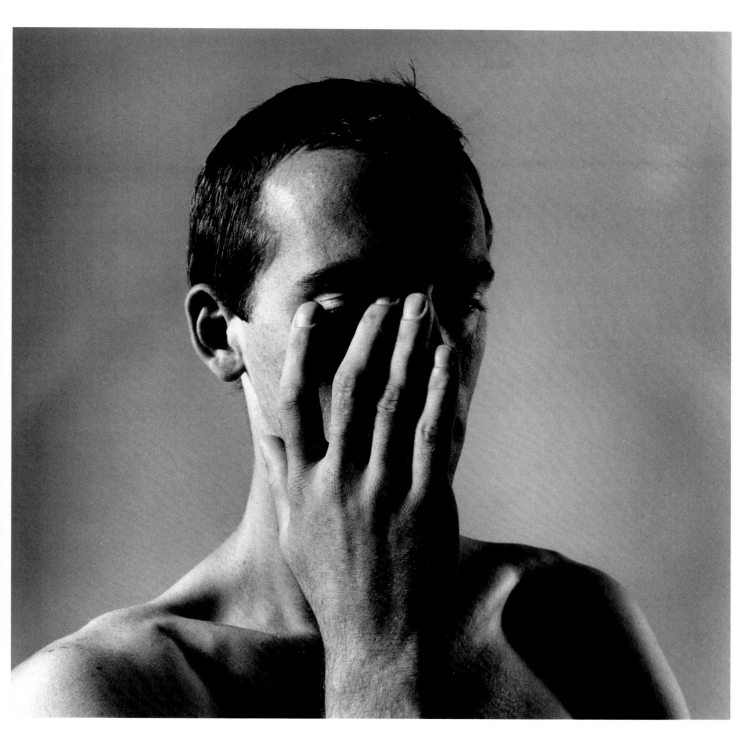

29. Peter Hujar.
Portrait of David
Wojnarowicz. 1981.
Photograph

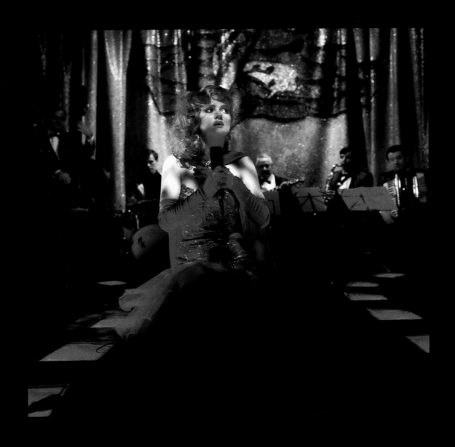

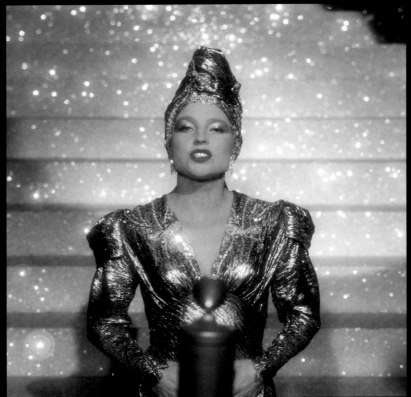

30. Rainer Werner Fassbinder.
Lola. 1981. Film

31. Rainer Werner Fassbinder.
Lili Marleen. 1981. Film

opposite:
32. James Welling. Untitled #46.
May 20, 1981. Photograph

33. Bernard Tschumi.
The Manhattan Transcripts.
Episode 4: The Block.
Project, 1976–81.
Architectural drawings

34. Frank Gohlke.
Aerial View, Downed
Forest near Elk Rock,
Approximately Ten
Miles Northwest of
Mount St. Helens,
Washington. 1981.
Photograph

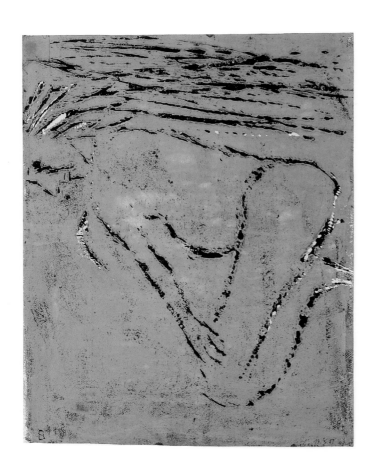

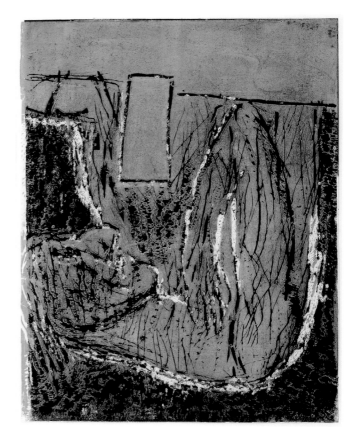

35. Georg Baselitz.
Woman on the Beach.
1981. Print

36. Georg Baselitz.
Drinker. 1981. Print

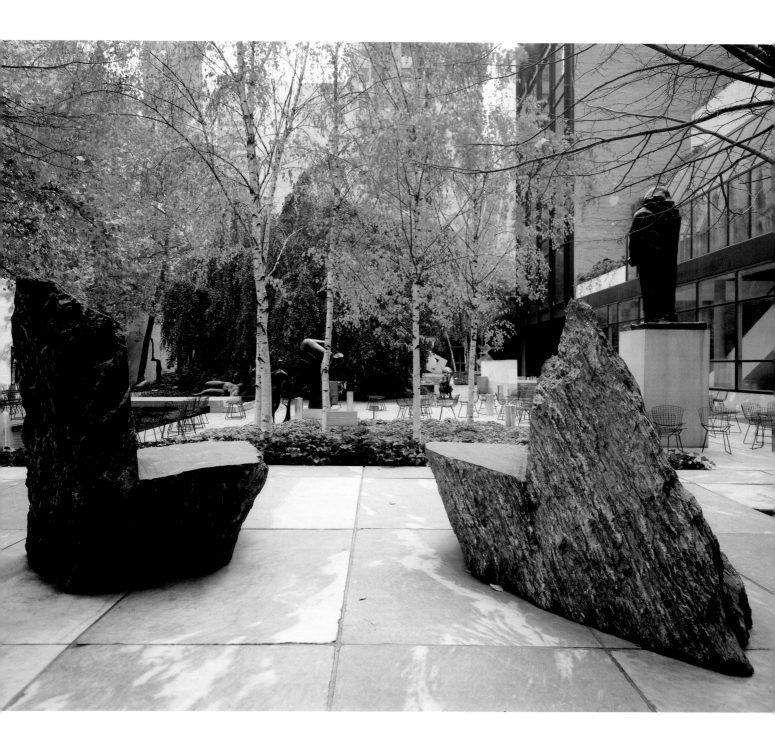

37. Scott Burton.
Pair of Rock Chairs.
1980–81. Sculpture

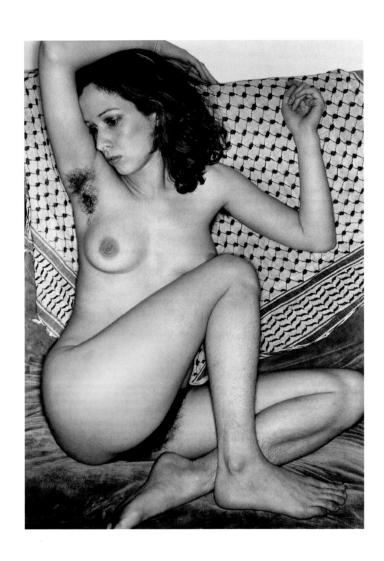

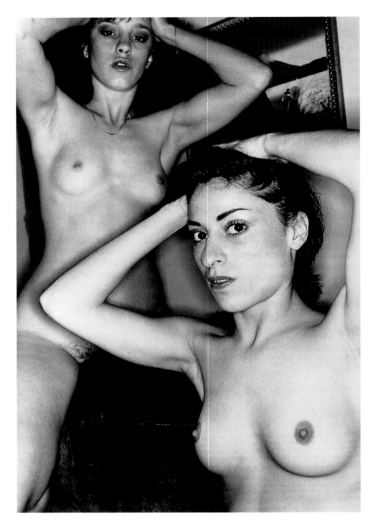

38. Lee Friedlander.
Untitled. 1980. Photograph

39. Lee Friedlander.
Untitled. 1980. Photograph

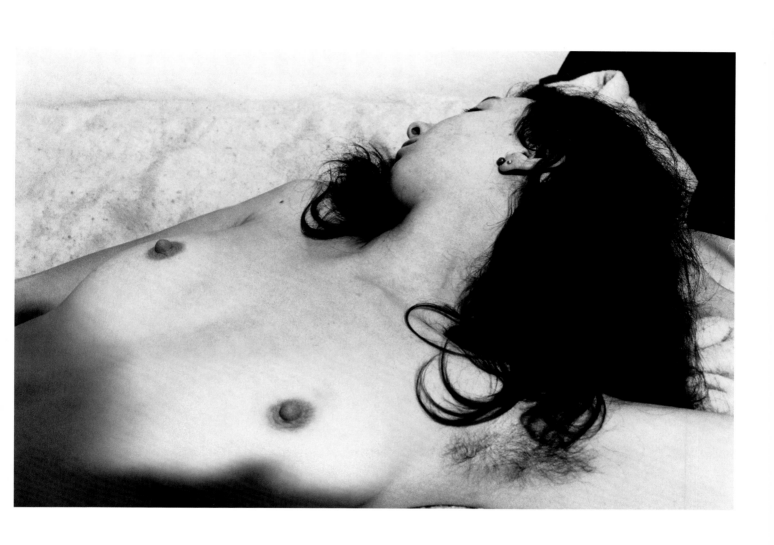

40. Lee Friedlander.
Untitled. 1981. Photograph

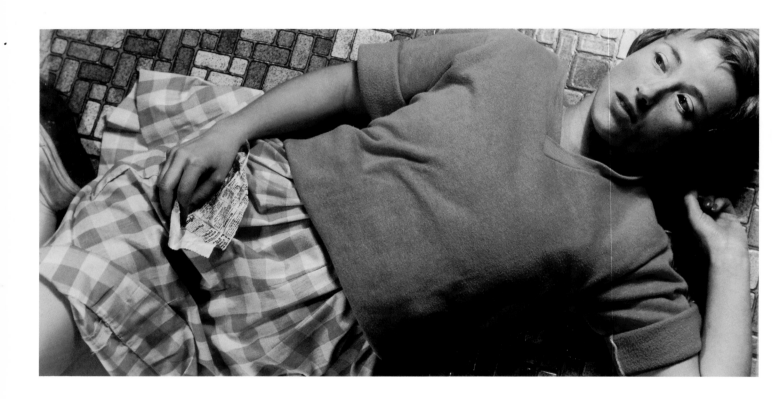

41. Cindy Sherman.
Untitled #96. 1981.
Photograph

opposite:
42. Willem de Kooning.
Pirate (Untitled II). 1981.
Painting

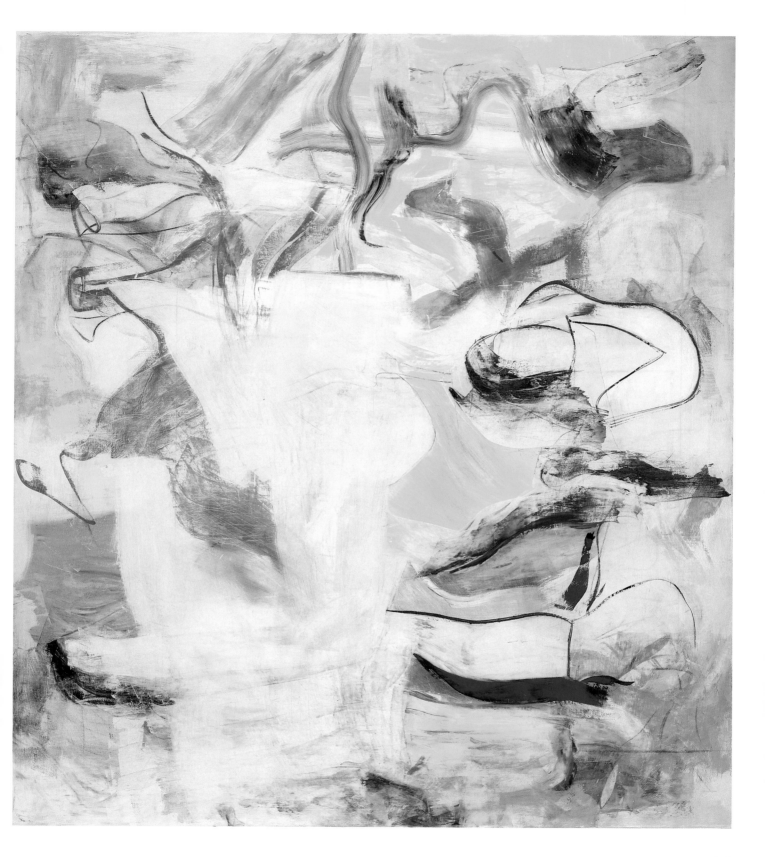

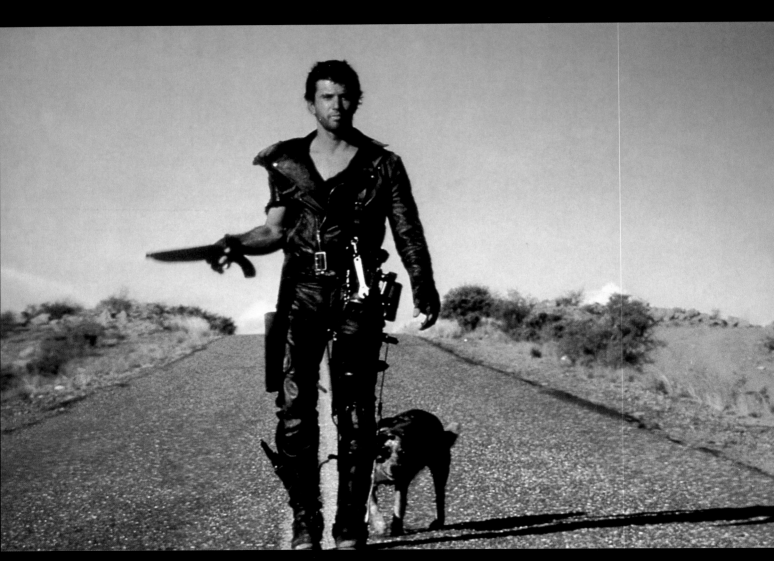

43. George Miller.
Mad Max 2 (The Road
Warrior). 1981. Film

opposite:
**44. A. R. Penck
(Ralf Winkler).**
Nightvision. 1982.
Print

45. Andrzej Pagowski.
Wolf's Smile (Usmiech Wilka).
1982. Poster

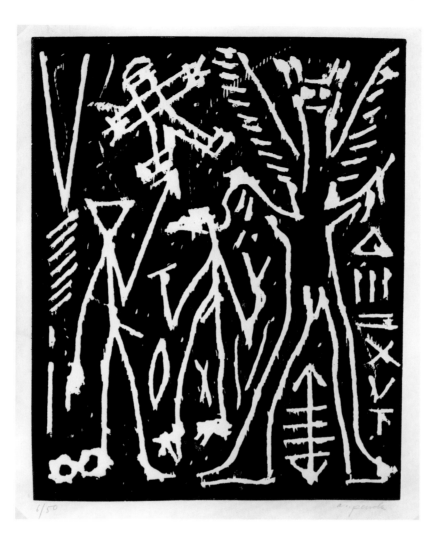

6/50

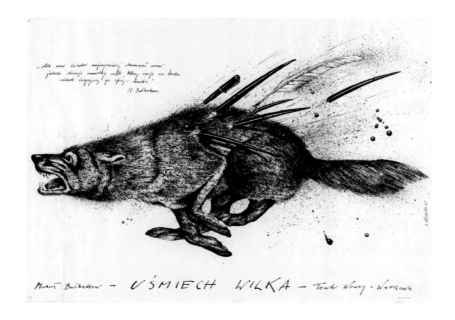

Michał Bułhakow — UŚMIECH WILKA — Teatr Nowy · Warszawa

46. **Vija Celmins.**
Alliance. 1982. Print

opposite:
47. **Werner Herzog.**
Fitzcarraldo. 1982. Film

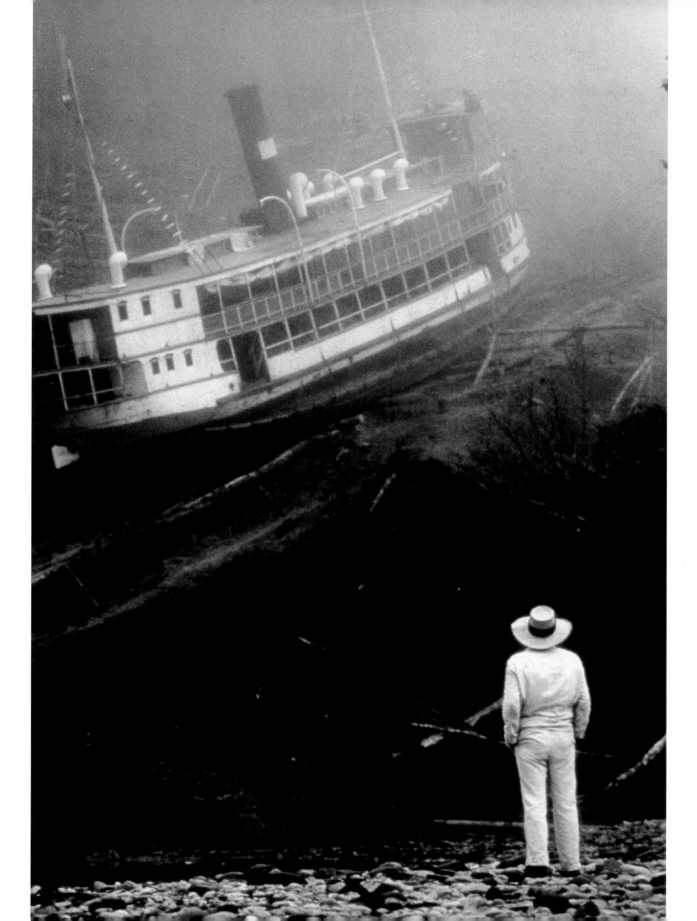

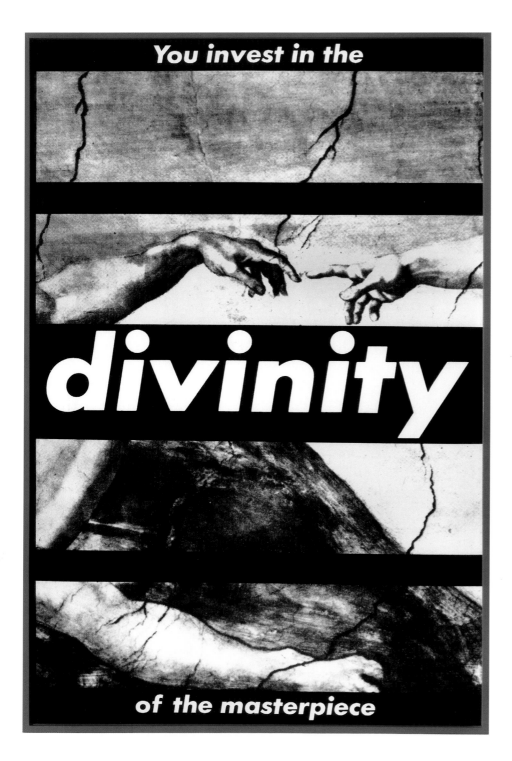

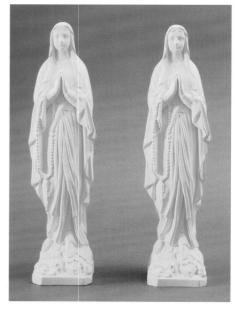

48. Barbara Kruger.
Untitled (You Invest in the
Divinity of the Masterpiece).
1982. Painting

49. Katharina Fritsch.
Madonna. 1982. Multiples

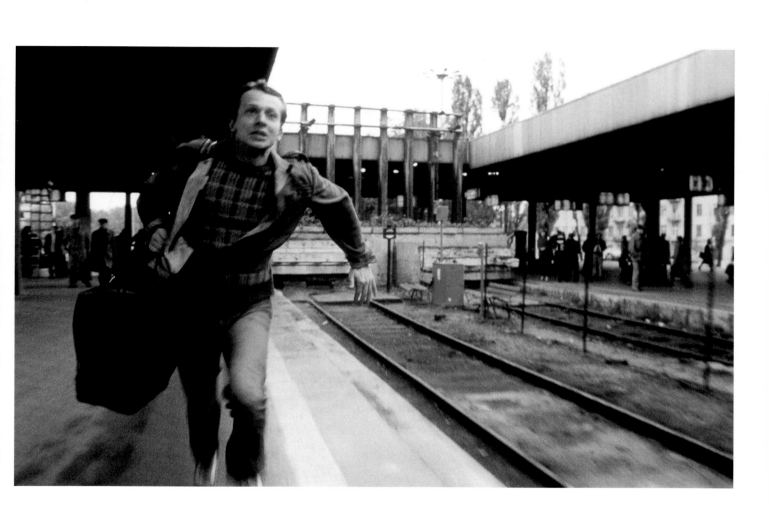

50. Krzysztof Kieslowski.
Blind Chance. 1982. Film

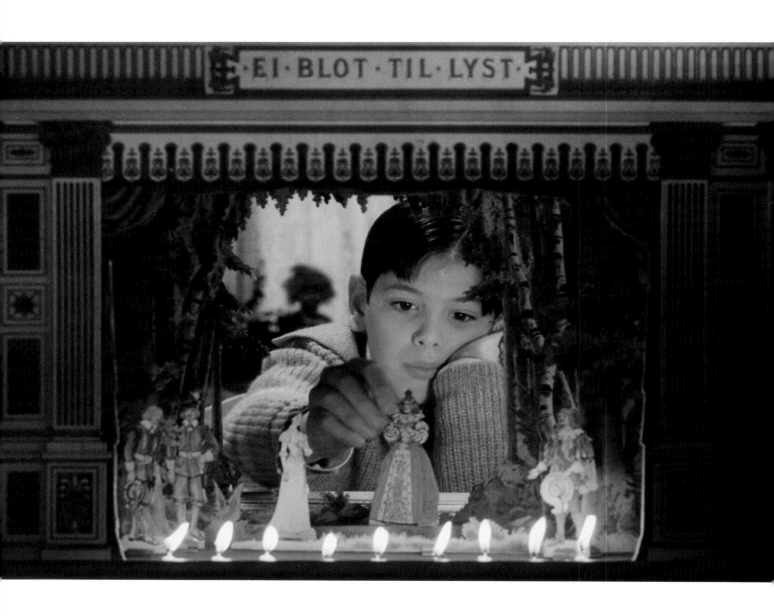

51. Ingmar Bergman.
Fanny and Alexander.
1982. Film

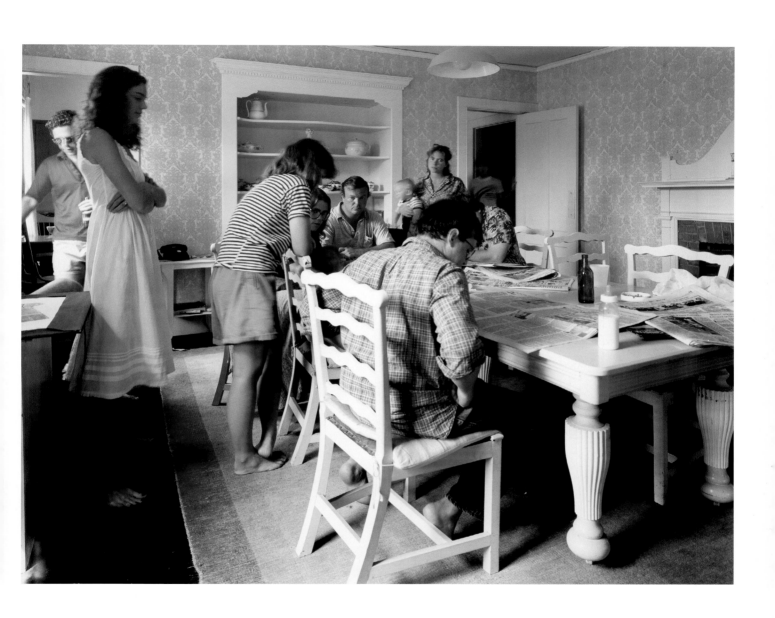

52. Tina Barney.
Sunday New York Times.
1982. Photograph

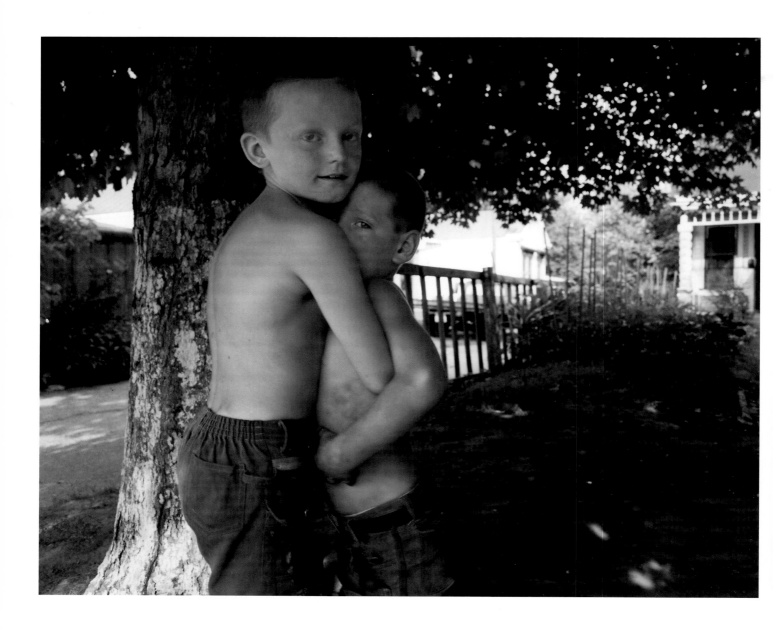

53. Nicholas Nixon.
Chestnut Street, Louisville,
Kentucky. 1982. Photograph

opposite:
54. Judith Joy Ross.
Untitled from Eurana Park,
Weatherly, Pennsylvania.
1982. Photograph

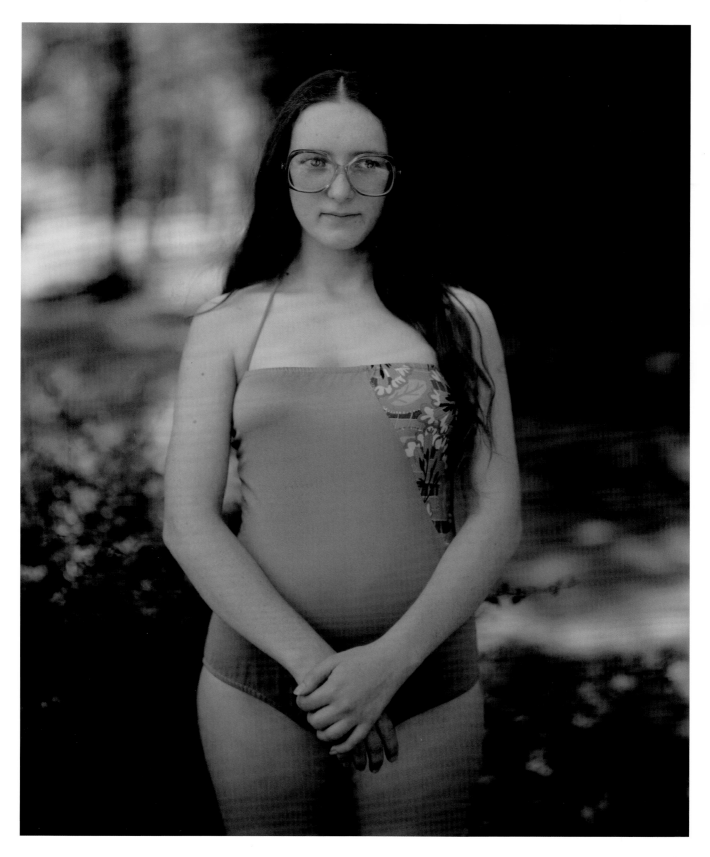

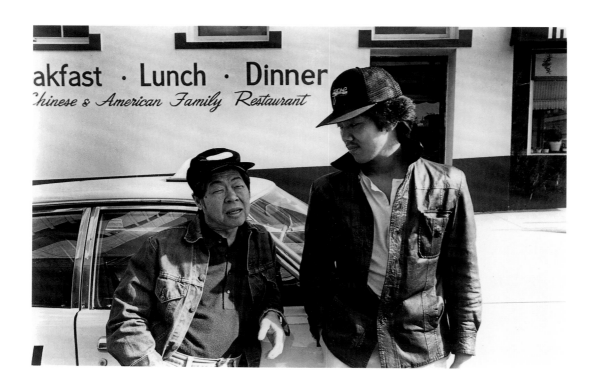

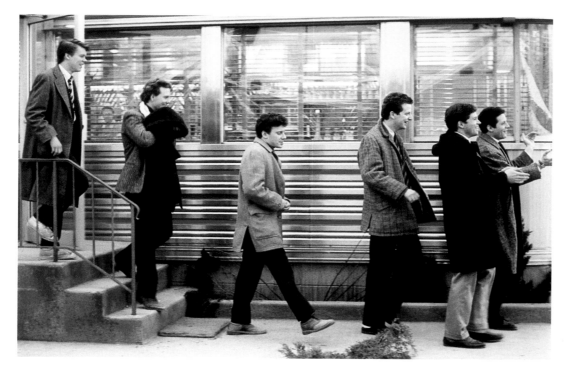

55. **Wayne Wang.**
Chan Is Missing.
1982. Film

56. **Barry Levinson.**
Diner. 1982. Film

opposite:
57. **Uwe Loesch.**
Point (Punktum).
1982. Poster

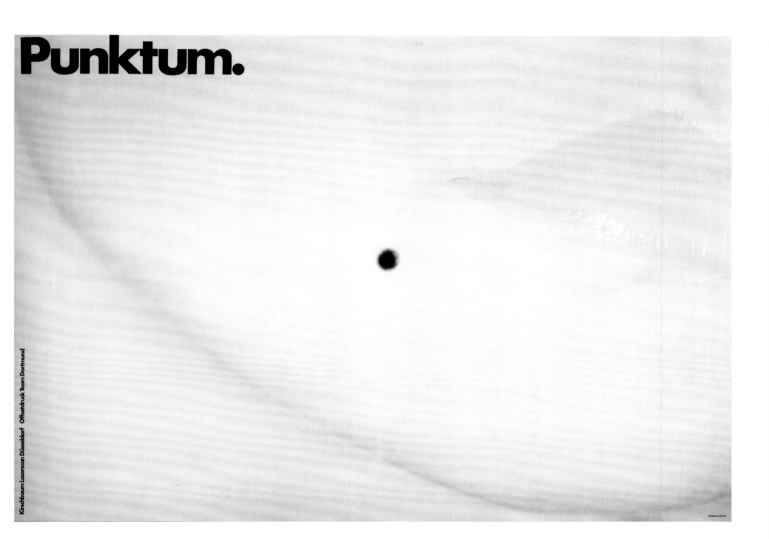

Punktum.

Kirschbaum Lasercom Düsseldorf Offsetdruck Team Dortmund

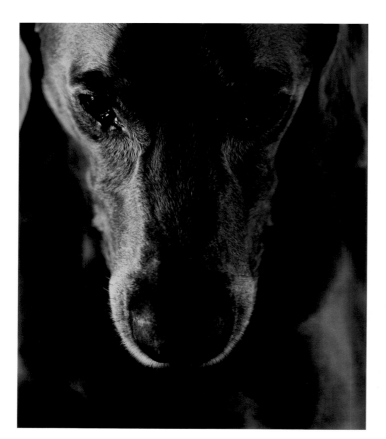

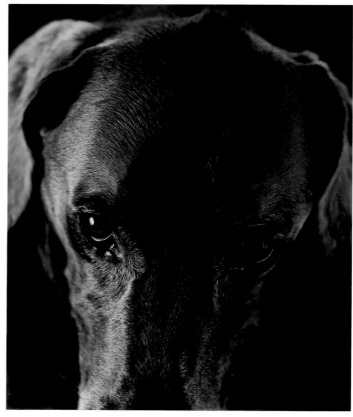

58. **William Wegman.**
Blue Head. 1982.
Photographs

opposite:
59. **Paul Rand.**
IBM. 1982. Poster

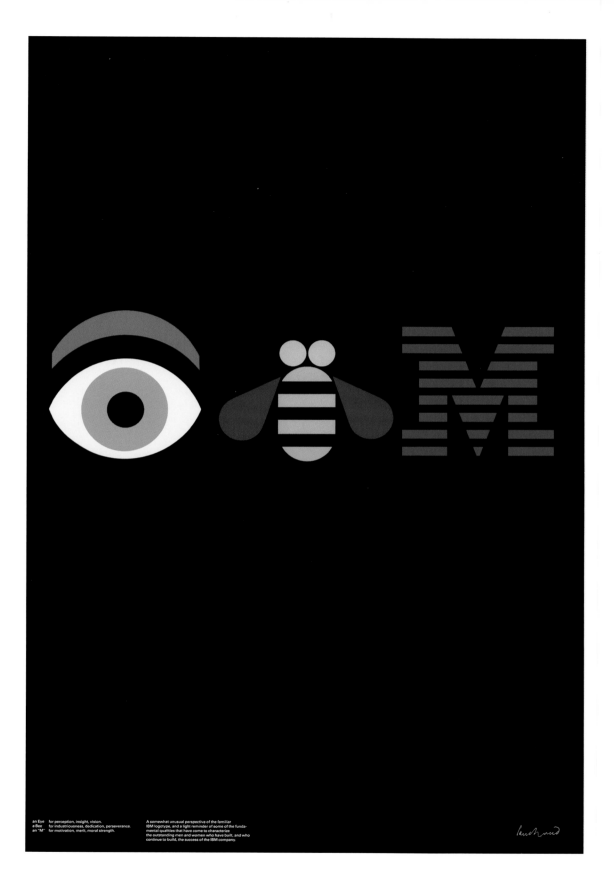

an Eye for perception, insight, vision.
a Bee for industriousness, dedication, perseverance.
an "M" for motivation, merit, moral strength.

A somewhat unusual perspective of the familiar
IBM logotype, and a light reminder of some of the funda-
mental qualities that have come to characterize
the outstanding men and women who have built, and who
continue to build, the success of the IBM company.

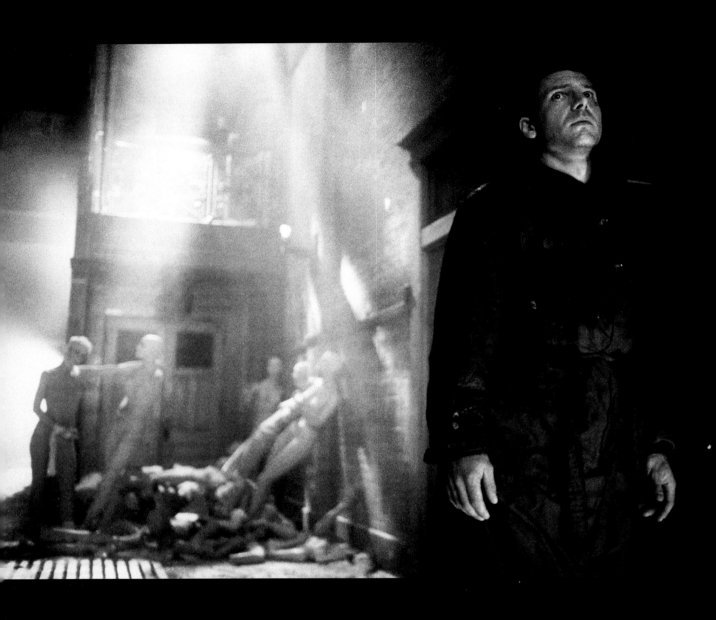

60. Ridley Scott.
Blade Runner. 1982. Film

opposite:
61. Joan Fontcuberta.
Guillumeta Polymorpha.
1982. Photograph

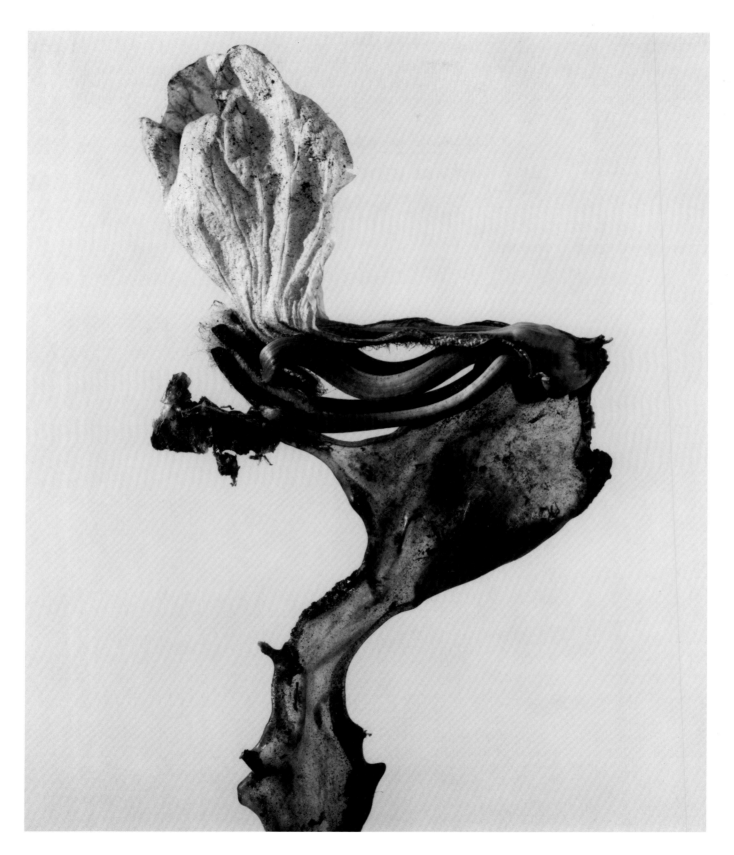

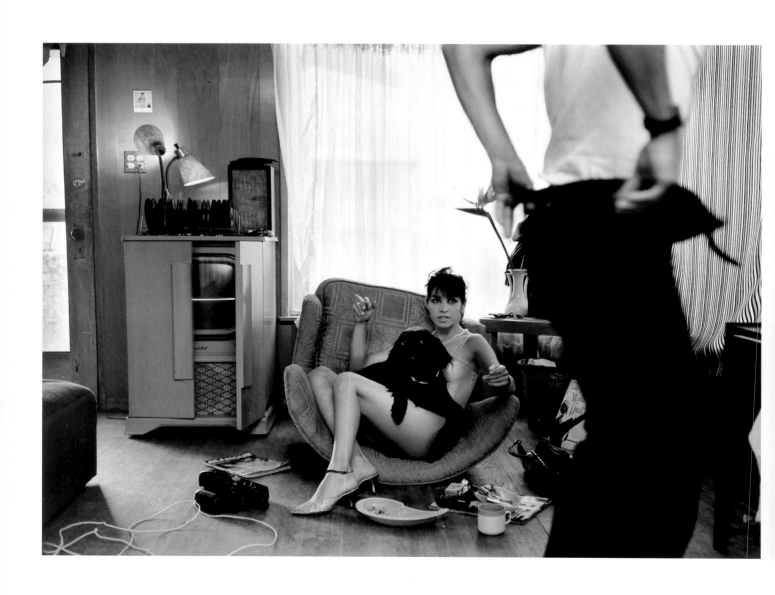

62. Philip-Lorca diCorcia.
Mary and Babe. 1982. Photograph

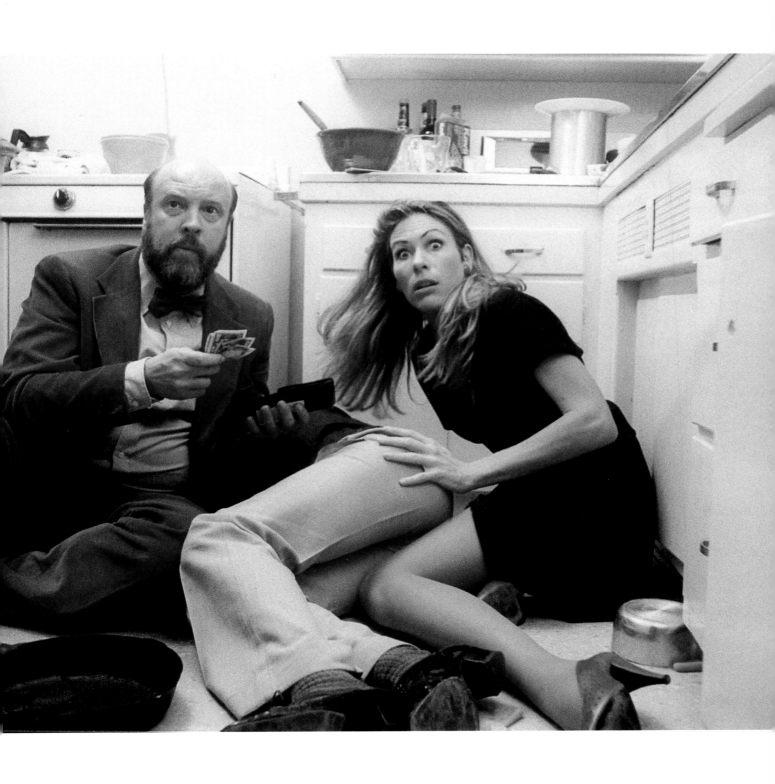

63. Paul Bartel.
Eating Raoul. 1982. Film

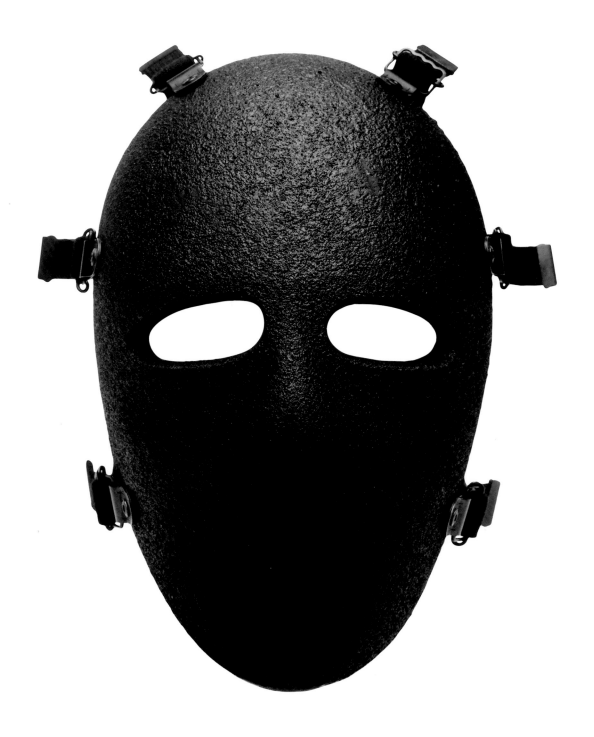

64. Stephen Armellino.
Bullet-Resistant Mask.
1983. Design

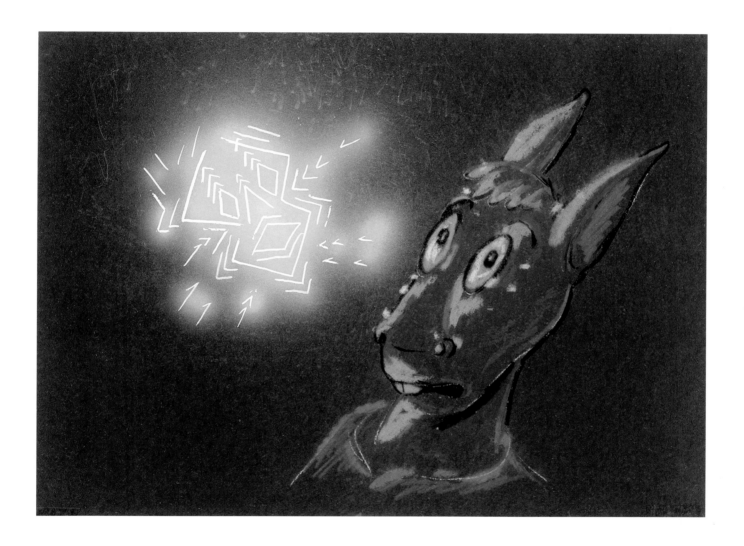

65. John Canemaker.
Bottom's Dream. 1983.
Animated film

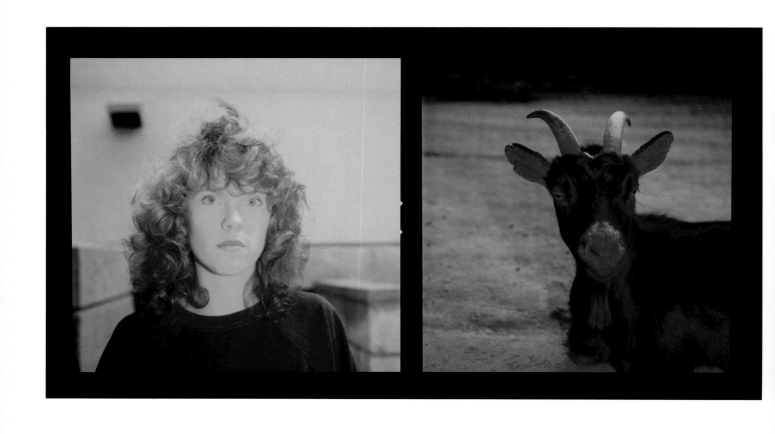

66. John Divola.
Untitled. 1983.
Photograph

opposite:
67. Jannis Kounellis.
Untitled. 1983.
Sculpture

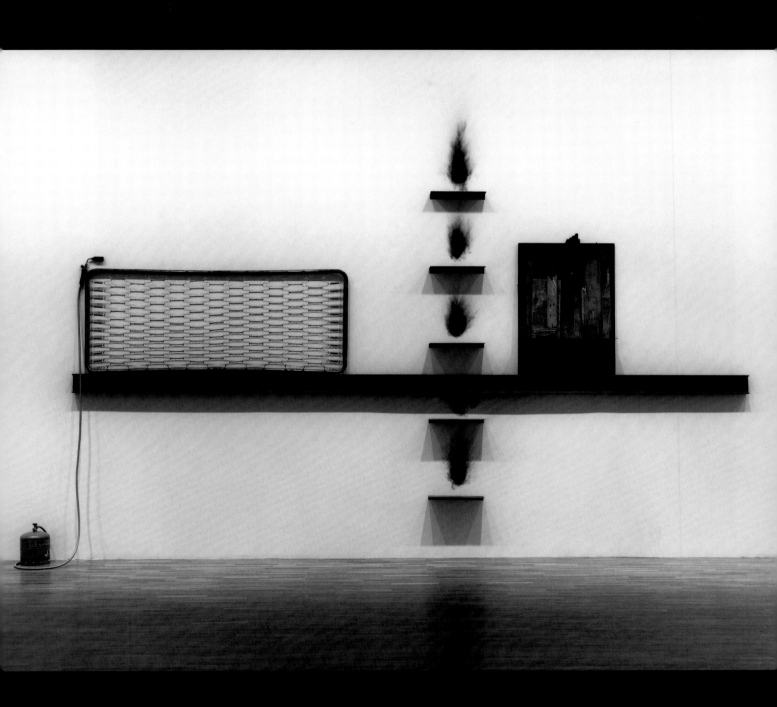

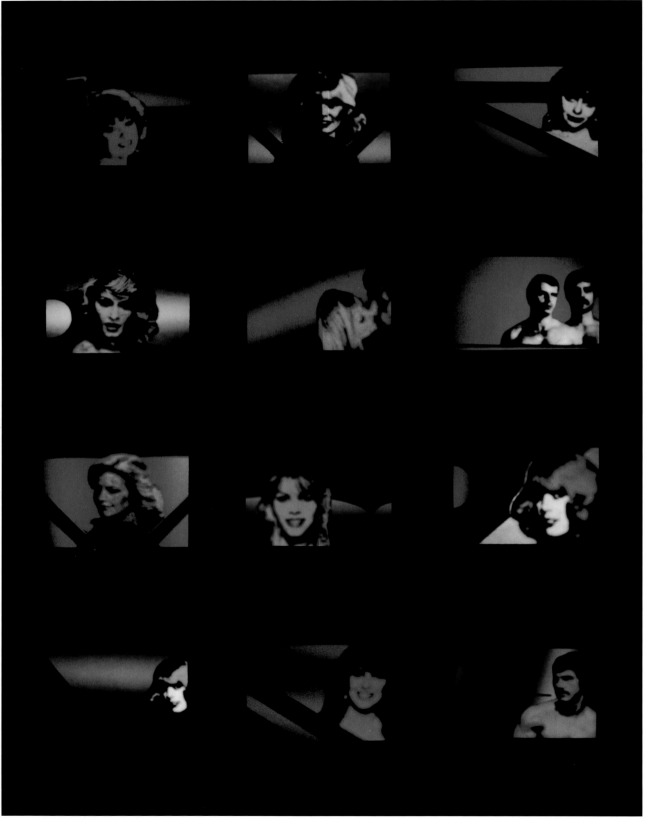

68. Richard Prince.
Entertainers.
1982–83.
Photograph

opposite:
69. Woody Allen.
Zelig. 1983. Film

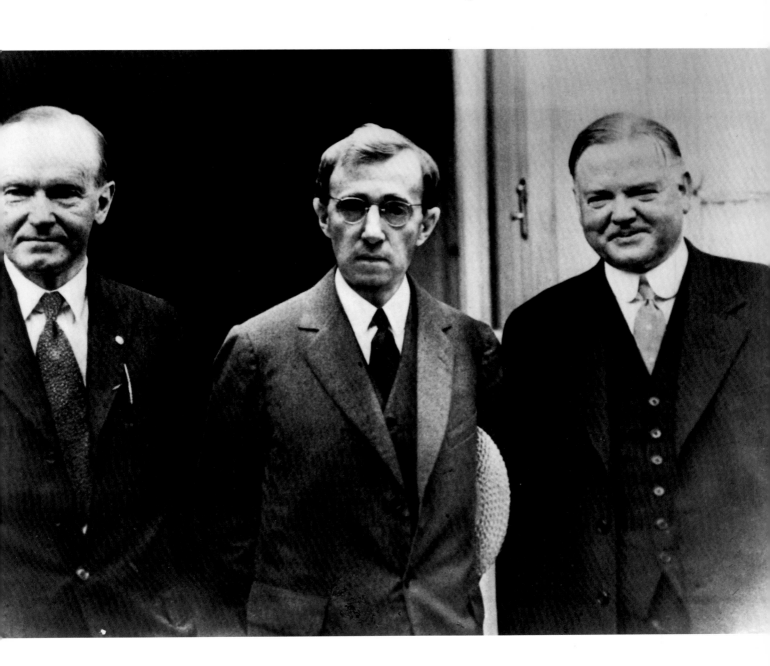

70. Terry Jones and Terry Gilliam.
Monty Python's The Meaning of Life.
1983. Film

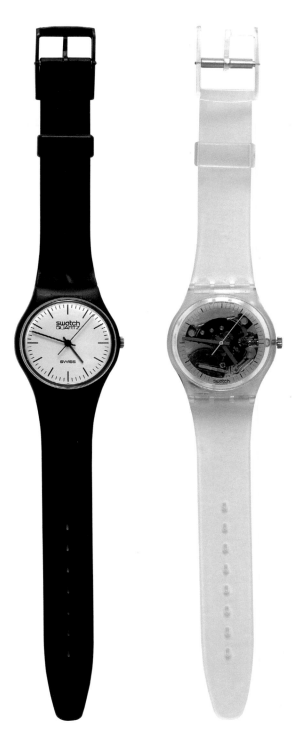

71. Swatch.
GB 001 Watch.
1983. Design

72. Swatch.
GK 100 Jellyfish Watch.
1983. Design

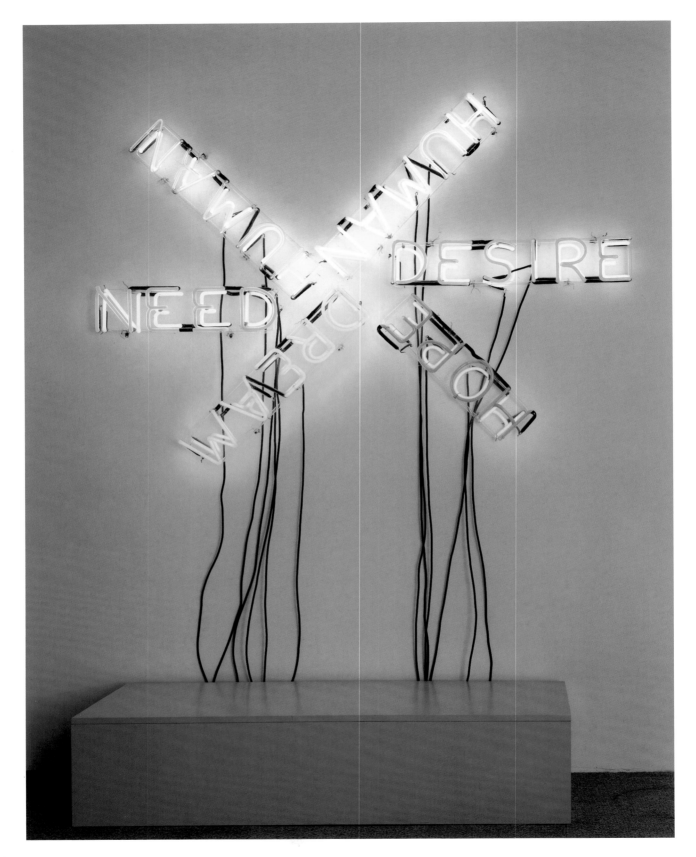

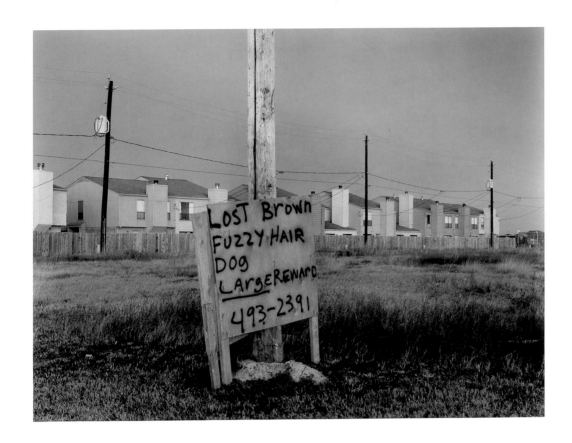

74. Joel Sternfeld.
Houston, Texas. 1983.
Photograph

75. Joel Sternfeld.
Canyon Country, California.
1983. Photograph

opposite:
73. Bruce Nauman.
Human/Need/Desire.
1983. Sculpture

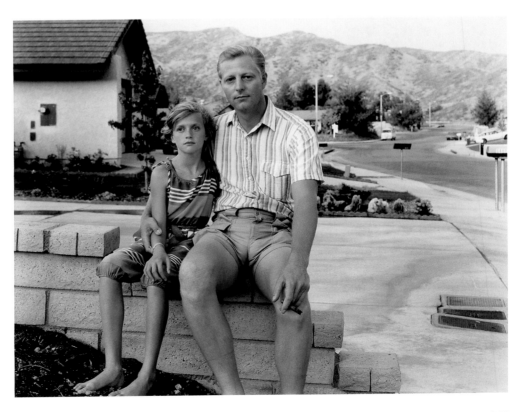

**76. Kathryn Bigelow and
Monty Montgomery.**
Breakdown (The Loveless).
1983. Film

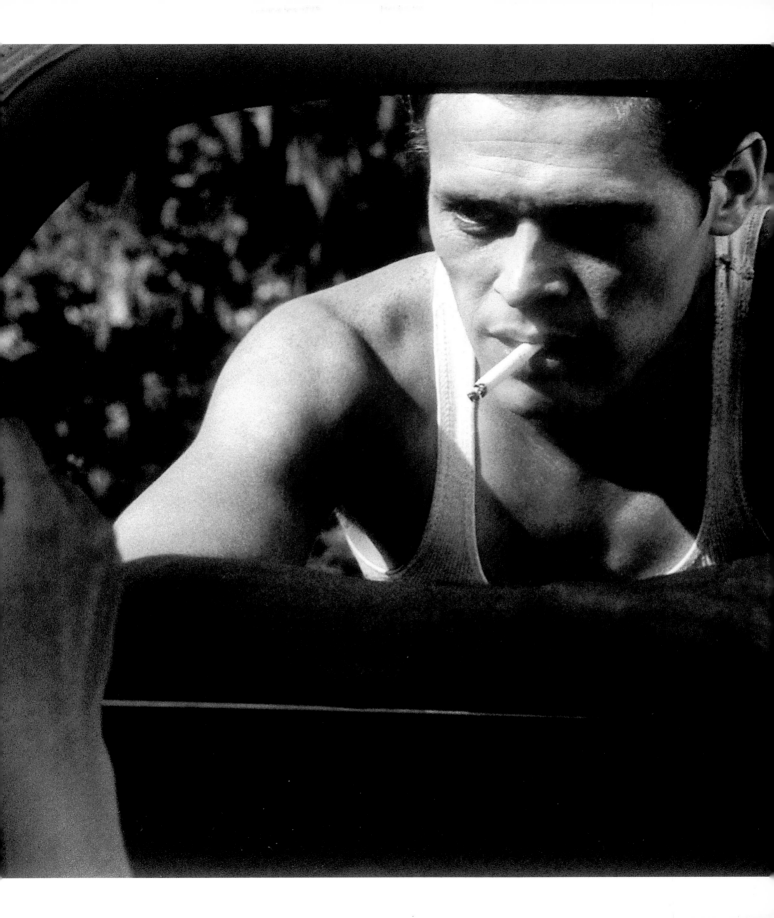

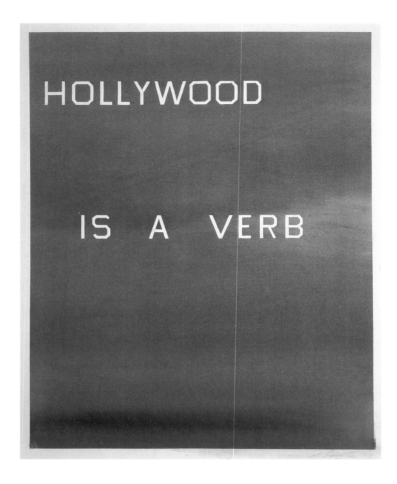

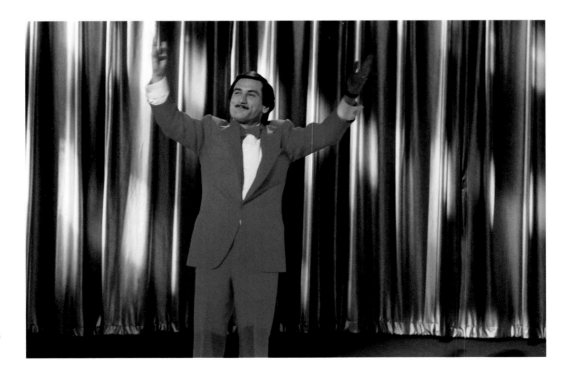

77. Edward Ruscha.
Hollywood Is a Verb.
1983. Drawing

78. Martin Scorsese.
The King of Comedy.
1983. Film

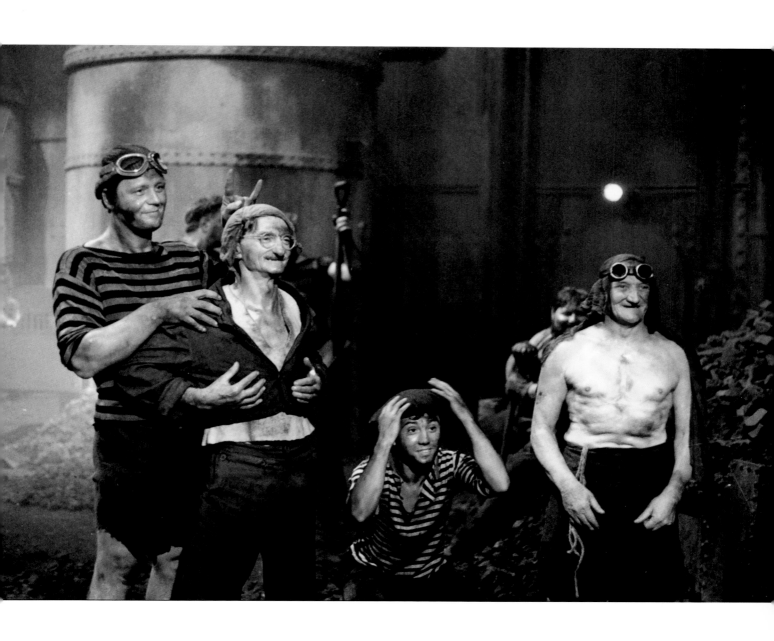

79. Federico Fellini.
And the Ship Sails On.
1983. Film

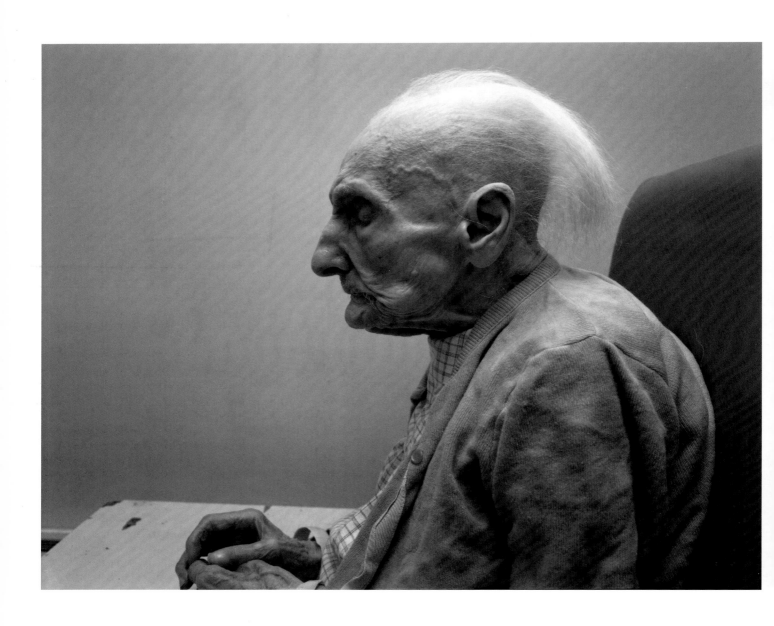

80. Nicholas Nixon.
C.C., Boston. 1983.
Photograph

opposite:
81. Anselm Kiefer.
Der Rhein. 1983.
Illustrated book

87. Mazda Motor Corporation.
MX5 Miata Automobile Taillights.
1983. Design

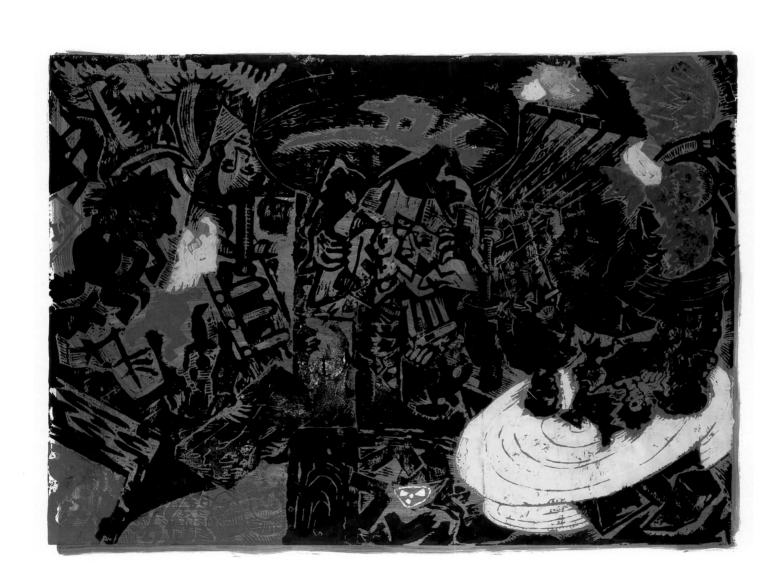

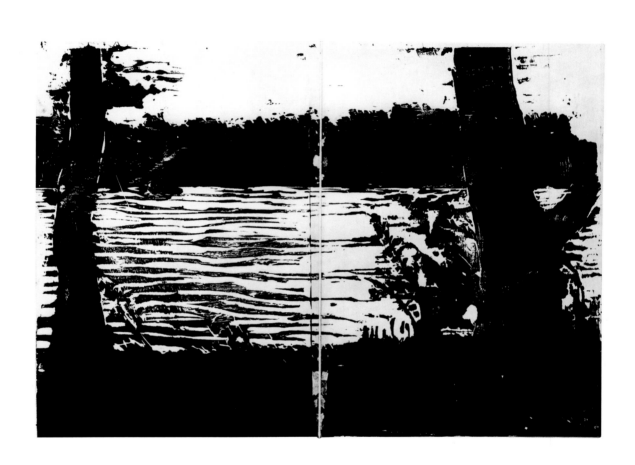

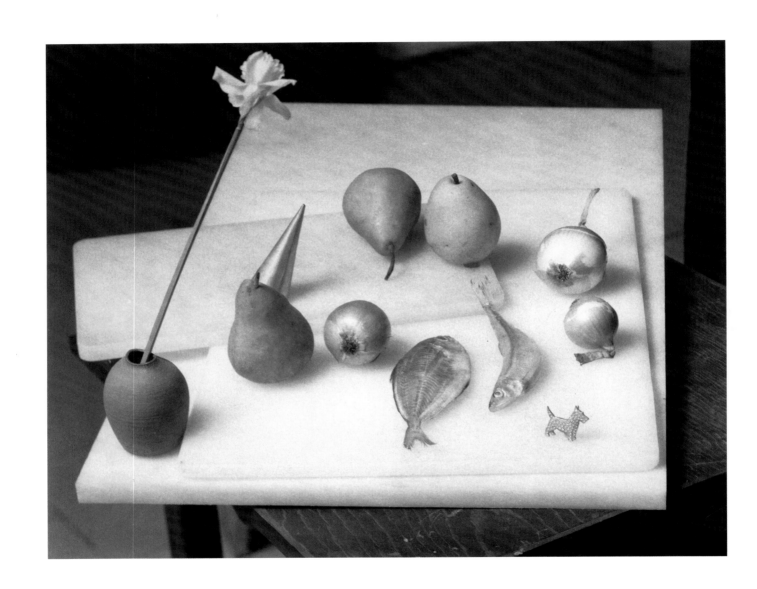

82. Jan Groover.
Untitled. 1983.
Photograph

opposite:
83. Francesco Clemente.
Conversion to Her. 1983.
Painting

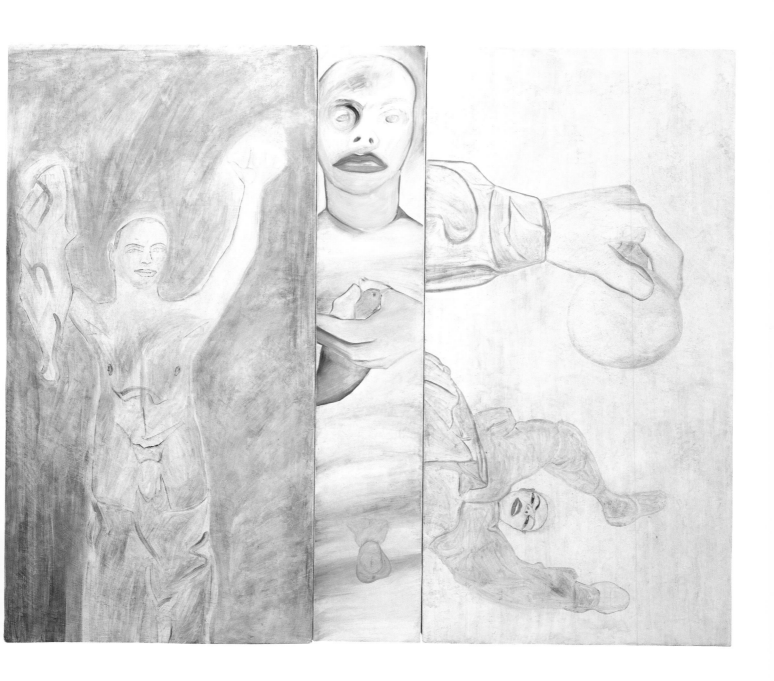

1 9 8 3 | 83

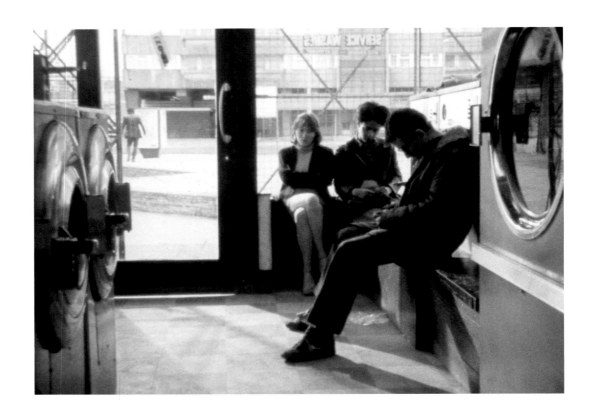

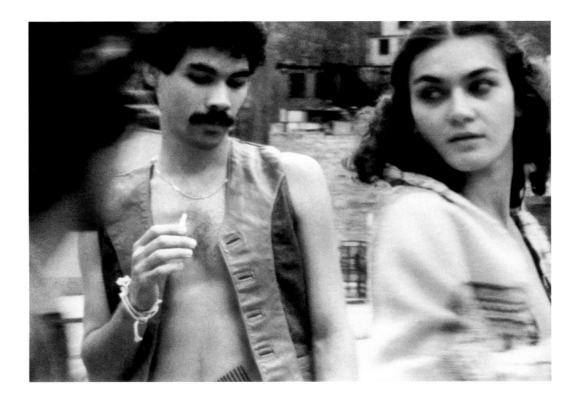

84. **Mike Leigh.**
Meantime. 1983. Film

85. **Lizzie Borden.**
Born in Flames. 1983. Film

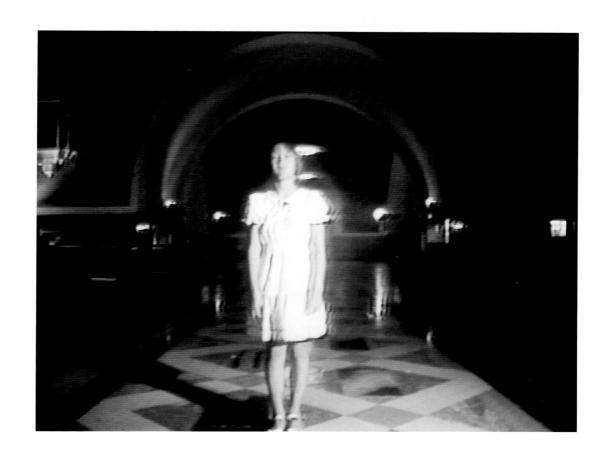

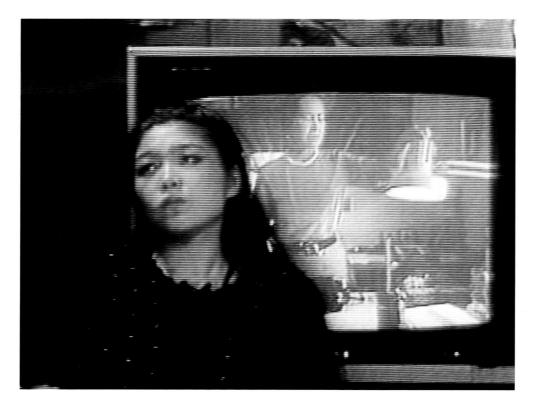

88. Bill Viola.
Anthem. 1983. Video

89. Mako Idemitsu.
Great Mother Part II: Yumiko.
1983. Video

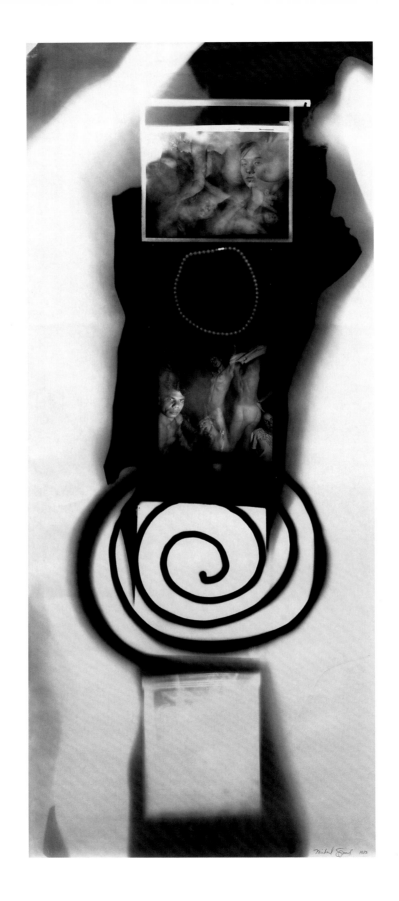

90. Michael Spano.
Photogram—Michael Spano.
1983. Photograph

opposite:
91. Jonathan Borofsky.
Stick Man. 1983. Print

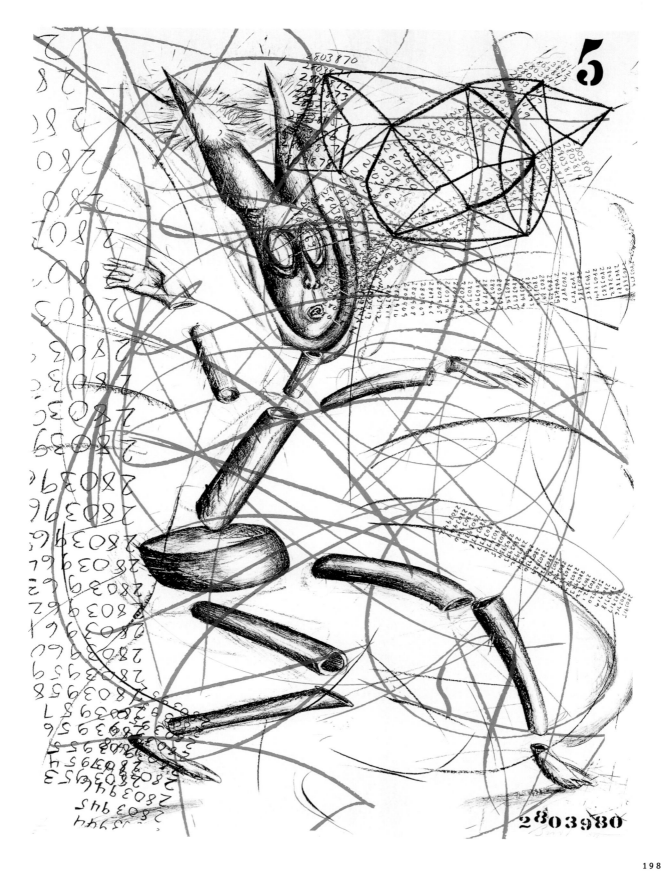

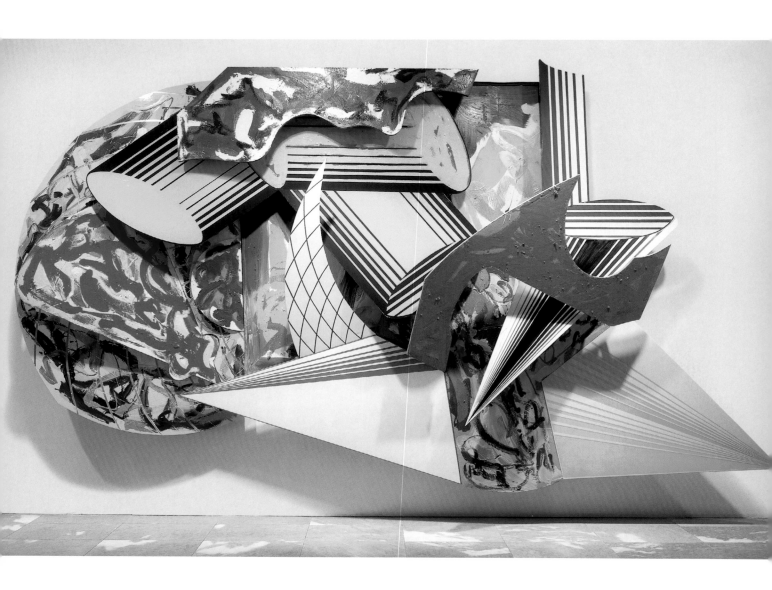

92. Frank Stella.
Giufà, la luna, i ladri e le guardie.
1984. Painting

opposite:
93. Sigmar Polke.
Watchtower. 1984. Painting

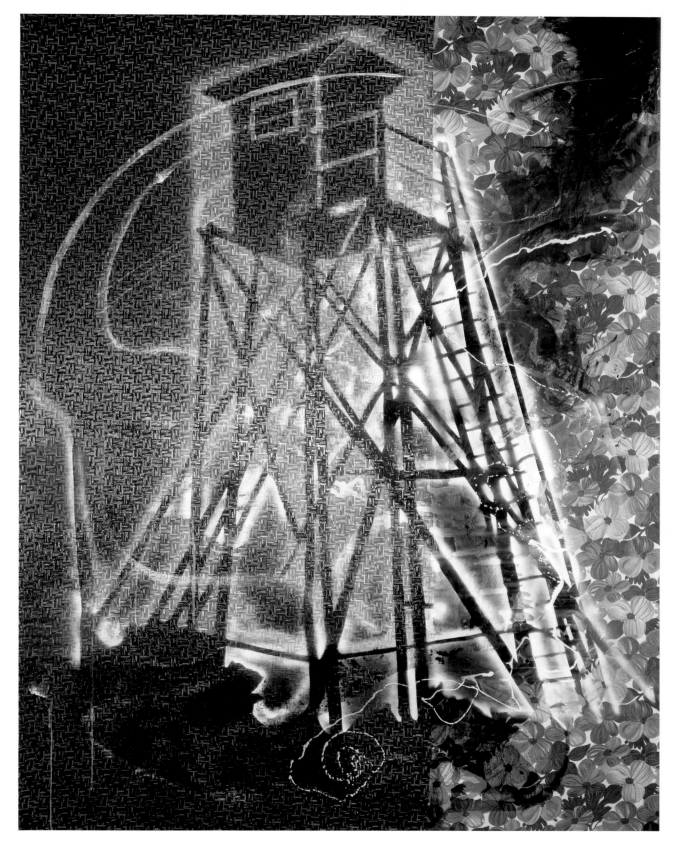

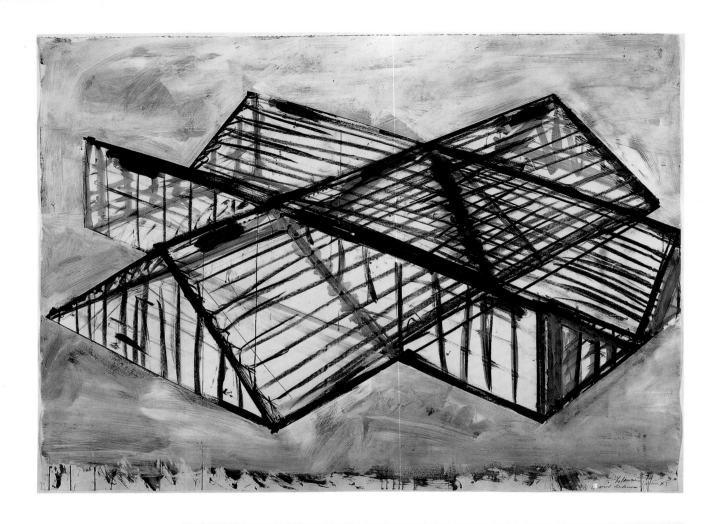

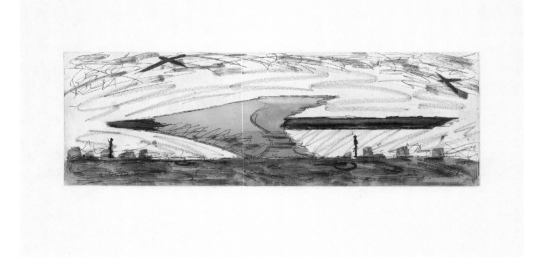

94. Bruce Nauman.
Crossed Stadiums. 1984.
Drawing

95. Claes Oldenburg.
Proposal for a Monument to
the Survival of the University
of El Salvador: Blasted Pencil
(That Still Writes). 1984. Print

opposite:
96. Sergio Leone.
Once upon a Time in America.
1984. Film

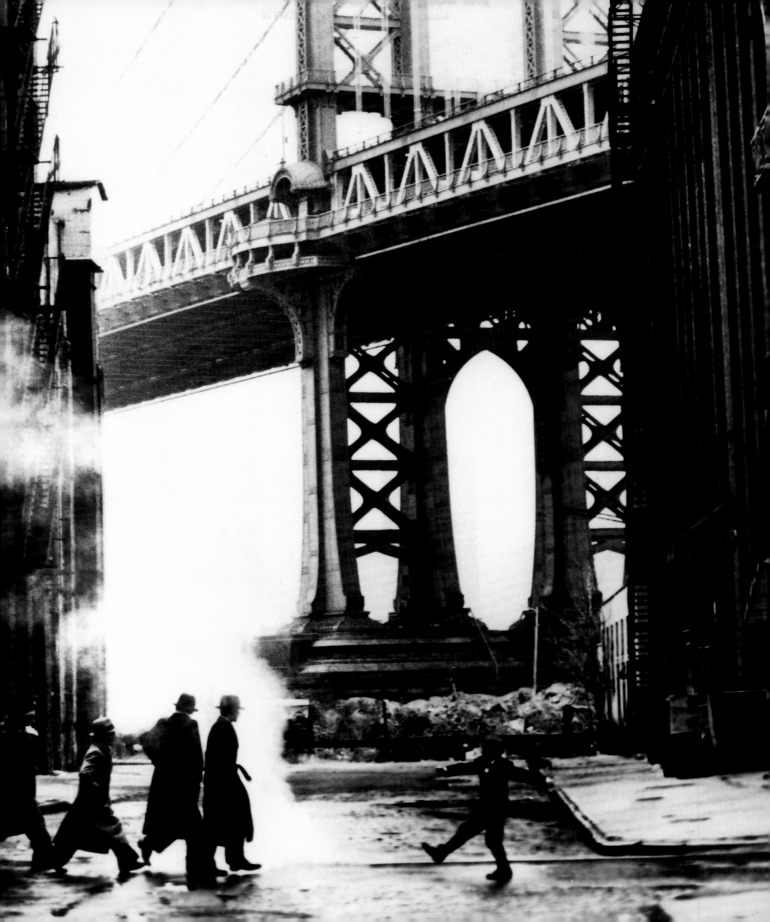

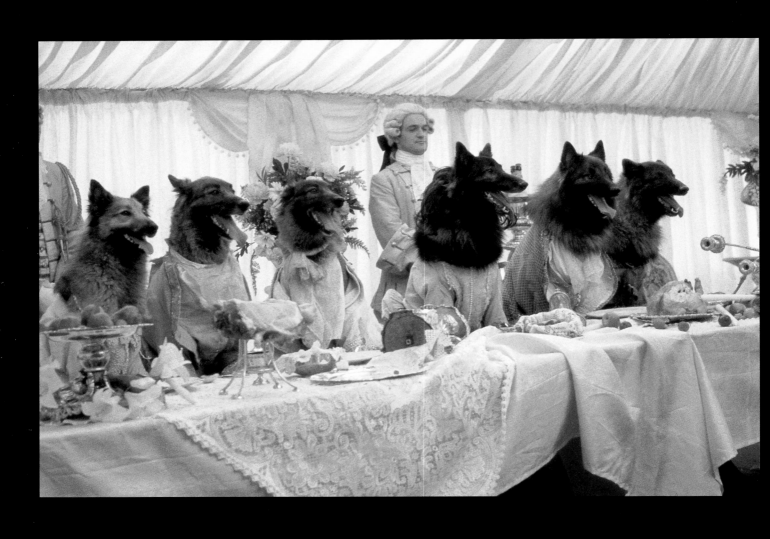

97. Neil Jordan.
The Company of Wolves.
1984. Film

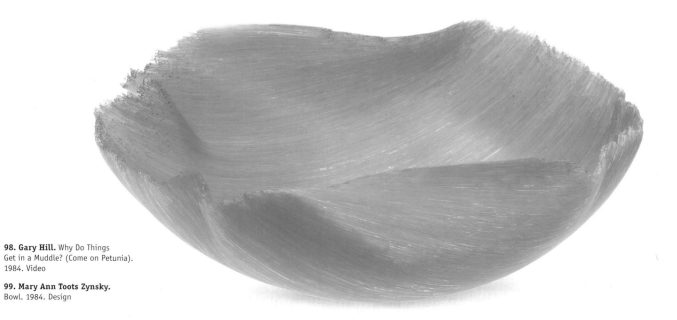

98. Gary Hill. Why Do Things
Get in a Muddle? (Come on Petunia).
1984. Video

99. Mary Ann Toots Zynsky.
Bowl. 1984. Design

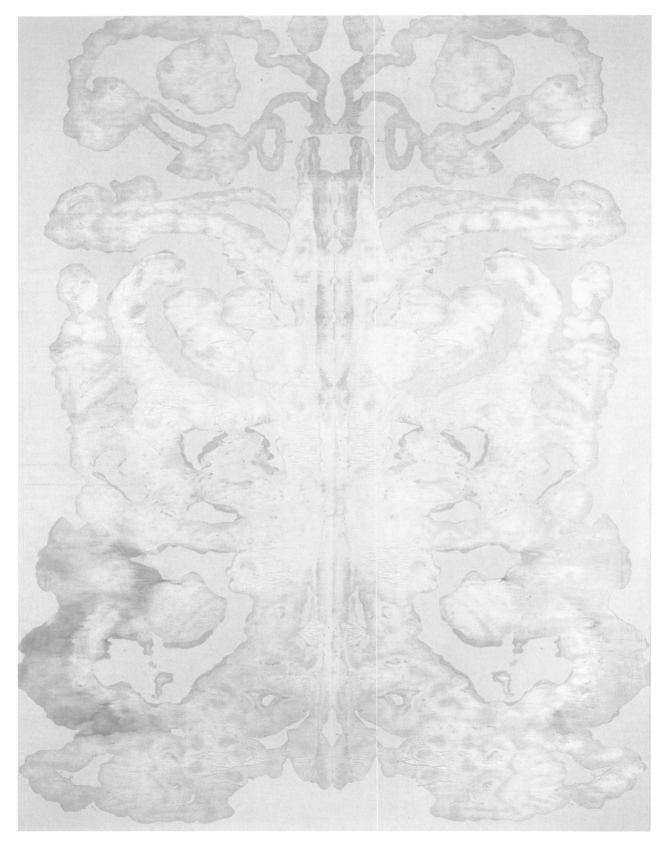

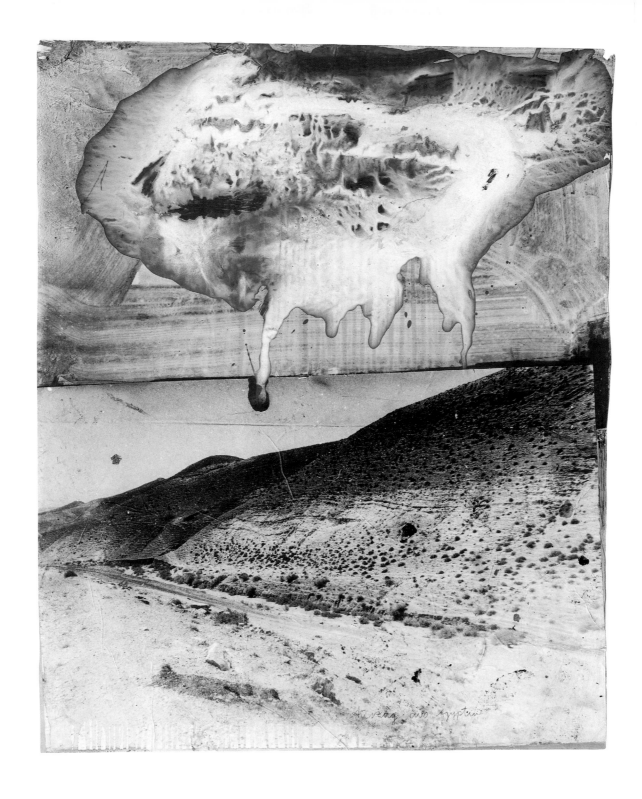

opposite:
100. Andy Warhol.
Rorschach. 1984.
Painting

101. Anselm Kiefer.
Departure from Egypt.
1984. Drawing

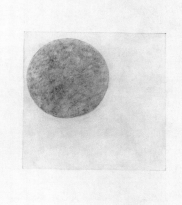

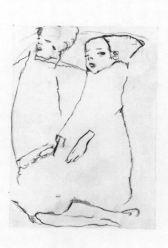

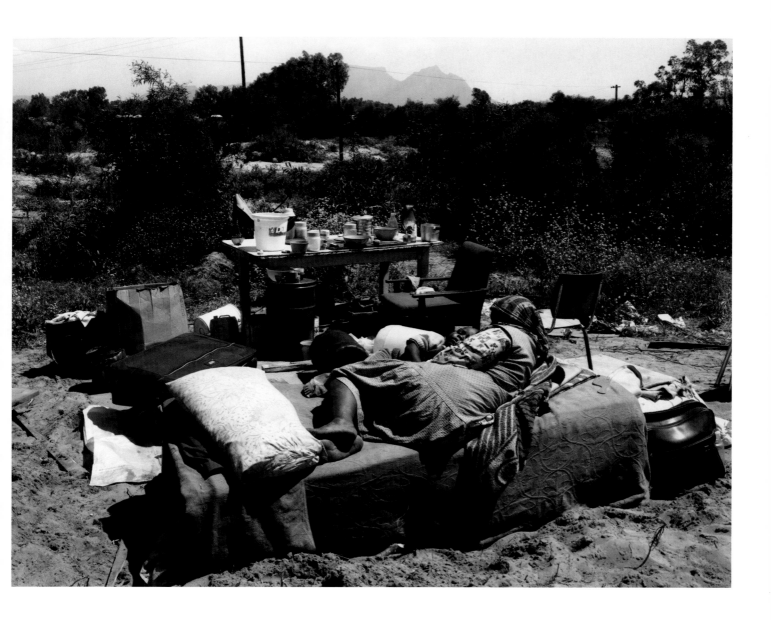

opposite:
102. Sherrie Levine.
Untitled (After Kasimir
Malevich and Egon Schiele).
1984. Drawings

103. David Goldblatt. Mother and child in their home after the destruction of its shelter by officials of the Western Cape Development Board, Crossroads, Cape Town, 11 October 1984. 1984. Photograph

The shelter was a framework of Port Jackson brushwood staked into loose sand of the Cape Flats and covered by plastic sheets—black plastic near the base for privacy, translucent plastic over the roof for light. Neatly, without touching the contents of the home or its occupants, a team of five overalled Black men, supervised by an armed White, lifted the entire structure of frame and plastic skin off the ground and placed it nearby. Then they pulled off the plastic, smashed the framework, and threw the pieces onto a waiting truck. Hardly a word was spoken. While they could legally destroy the wooden framework, they were forbidden, by the quirk of a court decision brought against the State seeking to prevent these demolitions, from confiscating or destroying the plastic. So it was left where it fell.

Then the convoy—a police Landrover, the truck with the demolition squad and broken wood, and a Casspir with policemen in camouflage lolling in its armoured back—moved towards the next group of shelters.

For a while the woman lay with the child. Then she got up and began to cut and strip branches of Port Jackson bush to make a new framework for her house.

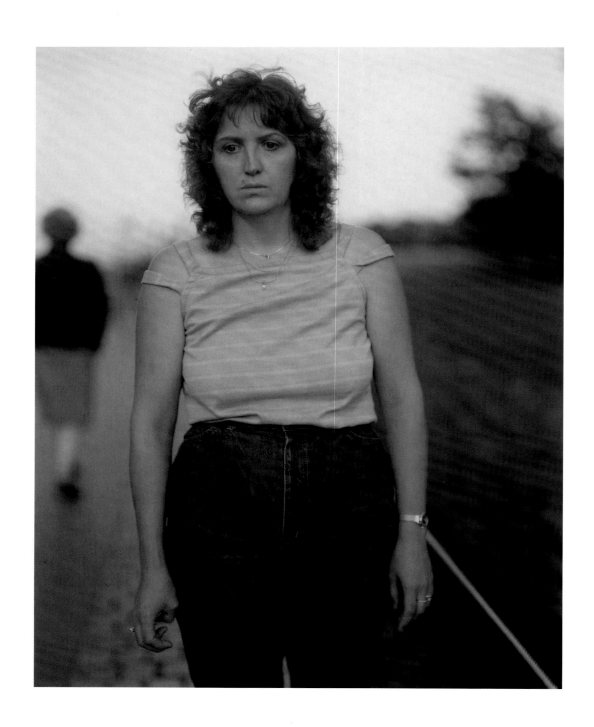

104. Judith Joy Ross.
Untitled from Portraits at the
Vietnam Veterans Memorial,
Washington, D.C. 1984.
Photograph

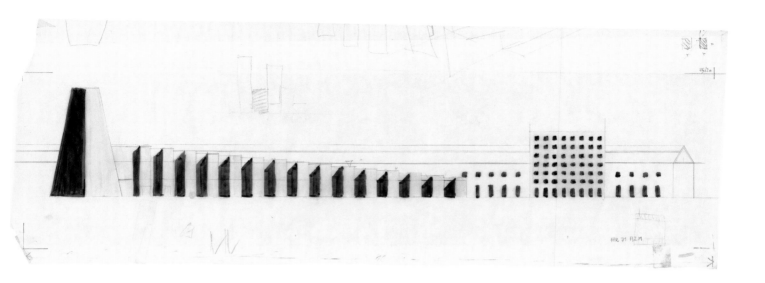

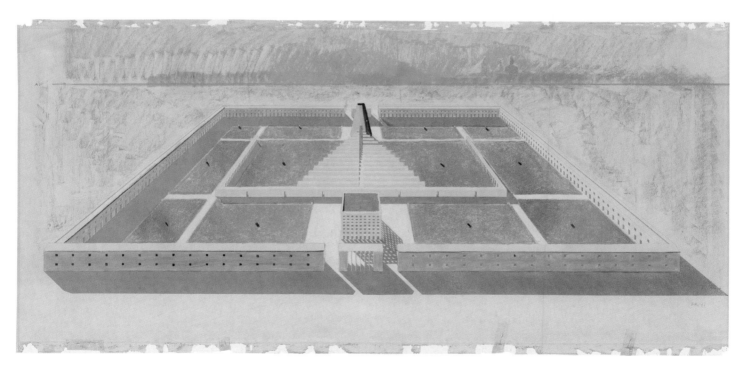

105. Aldo Rossi.
Cemetery of San Cataldo,
Modena, Italy. 1971–84.
Architectural drawing

106. Aldo Rossi.
Cemetery of San Cataldo,
Modena, Italy. 1971–84.
Architectural drawing

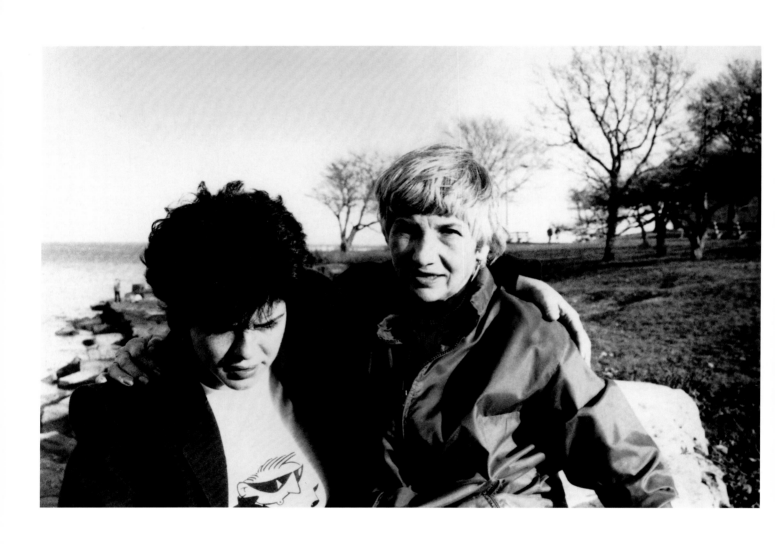

107. Su Friedrich.
The Ties That Bind.
1984. Film

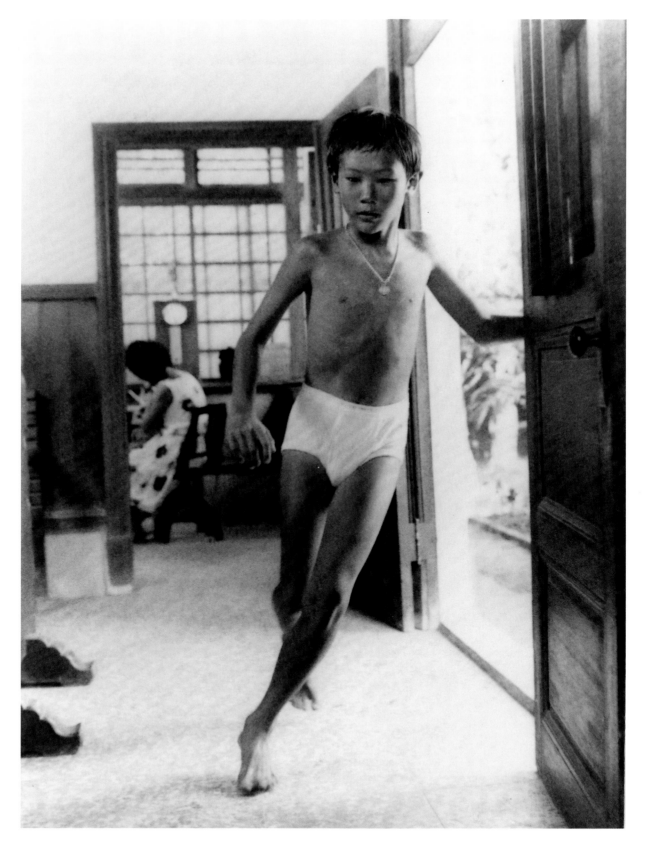

108. Hou Hsiao-hsien.
Summer at Grandpa's.
1984. Film

109. frogdesign.
Macintosh SE Home
Computer. 1984. Design

110. Allan McCollum.
40 Plaster Surrogates.
1982–84. Installation

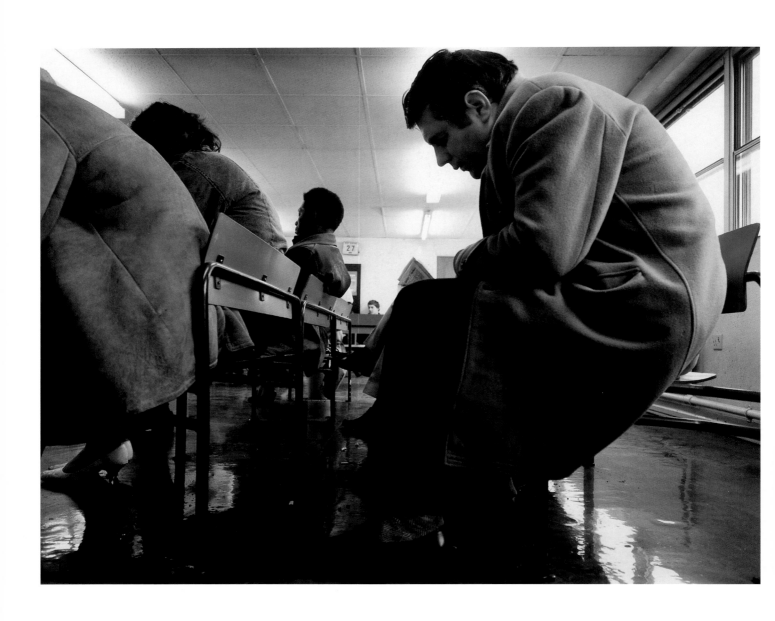

111. Paul Graham.
Crouched Man, DHSS
Waiting Room, Bristol.
1984. Photograph

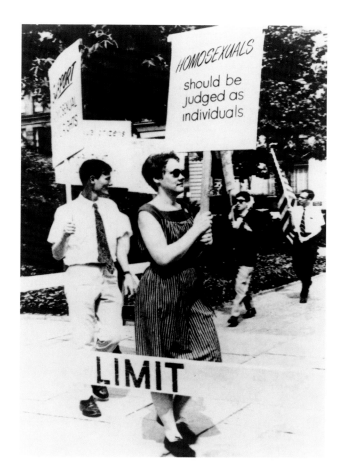

112. John Cassavetes.
Love Streams. 1984. Film

**113. Greta Schiller and
Robert Rosenberg.** Before
Stonewall. 1984. Film

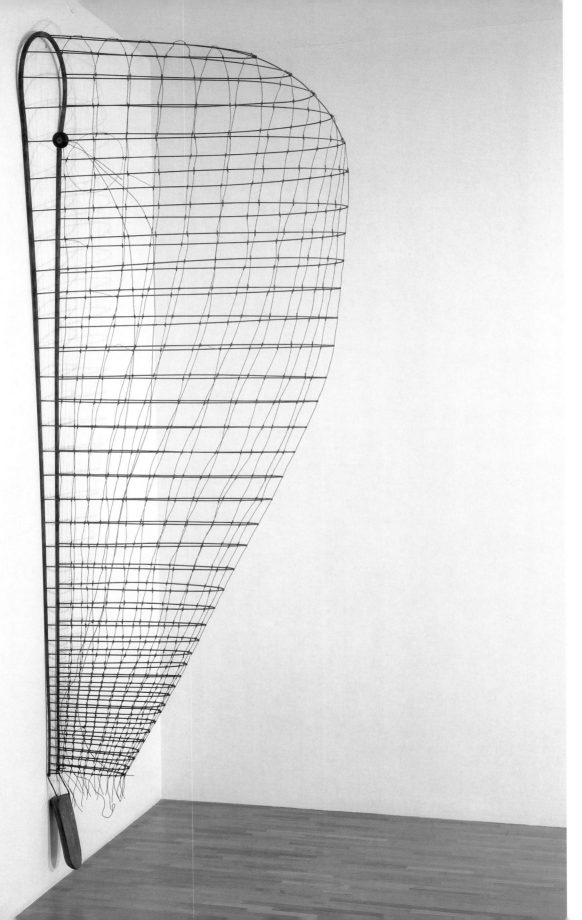

114. Martin Puryear.
Greed's Trophy. 1984.
Sculpture

opposite:
115. Robert Ryman.
Pace. 1984. Painting

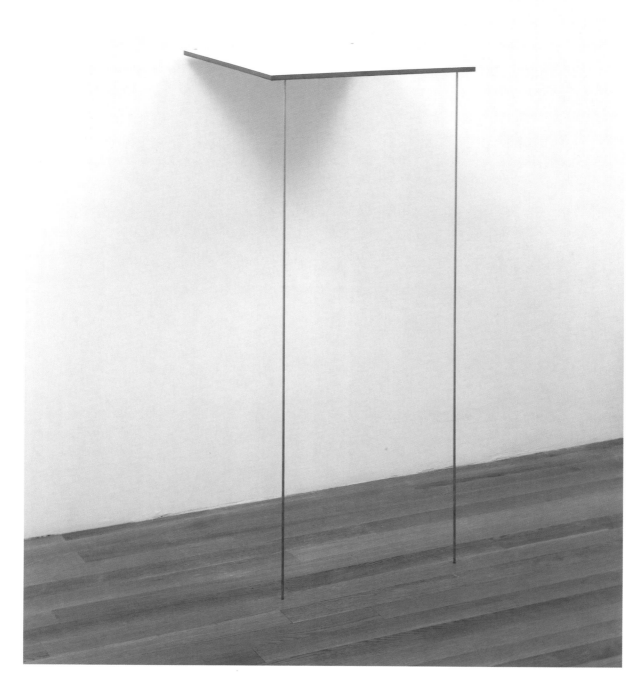

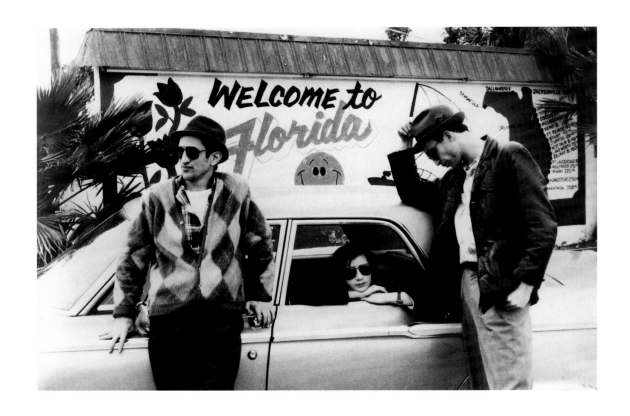

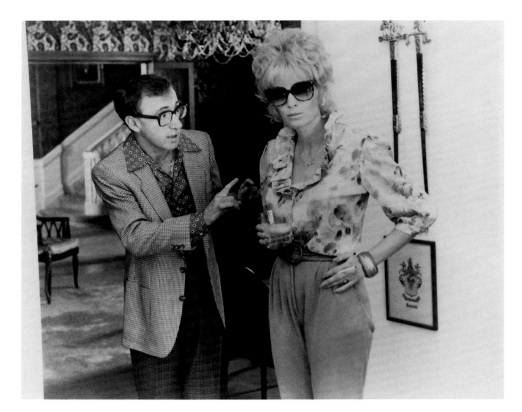

116. Jim Jarmusch.
Stranger Than Paradise.
1984. Film

117. Woody Allen.
Broadway Danny Rose.
1984. Film

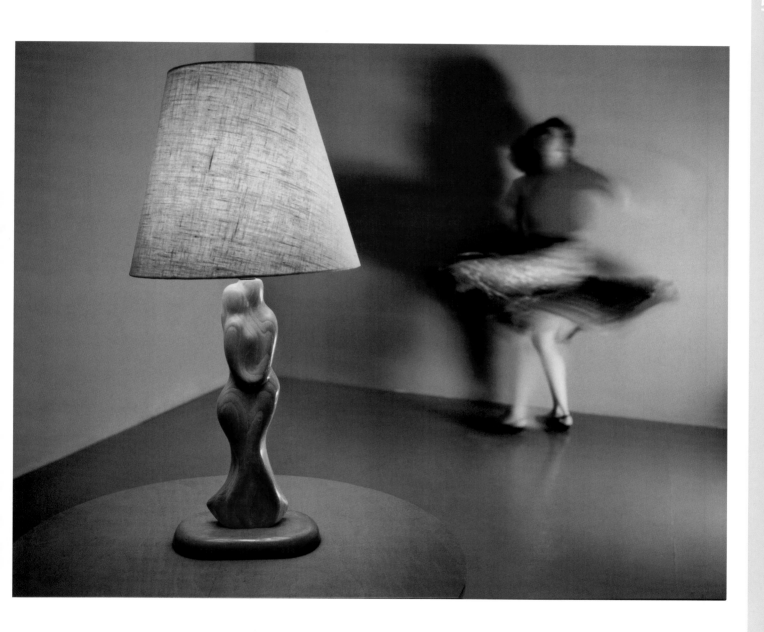

118. Jo Ann Callis.
Woman Twirling. 1985.
Photograph

 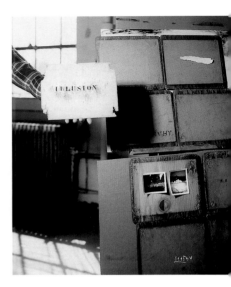

119. Robert Frank.
Boston, March 20, 1985.
1985. Photographs

120. Bernard Tschumi.
Parc de la Villette, Paris, France.
1985. Architectural model

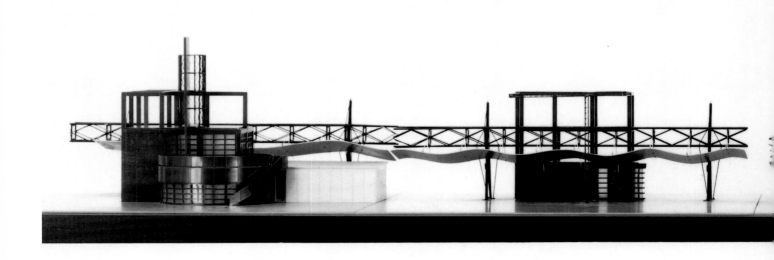

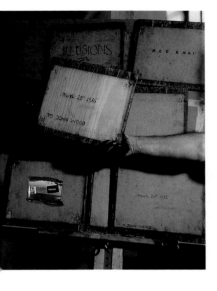

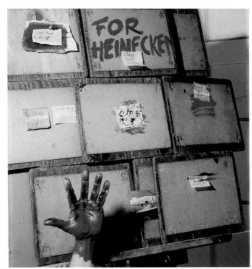

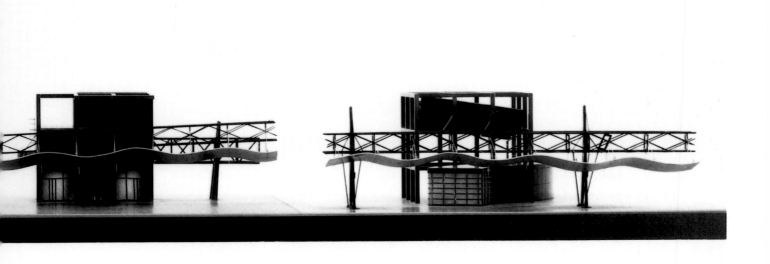

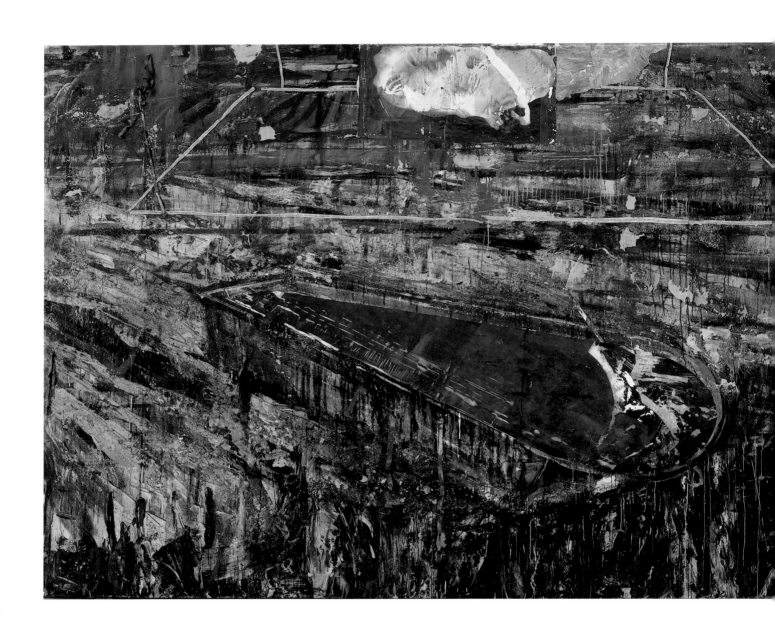

121. Anselm Kiefer.
The Red Sea. 1984–85.
Painting

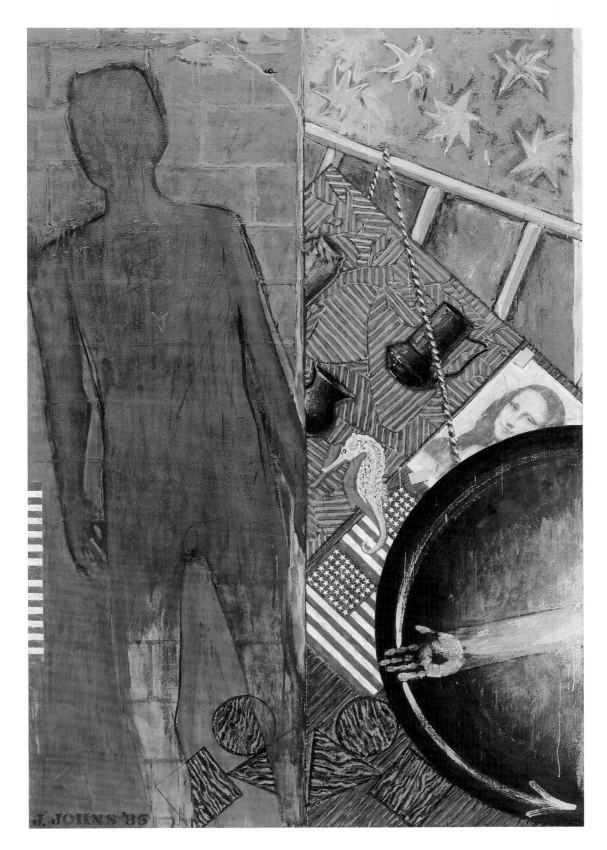

122. Jasper Johns.
Summer. 1985. Painting

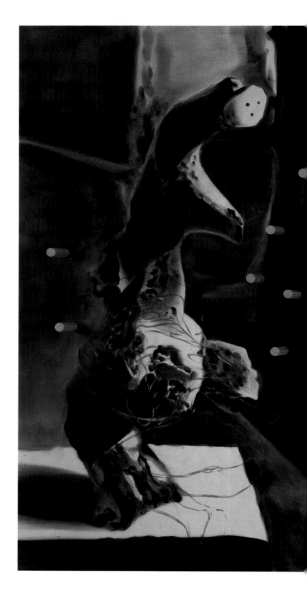

123. Jean-Michel Basquiat.
Untitled. 1985. Drawing

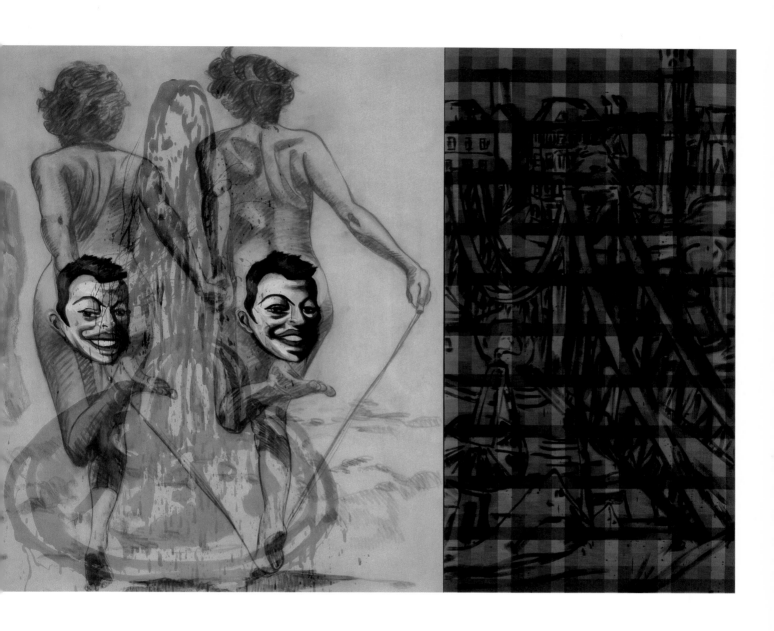

124. David Salle.
Muscular Paper. 1985.
Painting

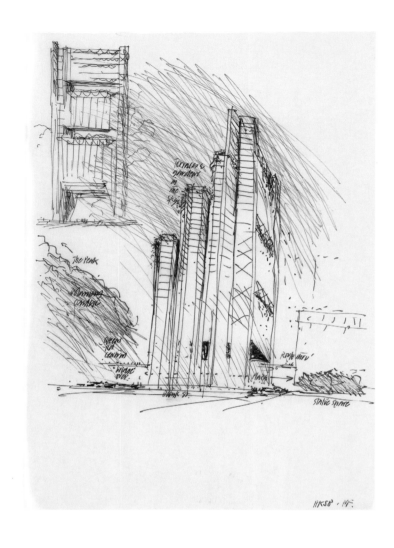

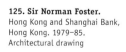

125. Sir Norman Foster.
Hong Kong and Shanghai Bank,
Hong Kong. 1979–85.
Architectural drawing

126. James Herbert.
River. 1985. Film

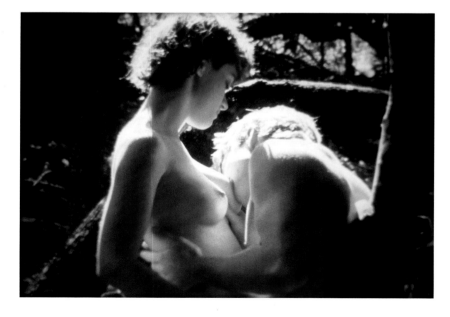

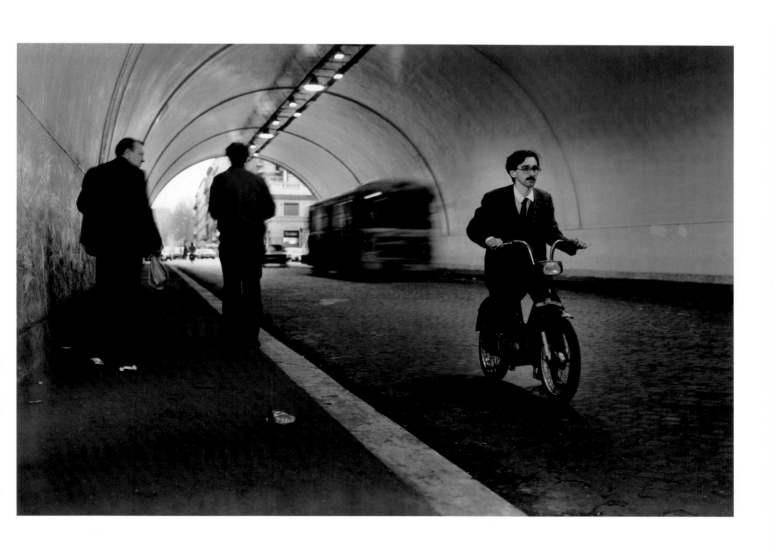

127. Philip-Lorca diCorcia.
Francesco. 1985. Photograph

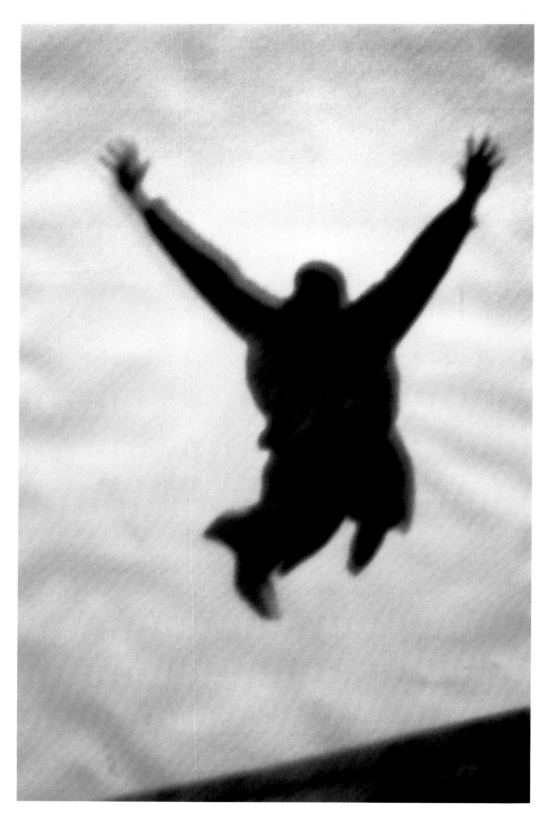

128. John Schlesinger.
Untitled. 1985. Photograph

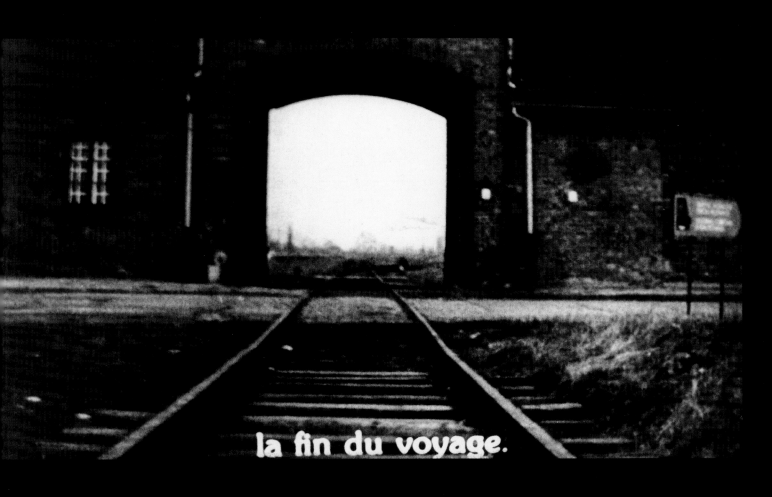

la fin du voyage.

129. Claude Lanzmann.
Shoah. 1985. Film

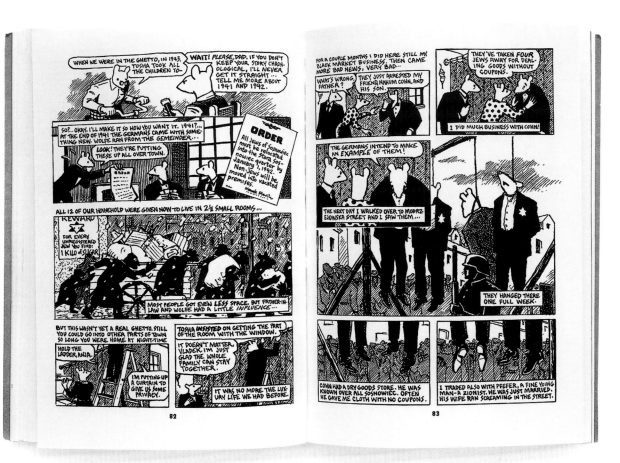

130. Art Spiegelman.
Maus: A Survivor's Tale.
1980–85. Illustrated book

opposite:
131. Mike Kelley.
Exploring (from "Plato's
Cave, Rothko's Chapel, Lincoln's
Profile"). 1985. Drawing

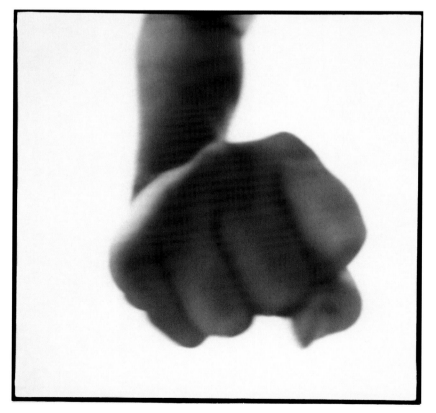

132. Thomas Florschuetz.
In Self-Defense. 1985.
Photographs

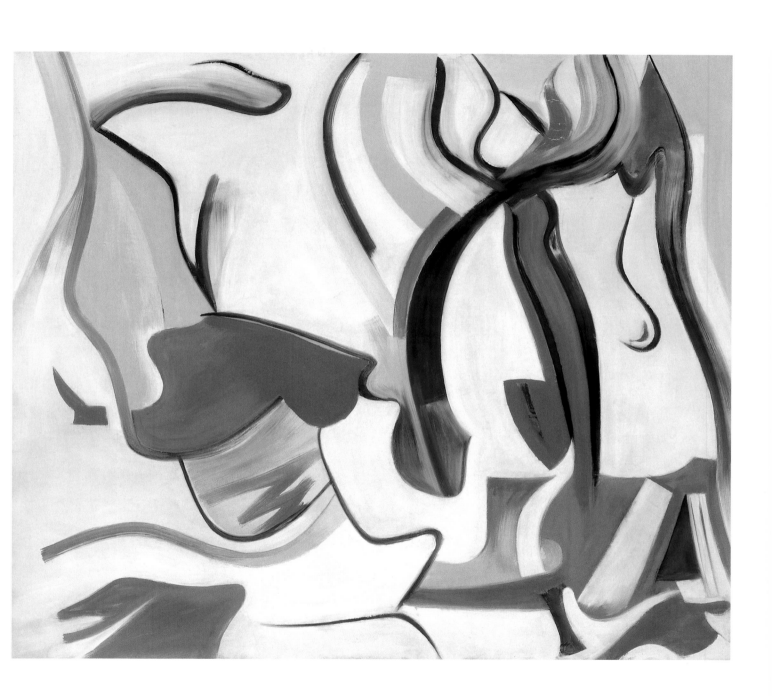

133. Willem de Kooning.
Untitled VII. 1985. Painting

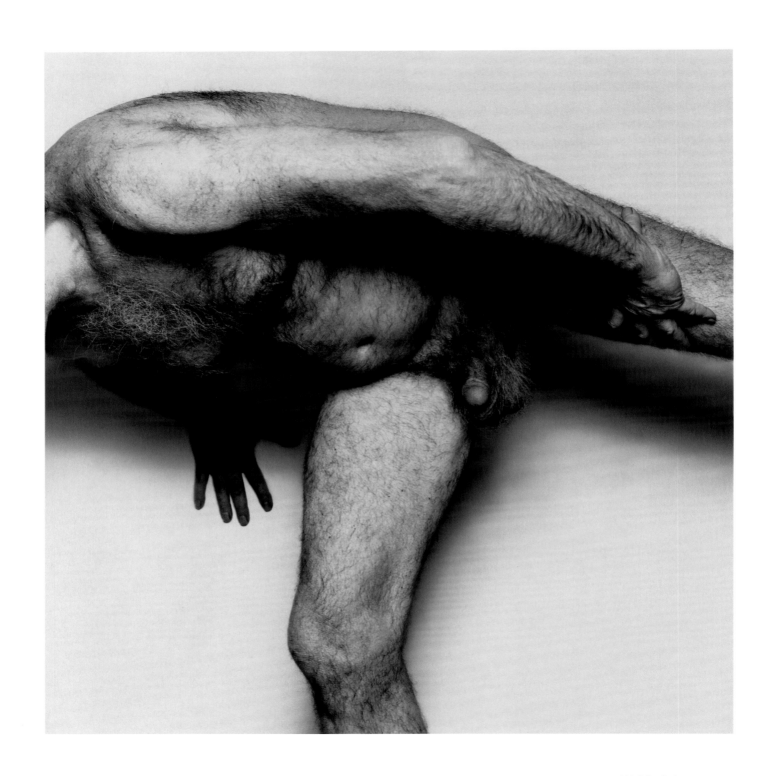

134. John Coplans.
Self-Portrait. 1985. Photograph

135. Lothar Baumgarten.
Untitled (Fish). 1985. Print

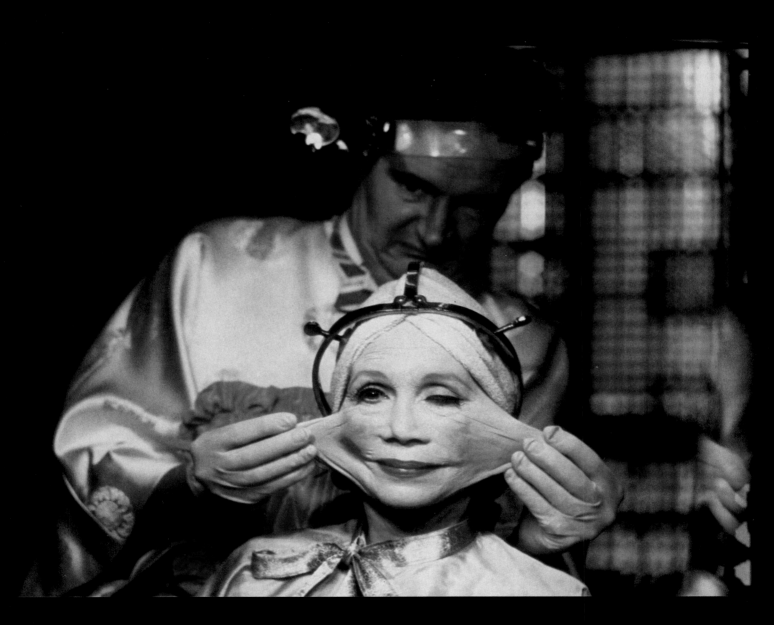

136. Terry Gilliam.
Brazil. 1985. Film

opposite:
137. Jeff Koons.
Three Ball 50/50 Tank.
1985. Sculpture

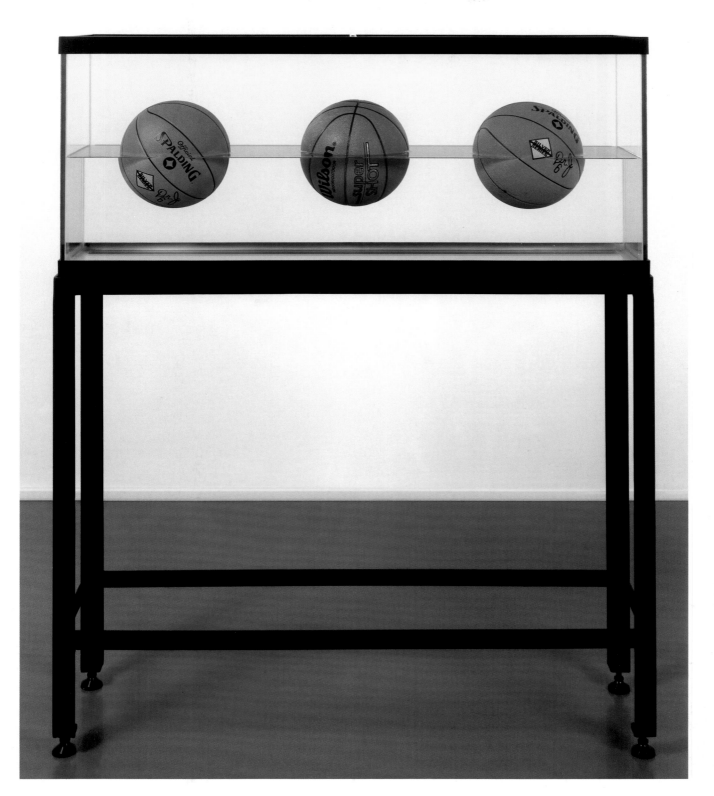

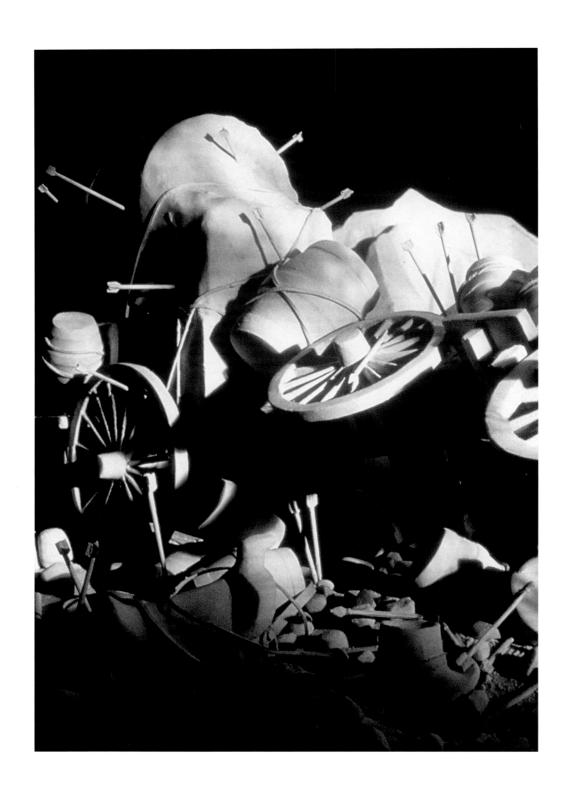

138. James Casebere.
Covered Wagons. 1985.
Photograph

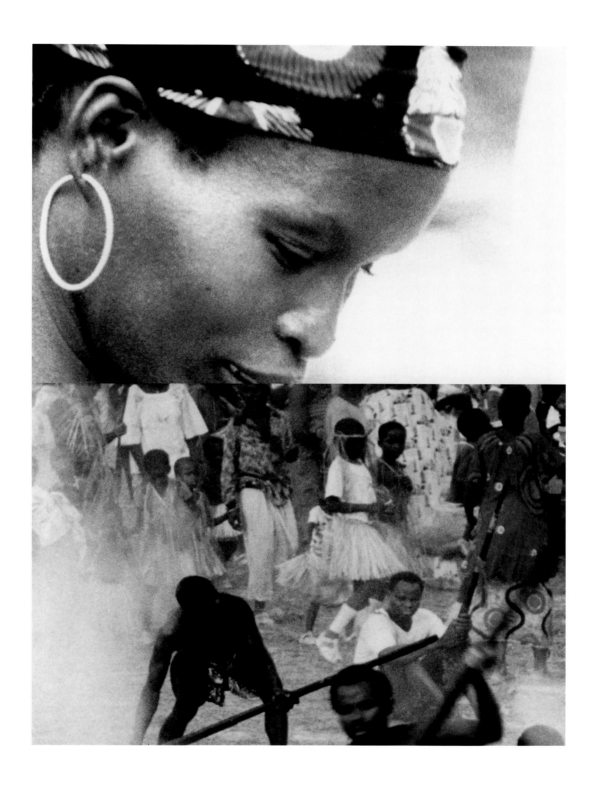

139. Trinh T. Minh-ha.
Naked Spaces: Living Is Round.
1985. Film

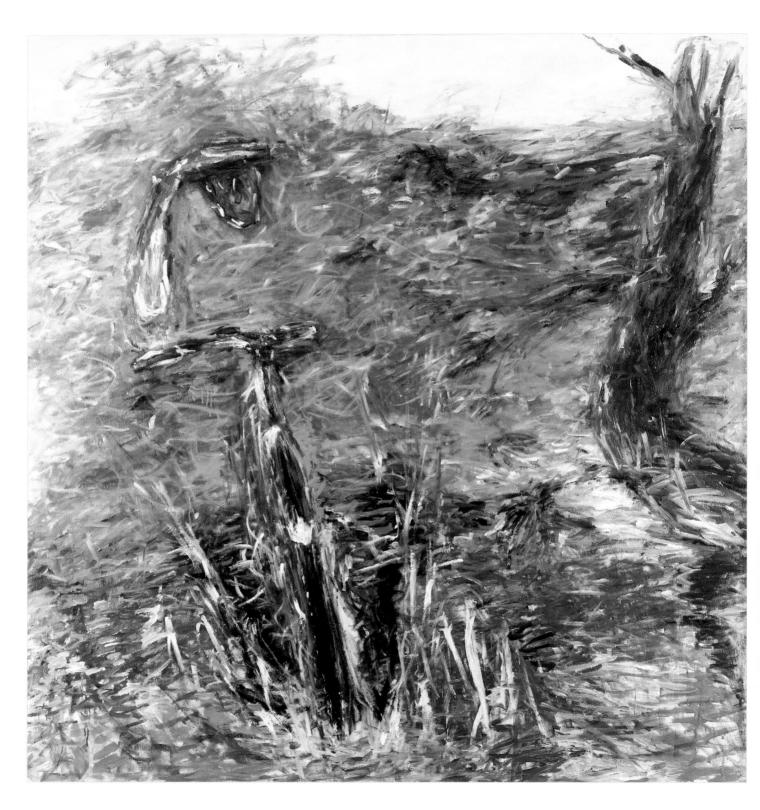

140. Susan Rothenberg.
Biker. 1985. Painting

141. Susan Rothenberg.
Boneman. 1986. Print

142. Bill Viola.
I Do Not Know What
It Is I Am Like.
1986. Video

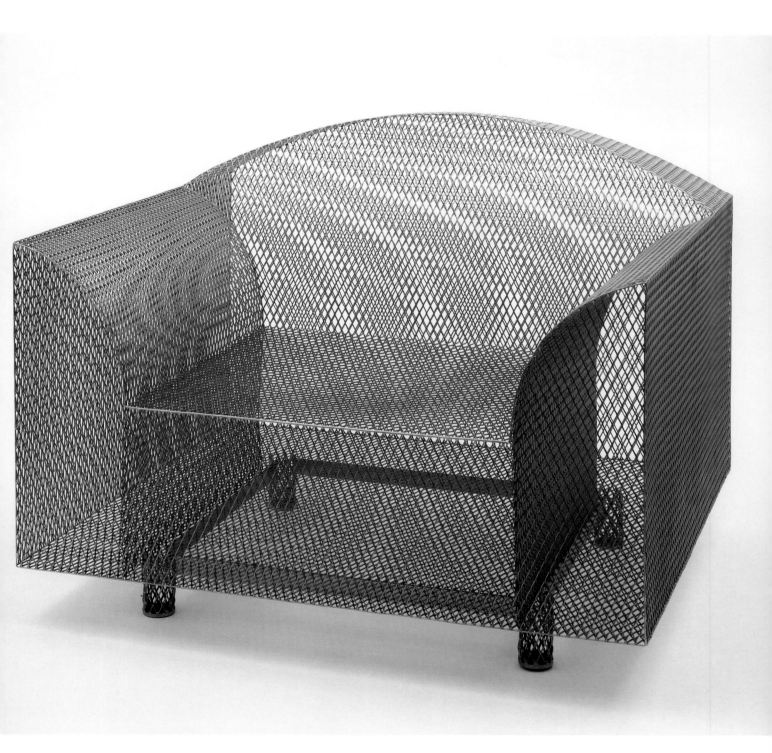

143. Shiro Kuramata.
How High the Moon Armchair.
1986. Design

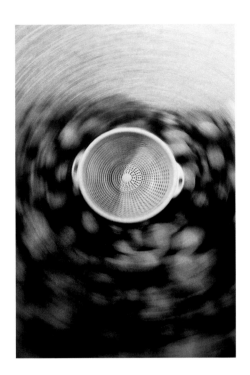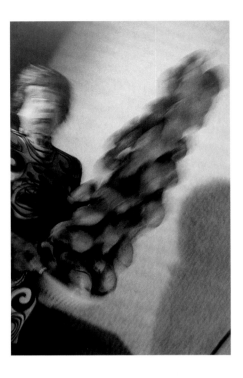

144. Bernhard and Anna Blume.
Kitchen Frenzy. 1986. Photographs

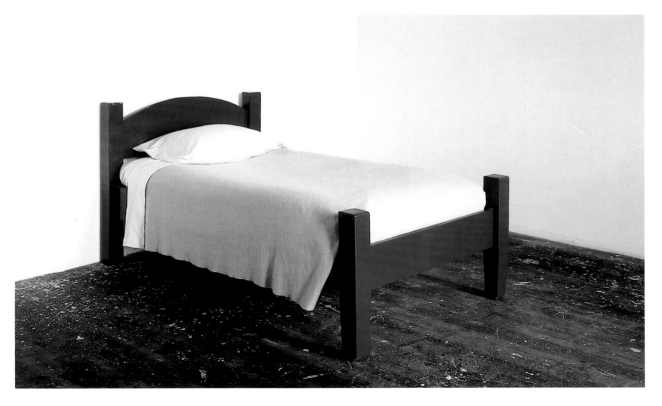

145. Robert Gober.
Untitled. 1986.
Sculpture

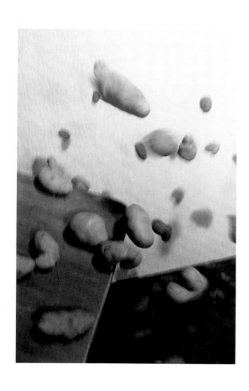
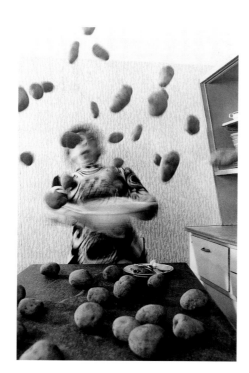
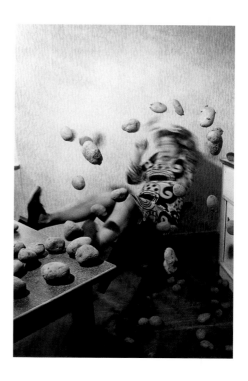

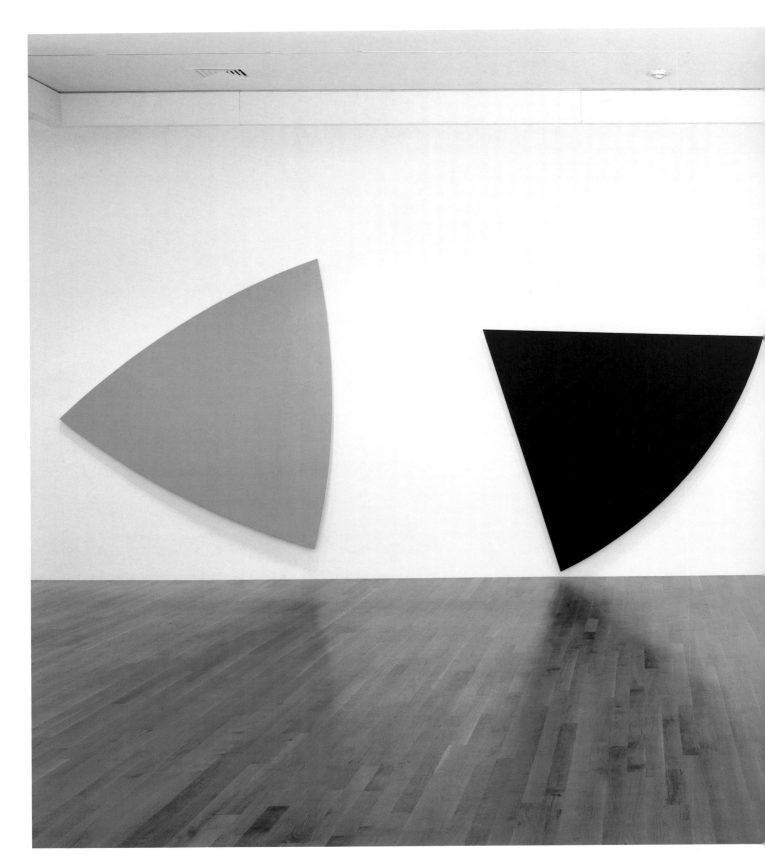

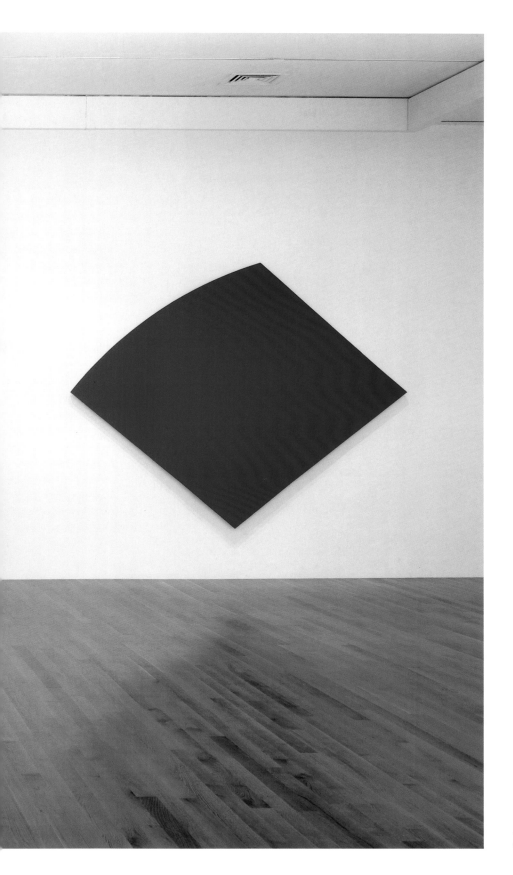

146. Ellsworth Kelly.
Three Panels: Orange, Dark
Gray, Green. 1986. Painting

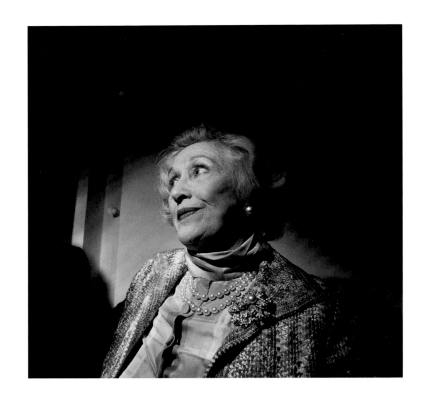

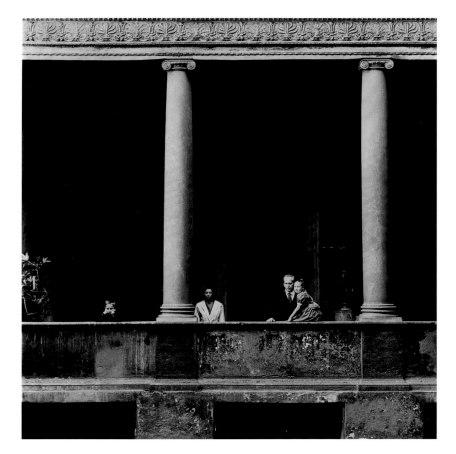

147. Larry Fink.
Pearls, New York City.
1986. Photograph

148. Patrick Faigenbaum.
Massimo Family, Rome. 1986.
Photograph

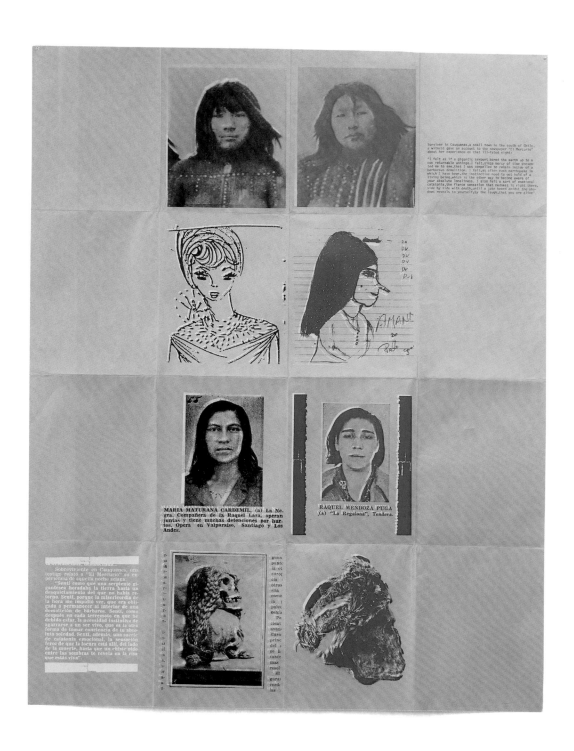

149. Eugenio Dittborn.
8 Survivors. 1986. Print

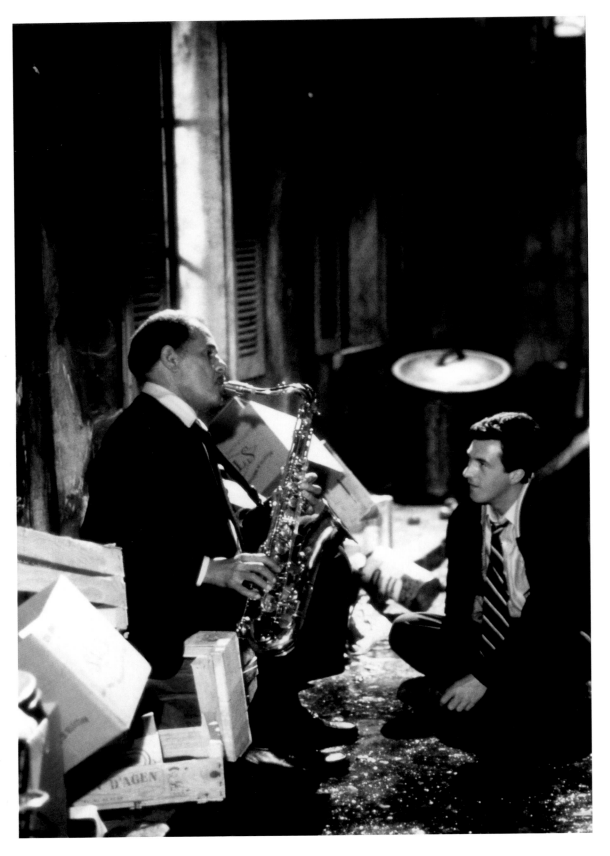

150. Bertrand Tavernier.
Round Midnight. 1986. Film

opposite:
151. Niklaus Troxler.
A Tribute to the Music of
Thelonious Monk. 1986. Poster

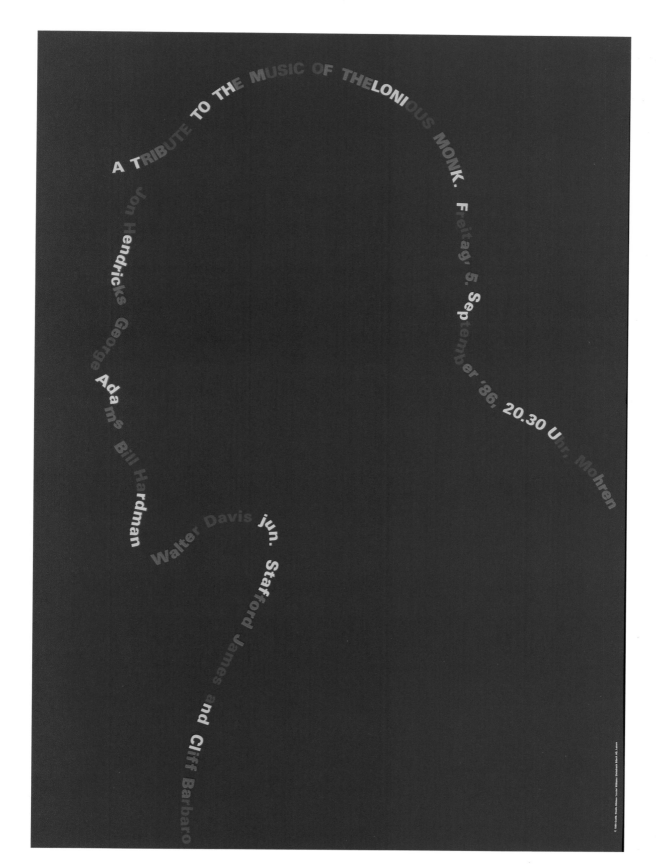

A TRIBUTE TO THE MUSIC OF THELONIOUS MONK. Freitag 5. September '86, 20.30 Uhr, Mohren

Jon Hendricks George Adams Bill Hardman Walter Davis jun. Stafford James and Cliff Barbaro

wounded English soldiers traveling with us, and shoes on feet – by
order of the captain. Our captain is a fat lobster from the south of
Italy, who, when in Taranto, dressed in the uniform of an ensign but
who, while steering the ship now, wears a pair of white trousers and a
dark blue jacket and cap with shiny visor, the border of which is
trimmed with chevroned silk. Our captain's duties are exactly as fol-
lows: to be present at the distribution of rations and to give the order
to put on our life jackets. Each time we leave port, at the first shock of
the propellers, the captain bounces like a spring up to the bridge,
armed with a cyclopean megaphone under which, it seems to me, he
could quite conveniently hide in case of danger. The captain blows a
rolling toot on his nickel whistle, which has the effect of drawing to
his modest person the one thousand two hundred eyes of the six hun-
dred soldiers on board, after which he noses the megaphone about
like a brigantine trombone, first in the direction of the stern, then in
the direction of the stern, and fires this command twice: "Present
life jackets!" But the captain lacks the temper of a commander: it's ob-
vious to me and – I believe – obvious to him as well; this explains the
diligence with which he tries to make up for this lack, having recourse
to bonhomie even. Before drawing anchor at Taranto, he informed us:
"I'm your father and you're my sons," but there as well, he lacked that
authority which distinguishes a respectable parent. The captain is a
good man; it would be better to say: he does good; better still, lacking
the more sterling qualities, he has diligently set himself to the task of
professing an intense affability. Beyond the boundaries of this putative
family of six hundred change sons, among them blackguards and ro-
gues from every part of Italy, I imagine him with his true, carnal fami-
ly and see him in the double role of pet-husband (being dragged on a
leash by an autocratic Amazon of a wife) and pet-father, overpowered,
washed out and resigned to the tyranny of a swarm of rosy-cheeked,
chubby, spoiled brats. Next I wonder what sort of control he can

possibly expect to hold over these six hundred "sons," unlike him in every way – babies who will have to leave the trenches, not the cradle, broken in for the human hunt by three years of war!... After the voice of the homunculus has exhausted itself in the giant funnel, there follows a bit of commotion on deck and one sees the raised arms and bent torsos of his "sons" in the sham gestures of putting on their life jackets. But once the captain's little round body slips into the hatchway, all arms fall, backs straighten up and the life jackets return to their primary function as seats, pillows and card tables. I find this swindle so exasperating that I decide to have an eye to eye talk with the captain just to make perfectly clear the psychological line to be followed in the performance of his duties: "It bears upon the matter, sir, of the life jackets issued to the six hundred soldiers committed to your care, the effectiveness of which is guaranteed, I'm sure. It could have been shown just how well they work by putting them to the test back at Taranto: If I were you, I'd have asked for a show of hands from all those men who can't swim. From their number I'd have picked two trustworthy lads and ordered them to tie on their life jackets and jump into the sea. They'd have floated like pumpkins. But nothing will alter the fact that this example wouldn't be nearly persuasive enough when applied to these boys, the ones assembled for the demonstration, these Italians, I might further add. Better alter the phrasing of your command in this manner: "Thro w awa y life jackets!" and you'll get the opposite result, I might even venture to say, the desired one." But while preparing my discourse, I realize that I'd better do a little psychological housecleaning first. Why disturb the captain's serene spirits? He's the one who has to order us to put on our life jackets and in so doing absolves himself of all obligations plain and simple. He hasn't any other duties to take care of, and, pronouncing the words for which the government pays him his salary, he's freed of every further responsibility, and with peace of mind he can go down to the officer's

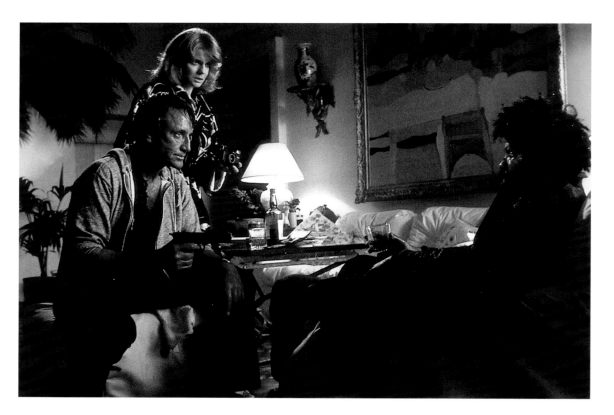

153. James Ivory.
A Room with a View.
1986. Film

154. John Frankenheimer.
52 Pick-Up. 1986. Film

155. John Baldessari.
Untitled. 1986. Drawing

156. Bill Sherwood.
Parting Glances. 1986. Film

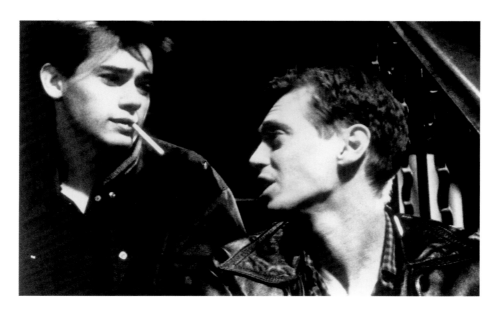

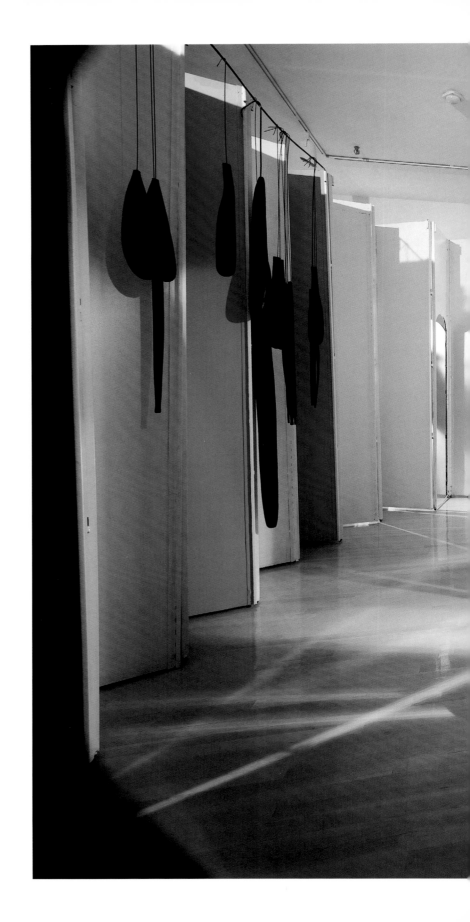

157. Louise Bourgeois.
Articulated Lair. 1986. Sculpture

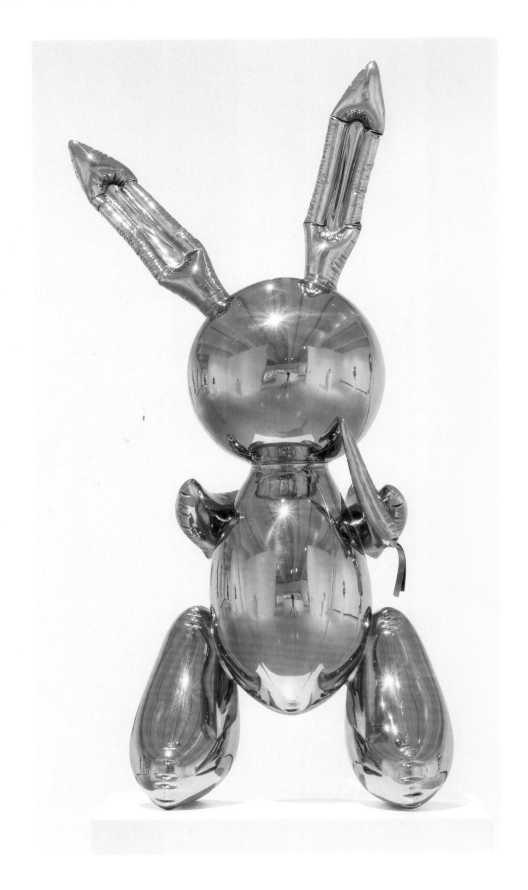

158. Jeff Koons.
Rabbit. 1986. Sculpture

159. Edward Ruscha.
Jumbo. 1986. Painting

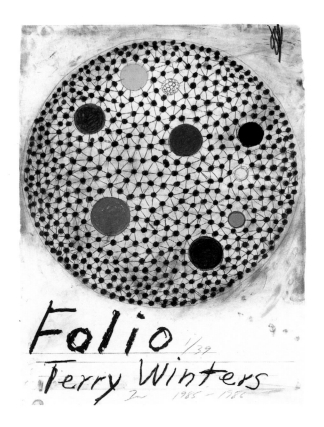

160. Terry Winters.
Folio. 1985–86. Prints

161. Robert Breer.
Bang! 1986. Animated film

162. Frank Gehry.
Fishdance Restaurant,
Kobe, Japan. c.1986.
Architectural drawing

163. Frank Gehry.
Winton Guest House,
Wayzata, Michigan.
1983–86.
Architectural model

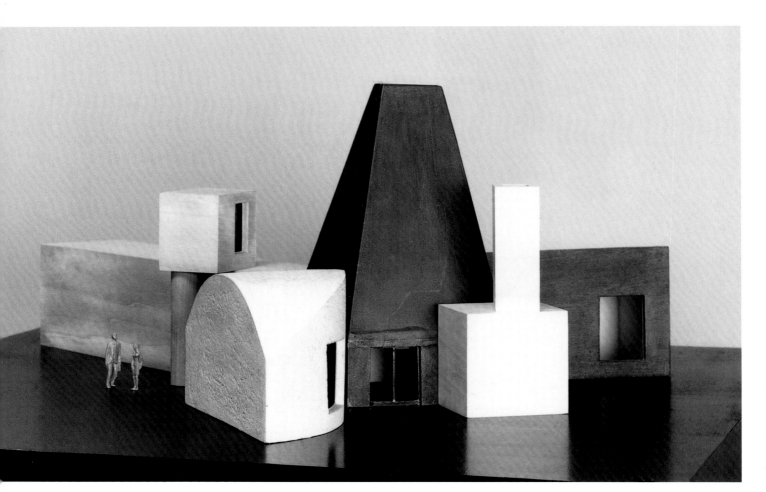

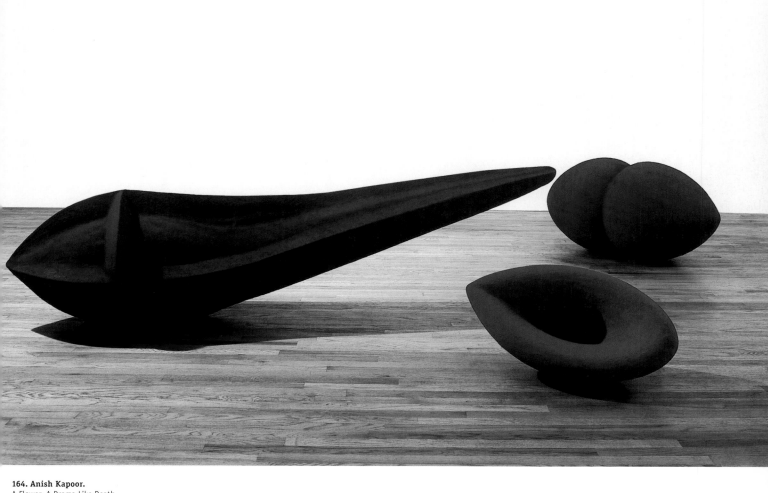

164. Anish Kapoor.
A Flower, A Drama Like Death.
1986. Sculpture

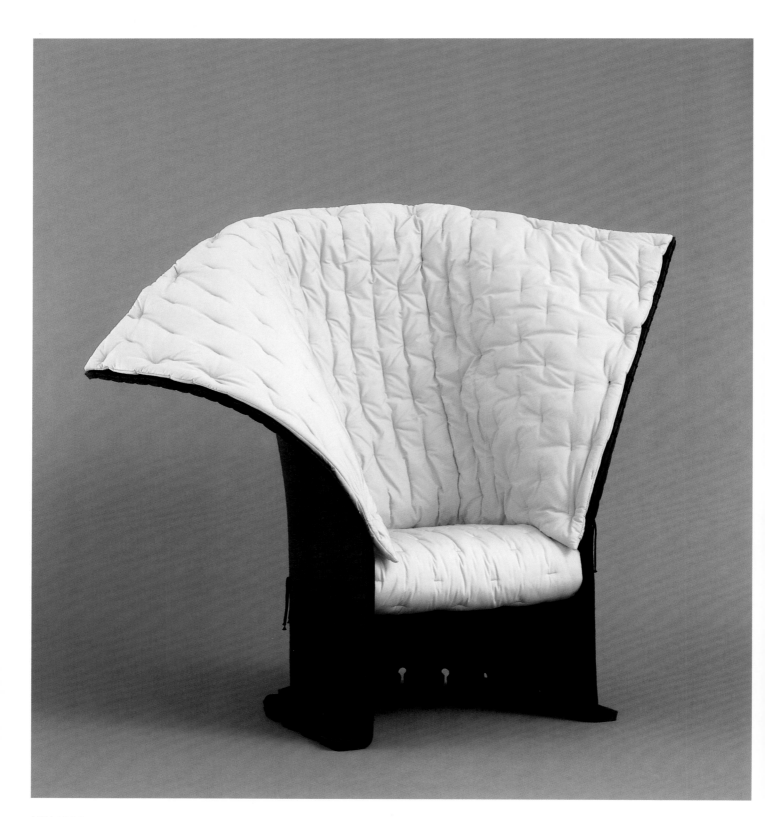

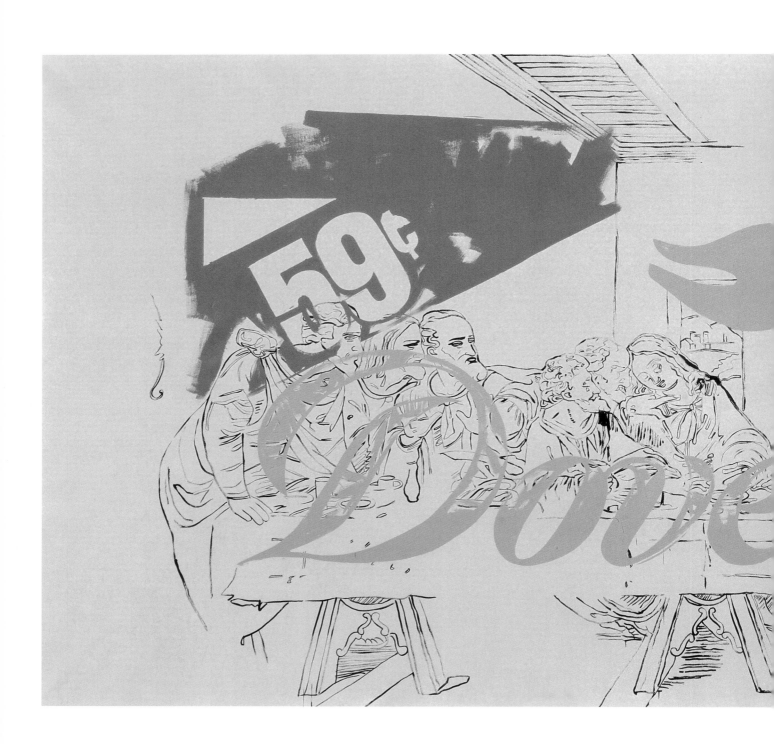

167. Andy Warhol.
The Last Supper. 1986. Painting

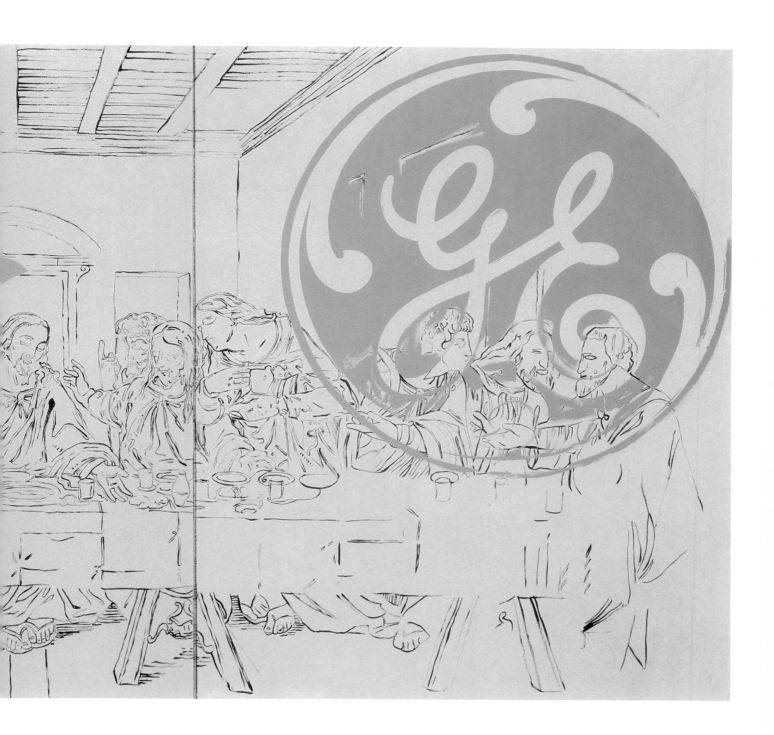

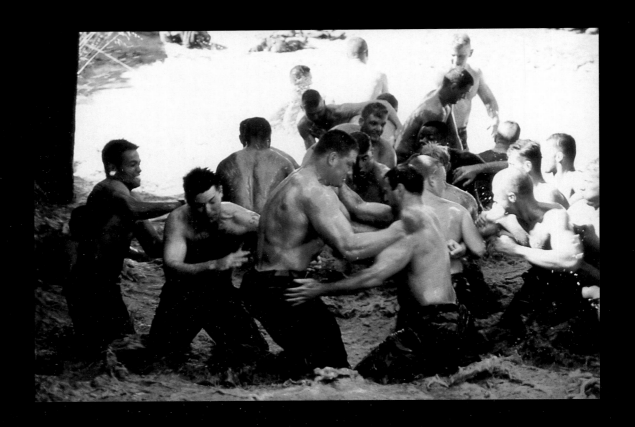

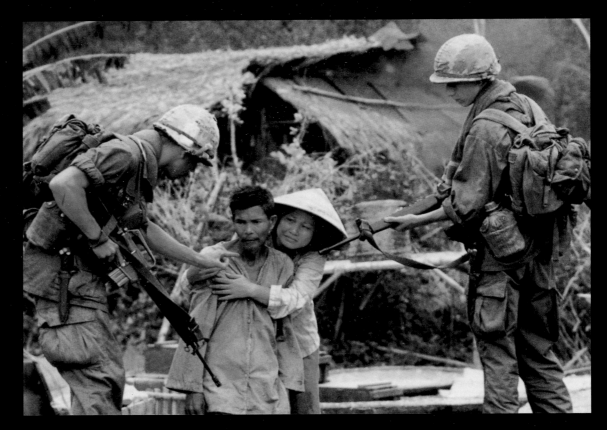

168. Clint Eastwood.
Heartbreak Ridge.
1986. Film

169. Oliver Stone.
Platoon. 1986. Film

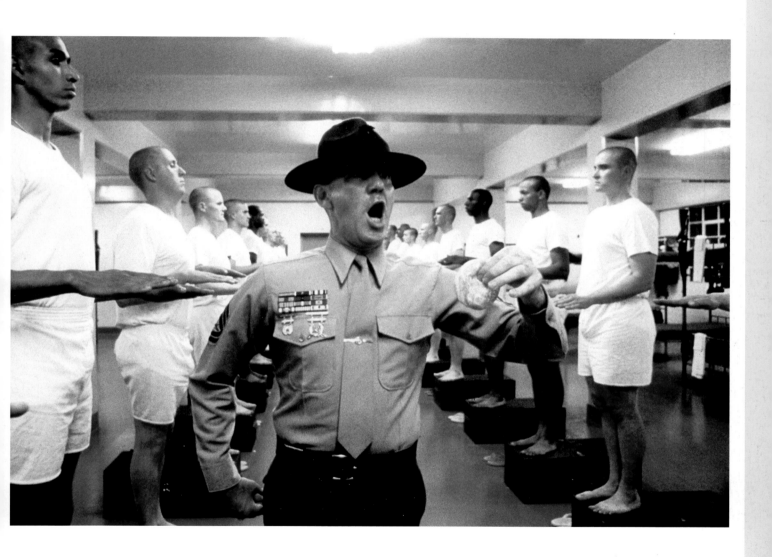

170. Stanley Kubrick.
Full Metal Jacket. 1987. Film

171. David Wojnarowicz.
Fire. 1987. Painting

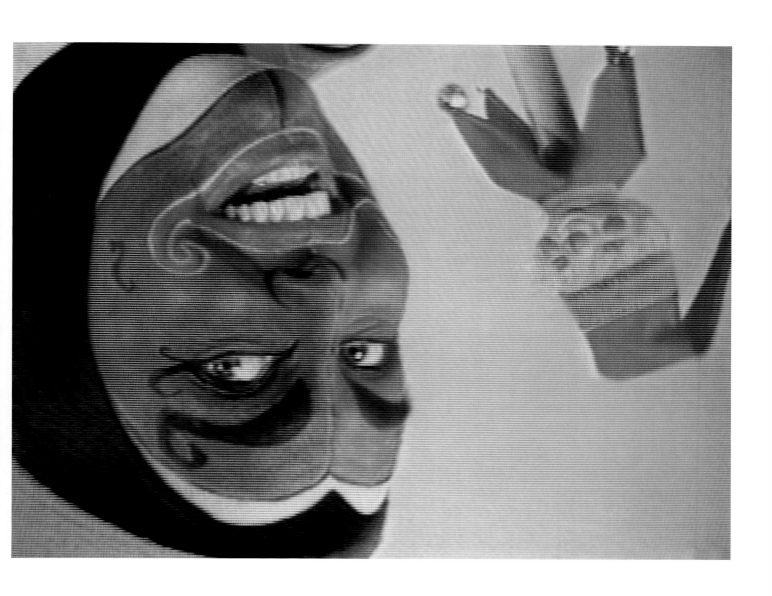

172. Bruce Nauman.
Dirty Story. 1987.
Video installation

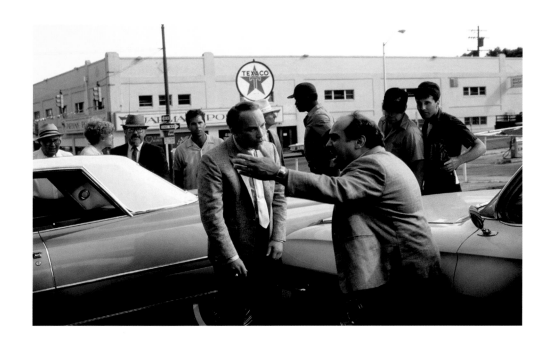

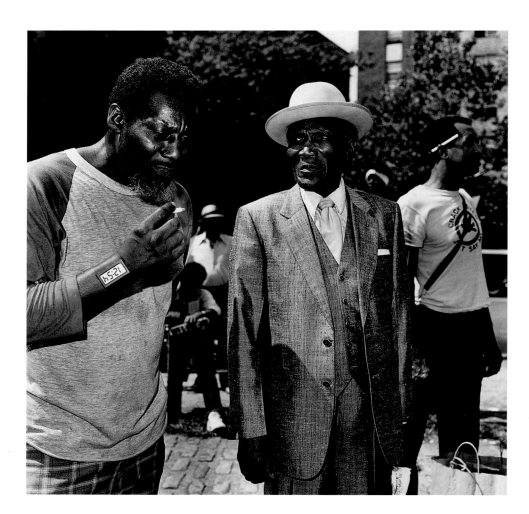

173. Barry Levinson.
Tin Men. 1987. Film

174. Jeffrey Scales.
12:54, A. Philip Randolph
Square. 1987. Photograph

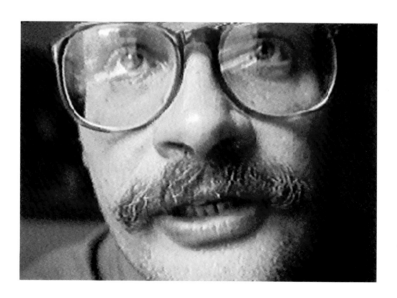

175. Abigail Child.
Mayhem. 1987. Film

176. George Kuchar.
Creeping Crimson. 1987. Video

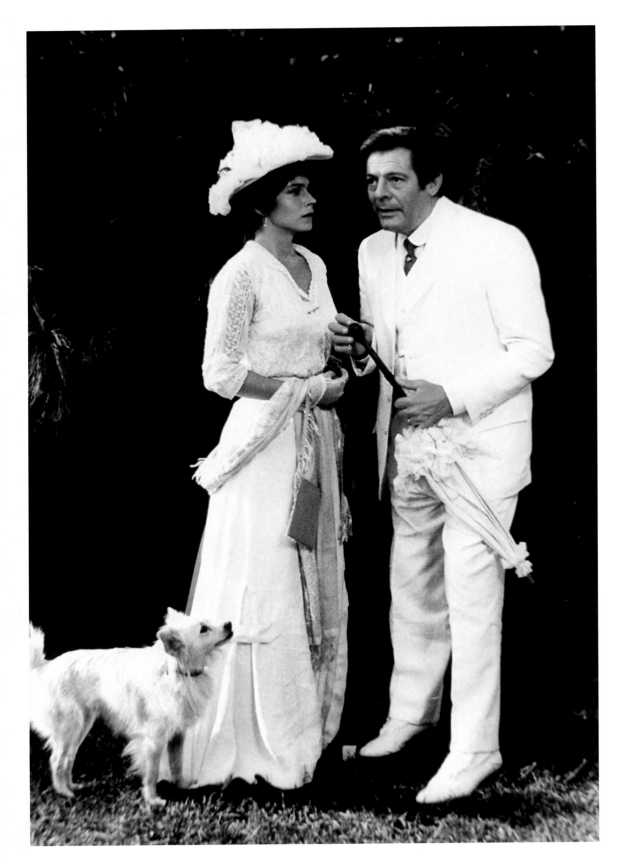

177. Nikita Mikhalkov.
Dark Eyes. 1987. Film

opposite:
**178. Paolo Taviani and
Vittorio Taviani.**
Good Morning Babylon.
1987. Film

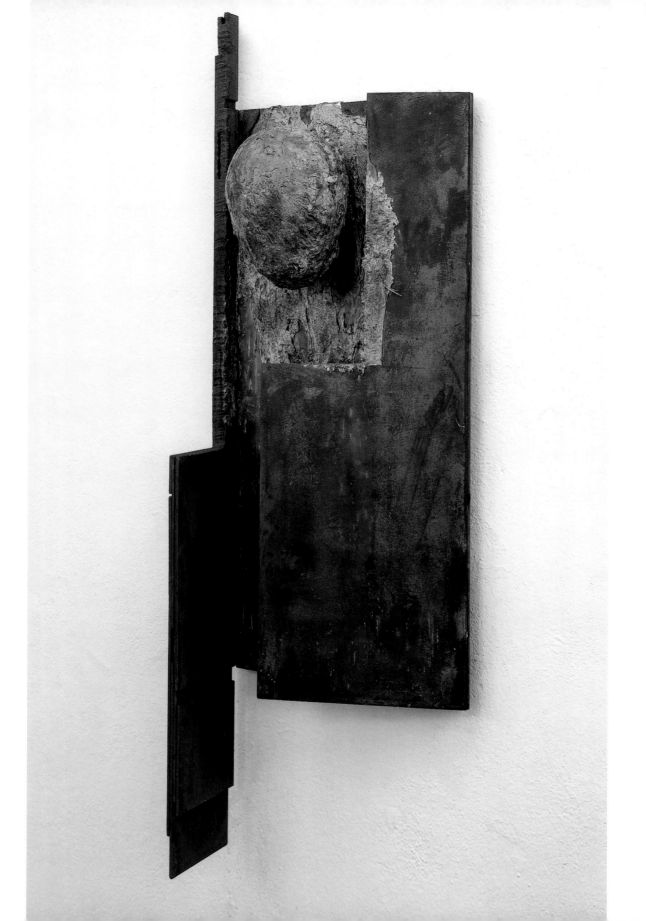

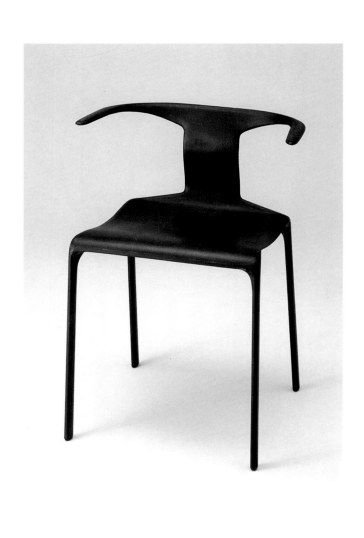

182. Alberto Meda.
Light Light Armchair.
1987. Design

183. Eric Fischl.
Portrait of a Dog.
1987. Painting

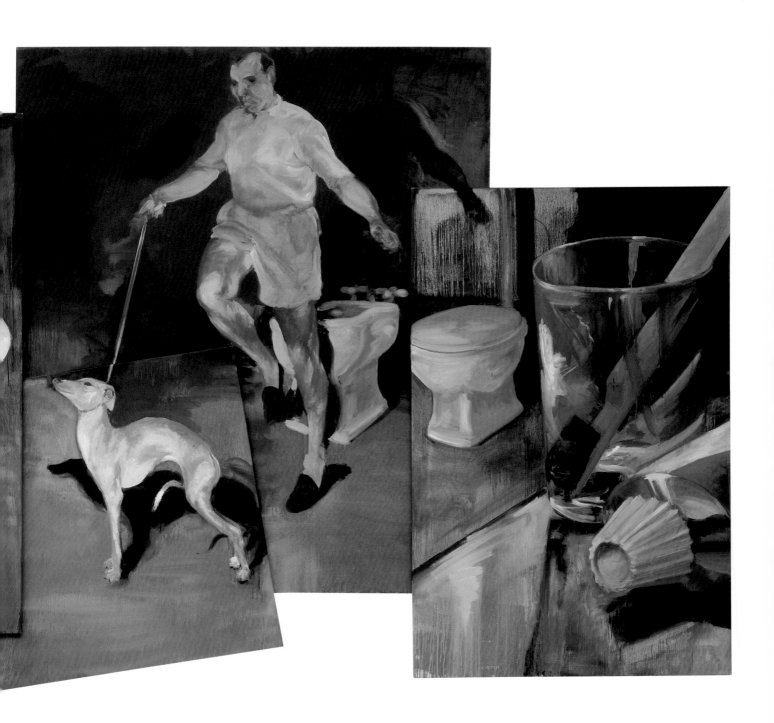

184. Tina Barney.
Sheila and Moya. 1987.
Photograph

185. Jac Leirner.
Lung. 1987. Sculpture

186. Tony Cragg.
Oersted Sapphire.
1987. Sculpture

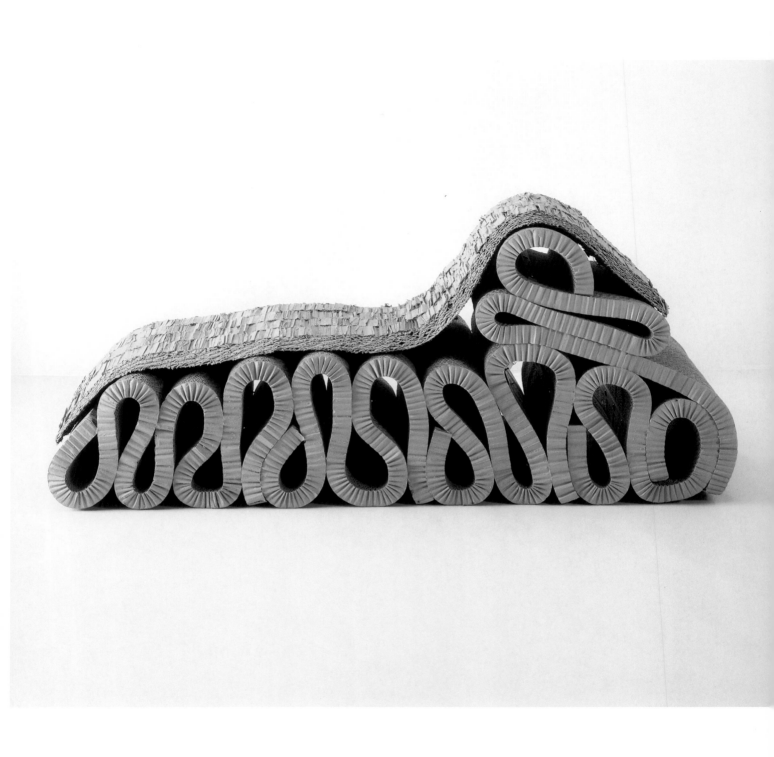

187. Frank Gehry.
Bubbles Lounge Chair.
1987. Design

188. Andy Warhol.
Camouflage. 1987. Prints

189. Nathaniel Dorsky.
Alaya. 1976–87. Film

190. Mary Lucier.
Ohio at Giverny: Memory
of Light. 1987. Video

191. Anish Kapoor.
Untitled (Red Leaf).
1987. Drawing

193. John Boorman.
Hope and Glory. 1987. Film

194. Aleksandr Askoldov.
The Commissar. 1967–87. Film

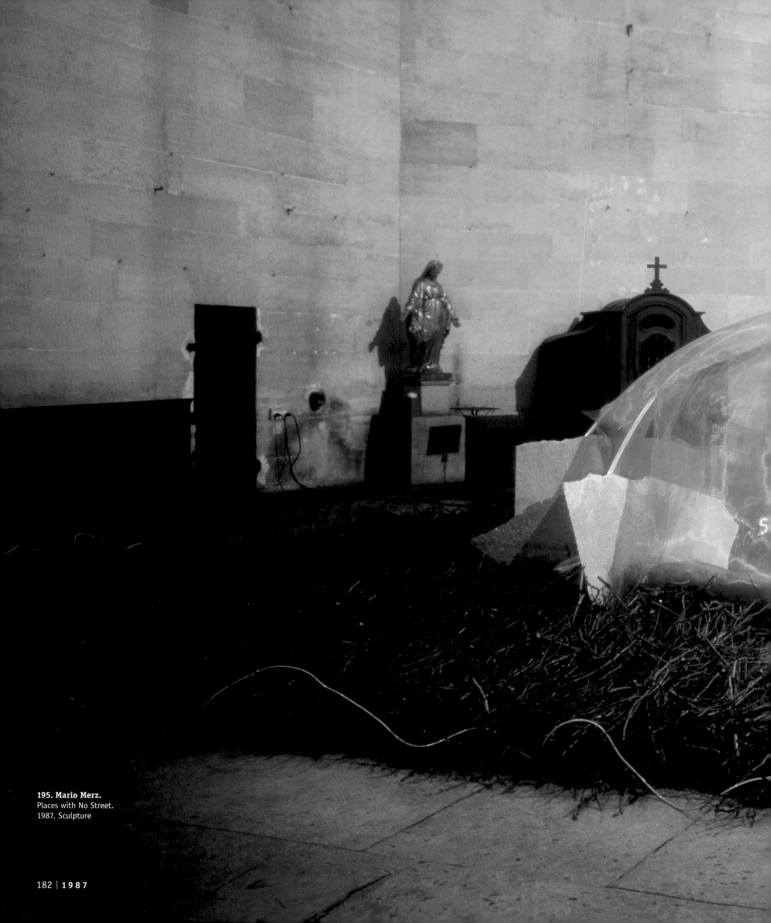

195. Mario Merz.
Places with No Street.
1987. Sculpture

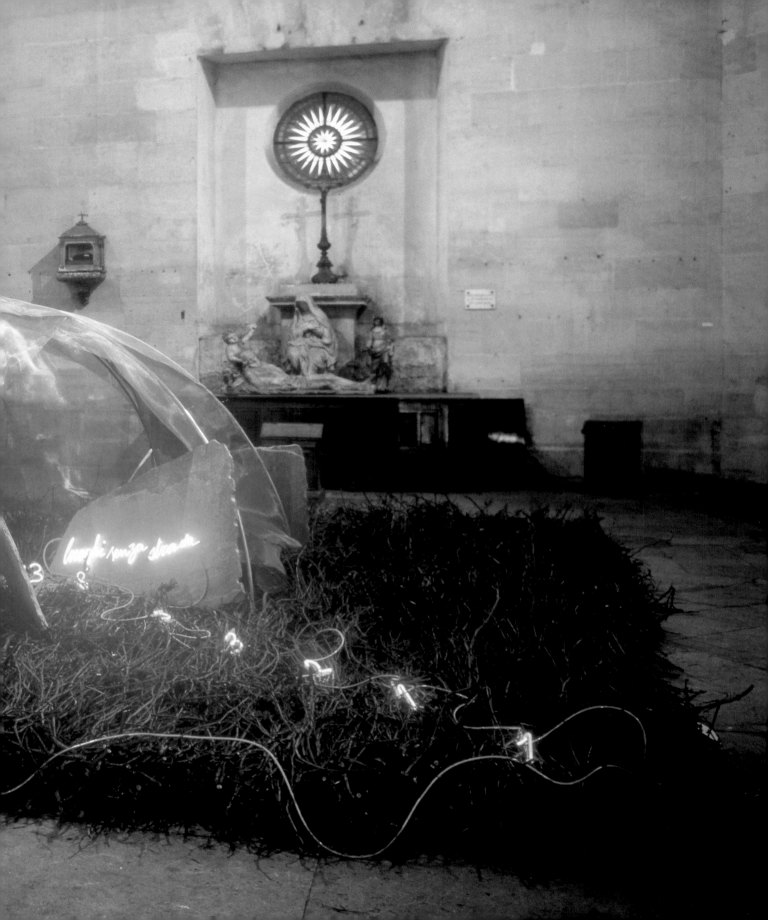

**196. Office for Metropolitan
Architecture.** City Hall Competition,
the Hague, the Netherlands. 1987.
Architectural drawing

opposite:
197. Wolfgang Laib.
The Passageway. 1988.
Sculpture

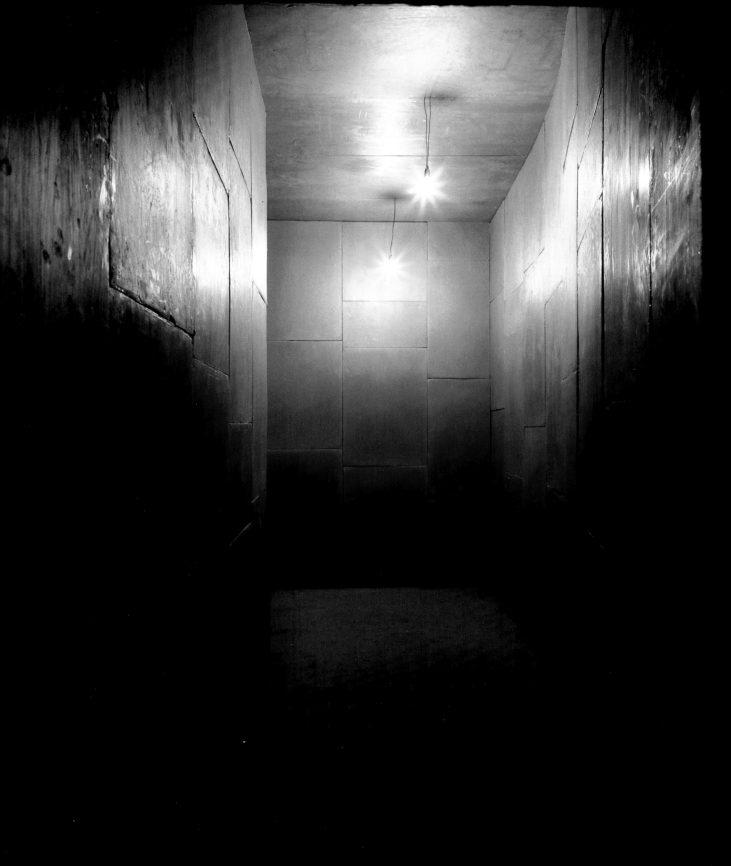

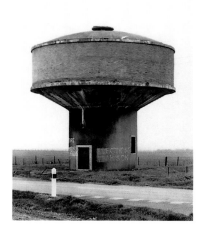
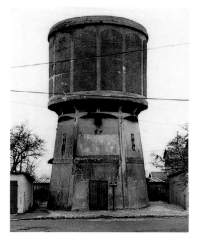
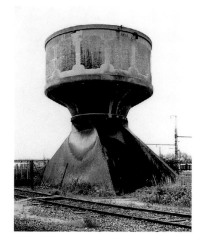
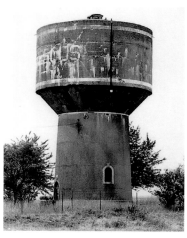
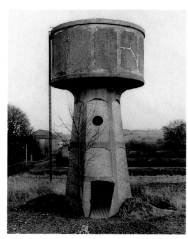
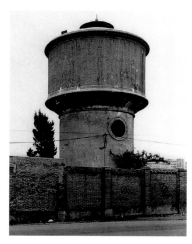
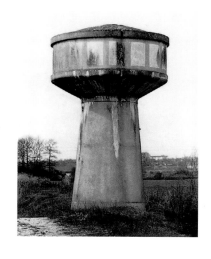
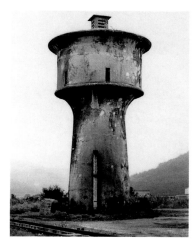
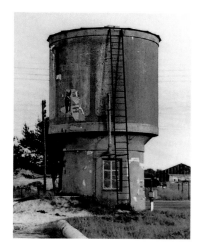

**198. Bernd and
Hilla Becher.**
Water Towers. 1988.
Photographs

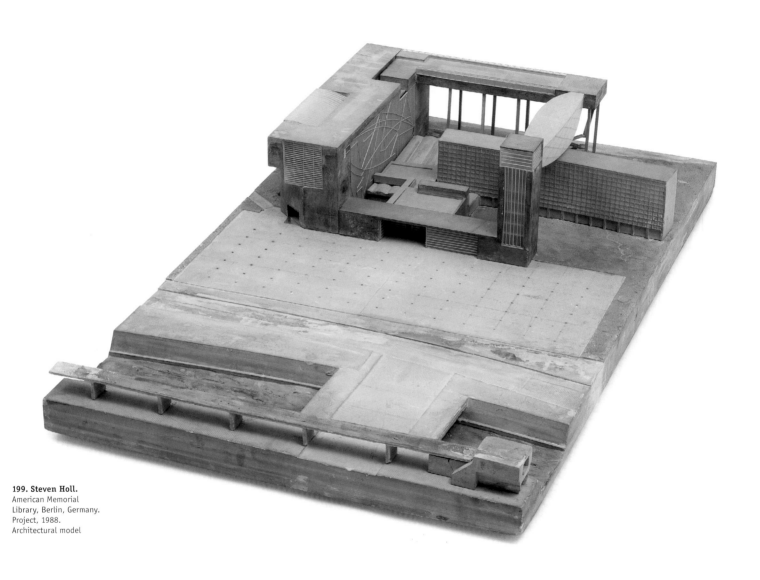

199. Steven Holl.
American Memorial
Library, Berlin, Germany.
Project, 1988.
Architectural model

200. Jean-Luc Godard.
Puissance de la parole.
1988. Film

opposite:
201. Christian Boltanski.
The Storehouse (La Grande Reserve).
1988. Sculpture

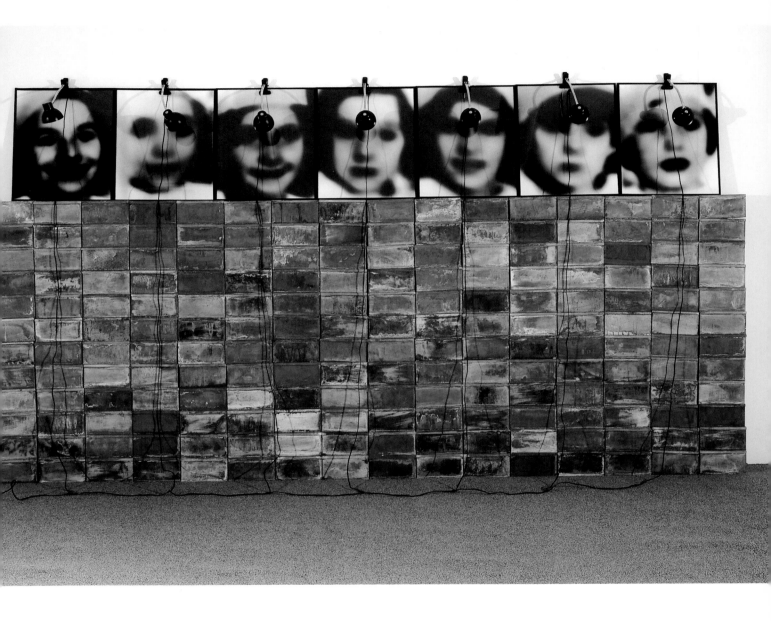

202. Allen Ruppersberg.
Preview. 1988. Prints

opposite:
203. Tadanori Yokoo.
Japanese Society for the
Rights of Authors, Composers,
and Publishers. 1988. Poster

204. David Wojnarowicz.
The Weight of the Earth, Part I.
1988. Photographs

opposite:
205. Ashley Bickerton.
Tormented Self-Portrait (Susie
at Arles). 1987–88. Painting

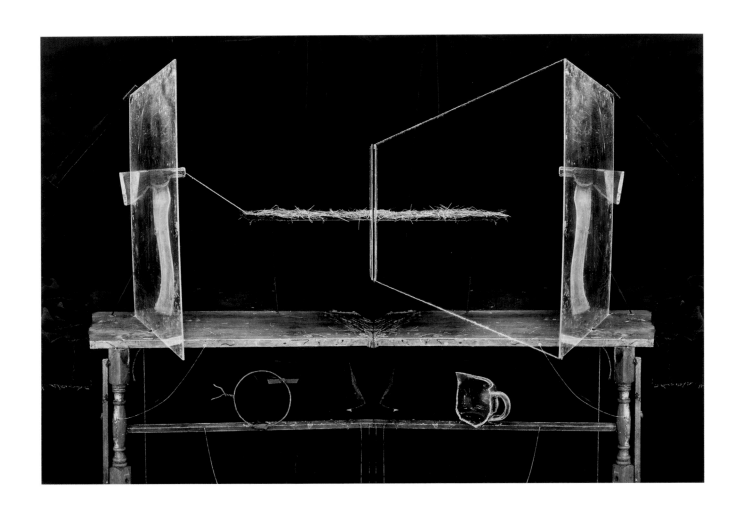

206. Zeke Berman.
Untitled. 1988. Photograph

opposite:
207. Morphosis.
6th Street House Project.
Santa Monica, California.
1987–88. Architectural print

41/50

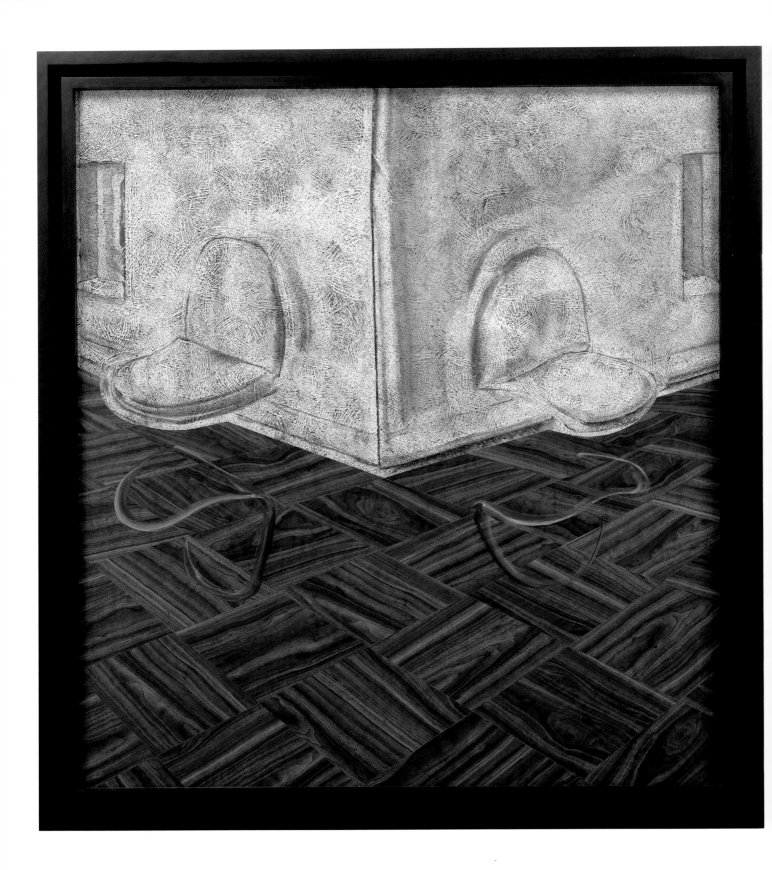

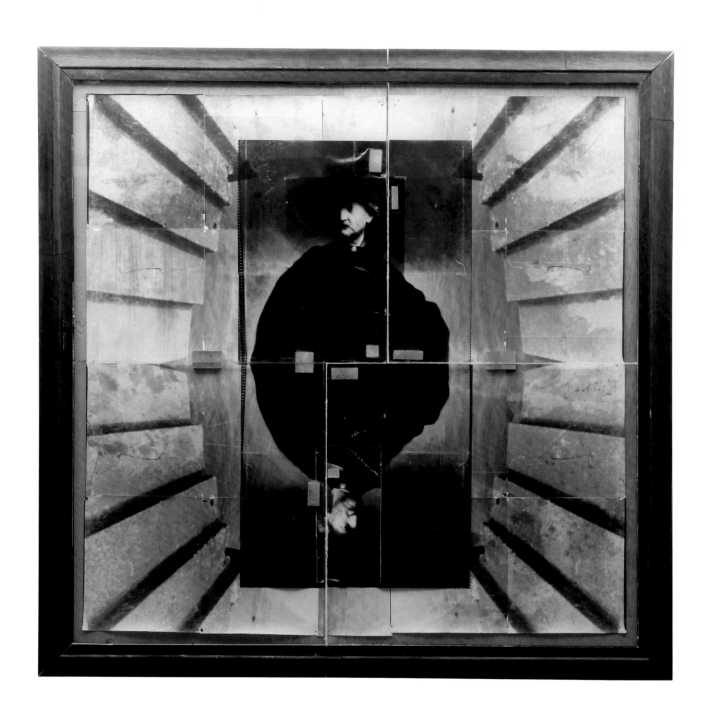

opposite:
208. Richard Artschwager.
Double Sitting. 1988. Painting

209. Mike and Doug Starn.
Double Rembrandt with Steps. 1987–88.
Photographic collage

210. Gerhard Richter.
October 18, 1977. 1988.
Five of fifteen paintings:
Funeral (Beerdigung)

overleaf:
Cell (Zelle); Hanged (Erhängte);
Youth Portrait (Jugendbildnis);
Record Player (Plattenspieler)

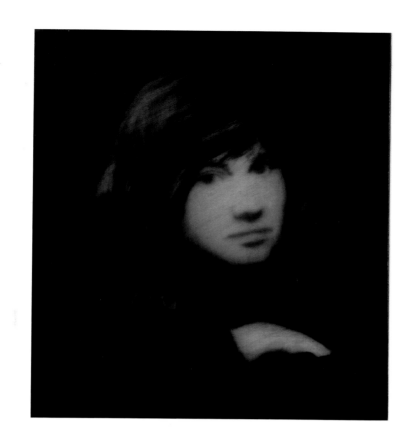

211. **Lawrence Charles Weiner.**
Rocks upon the Beach/Sand upon
the Rocks. 1988. Installation

opposite:
212. **Clint Eastwood.** Bird.
1988. Film

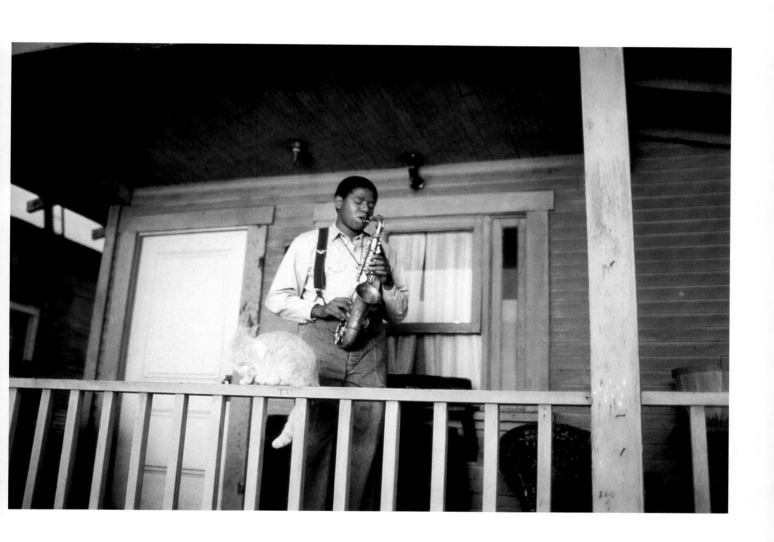

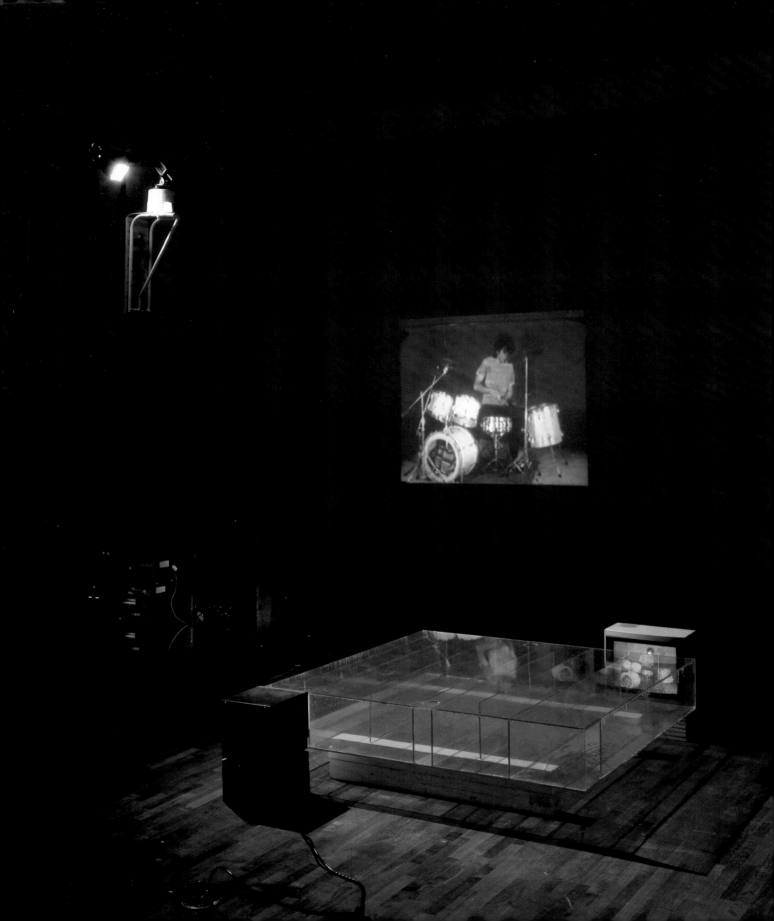

opposite:
213. Bruce Nauman.
Learned Helplessness in
Rats (Rock and Roll Drummer).
1988. Video installation

214. Ilya Kabakov. The Man
Who Flew Into His Picture.
1981–88. Installation

215. **Stephen Peart and Bradford Bissell.** "Animal" Wet Suit. 1988. Design

opposite:
216. **Jeff Koons.**
Pink Panther. 1988. Sculpture

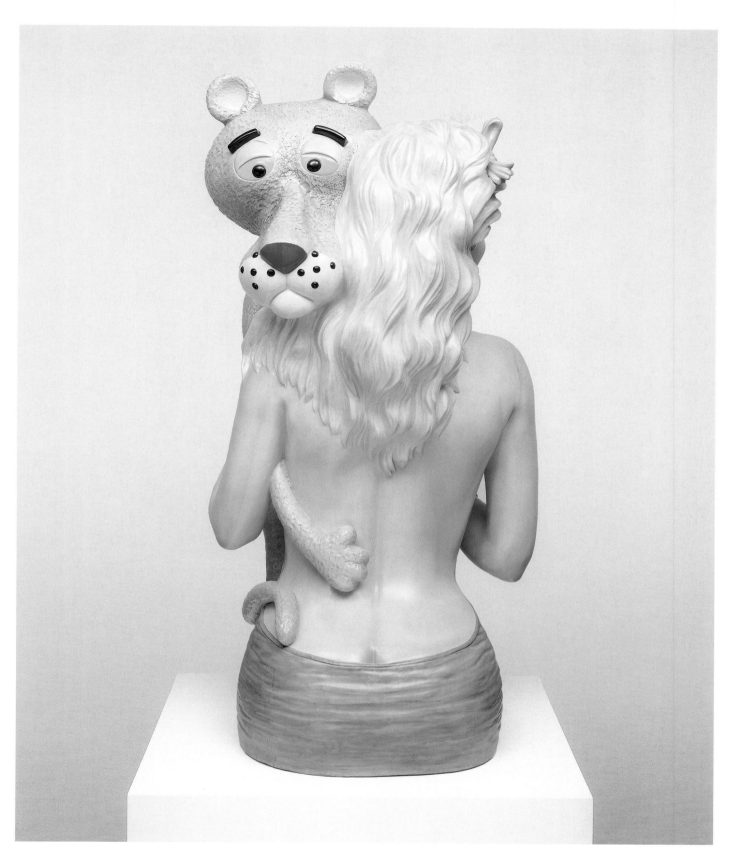

217. Günter Förg.
Stairway. 1988.
Photograph

opposite:
**218. Tony Oursler and
Constance DeJong.**
Joyride. 1988. Video

219. Julie Zando.
Let's Play Prisoners.
1988. Video

220. Louise Lawler.
Does Andy Warhol Make
You Cry? 1988. Photograph

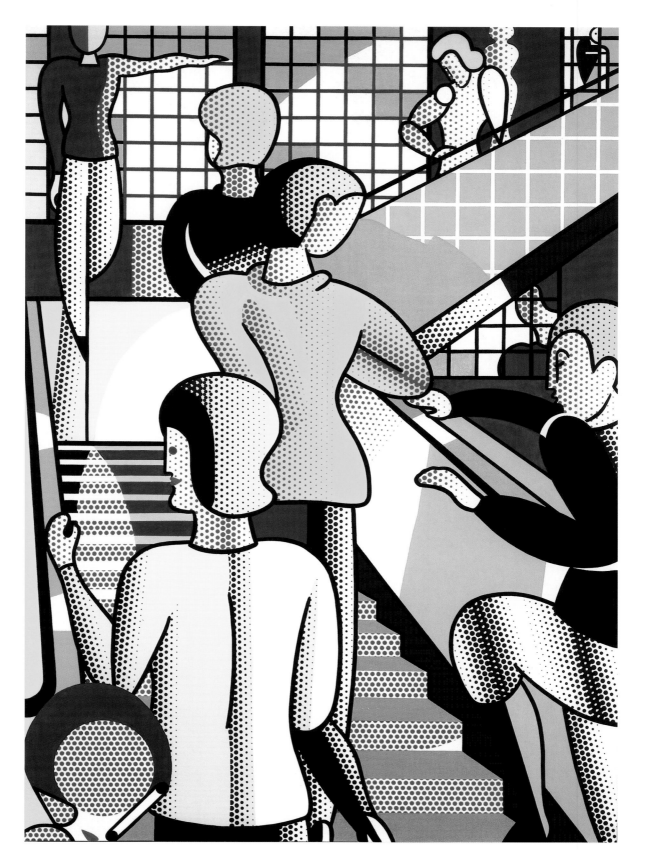

221. Roy Lichtenstein.
Bauhaus Stairway. 1988.
Painting

222. Matt Mullican.
Untitled. 1988. Prints

223. Martin Kippenberger.
The World of the Canary. 1988.
Drawings

opposite:
224. Marc Newson.
Wood Chair. 1988. Design

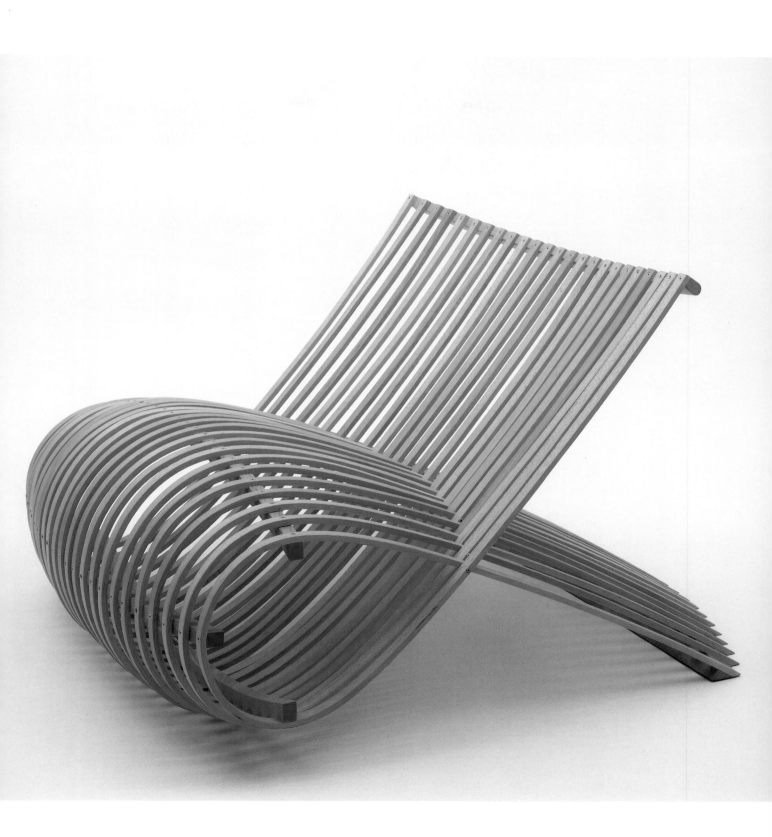

225. Gregory Crewdson.
Untitled from the series Natural
Wonder. 1988. Photograph

226. Adam Fuss.
Untitled. 1988. Photograph

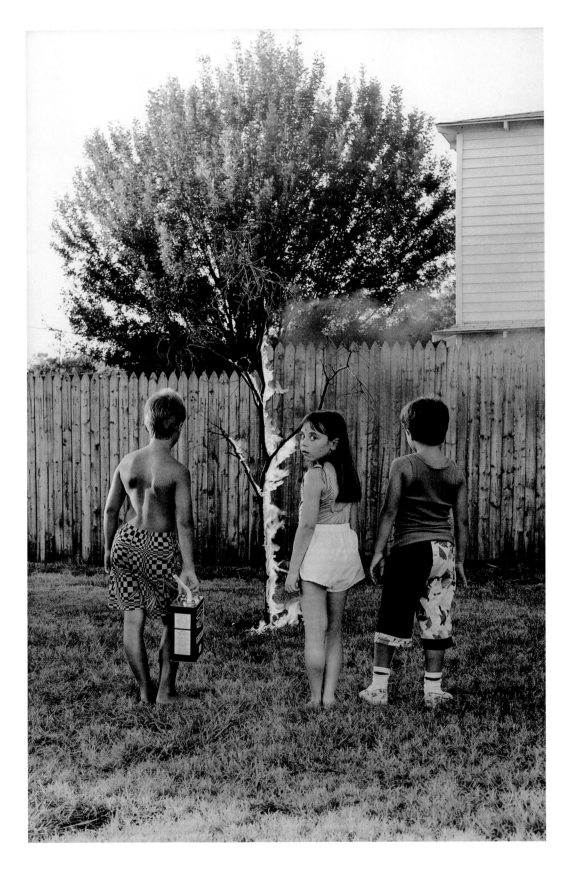

227. **Nic Nicosia.**
Real Pictures #11.
1988. Photograph

opposite:
228. **Paul Thek.**
The Soul Is the Need
for the Spirit. 1988.
Drawing

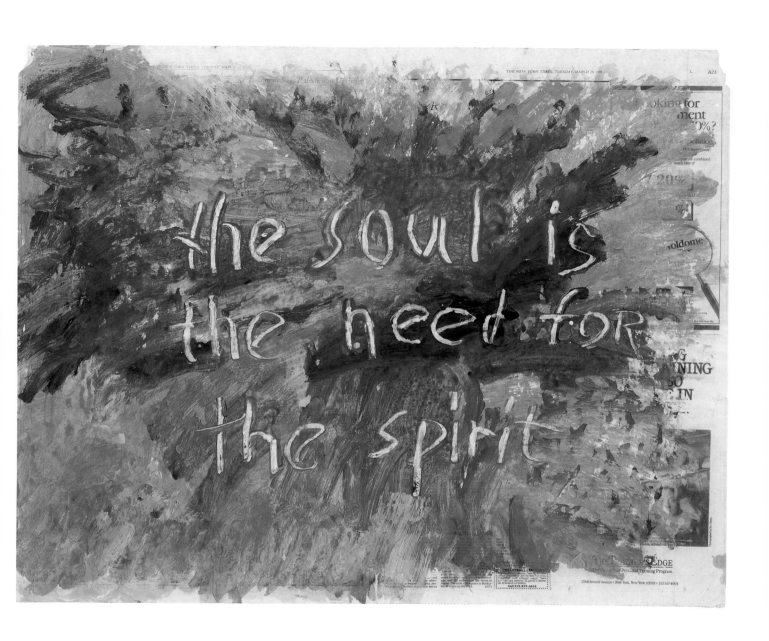

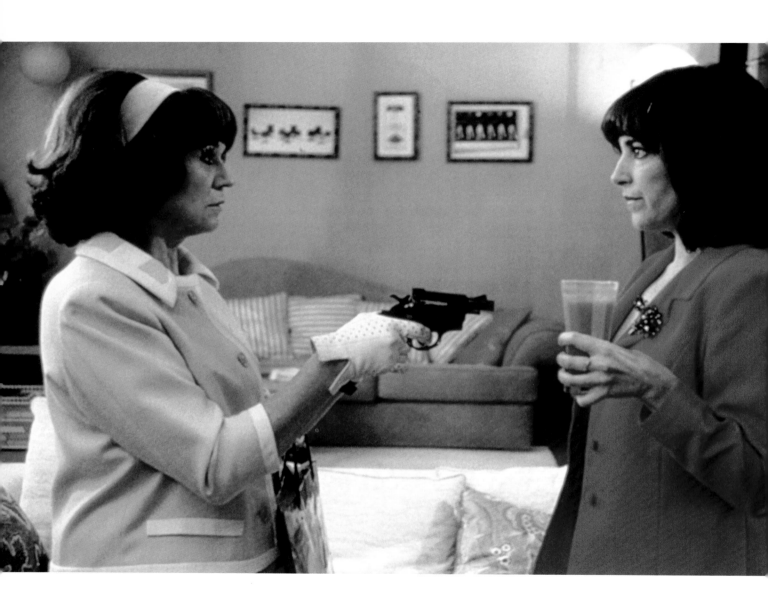

229. **Pedro Almodóvar.**
Women on the Verge of a
Nervous Breakdown.
1988. Film

opposite:
230. **Cindy Sherman.**
Untitled #197. 1989.
Photograph

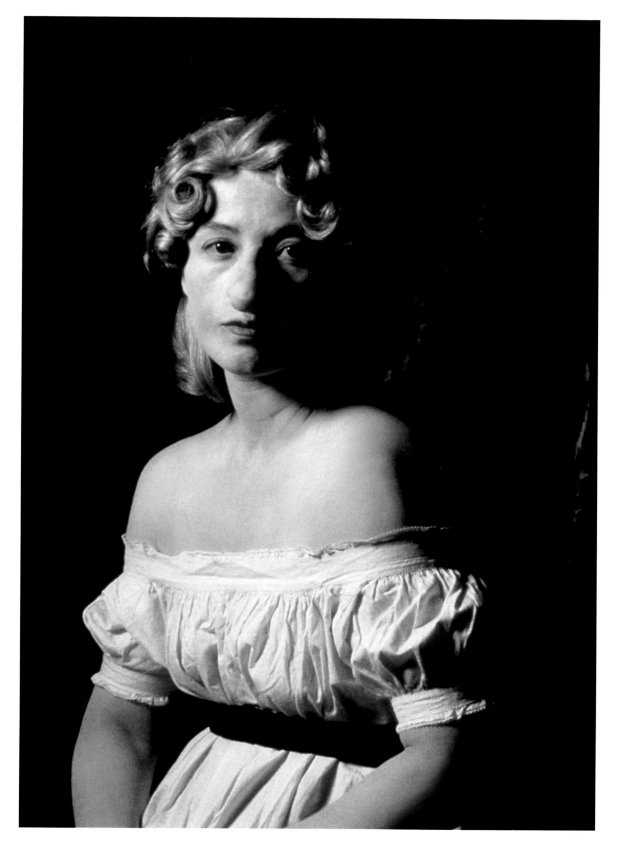

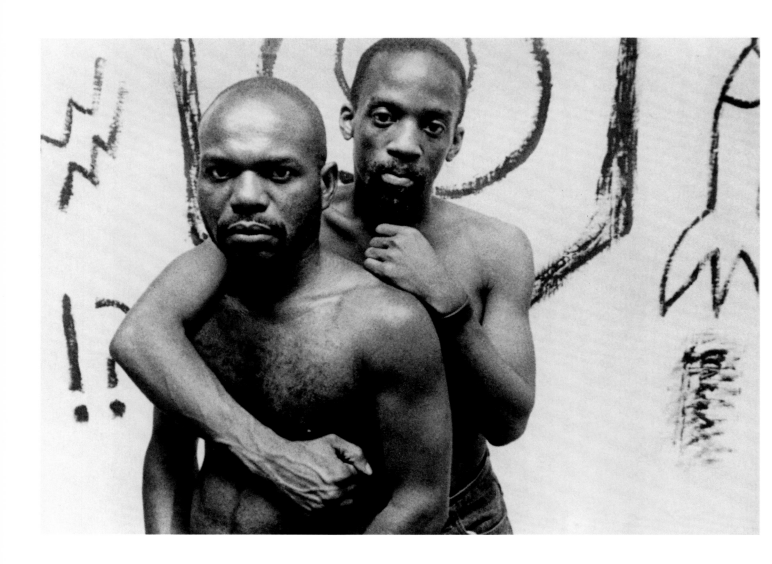

231. Marlon Riggs.
Tongues Untied. 1989. Video

opposite:
232. Martin Scorsese.
The Last Temptation of Christ.
1989. Film

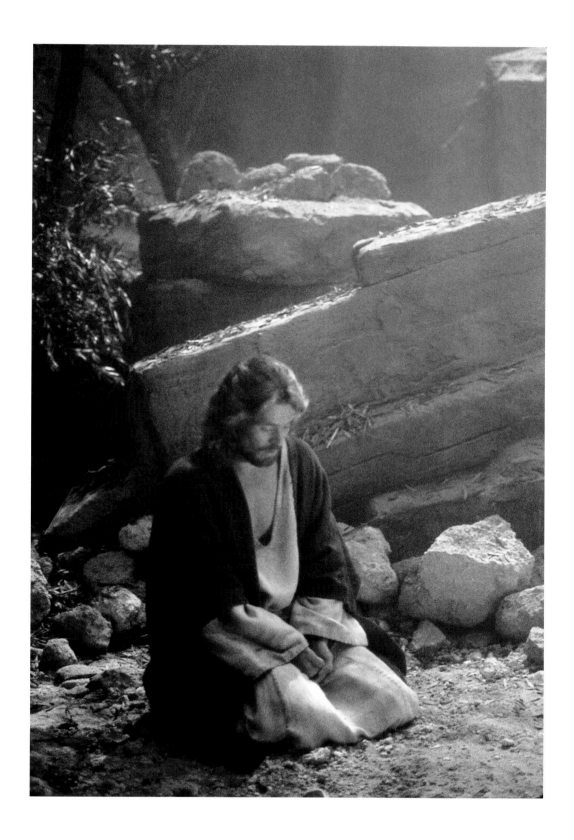

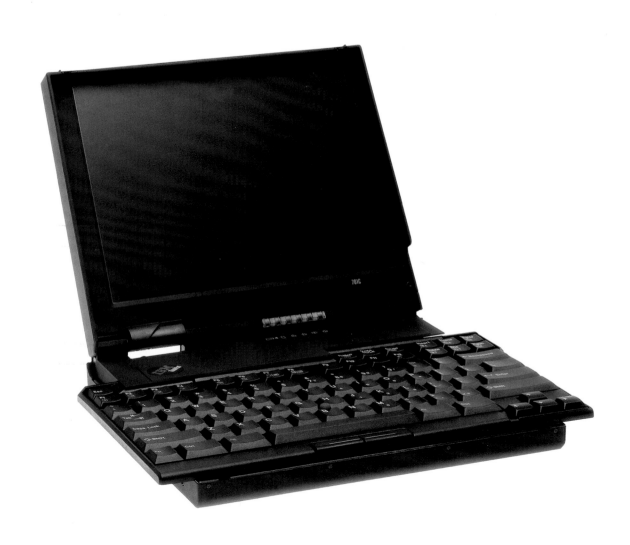

**233. Richard Sapper and
Sam Lucente.** Leapfrog Computer.
1989. Design

opposite:
234. Thomas Ruff. Portrait.
1989. Photograph

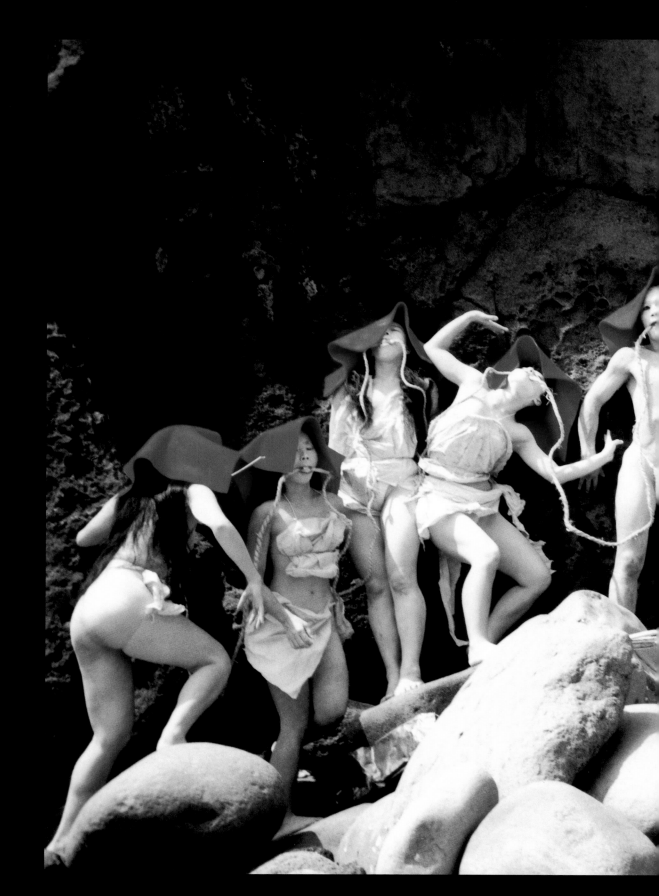

235. Edin Velez.
Dance of Darkness.
1989. Video

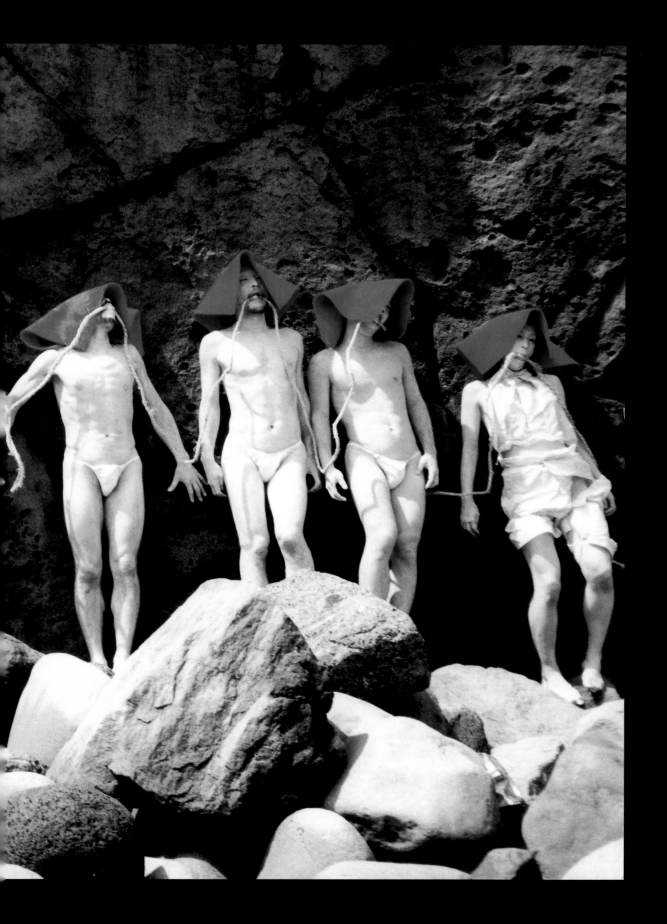

236. Carroll Dunham.
Shadows. 1989. Prints

opposite:
237. Tadanori Yokoo.
Fancydance. 1989. Poster

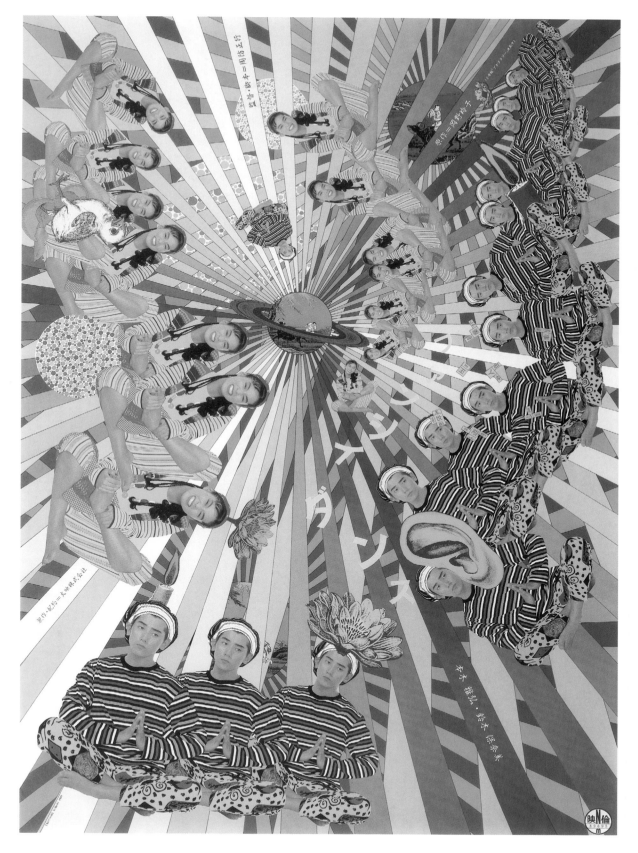

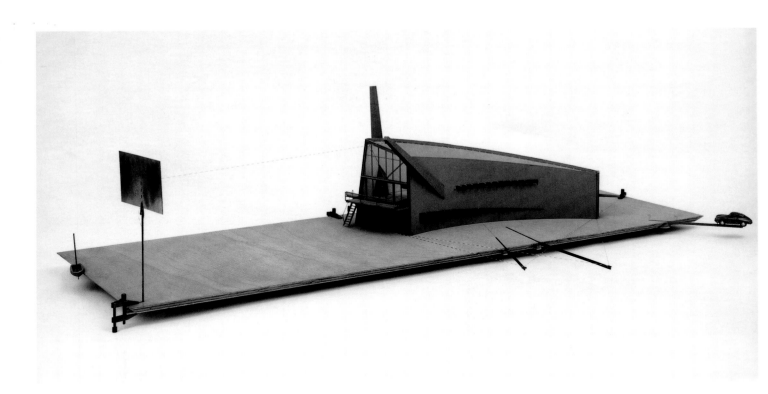

**238. Elizabeth Diller and
Ricardo Scofidio.** Slow House,
Long Island, New York. 1989.
Architectural model

239. Rafael Viñoly. Tokyo
International Forum, Tokyo, Japan.
1989. Architectural drawing

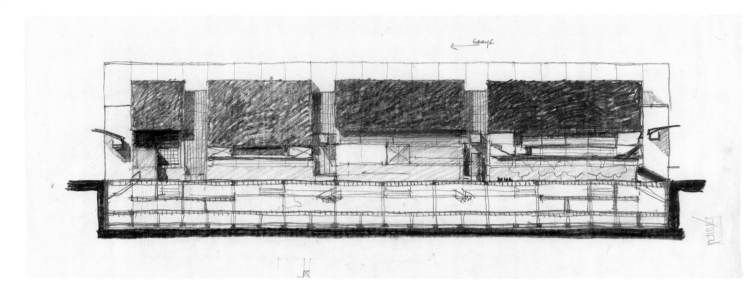

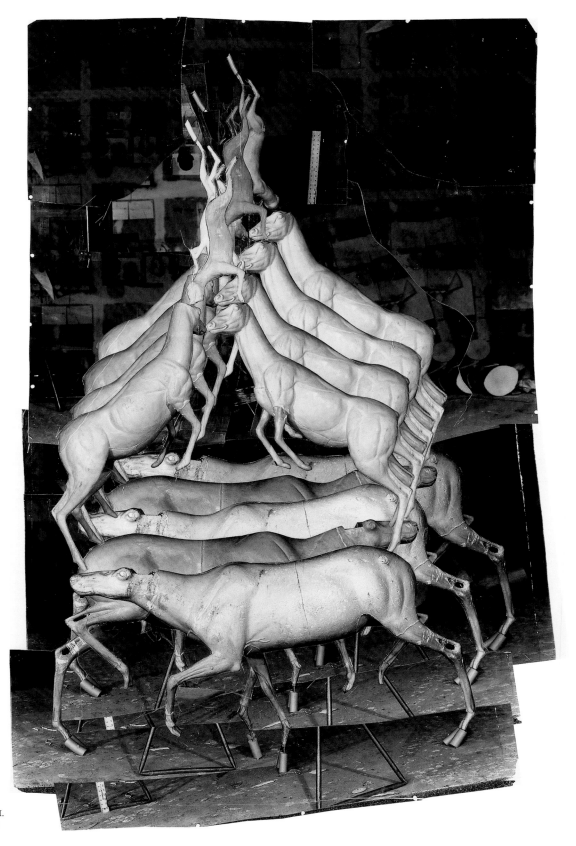

240. Bruce Nauman.
Model for Animal Pyramid II.
1989. Photographic collage

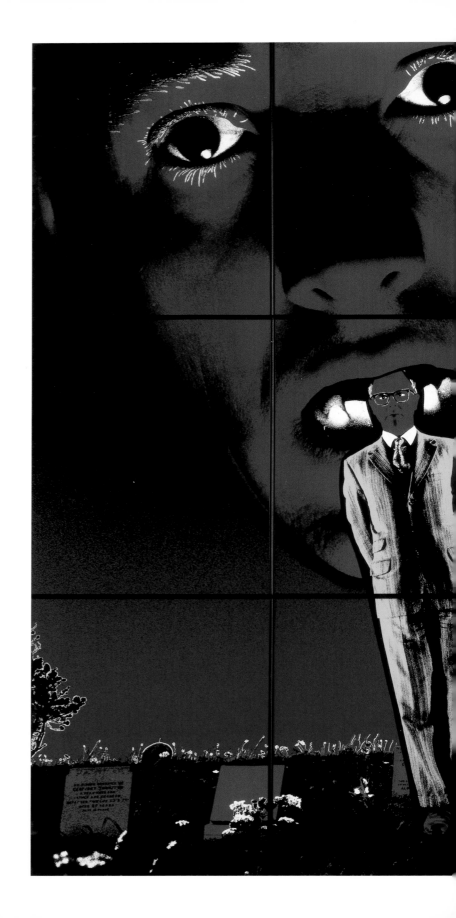

241. Gilbert and George.
Down to Earth. 1989. Painting

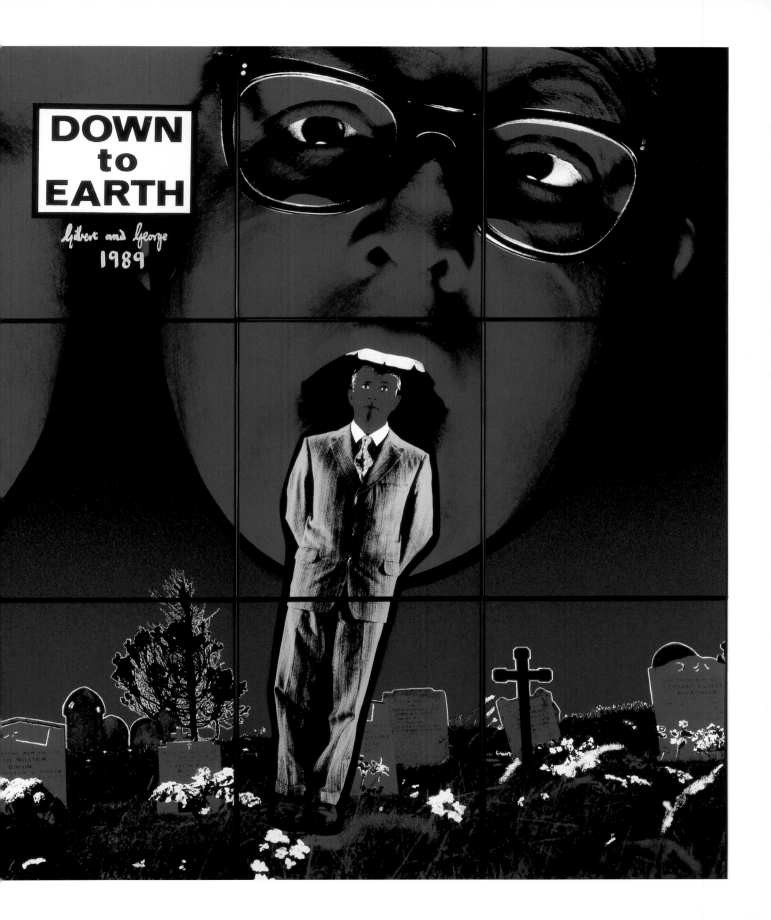

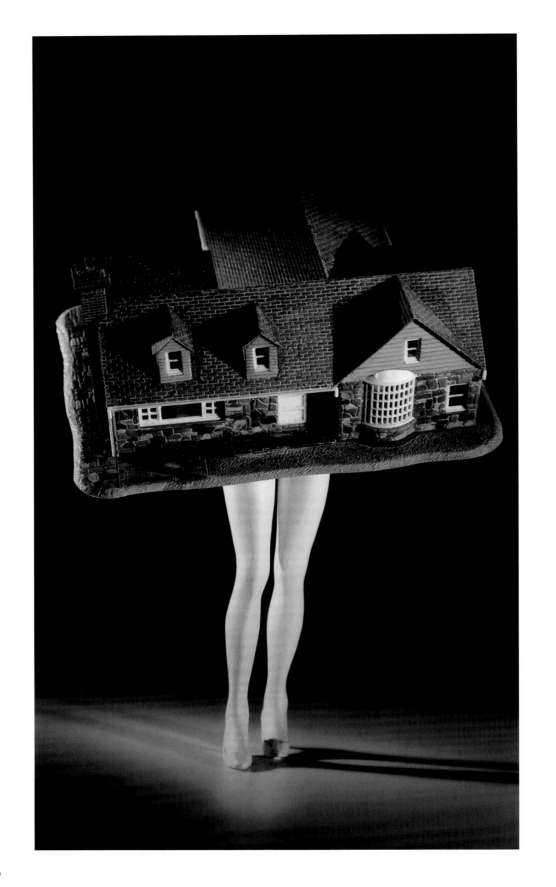

242. Laurie Simmons.
Walking House. 1989.
Photograph

opposite:
243. David Levinthal.
Untitled from the series
Cowboys. 1989.
Photograph

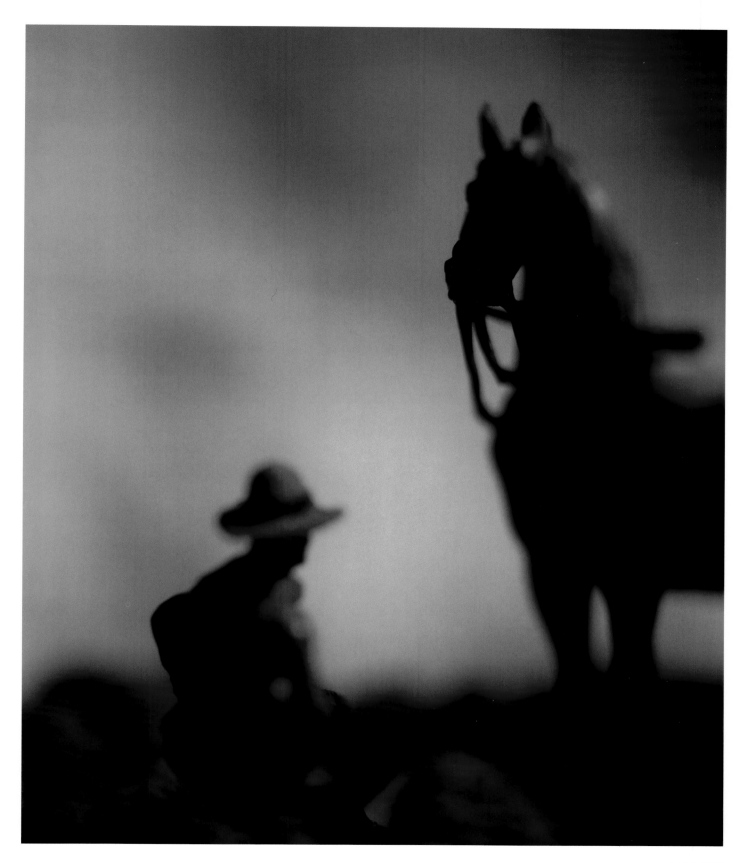

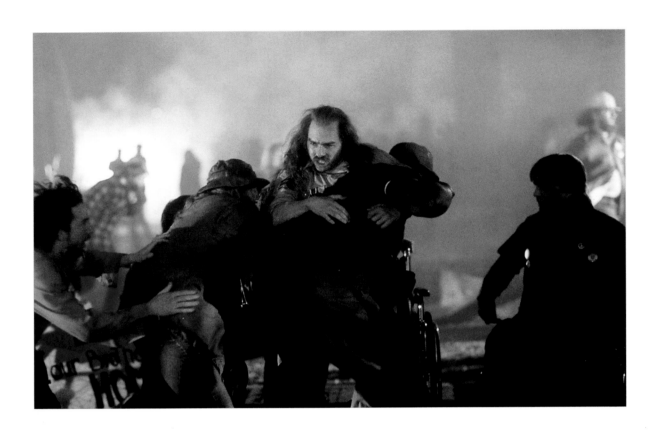

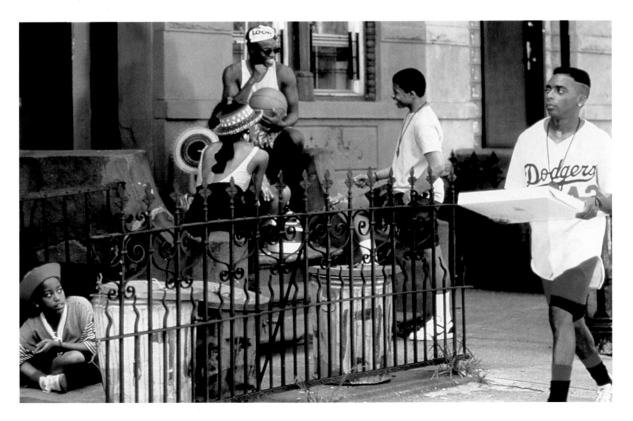

244. Oliver Stone.
Born on the Fourth of July.
1989. Film

245. Spike Lee.
Do the Right Thing.
1989. Film

opposite:
246. Chris Killip.
Untitled. 1989. Photograph

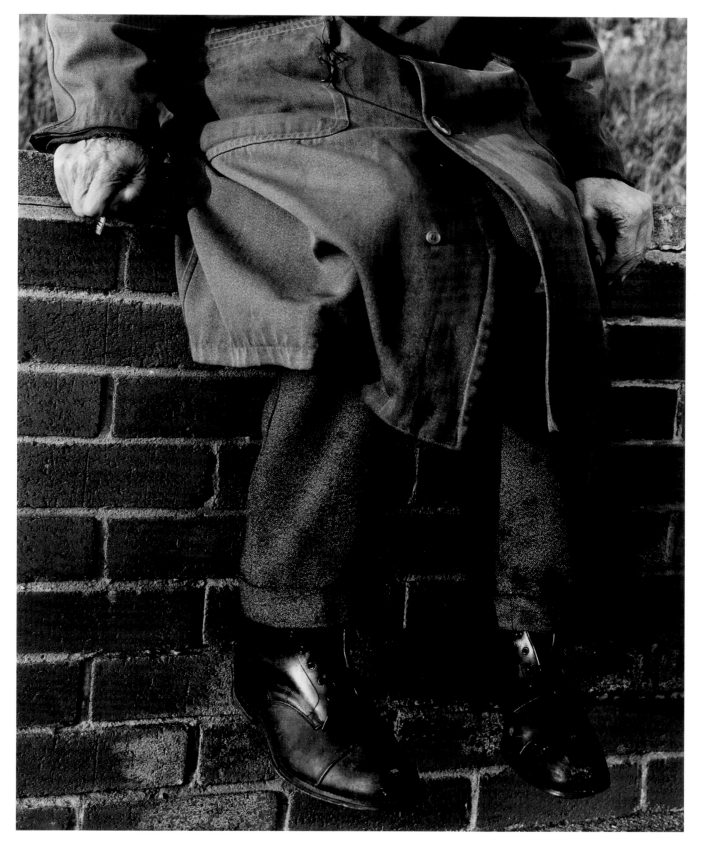

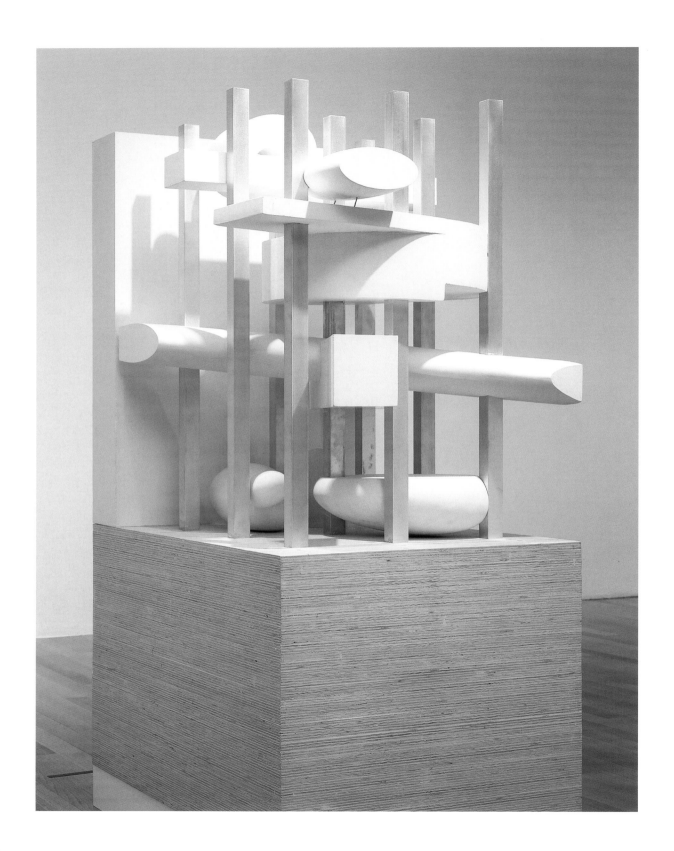

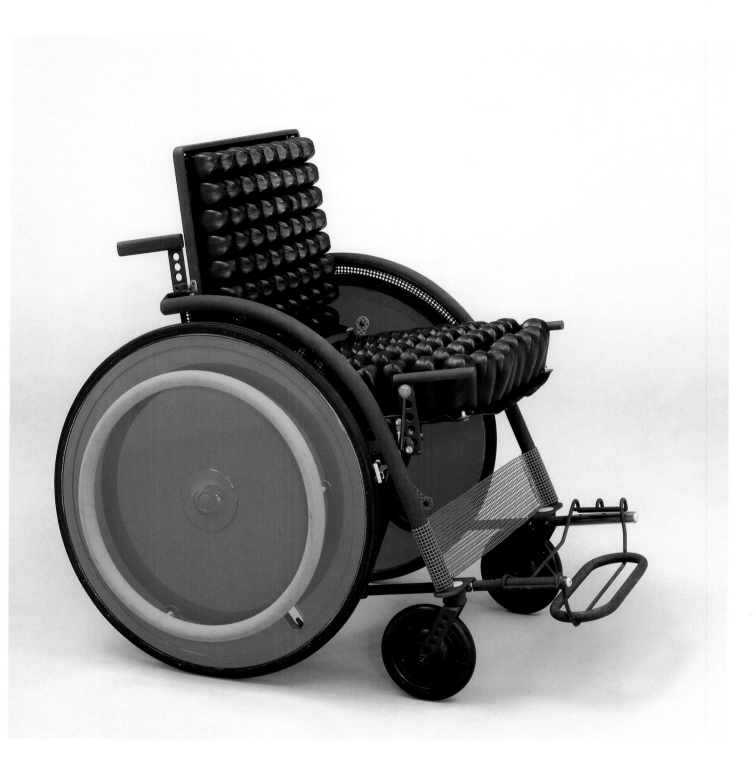

**247. Office for Metropolitan
Architecture.** National Library of
France (Très Grande Bibliothèque),
Paris. Project, 1989. Architectural
model

248. Kazuo Kawasaki.
Carna Wheelchair. 1989.
Design

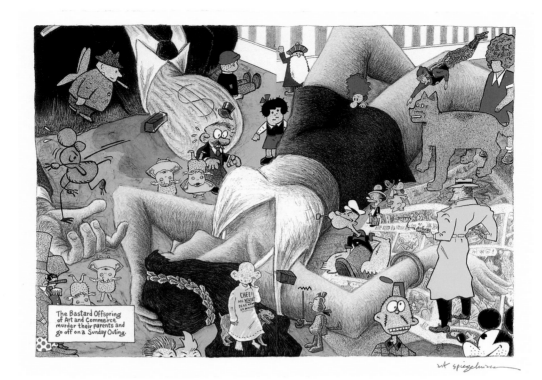

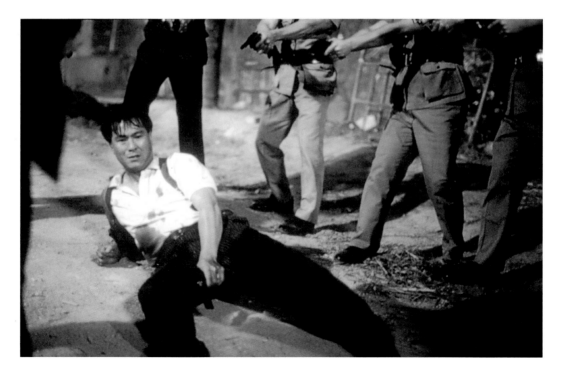

249. Art Spiegelman.
Lead Pipe Sunday. 1989.
Print

250. John Woo.
The Killer. 1989. Film

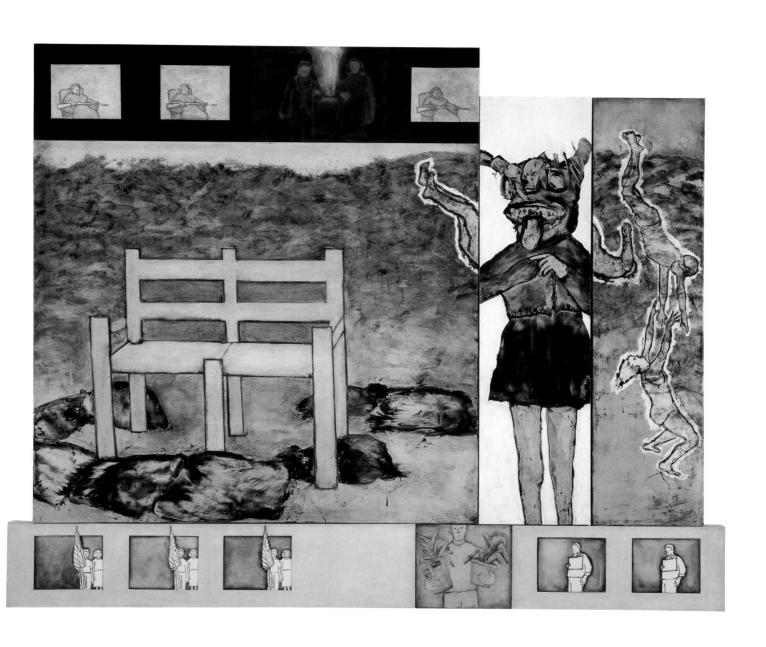

251. Ida Applebroog.
Chronic Hollow. 1989.
Painting

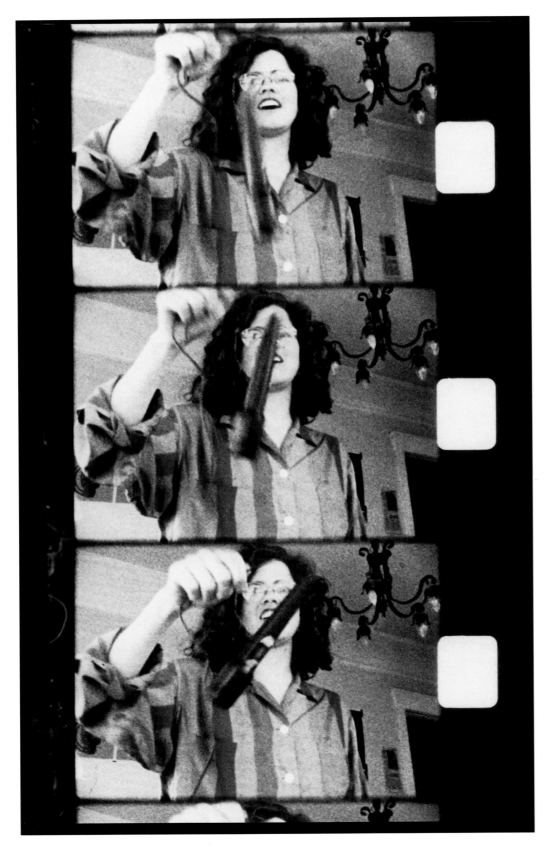

252. Peggy Ahwesh.
Martina's Playhouse.
1989. Film

opposite:
253. Shiro Kuramata.
Miss Blanche Chair. 1989.
Design

overleaf:
254. Edward Ruscha.
That Is Right and Other
Similarities. 1989. Prints

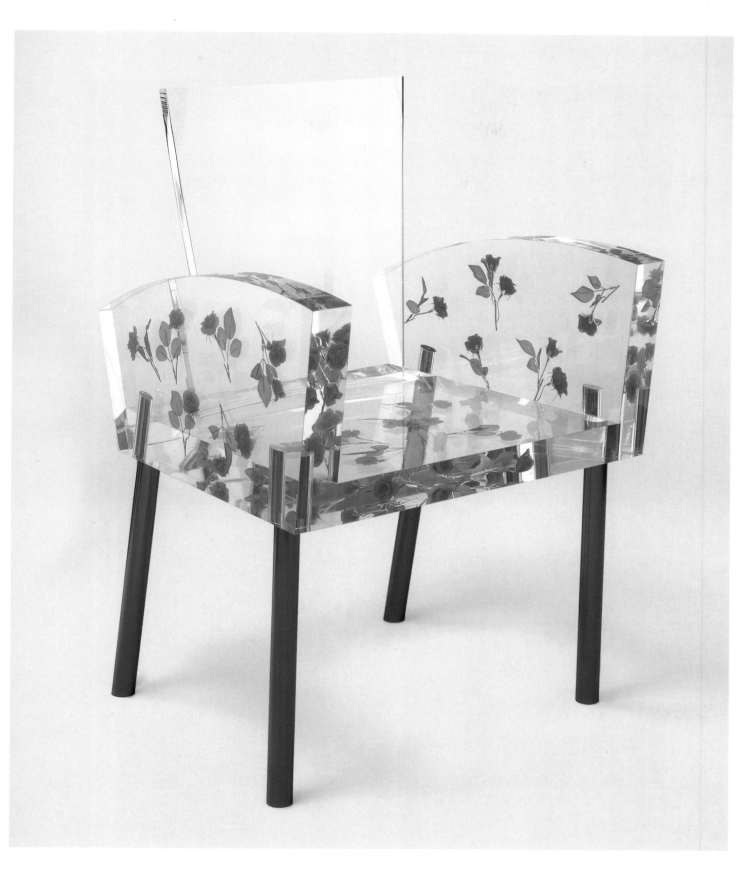

28/30 8 R 89

28/30 8 R 89

28/30 8 R 89

28/30 8 R 89

28/30 8 R 89

28/30

28/30

28/30

28/30

28/30

28/30

ER '89

ER '89

ER '89

ER '89

ER '89

ER '89

255. **José Leonilson.**
To Make Your Soul Close to Me.
1989. Drawing

256. **Sadie Benning.**
Me and Rubyfruit. 1989.
Video

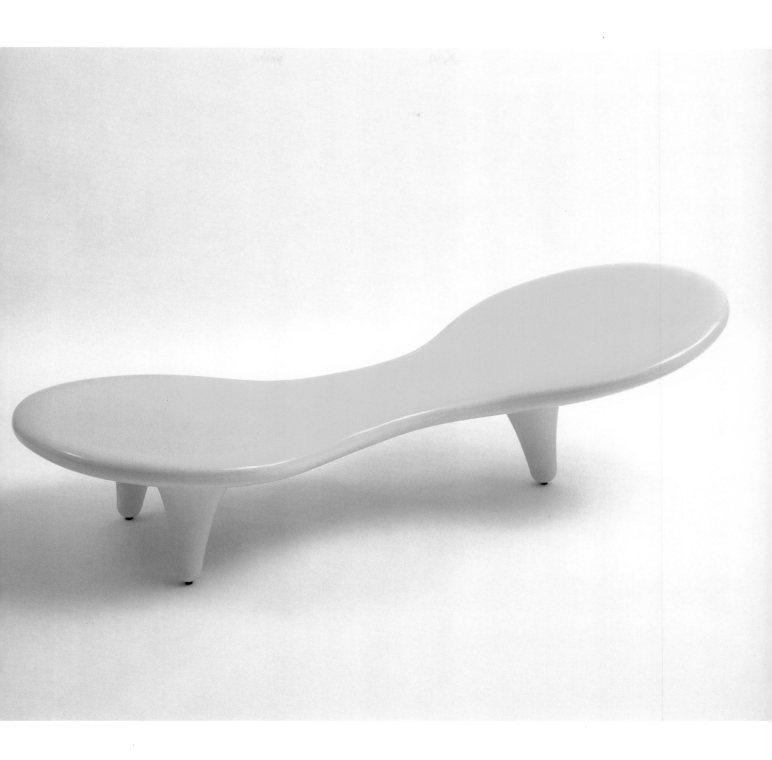

257. Marc Newson.
Orgone Chaise Longue.
1989. Design

258. Joan Jonas.
Volcano Saga. 1989. Video

opposite:
259. Giuseppe Penone.
Thirty-Three Herbs. 1989.
Prints

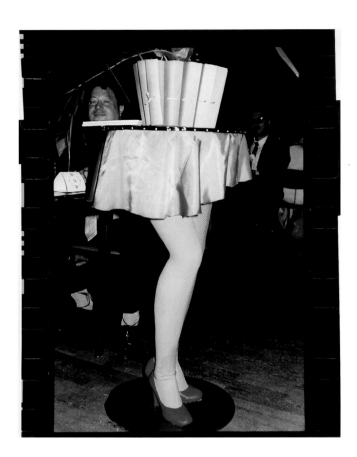

260. Gundula Schulze.
Dresden. 1989. Photograph

261. Martin Parr.
Midsummer Madness,
Conservative Party Social
Event. 1986–89.
Photograph

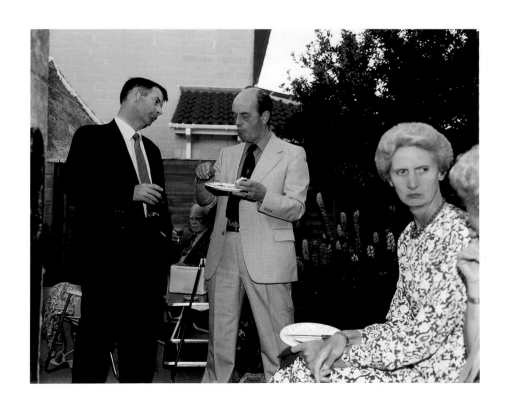

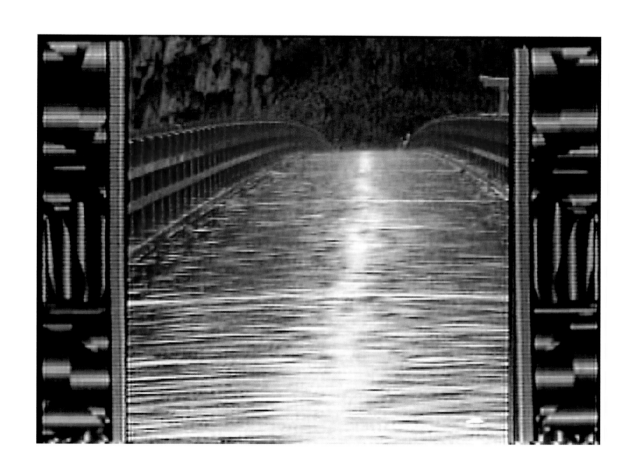

262. Steina Vasulka.
In the Land of the Elevator Girls.
1989. Video

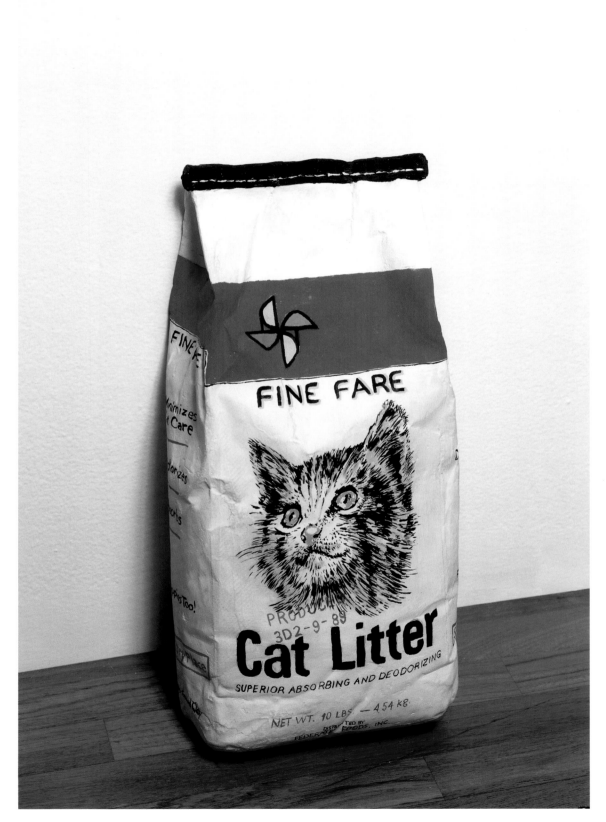

263. Robert Gober.
Cat Litter. 1989. Sculpture

opposite:
264. Thomas Schütte.
Untitled. 1989. Drawings

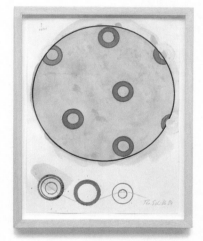

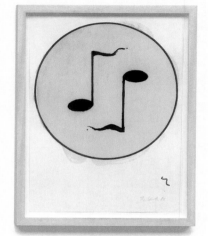

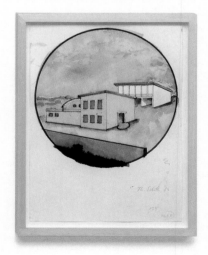

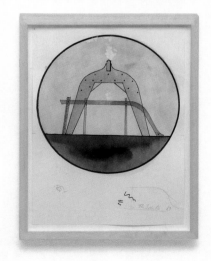

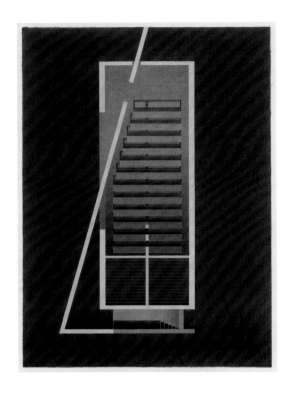

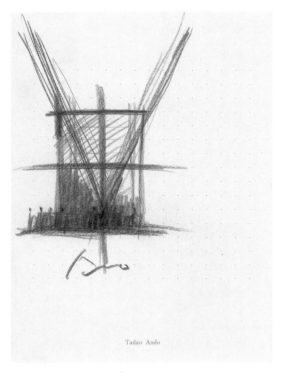

Tadao Ando

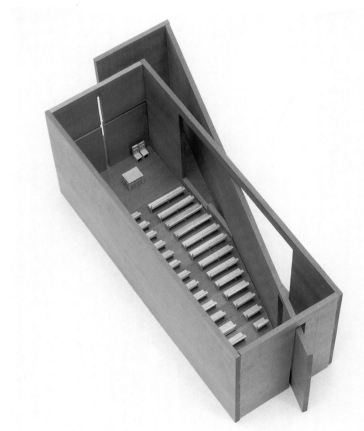

265. Tadao Ando.
Church of the Light,
Ibaraki, Osaka, Japan.
1984–89. Architectural print

266. Tadao Ando.
Church of the Light,
Ibaraki, Osaka, Japan.
1984–89. Architectural drawing

267. Tadao Ando.
Church of the Light,
Ibaraki, Osaka, Japan.
1984–89. Architectural model

opposite:
268. James Lee Byars.
The Table of Perfect. 1989.
Sculpture

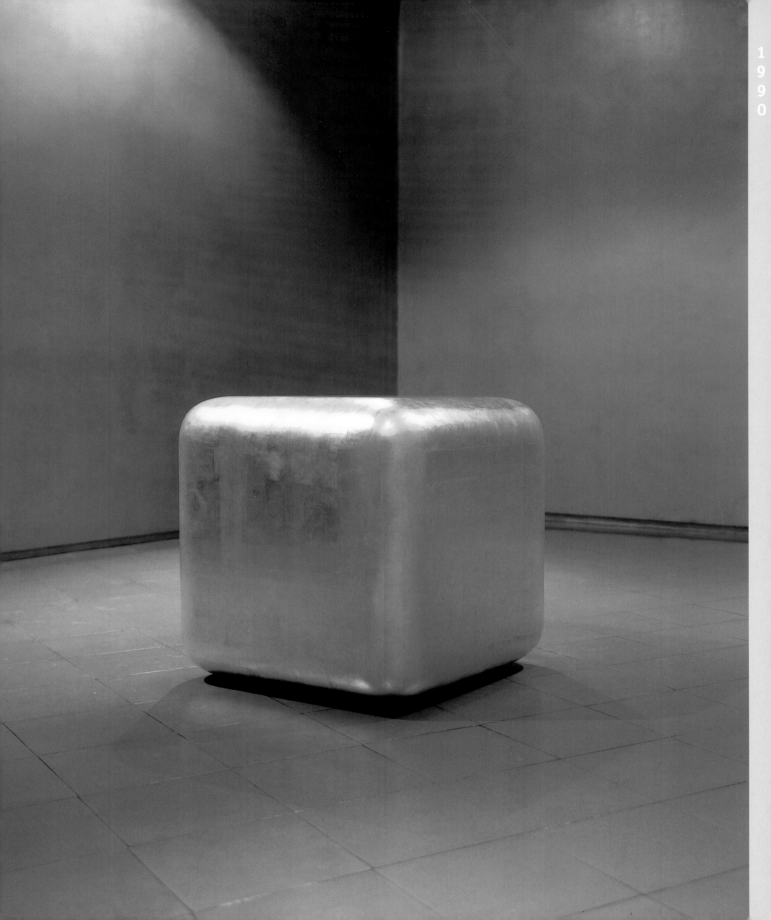

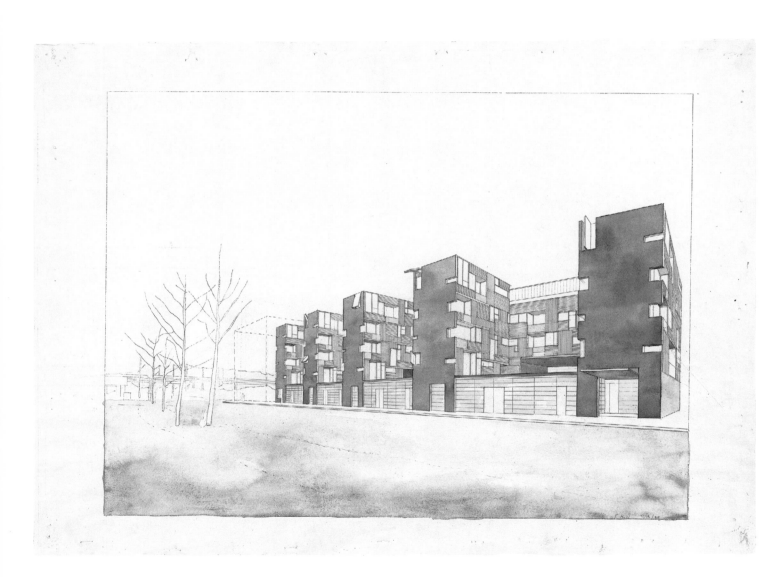

269. Steven Holl.
Nexus World Kashii,
Fukuoka, Japan. 1989.
Architectural drawing

opposite:
270. James Turrell.
First Light, Series C.
1989–90. Prints

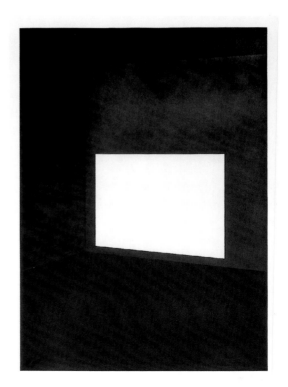

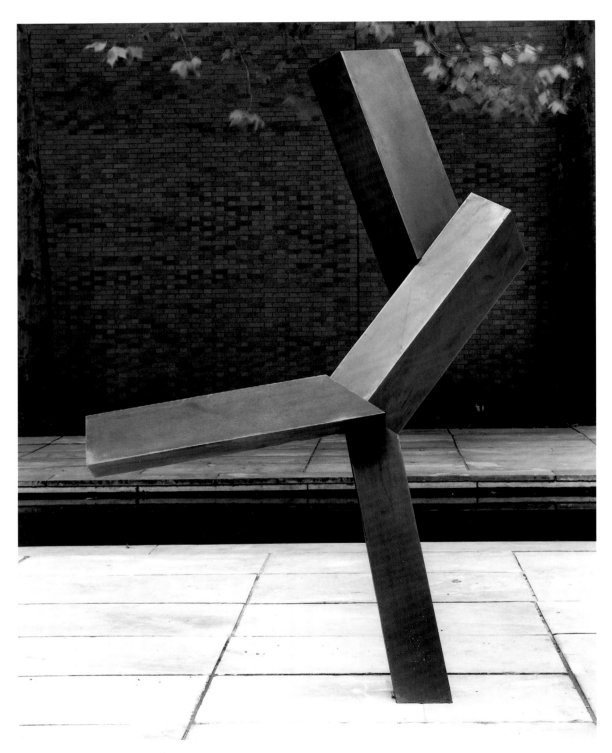

271. Joel Shapiro.
Untitled. 1989–90.
Sculpture

opposite:
272. Steven Holl.
"Edge of a City"
Parallax Towers,
New York. Project,
1990. Architectural
model

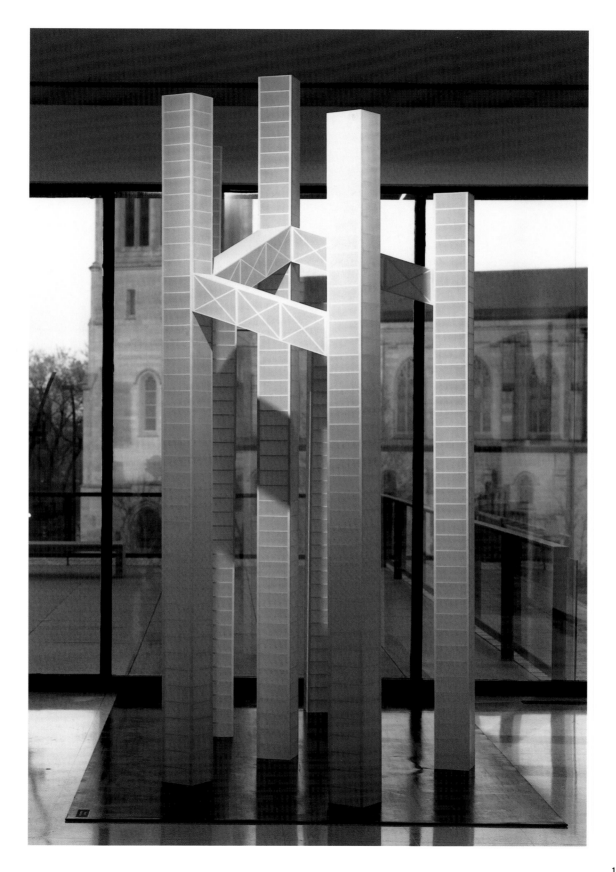

CATS INBAG BAGS IN RIVER

273. Christopher Wool.
Untitled. 1990. Painting

opposite:
274. Martin Kippenberger.
Martin, Stand in the Corner
and Be Ashamed of Yourself.
1990. Sculpture

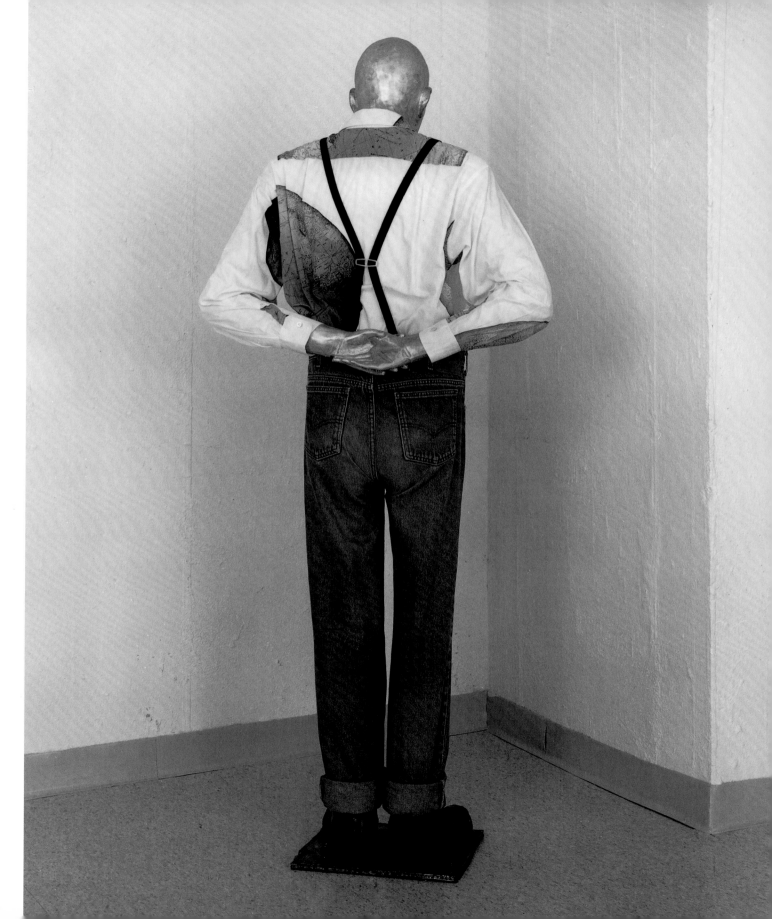

275. John Barnard.
Formula 1 Racing Car 641/2.
1990. Design

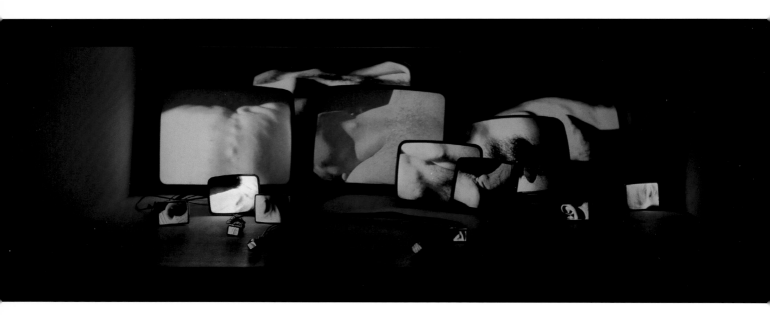

276. Gary Hill.
Inasmuch As It Is
Always Already Taking
Place. 1990. Video
installation

277. General Idea.
AIDS projects. 1988–90.
Prints

opposite:
278. Lari Pittman.
Counting to Welcome
One's Defrosting. 1990.
Drawing

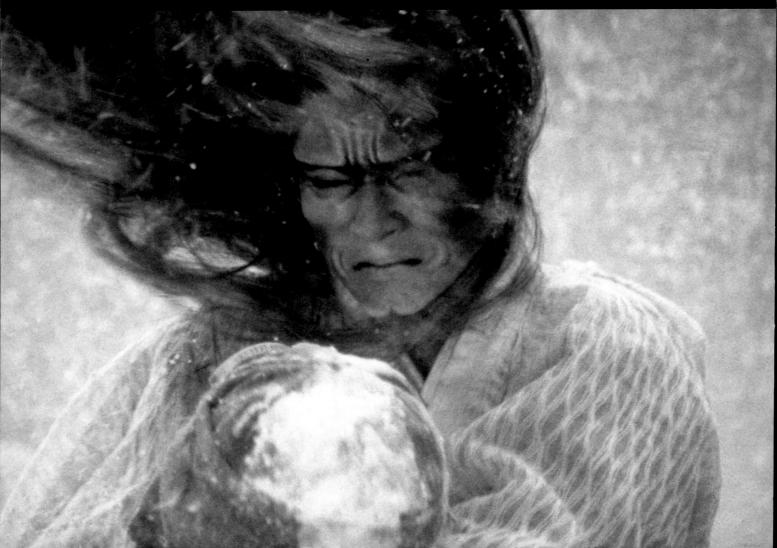

opposite:
279. Akira Kurosawa.
Dreams. 1990. Film

right:
280. Brice Marden.
Cold Mountain Series,
Zen Study 1 (Early State).
1990. Print

281. Brice Marden.
Cold Mountain Series,
Zen Study 3 (Early State).
1990. Print

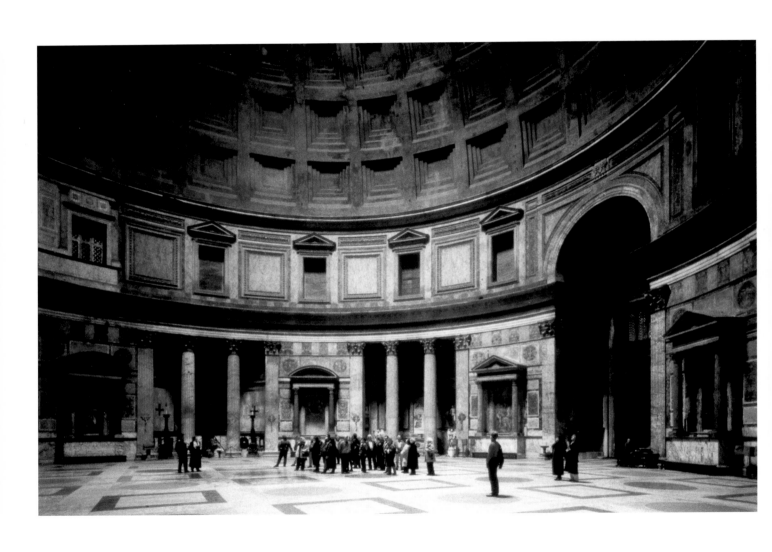

282. Thomas Struth.
Pantheon, Rome. 1990.
Photograph

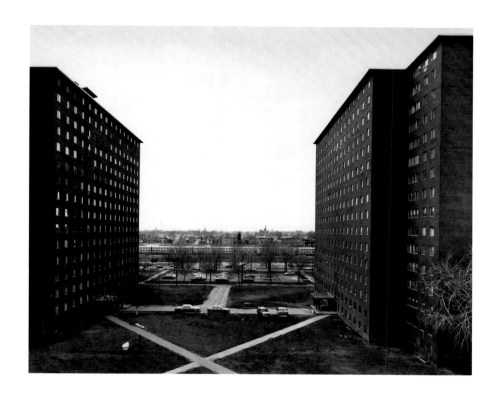

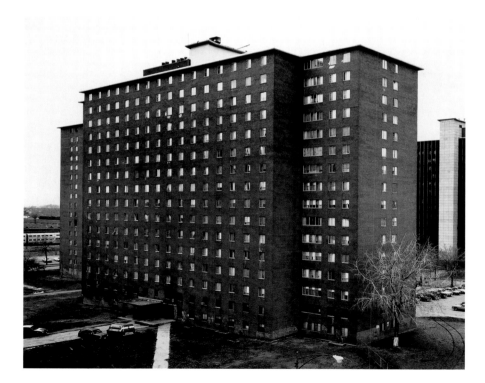

283. Thomas Struth.
South Lake Apartments 3,
Chicago. 1990. Photograph

284. Thomas Struth.
South Lake Apartments 4,
Chicago. 1990. Photograph

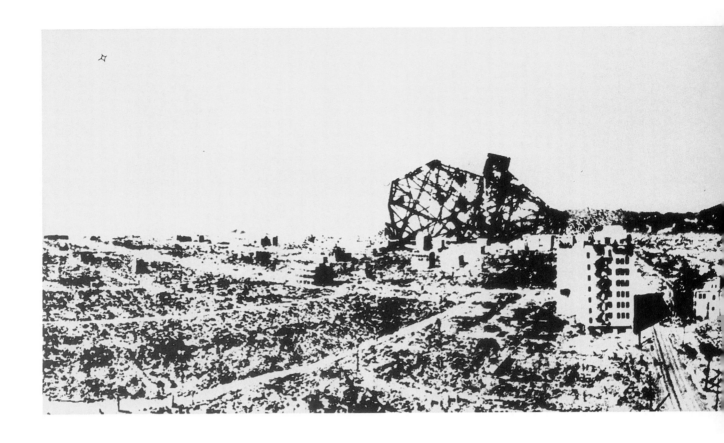

285. Arata Isozaki.
City in the Air: "Ruin of
Hiroshima." Project, 1990.
Architectural print

286. Arata Isozaki.
City in the Air: "Incubation
Process." Project, 1990.
Architectural print

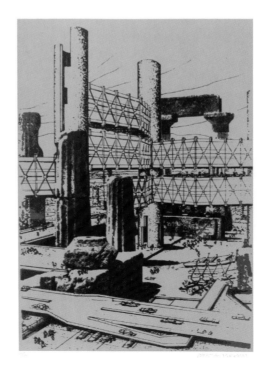

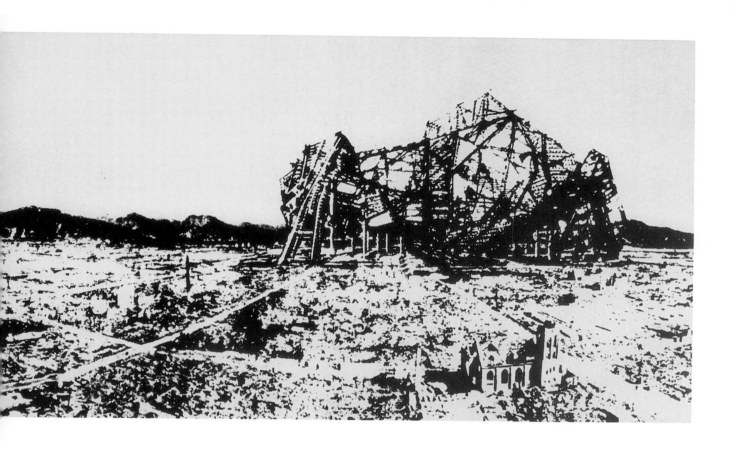

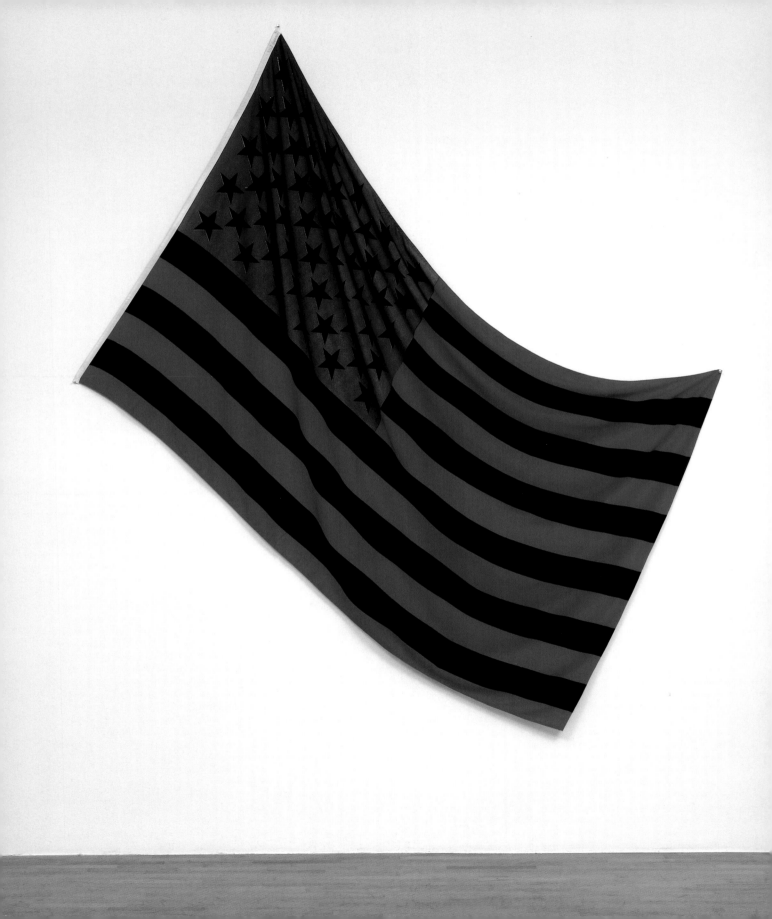

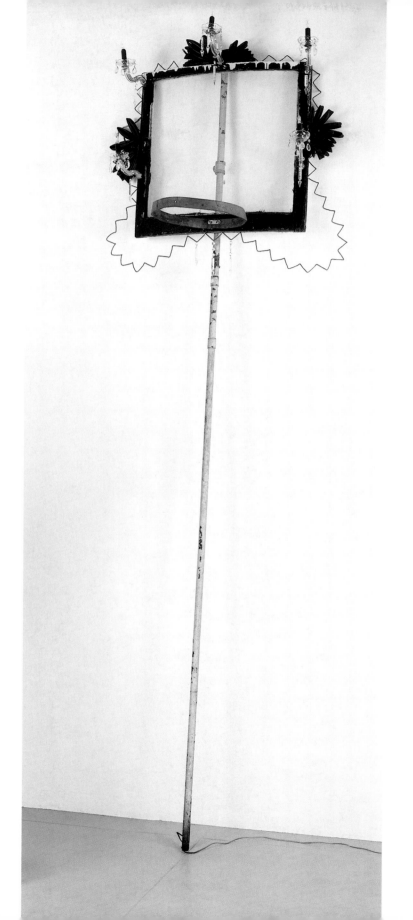

right:
288. David Hammons.
High Falutin'. 1990. Sculpture

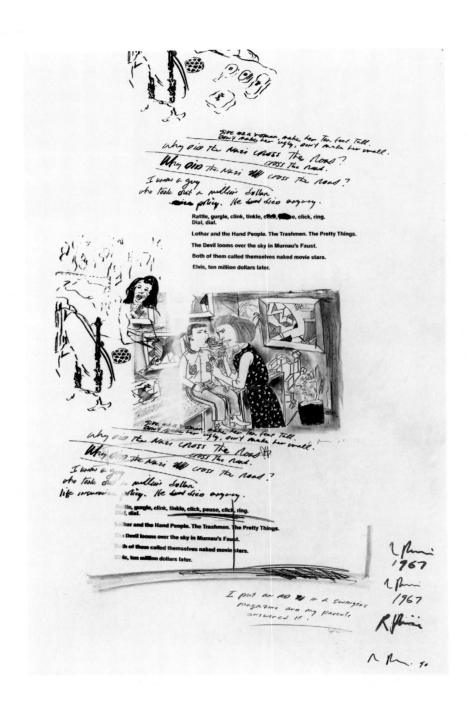

289. Richard Prince.
Untitled. 1984 and 1990.
Drawing

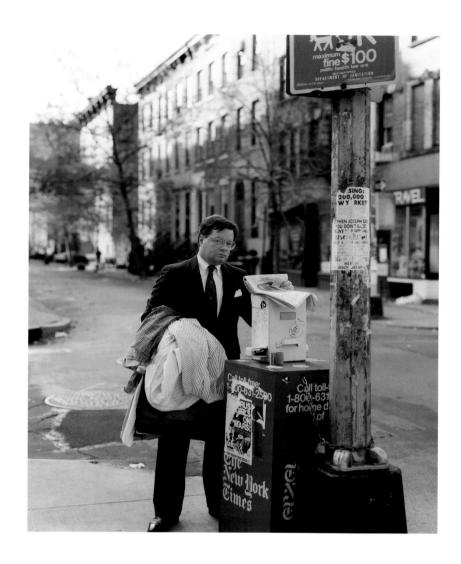

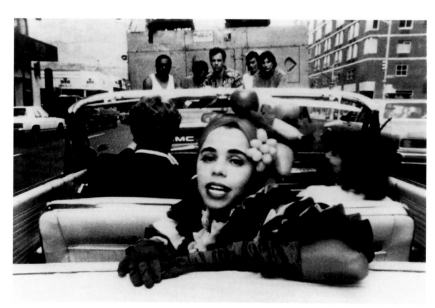

290. Joel Sternfeld.
An Attorney with Laundry,
Bank and Fourth, New York,
New York. 1990. Photograph

291. Yvonne Rainer.
Privilege. 1990. Film

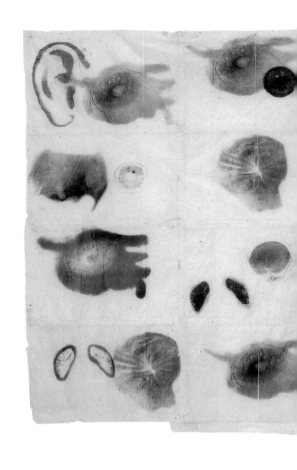

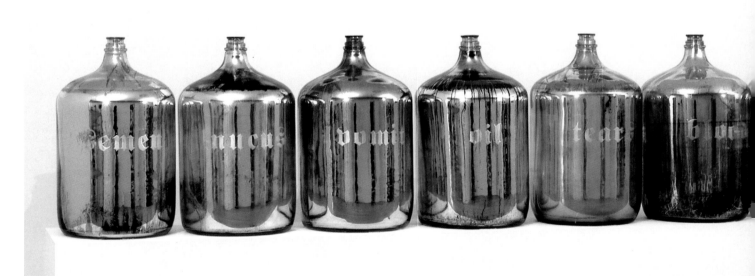

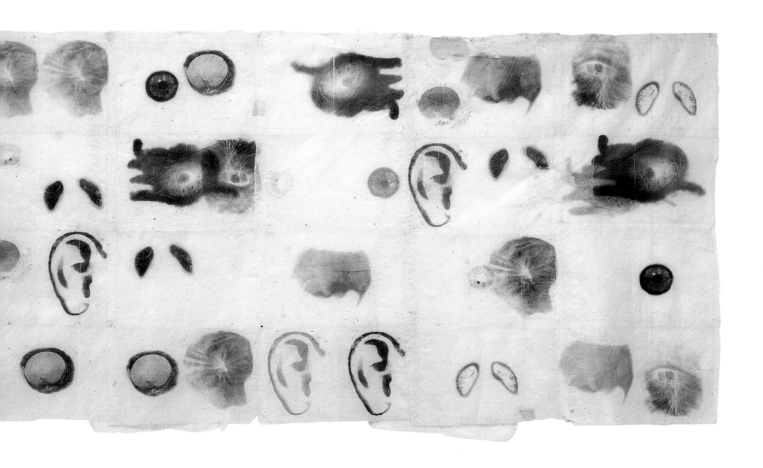

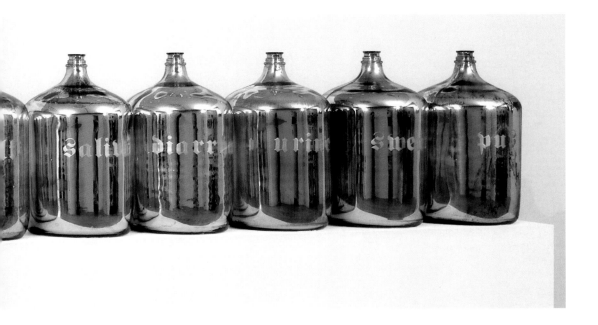

292. Kiki Smith.
A Man. 1990. Drawing

293. Kiki Smith.
Untitled. 1987–90.
Sculpture

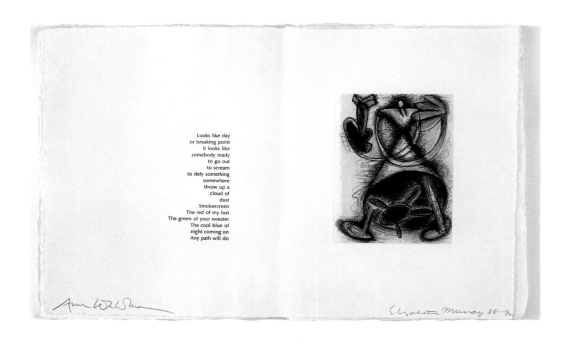

Looks like day
or breaking point
It looks like
somebody ready
to go out
to scream
to defy something
somewhere
throw up a
cloud of
dust
Smokescreen
The red of my lust
The green of your sweater
The cool blue of
night coming on
Any path will do

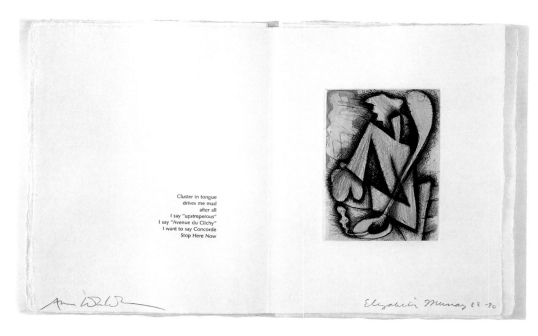

Cluster in tongue
drives me mad
after all
I say "upstreperous"
I say "Avenue du Clichy"
I want to say Concorde
Stop Here Now

294. Elizabeth Murray.
Her Story by Anne Waldman.
1990. Illustrated book

opposite:
295. Elizabeth Murray.
Dis Pair. 1989–90. Painting

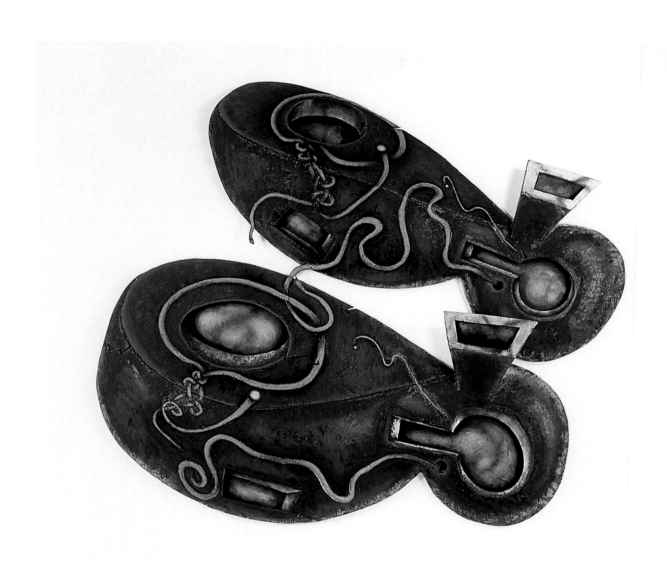

296. Mike Kelley.
Untitled. 1990.
Sculpture

297. John Cage.
Wild Edible Drawing No. 8.
1990. Drawing

298. Bruce Conner.
INKBLOT DRAWING. 1990.
Drawing

**299. Office for Metropolitan
Architecture.** Palm Bay Seafront
Hotel and Convention Center,
Florida. Project, 1990.
Architectural model

300. Felix Gonzalez-Torres.
"Untitled" (Death by Gun). 1990.
Prints

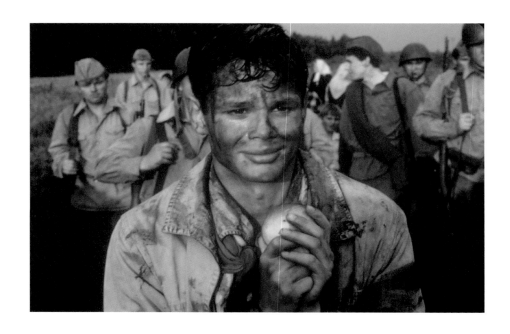

301. Agnieszka Holland.
Europa Europa. 1990. Film

302. Zhang Yimou and Yang Fengliang. Ju Dou. 1990. Film

303. Jim Nutt.
Drawing for Fret.
1990. Drawing

304. Stephen Frears.
The Grifters. 1990. Film

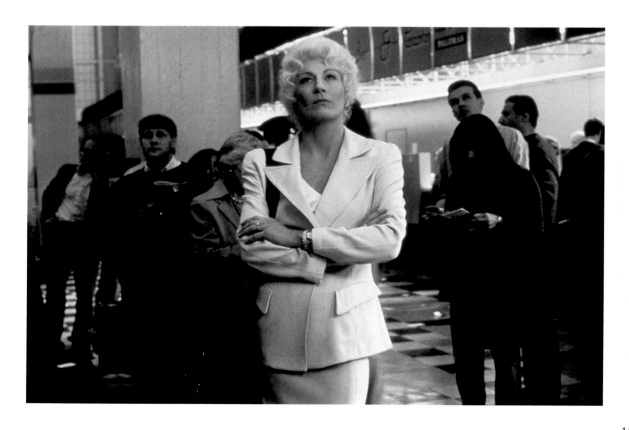

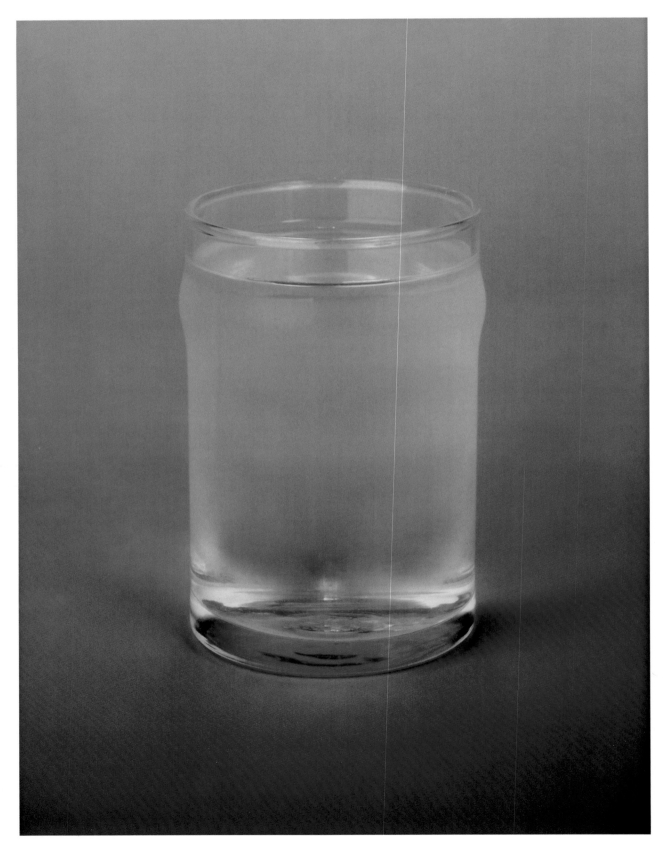

305. Neil Winokur.
Glass of Water. 1990.
Photograph

opposite:
306. Chris Killip.
Untitled. 1990.
Photograph

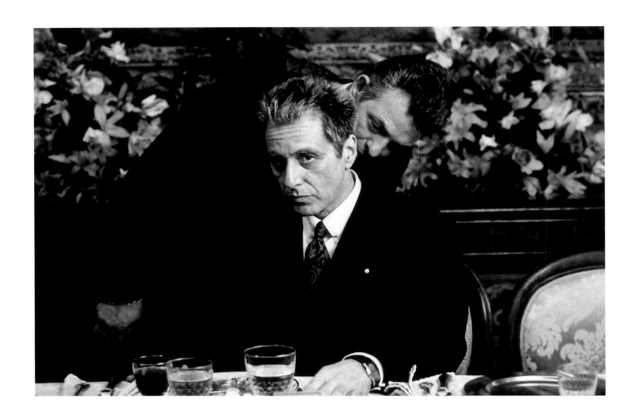

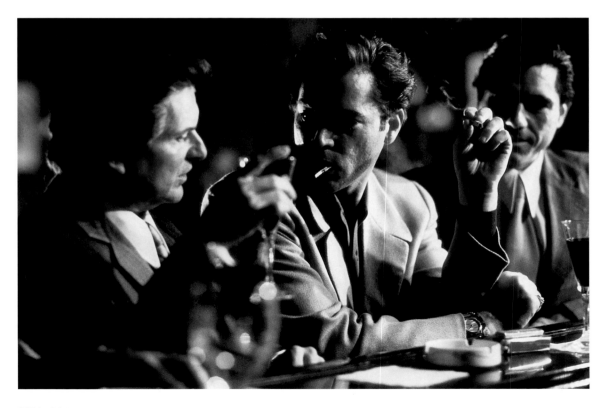

307. Francis Ford Coppola.
The Godfather, Part III. 1990.
Film

308. Martin Scorsese.
GoodFellas. 1990. Film

opposite:
309. Toshiyuki Kita.
The Multilingual Chair.
1991. Design

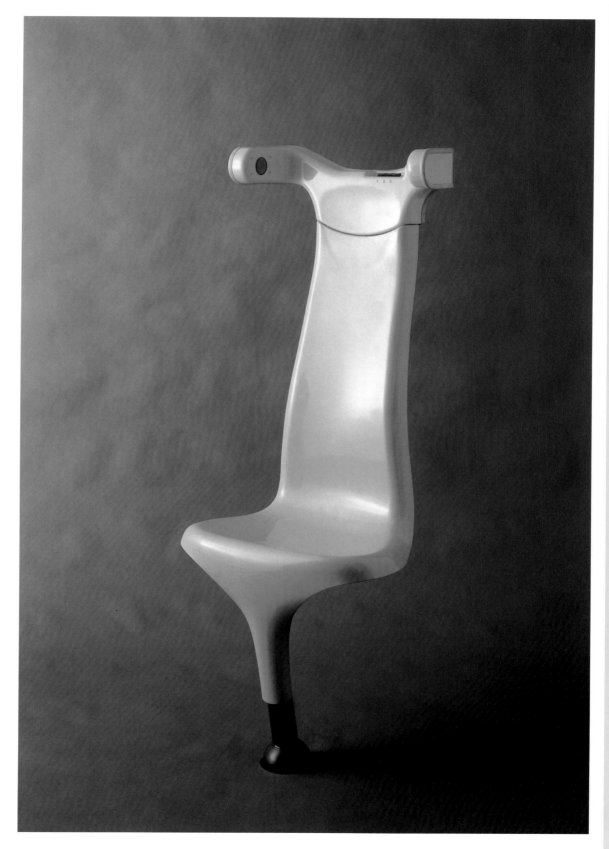

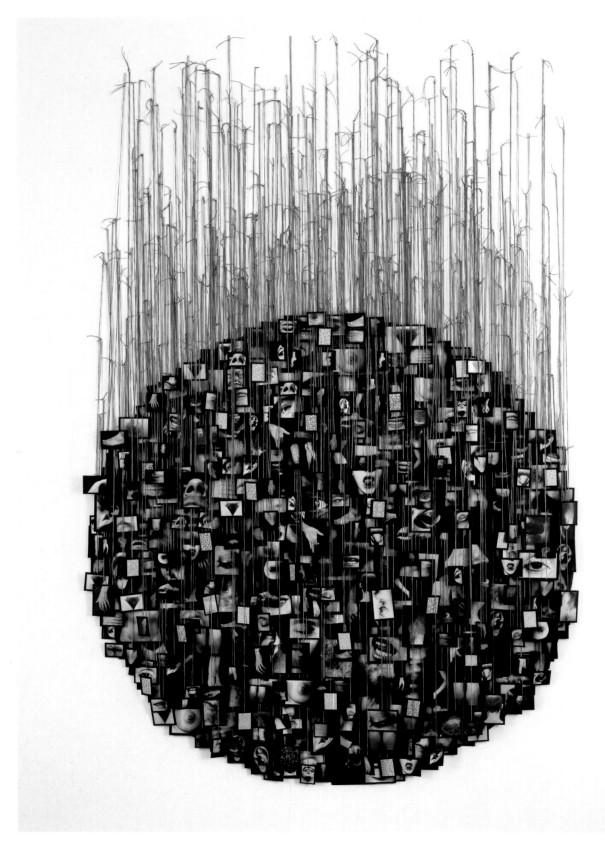

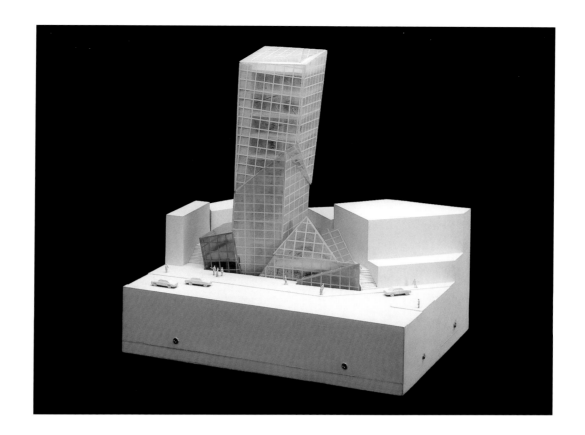

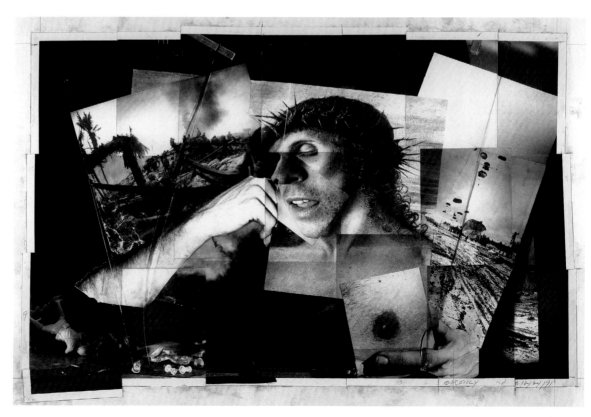

opposite:
310. Annette Messager.
My Vows. 1988–91.
Installation

right:
311. Peter Eisenman.
Alteka Tower, Tokyo. Project,
1991. Architectural model

312. John O'Reilly.
War Series #34: PFC USMC
Killed in Action, Gilbert
Islands, 1943, Age 23.
1991. Photographic collage

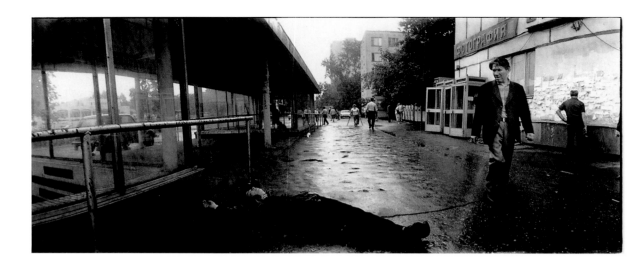

313. Boris Mihailov.
Untitled from the series
U Zemli (On the Ground).
1991. Photograph

314. Boris Mihailov.
Untitled from the series
U Zemli (On the Ground).
1991. Photograph

315. Boris Mihailov.
Untitled from the series
U Zemli (On the Ground).
1991. Photograph

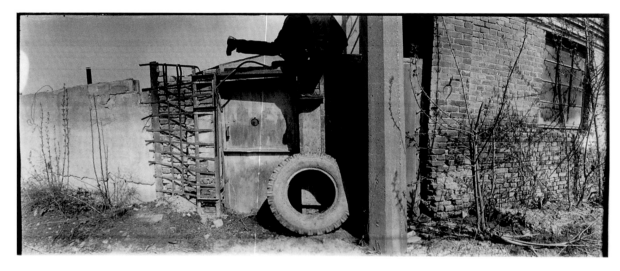

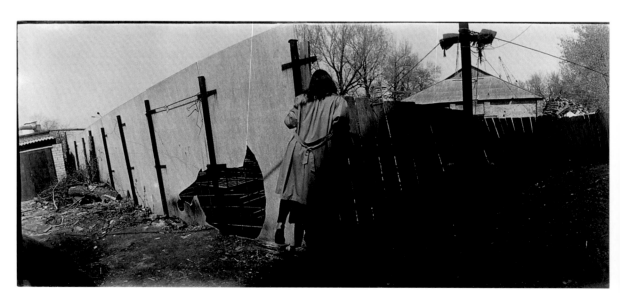

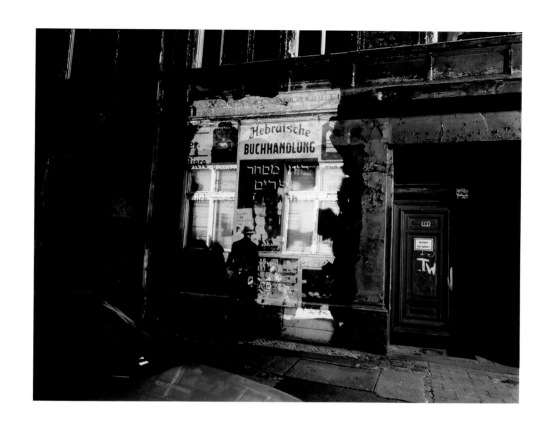

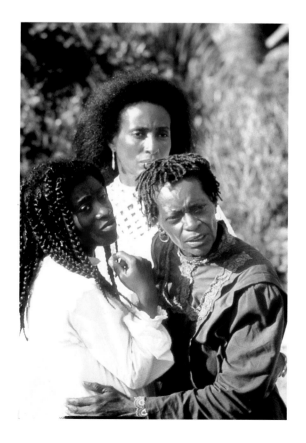

316. Shimon Attie.
Almstadtstrasse 43,
Berlin, 1991 (1930).
1991. Photograph

317. Julie Dash.
Daughters of the Dust.
1991. Film

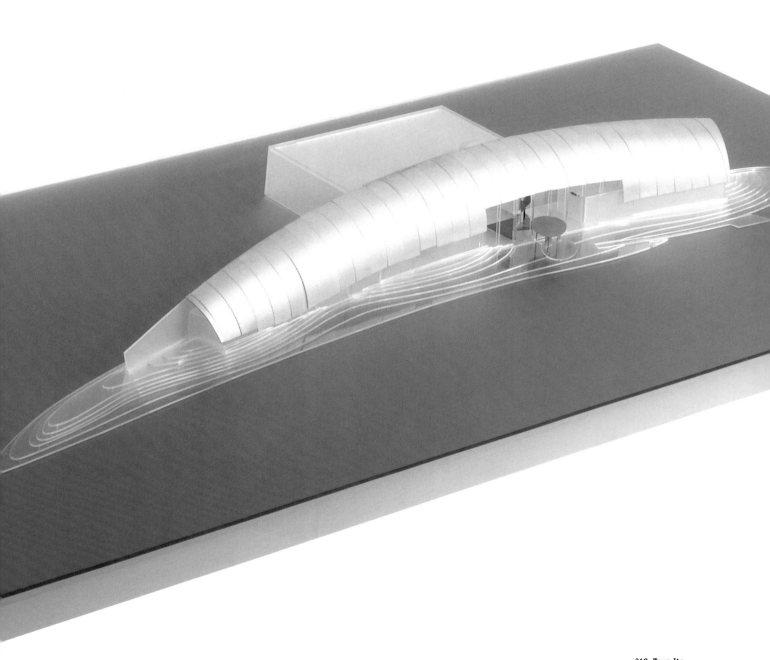

318. Toyo Ito.
Shimosuma Municipal
Museum, Shomosuma-machi,
Nagano Prefecture, Japan.
1991. Architectural model

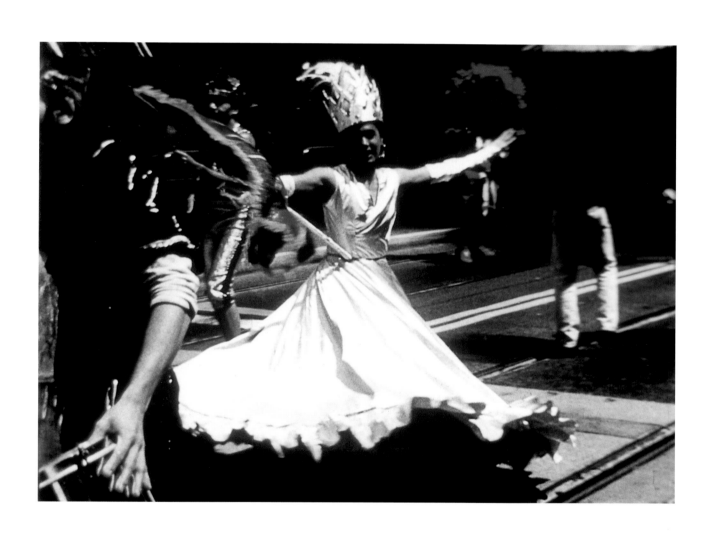

319. Warren Sonbert.
Short Fuse. 1991. Film

320. Ernie Gehr.
Side/Walk/Shuttle.
1991. Film

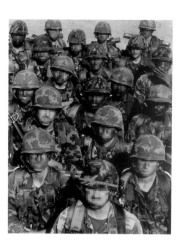

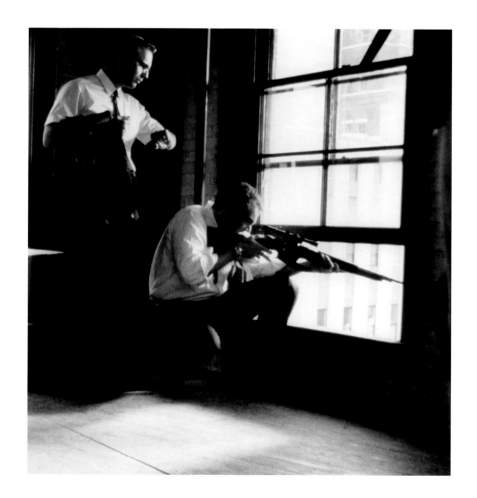

321. Annette Lemieux.
Stolen Faces. 1991. Print

322. Oliver Stone.
JFK. 1991. Film

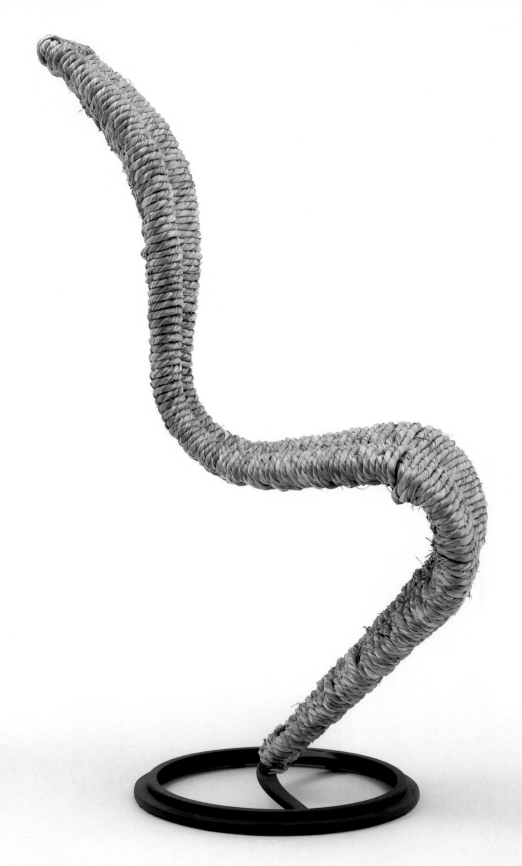

323. Tom Dixon.
S-Chair. 1991. Design

opposite:
324. Dieter Appelt.
The Field. 1991.
Photographs

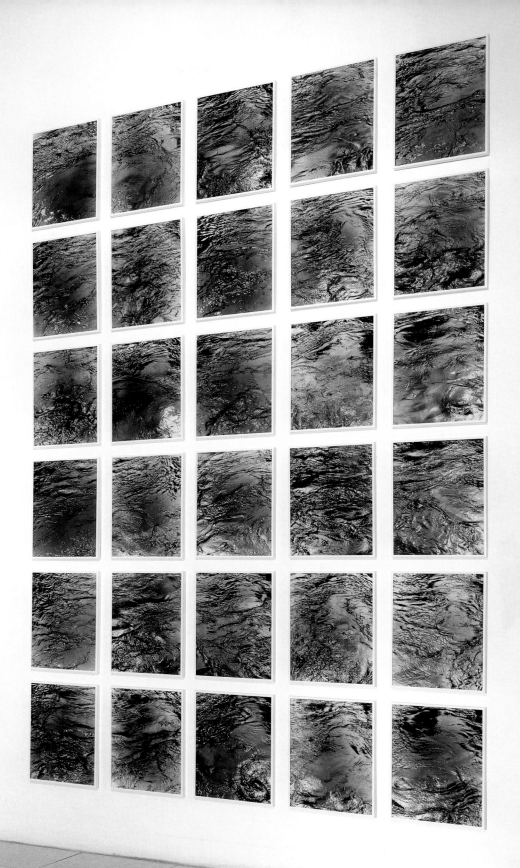

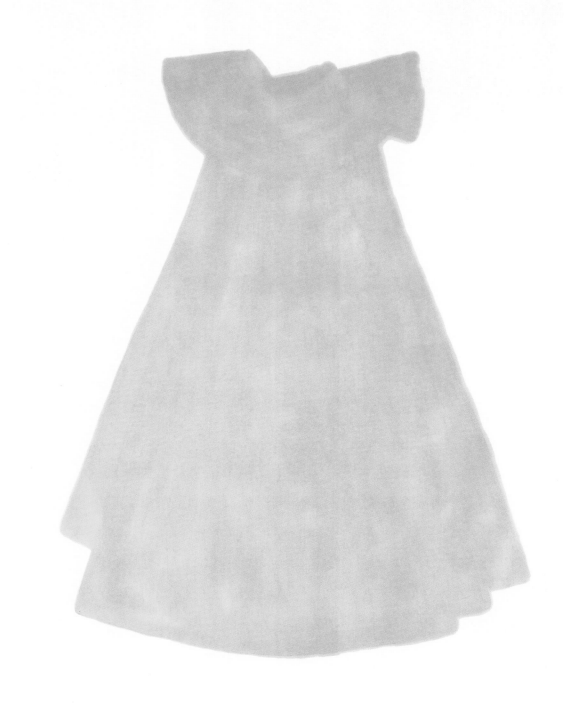

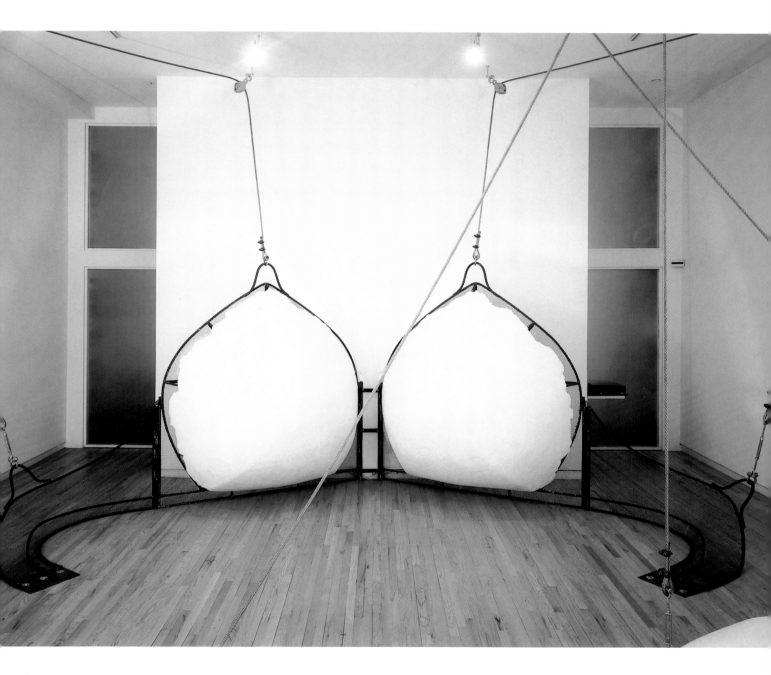

opposite:
325. Jean-Michel Othoniel.
The Forbidden. 1991. Print

above:
326. Vito Acconci.
Adjustable Wall Bra.
1990–91. Sculpture

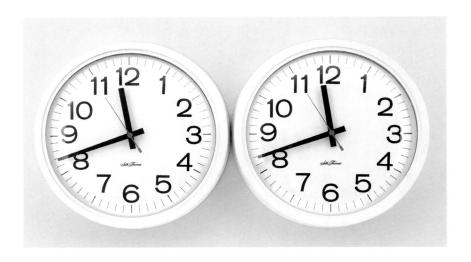

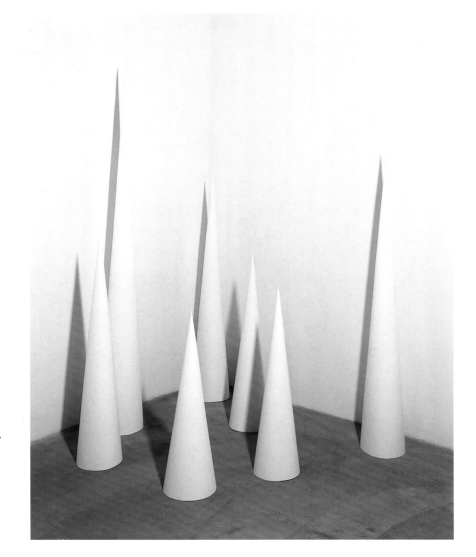

327. Felix Gonzalez-Torres.
"Untitled" (Perfect Lovers). 1991.
Sculpture

328. Felix Gonzalez-Torres.
"Untitled" (Supreme Majority).
1991. Sculpture

opposite:
329. Felix Gonzalez-Torres.
"Untitled" (Placebo). 1991.
Installation

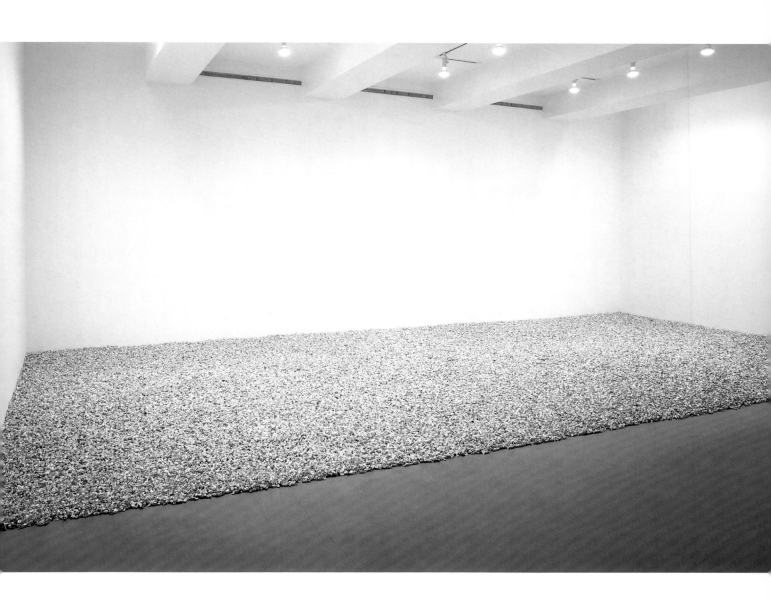

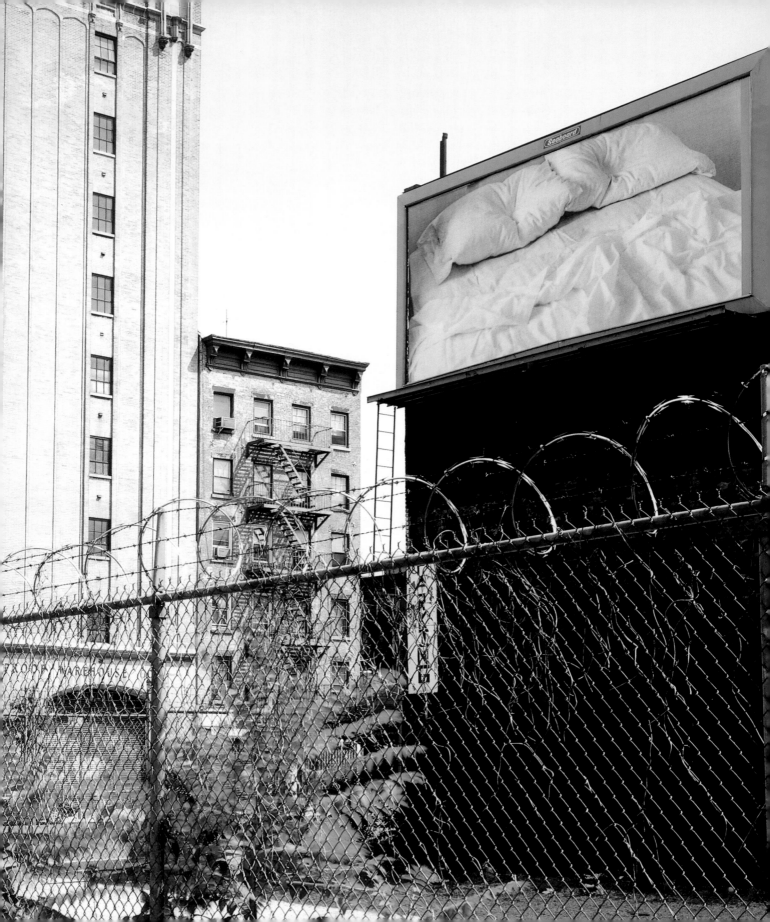

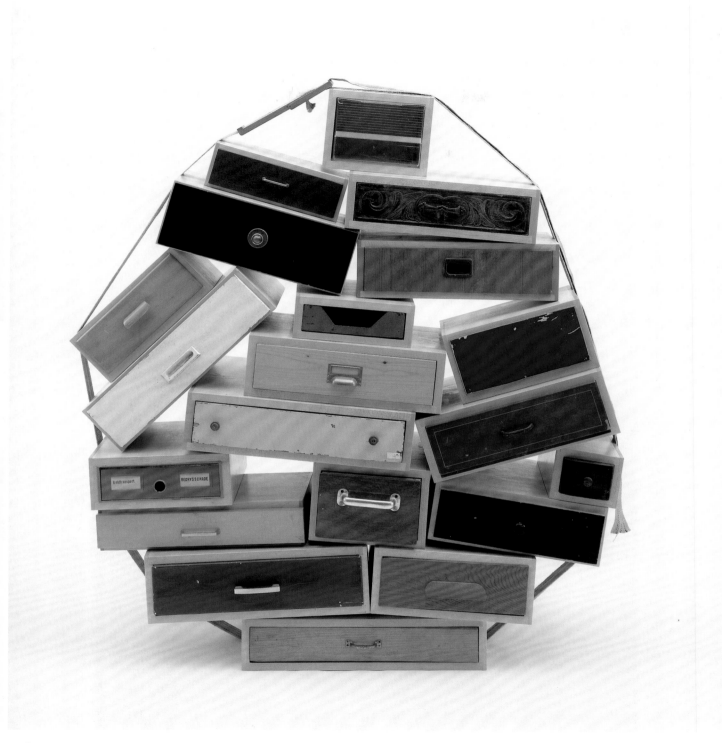

opposite:
330. Felix Gonzalez-Torres.
"Untitled." 1991. Installation

above:
331. Tejo Remy. "You Can't
Lay Down Your Memory" Chest
of Drawers. 1991. Design

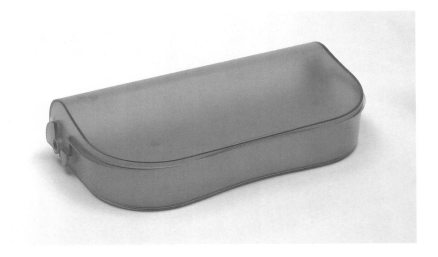

332. Enzo Mari.
Flores Box. 1991.
Design

333. Abelardo Morell.
Light Bulb. 1991.
Photograph

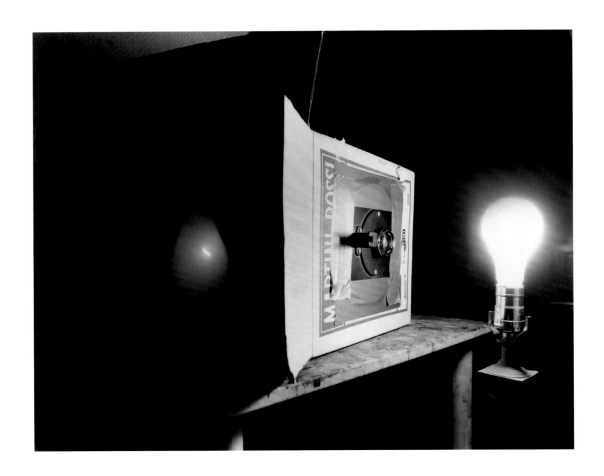

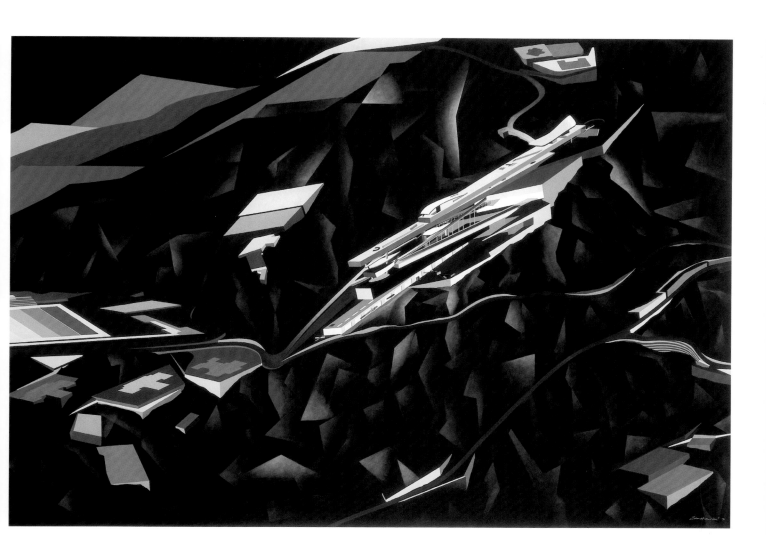

334. Zaha M. Hadid.
Hong Kong Peak Competition,
Hong Kong. 1991.
Architectural drawing

335. Glenn Ligon.
Untitled (How it feels to
be colored me. . . Doubled).
1991. Drawing

One day this kid will get larger. One day this kid will come to know something that causes a sensation equivalent to the separation of the earth from its axis. One day this kid will reach a point where he senses a division that isn't mathematical. One day this kid will feel something stir in his heart and throat and mouth. One day this kid will find something in his mind and body and soul that makes him hungry. One day this kid will do something that causes men who wear the uniforms of priests and rabbis, men who inhabit certain stone buildings, to call for his death. One day politicians will enact legislation against this kid. One day families will give false information to their children and each child will pass that information down generationally to their families and that information will be designed to make existence intolerable for this kid. One day this kid will begin to experience all this activity in his environment and that activity and information will compel him to commit suicide or submit to danger in hopes of being murdered or submit to silence and invisibility. Or one day this kid will talk. When he begins to talk, men who develop a fear of this kid will attempt to silence him with strangling, fists, prison, suffocation, rape, intimidation, drugging, ropes, guns, laws, menace, roving gangs, bottles, knives, religion, decapitation, and immolation by fire. Doctors will pronounce this kid curable as if his brain were a virus. This kid will lose his constitutional rights against the government's invasion of his privacy. This kid will be faced with electro-shock, drugs, and conditioning therapies in laboratories tended by psychologists and research scientists. He will be subject to loss of home, civil rights, jobs, and all conceivable freedoms. All this will begin to happen in one or two years when he discovers he desires to place his naked body on the naked body of another boy.

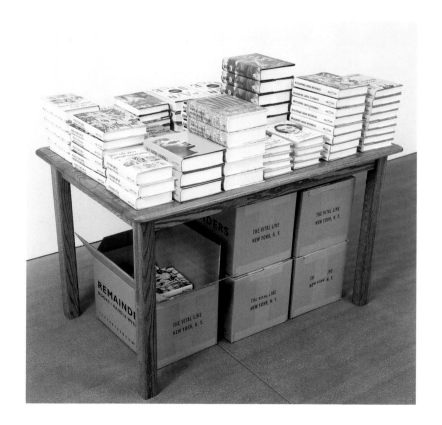

336. David Wojnarowicz.
Untitled. 1990–91. Print

337. Allen Ruppersberg.
Remainders: Novel, Sculpture,
Film. 1991. Installation

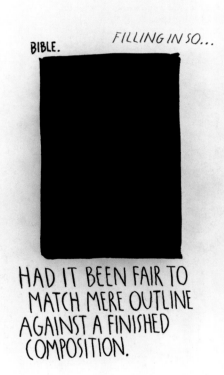

BIBLE. FILLING IN SO...

HAD IT BEEN FAIR TO
MATCH MERE OUTLINE
AGAINST A FINISHED
COMPOSITION.

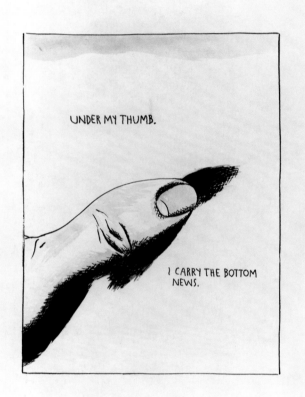

UNDER MY THUMB.

I CARRY THE BOTTOM
NEWS.

338. Raymond Pettibon.
No Title (Filling In So . . .).
1991. Drawing

339. Raymond Pettibon.
No Title (Under My Thumb).
1991. Drawing

opposite:
340. Christopher Wool.
Untitled. 1991. Drawing

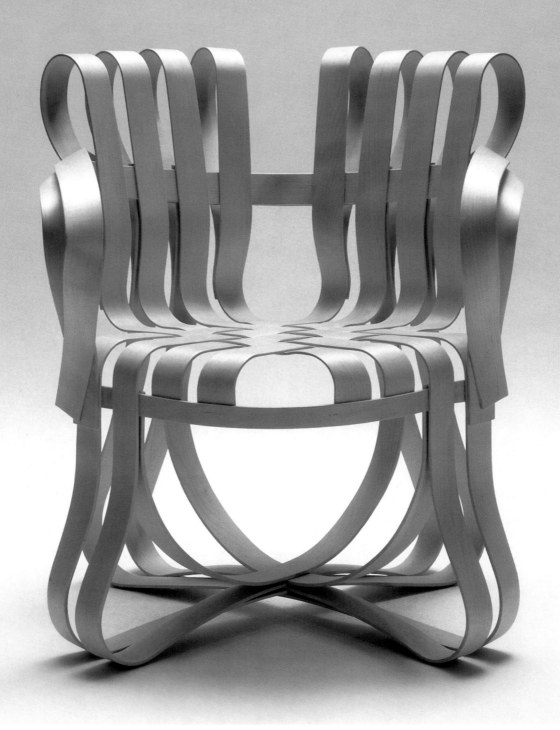

opposite:
41. Frank Gehry.
Cross Check Armchair.
1991. Design

above:
342. Brice Marden.
Rain. 1991. Drawing

343. Robert Gober.
Untitled. 1992. Sculpture

344. Robert Gober.
Untitled. 1991. Sculpture

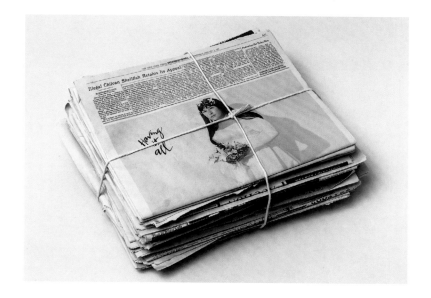

345. Robert Gober.
Untitled. 1992. Photograph

346. Robert Gober.
Newspaper. 1992. Multiple

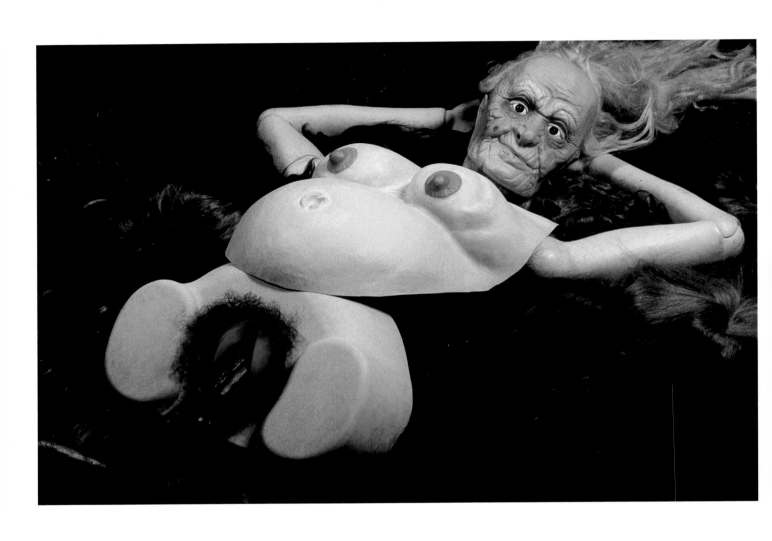

347. Cindy Sherman.
Untitled #250. 1992.
Photograph

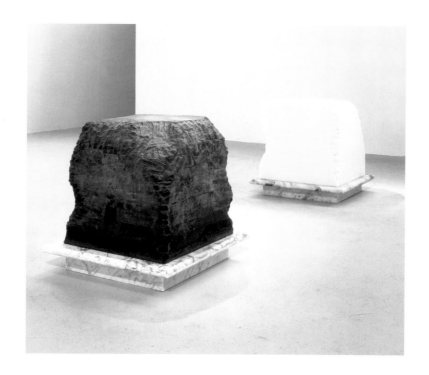

348. Janine Antoni.
Gnaw. 1992. Installation

349. Paul McCarthy.
Sketchbook "Heidi."
1992. Illustrated book

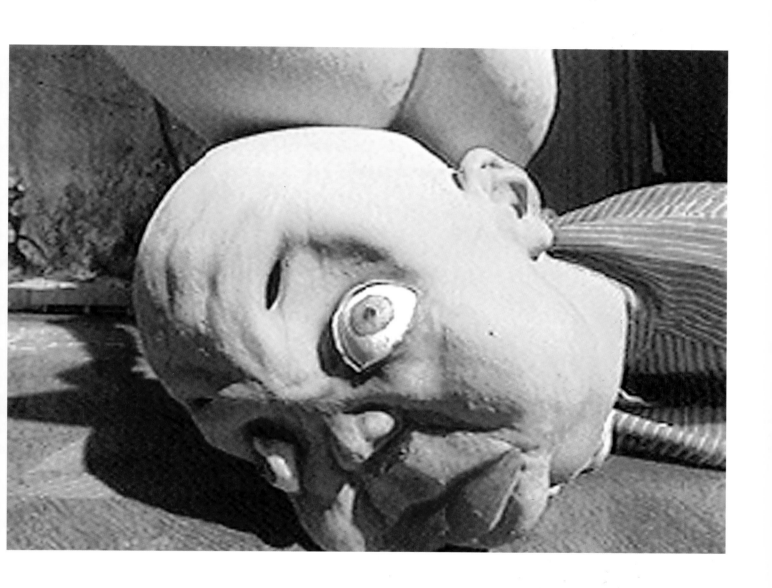

350. Paul McCarthy and Mike Kelley.
Heidi. 1992. Video

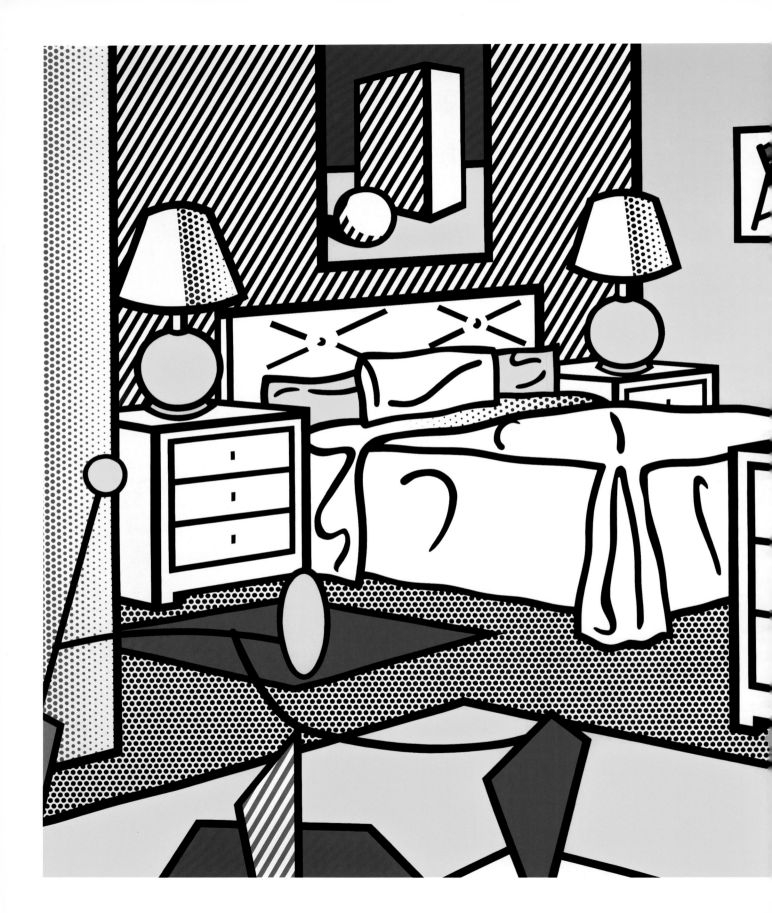

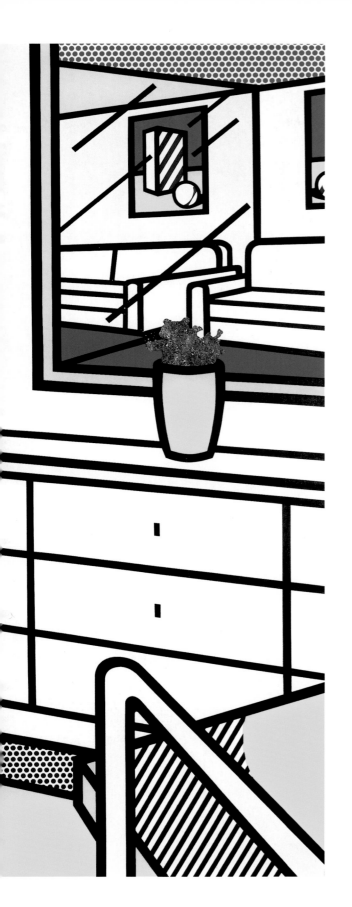

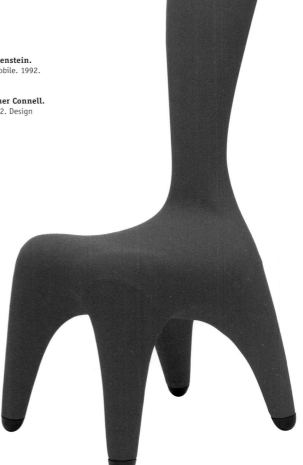

351. Roy Lichtenstein.
Interior with Mobile. 1992.
Painting

352. Christopher Connell.
Pepe Chair. 1992. Design

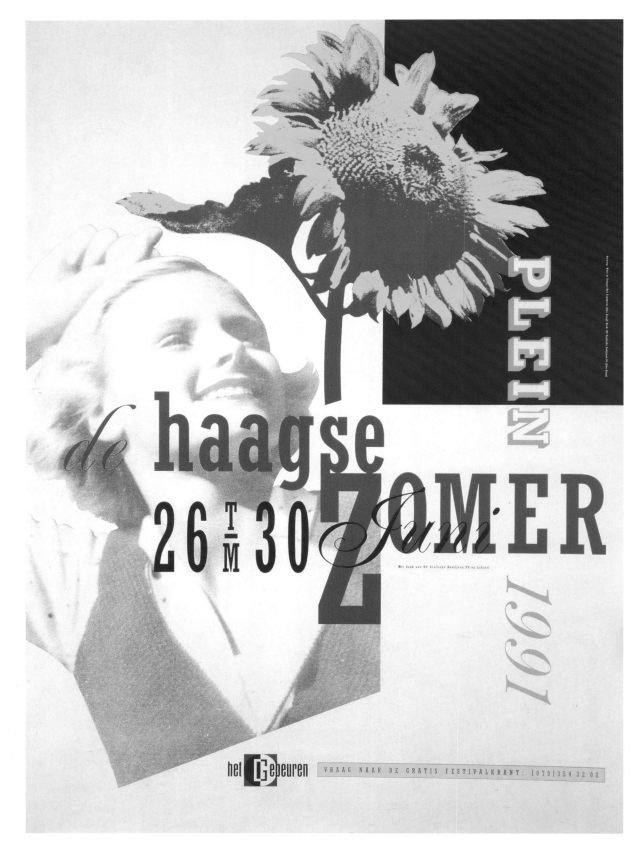

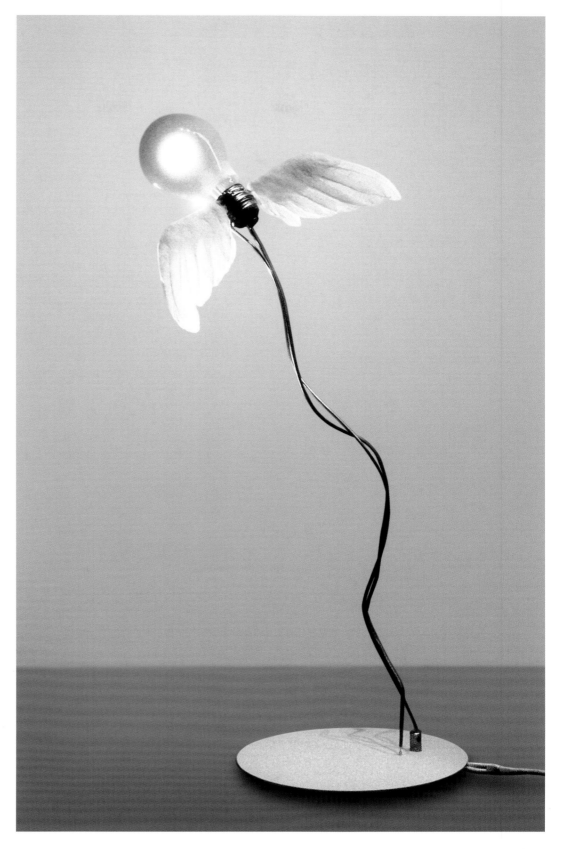

opposite:
353. Ben Faydherbe.
Festival in the Hague
(Wout de Vringer).
1992. Poster

right:
354. Ingo Maurer.
Lucellino Wall Lamp.
1992. Design

355. **Guillermo Kuitca.**
Untitled. 1992. Painting

opposite:
356. **Willie Cole.**
Domestic I.D., IV.
1992. Print

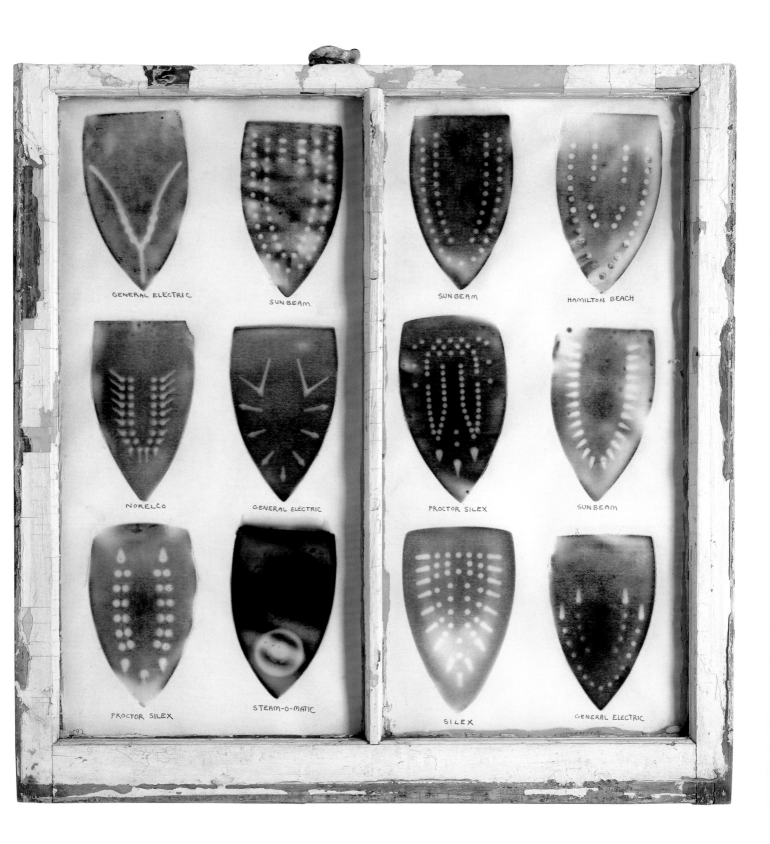

GENERAL ELECTRIC SUN BEAM SUN BEAM HAMILTON BEACH

NORELCO GENERAL ELECTRIC PROCTOR SILEX SUN BEAM

PROCTOR SILEX STEAM-O-MATIC SILEX GENERAL ELECTRIC

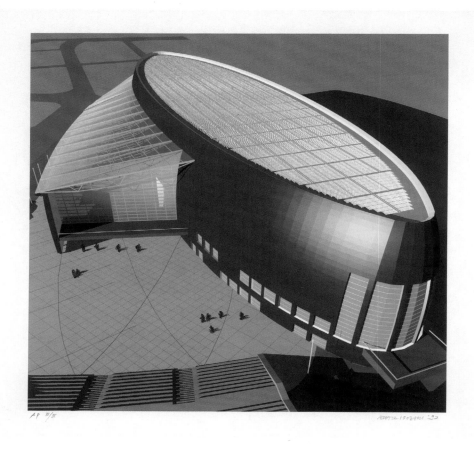

357. Arata Isozaki.
Convention Hall, Nara, Japan.
1992. Architectural drawing

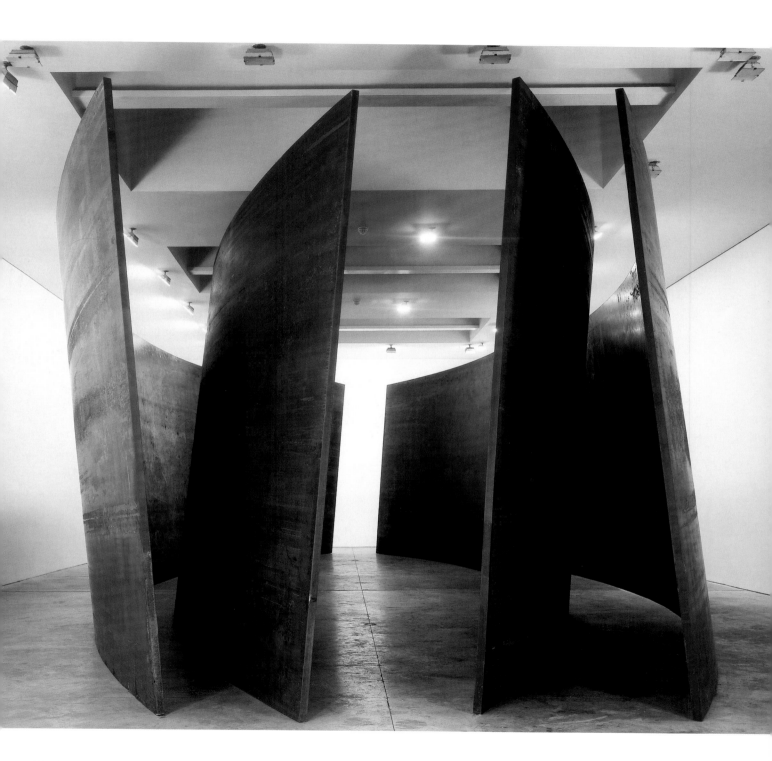

358. Richard Serra.
Intersection II. 1992.
Sculpture

359. Peter Campus.
Burning. 1992.
Photograph

360. Rudolf Bonvie.
Imaginary Picture I.
1992. Photograph

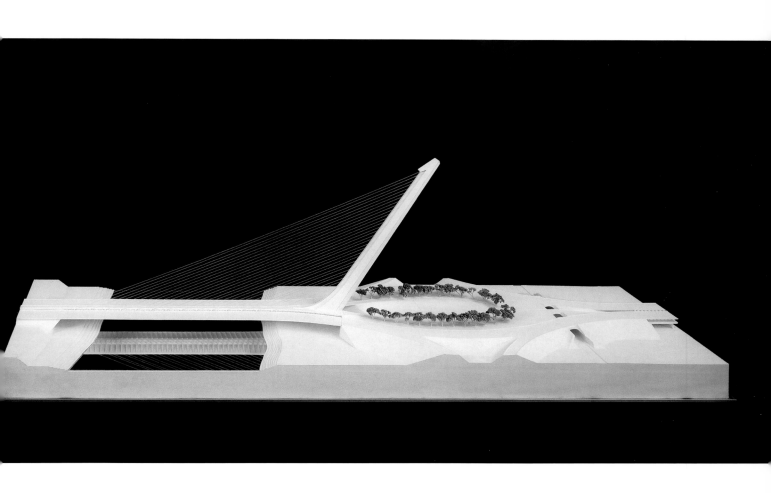

361. Santiago Calatrava. Alamillo Bridge
and Cartuga Viaduct, Seville, Spain.
1987–92. Architectural model

362. Santiago Calatrava. Alamillo Bridge
and Cartuga Viaduct, Seville, Spain.
1987–92. Architectural drawing

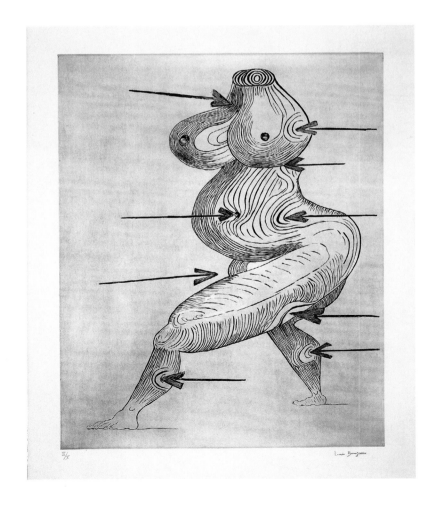

363. José Leonilson.
I Am Your Man. 1992.
Drawing

364. Louise Bourgeois.
Ste Sebastienne. 1992. Print

opposite:
365. Rody Graumans.
85 Lamps Lighting Fixture.
1992. Design

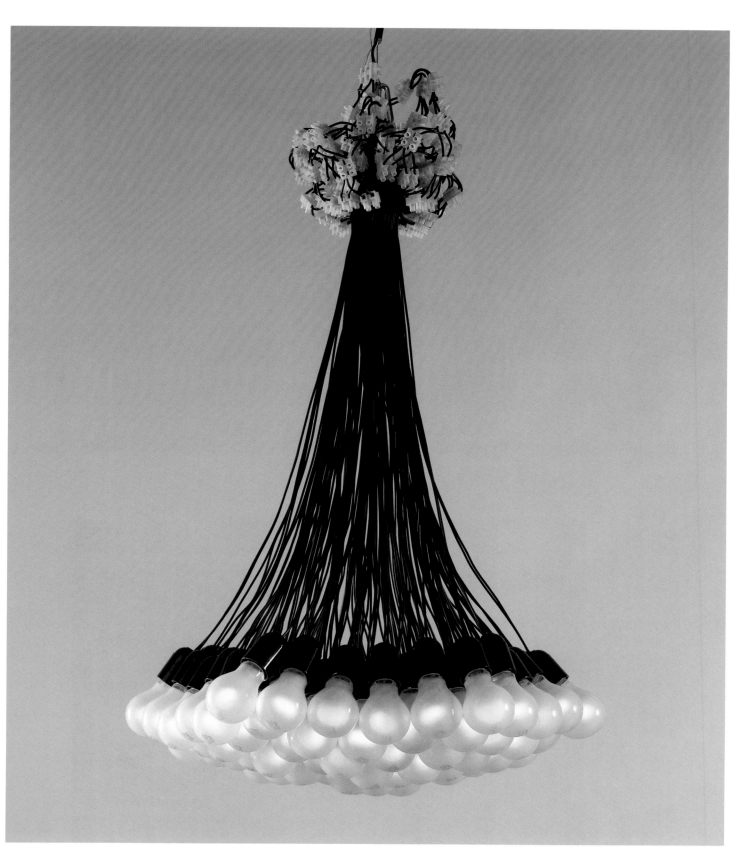

366. Christopher Bucklow.
14,000 Solar Images; 1:23 P.M.,
13th June 1992. 1992. Photograph

367. Terence Davies.
The Long Day Closes. 1992.
Film

368. Sigmar Polke.
The Goat Wagon. 1992.
Painting

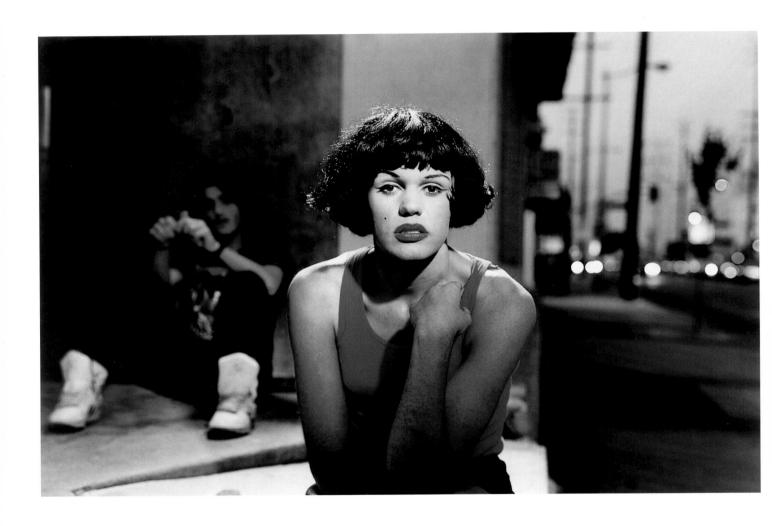

369. Philip-Lorca diCorcia.
Marilyn; 28 years old. Las Vegas,
Nevada; $30. 1990–92.
Photograph

opposite:
370. Juan Sánchez.
For don Pedro. 1992. Print

371. Raymond Pettibon.
No Title (The Sketch Is).
1992. Drawing

372. Rosemarie Trockel.
Untitled. 1992. Drawing

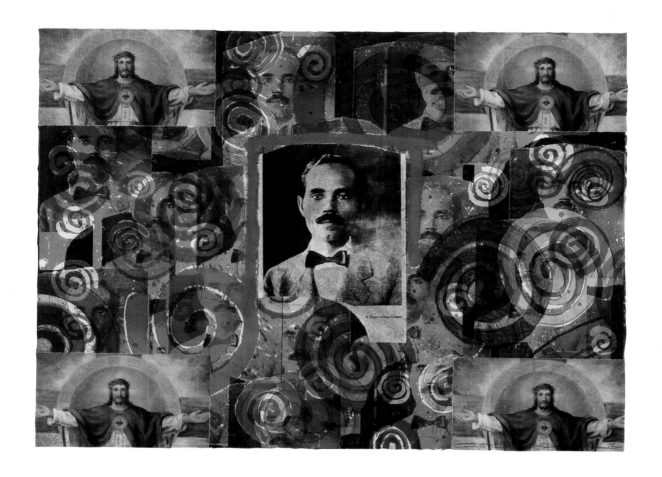

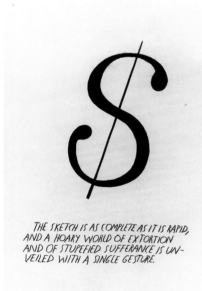

THE SKETCH IS AS COMPLETE AS IT IS RAPID,
AND A HOARY WORLD OF EXTORTION
AND OF STUPEFIED SUFFERANCE IS UN-
VEILED WITH A SINGLE GESTURE.

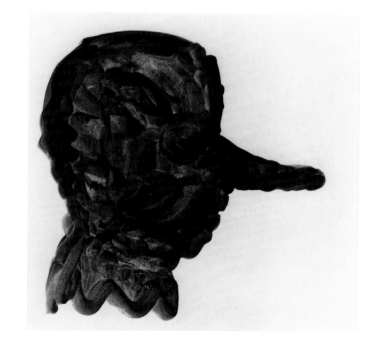

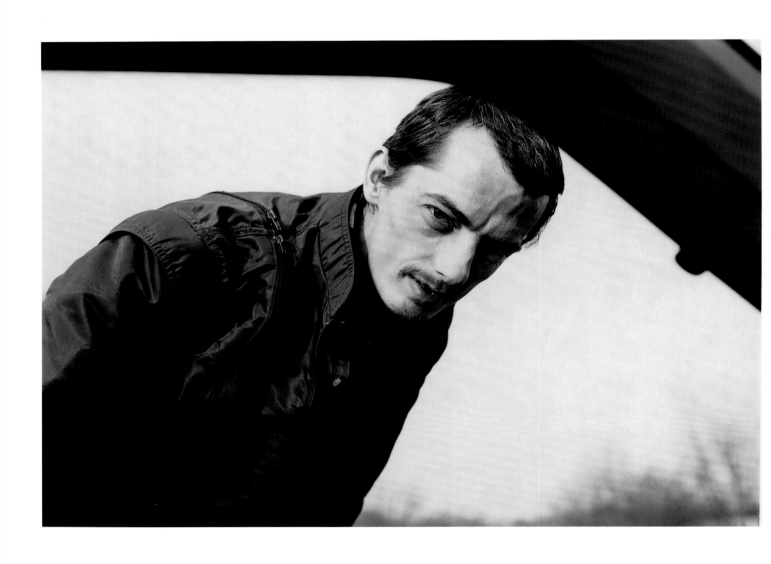

373. Mark Steinmetz.
Knoxville. 1992. Photograph

374. Gabriel Orozco.
Maria, Maria, Maria. 1992.
Drawing

This page is a telephone directory page consisting of densely printed columns of names, addresses, and phone numbers under the surname "Muñoz." The text is too faded and low-resolution to transcribe reliably.

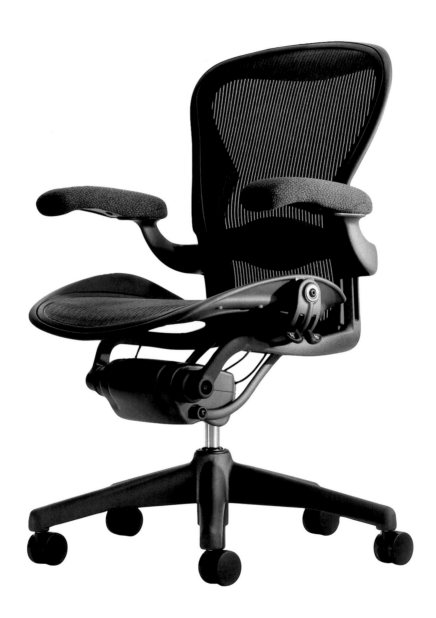

**375. Donald T. Chadwick
and William Stumpf.**
Aeron Office Chair. 1992.
Design

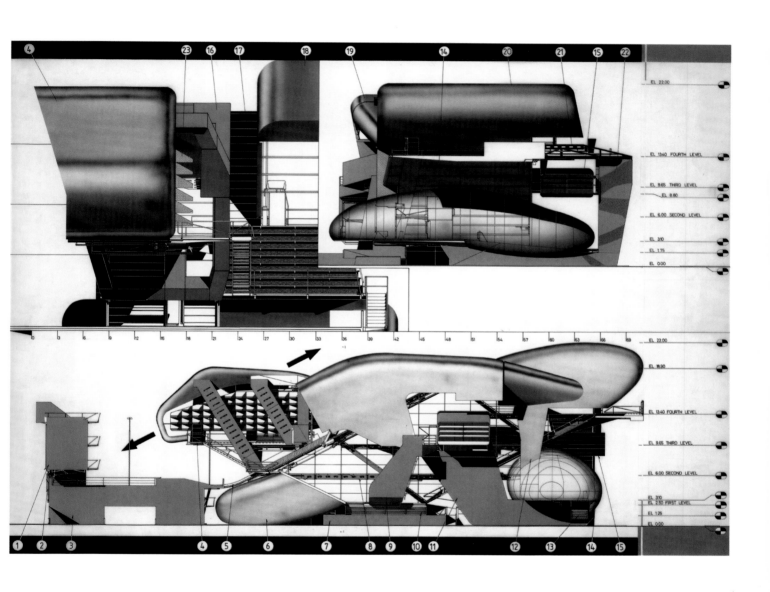

376. Neil M. Denari.
Prototype Architecture School,
Wilshire Boulevard, Los Angeles,
California. Project, 1992.
Architectural drawing

377. Simon Patterson.
The Great Bear. 1992.
Print

opposite:
378. Chris Burden.
Medusa's Head. 1989–92.
Sculpture

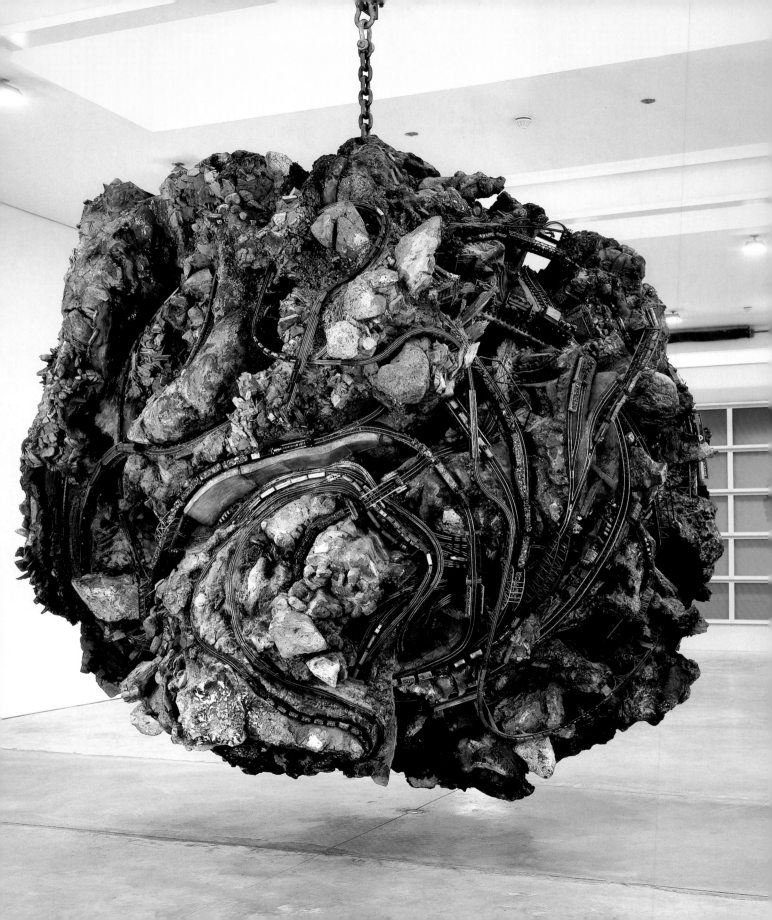

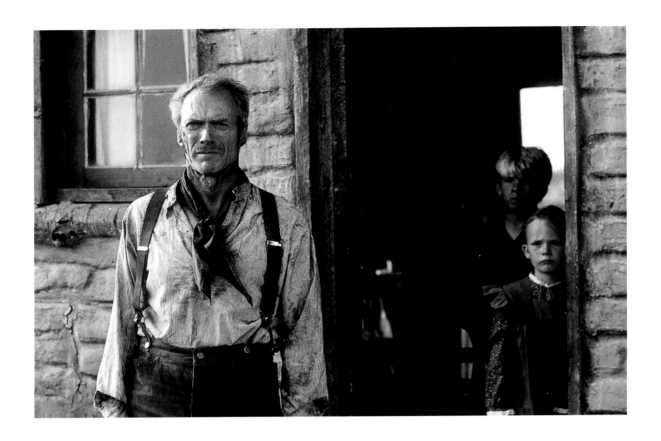

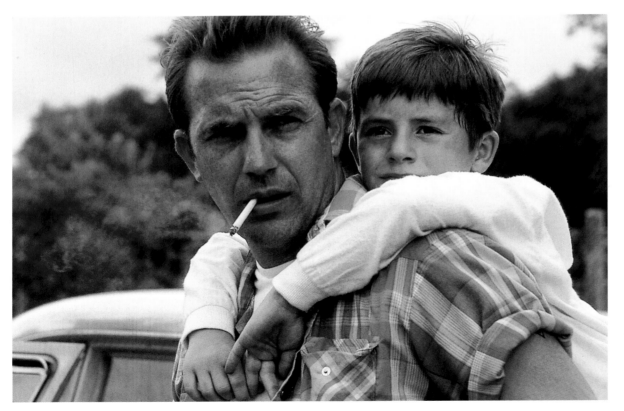

379. **Clint Eastwood.**
Unforgiven. 1992. Film

380. **Clint Eastwood.**
A Perfect World. 1993. Film

opposite:
381. **Reiko Sudo.**
Jellyfish Fabric. 1993.
Design

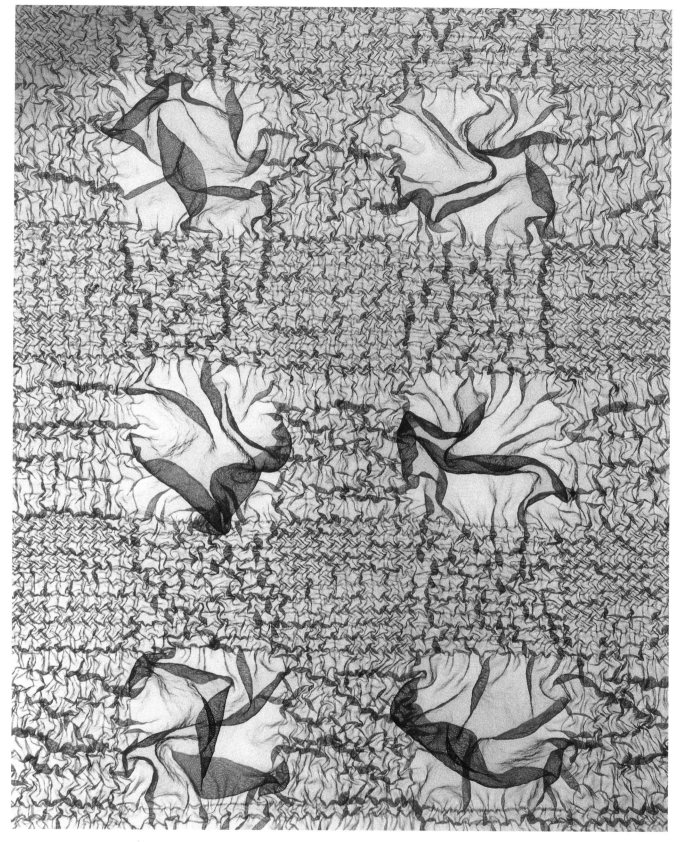

382. Helen Chadwick.
Number 11 from the series
Bad Blooms. 1992–93.
Photograph

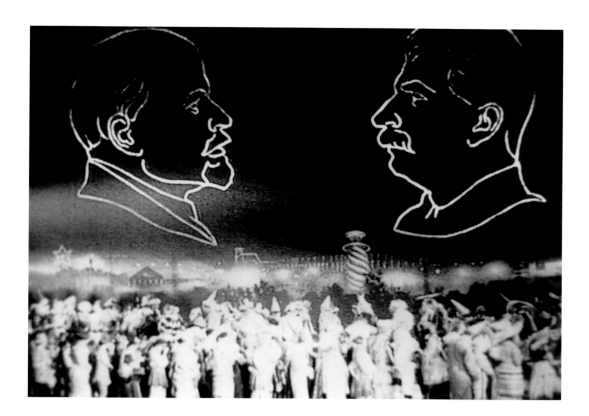

383. Chris Marker.
The Last Bolshevik
(Le Tombeau d'Alexandre).
1993. Video

384. Zacharias Kunuk.
Saputi. 1993. Video

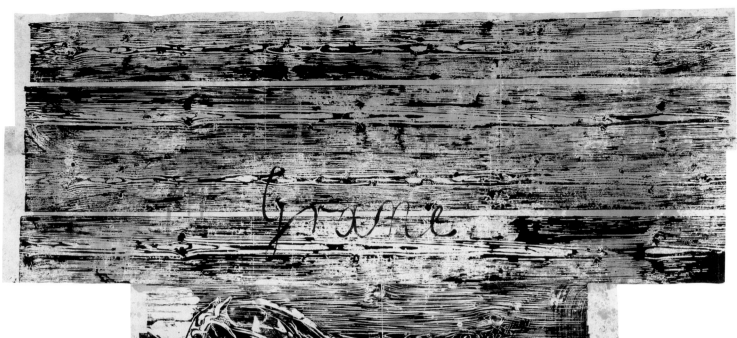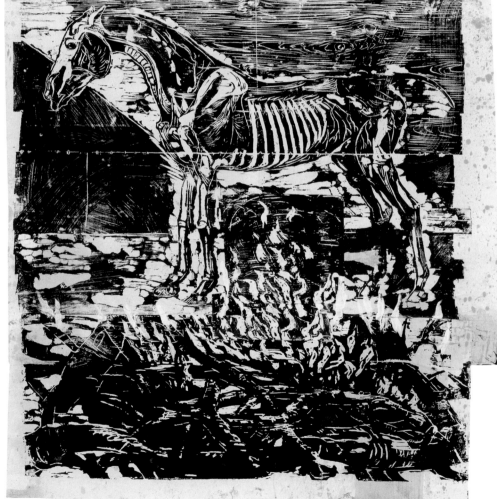

385. Anselm Kiefer.
Grane. 1980–93. Print

opposite:
386. Glenn Ligon.
Runaways. 1993. Prints

RAN AWAY, Glenn, a black male, 5'8", very short hair cut, nearly completely shaved, stocky build, 155-165 lbs., medium complexion (not "light skinned," not "dark skinned," slightly orange). Wearing faded blue jeans, short sleeve button-down 50's style shirt, nice glasses (small, oval shaped), no socks. Very articulate, seemingly well-educated, does not look at you straight in the eye when talking to you. He's socially very adept, yet, paradoxically, he's somewhat of a loner.

 17/45 '93

RAN AWAY, Glenn. Medium height, 5'8", male. Closely-cut hair, almost shaved. Mild looking, with oval shaped, black-rimmed glasses that are somewhat conservative. Thinly-striped black-and-white short-sleeved T-shirt, blue jeans. Silver watch and African-looking bracelet on arm. His face is somewhat wider on bottom near the jaw. Full-lipped. He's black. Very warm and sincere, mild-mannered and laughs often.

 17/45 '93

RAN AWAY, a man named Glenn. He has almost no hair. He has cat-eye glasses, medium-dark skin, cute eyebrows. He's wearing black shorts, black shoes and a short sleeve plaid shirt. He has a really cool Timex silver watch with a silver band. He's sort of short, a little hunky, though you might not notice it with his shirt untucked. He talks sort of out of the side of his mouth and looks at you sideways. Sometimes he has a loud laugh, and lately I've noticed he refers to himself as "mother."

 17/45 '93

Ran away, Glenn Ligon. He's a shortish broad-shouldered black man, pretty dark-skinned, with glasses. Kind of stocky, tends to look down and turn in when he walks. Real short hair, almost none. Clothes non-descript, something button-down and plaid, maybe, and shorts and sandals. Wide lower face and narrow upper face. Nice teeth.

17/45

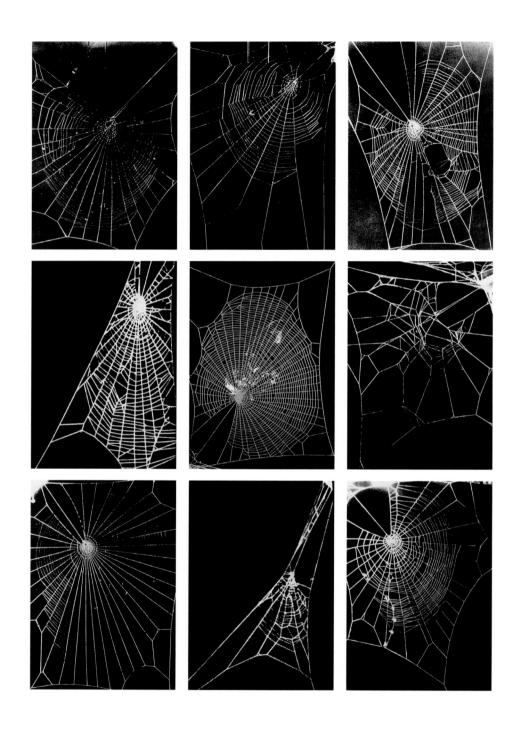

387. Rosemarie Trockel.
What It Is Like to Be What
You Are Not. 1993. Prints

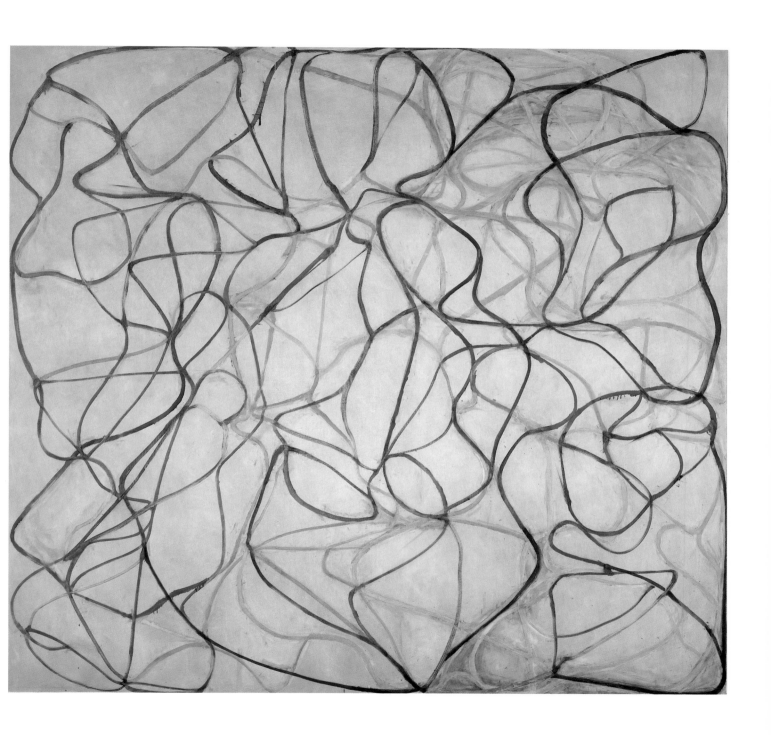

388. Brice Marden.
Vine. 1992–93. Painting

389. Herzog & de Meuron Architects. Facade panel from the Ricola Europe Factory and Storage Building. 1993. Architectural fragment

390. Herzog & de Meuron Architects. Ricola Europe Factory and Storage Building. 1993. Architectural model

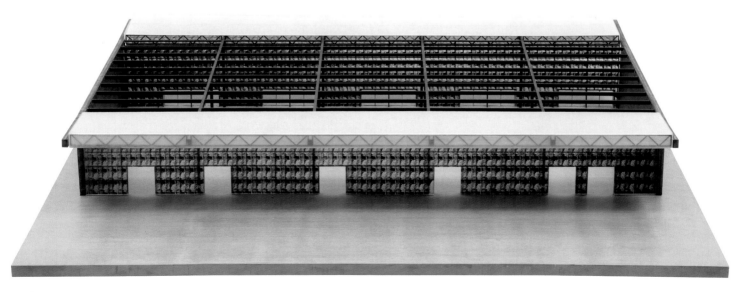

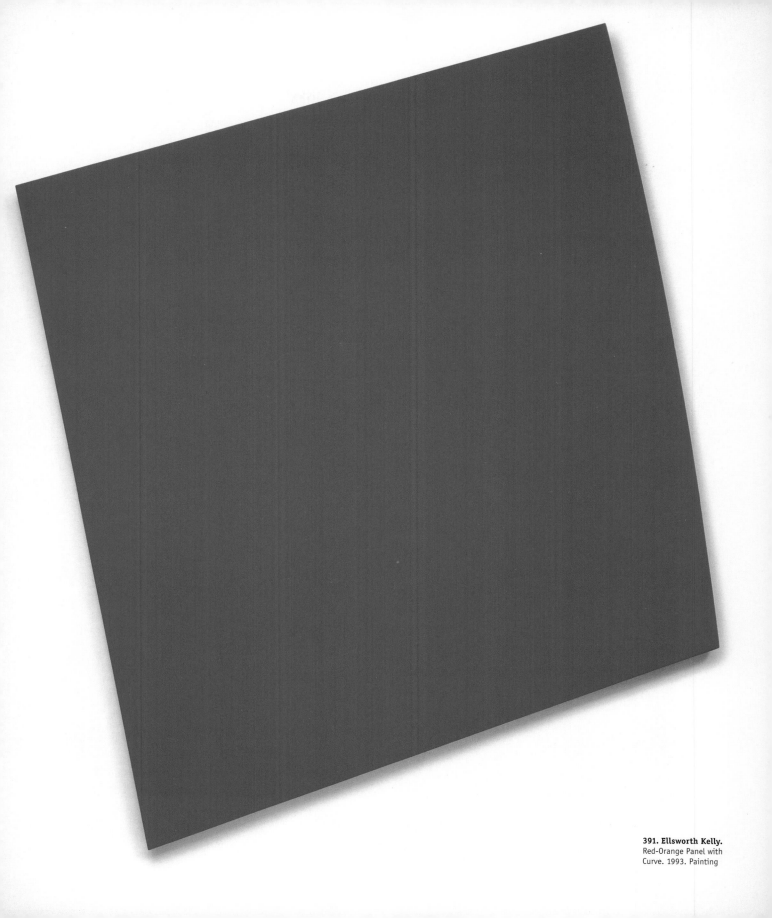

391. Ellsworth Kelly.
Red-Orange Panel with
Curve. 1993. Painting

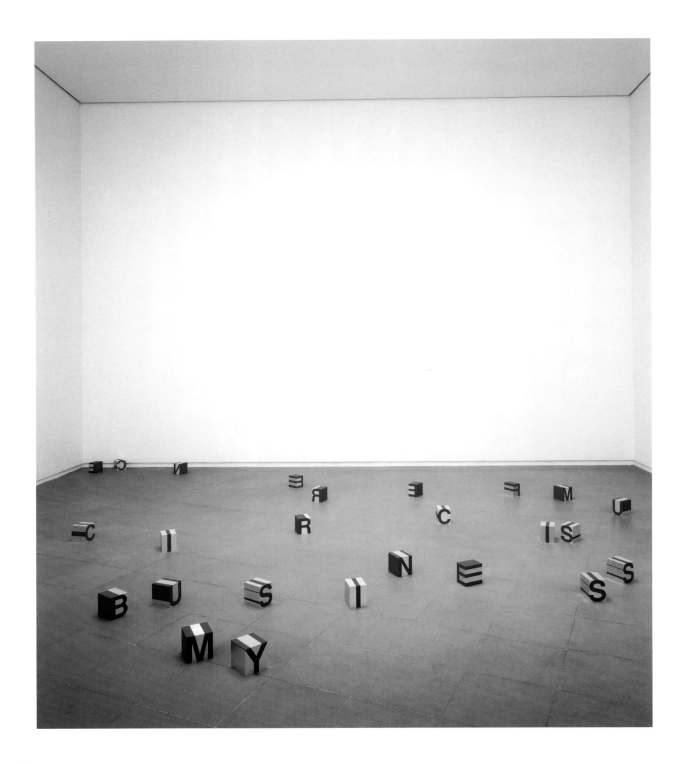

392. Roni Horn.
How Dickinson Stayed
Home. 1993. Installation

393. Robert Therrien.
No Title. 1993. Sculpture

394. Derek Jarman.
Blue. 1993. Film

opposite:
**395. Fernando Campana
and Humberto Campana.**
Vermelha Chair. 1993. Design

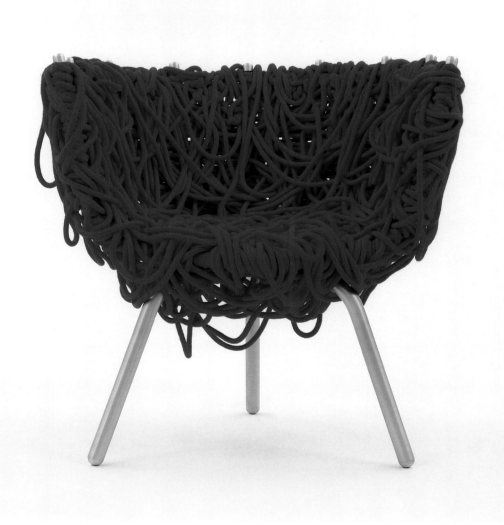

**396. Antonio Citterio
and Glen Oliver Löw.**
Mobil Container System.
1993. Design

397. Jean Nouvel.
Cartier Foundation for
Contemporary Art. 1992–93.
Architectural drawing

AN 18th CENTURY LINE ON A WATERING-CAN

The mute dispenser of the vernal shower

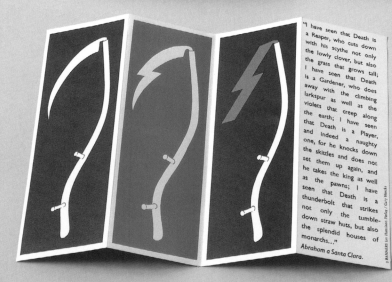

A grove of gean or wild cherry trees. On a small fluted column among the trees is a bronze or stone basket of cherries with the words *l'idylle des cerises.*

'I climbed into a cherry tree, and threw bunches of cherries down to the girls, who then returned the cherry-stones through the branches. Seeing one of the girls holding out her apron and tilting her head, I took such good aim that I dropped a bunch into her bosom. "Why are my lips not cherries?" I thought. "How gladly would I throw them there too!"'

Jean-Jacques Rousseau, *Confessions.* For a sympathetic account of the famous 'idyll of the cherries' see Renato Poggioli, *The Oaten Flute.*

"I have seen that Death is a Reaper, who cuts down with his scythe not only the lowly clover, but also the grass that grows tall; I have seen that Death is a Gardener, who does away with the climbing larkspur as well as the violets that creep along the earth; I have seen that Death is a Player, and indeed a naughty one, for he knocks down the skittles and does not set them up again, and he takes the king as well as the pawns; I have seen that Death is a thunderbolt that strikes not only the tumble-down straw huts, but also the splendid houses of monarchs..."
Abraham a Santa Clara

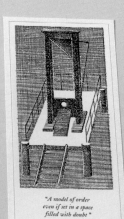

"A model of order even if set in a space filled with doubt"

399. Ian Hamilton Finlay.
Artist's book and cards. 1986–93.
Prints

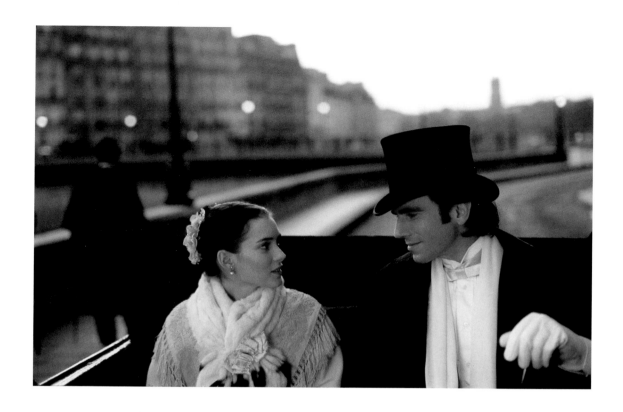

400. Martin Scorsese.
The Age of Innocence.
1993. Film

401. Ximena Cuevas.
Bleeding Heart. 1993.
Video

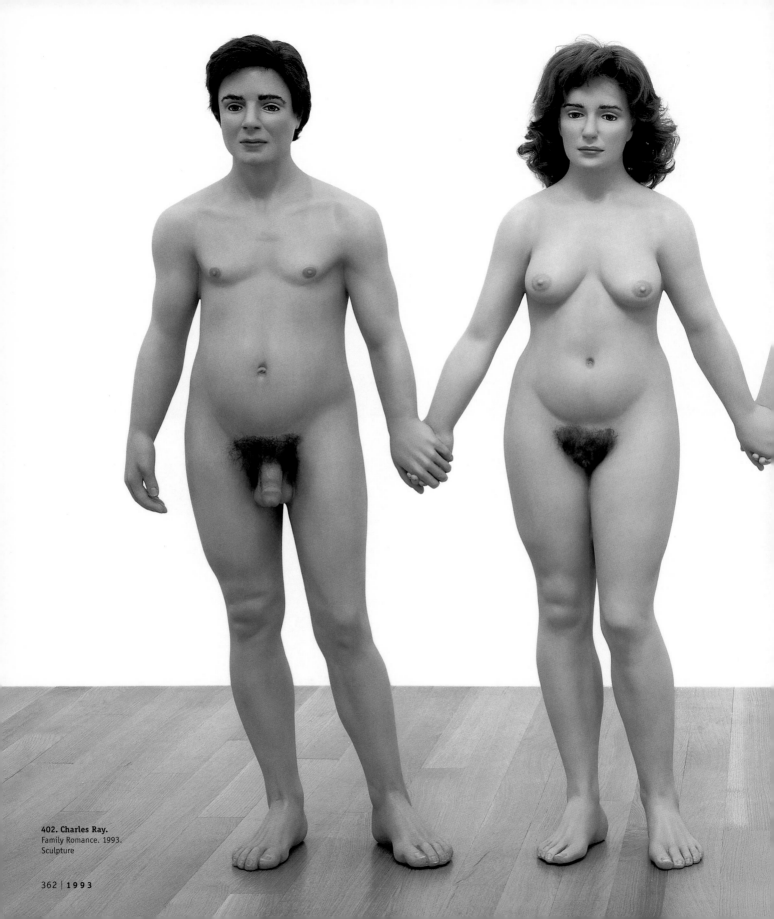

402. Charles Ray.
Family Romance. 1993.
Sculpture

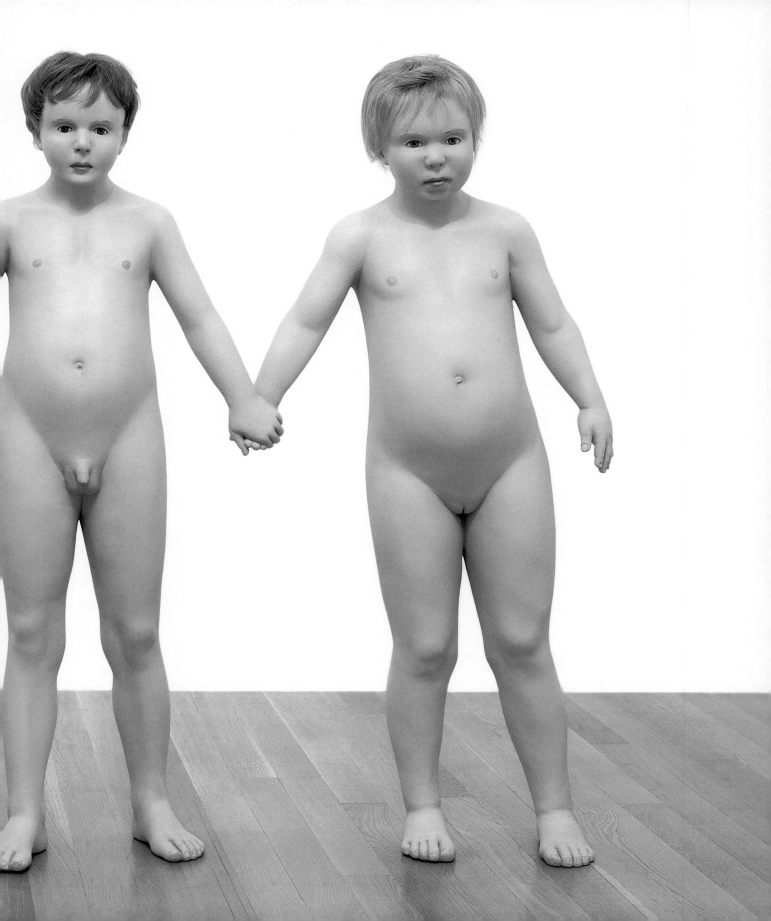

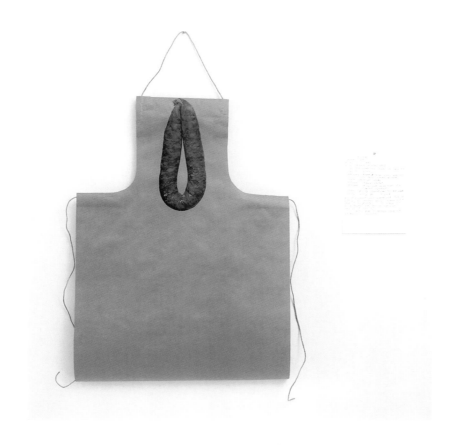

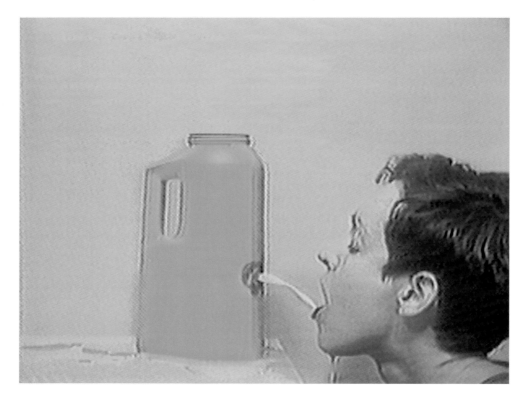

403. Rirkrit Tiravanija.
Untitled (apron and Thai pork sausage). 1993. Multiple

404. Cheryl Donegan.
Head. 1993. Video

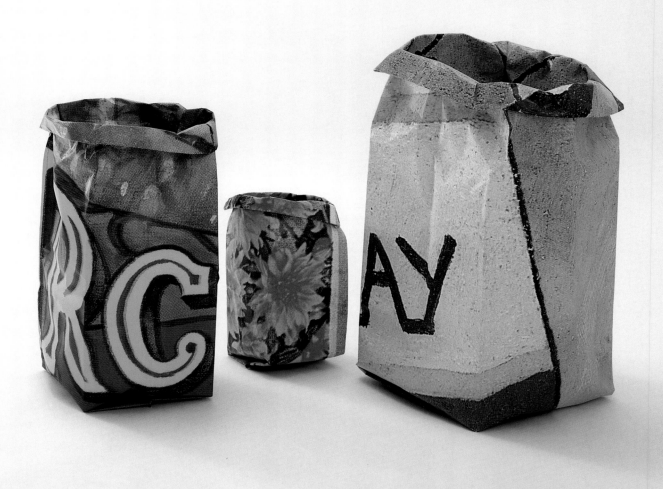

405. Jos van der Meulen.
Paper Bags Wastebaskets.
1993. Design

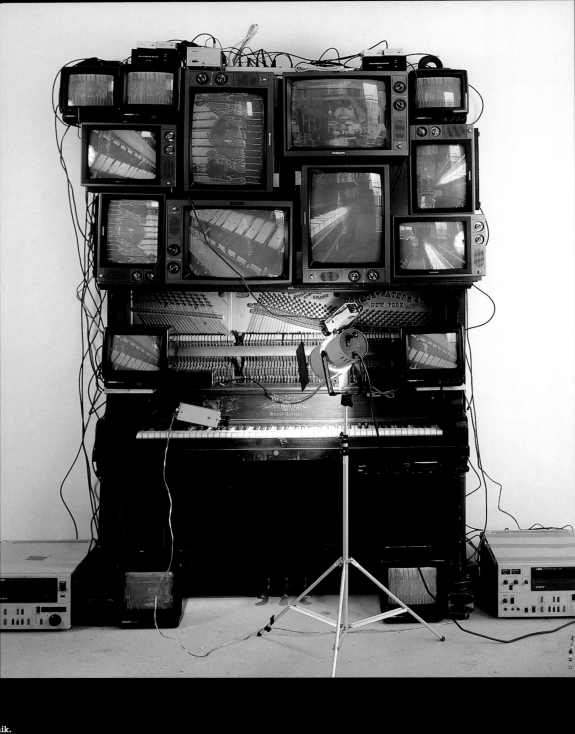

ik.
eo installation

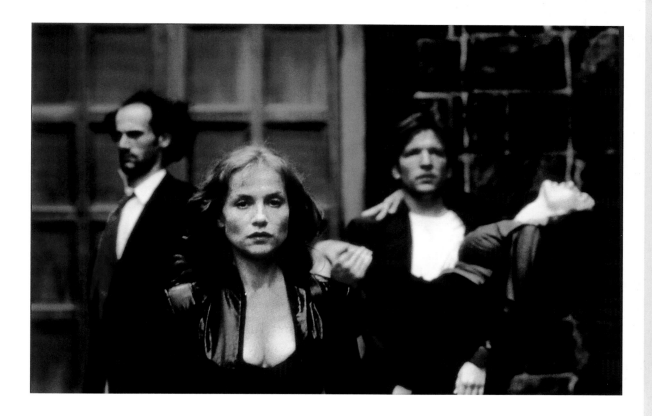

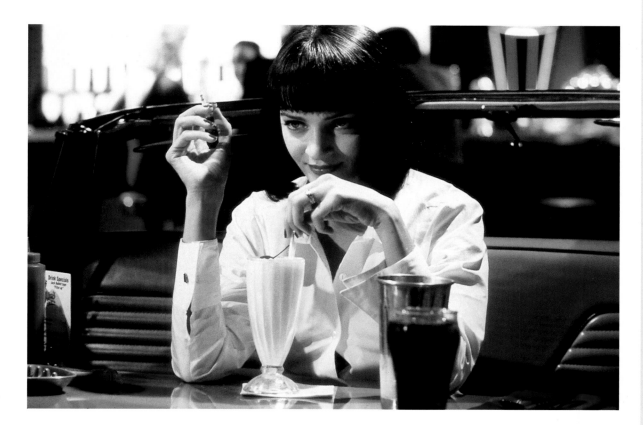

407. Hal Hartley.
Amateur. 1994. Film

408. Quentin Tarantino.
Pulp Fiction. 1994. Film

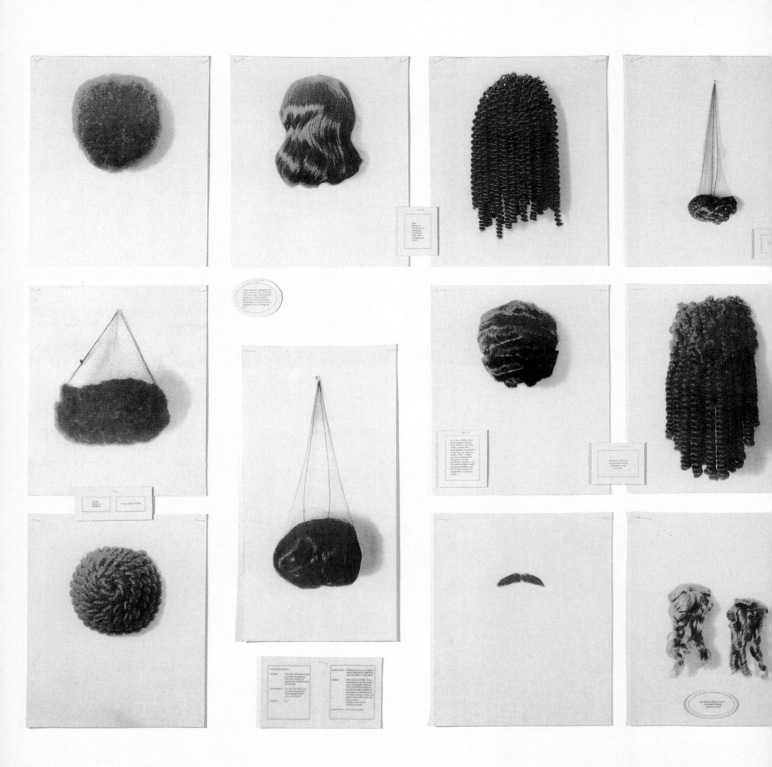

409. Lorna Simpson.
Wigs (Portfolio). 1994.
Prints

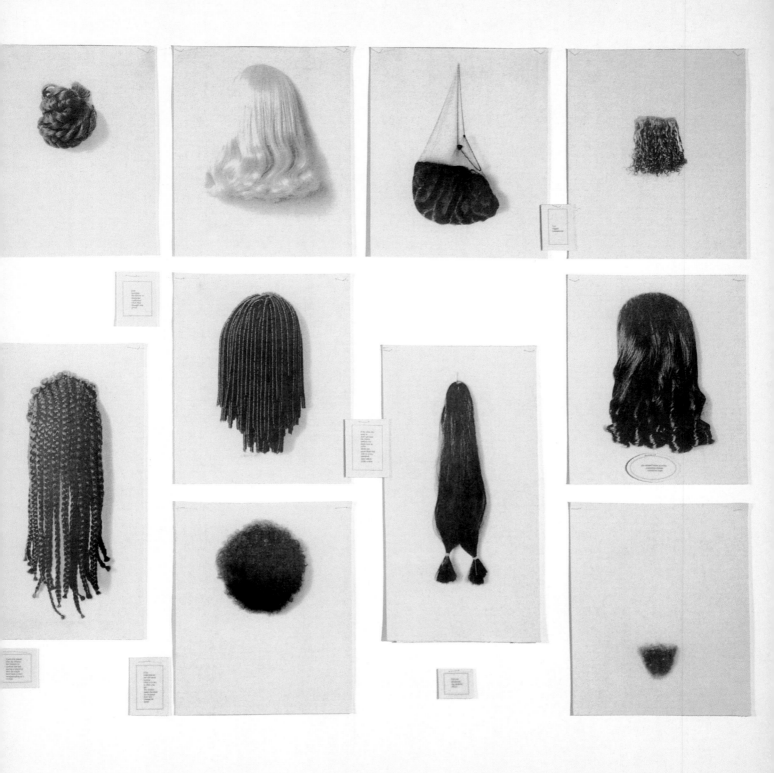

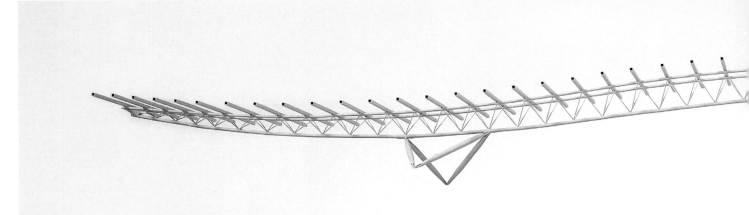

410. Renzo Piano.
Kansai International
Airport, Osaka, Japan.
1988–94.
Architectural model

411. Takeshi Ishiguro.
Rice Salt-and-Pepper Shakers.
1994. Design

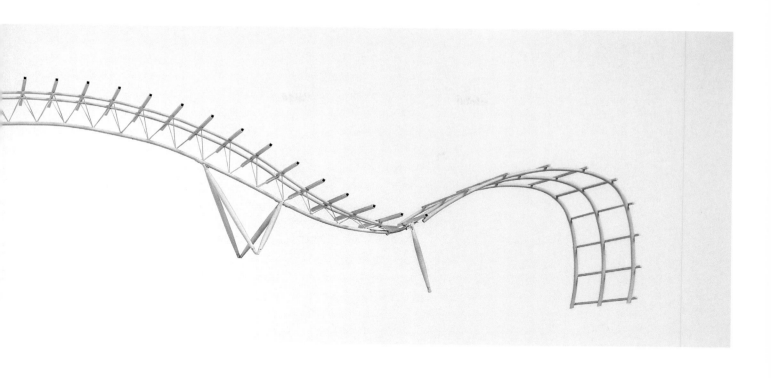

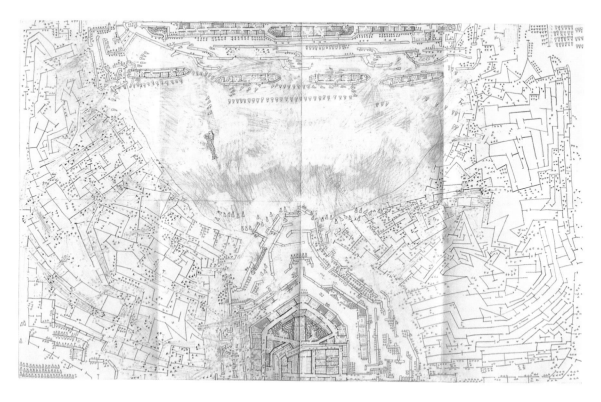

412. Kim Jones.
Untitled. 1991–94.
Drawing

413. Andreas Gursky.
Shatin. 1994. Photograph

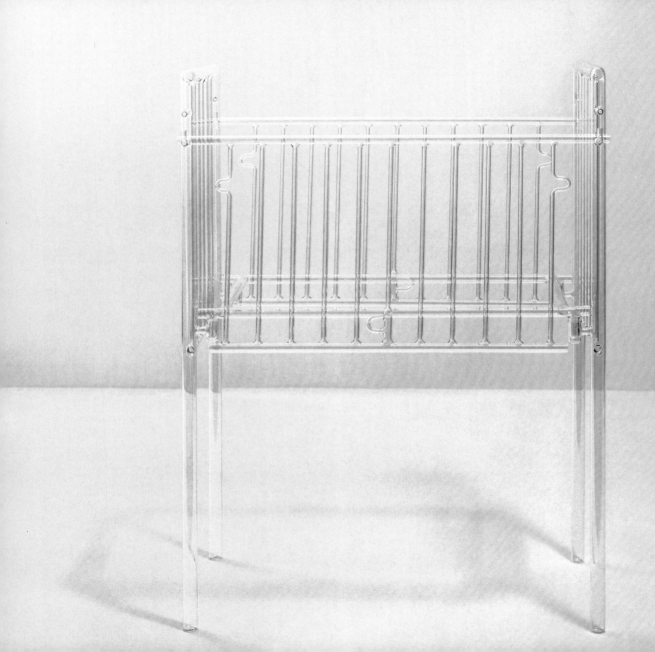

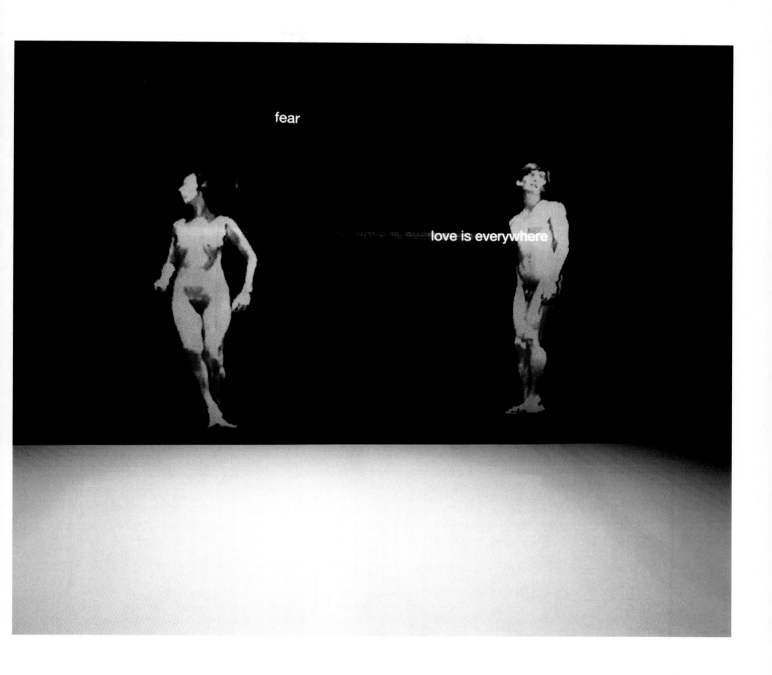

opposite:
414. Mona Hatoum.
Silence. 1994. Sculpture

above:
415. Teiji Furuhashi.
Lovers. 1994.
Video installation

1 9 9 4 | 375

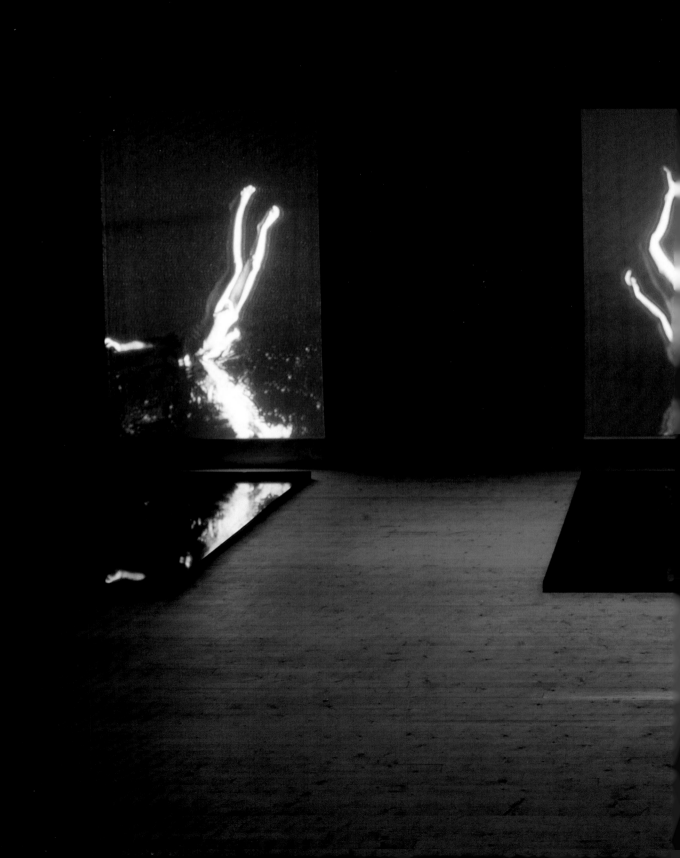

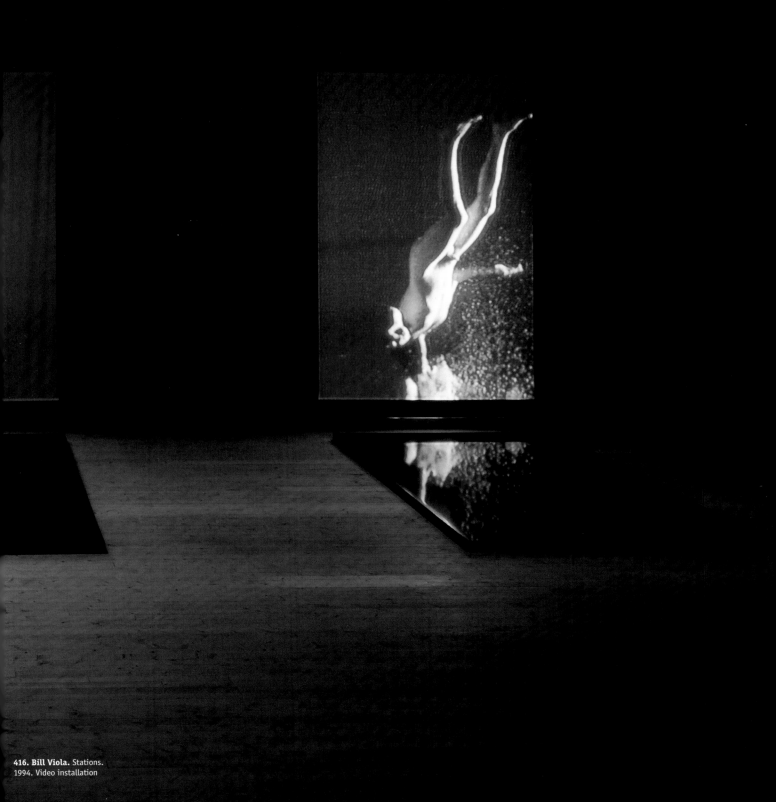

416. Bill Viola. Stations.
1994. Video installation

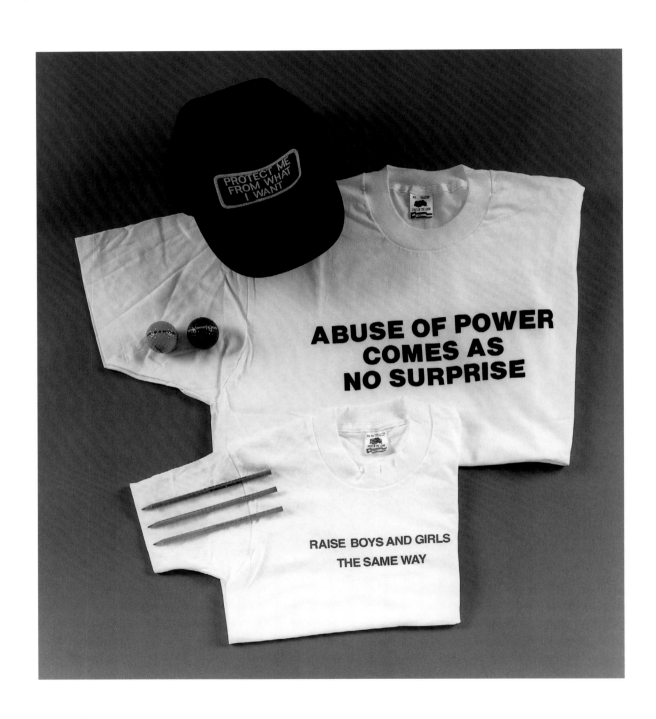

417. Jenny Holzer.
Truisms projects. 1980–94.
Multiples

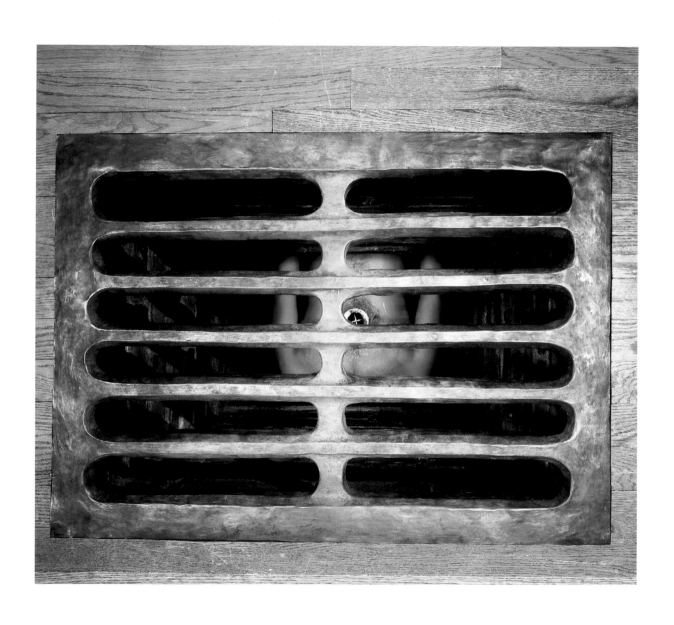

418. Robert Gober.
Untitled. 1993–94.
Sculpture

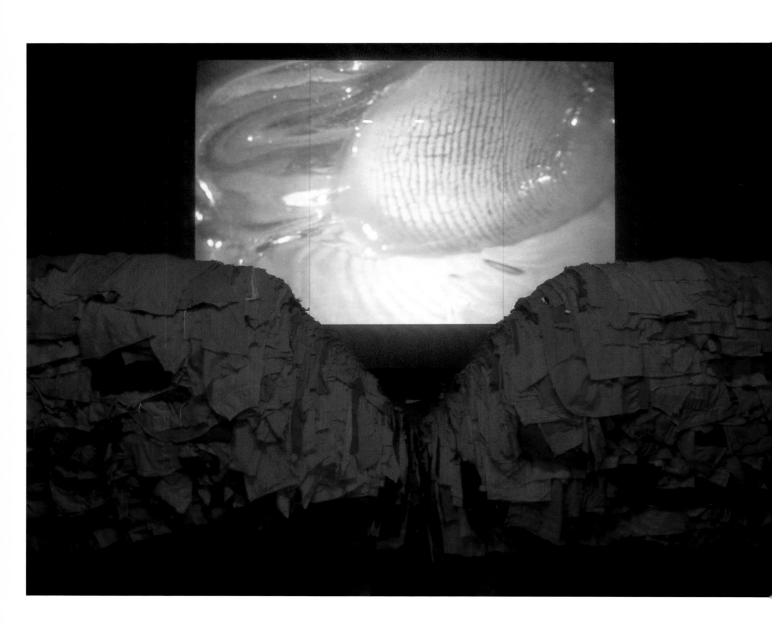

419. Ann Hamilton.
Seam. 1994. Video
installation

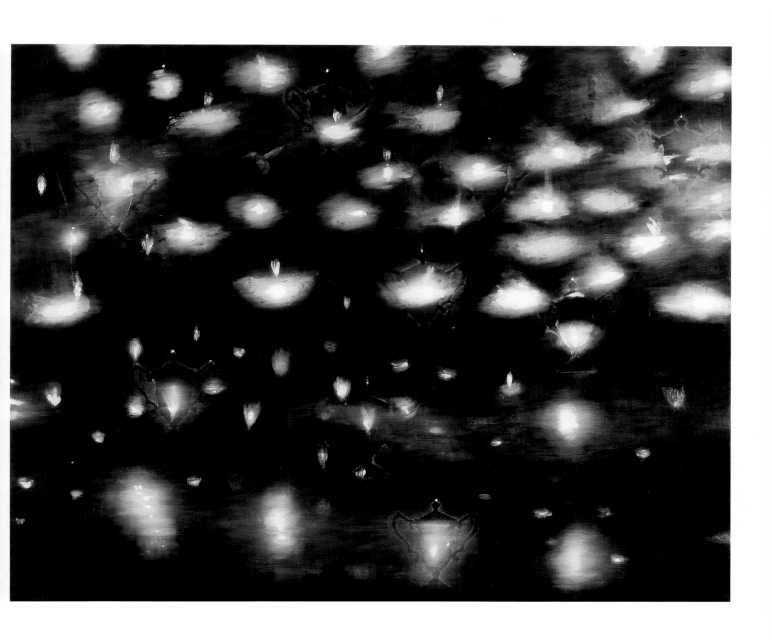

420. Ross Bleckner.
Memorial II. 1994. Painting

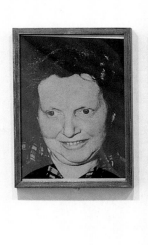
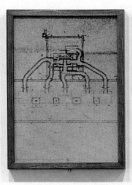

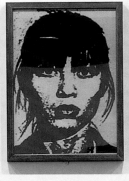
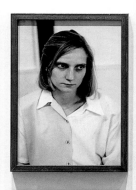
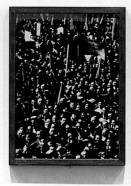
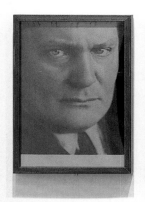

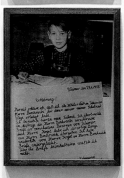
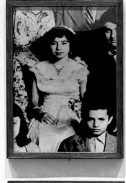
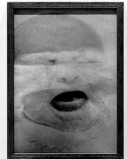

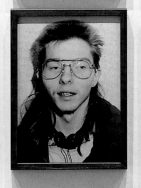

421. Michael Schmidt.
U-ni-ty (Ein-heit).
1991–94. Photographs

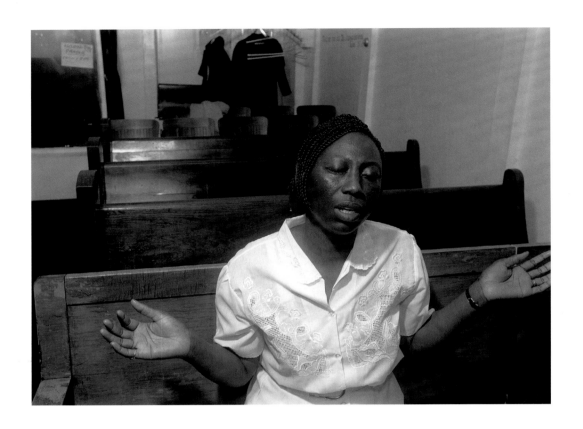

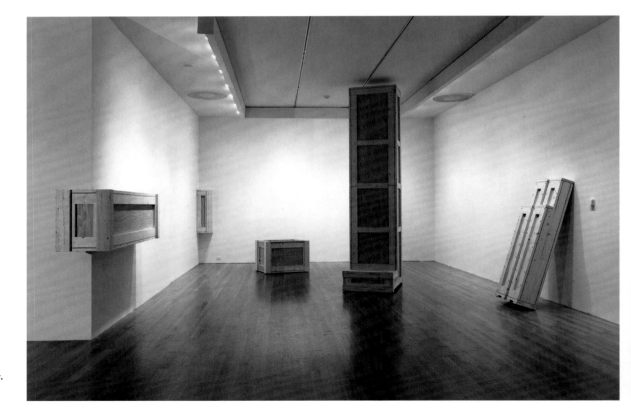

422. Thomas Roma.
Untitled from the series
Come Sunday. 1991–94.
Photograph

423. Richard Artschwager.
Five untitled works. 1994.
Sculptures

424. Uta Barth.
Ground #35. 1994.
Photograph

425. Cy Twombly.
The Four Seasons: Autumn,
Winter, Spring, and Summer.
1993–94. Paintings

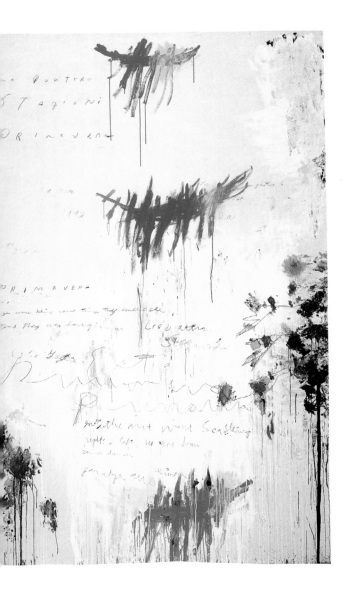

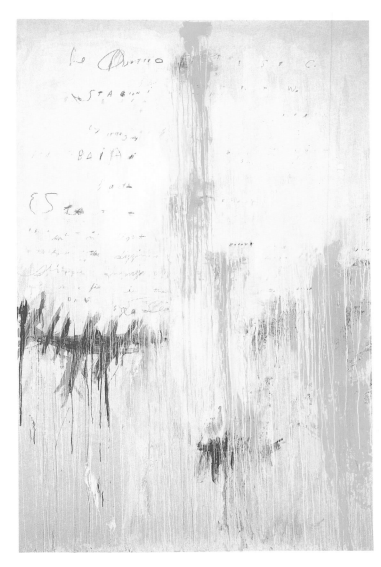

426. Philippe Starck.
Jim Nature Portable Television.
1994. Design

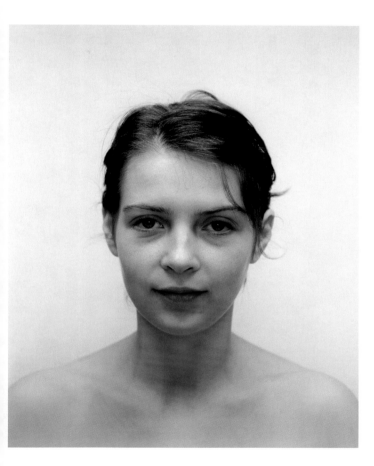
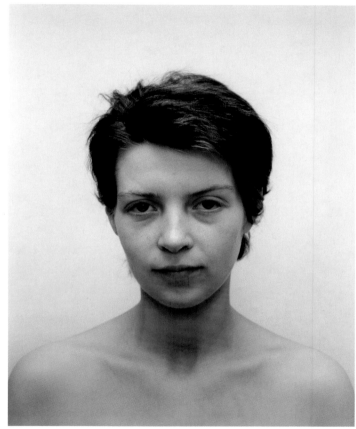

427. Rineke Dijkstra.
Tia, Amsterdam, the Netherlands,
14 November 1994. Tia, Amsterdam,
the Netherlands, 23 June 1994.
1994. Photographs

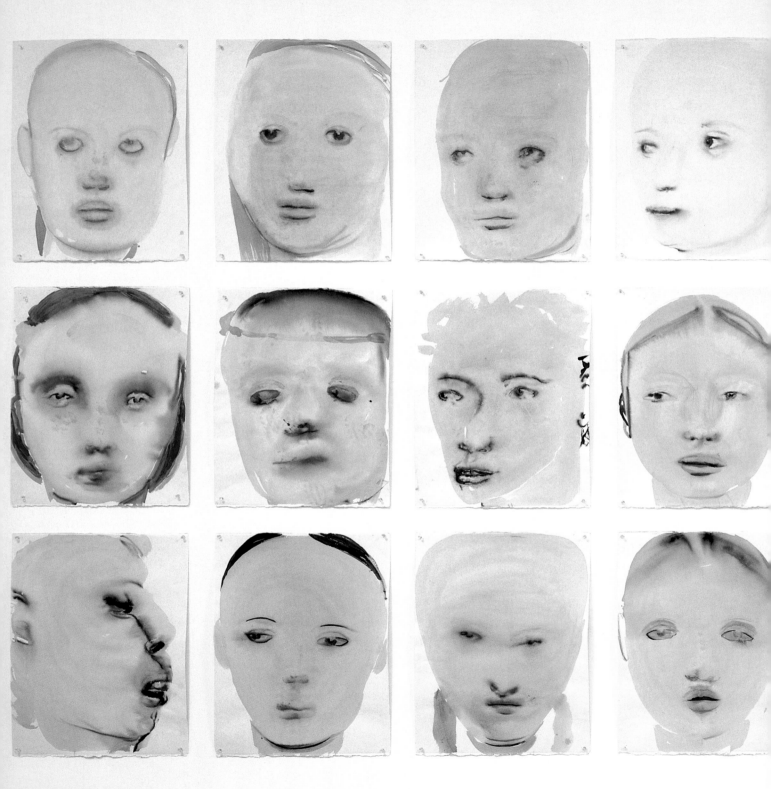

428. Marlene Dumas.
Chlorosis. 1994. Drawings

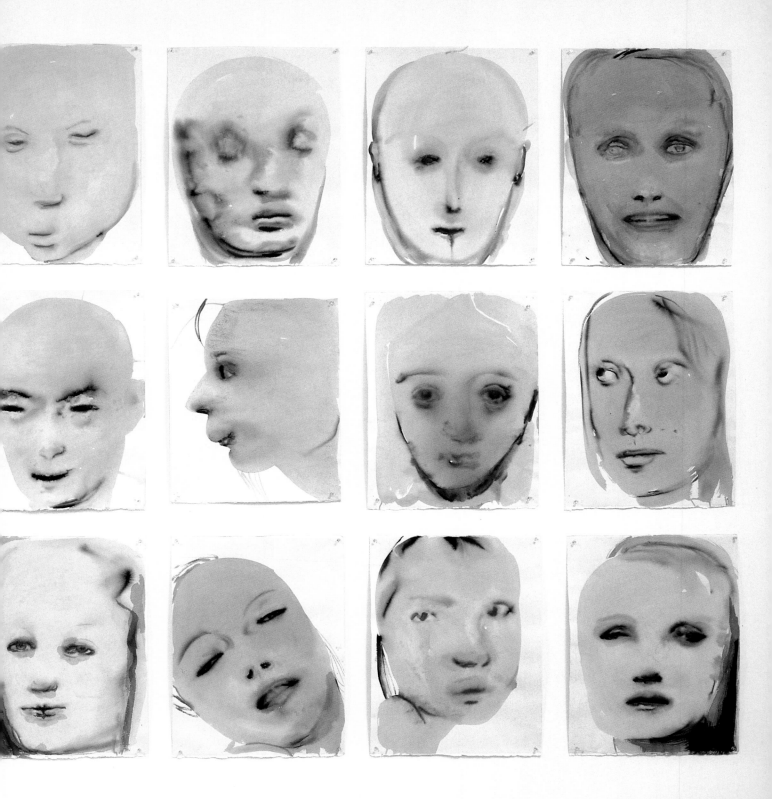

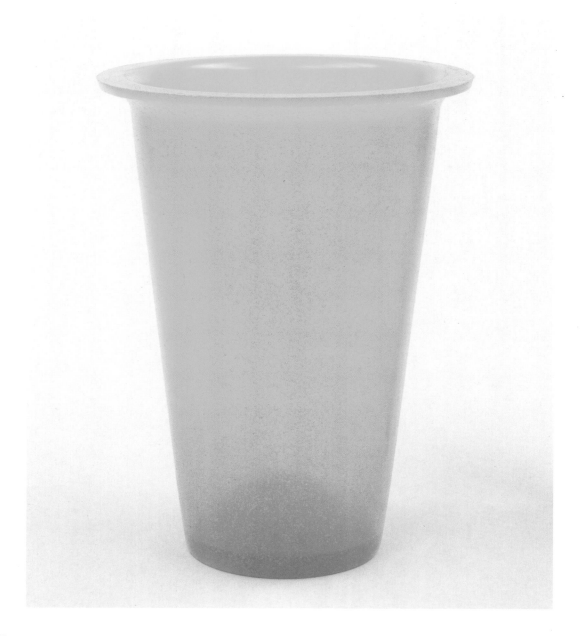

429. Hella Jongerius.
Soft Vase. 1994. Design

opposite:
430. James Turrell.
A Frontal Passage. 1994.
Installation

431. Jeff Scher.
Garden of Regrets.
1994. Film

432. Barbara Kruger.
Public projects and illustrated
book. 1986–94. Prints

433. Louise Bourgeois.
Fenelon. 1994. Drawing

434. Bob Evans.
Tan Delta Force Fin.
1994. Design

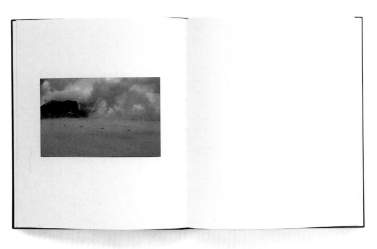

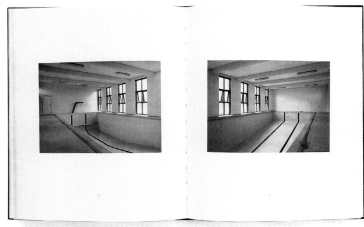

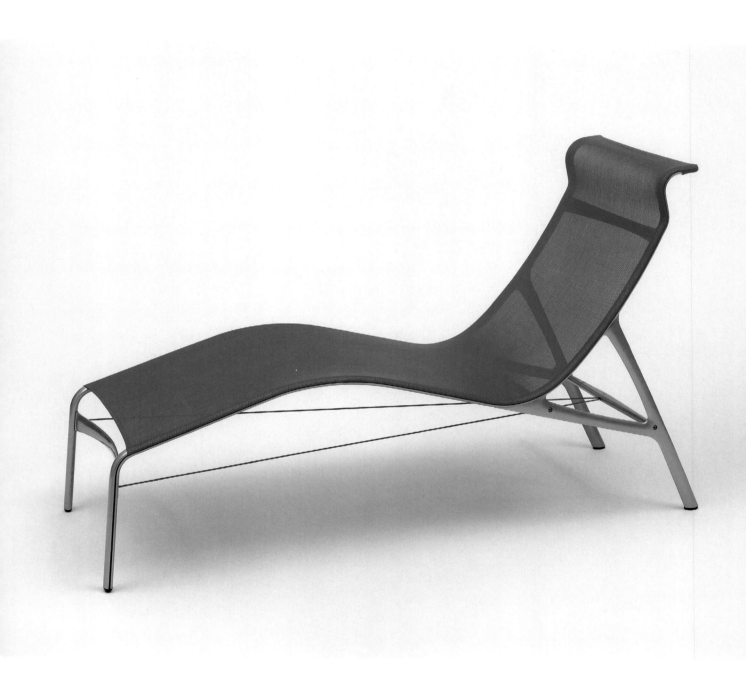

opposite:

435. Roni Horn.
Island-Pooling Waters.
1994. Illustrated book

436. Jean Nouvel.
Less Table. 1994. Design

437. Alberto Meda.
Long Frame Chaise Longue.
1994. Design

438. Glenn Ligon.
White #19. 1994. Painting

opposite:
439. Carrie Mae Weems.
You Became a Scientific
Profile from the series From
Here I Saw What Happened
and I Cried. 1995.
Photograph

YOU BECAME A
SCIENTIFIC PROFILE

440. Louise Bourgeois.
Ode à ma mère. 1995.
Illustrated book

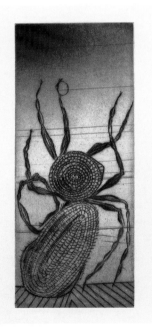

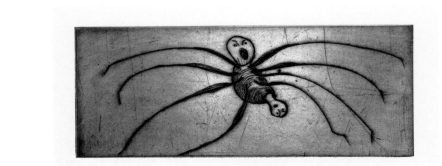

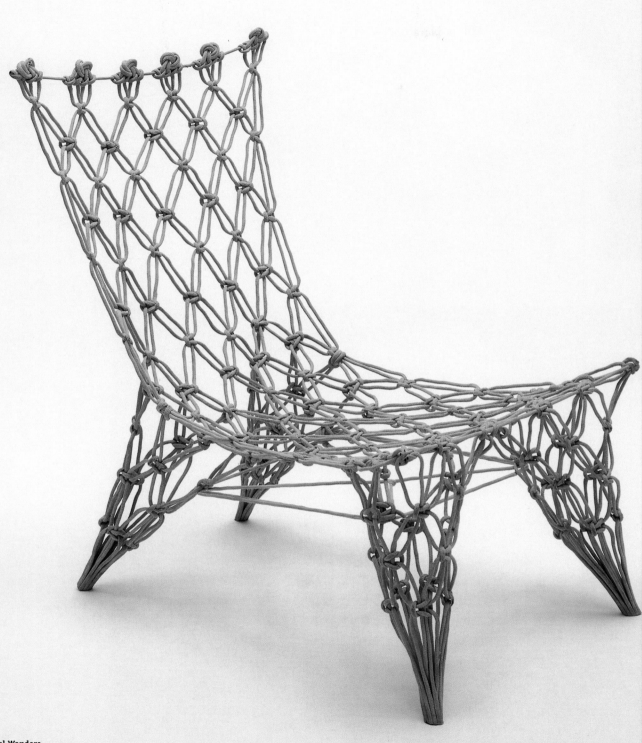

441. Marcel Wanders.
Knotted Chair. 1995. Design

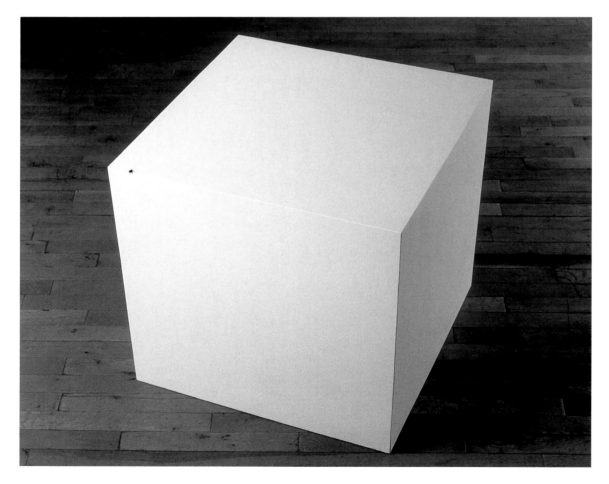

442. Tom Friedman.
Untitled. 1995. Sculpture

opposite:
443. Peter Halley.
Exploding Cell Wallpaper.
1995. Prints

overleaf:
444. Toba Khedoori.
Untitled (Doors). 1995.
Drawing

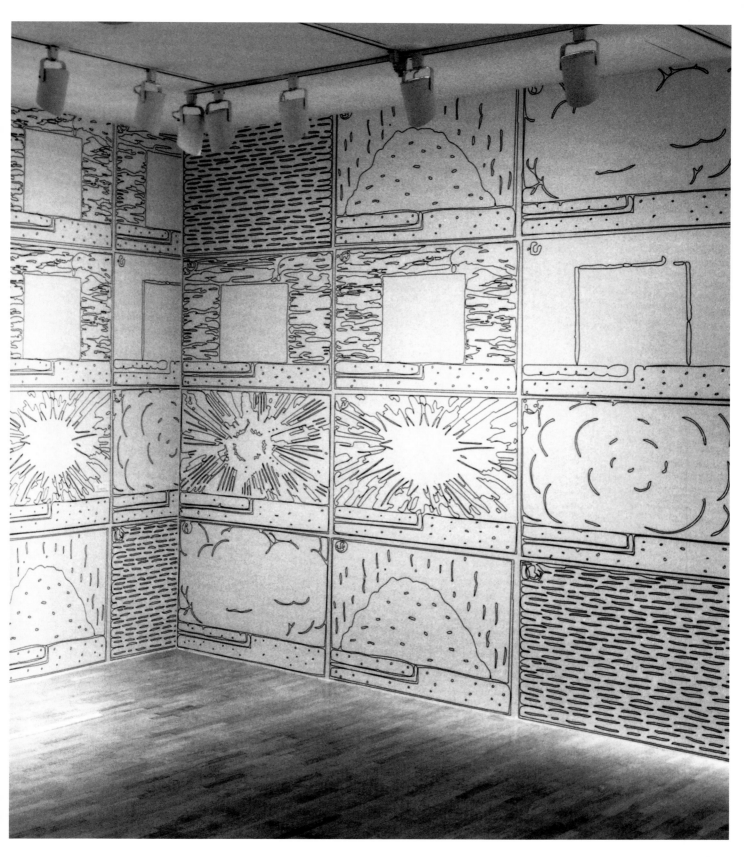

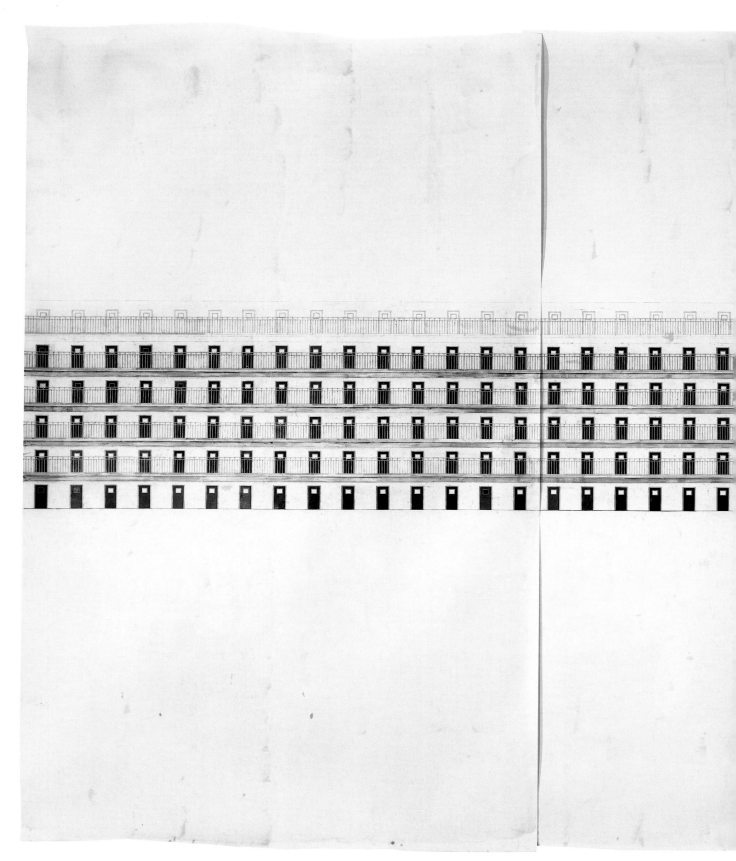

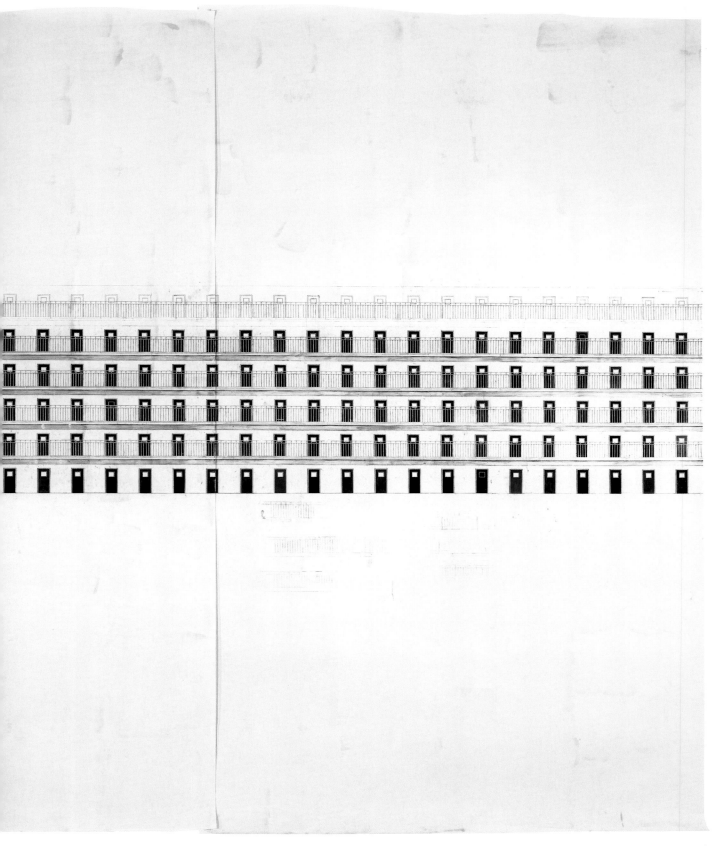

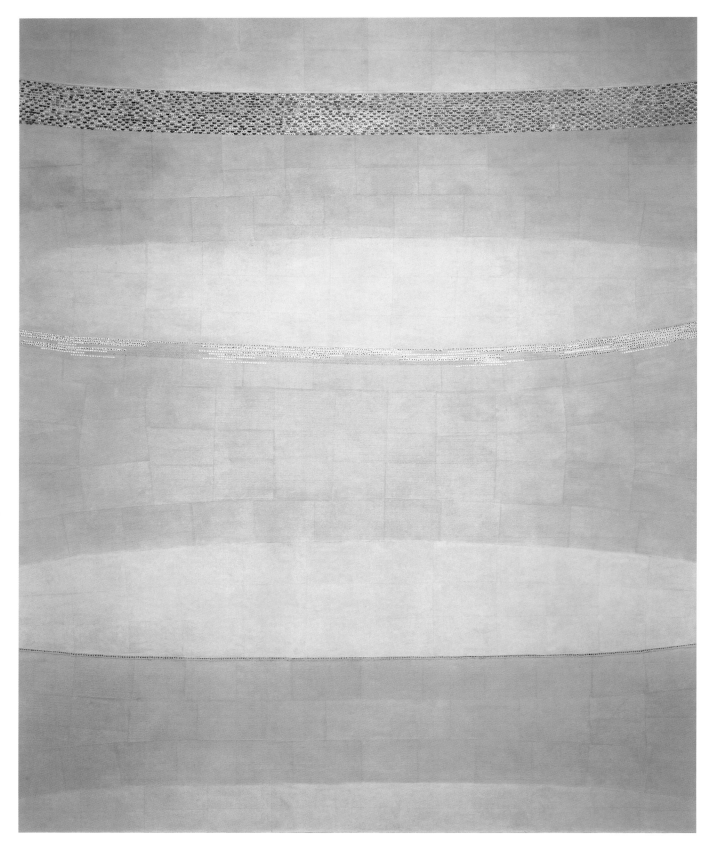

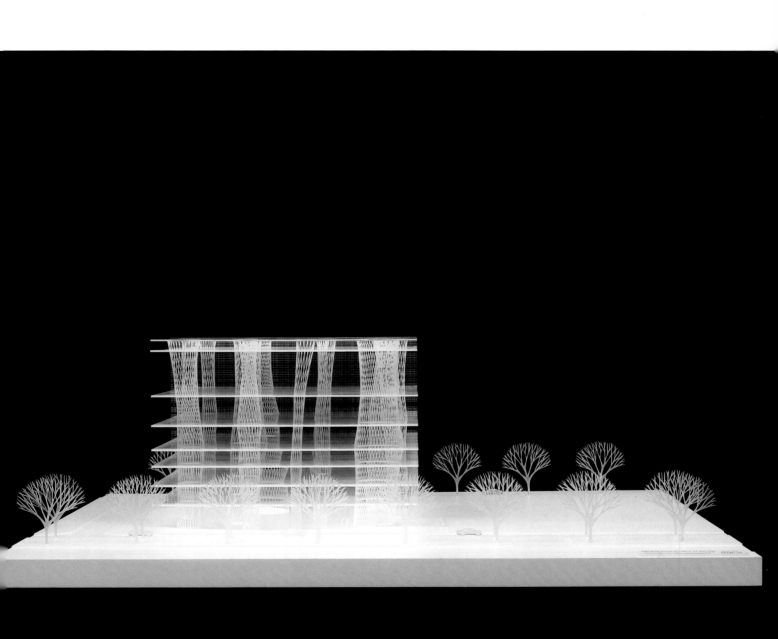

opposite:
445. Ellen Gallagher.
Oh! Susanna. 1995. Painting

above:
446. Toyo Ito.
Mediathèque Project,
Sendai, Japan. 1995.
Architectural model

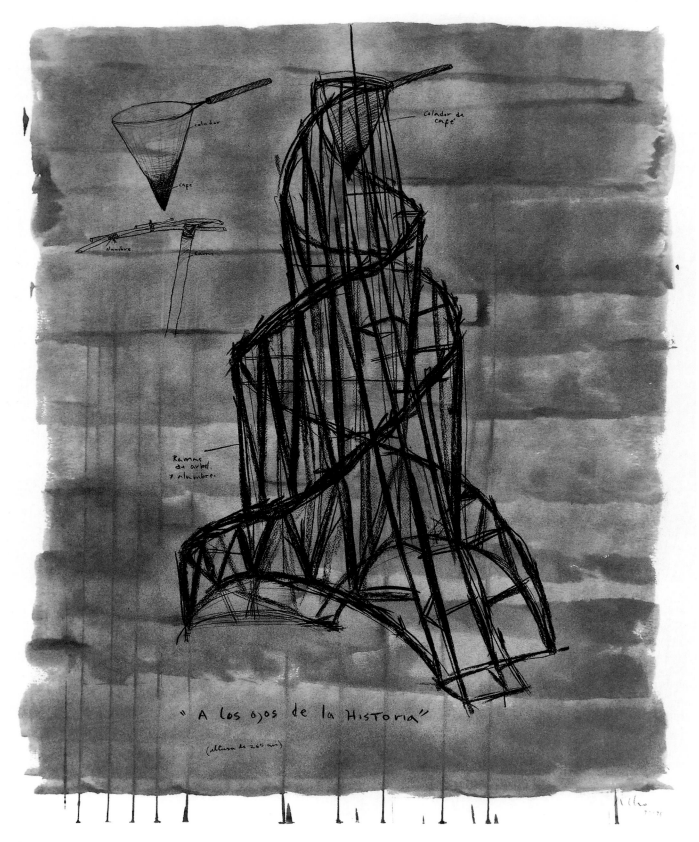

colador

café

alambre

rama

Colador de
café

Ramas
de arbol
y alambre.

"A los ojos de la Historia"

(altura de 265 cm)

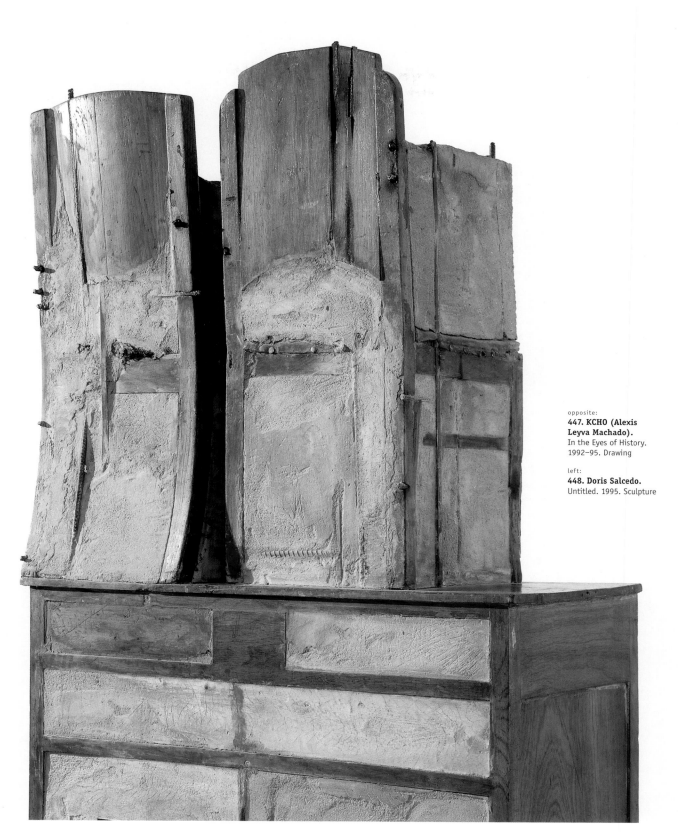

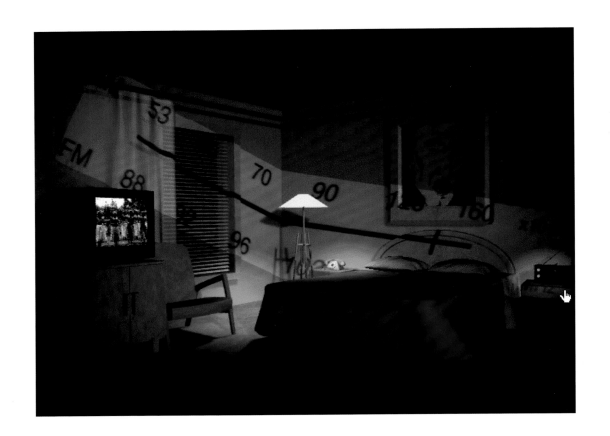

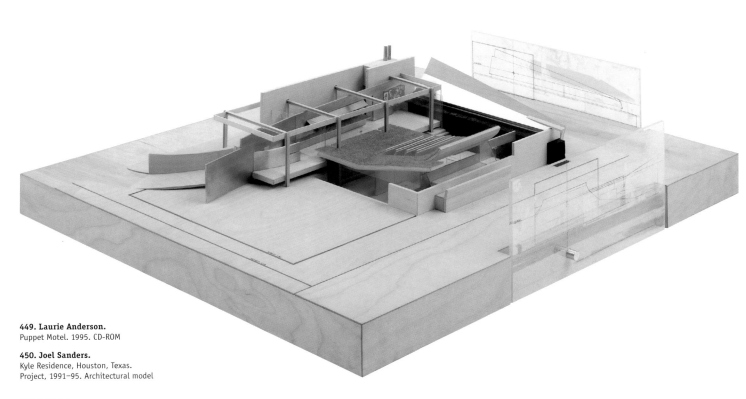

449. Laurie Anderson.
Puppet Motel. 1995. CD-ROM

450. Joel Sanders.
Kyle Residence, Houston, Texas.
Project, 1991–95. Architectural model

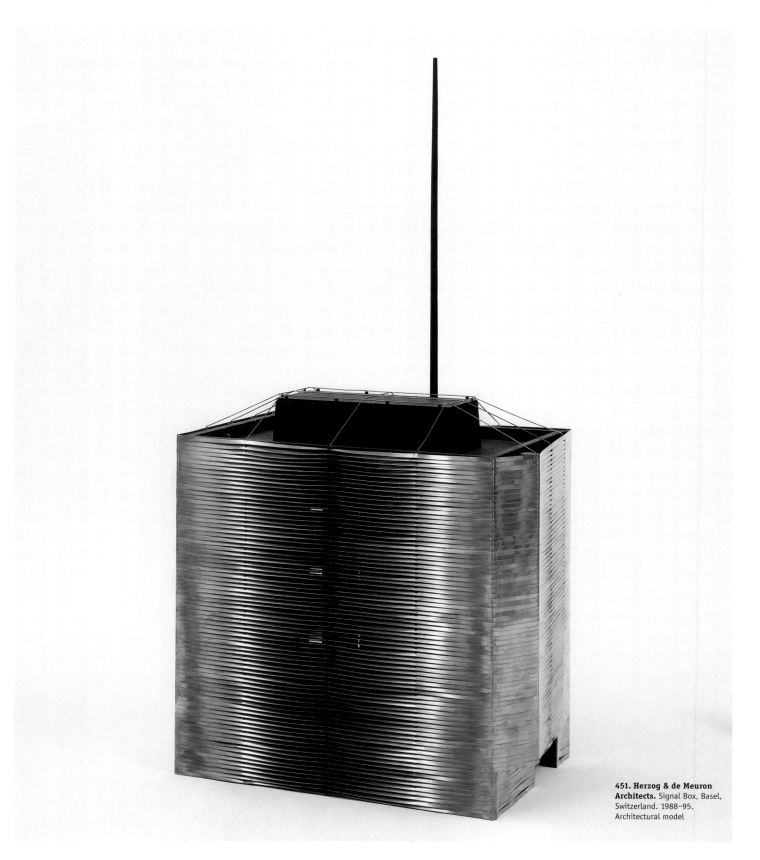

**451. Herzog & de Meuron
Architects.** Signal Box, Basel,
Switzerland. 1988–95.
Architectural model

452. Sigmar Polke.
Bulletproof Vacation
magazine. 1995. Prints

opposite:
453. Chuck Close.
Dorothea. 1995.
Painting

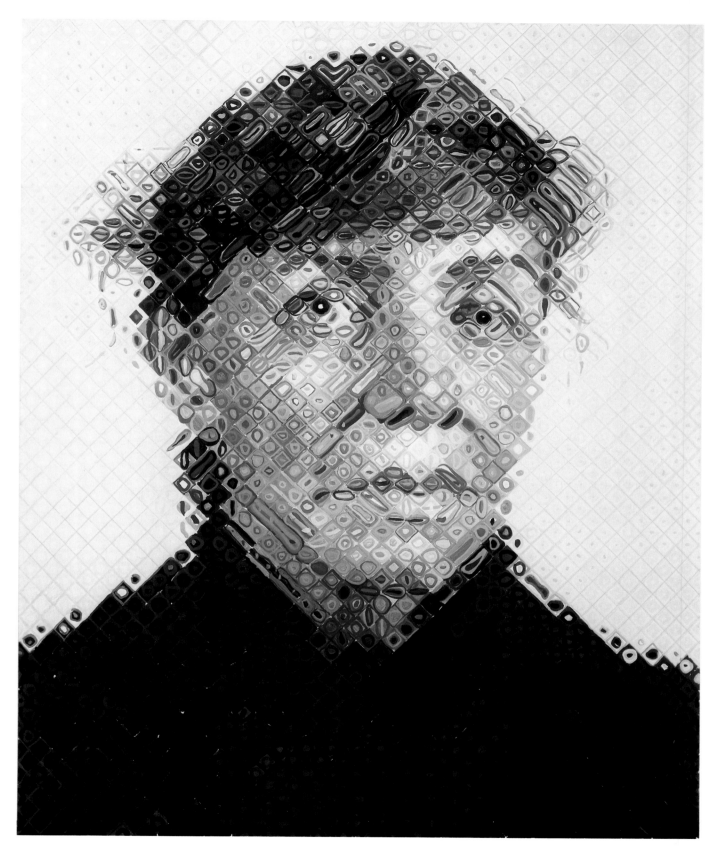

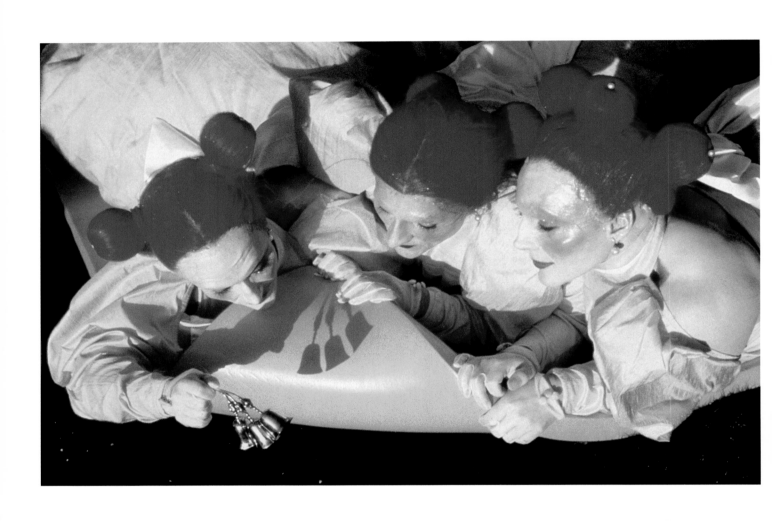

454. Matthew Barney.
Cremaster 4. 1994–95. Video

455. cyan.
Foundation Bauhaus
Dessau, Events,
July–August 1995
(Event Stiftung Bauhaus
Dessau, Jul–Aug 1995).
1995. Poster

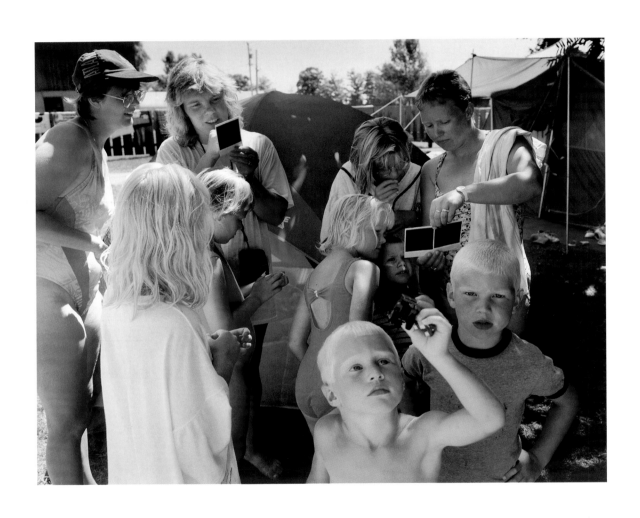

456. Sheron Rupp.
Untitled (Bayside,
Ontario, Canada).
1995. Photograph

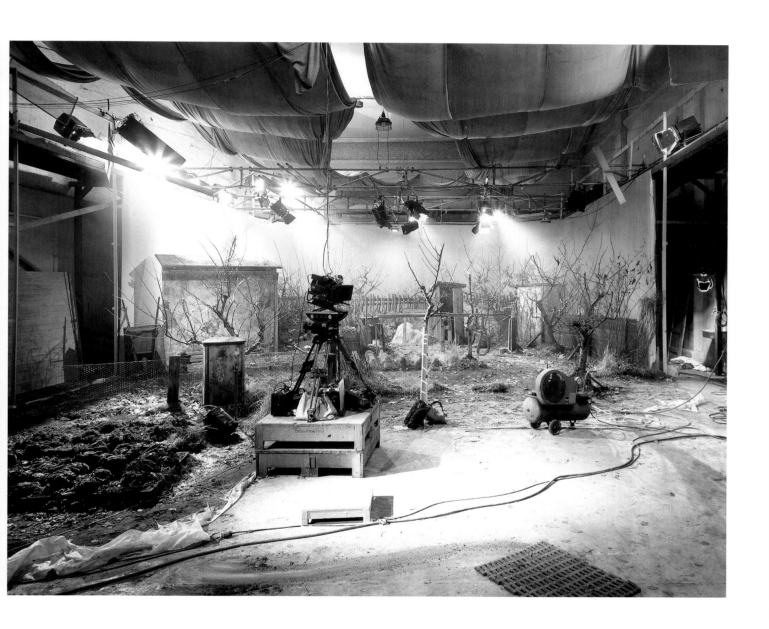

457. Stan Douglas.
Historic set for "Der Sandman"
at DOKFILM Studios, Potsdam,
Babelsburg, December 1994.
1995. Photograph

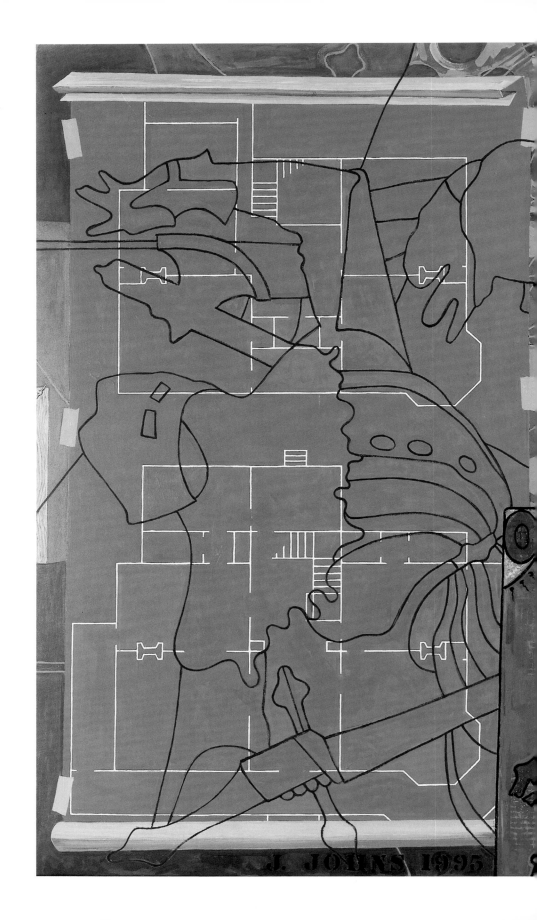

458. Jasper Johns.
Untitled. 1992–95. Painting

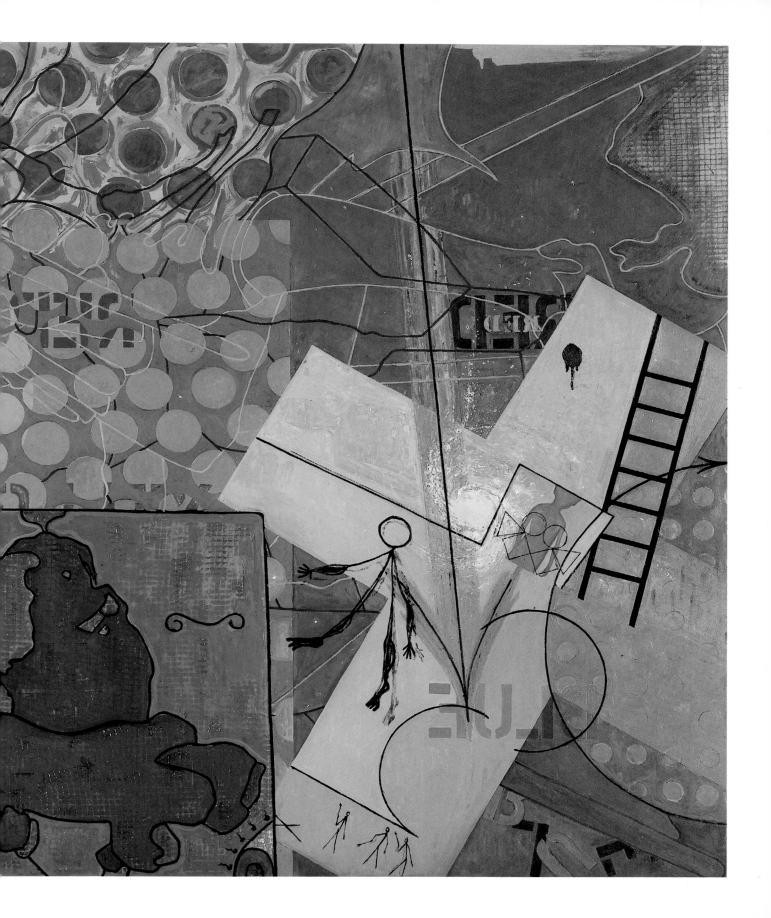

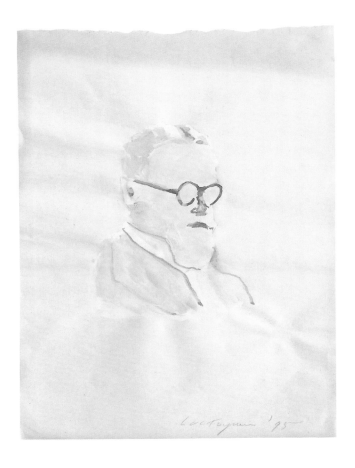

459. Inoue Pleats Co., Ltd.
Wrinkle P. 1995. Design

460. Luc Tuymans.
A Flemish Intellectual. 1995.
Drawing

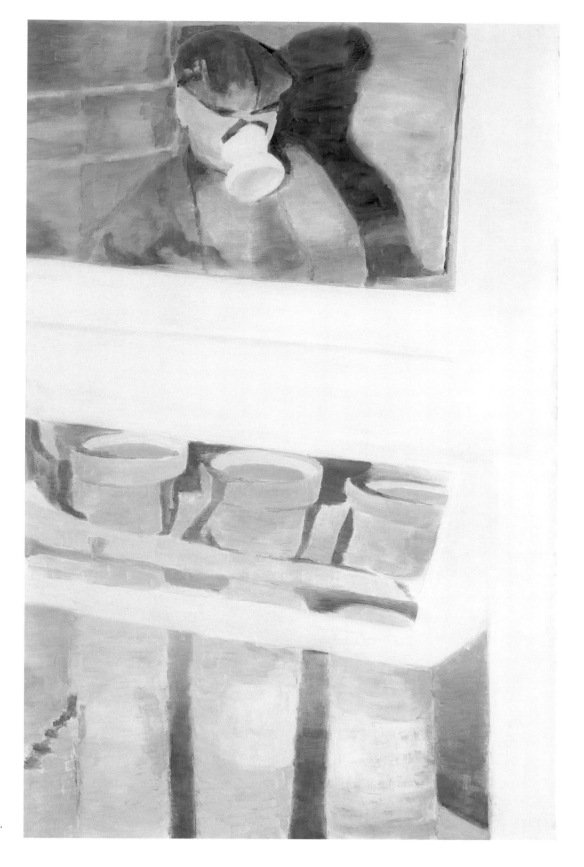

461. Luc Tuymans.
The Heritage IV. 1996.
Painting

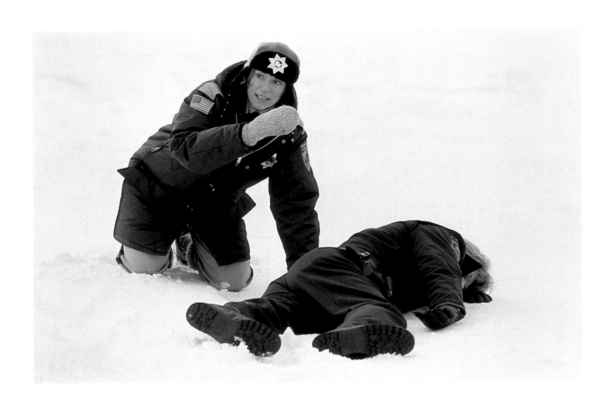

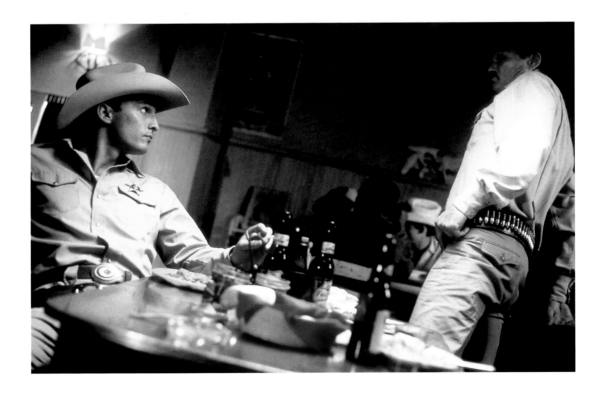

462. Joel Coen.
Fargo. 1996. Film

463. John Sayles.
Lone Star. 1996. Film

464. José María Sicilia.
Two volumes of Le Livre
des mille nuits et une nuit.
1996. Illustrated books

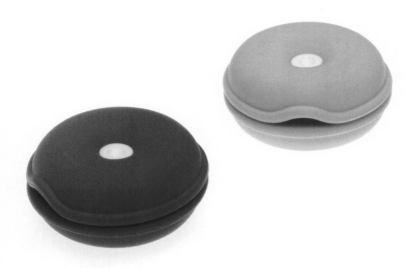

465. Flex Development B.V.
Cable Turtle. 1996. Design

466. Mona Hatoum.
Rubber Mat. 1996. Multiple

467. John Armleder.
Gog. 1996. Prints

468. David Hammons.
Out of Bounds. 1995–96.
Drawing

opposite:
469. KCHO (Alexis Leyva
Machado). The Infinite
Column I. 1996. Sculpture

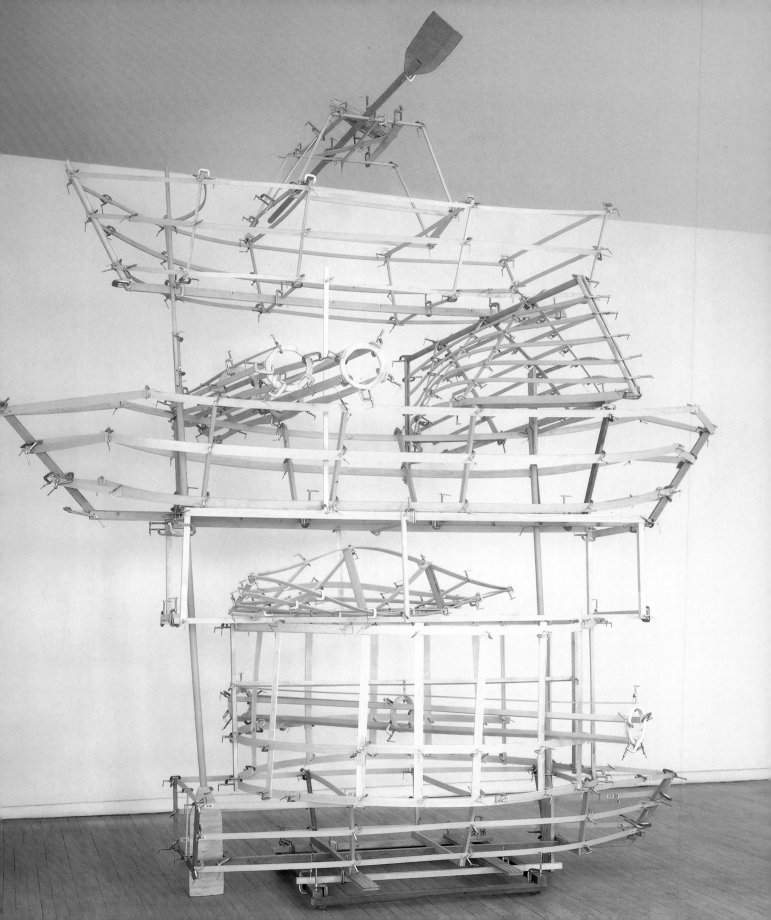

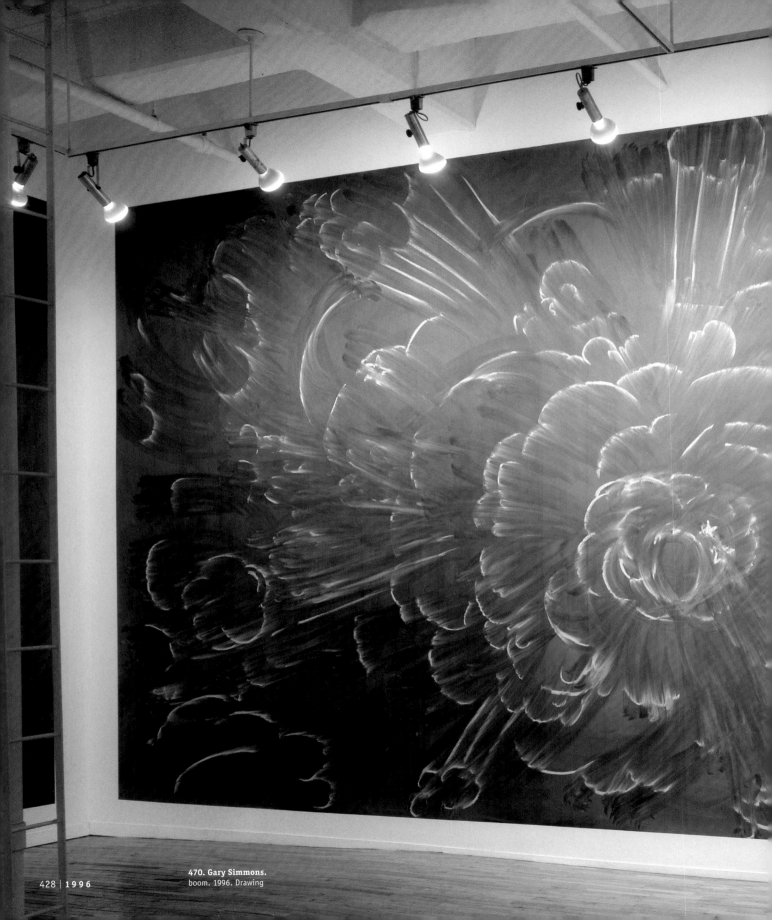

470. Gary Simmons.
boom. 1996. Drawing

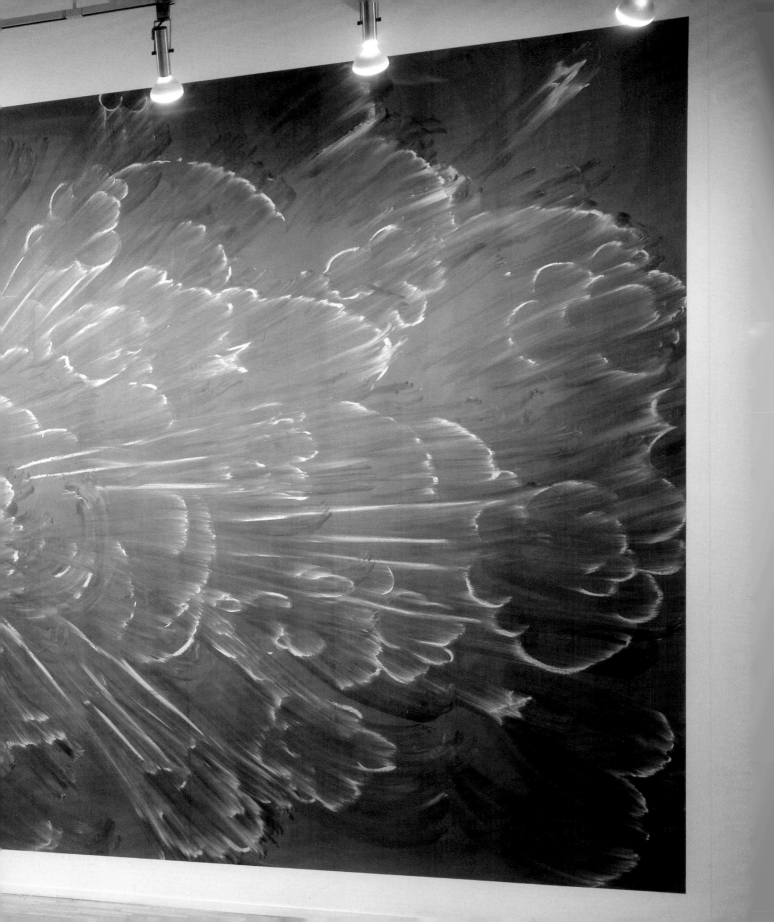

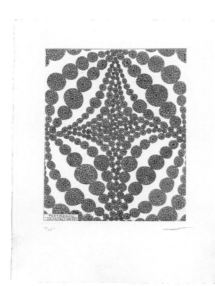

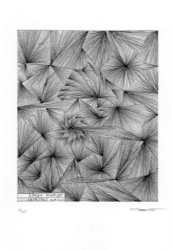

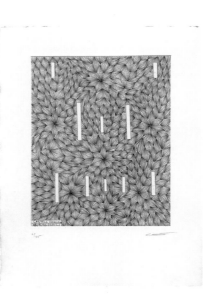

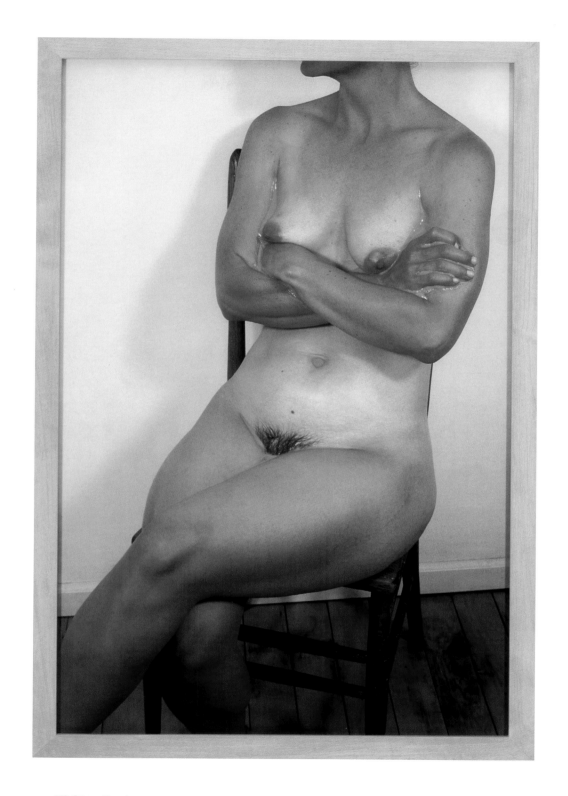

471. Gabriel Orozco.
Light Through Leaves.
1996. Print

472. Chris Ofili.
North Wales. 1996.
Prints

473. Jeanne Dunning.
Untitled. 1996. Photograph

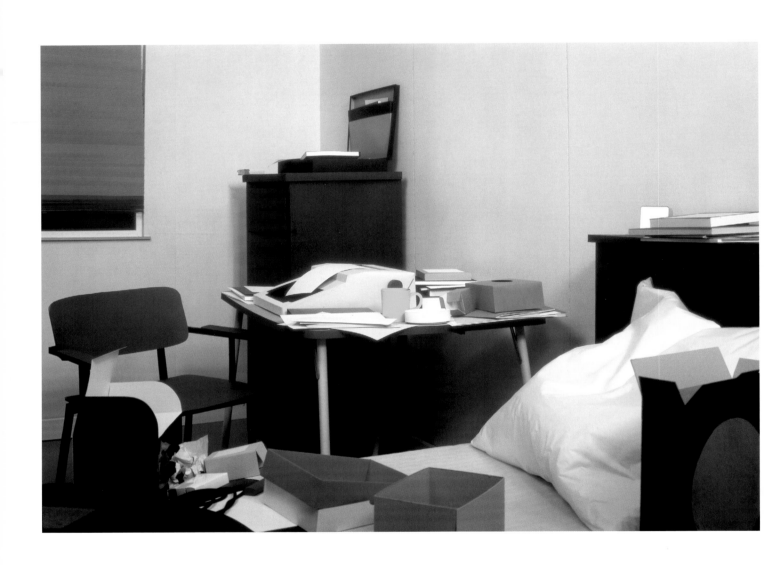

474. Thomas Demand.
Room. 1996. Photograph

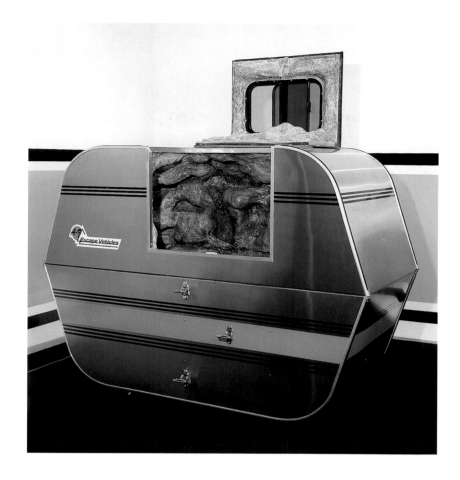

475. Andrea Zittel.
A-Z Escape Vehicle: Customized by Andrea Zittel. 1996. Sculpture

476. Werner Aisslinger.
Juli Armchair. 1996. Design

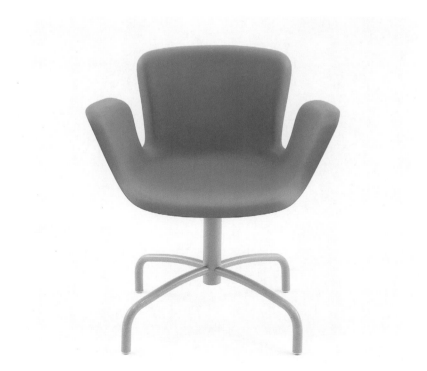

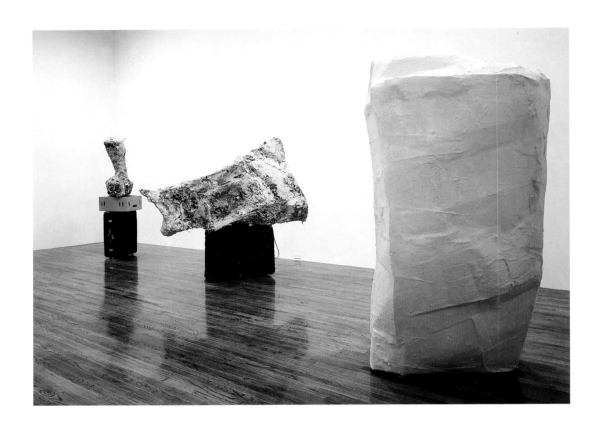

477. Franz West.
Spoonerism. 1996.
Installation

478. Al Pacino.
Looking for Richard.
1996. Film

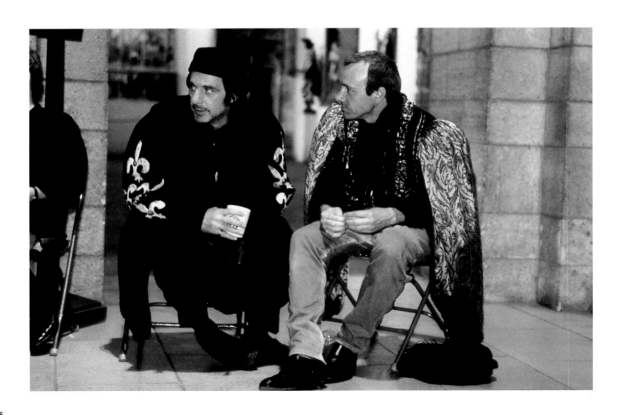

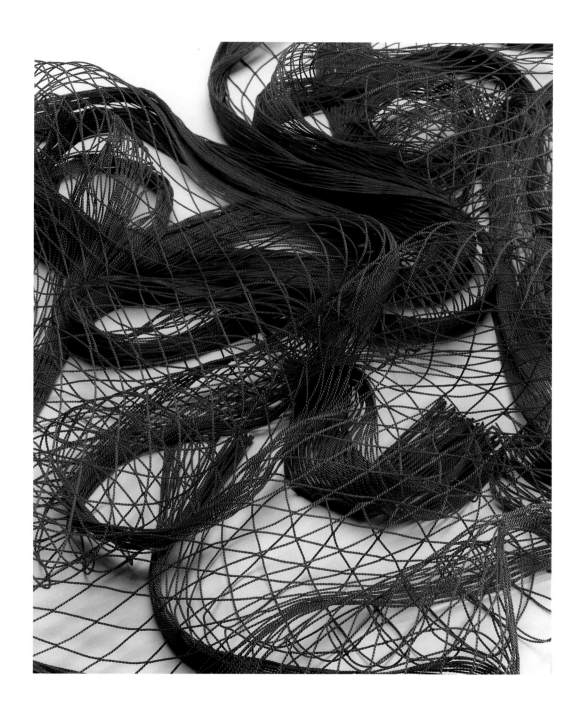

479. Toray Industries, Inc.
Encircling Fishing Net. 1996.
Design

480. Ken Jacobs.
Disorient Express.
1996. Film

481. Igor Moukhin.
Moscow, May 9, 1996.
1996. Photograph

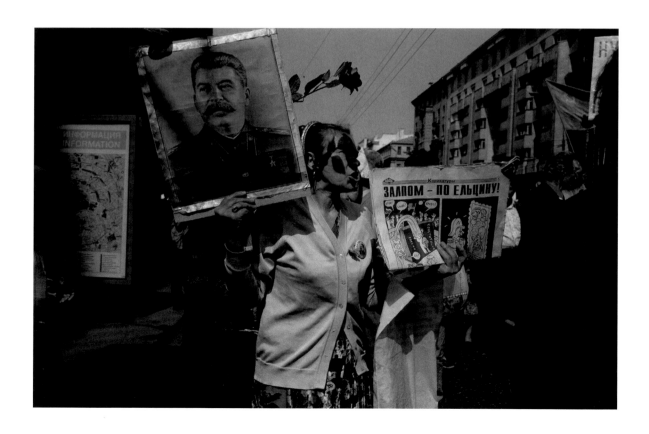

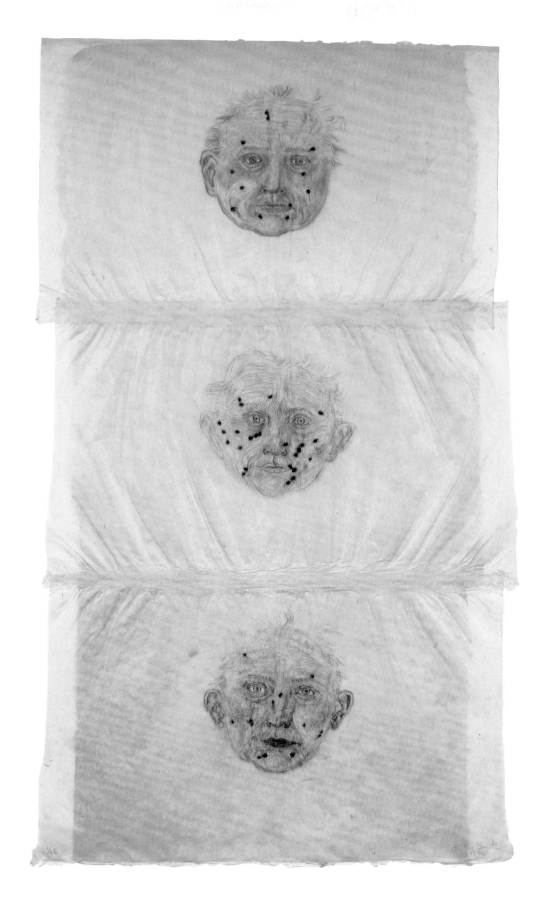

482. Kiki Smith.
Constellations. 1996.
Print

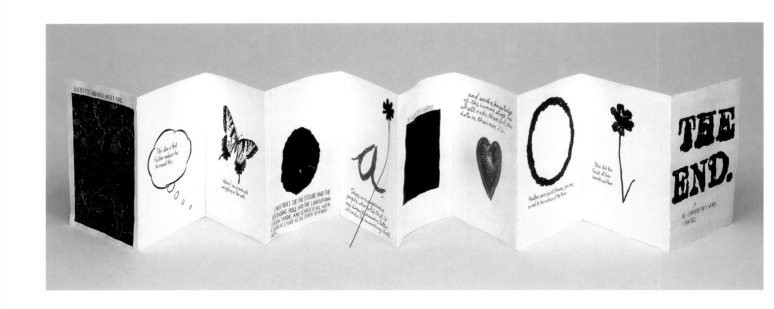

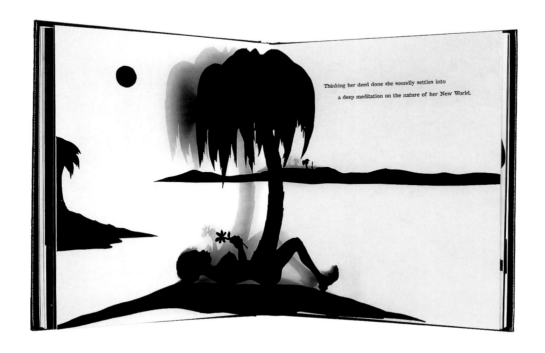

483. Raymond Pettibon.
Untitled (Justly Felt and
Brilliantly Said). 1996.
Illustrated book

484. Kara Walker.
Freedom: A Fable or A
Curious Interpretation of
the Wit of a Negress in
Troubled Times. 1997.
Illustrated book

opposite:
485. Arthur Omar.
The Last Mermaid.
1997. Video

486. Kristin Lucas.
Host. 1997. Video

overleaf:
487. Vik Muniz.
Mass from the series
Pictures of Chocolate.
1997. Photographs

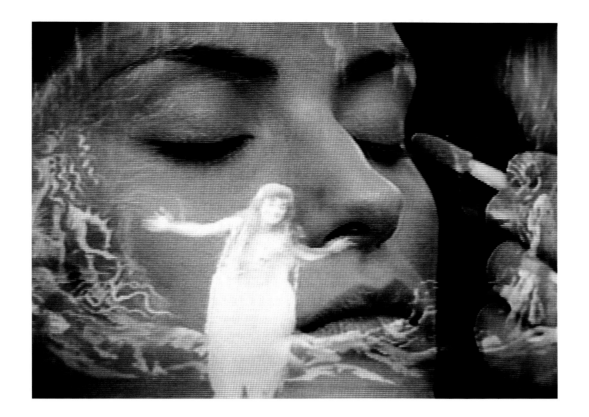

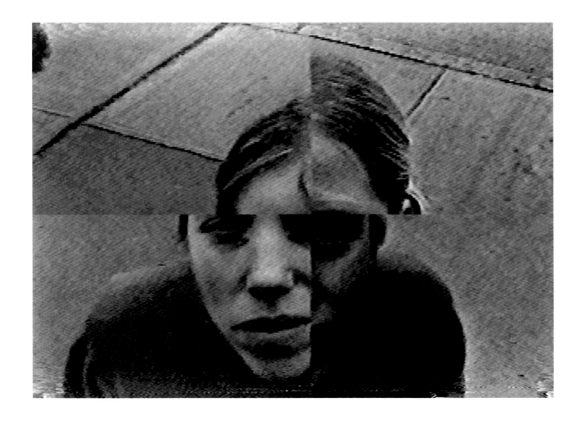

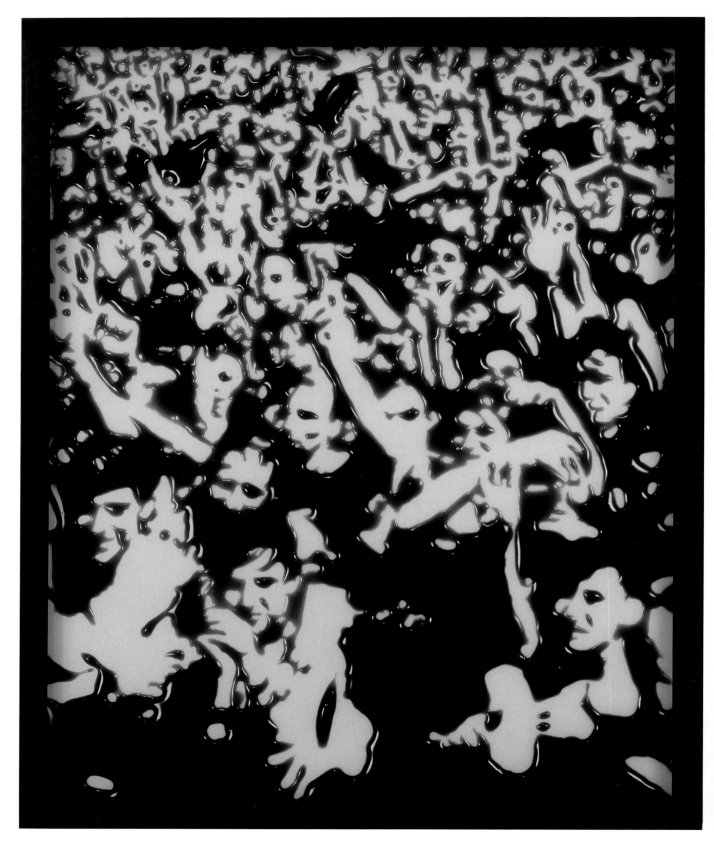

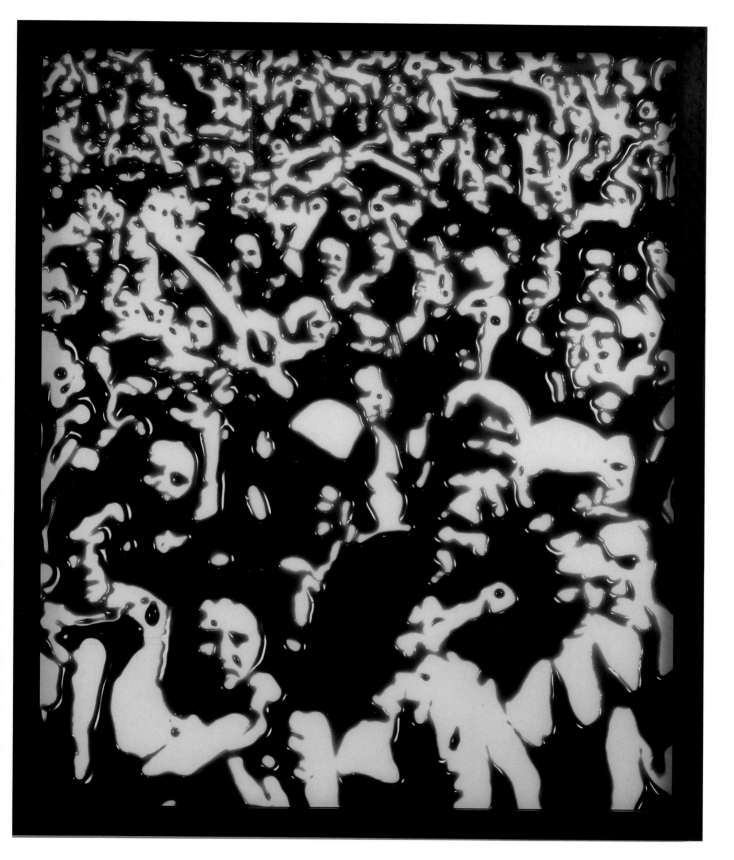

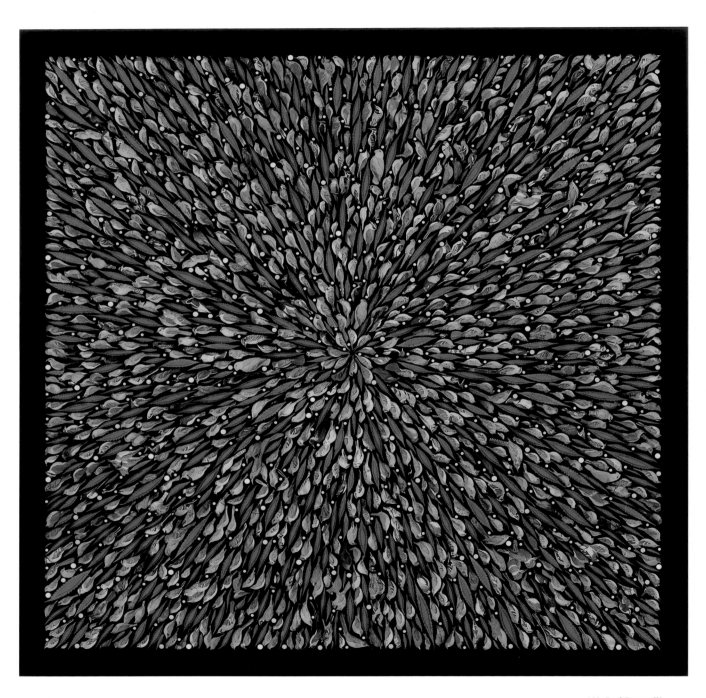

488. Fred Tomaselli.
Bird Blast. 1997. Painting

opposite:
489. Chuck Close.
Self-Portrait. 1997. Painting

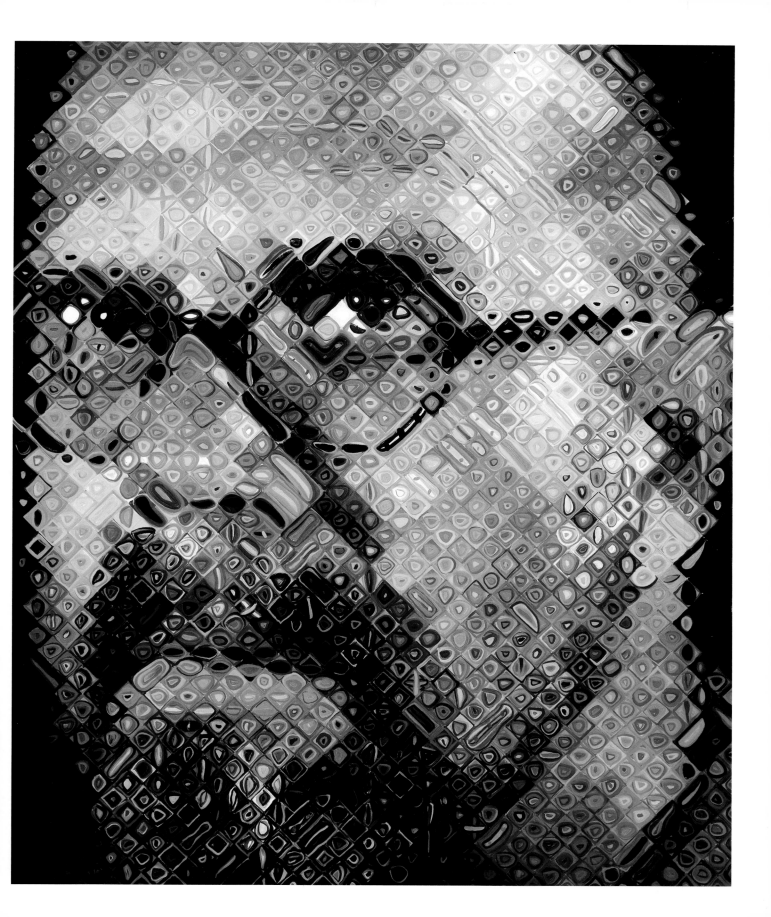

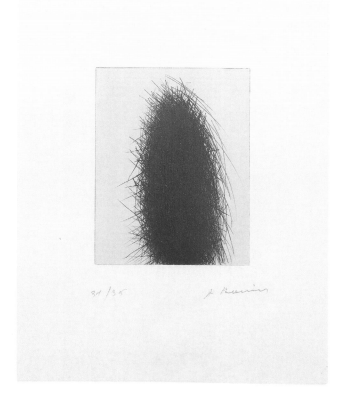

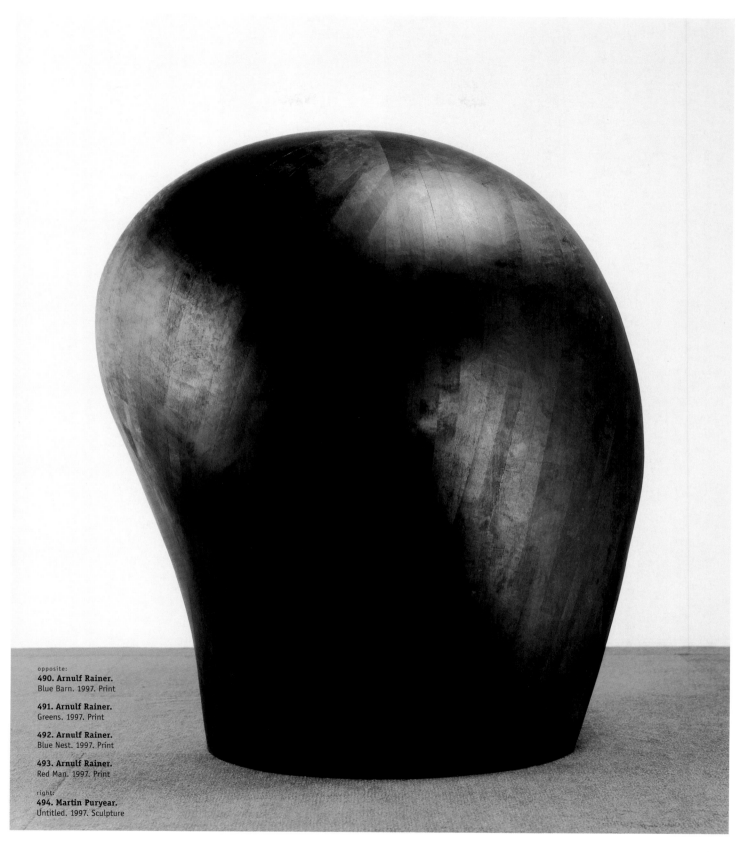

495. Stan Brakhage.
Commingled Containers.
1997. Film

opposite:
496. Reiko Sudo.
Origami Pleat Scarf.
1997. Design

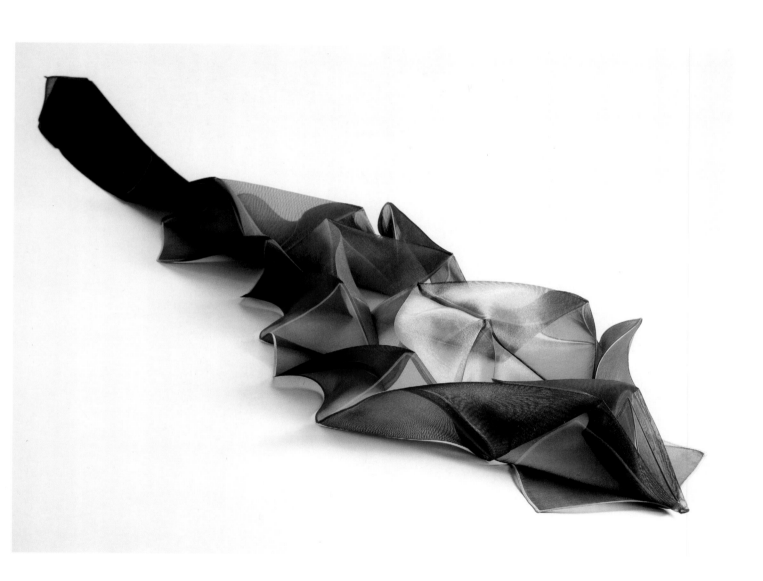

497. Reiko Sudo.
Shutter. 1997. Design

opposite:
498. Daniel Libeskind.
Berlin Museum with Jewish
Museum, Berlin, 1989–97.
Architectural model

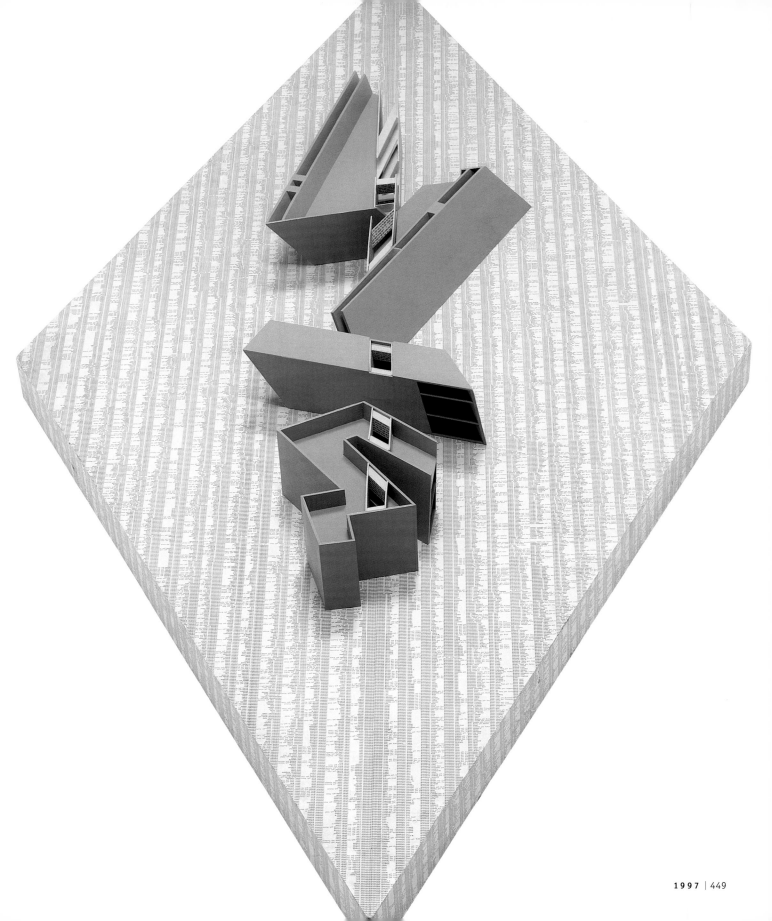

4/16

499. Willie Cole.
Stowage. 1997. Print

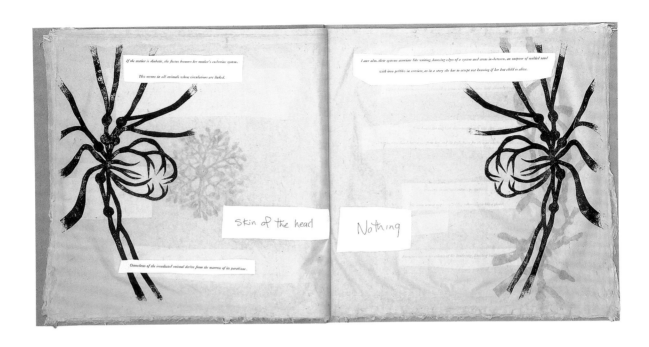

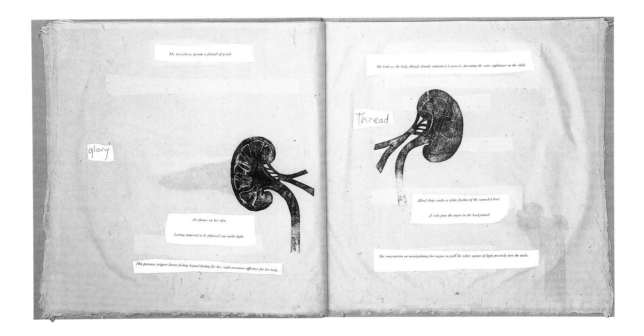

500. Kiki Smith.
Endocrinology. 1997.
Illustrated book

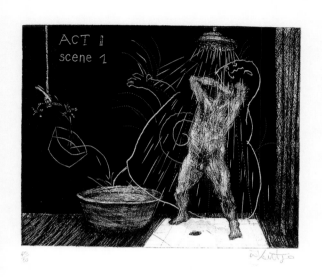

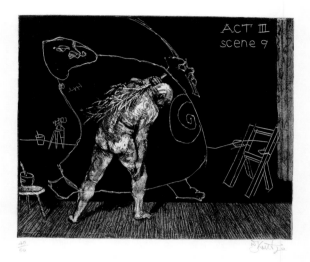

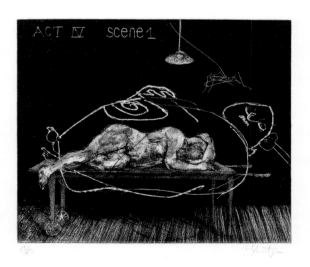

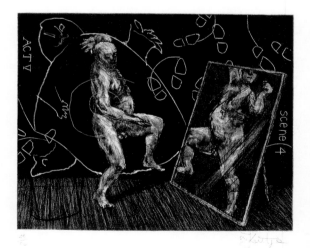

501. William Kentridge.
Ubu Tells the Truth. 1996–97.
Prints

AND

502. **John Baldessari.**
Goya Series: And. 1997.
Painting

opposite:
503. **Rachel Whiteread.**
Untitled (Paperbacks).
1997. Installation

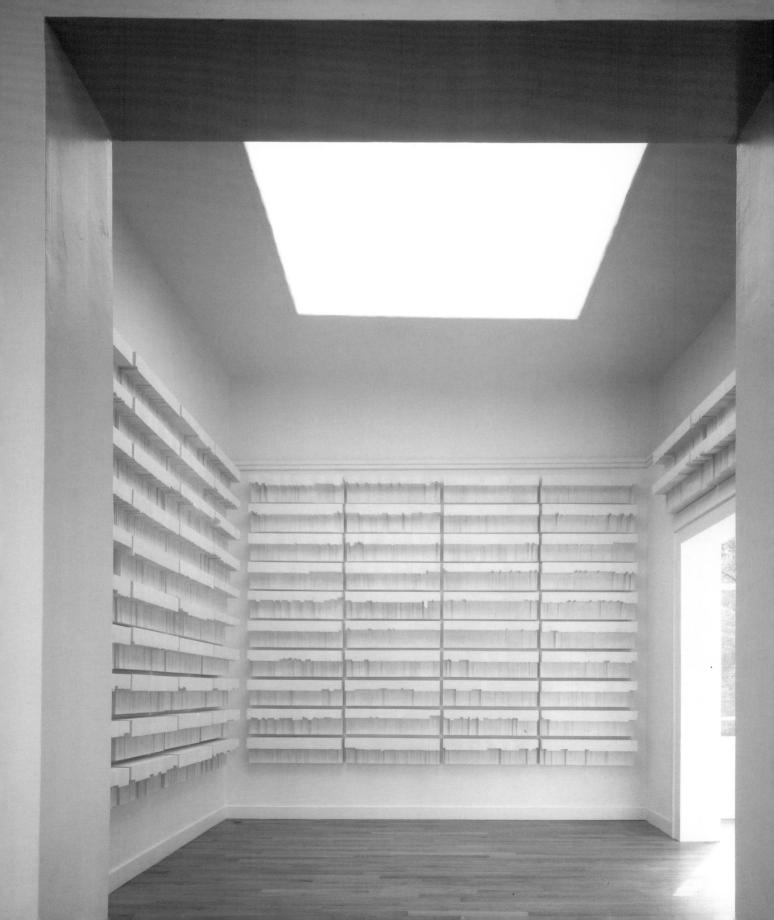

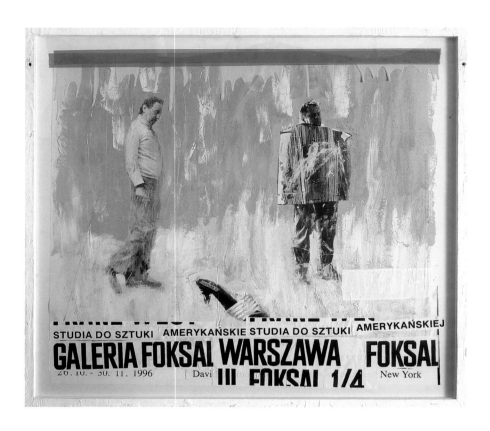

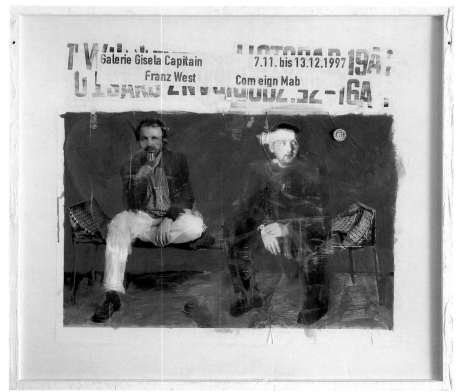

504. Franz West.
Hangarounds. 1997.
Drawing (two-sided)

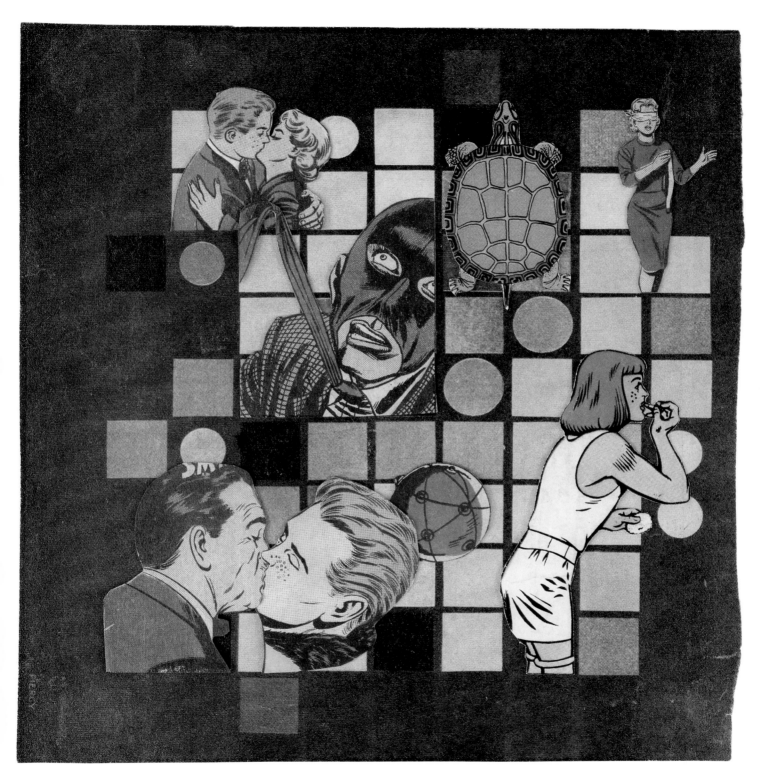

505. Lewis Klahr.
Pony Glass. 1997. Animated film

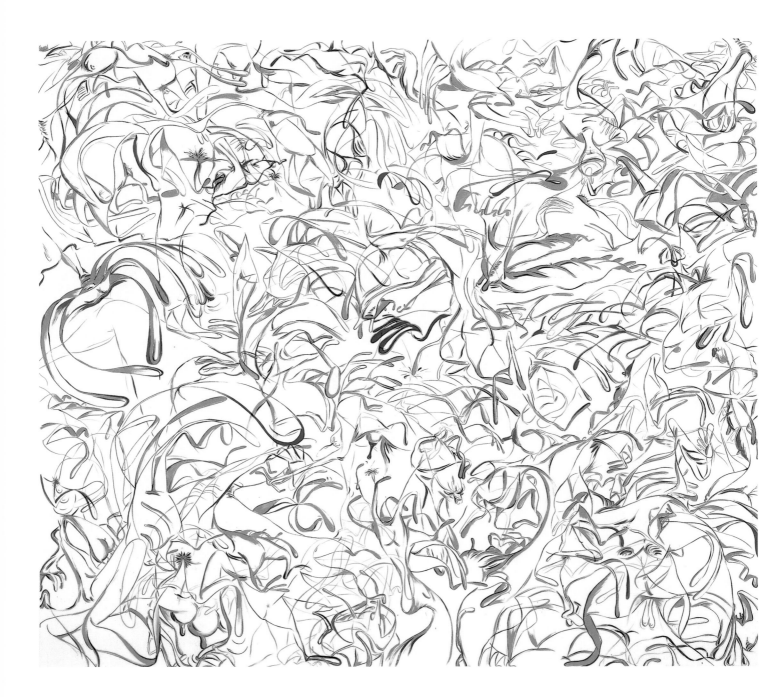

506. Sue Williams.
Mom's Foot Blue and
Orange. 1997. Painting

opposite:
507. Yukinori Yanagi.
Wandering Position. 1997.
Prints

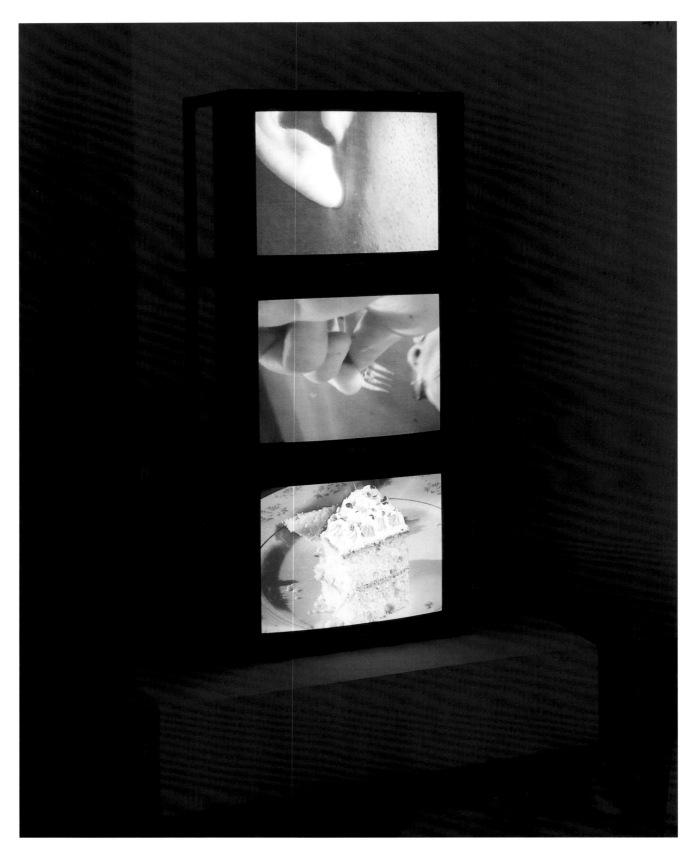

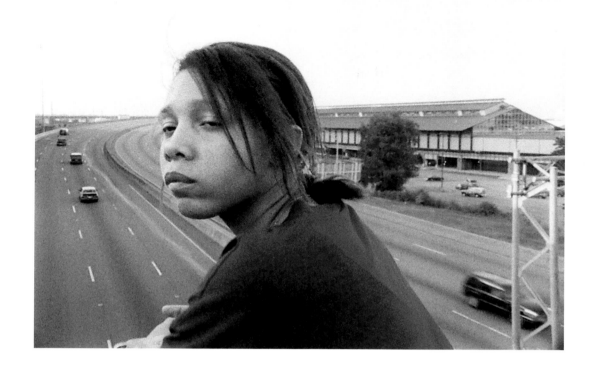

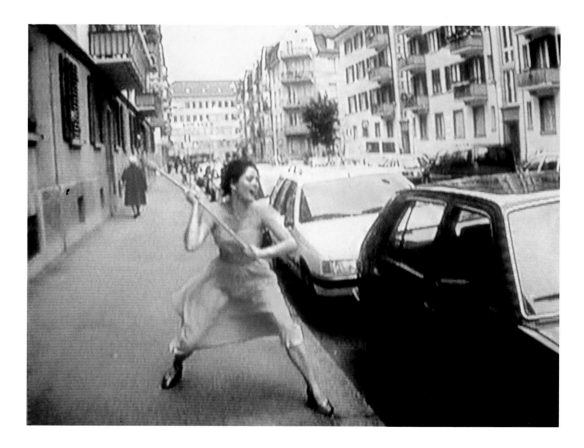

opposite:
508. Zhang Peili.
Eating. 1997.
Video installation

right:
509. David Williams.
Thirteen. 1997. Film

510. Pipilotti Rist.
Ever Is Over All. 1997.
Video installation

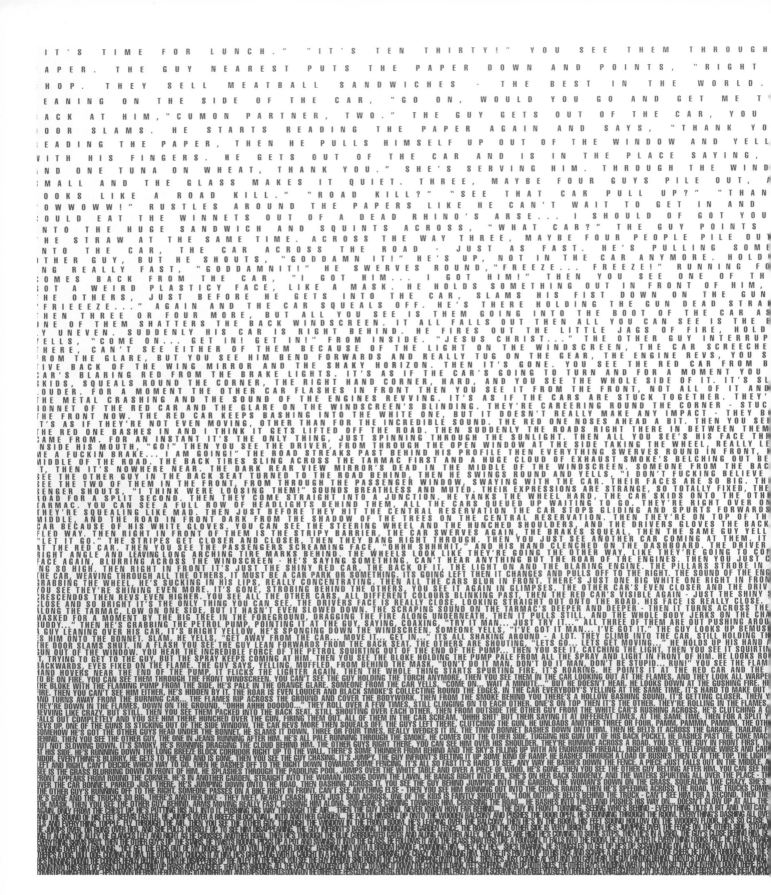

IT'S TIME FOR LUNCH." "IT'S TEN THIRTY!" YOU SEE THEM THROUGH

APER. THE GUY NEAREST PUTS THE PAPER DOWN AND POINTS, "RIGHT

HOP. THEY SELL MEATBALL SANDWICHES - THE BEST IN THE WORLD.

EANING ON THE SIDE OF THE CAR, "GO ON, WOULD YOU GO AND GET ME T

ACK AT HIM,"CUMON PARTNER, TWO." THE GUY GETS OUT OF THE CAR, YOU

OOR SLAMS. HE STARTS READING THE PAPER AGAIN AND SAYS, "THANK YO

EADING THE PAPER, THEN HE PULLS HIMSELF UP OUT OF THE WINDOW AND YELL

WITH HIS FINGERS. HE GETS OUT OF THE CAR AND IS IN THE PLACE SAYING,

ND ONE TUNA ON WHEAT, THANK YOU." SHE'S SERVING HIM. THROUGH THE WIND

MALL AND THE GLASS MAKES IT QUIET. THREE, MAYBE FOUR GUYS PILE OUT,

OOKS LIKE A ROAD KILL." "ROAD KILL?" "SEE THAT CAR PULL UP?" "THAN

OWWOWW!" RUSTLES AROUND THE PAPERS LIKE HE CAN'T WAIT TO GET IN AND

OULD EAT THE WINNETS OUT OF A DEAD RHINO'S ARSE... I SHOULD OF GOT YOU

NTO THE HUGE SANDWICH AND SQUINTS ACROSS, "WHAT CAR?" THE GUY POINTS

HE STRAW AT THE SAME TIME. ACROSS THE WAY THREE, MAYBE FOUR PEOPLE PILE OUT

NTO THE CAR, THE CAR ACROSS THE ROAD - JUST AS FAST. HE'S PULLING SOME

THER GUY, BUT HE SHOUTS, "GODDAMN IT!" HE'S UP, NOT IN THE CAR ANYMORE. HOLD

NG REALLY FAST, "GODDAMNIT!" HE SWERVES ROUND, "FREEZE... FREEZE" RUNNING FO

OMES BACK FROM THE CAR, "I GOT HIM... I GOT HIM!" THEN YOU SEE ONE OF TH

OT A WEIRD PLASTICY FACE, LIKE A MASK. HE HOLDS SOMETHING OUT IN FRONT OF HIM,

HE OTHERS, JUST BEFORE HE GETS INTO THE CAR, SLAMS HIS FIST DOWN ON THE GUN

FRIEEEZE..." AGAIN AND THE CAR SQUEALS OFF. HE'S THERE HOLDING THE GUN DEAD STRA

HEN THREE OR FOUR MORE, BUT ALL YOU SEE IS THEM GOING INTO THE BOOT OF THE CAR AS

NE OF THEM SHATTERS THE BACK WINDSCREEN. IT ALL FALLS OUT THEN ALL YOU CAN SEE IS THE

Y UNEVEN. SUDDENLY HIS CAR IS RIGHT BEHIND. HE FIRES OUT THE LITTLE JAGS OF FIRE, HOLD

YELLS, "COME ON... GET IN! GET IN!" FROM INSIDE. "JESUS CHRIST..." THE OTHER GUY INTERRUP

HERE, CAN'T SEE EITHER OF THEM BECAUSE OF THE LIGHT ON THE WINDSCREEN, THE CAR SCREECHE

ROM THE GLARE, BUT YOU SEE HIM BEND FORWARDS AND REALLY TUG ON THE GEAR, THE ENGINE REVS, YOU S

IVE BACK OF THE WING MIRROR AND THE SHAKY HORIZON. THEN IT'S GONE. YOU SEE THE RED CAR FROM B

AR'S BLARING RED FROM THE BRAKE LIGHTS. IT'S AS IF THE CAR'S GOING TO TURN AND FOR A MOMENT YOU

KIDS, SQUEALS ROUND THE CORNER, THE RIGHT HAND CORNER, HARD, AND YOU SEE THE WHOLE SIDE OF IT. IT'S SL

OUDER. FOR A MOMENT THE OTHER CAR FLASHES IN FRONT THEN YOU SEE IT FROM THE FRONT, NOT ALL OF IT AND

HE METAL CRASHING AND THE SOUND OF THE ENGINES REVVING. IT'S AS IF THE CARS ARE STUCK TOGETHER. THEY'

BONNET OF THE RED CAR AND THE GLARE ON THE WINDSCREEN'S BLINDING. THEY'RE CAREERING ROUND THE CORNER - STUC

HE FRONT NOW. THE RED CAR KEEPS BASHING INTO THE WHITE ONE, BUT IT DOESN'T REALLY MAKE ANY IMPACT - THEY B

T'S AS IF THEY'RE NOT EVEN MOVING, OTHER THAN FOR THE INCREDIBLE SOUND. THE RED ONE NOSES AHEAD A BIT. THEN YOU SEE

HE RED ONE BASHES IN AND I THINK IT GETS LIFTED OFF THE ROAD. THEN SUDDENLY THE ROADS RIGHT THERE IN BETWEEN THEM

AME FROM. FOR AN INSTANT IT'S THE ONLY THING, JUST SPINNING THROUGH THE SUNLIGHT. THEN ALL YOU SEE'S HIS FACE THR

NSIDE HIS MOUTH, "GO!" THEN YOU SEE THE DRIVER, FROM THROUGH THE OPEN WINDOW AT THE SIDE TAKING THE WHEEL, REALLY LE

ME A FUCKIN BRAKE... I AM GOING!" THE ROAD STREAKS PAST BEHIND HIS PROFILE THEN EVERYTHING SWERVES ROUND IN FRONT,

T, THEN IT'S NOWHERE NEAR. THE DARK REAR VIEW MIRROR'S DEAD IN THE MIDDLE OF THE WINDSCREEN. SOMEONE FROM THE BAC

SEE THE TWO OF THEM IN THE FRONT, FROM THROUGH THE PASSENGER WINDOW, SWAYING WITH THE CAR. THEIR FACES ARE SO BIG. YO

SENGER SHOUTS, "I THINK WERE LOOSING THEM" SOUNDS BREATHLESS AND MUTED. THEIR EXPRESSIONS ARE STRANGE, SO TOTALLY FIXED, THE

ROAD FOR A SPLIT SECOND. THEN THEY COME STRAIGHT INTO A JUNCTION. HE YANKS THE WHEEL HARD, THE CAR SKIDS ONTO THE OTH

TARMAC. YOU CAN SEE A FULL ROW OF HEADLIGHTS BEHIND THEM, ALL THE CARS QUEUED UP WAITING TO GO, THEY'RE RIGHT OVER ON

THEY'RE SQUEALING LIKE MAD. THEN JUST BEFORE THEY HIT THE CENTRAL RESERVATION THE CAR STOPS GLIDING AND SPURTS FORWARDS

MIDDLE, AND THE ROAD IN FRONT DARK FROM THE SHADOW OF THE TREES ON THE CENTRAL RESERVATION. THEN THEY'RE ON TOP OF TH

CAR BECAUSE OF HIS WHITE GLOVES. YOU CAN SEE THE STEERING WHEEL AND THE HUNCHED SHOULDERS, AND THE DRIVERS GLOVES THE BACK

FLED WAY. THEN RIGHT IN FRONT OF THEM IS THE STRIPY BARRIER, THE CAR SWERVES AGAIN, THE BRAKES SQUEAL, THEN THE SAME GUY YELL

"LET IT GO." THE STRIPES GET CLOSER AND CLOSER, THEN THEY BANG RIGHT THROUGH. THEN YOU JUST SEE ANOTHER CAR COMING AT THEM. IT

AT THE RED CAR. THEN YOU SEE THE PASSENGERS SCREAMING FACE "OHHH SHHHIT." AND HIS HAND CLENCHED ON THE DASHBOARD. THE DRIVER

RIGHT ANGLE AND LEAVING LONG ARCHING TIRE MARKS BEHIND. THE WHEELS LOOK LIKE THEY'RE GOING THE OTHER WAY, LIKE THEY'RE GOING TO CO

FACE AGAIN, BLURRING ACROSS THE WINDSCREEN - HE'S SAYING SOMETHING, CAN'T HEAR ANYTHING BUT THE ROAR OF THE ENGINES. THEN YOU JUST C

NG SO HIGH. THEN RIGHT IN FRONT IT'S JUST THE SHINY RED CAR, THE BACK OF IT, THE LIGHT ON AND THE BLARING ENGINE. THE PILLARS STROBE IN

THE CAR, WEAVING THROUGH ALL THE OTHERS, IT MUST BE A CAR PARK OR SOMETHING. ITS GOING LEFT THEN IT CHANGES AND PULLS OFF TO THE RIGHT. THE SOUND OF THE ENG

GRABBING THE WHEEL, HE'S SUCKING IN HIS LIPS, REALLY CONCENTRATING. THEN ALL THE CARS BLUR IN FRONT. THERE'S JUST ONE BIG WHITE ONE RIGHT IN FRON

YOU SEE THEY'RE SHINING EVEN MORE. IT'S GONE, STROBING BEHIND THE OTHERS. YOU SEE IT AGAIN IN GLIMPSES. THE OTHER CAR'S EVEN CLOSER AND THE DRIV

RESCENDOS THEN REVS EVEN HIGHER. YOU SEE ALL THE OTHER CARS, ALL DIFFERENT COLOURS BLINKING PAST, THEN THE RED CAR'S VISIBLE AGAIN - JUST THE SHINY

LOSE AND SO BRIGHT IT'S THE ONLY THING YOU CAN SEE. THE DRIVERS FACE IS REALLY CLOSE. LOOKING STRAIGHT OUT ONTO THE ROAD. HIS FACE IS REALLY CLOSE

ALONG THE TARMAC, LOW ON ONE SIDE, BUT IT HASN'T EVEN SLOWED DOWN. THE SCRAPING SOUND ON THE TARMAC'S DEEPER AND DEEPER - THEN IT TURNS ACROSS THE

MASKED FOR A MOMENT BY THE BIG TREE IN THE FOREGROUND, DRAGGING THE FIRE ALONG UNDERNEATH. THEN IT PULLS STILL, AND THE WHOLE BODY JERKS ON THE CHA

BUDDY..." THEN HE'S GRABBING THE PETROL PUMP, POINTING IT AT THE GUY, SAYING, COAXING "TRY IT MAN...JUST TRY IT..." ALL THREE OF THEM ARE OUT PUSHING AROU

A GUY LEANING OVER HIS CAR, IT'S BRIGHT YELLOW. HE'S SPONGING DOWN THE WINDSCREEN, SOMEONE YELLS "I'VE GOT IT MAN... I'VE GOT IT." THE GUY LOOKS UP BEMUS

S HIM ONTO THE BONNET. SLAM. HE YELLS "GET AWAY FROM THE CAR. MOVE IT. GET IN." ITS ALL SHAKING AROUND - A LOT. THEY CLIMB INTO THE CAR, STILL HOLDING TH

HE DOOR SLAMS SHUT. IN A FLASH YOU SEE THE GUY LEAN FORWARDS FROM THE BACK SEAT. THE OTHERS ARE SHOUTING, "LETS GO... LETS GET MOVING..." HE HOLDS UP HIS HAND

GUN OUT OF THE WINDOW. YOU HEAR THE INCREDIBLE FORCE OF THE PETROL SQUIRTING OUT OF THE END OF THE PUMP... THEN YOU SEE IT, CATCHING THE LIGHT, THEN YOU SEE IT STARTIN

, TRYING TO GET TO THE GUY, BUT THE SPRAY KEEPS COMING AT HIM. THEN YOU SEE THE BLOKE HOLDING THE PUMP PALE FROM ALL THE SPRAY AND LIGHT IN FRONT OF HIM. HE LOOKS RO

BACKWARDS, EYES FIXED ON THE FLAME. THE GUY SAYS, YELLING, MUFFLED, FROM BEHIND THE MASK "DON'T DO IT MAN, DON'T DO IT MAN, DON'T BE STUPID... RUN!" YOU SEE THE FLAM

HAND HOVERS NEAR THE END OF THE PUMP, IT FLICKS THE LIGHTER AGAIN. THEN THE WHOLE THING STARTS SPURTING FIRE, IT'S ROARING. HE POINTS IT AT THE RED CAR AND THE

TO BE ON FIRE. YOU CAN SEE THEM THROUGH THE FRONT WINDSCREEN. YOU CAN'T SEE THE GUY HOLDING THE TORCH ANYMORE, THEN YOU SEE THEM IN THE CAR LOOKING OUT AT THE FLAMES, AND THEY LOOK ALL WARPE

THE BLOKE WITH THE FLAMING PUMP FROM THE SIDE, HE'S PALE IN THE ORANGE GLARE. SOMEONE FROM THE CAR YELLS, "COME ON... WAIT A MINUTE..." BUT HE DOESN'T HEAR. HE LOOKS DOWN AT THE GUSHING FIRE.

FIRE. THEN YOU CAN'T SEE HIM EITHER, HE'S HIDDEN BY IT, THE ROAR IS EVEN LOUDER AND BLACK SMOKE'S COLLECTING ROUND THE EDGES, IN THE CAR EVERYBODY'S YELLING AT THE SAME TIME, IT'S HARD TO MAKE OUT

AND TURNS AWAY FROM THE BURNING CAR. THE FLAMES RIP ACROSS THE GROUND AND COVER THE BODYWORK. THEN FROM THE SMOKE BEHIND THERE'S A HOLLOW BASHING SOUND, IT'S GETTING CLOSER, THEN

THEY'RE DOWN IN THE FLAMES, DOWN ON THE GROUND, "OHHH AHHH DOOOOO..." THEY ROLL OVER A FEW TIMES, STILL CLINGING ON TO EACH OTHER, ONE'S ON TOP THEN IT'S THE OTHER. THEY'RE ROLLING IN THE FLAMES

REVVING LIKE CRAZY, BUT STILL, THEN YOU SEE THEM PACKED INTO THE BACK SEAT, STILL SHOUTING OVER EACH OTHER, THEN FROM OUTSIDE THE OTHER GUY FROM THE WHITE CAR'S RUSHING ACROSS, HE'S CLUTCHING A G

FALLS OUT COMPLETELY AND YOU SEE HIM THERE HUNCHED OVER THE GUN, FIRING THEM OUT. ALL OF THEM IN THE CAR SCREAM, "OHHH SHIT" BUT THEIR SAYING IT AT DIFFERENT TIMES, AT THE SAME TIME. THEN FOR A SPLIT

REVS UP. ONE OF THE GUNS IS STICKING OUT OF THE SIDE WINDOW. THE CAR REVS MORE THEN SQUEALS OFF. THE GUYS LEFT THERE, CLUTCHING THE GUN, HE UNLOADS ANOTHER THREE OR FOUR, PAMM, PAMMM, PAMMM. THE OTH

SOMEHOW GETS THE OTHER GUYS HEAD UNDER THE BONNET, HE SLAMS IT DOWN, THREE OR FOUR TIMES, REALLY WEDGES IT IN. THE TINNY BONNET BASHES DOWN ONTO HIM, THEN HE BELTS IT ACROSS THE GARAGE, TRAILING F

BEHIND. THEN YOU SEE THE OTHER GUY, THE ONE IN JEANS RUNNING AFTER HIM. HE'S ALL PALE RUNNING THROUGH THE SMOKE, HE COMES OUT THE OTHER SIDE, TUGGING HIS GUN OUT OF HIS BACK POCKET, HE DASHES PAST THE CONE MAC

BUT NOT SLOWING DOWN. IT'S SMOKY, HE'S RUNNING DRAGGING THE CLOUD BEHIND HIM. THE OTHER GUYS RIGHT THERE, YOU CAN SEE HIM OVER HIS SHOULDER. THEY'RE RUNNING ACROSS A ROAD. YOU SEE THE GUY IN FRONT FIRST

AT HIS SIDE, HE'S RUNNING DOWN THE LONG BREEZE BLOCK CORRIDOR RIGHT UP TO THE WALL, THERE'S SOME THUNDER FROM BEHIND AND THE SKY'S FILLING UP WITH AN ENORMOUS FIREBALL, RIGHT BEYOND THE TELEPHONE WIRES AND LIGH

RIDOR, EVERYTHING'S BLURRY, HE GETS TO THE END AND IS GONE, THEN YOU SEE THE GUY CHASING, IT'S JUMPY. THE GUY INFRONT'S BELTING IT UP SOME KIND OF RAMP, HE BASHES THROUGH A LOAD OF BUSHES RIGHT AT THE TOP, THE LIGHT

LEFT AND RIGHT, CAN'T DECIDE WHICH WAY TO GO. THEN HE DASHES OFF TO THE RIGHT DOWN TOWARDS SOME FENCING, IT'S ALL SO FAST IT'S HARD TO SEE, ANY WAY HE BASHES DOWN THE FENCE A PIECE JUST FALLS OUT IN THE MIDDLE

SEE IS THE GRASS BLURRING DOWN IN FRONT OF HIM, HE SPLASHES THROUGH THE PADDLING POOL, JUMPS OVER THE WHITE TABLE AND OVER A PIECE OF WOOD, HE'S GONE, THEN YOU SEE THE OTHER GUY BELTING AFTER HIM, YOU CAN SEE

FRONT APPEARS FROM ROUND THE CORNER, HE'S IN ANOTHER GARDEN, STRAIGHT INTO THE WOMAN HOSING DOWN THE LAWN, HE BANGS RIGHT INTO HER, SHE'S ON HER BACK SUDDENLY AND THE WATERS SPURTING ALL OVER THE PLACE - THE

OVER THE CAR BONNET, ROARED JUST THERE, HE'S JUMPING DOWN ONTO THE ROAD, THEN DASHING ACROSS IT, YOU SEE THE GUY BEHIND JUMPING INTO THE GARDEN, THE WOMAN'S DOWN ON THE GRASS, SQUEALING LIKE CRAZY, SHE'S

THE OTHER GUY'S RUNNING OFF TO THE RIGHT, SOMEONE PASSES ON A BIKE RIGHT IN FRONT, CAN'T SEE ANYTHING ELSE - THEN YOU SEE HIM RUNNING OUT INTO THE CROSS ROADS, THEN HE'S SPEEDING ACROSS THE ROAD, THE TRUCKS COMI

HE'S OTHER SIDE, THE TRUCKS SO BIG, THERE'S ANOTHER BIKE - THEY MEET, NEARLY CRASH, THEN JUST SKID ACROSS, ONE OF THE KIDS IS FAINTLY SHOUTING, "LOOK OUT" HE BELTS BEHIND THE TRUCK - CAN'T SEE HIM FOR A SECOND, THEN THE

511. Fiona Banner.
Break Point. 1998. Print

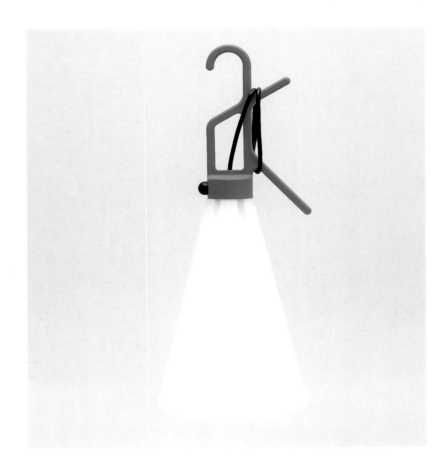

512. **Konstantin Greic.**
May Day Lamp. 1998. Design

513. **Julia Loktev.**
Moment of Impact. 1998.
Video

opposite:
514. **Paul Winkler.**
Rotation. 1998. Film

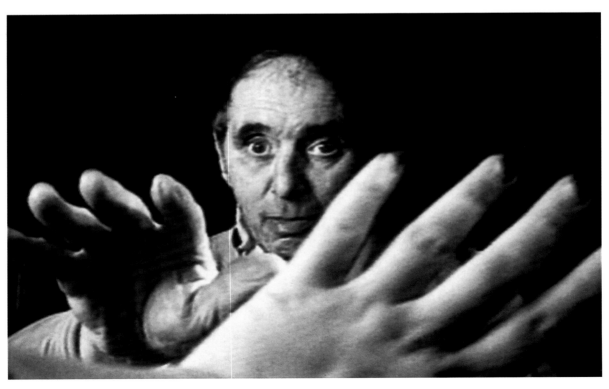

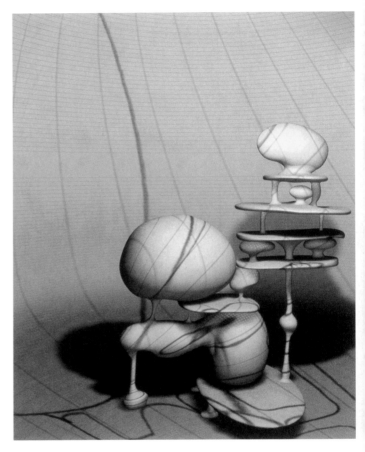

515. Charles Long.
Internalized Page Project.
1997–98. Prints

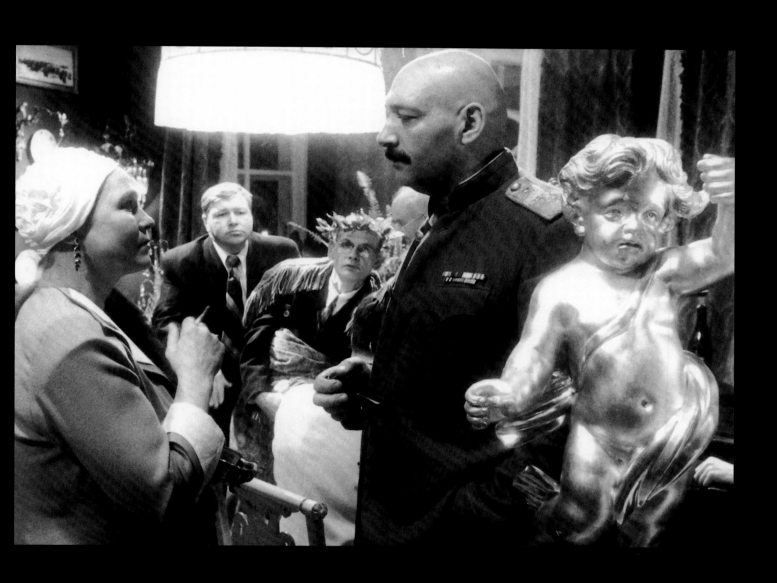

516. Aleksei German.
Khroustaliov, My Car!
1998. Film

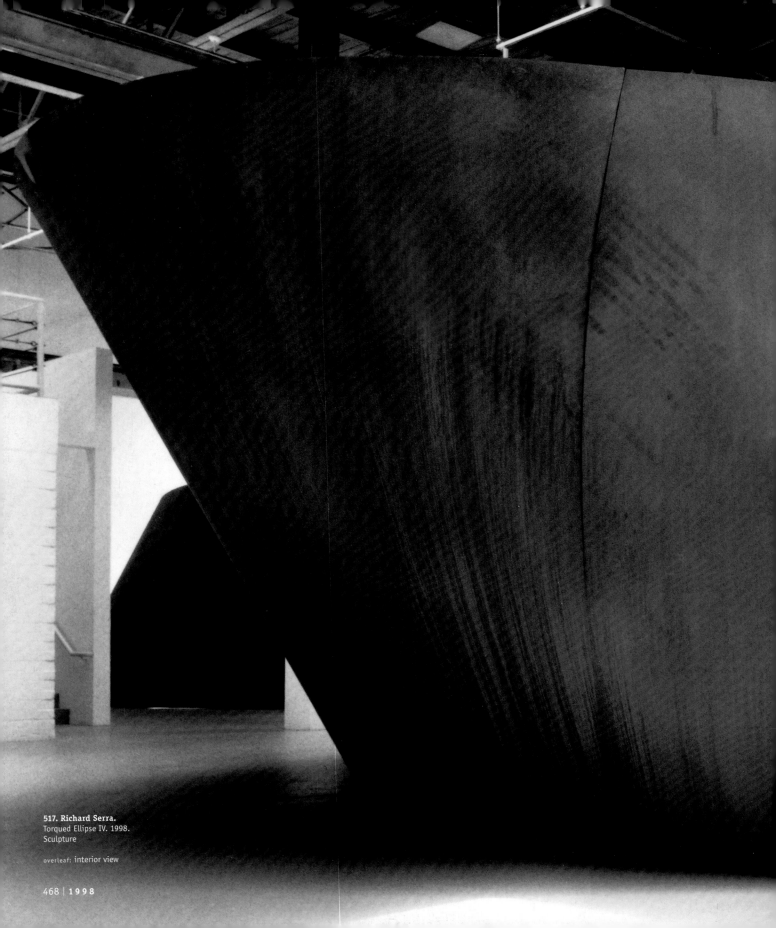

517. Richard Serra.
Torqued Ellipse IV. 1998.
Sculpture

overleaf: interior view

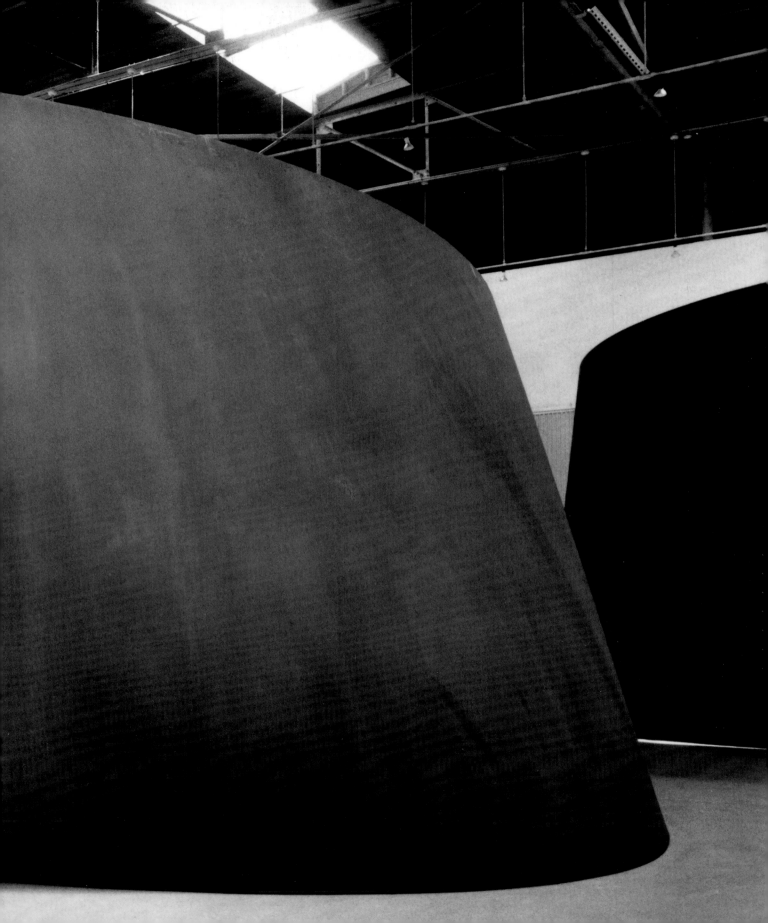

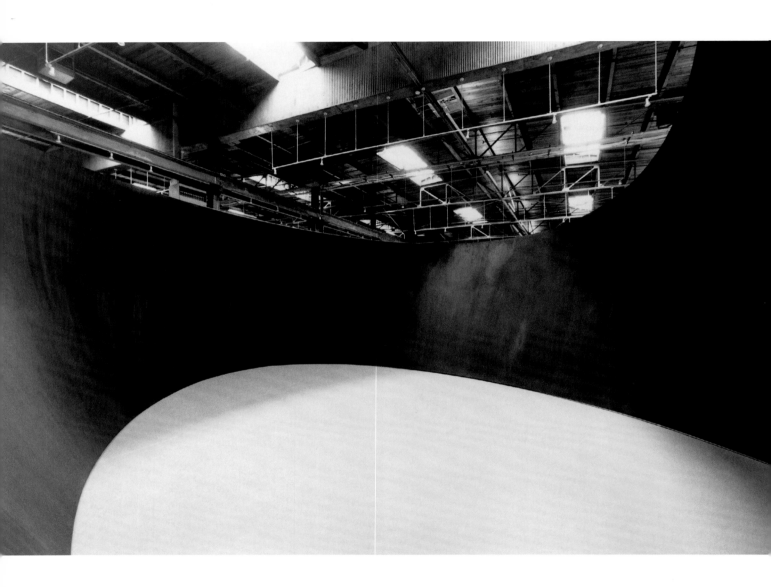

518. Anish Kapoor.
Wounds and Absent Objects.
1998. Prints

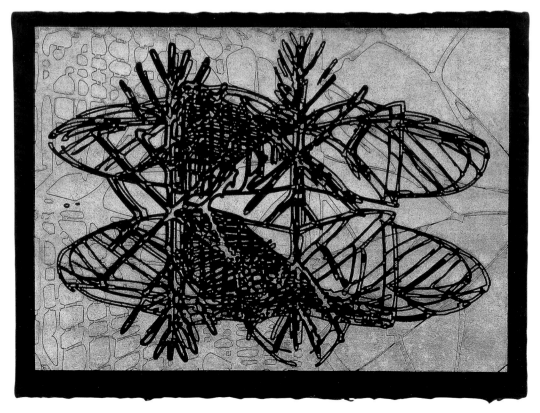

519. Terry Winters.
Graphic Primitives. 1998.
Prints

opposite:
520. Gerhard Richter.
128 Details from a Picture
(Halifax 1978). 1998. Prints

521. **Gabriel Orozco.**
I Love My Job. 1998.
Photograph

opposite:
522. **Christian Boltanski.**
Favorite Objects. 1998. Prints

523. Jia Zhang Ke.
Xiao Wu. 1998. Film

524. Matthew Barney.
C5: Elbocsatas. 1998.
Drawing

525. Kara Walker.
African/American.
1998. Print

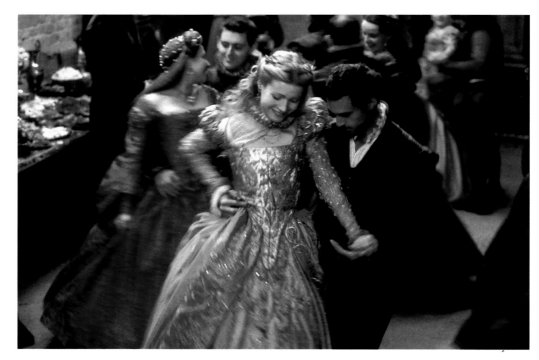

526. Luc Tuymans.
The Blue Oak. 1998.
Drawing

527. John Madden.
Shakespeare in Love.
1998. Film

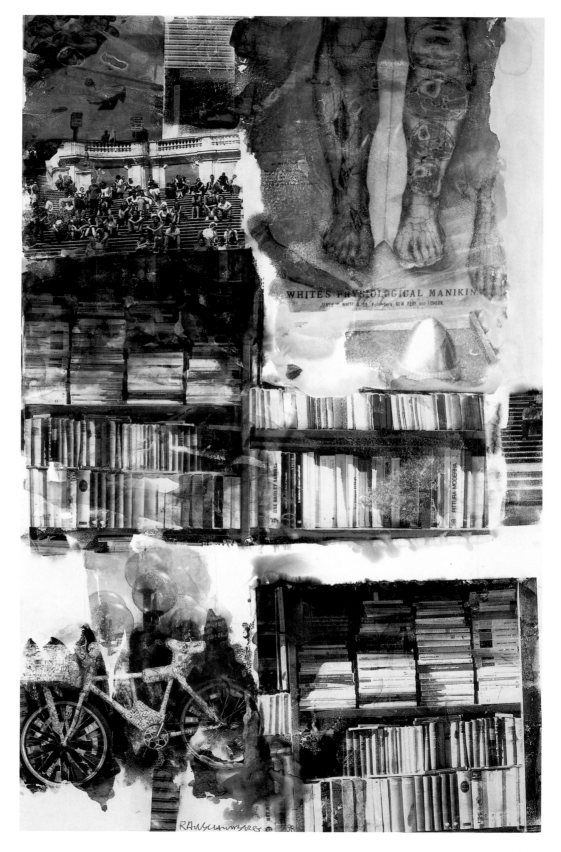

528. Robert Rauschenberg.
Bookworms Harvest. 1998. Painting

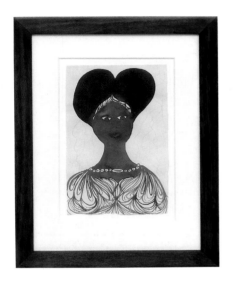
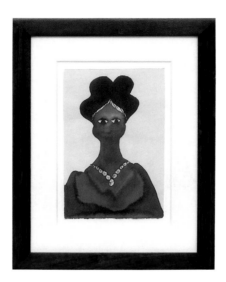
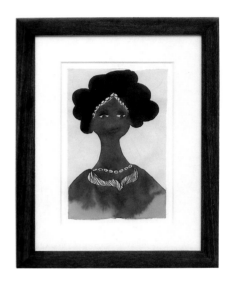

529. Chris Ofili.
Untitled. 1998. Drawings

530. Enrique Chagoya.
The Return of the Macrobiotic
Cannibal. 1998. Illustrated book

opposite:
531. Lisa Yuskavage.
Asspicker and Socialclimber.
1996–98. Prints

532. Elizabeth Peyton.
Bosie. 1998. Print

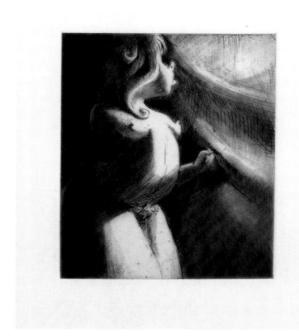

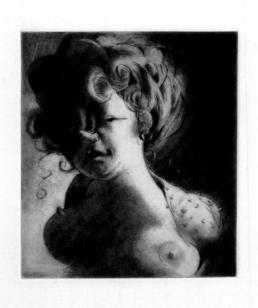

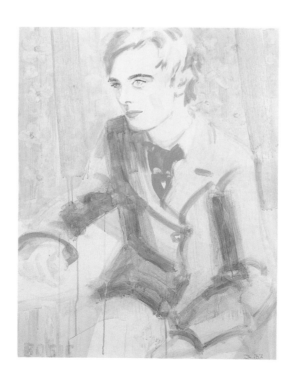

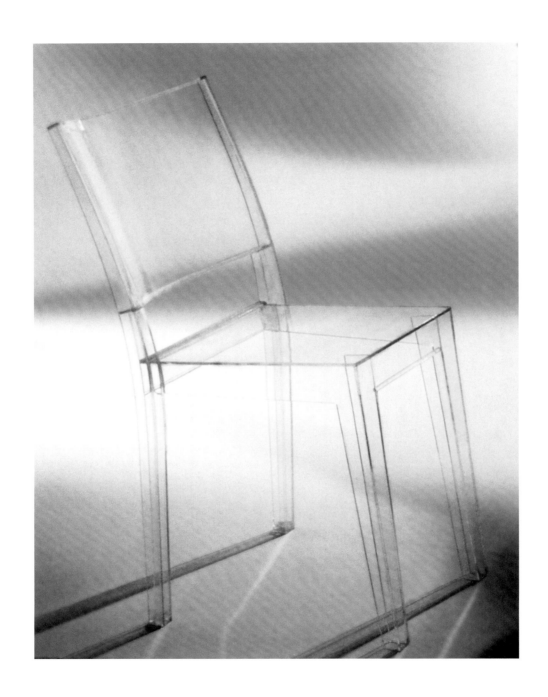

533. Philippe Starck.
La Marie Folding Chair.
1998. Design

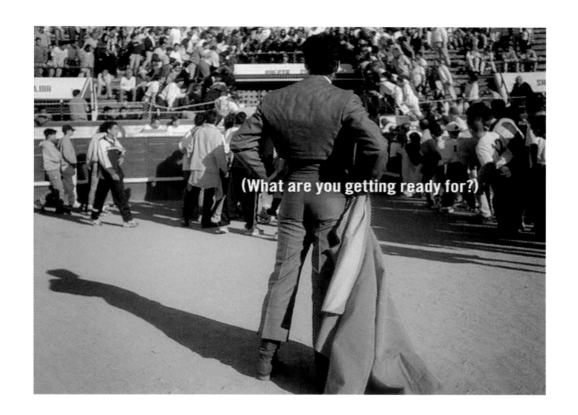

534. Ralph Schmerberg.
"Los Toros," a commercial
for Nike footwear. 1998. Film

535. Mariko Mori.
Star Doll. 1998. Multiple

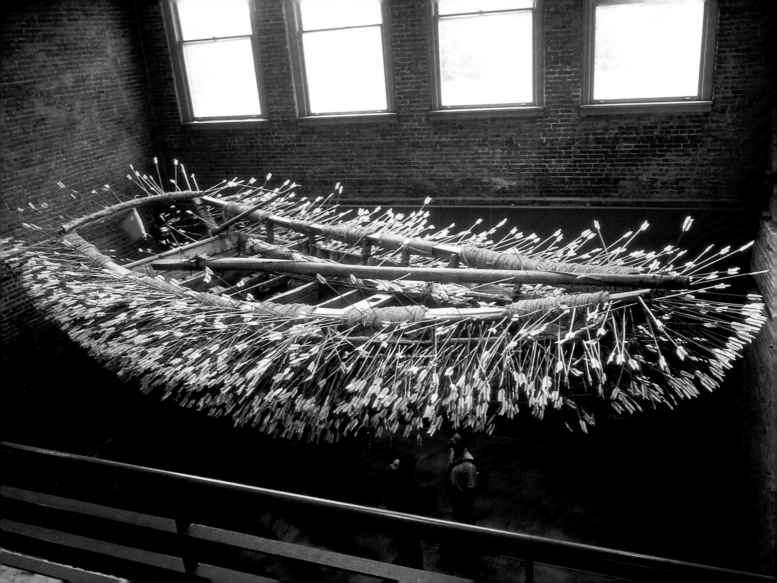

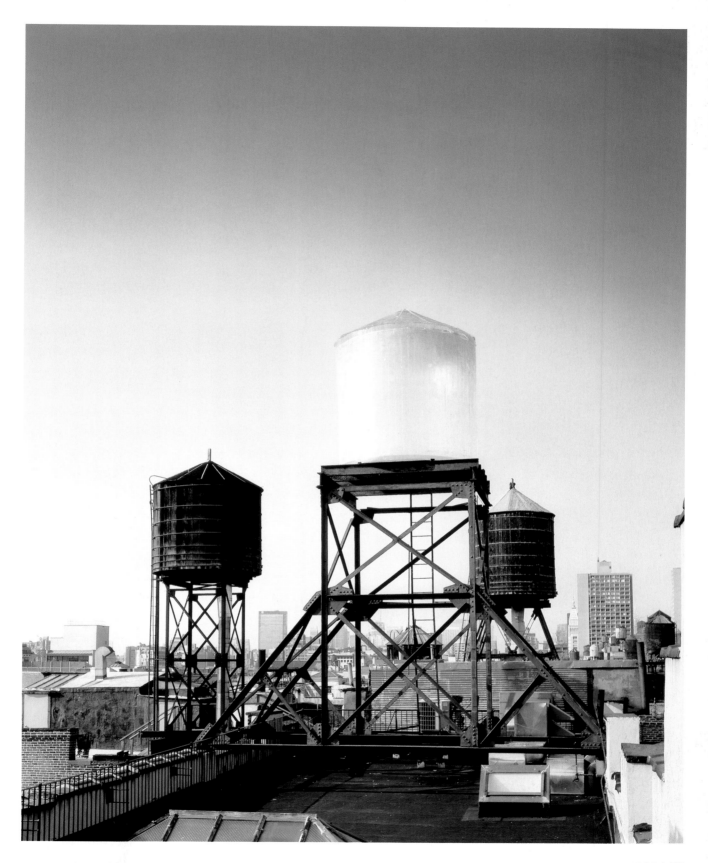

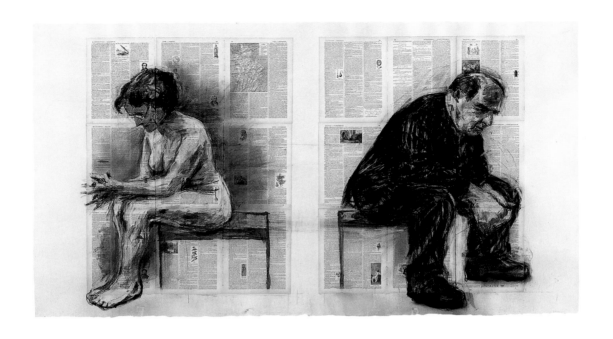

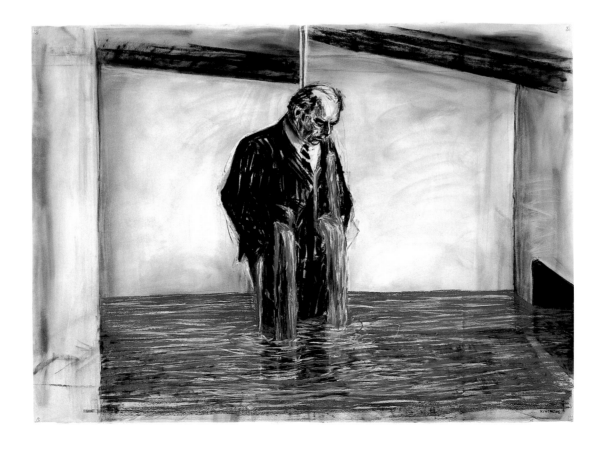

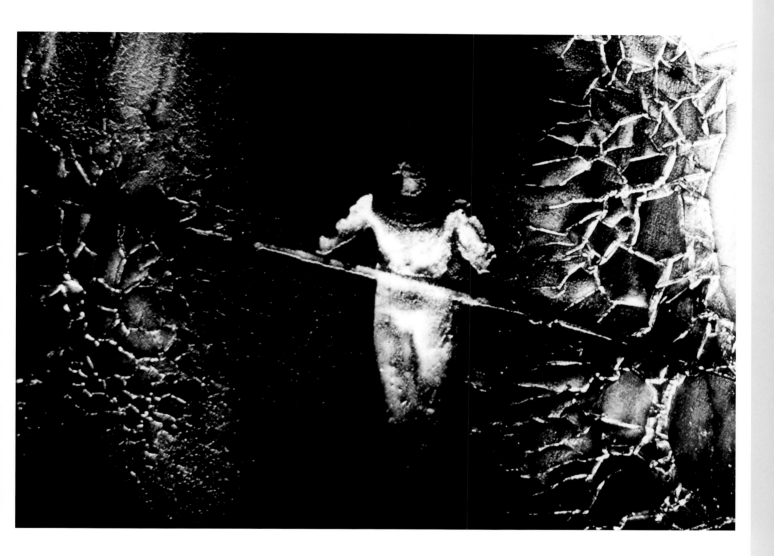

opposite:
538. William Kentridge.
Seated Couple (Back to Back).
1998. Drawing

539. William Kentridge.
Untitled (drawing for Stereoscope).
1998–99. Drawing

above:
540. Phil Solomon.
Twilight Psalm II: Walking
Distance. 1999. Film

541. Julian Opie.
Imagine You Are Driving;
Cars?; Imagine You Are
Walking; Cityscape?; Gary,
Popstar; Landscape?
1998–99. Prints

542. Andreas Gursky.
Toys "Я" Us. 1999.
Photograph

opposite:
543. Barbara Bloom.
A Birthday Party for Everything.
1999. Multiple

**544. Jean-Marie Straub
and Danièle Huillet.**
Sicilia! 1999. Film

above:
545. Carroll Dunham.
Ship. 1979–99. Painting

 Damien 5036-23

Steak and Kidney*
Ethambutol Hydrochloride

Tablets
400mg

100 Tablets PIE

Cornish 100mg/5ml
Pasty

Rifampicin B.P.

To be taken by mouth

Peas CHIPS

100ml Syrup

Salad ™ tablets
Lamivudine

Each coated tablet contains
lamivudine 150mg

60 tablets

HirstDamien

546. Damien Hirst.
The Last Supper.
1999. Prints

Chicken®

Concentrated **Oral Solution**
Morphine Sulphate

20mg/ml

Each 1ml contains Morphine
Sulphate BP 20mg

120ml

**Damien
Hirst**

Damien & Hirst

Beans™

Chips™

400 micrograms

112 Chips

Mushroom™

**30 tablets
Pyrimethamine
Tablets BP**

25mg

PIE

HirstDamien

Omelette™ ondansetron

tablets 8mg

Each tablet contains
8mg ondansetron
as ondansetron hydrochloride dihydrate
Also contains lactose and maize starch

10 tablets

HirstDamien

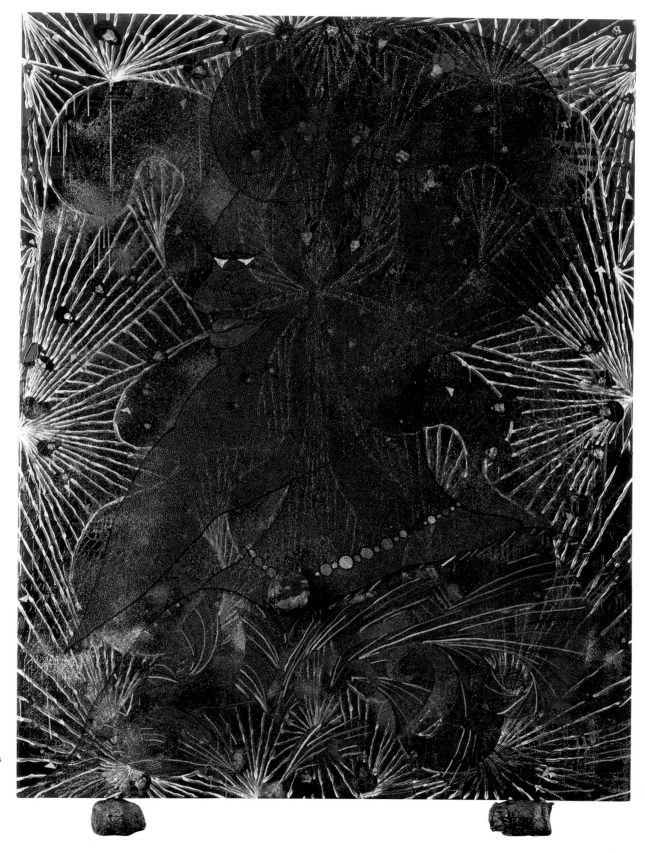

opposite:
547. E. V. Day.
Anatomy of Hugh Hefner's
Private Jet (1–5). 1999.
Prints

right:
548. Chris Ofili.
Prince amongst Thieves.
1999. Painting

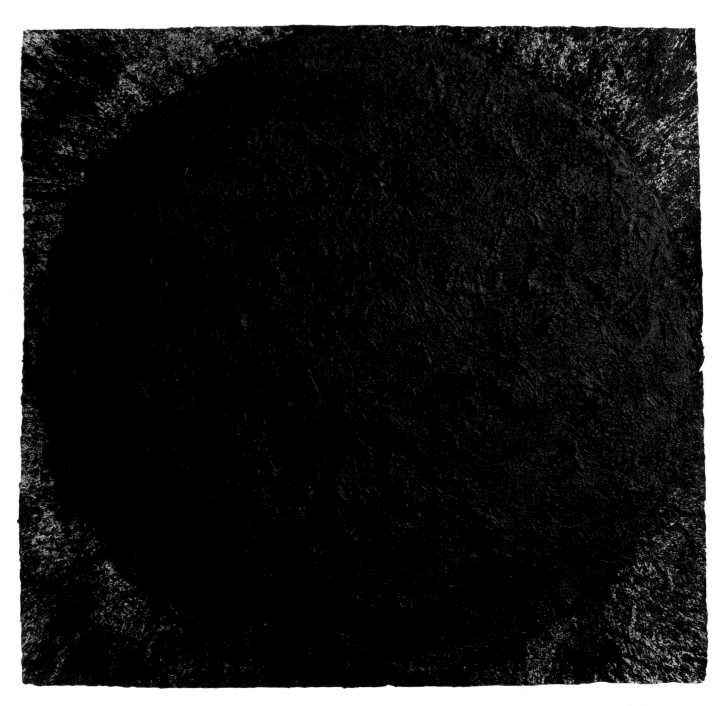

549. Richard Serra.
Out of Round XII. 1999.
Drawing

opposite:
550. Richard Serra.
Switch. 1999. Sculpture

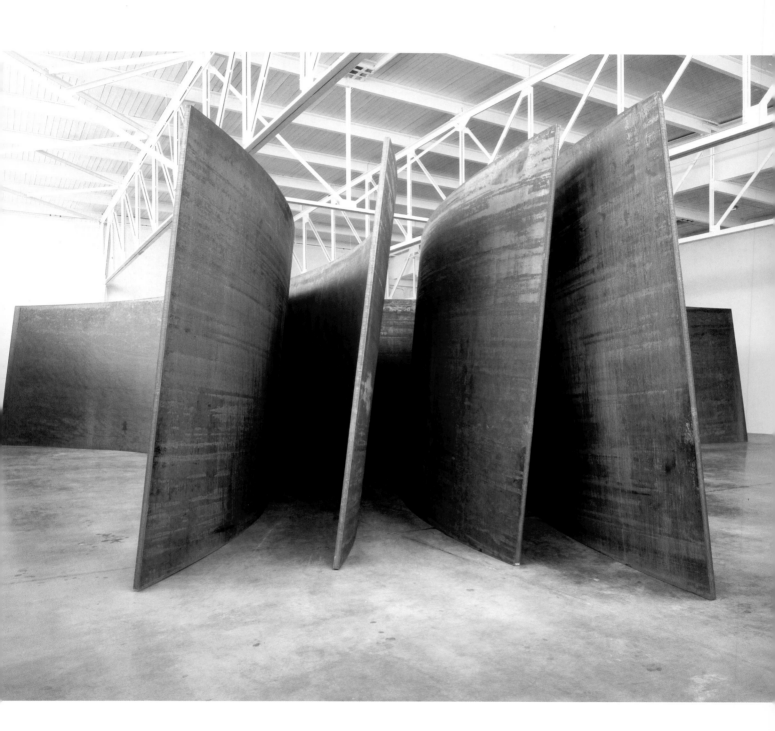

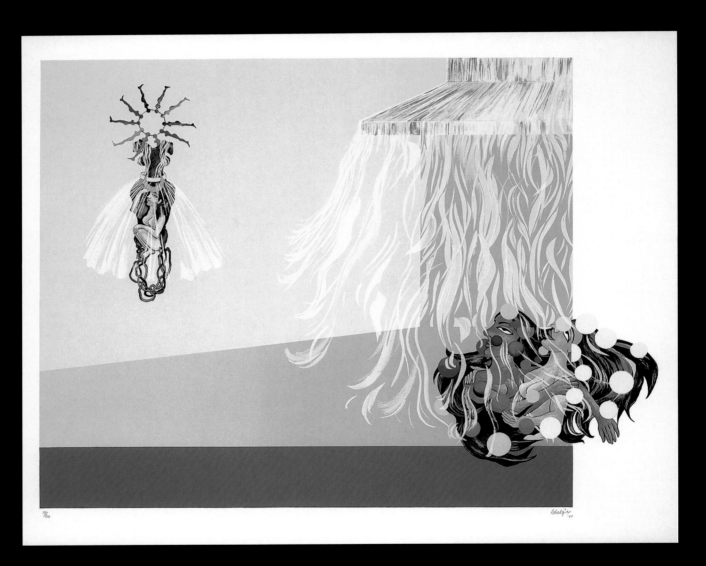

551. Shahzia Sikander.
Anchor. 1999. Print

RÊVERIE CINÉMA VÉRITÉ

552. Jean-Luc Godard.
The Old Place. 2000. Video

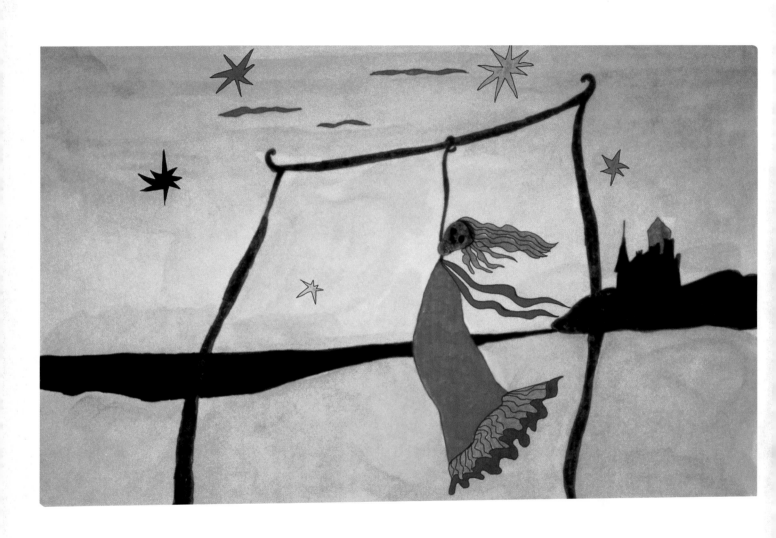

553. Faith Hubley.
Witch Madness. 2000. Film

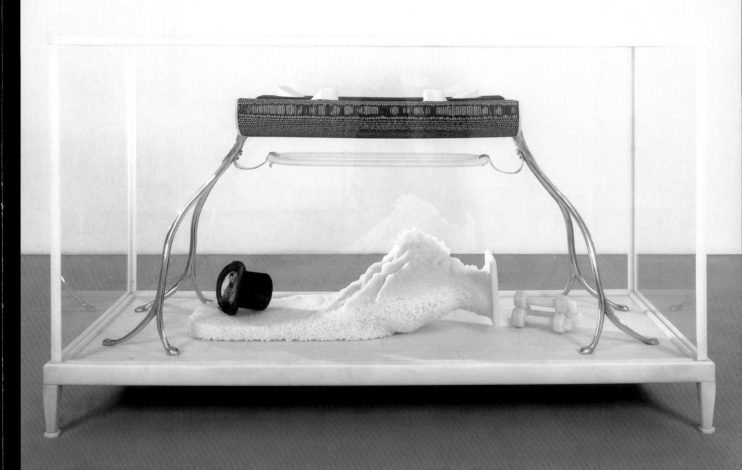

Essays

Sets and Situations | M. Darsie Alexander

view through a window opens to an idyllic outdoor scene (plate 225). Butterflies are gently perched on budding flowers. Carnations, daffodils, and roses grow from the earth, bathed in the bright light of the sun. Intense colors abound—blues, yellows, reds, lavenders—offset by the soft gauzy fabric of a curtain. A second space is implied, a domestic world demarcated by glass, curtain, and latticework. Moving back and forth between the scene and the window, the eye detects a disturbing incongruity: the window is at ground level, restricting the field of vision to a worm's-eye perspective. Once this peculiar orientation is registered, strange details previously overlooked become pronounced: a rotten piece of fruit overtaken by insects and a mammoth beetle crawling along a dead branch. Suddenly the whole scene becomes oversaturated: too many butterflies, too much color, too many flowers. Nature is all wrong.

At the same time, it is exactly right. The artist who made this photograph, Gregory Crewdson, carefully prepared every detail of this image, from the placement of the flowers to the strategically fallen tree, and assembled the entire scene on a platform in his studio. Crewdson belongs to a generation of artists who have forsaken the tradition of photographing the world of everyday events in order to fashion their own alternate realities, creating sets and situations exclusively for the camera. Using their skills as fabricators, sculptors, lighting technicians, and set designers, these artists build discrete self-contained environments, which range from the eerily familiar to the utterly fantastical, and sometimes encompass both.

Working in this state of "retreat" from the outside world has enabled them to exert a high level of control over all aspects of their endeavor, down to minute details. Whereas a photographer who takes pictures in the street traditionally depends on his or her instantaneous reaction to external stimuli, those who prefer a studio or staged outdoor environment engage in a fundamentally more studied and introspective process. Images do not present themselves through a rapid succession of encounters, but are born of a premeditated, elaborate, and imaginative process of execution.

A shift toward what has been termed "fabricated photography" or "the photography of invention" came about gradually, the result of a growing awareness of photography's fictionalizing attributes. During the 1960s, artists and critics began to challenge many of the prevailing assumptions about photography's objectivity, examining how the meaning of an image can be shaped by many factors, from the politics of its maker to the context of its presentation. As thinking about photography began to change, so too did the profiles of its practitioners. Artists with no conventional training in photography adapted the medium to their own ends, combining it with other practices such as painting, printmaking, and performance. Photography also served a practical purpose in the recording of impermanent installations and performances. Many artists began to devise their own Happenings for the camera, appearing as principal players in private dramas. These simultaneous developments—a growing critical awareness of photography's complex relationship to truth and fiction, and its new role in documenting artist-generated performance theater and tableaux—established the essential groundwork for what would become a move toward staged photography in the 1970s and 1980s.

James Casebere began to create simple cardboard cutouts for the camera in the 1970s, piecing together modest architectural elements for black-and-white tableaux. Though inspired by familiar structures and environments, Casebere's photographs present a deliberately alienating space in which themes of suppressed violence lurk just beneath the surface. One set may evoke a childhood classroom as remembered in a nightmare, another may suggest a scene from a forgotten movie. His 1985 image of an overturned covered wagon shot through with arrows (plate 138), for example, recalls a still from a Western in which Native Americans attack a migrating frontier family and leave the scene in ruins. The disturbing reference to recurring myths of Native American brutality that underlies this image is amplified by Casebere's stark execution. Built of plaster and Styrofoam and haunted by a surreal light, his generic model is frightening and severe. Harsh contrasts of black and white accent and disguise form, and the closely cropped compositional field is shallow and suffocating.

For Laurie Simmons, the invention of artificial worlds is not merely an artistic activity but one that has its roots in childhood games and playthings. Dolls, dollhouses, and toy furniture are the mass-produced props of her still-life tableaux, and the nexus of a universe centered on femininity and domesticity. Fascinated by how dolls serve to reinforce sexual stereotypes and shape girls' fantasies about their future lives as mothers, wives, and homemakers, Simmons orients her work on the plastic female figurine as the object of girlhood fixation. Her imagery is by turns bleak, nostalgic, and humorous. In the late 1980s she embarked on the Walking and Lying series, in which isolated accouterments—a handbag or perfume bottle, for example—function as the upper body for a (typically) female lower half (plate 242). These amalgamated figures are photographed head-on and in dramatic stage lighting, as if on display as a nightclub act.

Since the 1980s, staged photography has increasingly involved narrative situations in which human subjects engage in a form of role-playing, acting out particular attitudes and emotions according to the artist's designs. But unlike the work of an artist such as Casebere, which pro-

claims its artifice on impact, the contrived nature of these images is often more difficult to detect. Pictures that appear to provide a transparent view into the real world may show only subtle signs of staging—perhaps lighting that is unnatural, or an action that seems posed. Such images constitute a kind of puzzle that the viewer is left to sort out, measuring those elements that seem plausible against those that are not exactly "right." This game is further complicated when the photographer adopts a style or look—such as that of a snapshot, for example—that suggests the picture was made spontaneously.

To the extent that a staged photograph involves a human presence and storyline, it also requires acting. No artist has evinced talent in this realm more successfully than Cindy Sherman. In 1977, she began an experiment using costumes, props, and wigs as a means of casting herself in a variety of movie-inspired roles: femme fatale, runaway, sex kitten, working girl. The resulting series of sixty-nine photographs, the Untitled Film Stills, was ground-breaking in its interrogation of clichés of femininity, and established Sherman as a master of disguise who could imitate both the look of actual film stills and the heroine types they depicted (plates 2, 3, 4, 5, 6). In the Centerfolds series (1981) Sherman expanded her repertoire, this time playing teenage girls caught in a moment of extreme vulnerability—hanging by the telephone, daydreaming in bed, or simply waiting for someone unknown or for something unforeseen to happen. A girl lies dreamily on a linoleum floor in Untitled #96, grasping a newspaper clipping in her hand as if it holds the key to some future happiness (plate 41). Her faraway look belies a secret fantasy, perhaps of escape or romance. While the girl's attitude is one of tranquillity and repose, the image itself is replete with visual tensions: the tight cropping of the frame (which serves to entrap the figure), the bright clash of orange hues, and the threatening position of the camera (and viewer) bearing down on the subject from above. As the object of the camera and the eye behind it, Sherman creates a deliberately unsettling composition that captures with equal force themes of vulnerability and aggression.

The pictures of Philip-Lorca diCorcia are a blend of fact and fiction. Created in everyday

settings—on the street or indoors—they are dramatized excerpts of daily life, touching on universal themes of human isolation, boredom, and uncertainty. Often there is nothing specific "happening" in diCorcia's photographs; his subjects (who play themselves) are typically more reflective than active. Nevertheless the mood of the work is highly personal and psychological. In one picture, a woman looks up as her lover pulls at his pants in an ambiguous gesture of dressing or disrobing (plate 62). Is this an awkward moment of departure or the beginning of an afternoon tryst? In another, a heavily made-up transvestite clutches herself against the backdrop of the city street, as a young male prospect in high-top sneakers studies her from behind (plate 369). The emotional force of these pictures resides not only in the subjects' expressions and interactions (or lack thereof) but in the theatrical effects the artist has exploited to intensify the scenes, particularly through strong contrasts of light and dark. Experienced in commercial photography and inspired by the movies, diCorcia inflects reality with the suggestion of fantasy, frequently bestowing his subjects with an otherworldly aura. His pictures evoke the veneer of Hollywood and glossy magazines, but they also reflect a deep consideration of private human struggles, which ultimately form the center of his narratives.

Whether staged interactions between people or fabricated setups in the studio, the process of producing a photograph has become an increasingly complicated undertaking. The photographer's role—newly expanded to encompass that of visionary, director, and master of ceremonies—is no longer restricted to a position behind the camera, where an image is generated through a simple click of the shutter. On the contrary, the realization of a single idea may involve extensive measures and a team of professionals, a veritable movie crew of make-up artists, technicians, set designers, and prop masters. Yet the question remains: Why a photograph and not, say, a film or installation, as the culmination of these efforts? Perhaps one explanation is that the still photographic image continues to invite a suspension of disbelief, even when it is equally a product of fantasy and a reflection of reality. A photograph ultimately functions as a contained window through which an alternate world may be perceived, and in that way provides an opportunity, however momentary, for the viewer to glimpse something mysterious, unfamiliar, or out-of-the-ordinary. It is also a format that offers clues to an implied narrative; in this respect it functions as many paintings and film stills do.

Mind over Matter in Contemporary Design | Paola Antonelli

The best contemporary objects express history and contemporaneity; manifest physically the material culture that generated them; speak globally; carry memory as well as an idea of the future; and spark, like great movies, a sense of belonging while also carrying us to places we have never visited. The best contemporary objects express consciousness by showing the reasons they were made and the process that led to their making. Contemporary design is vigorous with experimentation and creativity—optimistic, honest, and aware.

The multifaceted character of contemporary materials calls for an essentially rigorous and conscious approach to design. Designers are already responding, spontaneously, to this call, and are conceiving products for a sophisticated progeny that has learned to recognize patterns of beauty in pragmatic and economic ideas.

Our perspective on the material world has changed dramatically during the past twenty years. After the sensory and material overdrive of the 1980s, the design world now privileges simplicity and originality. This new attitude is exemplified by the Dutch collective Droog Design ("dry design") formed in 1993 by curators Renny Ramakers and Gijs Bakker, who had noticed a unique brand of ingenuity and economy that connected several Dutch designers despite their differences in age and background. Their coherent minimalist aesthetic provided a link with Dutch tradition, as well as elements for a manifesto. Droog Design made its first appearance at a time when the material world seemed unable to tolerate redundancy. In the fashion world, Miuccia Prada and Tom Ford were breaking new ground by taking garments one step beyond the previous threshold set by the Japanese avant-garde, with a sophisticated blend of high-tech simplicity and visual rigor that, despite its minimal appearance, called for very steep price tags.

Likewise, the apparent modesty of the objects by Droog Design, made of recycled parts and using visibly low technology, was crowned by unexpectedly high prices. Droog Design became the international symbol of a new less-is-more approach and of a political correctness in design, so dry and visually spare as to look impoverished—an illusion supported neither by the manufacturing process nor by the retail prices. Thus a deeply ingrained character of hypocrisy entered the functional arts in the early 1990s. Among the most renowned objects from this period in the Museum's collection are Tejo Remy's 1991 "You Can't Lay Down Your Memory" Chest of Drawers (plate 331) and Rody Graumans's 1992 work, 85 Lamps Lighting Fixture (plate 365), both accumulations of found objects that seemingly use the resources of the world without asking the world for any further effort; and Hella Jongerius's Soft Vase of 1994 (plate 429), one of a series of straightforward, archetypal flower vases made of soft polyurethane.

Toward the mid-1990s, many signs confirmed this minimalist cultural shift toward subtraction. At a 1995 design conference, the third in a series of conferences known as Doors of Perception, organized in Amsterdam by the Netherlands Design Institute on the theme of "matter," Dutch trend forecaster Lidewij Edelkoort gave a poignant audiovisual presentation of natural fibers, Donald Judd-like furniture, recyclable materials, and translucent soap bars. The world, one could assume from her talk, wanted fewer, better, clearer, sounder things, and at any cost. In the same passionate search for cleanliness, Japan was the

first country to market air by offering whiffs of pure canned oxygen for sale in street-vending machines. In May 1997, at a symposium at the San Francisco Museum of Modern Art devoted to the theme of "icons," the art historian Alexander Nemerov spoke eloquently about a new American icon: bottled noncarbonated water. He had joined the chorus to point out an apparent need for a cleaner, purer lifestyle.

After the stylistic impositions of the 1980s, the succeeding years have been somewhat similar to the period that followed World War II, when a fresh injection of previously restricted technologies and new materials joined with an objective need for new dwellings and objects to build a triumphantly modern material culture. Just like the 1950s, these are optimistic times, marked by a renewed attention to domestic living and human mobility, guided by concerns about the environment and by a strong international political consciousness, and fueled by exuberant progress in technological research. In contemporary design, ethics are as important as aesthetics, and morality—even moralism—inspires many contemporary objects, fortifies their purpose, and motivates "users" to rid themselves of redundancies.

As a consequence, the design landscape has changed during the past twenty years. Furniture has become sleeker, and less formal and impertinent. Accessories have become smaller, more personalized, and easier to use. Technological advances, which allow for many more variations and degrees of freedom within the same manufacturing cycle, assist in this new phenomenon.

Today, high and low technology can coexist peacefully. Advanced materials, such as the aramid fibers of Marcel Wanders's 1995 Knotted Chair (plate 441)—roughly knotted in a fishnet, then dipped in epoxy resin, and finally frozen in the shape of a low chair—can be customized and adapted by the designers themselves. Some advanced materials, like the carbon fiber of Alberto Meda's Light Light Armchair of 1987 (plate 182), actually demand manual intervention. Indeed, experimentation at any technological level requires a hands-on approach to test new materials and techniques that do not yet have a fixed set of applications. In the process, thanks to the flexibility and novelty of the materials and manu-facturing methods available, designers have managed to discover new formal and functional possibilities. Japanese textiles, such as Reiko Sudo's work for Nuno (plates 381, 496, 497) provide a dramatic example of what technology based on materials can do for aesthetics.

New techniques are now used to customize, extend, and modify the physical properties of materials and to invent new ones. Materials can be transformed by engineers and by the designers themselves, and adapted in order to achieve their design goals. The 1995 exhibition *Mutant Materials* at The Museum of Modern Art introduced progress in material technology and culture through the innovative transformation of materials in product design and function. According to the exhibition, adherence to the truth of a material, a tenet of historical modern design, is no longer an absolute. Materials have become curiously malleable and sensitive to a designer's intentions. Ceramics, for example, can now look and act like metal, just as plastics can feel and perform like ceramics or glass. A "monastic" wood stool can be surprisingly soft. A knotted rope can be as sturdy as metal.

The substances we used to know and recognize have become the basic ingredients for unexpected combinations, opening up a new world of possibilities for designers and manufacturers. No longer adjuncts in passive roles, materials have been transformed into active interpreters of design. Instead of being mere tools in the design process, they inform and guide it. The changed character of a material is not merely a function of the quantity and diversity of the objects it can produce; it is related to the diversity of its functional properties. Design is energized by an endless search for the perfect balance between means—available materials and techniques—and goals, such as a super-light chair, a mass-produced steel floor lamp, or low-cost foldable furniture to be sent to disaster areas. In this quest, contemporary materials have acquired a new importance in that they are often instrumental in the inspiration for, and achievement of, superior design and manufacturing goals.

Lightness, for example, is the theme of many celebrated contemporary designers, the obsession of many researchers in materials technology, and a feature of almost instant appeal for consumers.

It is also widely accepted as an important ecological goal for the future: "In a sustainable economy, the guiding principle is 'the lighter the better.'"[1] One milestone of enlightened, precocious design in the Museum's collection is the already noted Light Light Armchair by Alberto Meda, a successful design that became a design paradox. When it was first introduced in 1987, the chair so literally pursued the idea of lightness that it sacrificed any chance of commercial success. The public did not accept the chair, which was made of carbon fiber, was perfectly sturdy and supportive, but weighed less than a kilo: its minimal mass made most customers feel uncomfortable and insecure, and production ended after a limited run of fifty samples.

Many new materials are able to embody even more evanescent and emotional functions than lightness, for example, in Mary Ann Toots Zinsky's Bowl, a work of glass filaments (plate 99) and Tom Dixon's S-Chair of 1991 (plate 323). One of the most sublime objects in the Museum's collection is Shiro Kuramata's 1989 Miss Blanche Chair (plate 253). Kuramata's masterpiece, a chair only in name, is in fact a sculpture, a lyrical exercise in contemporary beauty. Its goal and its intended function, as can be perceived subjectively, is sheer emotion, evoked by red silk roses suspended within a throne of perfectly translucent acrylic resin.

Kuramata indicated many new directions for design, employing the most up-to-date technologies to show how materials and objects can consciously and deliberately carry meaning, feeling, and memory. He contemplated the established rules of modernist design and filtered them through a Japanese sensibility. He chose a classic black-and-white cubic dresser and deformed it gently on its own axis. He took white bookshelves formed in a rigid grid and varied the rhythm of the grid within the piece. By attacking only one of the variables in the modernist equation instead of many at a time, he created surprise and enlightenment. He did this by looking deep into the well of his own material culture to apply its tenets to the most enhanced innovations of global technology. In the same fashion, the German lighting designer Ingo Maurer has taken advantage of the excellent technological tradition of his culture to perfect delicate and poetic lamps. The Lucellino Wall Lamp, 1992 (plate 354), a little angelic bulb with wings, can be gradually turned on and dimmed by touching with two fingers any metallic part of the lamp, thanks to a sophisticated and innovative wiring system.

Local tradition is a powerful antidote to modernist mannerism. In recent decades, local cultures have proven to be, for design and architecture alike, the most meaningful way to move beyond modernist style without giving up the salutary qualities of modern design. Materials and techniques are the ambassadors, the most visible manifestations of local material cultures. Some countries, whose material tradition is based on craftsmanship and whose economy is based on necessity, like Brazil, are being looked at as new models for inspiration in architecture and design. Fernando and Humberto Campana, brothers from São Paulo, elaborate on the rigid tubular-steel frame that is the signature of traditional modernist chairs and add to it traditional colorful cotton ropes to form their very comfortable Vermelha Chair of 1993 (plate 395). The available materials are used in harmony with their capabilities, according to what Arthur Pulos calls "the principle of beauty as the natural by-product of functional refinement,"[2] a timeless principle that has often been used to define quality in design.

notes

1. Dr. G. J. Wijers, [Preface], in A. Beukers and E. van Hinte, *Lightness* (Rotterdam: 010 publishers, 1998).
2. Arthur J. Pulos, *American Design Ethic* (Cambridge, Mass.: MIT Press, 1983).

Lest We Regret: Reflections in Film | Mary Lea Bandy

The evocation of memory is hardly new in art, but it can appear, especially in film, in unexpected ways. Contemporary independent filmmakers working in the narrative tradition have often imbued their stories with a reflectiveness as startling as it is seductive. Their thoughtful films—less ambitious technically than major studio productions, in terms of special visual effects and multitrack sound, yet no less so artistically—search the human spirit in intimate ways, pondering the preoccupations or obsessions of their writers and directors. An independent artist like John Cassavetes, struggling to understand emotional ties in *Love Streams,* 1984 (plate 112), or an eighty-year-old old-master, Akira Kurosawa, working on a small scale in *Dreams,* 1990 (plate 279), are filmmakers who follow no prescribed route, and adhere to no established school or studio. Their pursuits, instead, expand the notion of the "personal" cinema that has long characterized the individual vision, the poetry, and the astounding beauty put before us by truly independent filmmakers such as Stan Brakhage. His biomorphic abstractions in color, including the five-minute-long *Commingled Containers,* 1997 (plate 495), or the artistry of Ernie Gehr in his structuring of perspective and motion above city streets in *Side/Walk/Shuttle*, 1991 (plate 320), are riveting essays in cinematic experimentation.

From the 1960s onward, the concept of *auteurist* cinema, which emerged in critical discourse, served as a guide for our recognition of a Cassavetes or a Kurosawa, a consistent voice, identifiable in style, approach, or content, regardless of the size and scope of the production. Whether or not this concept still governs our thinking today, it is interesting to consider contemporary works that engage—much as the *auteur* works have—our hearts and minds in profound ways, rather than merely our senses. This is particularly pertinent in revisiting the works of filmmakers who are obsessed with memory and loss. Though it may seem contradictory, it is these filmmakers—like artists in other mediums who probe the distant or immediate past—who often evoke the most absorbing, at times elegiac, homages to truth in perception.

The perception of actuality, with a moral edge, has long been deemed a worthy goal of filmmaking. In the same sense, creators of films acting as journalists, have aimed at presenting factual truths, even as their works often got those facts wrong. Film genres established early in the twentieth century internationally included historical adaptations, gangster movies, war epics, and biographies of famous, or infamous, people. More often than not, these films glorified the past in broad strokes, even as they attempted to critique it.

In the last two decades of the twentieth century, filmmakers and commentators saw the world change several times over, in quick succession and in complex ways. They, and we, lacked simple threads to tie new developments into neat cultural packages. In a period of unprecedented economic prosperity and worldwide communication, we witnessed deep poverty and illiteracy, diseases and plagues, terrorism and ethnic cleansing, and ecological devastation. As entranced as we were by penetration into a vastly more complex universe than we previously had understood, so too were we horrified, in our earthbound neighborhoods, to learn of the abuse and murder of innocent children. Called into question, as we attempted to interpret our new times, were the

influential legacies of Marx, Lenin, Einstein, and Freud. Technological innovation threatened to substitute itself for ideology, but utopian visions of problem solving were countered by a growing sense of victimization. We were reminded that World War II was still of consequence.

Faced with so imposing an array of issues, numerous filmmakers pursued personal perceptions rather than attempt to mirror current events. Those who thought to step back from the complex present, to delve into memory and search understanding, opted to work within self-imposed boundaries: autobiographical musings, nostalgic recall, meditations on violence, and lamentations on illness and death. All of these came forth in formats that ranged from the miming of home movies to direct sociopolitical exposition. Genre and other traditional descriptive categories were of little use here; what were wondrous were the cinematic expressions of passions, fears, and delights in worlds closely observed and deeply felt. Some approaches are reticent, others instinctive, and still others cheeky. Some take a distinctly moral point of view, others are intentionally ambivalent.

The recycling of texts and tales is a constant source of inspiration, and the complete edition of Shakespeare's plays and sonnets gathers no dust in the filmmaker's study. In *Looking for Richard,* 1996 (plate 478), Al Pacino intuited a complex relationship between actor and text as he prepared the staging of the play *Richard III,* and he queried the relevance of Shakespeare for most everyone he encountered at the time, in neighborhood and workshop, including contemporary interpreters such as Kevin Kline and Kevin Spacey. The intensity of his search and his eagerness to grasp the essence of his theater through the particular rhythms of his daily investigative beat capture the passion that filmmakers bring to their obsessions.

Looking for meaning on the West Side of New York offers the restless artist an urban map for a personal odyssey. Woody Allen, that chronicler of Manhattan on both sides of town, created his homage to a passing West Side culture with *Broadway Danny Rose,* 1984 (plate 117), spicing its delicatessen hilarity with a melancholy touch, shot in the self conscious black-and-white cinematography that he used to great effect in capturing the urban scene.

Music, as much as cinematographic tonalities, is key to mood and character. Jazz, for example, is inseparable from Clint Eastwood's sensibility. In *Bird,* 1988 (plate 212), Eastwood concentrates with unusual intensity on the familiar theme of an artist's self-destruction—in this case the downfall of the saxophonist Charlie Parker, a gifted performer who revolutionized jazz during the 1940s but whose drug addiction overruled his efforts to behave. Forest Whitaker, as Parker, captured the angst of the musician, blowing on his sax to the soundtrack of Parker's recordings. The film itself entered territory thought to be off-limits for a mainstream filmmaker and amateur musician, but in taking us along on nights in the city in slow time, without giving us a pedantic history lesson, it tells us much about Eastwood's abilities to trust in his instinct and his passions, and to sidestep easy moralizing.

Martin Scorsese daringly interwove text and music in his most passionately felt probe for spiritual truth, *The Last Temptation of Christ*, 1988, adapted from the novel by Nikos Kazantzakis (plate 232). As the film reveals the torments of a sensual self-doubting Jesus when he becomes the messenger of God, its sincerity and beauty are enhanced by the provocative music of Peter Gabriel.

The last film of an American master surprised all who had met him decades earlier as the brash young director of *The Maltese Falcon,* 1941. For John Huston's *The Dead,* 1987 (plate 192), his son Tony adapted the short story from *The Dubliners* by James Joyce, and his daughter Angelica played the gracious wife who laments the lost true love of her youth. The finely calibrated atmosphere of melancholy, during a holiday dinner set in 1904, and the hushed elegance of the performances seemed a generous and extraordinary remembrance from a dying artist.

The sorrows and joys of childhood tugged at the memory of filmmakers who created some of their most expressive works about their own or others' youths. A narrative structure of quiet, gentle rhythms belies the intense preparation undertaken by the actors who were the protagonists of *Thirteen,* 1997 (plate 509), a Virginia family led by a devoted mother and her daughter, Nina, whose first year as a teenager finds her restless and confused. Filmmaker David Williams

dug deep, through a unique process of rehearsal and improvisation, to expose the sense of isolation and yearning that Nina is unable to articulate. So troubling is her struggle with adolescence that she must run away from a loving family and friends, in order to come back home and accept that she is too young to legally drive, let alone own a car. Similarly, Terence Davies crafted—through the rich, painterly colors of lush cinematography and nuanced blend of family chatter and music on the radio—a look back on his own childhood in *The Long Day Closes,* 1992 (plate 367), set in Liverpool during the mid-1950s. A sensitive eleven-year-old boy, loved and guarded by his mother and siblings, cherishes every chance to dream of Hollywood musicals, and we are transported with him into his world of magic and memory.

Such films take us through familiar territory in unexpected ways: Williams through his year-long association with his actors, and Davies through his exquisite selectivity of word and image. In neither film do we miss an explanation of a father's absence. A remarkably tough, seemingly almost brutal, rendering of a daughter and her father is *Moment of Impact,* 1998 (plate 513), by Julia Loktev. More stylized than *vérité*, the black-and-white cinematography coolly captures the daily miseries of Lotkev's father, paralyzed from an accident, and her mother, who must take care of every task. Each suffers terribly, and although the mother can articulate her frustrations, she resents her daughter's intrusions, and those of the camera. The filmmaker's strength fosters our sense of her weakness, for we are left wondering what is exploitation, and what is a search for truth and understanding.

The memory film—especially the sort devoted to making us reflect on the most incomprehensible horrors of World War II—was forever changed by Claude Lanzmann's *Shoah,* 1985 (plate 129), which gradually reveals layers of truth through nine hours of interviews, comprising the recollections of those who endured the Holocaust, as victims or oppressors.

Jean-Luc Godard, an artist who ceaselessly layers truths and serves them forth, in films or videos, as essays, dramas, or meditations on the past, is among the most personal of all makers of moving imagery. For Godard a work is a collage of seconds of fictional films, newsreels, television programs, paintings, and photographs overlaid with carefully chosen words whose letters are rearranged to suggest multiple meanings, and enhanced by his own narrative voice and the music of Beethoven or Bob Dylan. Since 1974 Godard has created films, such as *Sauve qui peut (la vie),* 1980 (plate 11), and videos that are intended to be discerned as a continuous discourse. This has been followed by essays of moving imagery spanning the twentieth century, including *The Old Place,* 2000 (plate 552), a meditation on art in collaboration with Anne-Marie Miéville.

Another creative partnership, is that of Jean-Marie Straub and Danièle Huillet, whose 1999 sixty-six-minute film *Sicilia!* closed the millennium on an uncompromising note (plate 544). Adapted from the 1939 novella *Conversations in Sicily* by Elio Vittorini, the narrative offers a dialogue between an exile returning to his country after many years and the people he meets on his voyage into the past. Each encounter, especially that with his mother, is understood as a passage for the man, yet seemingly buries more than it exposes in conversations as harsh as the intense sunlit landscape. Straub and Huillet shot the encounter of child and parent in black and white, as did Loktev, to give clarity to toughness and truth, and also focus to the quiet but unsettling perceptions of mothers who suffer and endure.

Reflection in film achieved no more astonishing impact than in *Blue,* 1993 (plate 394), directed by Derek Jarman. While dying of AIDS, Jarman recorded a monologue in which he talked of his treatment, set in part against the backdrop of a program of church music. All we see on the screen is a swath of color, a dense, bright, sky-blue that seems at times to quiver as we listen to the voices. It is not radio, it is not a painting, it does not appear to be cinema in any way in which we know it, but a more powerfully personal voice cannot be readily conceived, nor are we ever the same after experiencing this mighty film.

Home and Away | Fereshteh Daftari

In the last two decades, the escalating interconnections throughout the world have made "globalization" a master concept and a key term. An expanding market economy and thickening net of communication have touched, and often altered, an exceptionally broad range of cultures, traditions, and practices. There is no agreement as to what this ongoing process may ultimately yield, for better or worse. Where some have damned it as a new form of colonization, a kind of transnational dominance based on an ideology of consumerism, others have hailed the way it weakens oppression by nation-states and liberates local cultures. Pessimists see globalization as suppressing differences, while optimists see it fostering their proliferation. We have seen arguments that the phenomenon is an old one and a new one, a question of Eurocentrism or American capitalism, antagonism or emancipation.

Contemporary artists often cross cultural boundaries, and have been implicated in and attentive to these changes and debates. Their traffic within the networks of globalization is multidirectional. Western artists, such as John Cage (plate 297), Francesco Clemente (plates 83, 152), Wolfgang Laib (plate 197), and Bill Viola (plates 142, 416), by immersing themselves in the cultures of the East, have reaffirmed a familiar linkage between modern art's dominant centers and formerly peripheral cultures. But other artists, of non-Western origin, have also created more complex and unprecedented hybrids in their physical and in their spiritual "residences." Transition has been the order of the day, shuttling between a variety of global terms and an equal mix of local identities. It should not be surprising, then, that vessels of transit, such as boats, recur in the imagery of artists from so many different points of the globe.

Cai Guo-Qiang is a telling example. Born in Quanzhou, in the Fujian province of China, he studied in Shanghai, has exhibited in Asia, Europe, America, Australia, and South Africa, and now resides in New York—where he first showed *Borrowing Your Enemy's Arrows* (plate 536), a sculpture that embodies a metaphor for cross-cultural exchange. The work is built on the skeleton of an old fishing boat, excavated near the port where the artist began his personal journey. Bristling with 3,000 arrows designed by the artist, and fabricated in his native city, the ship flies the flag of contemporary China, but refers to the nation's deeper history. Historical texts (known as *sanguozhi*) recount how General Zhuge Liang, lacking ammunition in the face of a heavily armed enemy, was ordered to procure 100,000 arrows in ten days. The legend recounts that, on a foggy night, the general sent a boat loaded with bales of straw across the river, toward his foes. When the enemy had fired volley after volley of arrows at this decoy, the general pulled it back, full of a captured store of fresh ammunition. One subject of the sculpture, then, is how a culture may appropriate and transform foreign intrusions into a defensive strategy.

The Infinite Column I (plate 469), made in Cuba by the artist KCHO (Alexis Leyva Machado), also takes up the theme of the boat, but navigates in different waters, and points to another aspect of globalization: migration. KCHO, unlike Cai Guo-Qiang, lives in a country whose ties to the world market have been severed by a United States embargo. Still, he has been featured in numerous international exhibitions, and his field of reference cuts across political boundaries. *The Infinite Column I* is in part a conscious homage—in its

title, its form, and its artisanal mode of production—to the early modern sculptor Constantin Brancusi, who himself drew constantly on the folk traditions of his native Romania while living in Paris. Brancusi's major outdoor monument, a 1938 war memorial, includes a stacked and modular *Endless Column* made of steel. KCHO's open-lattice structure, seemingly jury-rigged from building scrap and common hardware, has a very different character. As flimsy as a drawing outlining a dream, it is willfully precarious and provisory. Embodying the triumph of aspiring ambition over impoverished means, these multiplied boat forms, rising upward, irresistibly conjure the worldwide migratory phenomenon of "boat people," fleeing their homelands—even if the sculpture, and its creator, elude any simple political categorization. KCHO's boats may in fact be traveling *to* the Cuban main island (and Havana) from his destitute native Isla de la Juventud.

Poetically ethereal yet monumental and looming, his ascending, gyrating boats open onto the broader meanings of voyage and transit, freighted with both hope and peril. Another KCHO work, the drawing *In the Eyes of History* (plate 447), may have a more pointed intent. By re-imagining one of early Communism's masterworks—Vladimir Tatlin's 1920 vision for a colossal *Monument to the Third International*—as a drip coffeemaker, KCHO seems to make a sardonic comment on the translation of distant Soviet ideals into local Cuban realities.

In such complex circumstances, where local inflections are informed by broad education in an international modern tradition, and where the artist's life experience may involve a variety of cultures, native and adopted, it is often far from obvious how one should identify any particular "ethnic element" in a given body of work. Perhaps it is more useful to think, as Edward Said has suggested, of the pervasiveness of a "contrapuntal" consciousness, inherent in the way exiles experience, by definition, more than one culture, one home. Mona Hatoum, for example, was born in Beirut to Christian Palestinian parents, but since 1975 she has been in effect an exile, based in England. The forms of her work reflect the West and her British art training, but the content is more personal and less easy to associate with any one culture. Often her expression involves

the use of, or reference to, the body—a device that may reflect what she says is the absence, in her Palestinian inheritance, of a simplistic mind-body dichotomy, but one that is also intimately tied to the epoch of AIDS and its broader artistic renewals of an often macabre fascination with the corporeal and organic. *Silence* (plate 414), for instance, made of test tubes on which the movement of light gives the illusion of fluid traveling in transparent arteries, seems quietly to fight for its own life. More generally, elements of instability—a lack of anchoring, slippery ground, shifting maps, and dangerous terrain—define the experience of much of Hatoum's art, and its lingering sense of deracination. A mat, as entrails (plate 466) beneath one's feet sums it all: no welcome at any location. Similarly, the art of Toba Khedoori (plate 444)—an artist living in Los Angeles, but born in Australia to Jewish Iraqi parents—has no particular ethnic inflection, but her ghostlike architectural sites may be taken to speak of an unspecified place left behind.

The work of Anish Kapoor, by contrast, involves a transnational vision that is deliberately, evidently bifocal. Half Jewish Iraqi, half Indian, Kapoor left Bombay for London in 1973, but has persistently maintained in his art traces of his Indian heritage. His 1986 sculpture *A Flower, A Drama Like Death* (plate 164) enacts a coming together of opposites—the male and the female, the erotic and the spiritual—in ways that evidently evoke such Western origins as Alberto Giacometti's Surrealist sculptures, Yves Klein's notions of color, and Carl Jung's typologies. But the work is just as evidently associated with the sexually charged Hindu combination of lingam and yoni, and the intense powdered pigments of Kapoor's Indian culture. The work is permanently bathed by the willful ebb and flow of two cultures.

Chris Ofili, especially, defies easy cultural categorization. Born in Europe—in Manchester, England—Ofili is the son of Nigerian immigrants. Living in London, he has been concerned less with any simple recovery of African roots than with contemporary stereotypes of his race. And the vehicles of his expression—intricately worked paintings that seem at once gaudy, pungent, and tender—are extravagant hybrid fictions. In *Prince amongst Thieves* (plate 548), the caricatured pro-

file of a black man, decked out in a necklace crowned by a rough ball of elephant dung, is embedded in an explosive web of elaborate pattern, iridescent color, and surrounded by countless small collaged heads of black men clipped from contemporary magazines. Derived from some exotic tale, the quintessential fiction of the *Thousand and One Nights*, he looms large in this nocturnal scene, like a dark, expanding, hallucinogenic vision.

As a sophisticated young member of a lively urban art community, Ofili is fully conversant with long-standing debates pitting abstraction against figuration, craft against ready-made appropriation, and so on. Hence the hybrids in his work bring together not only inflections of different cultures, but also elements of opposing approaches within modern Western art. The highly decorative, cake-icing surface, for example, seems right in step with certain trends of the 1990s, but its swarming fields of small resin dots actually stem from dot drawings the artist saw in Zimbabwe. The elephant dung offers a still more complex origin. An appropriated, "transgressive" ready-made material taken from the London zoo, it also conjures up African tribal art, where its presence is affirmative and even sacred. Its inclusion suggests an outsider translating European strategies, and, at the same time, an exile looking back with a new eye on indigenous practices. Ofili is neither and both. Playing on a complicated scale where respect and veneration match satire and degradation in a way that mingles an almost oversweetened lyricism and lushness with an occasional obscenity, Ofili reinvents—one might say fabricates—the experience of his richly layered selfhood, tethered to several cultural traditions and outsiders' perceptions.

Hybridization is no absolute novelty, but until now only Western artists (Gauguin and Matisse to name two) have received attention, at the expense of Third World artists grappling with the mainstream. The brand new spotlight currently focused on the many individual "creole" languages of various artists may represent nothing more than a trendy thirst for exoticism. Globalization, as stated before, raises a host of unresolved questions, and a globalized field of art poses similar conundrums. Are the borrowings from and minglings of references from marginalized cultures only a savvy strategy of "niche marketing," bound eventually to exhaust the freshness of their appeal, or are they the signal of a growing wave of art that will render obsolete many of the frontiers, boundaries, and self-enclosed traditions that have been so determining? Is this a phenomenon of greater tolerance of expanded diversity, or only the cloak for an increasing homogenization? In all the cases touched on here, fluency in the language of Western art has been a requisite for access to the global sphere of exhibitions, museums, galleries, and journals. It may be fair, then, to wonder whether, in the process of featuring and enabling difference, the new art world is ultimately weakening the authority of any zone of resistance, such as those artists who choose not to speak in the current vernacular of the marketplace.

One Thing After Another: Serial Print Projects | Judith B. Hecker

The making of art is, in many ways, predicated on the copy. The original, its likeness, and the successive presentation of related images have always been central to the development of artistic representation. But the arrival of Pop art and Minimalism in the 1960s, with their proliferation of reproductive and serial imagery, altered our understanding of these basic concepts. Andy Warhol's pervasive repetition of images from the mass media, and Sol LeWitt's infinitely repeatable geometric works, among many others, displaced the historical categories of the unique, original, and hand-made in art.

Printmaking played a crucial role in the development of these new art forms in the 1960s because it inherently involves mechanization, standardization, and serial production. The printmaker's ability to reproduce images quickly and repeatedly, as well as to create developmental imagery through the progressive printing and reworking of proofs, made printed work a natural medium of experimentation and innovation. Through the print series or portfolio, artists could show multiple images together, emphasizing the relationship among parts rather than a singular presence.

The innovations of the 1960s established strategies that contemporary artists have adopted, but with notable shifts. Whereas serial projects were formerly dominated by the modular repetition of geometric shapes (LeWitt and Judd), or the depersonalized successions of everyday objects and images (Warhol and Lichtenstein), today's projects emphasize content over formal experimentation, and engage more frequently with nontraditional mediums. Installation, performance, and video art, photography, and new-media technology (including digitization, virtual reality, and the internet) have expanded artistic vocabularies, and artists are increasingly drawn back to the printed series because it enables further exploration into the multiple, developmental, and spatial structures of these other mediums.

Standardization

The print series is perhaps most easily understood in terms of classic seriality, or the repetition and variation of a standardized part to build the larger structure of a work. Individual parts can sometimes be shown in isolation, but more often the artist's intentions are only fully grasped in the presentation of the entire set. Numerous contemporary works build upon such systems of logic and push them in new directions. In fact, in Warhol's last printed project, *Camouflage*, 1987 (plate 188), we can see a shift from the straightforward seriality of the 1960s (Campbell's Soup Cans, Marilyns) to a more experimental approach.

While Warhol continued to take his subjects from popular culture until the end of his life, in later years, he often stressed their abstract qualities. This abstraction provided his serial imagery with new complexity. The relationship of camouflage fabric to the artist's obsession with disguise, as well as its symbolic association with militarism, gives the project a satirical tone, but the portfolio is most compelling because of its complex visual structure. Warhol took the same section of camouflage fabric and subjected it to manipulation not only through color variation, but also through changes in scale and orientation, creating an enigmatic relationship among the prints. The group of eight prints in *Camouflage* actually comprises four

distinct pairs, each one depicting a different level of detail.

For John Armleder, whose work explores the relationships of art, design, and ornamentation, the print portfolio is an ideal correlative to his work in other mediums. In *Gog*, 1996 (plate 467), Armleder draws upon Minimalist strategies by using a standard shape—the circle—and creating thirteen different variations. Armleder infuses each print with shocking colors, including fluorescents and metallics, that make the targets pulsate. By virtue of these eye-teasing Op-art colors, the work parodies the aloof stillness and standardization associated with serial Minimalism. While the individual composition harks back to the 1960s, particularly to Kenneth Noland's concentric circle paintings and Bridget Riley's pulsating forms, the hard-edge variation from print to print—coupled with targets that burst beyond the square of the paper—turns a simple geometric motif into an ongoing optical event.

Gerhard Richter, who has dealt with recycled imagery since the 1960s, expands upon classic seriality by infusing the standardized unit of the square with abstract markings in the portfolio *128 Details from a Picture (Halifax 1978)*, 1998 (plate 520). Yet, in a typical Richter twist, the seeming irregularity and arbitrariness of these units are actually governed by a series of parameters established by the artist. The portfolio is based on 128 photographs the artist took in Halifax in 1978 of one of his abstract paintings. He then classified the photographs into eight sets of sixteen, each representing a particular angle, distance, and lighting condition. They were then arranged in a large grid for a unique collage. Continuing his long-standing practice of making printed images after photographs, Richter then transformed this collage into the print portfolio. The eight sheets—themselves each grids of sixteen similar units—yield 128 reconstituted parts that evoke images ranging from lunarscapes to oil spills.

Circles of subtle color create a serial structure of diaphanous forms in the portfolio *Wounds and Absent Objects*, 1998 (plate 518), by Anish Kapoor, whose work in sculpture explores the concepts of space and emptiness, using abstract forms and color. The portfolio is based on a project Kapoor did for BBC television in which an abstract void

continuously changed colors, creating the perception of emerging and receding space. To make the prints, the artist isolated this movement in nine video stills that were then printed onto rectangular plastic sheets through a complex pigment-transfer process. The resulting images, when shown together, give the impression of changing light, color, and space, as shown in the original video.

Spontaneity

Contemporary serial structures often strategically employ serendipity and embrace chance, spontaneity, and impulse. In the 1960s, art based on materials, surroundings, and actions, was often explored in printed form, and today artists continue to evolve and reinterpret these strategies by incorporating new systems and technological advances.

Terry Winters's portfolio of woodcuts, *Graphic Primitives*, 1998 (plate 519), comprises nine cellular networks that mutate from print to print, suggesting an organic metamorphosis rendered through drawing. This approach to imagery variation stands in stark contrast to the hard-edge, mechanical variance found in portfolios such as Warhol's *Camouflage* or Armleder's *Gog*. But like much of Winters's work, *Graphic Primitives* appears to merge natural formations with synthetic systems, creating tension between gesture-based and technological designs. This complexity, in fact, is no coincidence. The images were first drawn and then scanned into the computer and manipulated digitally, which gave the set a mechanical quality. In addition, the woodcuts were made from blocks cut with a computer-programmed laser, adding another twist to the shifting boundaries between standardization and impulse, mechanization and manual arts.

The tension between standardization and spontaneity also emerges in the prints of Yukinori Yanagi. The five etchings in *Wandering Position*, 1997 (plate 507), appear—at a distance—to be simple variations on the shape of the rectangle. Up close, however, these free-floating forms are filled with a dense network of wiry lines, which become less penetrable toward the corners and outer edges. To create each print, the artist traced the path of a single ant confined to the surface

of an etching plate. Based on a performance piece in which the artist tracked an ant with crayon directly onto the floor of a gallery, the prints subvert the rhetoric of Minimalism—dictated by the rectangular size of the metal etching plate—to explore the concepts of movement and entrapment. The irregularities of the rectangles create uneven pathways for the ants, underscoring the unpredictable forces driving the serial structure.

Chris Ofili's print project *North Wales*, 1996 (plate 472), is an expression of the artist's varying state of mind during his travels through the country. At each stop along his way, in a chronological fashion, Ofili incised a different metal plate prepared with an etching ground. These spontaneous visual ruminations were later transferred into ten printed images. The resulting networks are highly intricate patterns, loosely related to the patterning found within the layers of Ofili's large paintings, but more specifically based on the artist's ruminations at each creative moment. The images differ widely, yet serial uniformity is maintained by the artist's use of a consistent approach and format throughout his journey.

Time

Yanagi's incorporation of an ant's physical movement and Ofili's own visual travelogue suggest yet another type of the serial project in the contemporary period: the two-dimensional representation of time, motion, or events. The film-animation artist William Kentridge develops a narrative in his portfolio *Ubu Tells the Truth*, 1996–97 (plate 501), employing the Surrealist poet Alfred Jarry's fictional character Ubu—a symbol of the physically grotesque and politically brutal—as a metaphor for the South African Truth and Reconciliation Commission. Ubu is depicted in two ways, using different etching techniques: as a white chalkboard drawing based on Jarry's cartoonlike character (with a spiral belly and pointed head), and a more literal textured human counterpart (based on a photographic self-portrait of the artist). Ubu is shown acting out symbolically in ten different prints, for example, cleansing himself under the shower, scratching his back, lying on a table under an interrogation lamp, and looking at himself in the mirror. With this series, Kentridge illus-

trates the imaginary acts and scenes of a play (numbering each print), creating the basis for a subsequent film animation and a live theater production.

The progression of time within a singular dramatic moment is depicted in the prints of E. V. Day, known for her site-specific installations that capture stop-action explosions of socially-charged objects and materials, such as a blow-up sex doll or fashion gown. Seizing upon the sequencing capabilities of the print, Day illustrates the unfolding of an explosion from one stage to the next in *Anatomy of Hugh Hefner's Private Jet (1–5)*, 1999 (plate 547). She created the series of five prints by tracing a blueprint of Hefner's private jet, "Big Bunny," and then gradually transforming the drawing into a mass that permutates, from print to print, into diffuse matter. Furthermore, by replicating the medium of the blueprint, the project parodies the seriousness of the airplane's original design.

Movement and narrative are explored by Julian Opie with works that merge post-Pop imagery and the computer age to present scenes straight out of virtual reality. Using the flatness and color density of the screenprint, which is both friendly and alienating in his work, Opie takes us on a virtual trip through city and country: *Imagine You Are Driving; Cars?; Imagine You Are Walking; Cityscape?; Gary, Popstar; Landscape?,* 1998–99 (plate 541). The images are instantly recognizable for their generic simplicity, but also strangely unfamiliar because of their hyper-technological edge. The prints, in fact, are derived from the artist's evolving library of computer-scanned images, which he then manipulates. And although the sequence within the series is interchangeable, when shown together the prints create a narrative about the way we inhabit and navigate the different spaces of our world.

Peter Halley's Web project for *Exploding Cell* draws upon both classic seriality and the temporal structure of the printed series. In 1995 Halley created a series of nine black-and-white images, *Exploding Cell*, which depict a cartoonlike organic structure in the process of exploding. These technological abstractions, printed from a digital file onto sheets of paper, can be installed as wallpaper in a gallery (plate 443). Later Halley turned this

series into a Web project, which enables users to access and design their own exploding cells. Users are directed to choose one of the nine images and then to select from 256 colors available for shading the different parts of the cell. Once the design is complete, the image is printed. Taking its cue from the expansiveness of 1960s repetitive imagery, such as Warhol's endless grids of S&H Green Stamps or colors of the Marilyn portfolio, Halley's project provides unlimited replication of nine images, as well as over sixteen million possible color variations. The project is permanently installed on the Web and will never lose its quality—the first copy is as pristine as the millionth—marking a new chapter in the discourse on reproduction and seriality.

Although the serial project is strongly linked to the particulars of printmaking, its principles also extend beyond. Whether through formal experimentation, content-driven approaches, or the representation of action and time, the serial structure has assumed an increasingly important position in all mediums. Among examples in other mediums are the stark, gridded architectural photographs of Bernd and Hilla Becher (plate 198), and the stackable rectangular modules of Antonio Citterio's and Glen Oliver Löw's Mobil Container System (plate 396). The serial narrative of Gerhard Richter's monumental fifteen-canvas *October 18, 1977* (plate 210) relays media fragments from a singular event, the murder of the German Baader-Meinhof group; while the extended narrative of Seiichi Furuya's photographs (plates 27, 28), documents his wife in portraits over a four-year period. The pervasiveness of the serial project perhaps speaks to an overriding contemporary interest in process and continuity over the singular work or finite moment—a way of representing process itself as the reality of the world that surrounds and defines us.

Aspects of Documentary Photography in Europe Since 1980 | Susan Kismaric

In the last several decades, two countries have emerged as leading centers of contemporary documentary photography in Europe: Germany and Great Britain. Each has a distinct photographic tradition that extends back to the nineteenth and early twentieth centuries; and a significant segment of contemporary work frequently bears a debt to these early beginnings. Germany and Great Britain are now the most important sites in a field that also includes Spain, the Netherlands, France, and Russia, among others.

In Germany, despite the devastation of World War II, an infrastructure for a serious artistic photographic community had emerged from many diverse sources and was in place by the late 1970s. Beginning in the late 1960s, the German painters Sigmar Polke, Gerhard Richter, and Anselm Kiefer, all of whom use or have used photography as a medium, or use photographs as a basis or starting point for their work, contributed to the presence and consideration of photography within the German art world. The work of these important postwar painters began to be shown internationally in the 1970s, lending credibility to the consideration of photography as a significant medium that could be employed in complex ways. By the mid-1980s photographers were beginning to compete successfully with painters for attention and space on the walls of galleries and museums.

In 1959 Dr. Otto Steinert, hired to teach photography at the Folkwang School in Essen, Germany, set up a collection of historical photography at the Museum Folkwang, and used the collection to teach and organize annual exhibitions of historical photographs. Upon his death in 1978, Steinert's private collection and library were added to the museum's holdings, and one of his students, Ute Eskildsen, became the curator of the combined collections. Eskildsen provided a venue for new work by younger photographers, and her exhibitions of lesser known figures from German photographic history have added to the evolving photographic infrastructure. She has also organized biannual exhibitions of the photographs of the recipients of grants for contemporary German photography, among them Michael Schmidt, Anna and Bernhard Blume, and Andreas Gursky.

In addition, two German schools were major influences on students of documentary photography: those who studied with Bernd and Hilla Becher at the Kunstakademie in Düsseldorf (where Nam June Paik and Joseph Beuys also taught) and those who attended the Werkstatt für Photografie in Berlin, founded by Michael Schmidt.

The work of Bernd and Hilla Becher derives from the French encyclopedic tradition of typologies, in which the gathering and sorting of individual things within a category contributes, through comparison, to an understanding of the whole. Typology's photographic tradition is best exemplified by the work of the German photographer August Sander, who created a multi-volume atlas of German social and professional types. Sander's project was halted in 1933 when the Nazis confiscated the printing plates, but much of it was published posthumously as *Citizens of the Twentieth Century*. Other notable German photographic typologists were Albert Renger Patzsch and Karl Blossfeldt, both of whom applied the method to the study of plant life.

Gas tanks, blast furnaces, industrial facades, water towers, and coal tipples—the archaeological remains of the industrial age—have been the subject matter for Bernd and Hilla Becher since 1957. The Bechers and their students, now into a third generation, have taken this "objective," or neu-

tral, language of photographic description to create "proofs" of the historical symbology of the twentieth century. The Bechers' work (plate 198) comprises grids of black-and-white photographs of the same kinds of structures, frontal views made from the same distance and vantage point. They look more like pictures commissioned by engineers or industrial architects than expressive, artistic work. Contemporary German photographers who studied with the Bechers, such as Thomas Struth, Thomas Ruff, and Andreas Gursky, have applied this methodology (minus the grids) to other subjects, in photographs that are reflective of their own generation.

In the work of Thomas Struth (plates 282, 283, 284), this methodology has been applied to landscapes, city streets around the world, the housing flats of Chicago, and the office buildings of Hong Kong, as well as to people in various countries, notably visitors to museums. In his landscapes there are no people, recalling nineteenth-century photographs made for topographical purposes. Struth exploits the camera's capacity for seemingly uninflected vision. Rather than use photography to document the past, as in the case of the Frenchman Eugène Atget, however, he uses his neutral views of the present-day world to return the viewer to the self—in the present—in order to make us think about the future.

Thomas Ruff (plate 234) has photographed the expressionless faces of anonymous Germans, mostly students and friends, with a blandness that denies authorial intervention and invites a kind of microscopic inspection of his large-scale color portraits. Discouraging our interest in the individuals pictured, Ruff's portraits precipitate questions about the relationship between photography's descriptive capacity and the traditional implications of portraiture.

In the photographs of Andreas Gursky the typological methodology has been applied to subjects around the world, focusing on global commercialism as seen in stores, public institutions, and other sites. Through the use of advanced photographic technology Gursky has created a body of work that reflects the current world. He perfects his "neutral" color imagery through digital alteration of the work, erasing details that distract us from the intended impact of the picture. In the

case of *Toys "Я" Us* he removed birds, thus rendering the subject devoid of organic presence (plate 542). Or, as in another example, he uses the computer to replicate digitally half of a space to create a symmetrical whole. Gursky's large-scale pictures create a world we feel we can walk into; they alert our sensual and intellectual consciousness to the overwhelming presence of consumerism at the end of the twentieth century. In his pictures, Gursky seems to be striving toward a kind of perfection, a photograph that represents all pictures.

The work of Gursky and Struth, like that of the Bechers, is made from what might be called a middle distance, where the horizon line runs more or less across the center of the picture, providing a somewhat distant and seemingly unmediated view. The individual work of these young Germans comprises a kind of archive. In the work of the Bechers, selections from the archive are brought together by the grid system. In the work of the younger generations it is the gathering of pictures, often very large-scale work, that brings aspects of the archive to one site (the exhibition space or book) for contemplation.

Drawing on the style of the German typologist Karl Blossfeldt, the Spanish photographer Joan Fontcuberta (plate 61) has utilized a serious contemporary critique of photography to convey cultural clichés and stereotypes with a droll sense of humor. In his studio, Fontcuberta has created a pseudoscientific photographic study of nonexistent flora and fauna. In an effort to undermine the scientific and factual aspects of photography, he created plants in his studio using various materials, labeled them with invented Latin names, and "documented" them with invented data in the style of Blossfeldt.

The work of the Dutch artist Rineke Dijkstra is, tangentially, an extension of the German school of the Bechers. Dijkstra always works in series, photographing people who are experiencing similar psychologically and sensually heightened states of mind: self-conscious, awkward teenagers in bathing suits, women who have just given birth, or matadors who have just left the bull ring. The common denominator among these groups is vulnerability and how the individual copes with it in front of the camera. In the diptych, *Tia,*

Amsterdam, 1992 (plate 427), we see two close frontal views of the subject's expressionless face, one made the week she gave birth and the other six months later. The photographer complicates our notions of "before" and "after," by reversing the chronology of the pictures on display; the last comes first.

Bernhard and Anna Blume are Cologne artists who have been collaborating since 1980 on conceiving, staging, and photographing themselves in what they call Photo Actions. In the 1960s they studied at the Düsseldorf Kunstakademie when Joseph Beuys was there. Their work derives from the Performance art of the late 1960s and 1970s, which was often documented by photographs. *Kitchen Frenzy,* 1986 (plate 144), records nightmarish encounters with inanimate objects such as potatoes and kitchen utensils, which assume a life of their own. These photographs undermine the seriousness of the daily rituals of traditional, German middle-class life.

Another major aspect of German photography was produced by the students of the Werkstatt für Photografie in Kreuzberg, Berlin, beginning in 1976. Michael Schmidt, founder and director of the workshop, invited many American photographers to teach studio classes and to lecture, among them Robert Frank, William Eggleston, Ralph Gibson, Robert Adams, John Gossage, and Lewis Baltz. The work of these American documentary photographers, who were then largely unknown in Germany, was experienced through their widely published books and their visits to the workshop. Schmidt, reacting to the practice of German photographic trade schools designed to train photographers for applied photography, understood that the strong American infrastructure for photography was important to the future of German photography and that such an infrastructure could be created in Germany. Schmidt, born in 1945, confronted the wrenching and divisive effects of the war by making and nurturing work that would be expressive of the individuals of his generation.

Schmidt's project, *U-ni-ty (Ein-heit),* 1991–94 (plate 421), is represented by an installation view of photographs made in Berlin, where he lives. The work was done after the Berlin Wall came down and is a meditation on Berlin's condition as a newly united city, and one that is burdened with the weight of its historical past. As elliptical as the individual photographs may be, the sum is an overpowering montage evoking ineffable tensions and despair.

Thomas Florschuetz (plate 132) emigrated from East Germany in the late 1980s and lives in Berlin. Since he began photographing he has used himself as his subject, compiling diptychs and triptychs in which he rearranges close-up images of parts of his body into jarring juxtapositions evocative of neo-Expressionist art. The work is aggressive both through its monumentality and its intimacy. It also recalls European Performance art of the 1970s, especially the Vienna Actionists, whose extreme simulations of brutal self-mutilation were documented photographically.

In Great Britain the persistent division of classes created an insistent photographic anti-establishment that demanded a documentary tradition rooted in social change. As early as 1877–78, the photographs of John Thomson in his book, *Street Life in London*, documented the lives and work of the city's under-class. The work of Bill Brandt, who photographed his countrymen of all classes and conditions beginning in the 1930s, was of major significance to postwar documentary photographers. Such photography experienced a new life during the years that the conservative Margaret Thatcher was Prime Minister. Chris Killip, Paul Graham, and Martin Parr photographed the various rungs of England's social ladder. Killip's works (plates 246, 306), are a kind of bitter poem in which Newcastle is a place of unrelenting despair, where an irrevocable, unidentifiable social force has undermined the individual lives pictured. The cumulative expression of the reality of life in post-industrial England in his deeply original pictures is a political and personal cry of rage.

Paul Graham's work describes the boredom and frustration of people waiting in employment and social-service offices across Britain (plate 111). Often printed in large format and in color, his photographs are realistic depictions of demoralizing conditions. The use of color in social documentary photography is somewhat a case of "working against type." Black-and-white photography has traditionally been regarded as more "real"

than color, where the harsh "facts" of a situation are not softened through the seductive powers of appealing colors. In Graham's picture the garish colors of these well-worn government sites encourage us to accept the scene before us as a contemporary reality, not a historic abstraction.

The humor of Martin Parr's photographs (plate 261) is in sympathy with the British literary tradition of satirical writers such as Jonathan Swift and Evelyn Waugh, whose caustic wit lampooned England's social hypocrisy, landed aristocracy, and political institutions. Historically, social-documentary photography rarely focused on anyone but the poor or very rich. Parr's send-ups of Britain's middle classes are especially suited to description in color. The color charges his work with an energy descriptive of his subjects' contemporary vitality.

The French photographer Patrick Faigenbaum has photographed the Italian aristocracy in their homes since 1984 (plate 148). The people in his pictures, whose world is closed to most of us, are described as simultaneously available and distant. They often appear as small figures entrapped by the grandeur of the past and by the burden of their individual familial lineage.

Outside Europe, with the fall of the Soviet Union, pictures by Russian photographers critical of current social conditions and the former Soviet government have come to the fore. In the work of the Ukrainian Boris Mihailov, through a series of panoramic views we see a fallen population (literally and spiritually), victims of unemployment and alcoholism in his hometown of Kharklov, right after the fall of Communism (plates 313, 314, 315). This spontaneous moment, descriptive of a general cultural condition, is evocative of the work of the great French photographer Henri Cartier-Bresson and that of the Czech photographer Josef Koudelka.

One of the surprising aspects of much current European documentary photography—especially in relation to that of the United States—is that the Europeans seem to have reactivated and revitalized the potential of photographic description of the real world. While the Americans maintained a belief in and appreciation of what is traditionally called "documentary" photography well into the 1970s, many turned away from it mid-decade,

retreating to the studio to create their own worlds. Many European photographers, on the other hand, in returning to the origins of the medium, are confronting the world straight on and embracing it with updated tools (computers, color, and large-scale prints), despite its overpowering complexity and global scale.

The Vanishing Monument and the Archive of Memory | Roxana Marcoci

The question of memorialization has been salient in the thinking of the last half century. How do we remember the past? What role do public monuments play in mediating history and memory? In an era that resonates with the aftereffects of World War II, the Vietnam War, and the removal of the Berlin Wall, the need to recollect has intensified. Yet, paradoxically, the capacity of traditional monuments to preserve memories proves ever more precarious: considering that they either extol or absolve the deeds of history, monuments seal the process of remembering, thus reducing viewers to compliant observers. It is as if, James Young writes, once we ascribe "monumental form to memory we have to some degree divested ourselves of the obligation to remember."[1]

Post–World War II artists have systematically engaged in an aesthetic interrogation and implicit rejection of the monumental. Even as monuments continue to be commissioned, debates over how to probe the past from new critical perspectives have produced more active modes of memory-telling, fusing historical inquiry with an awareness of the ways history has been passed down to us.

The advent of "counter-monuments" (monuments conceived to undermine the premises of their own being) in the late 1960s constitutes an effective visual component to the period's protests over war and civil-rights issues. An early instance is Barnett Newman's *Broken Obelisk*, 1963–69, a twenty-six-foot-tall pillar forged on the unstable-looking tip-to-tip junction of an upright pyramid and an up-ended obelisk with a fractured shaft. Dedicated to Martin Luther King, Jr., following his assassination in 1968, the work at once represents

a conventional heroic form and reverses public expectations of it. A subsequent example is Robert Morris's *War Memorials,* 1970, a series of five lithographs conceived in direct response to the United States bombing of Cambodia in that year. Morris proposed a group of visionary monuments, each a colossal earthwork in the shape of a negative space: a crater, a trench, a star imprint, a nuclear-waste repository, and a void left behind by destruction.

Recent decades have seen the actualization of distinct negative-form memorials, particularly in Germany. Artists engaged in this practice, such as Horst Hoheisel or Jochen Gerz and Esther Shalev-Gerz, argue that no monument can better represent the conflicted motives of memory in contemporary Germany than a literally invisible or vanishing monument. In view of fascism's misuse of monumentality, their argument is especially appropriate to the antifascist memorial, but also holds true for the commemoration of other victimized peoples.

In his *Proposal for a Monument to the Survival of the University of El Salvador: Blasted Pencil (That Still Writes)*, 1984 (plate 95), an etching produced to protest Ronald Reagan's interventionist policies in Central America, Claes Oldenburg imagined a huge pencil as a monument, but presented it shattered, under erasure. Its point, however, is intact: this is a pencil "that still writes," and thus continues to tell its story. Memory survives uncensored.

Felix Gonzalez-Torres's *"Untitled" (Death by Gun)*, 1990 (plate 300), is a more particular analysis of violence, this time on the home front. Evoking the monolithic configuration of one of Donald Judd's Minimalist modules, the work is in fact transient, consisting of a stack of paper sheets that are steadily replaced as viewers, by invitation, take them away. On each sheet are printed the names of 464 Americans killed by guns

in a one-week period, along with their photographs and other personal data. Although commemorative, the piece is also unstable and exposed to a dissolution that lasts until the stack is created anew.

KCHO (Alexis Leyva Machado) makes sly references to historical monuments to address issues pertinent to the last quarter of the twentieth century, including problems of exile and cultural dislocation. *In the Eyes of History*, 1992–95 (plate 447), remakes one of the great propagandistic designs of Russian architecture, Vladimir Tatlin's never-realized *Monument to the Third International*, into a pragmatic, mock-functional coffee machine. In light of the special resonance Tatlin's model has in KCHO's homeland of Cuba, the work reads as a tongue-in-cheek response to the achievements of Soviet socialism and to the utopian promise of monuments generally. In *The Infinite Column I*, 1996 (plate 469), KCHO takes a different modernist icon, Constantin Brancusi's *Endless Column,* as the prototype of a thirteen-foot-high structure made of assembled bentwood frames which have in common the fact that they float: canoes, surfboards, kayaks, rowboats fully equipped with oars. Drawing on the imagery and construction methods of *balsas*, the homemade rafts that Cubans use to flee the island illegally, KCHO's flotilla serves as a trope for escape and freedom, referencing the mentality of migration.

KCHO rehashes the notion of the monument to explore the fluid, unbounded space that describes the "global condition of late modernity,"[2] while Rachel Whiteread turns to the notion of interiority, indeed, of the literal inversion of space, to dig into the pool of memory and collective history. Her casts in plaster, wax, rubber, resin, or concrete, which range from domestic objects to full-scale rooms (plate 398), convey a sense of history even as they signal human absence. *Untitled (Paperbacks)*, 1997 (plate 503), is the negative cast of a walk-in library, where row upon row of paperbacks, shelved spine inward, double as a mnemonic field. The installation is related to Whiteread's project for a Holocaust memorial in Vienna in the form of a book repository. Evincing the iconoclastic side of Jewish tradition, the library in this case is sealed, a solid cube sitting on a base inscribed with the names of all the concentration camps in which Austrian Jews per-

ished. Its proportions are based on the rooms of buildings near the city's old Judenplatz, where the memorial is to be sited. This square, like many others in Vienna, is pregnant with invisible memories, which recall the lives and culture lost to Nazi crimes.

Whiteread is not alone in formulating historical recollections on sites previously dominated by amnesia. Shimon Attie's haunting photograph of 1991, titled *Almstadtstrasse 43, Berlin, 1991 (1930)* (plate 316), one of many works in which archival images from the 1920s and 1930s are projected onto the buildings of Berlin's Scheunenviertel, the prewar Jewish ghetto, has the effect of disrupting the muteness of a conflicted neighborhood. Here, Jewish residents experience a return, but only as spectral beings to mark the site of destruction. While exuding a mood of Hollywood film noir, Attie's undertaking is deeply invested in the act of memory and archival reconstitution. However, the recovery of the past is never fully achieved. Although the archive to which Attie returns functions as a data bank, a storage for historical documents, it still cannot reconfigure conditions that have been irretrievably lost.

Significantly, Michael Schmidt's *U-ni-ty (Einheit)*, a photo-project made between 1991 and 1994 (plate 421) in response to the fall of the Berlin Wall, mixes 163 black-and-white photographs, some taken by the artist in a factual style, others culled from newspapers, propaganda journals, and related sources. In an effort to articulate the difficulties of constructing images of historical recollection in Germany today, Schmidt interfaces contemporary images of anonymous and notorious people, mass scenes, places, emblems, and monuments with archival ones. History is presented not as a linear sequence of events but as a decentered, simultaneous narration of separate and contingent frameworks. Having to determine personally whether a given image is taken in East or West Germany, prior to or after World War II, during division or since reunification, viewers begin to question the limits of historical representation.

Among contemporary artists focusing on the archive, and in particular on the sublimation of artifacts in the Holocaust archive, Christian Boltanski is the most controversial. In his early

work Boltanski invented "true" memories about his past using images of unidentified children to document his own childhood. In later installations, such as *The Storehouse*, 1988 (plate 201), he took signifiers of the Holocaust—blurry photographs, elegiac lamps, and hundreds of rusted biscuit tins containing cloth fragments—to overtly manipulate the viewer's emotions. The biscuit boxes are rusted to look old, the personal effects do not belong to Holocaust victims of concentration camps, and the Jewish adolescents in the prewar photographs may still be alive. His work succeeds to arouse emotions not because it relies on straight, documentary realism, but because it draws on the powers of suggestion and mediated memory.

Boltanski's representation of the Holocaust is based on recycled material. He typically rephotographs and enlarges his images, so that facial features are close-up, blurry, and less recognizable. Stylistically, these images come close to Gerhard Richter's murky, out-of-focus paintings of 1988 that comprise *October 18, 1977* (plate 210). Based on police snapshots of the incarceration and death of three young political radicals, members of the Baader-Meinhof group, the fifteen paintings replicate in minute detail, right down to their indistinct focus, the appearance of surveillance photographs. Both Richter and Boltanski turn the camera into a technology of incertitude. Richter confuses different orders of representation to undercut official history, while Boltanski suggests that postwar memory of the Holocaust is not first-hand but indirect, filtered through the altered lens of witness testimonies, films, photographs, and newsreel footage.

Similar views are expounded by Art Spiegelman, whose works convey the chilling memory of war and the Holocaust by fusing the facts of history with the reality of playthings in comic-book format. Spiegelman's comic book *Maus: A Survivor's Tale*, produced from 1980 to 1985 (plate 130), reconfigures the codes of war commemoration to create an intergenerational testimony. Composed of well over 1,500 drawings, *Maus* presents deportation and genocide as an allegorical saga between mice (Jews) and cats (Nazis). The narrative is constructed around two interlocking stories: one that recounts the artist's father's

attempts to survive the concentration camp in Auschwitz, and another that focuses on the artist's creative recording of his father's story. This is at once a work of history and autobiography that includes both events from the past and the present conditions under which they are remembered. The constant shifting from one register of recollection and narrative to the next grants renewed status to historical relativism. Throughout its narratives, *Maus* advances a particular paradigm for memory premised on acts of resistance against forgetting and of confrontation with an irrecoverable past.

notes

1. James E. Young, "The Counter-Monument: Memory Against Itself in Germany Today," *Critical Inquiry* 18, no.2 (Winter 1992): 273. See also idem, *The Texture of Memory: Holocaust Memorials and Meaning* (New Haven and London: Yale University Press, 1993), and *At Memory's Edge: After-Images of the Holocaust in Contemporary Art and Architecture* (New Haven and London: Yale University Press, 2000).
2. Douglas Fogle, "Volatile Memories," in *No Place (like Home)* (Minneapolis: Walker Art Center, 1997): 118.

Relentlessly Transparent | Terence Riley

The contemporary interest in transparency in architecture and design in work of the last two decades has a rich theoretical and artistic lineage.

In 1976 the architectural historians Colin Rowe and Robert Slutzky published "Transparency: Literal and Phenomenal," an essay in which a critical distinction was made between what they called "phenomenal transparency" and "literal transparency."[1] This dialogue favored the former, which was a theoretical transparency of forms, in the manner of a Purist composition, as opposed to actual material transparency, as in a glazed structure. The influence of their ideas on architectural theory was immediate and substantial, and it indicated the extent of the architectural community's disenchantment with glass architecture. This was acknowledged two years after the publication of "Transparency" in the form of an ironic collage by the Chicago architect Stanley Tigerman that shows Ludwig Mies van der Rohe's 1950–56 Crown Hall on the IIT campus in Chicago sinking, Titanic-like, into Lake Michigan.

Nearly half a century earlier, Mies's colleague, the German functionalist Ludwig Hilbersheimer, noted that Joseph Paxton's 1851 Crystal Palace in London, the first completely glazed structure, had "obliterated the old opposition of light and shadow, which had formed the proportions of past architecture. It made a space of evenly distributed brightness; it created a room of shadowless light." In contrast to the functional beauty he saw in Paxton's masterpiece, Hilbersheimer decried its contemporary use: "Glass is all the fashion today. Thus it is used in ways that are frequently preposterous, having nothing to do with functional but only formal and decorative purposes, to call attention to itself."[2]

By the time Rowe and Slutzky had published their essay, it would have been hard to say that glass, as a building material, enjoyed fashionable status. Whatever novelty might have been associated with it had long receded, as its use proliferated in the banal office towers built in the 1950s and 1960s throughout the world. By 1976, literal transparency had become a straw man in Rowe's and Slutzky's polemic, which became particularly potent in the architectural ferment of the post-1968 generation, whose rhetoric reviled glass boxes as the symbol of the architectural status quo.

Their arguments became the underpinnings of the formalist revival of the reputation of the radical modernist architect Le Corbusier in the work of the New York Five: Richard Meier, John Hedjuk, Peter Eisenman, Charles Gwathmey, and Michael Graves. Even as Rowe revived interest in Le Corbusier's Neo-Plasticism, he repositioned this master's work in a historicist manner in his essay "The Mathematics of the Ideal Villa," validating the more frankly traditional work of Robert Venturi, Robert A. M. Stern, and Philip Johnson— soon to follow that of the New York Five.[3]

Ironically, the ensuing excursion into the postmodern debates of the 1970s and 1980s seems to have provided the basis for the rediscovery of literal transparency in contemporary architecture and design. The sudden and extended renewal of interest in materially transparent structures and objects is notable for several reasons, not least of which is the originality of the work that was produced. While Mies's name is increasingly invoked, the current fascination with the glass box has successfully avoided the taint of revival.

Part of this renewed interest can be traced to the delight in new technologies that were only

recently available to designers and architects. Donald T. Chadwick's and William Stumpf's Aeron Office Chair, 1992 (plate 375), with its see-through "pellicle" seat and back and Bob Evans's Tan Delta Force Fin, 1994 (plate 434), cast in translucent and colored resins, both prominently utilize new processes and materials that seduce the eye with their ability to dissolve the boundaries between the solid and the transient. Shiro Kuramata's How High the Moon Armchair, 1986, constructed of perforated metal, appears to be the ghost of itself (plate 143).

The current fascination with transparency is also characterized by a rejection of absolutes and a greater sense of subtlety. Jean Nouvel's description of his Cartier Foundation for Contemporary Art in Paris, 1992–93, as haze and evanescence, describes a path beyond phenomenal or literal transparency (plate 397). Recognizing that glass is often as reflective as it is transparent, Nouvel speaks to the layering of images more familiar to the multiple exposures of the photographic eye or thin skeins of paint that lie one over the other.

Similarly, Rem Koolhaas's 1989 competition design for the National Library of France evinces little interest in the notion of absolute transparency (plate 247). Rather, the building seems to have a stronger conceptual relationship to the famous three-dimensional representation of the human body first exhibited at the German Hygiene Museum in 1930 than to a glass box. In both the museum's anatomical study and Koolhaas's design the "skin" is made of glass, allowing for a study of the internal organs. In the case of the former, the organs are the lungs, heart, liver, etc.; in the case of the latter, the revealed "organs" represent the principal interior functions suspended within an architectural body. The modernist metaphor of the relationship between architecture's "skin and bones" is here reworked: whereas Mies saw the glass skin as infill to the structural frame, Koolhaas's design follows a more anatomical model. In the National Library, the skin is a continuous membrane and the structure—the skeleton—is found within, as in a human body. Furthermore, the skin is inscribed with images of the exterior world, as images of clouds are "tattooed," if you will, on the structure's skin. The idea that the architectural skin might be a surface embedded with information,

rather than simply a climatic barrier, can be further seen in Herzog & de Meuron's Ricola Europe Factory and Storage Building, 1993 (plates 389, 390). Here the architects applied reproductions of Karl Blossfeldt's nineteenth-century photographs of plants—representing the herbs used to make the pharmaceuticals—in a screenlike pattern that alternately allows and blocks vision and light.

Mies van der Rohe's 1946–51 glass-and-steel Farnsworth House in Plano, Illinois, was conceived as a platform for contemplation of the outside world, a place from which to view outward, in contrast to a directed "gaze," or vision, that establishes a relationship of desire between the viewer and the subject. The current revitalization of the glass box as a formal type displays significant evidence of the difference between the objective and subjective viewpoints. This is, no doubt, related to its potential for creating relationships between viewers and subjects. The contemporary glass box, therefore, is no longer simply a place from which to look out but a screen that allows an exchange of views, as in the Ricola factory, a constant engagement with the world.

The same attitude is evident in the world of contemporary design, where Antonio Citterio's and Glen Oliver Löw's Mobil Container System, 1993 (plate 396), or Enzo Mari's Flores Box, 1991 (plate 332), contain, but do not remove from sight, the objects they hold. Architectural in their conception, both receptacles hold objects out of the way but not out of sight; the objects remain veiled presences, like the "organs" of Koolhaas's library, partially visible through their thermoplastic polymer walls. The appeal of this visual phenomenon may be discerned in the words of the literary critic Jean Starobinski: "The hidden fascinates. . . . Obstacle and interposed sign, [the] veil engenders a perfection that is immediately stolen away, and by its very flight demands to be recaptured by our desire."[4]

The "skin-and-bones" interpretation of the glass box favored not only a sense of absolute transparency but also—in Miesian architecture—an exposition of structural clarity. Toyo Ito's 1995 Mediathèque Project in Sendai, Japan, with its writhing trunklike supports, suggests that alternate structural readings are not only possible but also highly provocative (plate 446). Here, the classical repose of the trabeated pavilion gives way to

a dynamic expressivity that emerges from within, casting the building's glazed membrane as a screen through which the viewer sees an interior landscape.

Starobinski's sense of the subjective gaze lends itself to the idea of "mediated" vision. The idea that an interposed veil, or screen, conditions the viewer and subject alike cannot easily be separated from the world's burgeoning media sensibility. Elizabeth Diller's and Ricardo Scofidio's Slow House, 1989, removes any distinction between the transparency of glass and the transparency of digital media (plate 238). Oriented to a bayside view, the "picture window" is combined with a monitor that captures the same panorama. Similarly, Joel Sanders's 1991–95 project for the Kyle Residence in Houston interposes the small screen of the television with ersatz "vistas" of the American suburban landscape (plate 450). Both projects conflate the notion of a traditional landscape view and that of the global media landscape.

The connectedness of media culture is apparent in other design disciplines as well. In their overlapping layers of color, type, and images, the posters produced by the graphic design group cyan, such as *Foundation Bauhaus Dessau*, 1995, display a digital ecstasy that fuses the near and far and the now and then (plate 455).

If the notion of literal transparency has been vastly expanded, so, too, has the notion of phenomenal transparency. Indeed, Rowe's and Slutzky's definition of solid forms as intellectually transparent has roots that predate Le Corbusier's work of the 1920s. For example, the nineteenth-century Prussian architect Karl Friedrich Schinkel's design for the Schauspielhaus in Berlin, 1821, encouraged the audience to think of the proscenium as a window on the city beyond, going so far as to paint a view of Berlin on the curtain itself. And in Paris Henri Labrouste's Bibliothèque Sainte-Geneviève, 1843–50, bears across its facade the names of famous authors, a device that resounds with new meaning when it is realized that the names appear precisely in front of the library's bookshelves within—a marvelous example of a building's transparency even if made of stone.

The contemporary architect Tadao Ando's Church of the Light in Osaka, 1984–89, might also be seen in this manner (plates 265, 266, 267). Ando's affinity for simple cubic forms gives the viewer a prefiguration of the interior space. Judiciously placed openings in smooth concrete walls, in this instance a window in the shape of a cross, further open the opaque volume to spatial comprehension by the mind if not, completely, by the eye.

Herzog & de Meuron's Signal Box in Basel, 1988–95, further explores the notion of an intellectually transparent building (plate 451). Housing miles and miles of cable that regulate the complex movement of thousands of train cars and engines, the Signal Box is covered in ribbons of copper sheathing. The effect is compelling aesthetically but also gives visual expression to the structure's use: the cables within are, in fact, also made of copper. A similar reading of form and material might be applied to Renzo Piano's Kansai International Airport in Osaka, 1988–94 (plate 410). The shimmering, sensuous undulation of the roof and the complex trusses that support it need no justification beyond their beauty. Yet, it is all the more satisfying to know that the profile of the roof is meant to act as conduit for the blasts of cooled air that are projected into the space. In fact, the shape is derived from that of a gust of air, making visible an otherwise unknowable form.

Rody Graumans's 1992 design for the 85 Lamps Lighting Fixture, features eighty-five standard household lightbulbs suspended from ordinary electrical cable and insists on the absence of embellishment (plate 365). Shiro Kuramata's seductive Miss Blanche Chair, 1989 (plate 253), in which plastic roses are embedded in an acrylic seat and back, might be seen in the same way. Named after the tragic Blanche Dubois in Tennessee Williams's play *A Streetcar Named Desire*, the chair is a sensual send-up of the pretentiousness not only of its namesake but also of the omnipresent chintz in traditionally decorated houses.

The current fascination with transparency, in all its myriad forms, would suggest that Rowe's and Slutzky's attempts to parse out polarizing distinctions between the "literal" and the "phenomenal" may have missed a much larger point by failing to discuss the fact that, throughout the twentieth century, the relentless pursuit of the revelations afforded by transparency has been a constant theme that has defined the genesis, growth, and revitalization of modern architecture.

notes

1. Colin Rowe and Robert Slutzky, "Transparency: Phenomenal and Literal," in Rowe, *The Mathematics of the Ideal Villa and Other Essays* (Cambridge, Mass.: MIT Press, 1976): 221.
2. Ludwig Hilbersheimer, "Glassarchitektur," *Die Form* 4 (1929): 522.
3. Colin Rowe, "The Mathematics of the Ideal Villa," in idem, *The Mathematics of the Ideal Villa and Other Essays*.
4. Jean Starobinski, "Poppaea's Veil," in idem, *The Living Eye* (Cambridge, Mass.: Harvard University Press, 1989): 1.

We're No Angels: Recent Violent Movies | Joshua Siegel

At a time when high body counts, great volumes of spilled blood, and sensational special effects have earned movie violence the opprobrium of many viewers, it should be remembered that the cinema has always been violent—that it was born violent. *The Execution of Mary, Queen of Scots*, a kinetoscope made at the Edison Studio in 1895, used stop-motion to flaunt the queen's severed head, and the first movie Western, Edwin S. Porter's *The Great Train Robbery,* 1903, culminates in a bandit firing his six-shooter directly at the audience.

The suspicion of a causal connection between watching violent films and acting violently has also existed since the early days of cinema. In 1909, the Supreme Court of Illinois upheld a Chicago ordinance requiring movie exhibitors to get a permit from the police, ruling that Westerns such as *The James Boys* and *Night Riders* "portray exhibitions of mischief, arson, and murder [that] would necessarily be attended with evil effects on youthful spectators."[1]

Of course, today's technologies have rendered movie violence far more convincing and visceral. Old masters of the war film like Lewis Milestone, the director of *All Quiet on the Western Front*, 1930, and G. W. Pabst, the director of *Westfront 1918,* 1930, did not have the Steadicams that enabled Stanley Kubrick in *Full Metal Jacket,* 1987, and Oliver Stone in his Vietnam war trilogy, 1986–93, to thrust the viewer into the chaos of a firefight. Nor were there digital sound effects that can evoke the cacophony of battle with such harrowing immediacy (earth-trembling napalm blasts, hollow-tipped bullets shattering bones, a dying soldier's blood-sputtering gasps).

There is a seeming contradiction in our present relation to such violence. While war itself now seems to come to us through distanced images, packaged as tidily and as neatly as a Nintendo video game, we still go to the movies expecting, even craving, a full-fledged assault on our senses. This paradox has contributed to the fear that society has become even more prone to violence as it has become less sensitive to its consequences. Now, perhaps more than ever, the entertainment industry is accused of using violence irresponsibly. Lawsuits against the movie studios have proliferated, most notably cases in which victims' families blamed Oliver Stone's *Natural Born Killers* for a rash of killing sprees in the mid-1990s. Recently, President Clinton called on federal agencies to investigate the selling of violent media to children, film being only the oldest of its many siblings in the larger media culture. Under such pressures, and trying to stave off the loss of income from costly legal battles and national boycotts, the entertainment industry has agreed to music labels, a television ratings system, refinements in the movie ratings system, V-chips, and Internet regulation.

Still, despite hundreds of studies, the deleterious effects of film violence have not been proven. Moreover, discussions of film violence have been muddled by an assumption that all violence in cinema is the same, motivated by the same impulses and pursuing the same goals. Of course, there is a certain sameness to all film violence. With a keen eye on box-office receipts, Hollywood studios have continued to breed scripts for their familiarity, using codified narrative genres and favoring myths so clearly drawn that audiences can be sure to get what they paid for. Filmmakers have always known that crime pays handsomely, particularly if spiced with a lot of sex.

But a closer examination of recent films reveals that the contemporary use of violence has actually been a complex and varied matter—certainly more so than the public debate usually allows. Most violent films made since 1980 may be viewed in terms of three principal types: *violence shaped by myth,* which either fulfills or critiques the fantasies underlying political realities; *violence that bears witness* to some injustice in the hope of changing it; and an *aestheticized violence* that does not invite an audience's sense of grief or pity so much as its fond recognition of familiar movie formulas.

Violence Shaped by Myth

The genres that cinema has most successfully created or reinterpreted—gangster melodramas, Westerns, war epics, Biblical spectacles—use violence to illuminate character and to further narrative drive, usually culminating in a denouement that preserves or restores society's moral codes. This tradition of cinematic violence continued in the 1980s and 1990s in such films as George Miller's *Mad Max 2*, 1981, and Ridley Scott's *Blade Runner*, 1982, dystopic fantasies that gave new currency to the old movie icon of the renegade antihero who must become an outlaw in order to defeat one (plates 43, 60).

The lopsided American invasion of the Caribbean island of Grenada in 1983 is the barely camouflaged subject of Clint Eastwood's *Heartbreak Ridge,* 1986, another mythmaking film that seemed to capture the anxieties and longings in the contemporary political climate (plate 168). Eastwood plays a Marine sergeant once decorated for his bravery in Korea and Vietnam, now scorned as an anachronism. Because the modern army knows nothing of war, Eastwood alone is capable of turning a bunch of ragtag soldiers into an efficient platoon. After leading them in a heroic rescue of American medical students held hostage on a Latin American island, Eastwood picks a Cuban cigar off a dead enemy soldier and lights up, apparently satisfied that after one loss (Vietnam) and one tie (Korea), America has just evened the score.

Whether made in Hollywood or abroad, films of this period also extended the use of violence to fulfill a wish to symbolically vanquish "the others"— alien types who seemed to be corrupting the world

on their way to taking it over. The British director Ridley Scott's *Blade Runner* envisioned a future Los Angeles where crime and overcrowding have driven the wealthy elite to offshore colonies, leaving a non-English-speaking people to live like animals. Beneath the shadows of protofascist skyscrapers lies a labyrinth of neon-drenched streets teeming with the cacophony of a modern-day Tokyo. Harrison Ford, the reluctant hero, is summoned to hunt down and kill a group of genetically engineered artificial humans— including a particularly nasty one who has crushed his creator's skull with his bare hands—before they find the key to immortality and render humanity obsolete.

The Australian director George Miller's *Mad Max 2 (The Road Warrior)* is a postapocalyptic fantasy in which a psychotic band of savages lays siege to a group of settlers in a war over precious fuel. We know the enemy is unholy and deviant by their animal hides and motorcycles (like gay bikers) and from their Mohawks and war paint (like "Indians" or punks). One of their leaders calls himself the "Ayatollah of Rock-n-Rolla," and they hoard oil. It befalls Mel Gibson as the Road Warrior, once a family man before his wife and child were murdered, now a gun-toting nomadic mercenary, to rescue the settlers and lead them across the desert to "Tomorrow-morrow" land, where they can build a utopia founded on democracy and a capitalist free-market system.

Yet Hollywood in the 1980s also had its share of movies that tried to counter the tide of jingoist, wish-fulfillment films by using violence to shatter myths. In counterpoint to fanciful visions of avenging angels and glorifications of American invincibility were Kubrick's *Full Metal Jacket*, 1987, and Oliver Stone's war trilogy, *Platoon,* 1986, *Born on the Fourth of July,* 1989, and *Heaven and Earth,* 1993, all of which reopened the wounds of Vietnam (plates 169, 170, 244). In the sadomasochistic boot camp scenes of *Full Metal Jacket,* Kubrick illustrates with pitiless fascination how the military makes killing machines out of young men. Ron Kovic, the real-life protagonist of Stone's *Born on the Fourth of July*, went to Vietnam with dreams of glory but returned home at twenty-one paralyzed from the waist down. As a boy growing up in conservative suburbs, Kovic would pretend

he was John Wayne in *The Sands of Iwo Jima*, 1949. Now, confined to a wheelchair in a rat-infested Bronx Veterans' Hospital, he grows sick at the sight of *The Green Berets*, 1968, on television. The myth and the reality didn't match.

Violence as Witness

Some recent directors, particularly those of the Third World, have followed the neorealist tradition of using film as an instrument of social change by exposing the brutal realities of ghetto life, racial violence, and class warfare, and by embedding their militancy in colorful storytelling. In *They Don't Wear Black Tie*, 1981 (plate 25), the Brazilian director Leon Hirszman chose as his subject the violent industrial strikes of the late 1970s that were ground zero for the overthrow of the military dictatorship that had ruled since 1964. The harshest films of slum life—Vittorio DeSica's *Shoeshine*, 1946, Luis Buñuel's *Los Olvidados*, 1950, and Héctor Babenco's *Pixote*, 1980 (plate 26), among them—are devoid of romance. Babenco discovered Fernando Ramos da Silva, the young boy who would play Pixote, among the three million children living on the streets of São Paulo, who are forced to steal, turn tricks, deal drugs, even kill for a scrap of food. Fiction is bred from fact: several years after the film became an international success, its star, da Silva, was murdered by the police. The slum devours its own children.

Social-realist filmmakers in developing nations contend that until true democracy has been achieved, their art belongs to a larger struggle for justice. One of these artist-activists, the Filipino director Lino Brocka, insisted that it was only by going into the streets with his camera that he could attend to society's oppressed and counteract the obfuscations of government-controlled media. Because he made movies for what he fondly called "the Great Filipino Audience," Brocka would coat his polemics with the dangerous eroticism of Hollywood noir and melodrama. The title character of *Bona*, 1980, is an eighteen-year-old girl who abandons her middle-class family to slavishly serve a bit movie actor in the slums (plate 13). When her lover threatens to leave for America with his new girlfriend, she scalds him with a pot of boiling water, knowing that his departure will leave her

with nothing—almost an illustration of the Filipino saying, "A desperate man will hold on even to a double-edged knife."

In the United States, Spike Lee ignited a storm of anger and concern with *Do the Right Thing*, 1989 (plate 245). Many critics argued that Universal Pictures was fomenting fears of a race riot by releasing the film on a hot summer weekend, not unlike the one Lee represented. Throughout the summer of 1989 audiences and critics debated whether the film was indeed incendiary, or whether it was an articulate, angry protest against racism in America. Much of the controversy centered on a climactic riot scene in which black teenagers burn down a pizzeria that has served the Bedford-Stuyvesant community for twenty-five years. Lee maintained that he drew inspiration from actual incidents of white-on-black violence, and he was distressed that most critics ignored this point.

Aestheticized Violence

Some contemporary directors have dispensed with questions of morality or character motivation in favor a hyperstylized self-referential violence that plays ironically with the language of filmmaking. The reference point of their violence is not so much the world of history as the history of cinema itself.

The violence in Stanley Kubrick's *The Shining*, 1980 (plate 1), derives from countless other horror films. While acting as the winter caretaker of an isolated hotel, an author is driven to hunt down his wife and child with an axe. The roots of his violence are contemporary criminal defense arguments: whisky or writer's block, cabin fever or a haunted past.

Quentin Tarantino brings Pop sophistication to genre filmmaking. His *Pulp Fiction*, 1994 (plate 408), became known as the film that launched a thousand imitations, all similarly modeled on a structure of interconnecting narratives featuring cartoonish gangsters and their molls. Tarantino laced his film with references to earlier movies such as Robert Aldrich's *Kiss Me Deadly*, 1955, Gordon Parks's *Shaft*, 1971, and John Badham's *Saturday Night Fever*, 1977. *Pulp Fiction* may be rife with all manner of rape, torture, ritual execution, and gunplay, but since everything is

wrapped in quotation marks and Tarantino's tongue is so firmly planted in his cheek, he gets away with it. One reviewer safely described the killings and breaking of fingers committed by the film's main characters as "occupational banalities."[2] The hitmen disarm us with charm and wit. "Come on, let's get into character," Samuel L. Jackson says to John Travolta before they murder a couple of college students.

Fugitive love and the fetishism of violence are driving concerns in Kathryn Bigelow's and Monty Montgomery's *Breakdown (The Loveless),* 1983, a chrome-and-leather look at Beat bikers in the late 1950s and a story of incest that leads to patricide and suicide (plate 76). Drawing on the iconography and idolatry of Pop culture, they make references to Marlon Brando in *The Wild One,* 1953, and Kenneth Anger's *Scorpio Rising,* 1963, among others.

Martin Scorsese's *Raging Bull,* 1980 (plate 9), adopts the arc of classic Hollywood narrative to tell the story of Jake LaMotta, who rose out of the mean streets of the Bronx by pummeling his way to the world middleweight championship. Scorsese consciously emulates the gritty realism of George Bellows's paintings and boxing movies like Robert Rossen's *Body and Soul,* 1947. One critic described *Raging Bull*'s ring scenes as having "a cataclysmic beauty that deepens the terror"[3]— the terror being the violence that begins in the home. In Scorsese's darkest view of the Italian immigrant experience, family life cannot be purged of its violence any more than of its quotients of guilt and self-loathing.

The violence of Hong Kong action movies rests on surface spectacle, an athletic aestheticism. Action sequences are outrageously choreographed to resemble MGM musical numbers. Bullets fly and bombs detonate in crowded buses, restaurants, even churches and maternity wards. Everything is at the service of speed, in the manner of Road Runner cartoons and Douglas Fairbanks adventures, except when Sam Peckinpah's slow-motion bullet ballets are evoked. Underlying the overwrought melodrama of John Woo's *The Killer,* 1989 (plate 250), is the theme of fraternal loyalty: Chow Yun-Fat is a hitman who discovers that he lives by the same code of honor as the renegade cop who stalks him.

With box-office receipts higher than ever, film endures as our most important repository of archetypes, formulas, and signs that are so innate to our collective unconscious as to constitute a second language. It is not enough simply to ask whether the cinema has exceeded all bounds of morality by satisfying our lust for violence. We must also ask whether the cinema has fulfilled its original aesthetic and political purpose: to convince us that we are what we seem. "The cinema . . . aims at transforming the agitated witness into a conscious observer," Siegfried Kracauer wrote in 1960. "Nothing could be more legitimate than its lack of inhibitions in picturing spectacles that upset the mind. Thus it keeps us from shutting our eyes to the 'blind drive of things.'"[4]

notes

1. Garth S. Jowett, "'A Capacity for Evil': The 1915 Supreme Court *Mutual* Decision," in Matthew Bernstein, ed., *Controlling Hollywood: Censorship and Regulation in the Studio Era* (New Brunswick, N.J.: Rutgers University Press, 1999): 22.
2. Desson Howe, "Pulp Fiction," *Washington Post* (October 14, 1994).
3. Jack Kroll, "DeNiro's Bronx Bull," *Newsweek* (November 24, 1980): 128–29.
4. Siegfried Kracauer, *Theory of Film* (Princeton, N.J.: Princeton University Press, 1960): 58.

Size Specific | Lilian Tone

Q: *Why didn't you make it larger so that it would loom over the observer?*
A: *I was not making a monument.*
Q: *Then why didn't you make it smaller so that the observer could see over the top?*
A: *I was not making an object.*

— Tony Smith, responding to questions about his six-foot steel cube.[1]

One knows immediately what is smaller and what is larger than himself.

— Robert Morris[2]

The issue of scale, from the minuscule to the massive, has been of prime concern to many artists in the past decades, and it acquires renewed relevance as technological media assume greater importance in our daily lives. Increasingly, our access to works of art takes place through a world of reproductions—in books, posters, postcards, and electronic media—radically transforming the experience of art. André Malraux postulated the notion of a "museum without walls," a collection of artworks found not in the physical reality of the gallery but in the artificial space of the book page, subject to the laws of photography. Not surprisingly, this change in vehicle and format has dramatically altered our apprehension of artworks. Malraux wrote that "reproduction (like the art of fiction, which subdues reality to the imagination) has created what might be called 'fictitious' arts, by systematically falsifying the scale of objects;

by presenting oriental seals the same size as the decorative reliefs on pillars, and amulets like statues."[3] Perceptually, any expression of a work's three-dimensionality is mitigated in reproduction; the work is turned into a flat image that does not convey the quality of its texture, the intensity of its color, the extent of its depth, or the expressive potential of its scale. In this museum of images, miniatures may be perceived as colossal, and the viewer may notice details that the artist never intended to highlight. The reverse may happen as well: paintings intended to envelop the viewer as expansive fields of color when experienced in person might come across in books as mere color chips. Additionally, new visual hierarchies set up unprecedented relations: on the printed page, graphic components are rendered more evident, and the totality of the work also becomes more easily graspable. In any case, the original's relation to the viewer's body is negated.

In reaction to this, the growing prevalence of the disembodied artistic experience may have contributed to an increased interest in the ways in which only the real-life object can affect the viewer. Contemporary artists have manipulated scale and explored magnification and miniaturization—both widely employed in digital technologies—as a conscious means of expression. A paradigmatic precedent is René Magritte's *The Listening Room*, 1952. Following the devices of Surrealism, it induces unease by manipulating the relative size of a commonplace object within the confines of an otherwise ordinary room. A huge apple claustrophobically crowds the depicted space in a disturbing distortion of normal dimensional relations. But in the last few decades, instead of altering scale within the limits of the picture, artists have generated disruptive extremes of size, not in the fictive space of the canvas but in the actual space

shared by objects and their viewers. In direct confrontation with the viewer's body, the object proposes unexpected relationships, inducing a heightened state of spatial awareness, a sense of uneasy familiarity, or other potentially uncanny states of mind. If Abstract Expressionism, while signaling the movement toward a more public practice, resorted to expansiveness to generate a sense of envelopment, Pop art and Minimalism self-consciously engaged scale for very different purposes. Certain emblematic examples of Pop art, such as Claes Oldenburg's playful and outsized soft versions of ice-cream cones, cakes, and common-place objects, and James Rosenquist's gigantic images, draw their resonance from the scale of mass-culture advertising, particularly as seen in outdoor billboards and window displays. For Minimalists, scale was also a prime concern, relying on the viewer's experience of concrete physical objects as they relate to the viewer's body, on the one hand, and the surrounding space, on the other. As Carl Andre remarked, "I have come to the conclusion that perhaps the only single thing that art has is scale—something which has nothing at all do with size."[4]

Several works of contemporary art in the Museum's collection speak to the issue of scale in distinct ways, from manipulating expected dimensions to representing things in a one-to-one scale. At one extreme of scale disruption, for instance, is Robert Therrien's *No Title,* 1993 (plate 393). It consists of an oversized wood table appearing to emerge from the corner of a room, with only one of its legs protruding from the wall. *No Title*'s gigantism belies its generic appearance. Over nine feet high, it has a quasi-architectural impact: the viewer can walk under it, look up at it, be sheltered by it. A crucial transitional work in Therrien's career, *No Title* marks the use of several new practices. From this point on, Therrien's work becomes larger, less abstract, and more assertively three-dimensional. While evoking a child's vantage point, *No Title,* in fact, derives from Therrien's use of photography to register usual objects from unusual points of view, unhinging our customary surroundings and de-stabilizing a once familiar world.

Like Therrien's *No Title,* Vito Acconci's *Adjustable Wall Bra,* 1990–91 (plate 326), is so outsized that it becomes, in the artist's words, "part of the room's architecture—it's made like a wall and functions as part of a wall, like a wall on top of and bulging out from the existent wall." An enormous brassiere made of metal lathe, *Adjustable Wall Bra* constitutes an entire environment, complete with a light and sound system. Its cups are covered with a rough coat of plaster and lined with canvas, and contain the sound of steady breathing emanating from built-in speakers. *Adjustable Wall Bra* can be flexibly adapted to a number of given architectural configurations: against the wall, turned away from it, pushed into a corner, against the wall and the floor, or against the wall and the ceiling; but in all its possible incarnations, it can function as both shelter and seat, providing a support system that accommodates the viewer's body while leaving the mind unsettled. "I want to put the viewer on shaky ground, so he has to consider himself and his circumstances," commented Acconci.

Certain contemporary artists have addressed the issue of scale in exacting, literal ways, creating works in a one-to-one relation with the object being represented. With varying degrees of similitude, these works pose as slightly twisted duplicates of the real. Often painstakingly manufactured, they undermine absolute notions of true and false, bridging the distance between the authentic and the artificial. From Andy Warhol's *Brillo Box (Soap Pads),* 1964, to Jeff Koons's *Baccarat Crystal Set,* 1986, these are works whose identities and allegiances shift from props to doubles, stand-ins to facsimiles, and whose insistent theatricality often tricks the viewer's perception. Although these works obviously share a keen affinity with Marcel Duchamp's Readymades, they are not unmanipulated found objects, though they may look that way. Like Readymades, these works raise questions about where life ends and art begins, but their handcrafted aspect and artistic materials, following the footsteps of Jasper Johns's ale cans, lightbulbs, and flashlights, seem to imply a desire to feed the paradox of appropriating something from the world while engaging the language of art. Ironically, they are handmade ready-mades.

Robert Gober's humorous yet often macabre incursions into domesticity have included sinks,

beds, plywood sheets, bundles of newspaper, bags of kitty litter, and body parts rendered in actual size. In *Cat Litter,* 1989, the artist celebrates the informal nature of daily life by personally making a prosaic reminder of its everyday chores (plate 263). The work may pass for the real thing from a distance, though nothing is done to disguise the unmistakable signs of human manufacture. The lettering and other graphic elements are all quirkily hand-painted on plaster, counteracting any expectation of slick, industrial packaging. Adding a certain ambiguity to its already uncertain artistic status, *Cat Litter* sits directly on the floor, leaning against the wall nonchalantly, much as a bag of litter might be placed in a house. Gober has said, "For me the kitty litter was to a large degree a metaphor for a couple's intimacy."[5]

More illusionistic in appearance, Tom Friedman's Untitled, 1995, shares with *Cat Litter* the ability to disconcert viewers while challenging preconceived definitions of art (plate 442). Untitled is composed of two elements: a house fly meticulously constructed out of plastic, hair, fuzz, Play-doh, and wire, and a white cube made of painted wood, built like an ordinary pedestal. Owing to its realistic size and intricate craftsmanship, the fly occupies a space that vastly exceeds its size. Perched on the edge of the white cube, it speaks of the absence of conventional sculpture. Is this a pedestal under a sculpture of a fly, or a minimalist sculpture on which a fly happened to land? Reiterating Friedman's recurrent interest in scale, process, and perception, Untitled is ultimately an exercise in looking that rewards intense observation.

If perceptual double-takes are a likely response to works like Gober's *Cat Litter* or Friedman's Untitled, both of which produce a kind of three-dimensional *trompe l'oeil* in their realistic scale, a work like Charles Ray's *Family Romance,* 1993, through an equally simple scale operation, produces a delayed reaction of a different kind (plate 402). As described by the artist, this work is "a nuclear family, the dad is forty, the mother is thirty, the son is like eight, and the daughter is four. They are all naked, holding hands, but I am taking them all to the same scale, four feet three inches. So the children have come up and the parents have come down. . . . The politics are

dead through scale, all leveled out at the same height." The title, *Family Romance*, is a Freudian concept related to the Oedipus complex that refers to the fictional story that a boy tells himself to reinvent his family origin, his real family replaced by an imagined one. The family that Ray reinvented is not only bluntly sexualized (given the four mannequins' frontal nudity), but levels traditional hierarchical structures, based on age and gender, within the family unit. And it does so by equating each member's stature, thereby not only disrupting our conventional assumptions of balance and parental power, but also our tendency to correlate size with significance. *Family Romance* points to something that all the works mentioned above suggest, namely that scale matters, and that it would be a blunder of considerable size to mistake Malraux's "fictitious arts" for actual works of art.

notes

1. Quoted in Robert Morris, *Continuous Project Altered Daily: The Writings of Robert Morris.* (Cambridge, Mass., and London: MIT Press, 1993): 11.
2. Ibid.
3. André Malraux, "Museum without Walls," *The Voices of Silence.* Trans. Stuart Gilbert). (Princeton: Princeton University Press, 1978): 24.
4. Carl Andre, (press release, April 12, 1973) for the exhibition *Projects: Carl Andre ("Waterbodies"),* The Museum of Modern Art, New York, April 21–May 13, 1973.
5. Richard Flood, "Robert Gober: Special Editions, An Interview," *Print Collector's Newsletter* 21, no.1 (March–April 1990): 9

Wednesday's Child | Kirk Varnedoe

Contemporary art is rife with images of childhood and adolescence, often of an unsettling flavor. Jeff Koons's armored toys (plates 137, 158), Laurie Simmons's dollhouse photographs (plate 242), Kristin Lucas's video self-dissections (plate 486), and Mona Hatoum's pipette crib (plate 414) each contribute to what seems a darkling phase of modern culture's ongoing obsession with the world we all leave behind us.

Faith in the superiority of childhood, as a time of uncorrupted perception and unimpeded creativity, was a foundation stone of progressive aesthetics in the early twentieth century. But modern artists often talk about absolutes while trafficking in ambiguities, and their rhetoric about infantile purity was shadowed from the outset by their fascination with the impure state of adolescence, whose power to discomfit derives as much from its proximity to adult life as from its still "uncivilized" distance. A prominent French historian, Phillipe Arlès, has argued, in fact, that the seventeenth century's concern with youth, transmuted into the nineteenth century's idealization of childhood, was supplanted in the twentieth century by the "invention" of adolescence as a separate age. Freud's speculations on children's sexuality played a central role in that new body of thought, blurring the line between early and adult experience, and powerfully desanctifying the idylls of life's beginnings that had descended from the age of Wordsworth and the Romantics. On the broader level of popular culture, this focus on the special significance of the "in-between" stage of passage from child to adult—and with it a wary concern—has continued through the worlds of juvenile delinquents and mall rats to the slackers and hackers of the recent century's turn; and in the twentieth century's final decades, a vast body of film, from *Rebel Without a Cause* to *The 400 Blows*, with Satyajit Ray's Apu trilogy before and countless others after, has dealt with coming-of-age stories.

A watershed was passed, though, in the 1960s, with its youth culture in general, and with Pop art in particular. This was the decade of "Puff the Magic Dragon" and the cult of Tolkien's *Lord of the Rings*, when it was advised not to trust anyone over thirty, and when rejection of adult values had a serious political edge. Looking back at the imagery of Pop—at Lichtenstein's comic-book canvases and Oldenburg's giant soft ice-cream cones—one is struck by its glorification of adolescent appetites, and by its special kind of subversive utopianism. The dream of the blown-up teen romance comic, and of the Good Humor bar reimagined as a monument, was that unabashed amusement and clever irony (dumb and smart, innocent and knowing) could join hands to turn the grown-up life of high art and civic symbolism on its head, and yield something more democratic and more fun. The apparatus of the establishment—in advertising, consumer marketing, and mass entertainment—was to be hijacked for a joyride, and turned to anti-establishment ends.

Such Pop art was first made by artists in their thirties, give or take, and its insistently upbeat childishness rebuked the boozy, smoky sophistication of a 1950s world dominated by veterans of a war these artists had been too young to fight. But by the 1980s, a new generation—this time born too late to have sweated out Vietnam—in turn redrew the terms it had inherited. In the years of Ronald Reagan and Margaret Thatcher, when Pop itself had been eagerly co-opted as another selling device for a packaged youth culture, much of what

had passed for sharp, corrosive smartness in the 1960s seemed foolishly naive. Artists of the late 1980s and 1990s began producing an altered imagery of childhood, laced with a distancing cynicism and fixed on the perversion of innocence.

Jeff Koons's *Rabbit* of 1986 (plate 158) is perhaps the paradigmatic example of the shift. Produced by an artist then in his twenties, in the year the baby-boom generation just began turning forty, it has a double backward reference, both to the polished reflectivity of Constantin Brancusi's early-modern metal sculptures and to the "soft-and-hard" transformations Oldenburg had performed on commonplace objects in his sculptures of the 1960s. The nose-thumbing impertinence against Brancusi's spiritual ambitions is obvious, but the chill imposed on Oldenburg's floppy, garrulous bumptiousness may be even more devastating. This object—no signature mass mascot like Mickey or Bugs, but an off-the-shelf generic inflatable—has been transformed by its casting into an uncanny, preternaturally swollen and hieratically rigid icon of gleamingly sterilized kitsch. Wildly ludicrous and icily inert all at once, this frozen silvered phantom of a toy subsumes the chromed curves that were the machine age's expression of sleek optimism, and parodies them, deadpan, as a hollow plastic triviality, glamorized by the hard glint of cupidity. Innocence and the Pop valuation of raucous young appetites seem far, far away.

A later, soft corollary to Koons's totem-toy might be seen in the array of dolls Mike Kelley lays out on his crocheted afghan (plate 296) of 1990. Every cue of the material and format invokes the reassuring world of baby blankets and maternal care. Yet, when the piece splays out before us on the floor, the floppy, disjointed anonymity of the sewn-down dolls has the insidious overtones of a crime scene, and the little "bodies" on the huge field speak discomfitingly of exposure and vulnerability. The darker undercurrent fits, too, with other work by Kelley (see, for example, plates 131, 350) and his cohort of contemporaries in Los Angeles in the late 1980s and 1990s, where a range of "bad-boy" art embraced imagery and styles from pulp comics, and put a more funky, surrealistic spin on what had been the cheerily philistine cartoon jokes of mainstream Pop.

In other areas, too, younger art at the end of the twentieth century became a twisted doll's house. Where Pop had loved the device of enlargement—making the common little thing into a mural, a billboard, or a monument—artists now often dwelled on miniaturization, as if inverting the former sense of emergent public power into one of a more closeted sublimation. Yet the intent was serious. Transposing the hard world of history into the pliable domain of surrogate play, whether in comic strips or in tin soldiers, provided fresh ways to sneak up on things as hard to confront and as stale with convention as World War II and the Holocaust (see Art Spiegelman's *Maus: A Survivor's Tale*, plate 130). And women artists, such as Laurie Simmons and Mariko Mori, concerned with the way femininity gets constructed and constrained, found in the fabrication of toy environments an appealing way to critique simultaneously the myths of ideal womanhood and the mechanisms by which those myths invade a little girl's awareness (plates 242, 535). In these ways the languages of lightness were co-opted to do heavy lifting, small worlds encapsulated large issues, and the former domains of carefree fantasy were re-presented as sites of indoctrination.

A chilling ambiguity can be found in the spindly upright crib of Mona Hatoum's *Silence* (plate 414). There, the glass tubing simultaneously evokes and cancels early modern notions of precision and clarity (as did Koons's shiny metal), mutating cuddly security into brittle vulnerability, with a quietly breath-stopping sense of imminent violence. The title seems double-edged, implying a lifelessness utterly at odds with normal expectations of an infant, and inviting into the fragile void an imagined cacophony of shattering and shards.

A more literal spelling-out of the perils that impinge on defenseless childhood appears in David Wojnarowicz's forced collision between the towheaded image of appealing boyhood and the bitterly disillusioned text of a fate foreseen (plate 336). As a kind of pre-imposed tombstone, the work evokes promise only to snuff it, and insists, in relentless pessimism, on the crushing inevitability of the countless traps and pitfalls involved in coming to maturity within contemporary society. Set out in the format of a warped grade-school album—pencil-necked, grinning mug-shot sur-

rounded by "personal notes" or "achievements," Wojnarowicz's piece plays in a somber key the same cynicism about the disjunctions of innocence and experience that prompted a classroom of tykes in Woody Allen's *Annie Hall* to stand up one by one and announce their incongruous adult identities ("I'm into leather," pipes one little ingenue).

Childhood is always threatened, of course, not only from without but from within, by the drive of physiological change that will inexorably replace its smooth perfections with lumpy, hairy adulthood. Especially in an epoch when AIDS has refocused an awareness of the body and its mortality, and touched sexuality with new associations of morbidity and danger, an altered attention to the changeling body seemed almost ordained. In a curious echo, the unsettled obsession with adolescence and the onset of sexual knowledge that pervaded art at the previous turn of the century (in the work of Paul Gauguin, Georges Minne, Auguste Rodin, Egon Schiele, and many others) returned in several corners of art during the most recent fin de siècle. But it was Robert Gober who gave us one of the pithiest and most disturbing tokens of this new sensibility, in his monstrous little werewolf of a child's shoe, which sprouts hair in its creepily waxen sole (plate 343). If Koons and Hatoum had twisted childhood's allure by rendering its objects in cold and alien hardness, this little souvenir suggests a world where even inorganic accouterments are not safe from hormonal predation.

The early 1990s were a period where issues of repressed memory and childhood abuse surged up in every social venue from the courtroom to confessional television, a new currency developed for Freud's earlier concern with the interaction between adults and their offspring, and for the overlaps and collisions between unformed and grown-up desires. Mass advertising, by selling youth and infantilizing their elders, did its part to confuse the dividing lines; and the recurrent horrors of murderous suburban preteens and high-schoolers with guns added to the anxieties in a way that made the "delinquency" of mid-century seem cut-and-dried by comparison. One of the most telling images to emerge from this climate of disequilibrium is Charles Ray's unforgettable *Family Romance* (plate 402), a potent one-liner of a sculpture that lingers under the skin. Here enlargement and miniaturization get confounded, as mutant monster toddlers are leveled with their dwarfed parents, all rendered in anatomical correctness. Ray's unsettlingly specific daisy chain makes the beatific and the horrific, treacly blandness and obscene grotesquerie, all join hands in a dance of precocity and diminishment that provokes a fused laugh and shudder as it destabilizes the viewer's awareness of his or her own body, no matter what age.

Even beyond the disheartening contexts of the tabloid headlines and social dilemmas of what used to be called "the youth of our time," can we wonder that the idea of childhood—its appeal as a separate, uncorrupt land of promise, forever renewing its revolutionary potential for each generation—should take such a beating in contemporary art? In intellectual life, it has been one of the conceits of our age to pride ourselves on our loss of illusions, and to count ourselves superior by virtue of a more thorough-going cynicism. Much of the writing about art in recent decades has, in this spirit, trumpeted the force of new art and new thought as that of debunking and discarding the ideals and mythologies—of autonomy, of teleology, of universality, of purity—that permeate the rhetoric of earlier modern art. It has become a ritual act, for advocates of this line of criticism, to recurrently wring dead whatever residual life might be seen to remain in ideals of originality, or of escape from cultural determination. In such a climate, the ideals of childhood in earlier modern art—as blissfully pristine or subversively potent—were bound to age poorly.

Checklist of Illustrations

This listing follows the arrangement of the plate section and provides full citations for the works illustrated. Following the plate number and artist, the title and date of the work are given; then the medium and dimensions in feet and inches, and centimeters (or meters); the entry concludes in most cases with a credit line. All works are in the collection of The Museum of Modern Art, New York. The data vary for films and videotapes, and additional information about publication and manufacture is included for prints, architecture, and design. For multiple works by a single artist, see the Index of Illustrations.

1. Stanley Kubrick
The Shining. 1980. Great Britain/USA. 35mm film, color, 146 minutes

2. Cindy Sherman
Untitled Film Still #59. 1980. Gelatin silver print, 6¾ x 9½ in. (17.1 x 24.1 cm). Purchase

3. Cindy Sherman
Untitled Film Still #58. 1980. Gelatin silver print, 6⁵⁄₁₆ x 9⁷⁄₁₆ in. (16 x 24.2 cm). Purchase

4. Cindy Sherman
Untitled Film Still #57. 1980. Gelatin silver print, 6⁹⁄₁₆ x 9⁷⁄₁₆ in. (16.6 x 24.2 cm). Purchase

5. Cindy Sherman
Untitled Film Still #56. 1980. Gelatin silver print, 6⅜ x 9⁷⁄₁₆ in. (16.2 x 24.2 cm). Purchase

6. Cindy Sherman
Untitled Film Still #54. 1980. Gelatin silver print, 6¹³⁄₁₆ x 9⁷⁄₁₆ in. (17.3 x 24.2 cm). Purchase

7. Vito Acconci
Instant House #2, Drawing. 1980. Color inks and pencil on paper, 18 x 26 in. (46 x 66 cm). Fractional gift of Joyce Pomeroy Schwartz

8. Vito Acconci
20 Foot Ladder for Any Size Wall. 1979–80. Photoetching on eight sheets, overall: 19 ft. 4 in. x 41 in. (589.3 x 104.2 cm). Publisher and printer: Crown Point Press, Oakland, Calif. Edition: 15. Frances Keech Fund

9. Martin Scorsese
Raging Bull. 1980. 35mm film, black and white and color, 119 minutes. Acquired from United Artists

10. Niklaus Troxler
McCoy/Tyner/Sextet. 1980. Poster: offset lithograph, 50⅜ x 35⅝ in. (128 x 90.5 cm). Leonard and Evelyn Lauder Fund

11. Jean-Luc Godard
Sauve qui peut (la vie). 1980. France/Switzerland. 35mm film, color, 88 minutes. Gift of Dan Talbot

12. Rainer Werner Fassbinder
Berlin Alexanderplatz. 1980. West Germany. 16mm film, color, 378 minutes

13. Lino Brocka
Bona. 1980. Philippines. 35mm film, color, 83 minutes. Acquired from Pierre Rissient

14. John Hejduk
A. E. Bye House. Ridgefield, Connecticut. Project, 1968–80. Axonometric projection, color pencil and sepia print, 36¼ x 21¼ in. (92.1 x 53.9 cm). D. S. and R. H. Gottesman Foundation

15. Toshiyuki Kita
Wink Lounge Chair. 1980. Polyurethane foam, welded steel, and Dacron fiber-fill, upright: 40⅝ x 33 x 31⅝ in. (103.2 x 83.9 x 80.3 cm); reclining: 24⅜ in. x 33 x 6 ft. 3¾ in. (62 x 83.9 x 192.5 cm); seat height: 14¾ in. (37.5 cm). Manufacturer: Cassina S.p.A., Italy. Gift of Atelier International, Ltd.

16. Philip Guston
Untitled. 1980. Synthetic polymer paint and ink on board, 19⅞ x 30 in. (50.5 x 76 cm). Gift of Musa Guston

17. Philip Guston
Untitled. 1980. Synthetic polymer paint and ink on paper, 23 x 29 in. (58.9 x 76.2 cm). Gift of Musa Guston

18. Philip Guston
Untitled. 1980. Synthetic polymer paint and ink on board, 20 x 30 in. (50.7 x 76.2 cm). Gift of Musa Guston

19. Philip Guston
Untitled. 1980. Synthetic polymer paint and ink on paper, 20 x 30 in. (50.9 x 76.2 cm). Gift of Musa Guston

20. Jörg Immendorff
Cafe Deutschland (Style War). 1980. Oil on canvas, 9 ft. 2¼ in. x 11 ft. 6 in. (280 x 350.7 cm). Gift of Emily and Jerry Spiegel

21. Louis Malle
Atlantic City. 1980. Canada/France/USA. 35mm film, color, 104 minutes. Acquired from Paramount Pictures

22. Shohei Imamura
Vengeance Is Mine. 1980. Japan. 35mm film, color, 128 minutes. Gift of Janus Films

23. Yoji Yamamoto
A River. 1980. Poster: offset lithograph, 40⅝ x 28⅝ in. (103.1 x 72.8 cm). Gift of the artist and Japan Graphic Idea Exhibition

24. Carlos Diegues
Bye Bye Brazil. 1980. Brazil/France. 35mm film, color, 110 minutes. Acquired from Dan Talbot

25. Leon Hirszman
They Don't Wear Black Tie. 1981. Brazil. 35mm film, color, 120 minutes. Acquired from Dan Talbot

26. Héctor Babenco
Pixote. 1980. Brazil. 35mm film, color, 127 minutes. Acquired from Dan Talbot

27. Seiichi Furuya
Graz. 1980. Gelatin silver print, 14¾ x 9¹⁵⁄₁₆ in. (37.5 x 25.3 cm). Gift of the Edward and Marjorie Goldberger Foundation

28. Seiichi Furuya
Schattendorf. 1981. Gelatin silver print, 14¾ x 10 in. (37.4 x 25.4 cm). Gift of the photographer

29. Peter Hujar
Portrait of David Wojnarowicz. 1981. Gelatin silver print, 14 x 14 in. (35.6 x 35.6 cm). The Fellows of Photography Fund

30. Rainer Werner Fassbinder
Lola. 1981. West Germany. 35mm film, color, 113 minutes. Acquired from the Rainer Werner Fassbinder Foundation

31. Rainer Werner Fassbinder
Lili Marleen. 1981. West Germany. 35mm film, color, 120 minutes. Acquired from the Rainer Werner Fassbinder Foundation

32. James Welling
Untitled #46. May 20, 1981. Gelatin silver print, 9½ x 7½ in. (19.5 x 24.3 cm). Gift of Carole Littlefield

33. Bernard Tschumi
The Manhattan Transcripts. Episode 4: The Block. Project, 1976–81. Ink and photographs on vellum, four of fourteen sheets, each 19 x 31 in. (48.2 x 78.7 cm). Purchase and partial gift of the architect in honor of Lily Auchincloss

34. Frank Gohlke
Aerial View, Downed Forest near Elk Rock, Approximately Ten Miles Northwest of Mount St. Helens, Washington. 1981. Gelatin silver print, 17⅞ x 21⅞ in. (45.7 x 55.8 cm). Purchased as the gift of Shirley C. Burden

35. Georg Baselitz
Woman on the Beach. 1981. Woodcut and linoleum cut, comp. and sheet: 31⅜ x 24¹⁄₁₆ in. (79.8 x 61.1 cm). Publisher: Maximilian Verlag/Sabine Knust, Munich. Printer: Elke Baselitz, Derneburg, Germany. Edition: proof, before edition of 50. Gift of Nelson Blitz, Jr.

36. Georg Baselitz
Drinker. 1981. Linoleum cut, comp. and sheet: 31¹³⁄₁₆ x 23¹³⁄₁₆ in. (80.8 x 60.5 cm). Publisher: Maximilian Verlag/Sabine Knust, Munich. Printer: Elke Baselitz, Derneburg. Edition: proof, before edition of 50. Gift of Mr. and Mrs. Philip A. Straus

37. Scott Burton
Pair of Rock Chairs. 1980–81. Gneiss, in two parts: 49¼ x 43½ x 40 in. (125.1 x 110.5 x 101.6 cm), 44 x 66 x 42½ in. (111.6 x 167.7 x 108 cm). Acquired through the Philip Johnson, Mr. and Mrs. Joseph Pulitzer, Jr., and Robert Rosenblum funds

38. Lee Friedlander
Untitled. 1980. Gelatin silver print, 18½ x 12⁷⁄₁₆ in. (47.1 x 31.5). Purchase

39. Lee Friedlander
Untitled. 1980. Gelatin silver print, 18⁵⁄₁₆ x 12⅜ in. (47.2 x 31.4 cm). The Fellows of Photography Fund

40. Lee Friedlander
Untitled. 1981. Gelatin silver print, 7¹⁵⁄₁₆ x 12 in. (20.1 x 30.5 cm). Gift in honor of John Szarkowski from the curatorial interns who worked for him

41. Cindy Sherman
Untitled #96. 1981. Chromogenic color print (Ektacolor), 23¹⁵⁄₁₆ x 48⅛ in. (61 x 122.1 cm). Gift of Carl D. Lobell

42. Willem de Kooning
Pirate (Untitled II). 1981. Oil on canvas, 7 ft. 4 in. x 6 ft. 4¾ in. (223.4 x 194.4 cm). Sidney and Harriet Janis Collection Fund

43. George Miller
Mad Max 2 (The Road Warrior). 1981. Australia. 35mm film, color, 94 minutes

44. A. R. Penck (Ralf Winkler)
Nightvision from the portfolio *First Concentration I.* 1982. Woodcut, comp.: 35⅜ x 27¼ in. (89.8 x 69.3 cm), sheet: 39⅜ x 30¾ in. (100 x 78.1 cm). Publisher: Maximilian Verlag/Sabine Knust, Munich. Printer: Atelier von Karl Imhof, Munich. Edition: 50. Gift of Nelson Blitz, Jr.

45. Andrzej Pagowski
Wolf's Smile (Usmiech Wilka). 1982. Poster: offset lithograph, 26⅜ x 37 in. (67 x 94 cm). Purchase

46. Vija Celmins
Alliance. 1982. Drypoint, mezzotint, and aquatint, plate.: 10¹⁄₁₆ x 7⁷⁄₁₆ in. (25.5 x 18.9 cm) (irreg.), sheet: 24 x 19⅜ in. (61 x 49.2 cm). Publisher and printer: Gemini G.E.L., Los Angeles. Edition: 48. Mrs. John D. Rockefeller 3rd Fund

47. Werner Herzog
Fitzcarraldo. 1982. West Germany. 35mm film, color, 157 minutes

48. Barbara Kruger
Untitled (You Invest in the Divinity of the Masterpiece). 1982. Unique photostat, 71¾ x 45⅝ in. (182.2 x 115.8 cm), with frame 6 ft. ⅞ in. x 46¾ in. (185.6 x 118.7 cm). Acquired through an anonymous fund

49. Katharina Fritsch
Madonna. 1982. Two multiples of plaster with pigment, each 11¹³⁄₁₆ x 3⅛ x 2⅜ in. (30 x 8 x 6 cm). Publisher and fabricator: the artist. Edition: unlimited. Purchased with funds given by Linda Barth Goldstein

50. Krzysztof Kieslowski
Blind Chance. 1982. Poland. 35mm film, color, 122 minutes. Acquired from Film Polski

51. Ingmar Bergman
Fanny and Alexander. 1982. Sweden/France/West Germany. 35mm film, color, 188 minutes

52. Tina Barney
Sunday New York Times. 1982. Chromogenic color print (Ektacolor), 47½ x 60⅜ in. (120.7 x 154.8 cm). Given anonymously

53. Nicholas Nixon
Chestnut Street, Louisville, Kentucky. 1982. Gelatin silver print, 7¹¹⁄₁₆ x 9¹⁵⁄₁₆ in. (19.5 x 24.5 cm). The Family of Man Fund

54. Judith Joy Ross
Untitled from *Eurana Park, Weatherly, Pennsylvania.* 1982. Gelatin silver printing-out-paper print, 9¾ x 7¾ in. (24.8 x 19.7 cm). Joseph G. Mayer Fund

55. Wayne Wang
Chan Is Missing. 1982. USA. 35mm film, black and white, 80 minutes. Acquired from Dan Talbot

56. Barry Levinson
Diner. 1982. USA. 35mm film, color, 110 minutes. Gift of Warner Bros.

57. Uwe Loesch
Point (Punktum). 1982. Poster: offset lithograph, 33⅛ x 46⅞ in. (84 x 119 cm). Gift of the designer

58. William Wegman
Blue Head. 1982. Two color instant prints (Polaroid), left: 24 x 20½ in. (60.9 x 52 cm), right: 24½ x 20½ in. (62.2 x 52 cm). Gift of Mrs. Ronald S. Lauder

59. Paul Rand
IBM. 1982. Poster: offset lithograph, 36 x 24 in. (91.4 x 61 cm). Gift of the designer

60. Ridley Scott
Blade Runner. 1982. USA. 35mm film, color, 114 minutes

61. Joan Fontcuberta
Guillumeta Polymorpha. 1982. Gelatin silver print, 10½ x 8⁹⁄₁₆ in. (26.6 x 21.8 cm). Robert and Joyce Menschel Fund

62. Philip-Lorca diCorcia
Mary and Babe. 1982. Chromogenic color print (Ektacolor), 17⅜ x 23¼ in. (44.1 x 59 cm). Purchased as the gift of Harriette and Noel Levine

63. Paul Bartel
Eating Raoul. 1982. USA. 35mm film, color, 87 minutes. Gift of the artist

64. Stephen Armellino
Bullet-Resistant Mask. 1983. Kevlar and polyester resin, 11 x 6¾ x 3¾ in. (28 x 17.1 x 9.5 cm). Manufacturer: U.S. Armor Corporation, California. Gift of the manufacturer

65. John Canemaker
Bottom's Dream. 1983. USA. Animation cel from 35mm film, color, 6 minutes. Gift of the artist

66. John Divola
Untitled. 1983. Silver dye bleach print (Cibachrome), overall: 10⅞ x 21⅞ in. (27.8 x 55.6 cm). Purchased with funds given anonymously

67. Jannis Kounellis
Untitled. 1983. Steel beam, steel bed-frame with propane-gas torch, five steel shelves, smoke traces, and steel panel and shelf with wood, dimensions variable, overall: 10 ft. 11½ in. x 17 ft. 7¼ in. x 16¼ in. (333.9 x 536.5 x 41.2 cm). Sid R. Bass, Blanchette Rockefeller, and The Norman and Rosita Winston Foundation, Inc., funds, and purchase

68. Richard Prince
Entertainers. 1982–83. Chromogenic color print (Ektacolor), 61½ x 46½ in. (156.2 x 118.1 cm). Fractional gift of Werner and Elaine Dannheisser

69. Woody Allen
Zelig. 1983. USA. 35mm film, black and white and color, 79 minutes. Acquired from the artist

70. Terry Jones and Terry Gilliam
Monty Python's The Meaning of Life. 1983. Great Britain. 35mm film, color, 103 minutes

71. Swatch
GB 001 Watch. 1983. Plastic and metal, ⅛ x 1⅜ x 9¼ in. (.3 x 3.5 x 23.4 cm). Manufacturer: Swatch AG, Switzerland. Gift of the manufacturer

72. Swatch
GK 100 Jellyfish Watch. 1983. Plastic and metal, ¾ x 1⅜ x 8⅛ in. (.8 x 3.5 x 22.7 cm). Manufacturer: Swatch AG, Switzerland. Gift of the manufacturer

73. Bruce Nauman
Human/Need/Desire. 1983. Neon tubing, transformer, and wires, overall: 7 ft. 10⅜ in. x 70½ in. x 25¾ in. (239.8 x 179 x 65.4 cm). Gift of Emily and Jerry Spiegel

74. Joel Sternfeld
Houston, Texas. 1983. Chromogenic color print, 13⁷⁄₁₆ x 17 in. (34.2 x 43.2 cm). Purchased as the gift of the Joel W. Solomon Estate

75. Joel Sternfeld
Canyon Country, California. 1983. Chromogenic color print, 13½ x 17 in. (34.3 x 43.2 cm). Gift of the photographer

76. Kathryn Bigelow and Monty Montgomery
Breakdown (The Loveless). 1983. USA. 35mm film, color, 82 minutes. Gift of Kathryn Bigelow

77. Edward Ruscha
Hollywood Is a Verb. 1983. Dry pigment on paper, 29 x 23 in. (73.7 x 58.4 cm). Purchased with funds given by Agnes Gund, Mr. and Mrs. James Hedges IV, Ronald S. Lauder, and the General Drawings Fund

78. Martin Scorsese
The King of Comedy. 1983. 35mm film, color, 101 minutes

79. Federico Fellini
And the Ship Sails On. 1983. Italy/France. 35mm film, color, 128 minutes

80. Nicholas Nixon
C.C., Boston. 1983. Gelatin silver print, 7¾ x 9⁷⁄₁₆ in. (19.6 x 24.5 cm). Gift of Nicholas Nixon in memory of Garry Winogrand

81. Anselm Kiefer
Der Rhein. 1983. Illustrated book with twenty-one woodcuts (including front and back covers), page: 23¼ x 16½ in. (59 x 42 cm). Publisher and printer: the artist. Edition: 10. Purchase

82. Jan Groover
Untitled. 1983. Platinum-palladium print, 7½ x 9⅜ in. (19 x 23.8 cm). Robert and Joyce Menschel Fund

83. Francesco Clemente
Conversion to Her. 1983. Fresco of plaster on three Styrofoam and fiberglass panels, overall: 8 ft. 9 ft. ¾ in. x 2¾ in. (244 x 286.7 x 7 cm) (irreg.). Anne and Sid Bass Fund

84. Mike Leigh
Meantime. 1983. Great Britain. 16mm film, color, 90 minutes. Acquired from Gerald Rappaport

85. Lizzie Borden
Born in Flames. 1983. USA. 16mm film, color, 90 minutes. Acquired from the artist

86. Jörg Immendorff
Futurology. 1983. Linoleum cut, comp.: 63¼ x 82⁷⁄₁₆ in. (160.6 x 209.4 cm) (irreg.), sheet: 71³⁄₁₆ x 90 in. (180.8 x 228.7 cm). Publisher: Maximilian Verlag/Sabine Knust, Munich. Printer: the artist. Edition: 8. Gift of Nelson Blitz, Jr.

87. Mazda Motor Corporation
MX5 Miata Automobile Taillights. 1983. Double-shot injection-molded acrylic resin, injection-molded polypropylene, and other materials, 6½ x 15 x 5 in. (16.5 x 38.1 x 12.7 cm). Manufacturer: Mazda Motor Corporation, Japan. Gift of Mazda Motor Corporation, California

88. Bill Viola
Anthem. 1983. USA. Videotape, color, sound, 11 minutes 30 seconds. Gift of the Friends of Jane Fluegel

89. Mako Idemitsu
Great Mother Part II: Yumiko. 1983. Japan. Videotape, color, sound, 24 minutes 30 seconds. Gift of Margot Ernst

90. Michael Spano
Photogram—Michael Spano. 1983. Gelatin silver print, 57⅛ x 23¹⁵⁄₁₆ in. (145.2 x 60.8 cm) (irreg.). Robert and Joyce Menschel Fund

91. Jonathan Borofsky
Stick Man. 1983. Lithograph, comp. and sheet: 52½ x 37¾ in. (133.3 x 95.9 cm). Publisher and printer: Gemini G.E.L., Los Angeles. Edition: 27. John B. Turner Fund

92. Frank Stella
Giufà, la luna, i ladri e le guardie from the Cones and Pillars series. 1984. Synthetic polymer paint, oil, urethane enamel, fluorescent alkyd, and printing ink on canvas, and etched magnesium, aluminum, and fiberglass, 9 ft. 7¼ in. x 16 ft. 3¼ in. x 24 in. (292.7 x 495.9 x 61 cm). Acquired through the James Thrall Soby Bequest

93. Sigmar Polke
Watchtower. 1984. Synthetic polymer paints, dry pigment, and oilstick on various fabrics, 9 ft. 10 in. x 7 ft. 4½ in. (300 x 224.8 cm). Fractional gift of Ronald S. Lauder

94. Bruce Nauman
Crossed Stadiums. 1984. Synthetic polymer paint, watercolor, charcoal, and pastel on paper, 53 x 72½ in. (134.7 x 184.2 cm). Gift of The Lauder Foundation

95. Claes Oldenburg
Proposal for a Monument to the Survival of the University of El Salvador: Blasted Pencil (That Still Writes). 1984. Etching and aquatint, plate: 6⁹⁄₁₆ x 20⅞ in. (17.7 x 52.9 cm), sheet: 22¹³⁄₁₆ x 30¼ in. (58 x 76.8 cm).

Publisher: Multiples, Inc., New York, for Artists Call Against US Intervention in Central America. Printer: Aeropress, New York. Edition: 35. John B. Turner Fund

96. Sergio Leone
Once upon a Time in America. 1984. USA/Italy. 35mm film, color, 227 minutes. Purchase

97. Neil Jordan
The Company of Wolves. 1984. Great Britain. 35mm film, color, 96 minutes

98. Gary Hill
Why Do Things Get in a Muddle? (Come on Petunia). 1984. USA. Videotape, color, sound, 33 minutes 9 seconds. Purchase

99. Mary Ann Toots Zynsky
Bowl. 1984. Lead crystal (filet-de-verre), 3 x 11 in. (7.6 x 28 cm) diameter. Emilio Ambasz Fund

100. Andy Warhol
Rorschach. 1984. Synthetic polymer paint on canvas, 13 ft. 8¼ in. x 9 ft. 7 in. (417.2 x 292.1 cm). Purchase

101. Anselm Kiefer
Departure from Egypt. 1984. Synthetic polymer paint, charcoal, and string on cut-and-pasted photograph and cardboard, 43⅛ x 33½ in. (109.5 x 85 cm) (irreg.). Gift of the Denise and Andrew Saul Fund

102. Sherrie Levine
Untitled (After Kasimir Malevich and Egon Schiele). 1984. Pencil and watercolor on paper, four of forty sheets, each 14 x 11 in. (36 x 27.9 cm). Gift of Constance B. Cartwright, Roger S. and Brook Berlind, Marshall S. Cogan, and purchase

103. David Goldblatt
Mother and child in their home after the destruction of its shelter by officials of the Western Cape Development Board, Crossroads, Cape Town, 11 October 1984. 1984. Gelatin silver print, 10¹⁵⁄₁₆ x 13¹¹⁄₁₆ in. (27.9 x 34.8 cm). Gift of Wm. Brian Little

104. Judith Joy Ross
Untitled from Portraits at the Vietnam Veterans Memorial, Washington, D.C. 1984. Gelatin silver printing-out-paper print, 9⅝ x 7⅝ in. (24.5 x 19.5 cm). Purchased as the gift of Paul F. Walter

105. Aldo Rossi with Gianni Braghieri
Cemetery of San Cataldo, Modena, Italy. 1971–84. Elevation study: ink and pencil on paper, 7¾ x 29⅝ in. (19.7 x 75.2 cm). Gift of The Howard Gilman Foundation

106. Aldo Rossi with Gianni Braghieri
Cemetery of San Cataldo, Modena, Italy. 1971–84. Aerial perspective: ink and pencil on paper, 29¹³⁄₁₆ x 56⅛ in. (75.8 x 142.6 cm). Gift of The Howard Gilman Foundation

107. Su Friedrich
The Ties That Bind. 1984. USA. 16mm film, black and white, 55 minutes. Acquired from the artist

108. Hou Hsiao-hsien
Summer at Grandpa's. 1984. Taiwan. 35mm film, color, 102 minutes

109. frogdesign, company design
Macintosh SE Home Computer. 1984. ABS plastic casing, 13¾ x 9¾ x 10¾ in. (34.9 x 25 x 27.5 cm). Manufacturer: Apple Computer, California. Gift of the designer and manufacturer

110. Allan McCollum
40 Plaster Surrogates. 1982–84. Enamel on Hydro-Stone, forty panels ranging from 5 x 4⅛ in. (12.8 x 10.2 cm) to 20¼ x 16¼ in. (51.3 x 41.1 cm), overall: 64 in. x 9 ft. 2 in. (162.5 x 279.4 cm). Robert and Meryl Meltzer and Robert F. and Anna Marie Shapiro funds

111. Paul Graham
Crouched Man, DHSS Waiting Room, Bristol. 1984. Chromogenic color print (Ektacolor), 26¾ x 34⅜ in. (68 x 88.1 cm). Purchased as the gift of Shirley C. Burden

112. John Cassavetes
Love Streams. 1984. USA. 35mm film, color, 141 minutes. Gift of the artist and Cannon Films, Inc.

113. Greta Schiller and Robert Rosenberg
Before Stonewall. 1984. USA. 16mm film, black and white and color, 87 minutes. Gift of Vito Russo

114. Martin Puryear
Greed's Trophy. 1984. Steel rods and wire, wood, rattan, and leather, 12 ft. 9 in. x 20 in. x 55 in. (388.6 x 50.8 x 139.7 cm). David Rockefeller Fund and purchase

115. Robert Ryman
Pace. 1984. Synthetic polymer paint on fiberglass on wood with aluminum, 59½ x 26 x 28 in. (151.2 x 66 x 71.1 cm). Gift of anonymous donor and purchase of Ronald S. Lauder

116. Jim Jarmusch
Stranger Than Paradise. 1984. USA/West Germany. 35mm film, black and white, 89 minutes. Acquired from the artist

117. Woody Allen
Broadway Danny Rose. 1984. USA. 35mm film, black and white, 84 minutes. Acquired from the artist

118. Jo Ann Callis
Woman Twirling. 1985. Silver dye bleach print (Cibachrome), 29¼ x 36⁷⁄₁₆ in. (74.3 x 92.6 cm). The Fellows of Photography Fund

119. Robert Frank
Boston, March 20, 1985. 1985. Six color instant prints (Polaroid) with hand-applied paint and collage, each 27¾ x 22¼ in. (70.3 x 56.4 cm). Purchased as the gift of Polaroid Corporation

120. Bernard Tschumi
Parc de la Villette, Paris, France: Four Follies Intersecting North-South Gallery. 1985. Model: acrylic and metal, 6½ x 60 x 15¼ in. (16.5 x 152.4 x 38.7 cm). Gift of the architect

121. Anselm Kiefer
The Red Sea. 1984–85. Oil, lead, woodcut, photograph, and shellac on canvas, 9 ft. 1¾ in. x 13 ft. 11⅜ in. (278.8 x 425.1 cm). Enid A. Haupt Fund

122. Jasper Johns
Summer. 1985. Encaustic on canvas, 6 ft. 3 in. x 50 in. (190.5 x 127 cm). Gift of Philip Johnson

123. Jean-Michel Basquiat
Untitled. 1985. Color oilstick and cut-and-pasted paper on paper, 41½ x 29½ in. (105.4 x 75 cm). Acquired in memory of Kevin W. Robbins through funds provided by his friends and family and by the Committee on Drawings

124. David Salle
Muscular Paper. 1985. Oil, synthetic polymer paint, and charcoal on canvas and fabric, with painted wood, in three parts, overall: 8 ft. 2⅛ in. x 15 ft. 7⅛ in. (249.3 x 475 cm). Gift of Douglas S. Cramer Foundation

125. Sir Norman Foster
Hong Kong and Shanghai Bank, Hong Kong, 1979–85. Exterior perspectives sketch: ink on paper, each sheet: 16½ x 11¹¹⁄₁₆ in. (41.9 x 59.4 cm). Gift of the architect in honor of Philip Johnson

126. James Herbert
River. 1985. USA. 16mm film, black and white and color, 13 minutes. Gift of the artist

127. Philip-Lorca diCorcia
Francesco. 1985. Chromogenic color print (Ektacolor), 16⅛ x 23¼ in. (41 x 59.1 cm). Purchased as the gift of Harriette and Noel Levine

128. John Schlesinger
Untitled. 1985. Gelatin silver print, 51⅞ x 35½ in. (132 x 90.2 cm). The Family of Man Fund

129. Claude Lanzmann
Shoah. 1985. France/Switzerland. 16mm film transferred to 35mm, color, 561 minutes. Acquired from Dan Talbot

130. Art Spiegelman
Maus: A Survivor's Tale. 1980–85. Two pages from a series of six artist's books, page (approx.), 8¹⁵⁄₁₆ x 6 in. (22.7 x 15.3 cm). Publisher: RAW Books and Graphics, New York. Edition: 5,000–15,000. The Museum of Modern Art/Franklin Furnace/Artist's Book Collection, The Museum of Modern Art Library, New York

131. Mike Kelley
Exploring (from "Plato's Cave, Rothko's Chapel, Lincoln's Profile"). 1985. Synthetic polymer paint on paper, 6 ft. 4½ in. x 64 in. (194.3 x 162.6 cm). Gift of the Friends of Contemporary Drawing, The Contemporary Arts Council, and The Junior Associates of The Museum of Modern Art

132. Thomas Florschuetz
In Self-Defense. 1985. Two gelatin silver prints, each 19½ x 19⅝ in. (49.5 x 49.8 cm). E. T. Harmax Foundation Fund

133. Willem de Kooning
Untitled VII. 1985. Oil on canvas, 70 in. x 6 ft. 8 in. (177.8 x 203.2 cm). Purchase, and gift of Milly and Arnold Glimcher

134. John Coplans
Self-Portrait. 1985. Gelatin silver print, 18½ x 17⅞ in. (47.2 x 45.6 cm). Robert and Joyce Menschel Fund

135. Lothar Baumgarten
Untitled. 1985. Screenprint, comp.: 26⅞ x 39⅝ in. (68.2 x 100.1 cm), sheet: 31½ x 45¼ in. (80 x 115 cm). Publisher: the artist. Printer: the artist. Edition: 35. Purchase

136. Terry Gilliam
Brazil. 1985. Great Britain. 35mm film, color, 142 minutes

137. Jeff Koons
Three Ball 50/50 Tank. 1985. Glass, painted steel, water, plastic, and three basketballs, 60⅛ x 48¾ x 13¼ in. (154 x 123.9 x 33.6 cm). Fractional gift of Werner and Elaine Dannheisser

138. James Casebere
Covered Wagons. 1985. Gelatin silver print, 29½ x 22¾ in. (75 x 57.8 cm). Purchase

139. Trinh T. Minh-ha
Naked Spaces: Living Is Round. 1985. West Africa/USA. 16mm film, color, 135 minutes

140. Susan Rothenberg
Biker. 1985. Oil on canvas, 6 ft. 2¼ in. x 69 in. (188.3 x 175.2 cm). Fractional gift of PaineWebber Group Inc.

141. Susan Rothenberg
Boneman. 1986. Mezzotint, plate: 23⅞ x 20⅛ in. (60.6 x 51.2 cm) (irreg.), sheet: 30 x 20⅛ in. (76.2 x 51.2 cm). Publisher and printer: Gemini G.E.L., Los Angeles. Edition: 42. John B. Turner Fund

142. Bill Viola
I Do Not Know What It Is I Am Like. 1986. USA. Videotape, color, sound, 89 minutes. Gift of Catherine Meacham

143. Shiro Kuramata
How High the Moon Armchair. 1986. Nickel-plated steel mesh, 28½ x 37⅜ x 32¾ in. (72.4 x 95 x 83.2 cm). Manufacturer: Vitra International Ltd., Switzerland. Gift of the manufacturer

144. Bernhard and Anna Blume
Kitchen Frenzy. 1986. Five gelatin silver prints, each 66¹⁵⁄₁₆ x 42½ in. (170 x 108 cm). Gift of the Contemporary Arts Council

145. Robert Gober
Untitled. 1986. Enamel paint on wood, cotton, wool, and down, 36½ in. x 43 in. x 6 ft. 4⅜ in. (92.7 x 109.2 x 194 cm). Fractional gift of Werner and Elaine Dannheisser

146. Ellsworth Kelly
Three Panels: Orange, Dark Gray, Green. 1986. Oil on canvas, left panel: 8 ft. 8½ in. x 7 ft. 10 in. (265.4 x 238.7 cm), center panel: 7 ft. 4 in. x 8 ft. 2 in. (223.5 x 248.9 cm), right panel: 8 ft. 1½ in. x 9 ft. 11½ in. (247.6 x 303.5 cm), overall: 9 ft. 8 in. x 34 ft. 4½ in. (294.6 x 1047.7 cm). Gift of Douglas S. Cramer Foundation

147. Larry Fink
Pearls, New York City. 1986. Gelatin silver print, 14⅝ x 14⅝ in. (36.5 x 37.1 cm). Gift of Pauline Marks

148. Patrick Faigenbaum
Massimo Family, Rome. 1986. Gelatin silver print, 19½ x 19¼ in. (49.6 x 48.9 cm). Gift of the photographer and Sylviane de Decker Heftler

149. Eugenio Dittborn
8 Survivors. 1986. Screenprint (unfolded) and envelope screenprinted with artist's standard mailing form and collaged documentation label, comp.: 75⁹⁄₁₆ x 57½ in. (192 x 146.1 cm) (irreg.), sheet (unfolded): 79⅞ x 60½ in. (202.9 x 153.7 cm), envelope: 20¹¹⁄₁₆ x 15¹⁵⁄₁₆ in. (52.5 x 40.5 cm). Publisher: the artist. Printer: Impresos Punto Color Limitada, Santiago. Edition: 4. Purchase

150. Bertrand Tavernier
Round Midnight. 1986. France/USA. 35mm film, color, 133 minutes

151. Niklaus Troxler
A Tribute to the Music of Thelonious Monk. 1986. Poster: offset lithograph, 50⅜ x 35⅝ in. (128 x 90.5 cm). Gift of the designer

152. Francesco Clemente
The Departure of the Argonaut by Alberto Savinio (Andrea de Chirico). 1986. (Prints executed 1983–86). Illustrated book with forty-nine photolithographs, page: 25⅝ x 19¹¹⁄₁₆ in. (65 x 50 cm). Publisher: Petersburg Press, London. Printers: plates by Rolf Neumann, Stuttgart; text by Staib and Mayer, Stuttgart. Bound edition: 232, unbound edition: 56. Gift of Petersburg Press

153. James Ivory
A Room with a View. 1986. Great Britain. 35mm film, color, 115 minutes

154. John Frankenheimer
52 Pick-Up. 1986. USA. 35mm film, color, 114 minutes

155. John Baldessari
Untitled. 1986. Black-and-white photograph with colored round stickers overlaid with plastic sheet with color crayon, 9¾ x 7½ in. (24.8 x 18.7 cm). Gift of Brooke Alexander and of the artist

156. Bill Sherwood
Parting Glances. 1986. USA. 35mm film, color, 90 minutes

157. Louise Bourgeois
Articulated Lair. 1986. Painted steel, rubber, and metal, overall: 9 ft. 3 in. x 21 ft. 6 in. x 16 ft. 1 in. (281.7 x 655.7 x 555.6 cm). Gift of Lily Auchincloss, and of the artist in honor of Deborah Wye (by exchange)

158. Jeff Koons
Rabbit. 1986. Stainless steel, 41½ x 19 x 11⅜ in. (105.4 x 48.3 x 30.2 cm). Fractional and promised gift of Mr. and Mrs. S. I. Newhouse, Jr.

159. Edward Ruscha
Jumbo. 1986. Synthetic polymer paint on canvas, 6 ft. 10⅛ in. x 8 ft. 2⅛ in. (208.6 x 249 cm). Given anonymously in memory of Nicholas Wilder; Sid R. Bass, Douglas S. Cramer, and Jeanne C. Thayer funds; and gift of The Cowles Charitable Trust

160. Terry Winters
Folio. 1985–86. Three from a portfolio of eleven lithographs, comp. and sheet, each approx. 30¹¹⁄₁₆ x 22⁷⁄₁₆ in. (78 x 57 cm). Edition: 39. Printer: Universal Limited Art Editions. Gift of Emily Fisher Landau

161. Robert Breer
Bang! 1986. USA. Animation cels from 16mm film, color, 8 minutes

162. Frank Gehry
Fishdance Restaurant, Kobe, Japan. c. 1986. Sketch: ink on paper, 9 x 12 in. (22.9 x 30.5 cm). Gift of Barbara Pine in memory of Morris Goldman

163. Frank Gehry
Winton Guest House, Wayzata, Michigan. 1983–86. Model: wood, plastic, and plaster, 11¾ x 24 x 24 in. (29.8 x 61 x 61 cm). Gift of the architect

164. Anish Kapoor
A Flower, A Drama Like Death. 1986. Polystyrene, plaster, cloth, gesso, and raw pigment, in three parts: 15¼ x 28½ x 14½ in. (39.4 x 72.4 x 36.8 cm), 22½ x 44 x 22 in. (54.6 x 111.8 x 55.9 cm), 25 in. x 7 ft. 7½ in. x 22½ in. (63.5 x 232.9 x 57.4 cm). Sid R. Bass Fund

165. Gaetano Pesce
Feltri Chair. 1986. Wool felt, polyester resin, and hemp string; cushion: cotton/polyester cover with polyester padding, 55½ x 29¼ x 25¼ in. (140 x 74 x 64 cm). Manufacturer: Cassina S.p.A., Italy. Gift of the manufacturer

166. Janice Findley
Beyond Kabuki. 1986. USA. 16mm film, color, 10 minutes. Acquired from the artist

167. Andy Warhol
The Last Supper. 1986. Synthetic polymer paint on canvas, 9 ft. 11¼ in. x 21 ft. 11¼ in. (302.9 x 668.7 cm). Gift of The Andy Warhol Foundation for the Visual Arts, Inc.

168. Clint Eastwood
Heartbreak Ridge. 1986. USA. 35mm film, color, 130 minutes. Gift of the artist and Warner Bros.

169. Oliver Stone
Platoon. 1986. USA. 35mm film, color, 111 minutes. Gift of the artist

170. Stanley Kubrick
Full Metal Jacket. 1987. USA. 35mm film, color, 116 minutes

171. David Wojnarowicz
Fire. 1987. Synthetic polymer paint and pasted paper on plywood, in two parts, overall: 6 x 8 ft. (182.9 x 243.8 cm). Gift of Agnes Gund and Barbara Jakobson Fund

172. Bruce Nauman
Dirty Story. 1987. USA. Video installation of two ¾-inch videotape players, two 16-inch color monitors, and two videotapes (color, sound), dimensions variable. Gift of Werner and Elaine Dannheisser

173. Barry Levinson
Tin Men. 1987. USA. 35mm film, color, 110 minutes. Gift of Buena Vista Pictures Distribution, Inc.

174. Jeffrey Scales
12:54, A. Philip Randolph Square. 1987. Gelatin silver print, 19⅛ x 19⅛ in. (48.6 x 48.6 cm). The Family of Man Fund

175. Abigail Child
Mayhem. 1987. USA. 16mm film, black and white, 19 minutes. Acquired from the artist

176. George Kuchar
Creeping Crimson. 1987. USA. Videotape, color, sound, 12 minutes 50 seconds. Purchase

177. Nikita Mikhalkov
Dark Eyes. 1987. Italy. 35mm film, color, 118 minutes. Gift of Janus Films

178. Paolo Taviani and Vittorio Taviani
Good Morning Babylon. 1987. Italy/France/USA. 35mm film, color, 115 minutes. Acquired from Vestron

179. David Hammons
Free Nelson Mandela. 1987. Stencil, comp.: 20⅝ x 23⅜ in. (52.4 x 60 cm) (irreg.), sheet: 28¹³⁄₁₆ x 28⁵⁄₁₆ in. (73.2 x 72.5 cm) (irreg.). Publisher and printer: the artist. Edition: unique. John B. Turner Fund

180. Leon Golub
White Squad. 1987. Lithograph, comp. and sheet: 29¼ x 41¼ in. (74.3 x 104.8 cm). Publisher: Mason Gross School of the Arts, Rutgers University, New Brunswick, N.J. Printer: Rutgers Center for Innovative Print and Paper, New Brunswick. Edition: 60. Gift of Arnold Smoller

181. Christopher Wilmarth
Self-Portrait with Sliding Light. 1987. Steel, bronze, and lead, 53⅝ x 16⅞ x 7¼ in. (136.2 x 42.8 x 18.4 cm). Gift of Susan Wilmarth

182. Alberto Meda
Light Light Armchair. 1987. Carbon fiber and Nomex honeycomb, 29¼ x 15 x 19½ in. (74.3 x 38.3 x 49.5 cm). Manufacturer: Alias S.r.l., Italy. Gift of the manufacturer

183. Eric Fischl
Portrait of a Dog. 1987. Oil on canvas, in four parts, overall: 9 ft. 5 in. x 14 ft. 2¾ in. (287 x 433.7 cm). Gift of the Louis and Bessie Adler Foundation, Inc., Seymour M. Klein, President; Agnes Gund; President's Fund Purchase (1987), Donald B. Marron, President; Jerry I.

Speyer; the Douglas S. Cramer Foundation; Philip Johnson; Robert and Jane Meyerhoff; Anna Marie and Robert F. Shapiro; Barbara Jakobson; Gerald S. Elliott; and purchase

184. Tina Barney
Sheila and Moya. 1987. Chromogenic color print, 30½ x 38¾ in. (77.5 x 98.5 cm). Gift of the photographer and Janet Borden.

185. Jac Leirner
Lung. 1987. 1,200 Marlboro cigarette packages strung on a polyurethane cord, dimensions variable, length ranges from 14 ft. 5¼ in. (440 cm) to 15 ft. 9 in. (480 cm). David Rockefeller Fund for Latin-American Art and Brazil Fund

186. Tony Cragg
Oersted Sapphire. 1987. Cast aluminum, in six parts: large beaker: 7 ft. 6 in. x 41 in. x 41 in. (228.5 x 104 x 104 cm); small beaker: 50¾ x 20¼ x 20¼ in. (129 x 51.5 x 51.5 cm); round beaker: 22 x 31½ x 37¼ in. (55.8 x 54.5 x 94.6 cm); long test tube: 7½ x 48½ x 7⅛ in. (19.1 x 123.1 x 18.2 cm); short test tube: 8¼ x 38⅝ x 8 in. (21 x 98.6 x 20.3 cm); curved test tube: 8¾ in. x 6 ft. 8½ in. x 43½ in. (22.2 x 204.5 x 110.5 cm); overall: approx. 7 ft. 6 in. x 18 ft. 10 in. x 11 ft. 1 in. (228.5 x 574.1 x 337.8 cm). Fractional gift of Werner and Elaine Dannheisser

187. Frank Gehry
Bubbles Lounge Chair. 1987. Corrugated cardboard with fire-retardant coating, 35 x 28½ x 73 in. (89 x 72.5 x 185.5 cm). Manufacturer: New City Editions, California. Kenneth Walker Fund

188. Andy Warhol
Camouflage. 1987. Portfolio of eight screenprints, comp. and sheet: each 37¹⁵⁄₁₆ x 37¹⁵⁄₁₆ in. (96.5 x 96.5 cm). Publisher: the artist. Printer: Rupert Jason Smith, New York. Edition: 80. John B. Turner Fund.

189. Nathaniel Dorsky
Alaya. 1976–87. USA. 16mm film, color, silent, 27 minutes (18 frames per second). Acquired from the artist

190. Mary Lucier
Ohio at Giverny: Memory of Light. 1987. USA/France. Videotape, color, sound, 25 minutes. Gift of the Jerome Foundation

191. Anish Kapoor
Untitled (Red Leaf). 1987. Gouache and pencil on paper, 13¾ x 12¼ in. (35 x 31.1 cm). Gift of Patricia and Morris Orden and an anonymous donor

192. John Huston
The Dead. 1987. USA. 35mm film, color, 83 minutes. Acquired from Vestron

193. John Boorman
Hope and Glory. 1987. Great Britain. 35mm film, color, 113 minutes

194. Aleksandr Askoldov
The Commissar. 1967–87. Soviet Union. 35mm film, black and white, 110 minutes. Acquired from Gerald Rappaport

195. Mario Merz
Places with No Street. 1987. Aluminum, wire mesh, stones, twigs, neon tubing, transformer, and wires, dimensions variable, museum installation, 6 ft. 6¾ in. x 21 ft. x 28 ft. (200 x 640.5 x 854 cm). Sid R. Bass and Enid A. Haupt funds

196. Office for Metropolitan Architecture (Rem Koolhaas, Götz Keller, Willem-Jan Neutelings, Martin Kohn, Luc Reuse, Ron Steiner, Jeroen Thomas, and Graciella Torre)
City Hall Competition. the Hague, the Netherlands. 1987. Perspective: charcoal on paper, 62 x 81 in. (157.5 x 205.7 cm). Purchase

197. Wolfgang Laib
The Passageway. 1988. Beeswax, wood construction, with two electric light bulbs, exterior dimensions variable, interior dimensions, 10 ft. 11⅛ in. x 6 ft. 1½ in. x 18 ft. 9¼ in. (333.6 x 186.6 x 572.1 cm). Committee on Painting and Sculpture Funds

198. Bernd and Hilla Becher
Water Towers. 1988. Nine gelatin silver prints, each 15¹⁵⁄₁₆ x 12⅛ in. (40.5 x 30.8 cm), overall: 67¹¹⁄₁₆ x 55⅛ in. (172 x 140 cm). Fractional Gift of Werner and Elaine Dannheisser

199. Steven Holl with Bryan Bell, Stephen Cassell, Pier Copat, and Peter Lynch.
American Memorial Library, Berlin, Germany. Project, 1988. Model: concrete, wood, paper, pigment, and steel, 10¼ x 48 x 24 in. (26 x 121.9 x 61 cm). Given anonymously and David Rockefeller, Jr., Purchase Fund

200. Jean-Luc Godard
Puissance de la parole. 1988. France/Switzerland. Videotape, color, 25 minutes. Acquired from France Telecom

201. Christian Boltanski
The Storehouse (La Grande Reserve). 1988. Seven photographs, seven electric lamps, and 192 tin biscuit-boxes containing cloth fragments, overall: 6 ft. 11⅛ in. x 7 ft. 4 in. x 8½ in. (211.2 x 375.8 x 21.6 cm). Jerry I. Speyer, Mr. and Mrs. Gifford Phillips, Barbara Jakobson, and Arnold A. Saltzman funds, and purchase

202. Allen Ruppersberg
Preview. 1988. Series of ten lithographs, comp.: each 21¼6 x 13¾ in. (54.1 x 33.5 cm), sheet: each 22¹⁄₁₆ x 13¹⁵⁄₁₆ in. (56.1 x 35.1 cm). Publisher and printer: Landfall Press, Chicago. Edition: 30. John B. Turner Fund

203. Tadanori Yokoo
Japanese Society for the Rights of Authors, Composers, and Publishers. 1988. Poster: screenprint, 40½ x 28⅝ in. (102.8 x 72.5 cm). Gift of the designer

204. David Wojnarowicz
The Weight of the Earth, Part I. 1988. Fourteen gelatin silver prints, overall: 39 x 41¼ in. (99.1 x 104.8 cm). The Family of Man Fund

205. Ashley Bickerton
Tormented Self-Portrait (Susie at Arles). 1987–88. Synthetic polymer paint, bronze powder, and lacquer on wood, anodized aluminum, rubber, plastic, Formica, leather, chrome-plated steel, and canvas, 7 ft. 5⅜ in. x 68¾ in. x 15⅜ in. (227.1 x 174.5 x 40 cm). Purchase

206. Zeke Berman
Untitled. 1988. Gelatin silver print, 27¹¹⁄₁₆ x 39⅜ in. (70 x 100.1 cm). The Fellows of Photography Fund

207. Morphosis (Thom Mayne and Kim Groves)
6th Street House Project, Santa Monica, California. 1987–88. Silkscreen and metal foil on paper, 40 x 30 in. (101.6 x 76.2 cm). Given anonymously

208. Richard Artschwager
Double Sitting. 1988. Synthetic polymer paint on composition board and Formica, 6 ft. 3⅝ in. x 67⅞ in. (192 x 172.3 cm), including painted wood frame. Fractional and promised gift of Agnes Gund

209. Mike and Doug Starn
Double Rembrandt with Steps. 1987–88. Toned gelatin silver prints, ortho film, wood, adhesive, and Plexiglas, 42½ x 42½ in. (108 x 108 cm). Gift of Barbara and Eugene Schwartz

210. Gerhard Richter
October 18, 1977. 1988. Five of fifteen paintings, oil on canvas, installation variable. Shown: *Funeral (Beerdigung),* 6 ft. 6¾ in. x 10 ft. 6 in. (200 x 320 cm); *Cell (Zelle),* 6 ft. 7 in. x 55 in. (201 x 140 cm); *Hanged (Erhängte),* 6 ft. 7 in. x 55 in. (201 x 140 cm); *Youth Portrait (Jugendbildnis),* 28½ x 24½ in. (72.4 x 62 cm); *Record Player (Plattenspieler),* 24⅜ x 32¼ in. (62 x 83 cm). The Sidney and Harriet Janis Collection, gift of Philip Johnson, and acquired through the Lillie P. Bliss Bequest (all by exchange); Enid A. Haupt Fund; Nina and Gordon Bunshaft Bequest Fund; and gift of Emily Rauh Pulitzer

211. Lawrence Charles Weiner
Rocks upon the Beach/Sand upon the Rocks. 1988. Paint on wall, dimensions variable. Acquisition from the Werner Dannheisser Testamentary Trust

212. Clint Eastwood
Bird. 1988. USA. 35mm film, color, 161 minutes. Gift of the artist and Warner Bros.

213. Bruce Nauman
Learned Helplessness in Rats (Rock and Roll Drummer). 1988. USA. Video installation of Plexiglas maze, closed-circuit video camera, scanner and mount, switcher, two videotape players, 13-in. color monitor, 9-in. black-and-white monitor, video projector, and two videotapes (color, sound); maze: 22 in. x 10 ft. 6 in. x 10 ft. 10 in. (55.9 x 320 x 330.2 cm);

overall dimensions variable. Acquisition from the Werner Dannheisser Testamentary Trust

214. Ilya Kabakov
The Man Who Flew Into His Picture from the Ten Characters series. 1981–88. Room installation of painted drywall, composition board, and painted Homasote, containing enamel paint on composition board, ink and color graphite on paper, photographs, watercolor on paper, painted wood doors, wood chair, painted wood shelf, and painted electric lightbulb, dimensions variable, museum installation 8 ft. 8½ in. x 24 ft. 6 in. x 17 ft. 3 in. (265.4 x 746.8 x 525.8 cm). Gift of Marcia Riklis, Jerry I. Speyer Fund, and Michael and Judy Ovitz Fund

215. Stephen Peart and Bradford Bissell
"Animal" Wet Suit. 1988. Molded neoprene, thermoplastic elastomer, nylon jersey, and Derlin zipper, dimensions variable. Manufacturer: O'Neill, Inc., California. Gift of the designers

216. Jeff Koons
Pink Panther. 1988. Porcelain, 41 x 20½ x 19 in. (104.1 x 52.1 x 48.2 cm). Fractional gift of Werner and Elaine Dannheisser

217. Günter Förg
Stairway. 1988. Gelatin silver print, 70⅞ x 47¼ in. (180 x 120 cm). Gift of Robert F. and Anna Marie Shapiro

218. Tony Oursler and Constance DeJong
Joyride. 1988. USA. Videotape, color, sound, 14 minutes 23 seconds. Purchase

219. Julie Zando
Let's Play Prisoners. 1988. USA. Videotape, black and white, sound, 22 minutes. Purchase

220. Louise Lawler
Does Andy Warhol Make You Cry? 1988. Silver dye bleach print (Cibachrome), 27¹⁄₁₆ x 39⅜ in. (70 x 100 cm), with a Plexiglas wall label (not shown), 4³⁄₁₆ x 6⅞ in. (10.2 x 15.1 cm). Gift of Gabriella de Ferrari in honor of Karen Davidson

221. Roy Lichtenstein
Bauhaus Stairway. 1988. Oil and synthetic polymer paint (Magna) on canvas, 7 ft. 10 in. x 66 in. (238.8 x 167.7 cm). Gift of Dorothy and Roy Lichtenstein

222. Matt Mullican
Untitled. 1988. Portfolio of fifteen etchings (twelve with aquatint and one with photogravure) and one aquatint, plate: each 21½ x 14½ in. (54.6 x 36.8 cm), sheet: each 22¼6 x 15⅛ in. (56 x 38.4 cm). Publisher: Carl Solway Gallery, Cincinnati. Printer: Mark Patsfall Graphics, Cincinnati. Edition: 64. Purchase

223. Martin Kippenberger
The World of the Canary. 1988. Pencil on paper, four of 156 sheets,

each 5½ x 4⅛ in. (14 x 10.5 cm). Gift of Walter Bareiss and R. L. B. Tobin

224. Marc Newson
Wood Chair. 1988. Fujo wood, 24⅜ x 32¼ x 39¾ in. (62 x 82 x 100 cm). Manufacturer: Cappellini S.p.A., Italy. Gift of the manufacturer

225. Gregory Crewdson
Untitled from the series Natural Wonder. 1988. Chromogenic color print (Ektacolor), 26⅝ x 37¼ in. (67 x 95.9 cm). Purchased as a gift of Barbara Jakobson

226. Adam Fuss
Untitled. 1988. Gelatin silver print, 54⅞ x 49¹⁄₁₆ in. (139.4 x 124.6 cm). Polaroid Foundation Fund

227. Nic Nicosia
Real Pictures #11. 1988. Gelatin silver print, 6 ft. 7 in. x 48⅜ in. (200.7 x 122.9 cm). E. T. Harmax Foundation Fund

228. Paul Thek
The Soul Is the Need for the Spirit. 1988. Synthetic polymer paint on newspaper, 22 x 27 in. (55.9 x 69.9 cm). Purchased with funds given by The Judith Rothschild Foundation

229. Pedro Almodóvar
Women on the Verge of a Nervous Breakdown. 1988. Spain. 35mm film, color, 98 minutes

230. Cindy Sherman
Untitled #197. 1989. Chromogenic color print (Ektacolor), 31¹⁄₁₆ x 20¹⁵⁄₁₆ in. (78.9 x 53.2 cm). Purchase

231. Marlon Riggs
Tongues Untied. 1989. USA. Videotape, color, sound, 55 minutes. Purchase

232. Martin Scorsese
The Last Temptation of Christ. 1989. USA/Canada. 35mm film, color, 164 minutes

233. Richard Sapper and Sam Lucente
Leapfrog Computer. 1989. Carbon-fiber-reinforced plastic, magnesium alloy, ABS, and other materials, 1½ x 10⅝ x 13¾ in. (3.8 x 27 x 35 cm). Manufacturer: IBM Corporation, New York. Gift of the manufacturer

234. Thomas Ruff
Portrait. 1989. Chromogenic color print (Ektacolor), 47¹⁄₁₆ x 22⅝ in. (119.6 x 57.5 cm). The Fellows of Photography Fund

235. Edin Velez
Dance of Darkness. 1989. USA. Videotape, color, sound, 54 minutes 57 seconds. Gift of the Jerome Foundation

236. Carroll Dunham
Shadows. 1989. Two from a portfolio of ten drypoints, plate and sheet: each approx. 15¼ x 22¹³⁄₁₆ in. (39.3 x 58 cm). Publisher and printer: Universal Limited Art Editions, West Islip, N.Y. Edition: 14. Gift of Emily Fisher Landau

237. Tadanori Yokoo
Fancydance. 1989. Poster: offset lithograph, 40½ x 28⅝ in. (102.8 x 72.5 cm). Gift of the designer

238. Elizabeth Diller and Ricardo Scofidio
Slow House, Long Island, New York. 1989. Model: wood, cardboard, metal, plastic and twine, 12 x 60 x 30¼ in. (30.5 x 152.5 x 77 cm). Marshall Cogan Purchase Fund, Bertha and Isaac Liberman Foundation Fund

239. Rafael Viñoly
Tokyo International Forum, Tokyo, Japan. 1989. East elevation of theater structures: crayon and graphite on tracing paper, 12 x 31¾ in. (30.5 x 80.6 cm). Gift of the architect

240. Bruce Nauman
Model for *Animal Pyramid II.* 1989. Cut-and-taped photographs, 7 ft. 6½ in. x 60⅛ in. (229.9 x 152.8 cm). Gift of Agnes Gund and Ronald S. Lauder

241. Gilbert and George
Down to Earth. 1989. Fifteen black-and-white photographs, hand colored with ink and dyes, mounted and framed, each 29¾ x 25 in. (74.9 x 63 cm), overall: 7 ft. 4½ in. x 10 ft. 5 in. (224.8 x 317.5 cm). Fractional gift of Werner and Elaine Dannheisser

242. Laurie Simmons
Walking House. 1989. Gelatin silver print, 83¼ x 47⅜ in. (211.4 x 120.4 cm). Richard E. and Christie Salomon Fund and The Family of Man Fund

243. David Levinthal
Untitled from the series *Cowboys.* 1989. Color instant print (Polaroid), 24 x 19½ in. (61 x 49.6 cm) (irreg.). The Fellows of Photography Fund and Anonymous Purchase Fund

244. Oliver Stone
Born on the Fourth of July. 1989. USA. 35mm film, color, 145 minutes. Gift of the artist and Universal Pictures

245. Spike Lee
Do the Right Thing. 1989. USA. 35mm film, color, 120 minutes

246. Chris Killip
Untitled. 1989. Gelatin silver print, 22¹¹⁄₁₆ x 18⅛ in. (57.6 x 46.8 cm). The Family of Man Fund

247. Office for Metropolitan Architecture (Elizabeth Alford, Xaveer de Geyter, Rem Koolhaas, Winy Maas, and Ray Maggiore)
National Library of France (Très Grande Bibliothèque), Paris. Project, 1989. Model: plaster, aluminum and wood. 41 x 29½ x 33⅜ in. (104.1 x 74.9 x 85 cm). Frederieke Taylor Purchase Fund

248. Kazuo Kawasaki
Carna Wheelchair. 1989. Titanium, rubber, and honeycomb-core aluminum, 33 x 22 x 35¼ in. (84 x 56 x 89.6 cm). Manufacturer: SIG Workshop Co. Ltd., Japan. Gift of the designer

249. Art Spiegelman
Lead Pipe Sunday. 1989. Folded

double-sided lithograph, comp. (unfolded): 20 x 28 in. (50.8 x 71.1 cm), sheet (unfolded): 22¼ x 30¼ in. (56.5 x 76.8 cm). Publisher: The Print Club, Philadelphia. Printer: Corridor Press, Philadelphia. Edition: 100. John B. Turner Fund

250. John Woo
The Killer. 1989. Hong Kong. 35mm film, color, 110 minutes

251. Ida Applebroog
Chronic Hollow. 1989. Oil on six canvases, overall: 7 ft. 10½ in. x 9 ft. 8⅛ in. (240 x 295 cm). Acquired with matching funds from The Millstream Fund and the National Endowment for the Arts, and purchase

252. Peggy Ahwesh
Martina's Playhouse. 1989. USA. Super-8mm film, color, 20 minutes. Acquired from the artist

253. Shiro Kuramata
Miss Blanche Chair. 1989. Paper flowers, acrylic resin, and aluminum, 36⅝ x 24⅛ x 20¼ in. (93.7 x 63.2 x 52 cm). Manufacturer: Ishimaru Co., Japan. Gift of Agnes Gund in honor of Patricia Phelps de Cisneros

254. Edward Ruscha
That Is Right and Other Similarities. 1989. Portfolio of twelve lithographs, comp.: each approx. 5⅛ x 6⅞ in. (13.1 x 17.5 cm), sheet: each approx. 9¹⁄₁₆ x 11 in. (23 x 28 cm). Publisher: the artist. Printer: Edward Hamilton, Los Angeles. Edition: 30. Gift of Jeanne C. Thayer and purchase

255. José Leonilson
To Make Your Soul Close to Me. 1989. Watercolor and ink on paper, 12½ x 9⅜ in. (31.9 x 23.9 cm). Gift of the artist's estate

256. Sadie Benning
Me and Rubyfruit. 1989. USA. Videotape made with Pixelvision camera, black and white, sound, 4 minutes. Purchase

257. Marc Newson
Orgone Chaise Longue. 1989. Fiberglass, 19¹¹⁄₁₆ x 29½ x 70⅞ in. (50 x 75 x 180 cm). Manufacturer: Cappellini S.p.A., Italy. Gift of the manufacturer

258. Joan Jonas
Volcano Saga. 1989. USA. Videotape, color, sound, 28 minutes. Purchase

259. Giuseppe Penone
Thirty-Three Herbs. 1989. Four from a portfolio of thirty-three lithographs and photolithographs, comp: various dimensions, sheet: each 16½ x 11⅝ in. (41.9 x 29.5 cm). Printer and publisher: Marco Noire Editore, Turin. Edition: 150. Frances Keech Fund

260. Gundula Schulze
Dresden. 1989. Chromogenic color print (Ektacolor), 24¼ x 15½ in. (61.6 x 39.4 cm). The Family of Man Fund

261. Martin Parr
Midsummer Madness, Conservative Party Social Event. 1986–89. Chromogenic color print (Ektacolor),

16¹¹⁄₁₆ x 20⅜ in. (42.4 x 52.3 cm). The Family of Man Fund

262. Steina Vasulka
In the Land of the Elevator Girls. 1989. Japan. Videotape, color, sound, 4 minutes. Purchase

263. Robert Gober
Cat Litter. 1989. Plaster, ink, and latex paint, 17 x 8 x 5 in. (43.2 x 20.3 x 12.7 cm). Edition: 2/7. Acquisition from the Werner Dannheisser Testamentary Trust

264. Thomas Schütte
Untitled. 1989. Watercolor, ink, gouache, and pencil on paper. Seven watercolors, each 12½ x 9⅜ in. (31.7 x 23.8 cm). Purchase

265. Tadao Ando
Church of the Light, Ibaraki, Osaka, Japan. 1984–89. Plan: lithograph with color pencil, 40 x 28 in. (101.6 x 71.12 cm). Gift of the architect in honor of Philip Johnson

266. Tadao Ando
Church of the Light, Ibaraki, Osaka, Japan. 1984–89. Interior perspective: color pencil on note paper, 10⅛ in. x 7⅛ in. (25.7 x 18.1 cm). Gift of the architect in honor of Philip Johnson

267. Tadao Ando
Church of the Light, Ibaraki, Osaka, Japan. 1984–89. Model: wood, 7⅛ x 17¾ x 7 in. (18.1 x 45.2 x .6 cm). Gift of the architect in honor of Philip Johnson

268. James Lee Byars
The Table of Perfect. 1989. Gold leaf on white marble, 39¼ x 39¼ x 39¼ in. (99.7 x 99.7 x 99.7 cm). Committee on Painting and Sculpture Funds

269. Steven Holl
Nexus World Kashii, Fukuoka, Japan. 1989. Exterior perspective of housing: watercolor and graphite on paper, 22 x 30 in. (55.9 x 76.2 cm). Gift of the architect in honor of Lily Auchincloss

270. James Turrell
First Light, Series C. 1989–90. Series of four aquatints, plate: each 39¹⁄₁₆ x 27¼ in. (99.3 x 69.3 cm), sheet: each approx. 42⅜ x 29¹³⁄₁₆ in. (107.7 x 75.8 cm). Publisher: Peter Blum Edition, New York. Printer: Peter Kneubühler, Zurich. Edition: 30. Gift of Peter Blum Edition

271. Joel Shapiro
Untitled. 1989–90. Bronze, 8 ft. 3¼ in. x 69½ in x 30 in. (253.5 x 176.5 x 76.2 cm). Edition: 4/4. Sid R. Bass Fund; gift of Jeanne C. Thayer, Anna Marie and Robert F. Shapiro, Agnes Gund, and William L. Bernhard; President's Fund Purchase (1990), Donald B. Marron, President; Jerry I. Speyer Fund; and Emily and Jerry Spiegel Fund

272. Steven Holl
"Edge of a City" Parallax Towers, New York. Project, 1990. Model:

wood and paper, 13 ft. 10½ in. x 7 ft. 2 in. (422.9 x 218.5 cm). Given anonymously and David Rockefeller, Jr., Purchase Fund

273. Christopher Wool
Untitled. 1990. Enamel on aluminum, 9 x 6 ft. (274.3 x 182.9 cm). Gift of the Louis and Bessie Adler Foundation, Inc.

274. Martin Kippenberger
Martin, Stand in the Corner and Be Ashamed of Yourself. 1990. Cast aluminum, clothing, and iron plate, 71½ x 29½ x 13½ in. (181.6 x 74.9 x 34.3 cm). Blanchette Hooker Rockefeller Fund Bequest; Anna Marie and Robert F. Shapiro, Jerry I. Speyer, and Michael and Judy Ovitz funds

275. John Barnard
Formula 1 Racing Car 64 1/2. 1990. Various materials, 40½ in. x 7 ft. 14 ft. 8½ in. (102.8 x 213.5 x 448.4 cm). Manufacturer: Ferrari S.p.A., Italy. Gift of the manufacturer

276. Gary Hill
Inasmuch As It Is Always Already Taking Place. 1990. Video/sound installation of 16 black-and-white video monitors (all cathode-ray tubes are removed from chassis and extended with wires), 16 laser-disc players, one audio mixer, and two speakers, recessed in a wall 42 in. (106.7 cm) from the floor, overall: 16 x 53¾ x 68 in. (40.6 x 136.5 x 172.7 cm). Gift of Agnes Gund, Marcia Riklis, Barbara Wise, and Margot Ernst; and purchase

277. General Idea (AA Bronson, Felix Partz, Jorge Zontal)
AIDS projects. 1988–90. *AIDS (Stamps)* for the journal *Parkett 15.* Photolithograph, comp. and sheet: 10 x 8¼ in. (25.4 x 21 cm). Edition: 200. Purchased with funds given by Linda Barth Goldstein. *AIDS (Lottery Ticket).* 1989. Photolithograph on four sheets, each 4³⁄₁₆ x 6⅜ in. (10.6 x 16.2 cm). Edition: unlimited. Gift of A. A. Bronson. *AIDS (Adhesive-backed Label).* 1990. Photolithograph, sheet: 6³⁄₁₆ x 6³⁄₁₆ in. (16 x 16 cm). Edition: unlimited. Gift of A. A. Bronson. *AIDS (Project for Ohio Dentist).* 1988. Photolithograph, page 10⅞ x 8¼ in. (27.6 x 20.9 cm). Edition: unlimited. Gift of A. A. Bronson

278. Lari Pittman
Counting to Welcome One's Defrosting. 1990. Synthetic polymer paint and enamel on paper, 30 x 22 in. (76.2 x 55.9 cm). Gift of Hudson

279. Akira Kurosawa
Dreams. 1990. Japan/USA. 35mm film, color, 119 minutes

280. Brice Marden
Cold Mountain Series, Zen Study 1 (Early State). 1990. Etching and aquatint, plate: 20¹¹⁄₁₆ x 27¹⁄₁₆ in. (52.6 x 69.1 cm), sheet: 27⅜ x 35¼ in. (69.5 x 89.6 cm). Publisher: the artist. Printer: Jennifer Melby, New York. Edition: 3. Linda Barth Goldstein Fund

281. Brice Marden
Cold Mountain Series, Zen Study 3 (Early State). 1990. Aquatint, plate: 20¹¹⁄₁₆ x 27³⁄₁₆ in. (52.6 x 69 cm), sheet: 27¹⁄₁₆ x 35⅜ in. (69.7 x 89.8 cm). Publisher: the artist. Printer: Jennifer Melby, New York. Edition: 3. Purchase

282. Thomas Struth
Pantheon, Rome. 1990. Chromogenic color print, 54⅛ x 6 ft. 4⅜ in. (137.5 x 194 cm). Fractional gift of Werner and Elaine Dannheisser

283. Thomas Struth
South Lake Apartments 3, Chicago. 1990. Gelatin silver print, 18⅜ x 22⅜ in. (46.5 x 56.8 cm). Anonymous Purchase Fund

284. Thomas Struth
South Lake Apartments 4, Chicago. 1990. Gelatin silver print, 17¹⁵⁄₁₆ x 22⅜ in. (45.5 x 57.5 cm). Anonymous Purchase Fund

285. Arata Isozaki
City in the Air: "Ruin of Hiroshima." Project, 1990. Silkscreen, 34⅜ in. x 9 ft. 9 in. (88.3 x 297 cm). Gift of the architect in honor of Philip Johnson

286. Arata Isozaki
City in the Air: "Incubation Process." Project, 1990. Silkscreen, 41 x 34⅜ in. (104.2 x 87.4 cm). Gift of the architect in honor of Philip Johnson

287. David Hammons
African-American Flag. 1990. Dyed cotton, 56 in. x 7 ft. 4 in. (142.2 x 223.5 cm). Gift of The Over Holland Foundation

288. David Hammons
High Falutin'. 1990. Metal (some parts painted with oil), oil on wood, glass, rubber, velvet, plastic, and electric light bulbs, overall: 13 ft. 2 in. x 48 in. x 30½ in. (396 x 122 x 77.5 cm). Robert and Meryl Meltzer Fund and purchase

289. Richard Prince
Untitled. 1984 and 1990. Silkscreen, graphite, and spray paint on paper, 40 x 26 in. (101.5 x 66 cm). Gift of the Robert Lehman Foundation, Inc.

290. Joel Sternfeld
An Attorney with Laundry, Bank and Fourth, New York, New York. 1990. Chromogenic color print, 42½ x 33½ in. (107.9 x 85.1 cm). The Family of Man Fund

291. Yvonne Rainer
Privilege. 1990. USA. 16mm film, black and white and color, 103 minutes. Acquired from the artist and Zeitgeist Films

292. Kiki Smith
A Man. 1990. Printed ink on torn and pasted handmade paper. 6 ft. 6 in. x 16 ft. 8 in. (198.1 x 508 cm). Gift of Patricia and Morris Orden

293. Kiki Smith
Untitled. 1987–90. Twelve silvered glass water bottles arranged in a

row, each bottle 20½ in. (52.1 cm) high x 11½ in. (29.2 cm) diameter at widest point. Gift of the Louis and Bessie Adler Foundation, Inc.

294. Elizabeth Murray
Her Story by Anne Waldman. 1990. (Prints executed 1988–90). Two plates from the illustrated book of thirteen etching and photolithographs, page: 11¼ x 8⅞ in. (28.5 x 22.5 cm). Publisher and printer: Universal Limited Art Editions, West Islip, N.Y. Edition: 74. Gift of Emily Fisher Landau

295. Elizabeth Murray
Dis Pair. 1989–90. Oil and synthetic polymer paint on two canvases and wood, overall: 10 ft. 2½ in. x 10 ft. 9¼ in. x 13 in. (331.3 x 328.3 x 33 cm). Gift of Marcia Riklis, Arthur Fleischer, and Anna Marie and Robert F. Shapiro; Blanchette Rockefeller Fund; and purchase

296. Mike Kelley
Untitled. 1990. Found afghans and stuffed dolls, overall: 6 in. x 20 ft. 5 in. x 52 in. (15.3 x 622.3 x 132.1 cm); length of dolls: 25 in. (63.5 cm), 15 in. (38.1 cm), 16 in. (40.6 cm), 9 in. (22.7 cm). Gift of the Louis and Bessie Adler Foundation, Inc., and purchase

297. John Cage
Wild Edible Drawing No. 8. 1990. Milkweed, cattail, saffron, pokeweed, and hijiki pressed onto paper, 17 x 12 in. (43 x 30.5 cm). Gift of Sarah-Ann and Werner H. Kramarsky

298. Bruce Conner
INKBLOT DRAWING. 1990. Ink on folded paper with circular paper cutouts, 22¼ x 30⅛ in. (57.2 x 76.5 cm). Purchased with funds given by Sarah-Ann and Werner H. Kramarsky

299. Office for Metropolitan Architecture (Elizabeth Alford, Xaveer de Geyter, Rem Koolhaas, Winy Maas, and Ray Maggiore)
Palm Bay Seafront Hotel and Convention Center, Florida. Project, 1990. Model: plaster, aluminum, and goldplate, 5⅝ x 27⅓ x 27⅜ in. (14.3 x 69.6 x 69.6 cm). Gift of the architects in honor of Philip Johnson

300. Felix Gonzalez-Torres
"Untitled" (Death by Gun). 1990. Nine-inch stack of photolithographs, comp.: 44½ x 32¼ in. (113 x 82.5 cm), sheet: 44¹⁵⁄₁₆ x 32¹⁵⁄₁₆ in. (114.1 x 83.6 cm). Printer: Register Litho, New York. Edition: unlimited. Purchased in part with funds from Arthur Fleischer, Jr., and Linda Barth Goldstein

301. Agnieszka Holland
Europa Europa. 1990. Germany/France. 35mm film, color, 113 minutes

302. Zhang Yimou and Yang Fengliang
Ju Dou. 1990. China/Japan. 35mm film, color, 95 minutes

303. Jim Nutt
Drawing for Fret. 1990. Graphite on paper, 13 x 13 in. (33 x 33 cm). Purchased with funds given by Richard E. Salomon

304. Stephen Frears
The Grifters. 1990. USA. 35mm film, color, 113 minutes

305. Neil Winokur
Glass of Water. 1990. Silver dye bleach print (Cibachrome), 40 x 30 in. (101.6 x 76.2 cm). Anonymous Purchase Fund

306. Chris Killip
Untitled. 1990. Gelatin silver print, 22¹³⁄₁₆ x 18½ in. (57.9 x 47 cm). The Family of Man Fund

307. Francis Ford Coppola
The Godfather, Part III. 1990. USA. 35mm film, color, 161 minutes

308. Martin Scorsese
GoodFellas. 1990. USA. 35mm film, color, 146 minutes

309. Toshiyuki Kita
The Multilingual Chair. 1991. Fiberglass and steel, 52¾ x 23¾ x 23¾ in. (125.8 x 460 x 444.6 cm). Manufacturer: Kotobuki Corporation, Japan. Gift of the manufacturer

310. Annette Messager
My Vows. 1988–91. Photographs, color graphite on paper, string, glass, black tape, and pushpins over black paper or black synthetic polymer paint, dimensions variable, museum installation 11 ft. 8¼ in. x 6 ft. 6¾ in. (356.2 x 200 cm). Gift of the Norton Family Foundation

311. Peter Eisenman
Alteka Tower, Tokyo. Project, 1991. Model: wood, acrylic, color tape, 14¼ x 12⅛ x 9½ in. (36.3 x 30.8 x 24.2 cm). Gift of the architect in honor of Philip Johnson

312. John O'Reilly
War Series #34: PFC USMC Killed in Action, Gilbert Islands, 1943, Age 23. 1991. Collage of black-and-white instant prints (Polaroids), 10¹¹⁄₁₆ x 16¼ in. (27.2 x 41.3 cm). Geraldine J. Murphy Fund

313. Boris Mihailov
Untitled from the series U Zemli (On the Ground). 1991. Gelatin silver print, 4¹³⁄₁₆ x 11⅜ in. (12.2 x 28.9 cm). Anonymous Purchase Fund

314. Boris Mihailov
Untitled from the series U Zemli (On the Ground). 1991. Gelatin silver print, 5 x 11¹¹⁄₁₆ in. (12.7 x 29.7 cm). Anonymous Purchase Fund

315. Boris Mihailov
Untitled from the series U Zemli (On the Ground). 1991. Gelatin silver print, 5⅜ x 11¹¹⁄₁₆ in. (13.6 x 29.7 cm). Anonymous Purchase Fund

316. Shimon Attie
Almstadtstrasse 43, Berlin, 1991 (1930). 1991. Chromogenic color print (Ektacolor), 17¹⁵⁄₁₆ x 22³⁄₁₆ in. (45.6 x 56.4 cm). The Family of Man Fund

317. Julie Dash
Daughters of the Dust. 1991. USA.

35mm film, color, 114 minutes. Gift of Kino International

318. Toyo Ito
Shimosuma Municipal Museum, Shomosuma-machi, Nagano Prefecture, Japan. 1991. Model: Plexiglas, aluminum, and lightbulb, 2½ x 47¼ x 23¾ in. (5.7 x 120 x 60.2 cm). Gift of the architect

319. Warren Sonbert
Short Fuse. 1991. USA. 16mm film, color, 37 minutes. Acquired from the artist

320. Ernie Gehr
Side/Walk/Shuttle. 1991. USA. 16mm film, color, 41 minutes. Gift of the artist

321. Annette Lemieux
Stolen Faces. 1991. Photolithograph printed on three sheets, overall: 30⅜ x 7 ft. 4 in. (76.7 x 223.5 cm). Publisher: I. C. Editions, New York. Printer: Trestle Editions, New York. Edition: 26. Purchased with funds given by Howard B. Johnson

322. Oliver Stone
JFK. 1991. USA. 35mm film, black and white and color, 188 minutes. Gift of the artist

323. Tom Dixon
S-Chair. 1991. Straw and metal, 39¾ x 20½ x 16½ in. (100 x 52 x 42 cm). Manufacturer: Cappellini S.p.A., Italy. Gift of the manufacturer

324. Dieter Appelt
The Field. 1991. Thirty gelatin silver prints, each 19½ x 14¼ in. (49.5 x 36.2 cm). Joel and Anne Ehrenkranz Fund, John Parkinson III Fund, and The Fellows of Photography Fund

325. Jean-Michel Othoniel
The Forbidden. 1991. Sulfur print with oil additions, plate: 63⅝ x 38¾ in. (161 x 98.4 cm), sheet: 65³⁄₁₆ x 42⅜ in. (165.5 x 108 cm). Publisher and printer: Centre genevois de gravure contemporaine, Geneva. Edition: 5. Joanne M. Stern Fund

326. Vito Acconci
Adjustable Wall Bra. 1990–91. Plaster, steel, canvas, electrical lightbulbs, and audio equipment, installation variable, each cup 7 ft. 3 in. x 7 ft. 10½ in. x 37 in. (221 x 240 x 94 cm). Sid R. Bass Fund and purchase

327. Felix Gonzalez-Torres
"Untitled" (Perfect Lovers). 1991. Two clocks, each 14 in. (35.6 cm) diameter x 2¼ in. (5.7 cm) deep, overall dimensions variable, museum installation, 14 x 28 x 2¼ in. (35.6 x 71.1 x 5.7 cm). Gift of the Dannheisser Foundation

328. Felix Gonzalez-Torres
"Untitled" (Supreme Majority). 1991. Paper, in seven parts, dimensions variable, overall: approx. 61 x 40 x 36 in. (154.9 x 100.6 x 91.4 cm). Fractional gift of Werner and Elaine Dannheisser

329. Felix Gonzalez-Torres
"Untitled" (Placebo). 1991. Silver-

cellophane-wrapped candies, endlessly replenished supply, ideal weight 1,000 lbs., dimensions variable, museum installation, 2 in. x 12 ft. x 20 ft. 4 in. (5 x 375.9 x 619.9 cm). Gift of Elisa and Barry Stevens

330. Felix Gonzalez-Torres
"Untitled." 1991. Printed billboard, dimensions variable, museum installation 10 ft. 5 in. x 22 ft. 8 in. (317.5 x 690.9 cm). Gift of Werner and Elaine Dannheisser

331. Tejo Remy
"You Can't Lay Down Your Memory" Chest of Drawers. 1991. Metal, paper, plastic, burlap, contact paper, and paint, 55½ x 53 x 20 in. (141 x 134.6 x 50.8 cm). Manufacturer: Tejo Remy. Frederieke Taylor Purchase Fund

332. Enzo Mari
Flores Box. 1991. Thermoplastic polymer, 3⅛ x 11¾ x 6 in. (7.8 x 29.9 x 15.2 cm). Manufacturer: Danese S.r.l., Italy. Gift of the manufacturer

333. Abelardo Morell
Light Bulb. 1991. Gelatin silver print, 18 x 22⁵⁄₁₆ in. (45.5 x 56.5 cm). Purchased with funds given by Marian and James Cohen in memory of their son Michael Harrison Cohen

334. Zaha M. Hadid
Hong Kong Peak Competition, Hong Kong. 1991. Exterior perspective: acrylic on paper mounted on canvas, 51 x 72 in. (129.5 x 183 cm). David Rockefeller, Jr., Fund

335. Glenn Ligon
Untitled (How it feels to be colored me. . . Doubled). 1991. Oilstick on paper, 31½ x 16 in. (80 x 41 cm). Gift of The Bohen Foundation

336. David Wojnarowicz
Untitled. 1990–91. Photostat, comp.: 27¹⁵⁄₁₆ x 37³⁄₁₆ in. (70.9 x 94.4 cm) (irreg.), sheet: 32 x 41 in. (81.3 x 104.2 cm). Publisher: the artist. Printer: Giant Photo, New York. Edition: 10. Purchased in part with funds from Linda Barth Goldstein and Art Matters Inc.

337. Allen Ruppersberg
Remainders: Novel, Sculpture, Film. 1991. Books, cardboard, and oak, overall: 45 x 47½ x 29⅝ in. (114.4 x 120.6 x 75.9 cm). Given anonymously

338. Raymond Pettibon
No Title (Filling In So . . .). 1991. Black and color inks on paper, 13½ x 10⅜ in. (34.2 x 26.3 cm). Gift of the Friends of Contemporary Drawing

339. Raymond Pettibon
No Title (Under My Thumb). 1991. Ink and wash on paper, 18 x 12 in. (45.7 x 30.5 cm). Gift of the Friends of Contemporary Drawing

340. Christopher Wool
Untitled. 1991. Alkyd paint stamped on paper, 52 x 40 in. (132.2 x 101.6 cm). Gift of Charles B. Benenson

341. Frank Gehry
Cross Check Armchair. 1991. Bent-

laminated maple, 32¾ x 30½ x 31½ in. (85 x 71.1 x 67.4 cm). Manufacturer: The Knoll Group, New York. Gift of the designer and the manufacturer

342. Brice Marden
Rain. 1991. Black and color ink on paper, 25¾ x 34¼ in. (65.4 x 87.2 cm). Gift of The Edward John Noble Foundation, Inc., and Ronald S. Lauder

343. Robert Gober
Untitled. 1992. Wax and human hair, shoe: 3 x 2⅝ x 7⅛ in. (7.6 x 6.7 x 19.1 cm). Edition: 7/15. Gift of the Dannheisser Foundation

344. Robert Gober
Untitled. 1991. Wax, cotton, leather, human hair, wood, and steel, 12½ x 35½ x 9¾ in. (31.8 x 90.2 x 23.5 cm). Robert and Meryl Meltzer Fund, Anna Marie and Robert F. Shapiro Fund, The Norman and Rosita Winston Foundation, Inc., Fund, The Millstream Fund, and Jerry I. Speyer Fund

345. Robert Gober
Untitled. 1992. Toned gelatin silver print, 16¾ x 12⅝ in. (42.5 x 32.1 cm). Gift of Werner and Elaine Dannheisser

346. Robert Gober
Newspaper. 1992. Multiple of a bundle of photolithographs, tied with twine, from a series of twenty-two, 6 x 16¾ x 13¼ in. (15.3 x 42.5 x 33.6 cm). Publisher: the artist. Printer: Derrière L'Étoile, New York. Edition: 10. Gift of The Associates of the Department of Prints and Illustrated Books in honor of Deborah Wye

347. Cindy Sherman
Untitled #250. 1992. Chromogenic color print, 49¾ x 74½ in. (125.5 x 189.2 cm). Gift of Werner and Elaine Dannheisser

348. Janine Antoni
Gnaw. 1992. 600 lbs. of chocolate before biting; 600 lbs. of lard before biting; phenylethylamine; 45 heart shaped packages made from chewed chocolate removed from Chocolate Gnaw; 400 lipsticks made from pigment, beeswax and chewed lard removed from Lard Gnaw; display cabinet, dimensions variable. Purchase

349. Paul McCarthy
Sketchbook "Heidi." 1992. Illustrated book with nine screenprints and corrugated-cardboard cover, page: 22 x 14¹⁵⁄₁₆ in. (56 x 37.9 cm). Edition: 50. Publisher: Galerie Krinzinger, Vienna. Printer: Edition Schilcher, Graz, Austria. John B. Turner Fund

350. Paul McCarthy and Mike Kelley
Heidi. 1992. USA. Videotape, color, sound, 62 minutes 40 seconds. Purchase

351. Roy Lichtenstein
Interior with Mobile. 1992. Oil and synthetic polymer paint (Magna) on canvas, 10 ft. 10 in. x 14 ft. 3 in. (330.2 x 434.4 cm). Enid A. Haupt Fund; gift of Agnes Gund, Ronald S. Lauder, Michael and Judy Ovitz in honor of Roy and Dorothy Lichtenstein, and Anna Marie and Robert F. Shapiro

352. Christopher Connell
Pepe Chair. 1992. Thermoplastic polymer, 51¾ x 20 x 24 in. (131.5 x 50.8 x 61 cm). Manufacturer: MAP (Merchants of Australian Products Pty., Ltd.), Australia. Gift of the manufacturer

353. Ben Faydherbe
Festival in the Hague (Wout de Vringer). Poster: offset lithograph, 46½ x 33 in. (118.2 x 83.8 cm). Gift of the designer through the Netherlands Design Institute

354. Ingo Maurer
Lucellino Wall Lamp. 1992. Glass, brass, plastic, and goose-feathers, 4¼ x 8 x 12¼ in. (11.5 x 20.3 x 31.1 cm). Manufacturer: Ingo Maurer GmbH, Germany. Gift of the designer

355. Guillermo Kuitca
Untitled. 1992. Mixed mediums on canvas, 8 ft. 4½ in. x 6 ft. 1¼ in. (255.7 x 186.1 cm). Gift of Patricia Phelps de Cisneros in memory of Thomas Ammann

356. Willie Cole
Domestic I.D., IV. 1992. Iron scorch and pencil on paper mounted in recycled painted-wood window-frame, comp. (including frame): 35 x 32 x 1⅜ in. (88.9 x 81.3 x 3.5 cm). Printer and fabricator: the artist. Edition: unique. Purchased with funds given by Agnes Gund

357. Arata Isozaki
Convention Hall, Nara, Japan. 1992. Exterior perspective: computer-generated print, 24½ x 40¼ in. (62.2 x 102.9 cm). Gift of the artist

358. Richard Serra
Intersection II. 1992. Cor-Ten steel, four plates, each 13 ft. 1½ in. x 55 ft. 9⅝ in. x 2 in. (400 x 1700 x 5 cm). Gift of Ronald S. Lauder

359. Peter Campus
Burning. 1992. Chromogenic color print, 39¹⁵⁄₁₆ x 50⅜ in. (101.4 x 128 cm). Gift of Paul F. Walter in memory of Mark Kaminski

360. Rudolf Bonvie
Imaginary Picture I. 1992. Gelatin silver print, 34¼ in. x 8 ft. 11⅜ in. (87 x 298 cm). The Fellows of Photography Fund

361. Santiago Calatrava
Alamillo Bridge and Cartuga Viaduct, Seville, Spain. 1987–92. Model: acrylic and mirror glass, 34 in. x 8 ft. 8 in. x 24½ in. (86.3 x 264.2 x 62.3 cm). Gift of the architect

362. Santiago Calatrava
Alamillo Bridge and Cartuga Viaduct, Seville, Spain. 1987–92. Elevations: conté crayon on tracing paper, approx. 17 x 53½ in. (43.2 x 135.9 cm). Gift of the architect

363. José Leonilson
I Am Your Man. 1992. Watercolor and ink on paper, 9 x 12 in. (22.8 x 30.5 cm). Gift of the Friends of Contemporary Drawing

364. Louise Bourgeois
Ste Sébastienne. 1992. Drypoint, plate: 38¹⁵⁄₁₆ x 30⅞ in. (98.9 x 78.4 cm), sheet: 47½ x 37 in. (120.6 x 94 cm). Publisher: Peter Blum Edition, New York. Printer: Harlan & Weaver Intaglio, New York. Gift of the artist

365. Rody Graumans
85 Lamps Lighting Fixture. 1992. Light bulbs, standard cords, and sockets, 31½ in. (100 cm) diameter. Manufacturer: DMD, the Netherlands. Patricia Phelps de Cisneros Purchase Fund

366. Christopher Bucklow
14,000 Solar Images; 1:23 P.M., 13th June 1992. 1992. Gelatin silver print, 13¾ x 15⅝ in. (34.5 x 39.7 cm). E. T. Harmax Foundation Fund

367. Terence Davies
The Long Day Closes. 1992. Great Britain. 35mm film, color, 85 minutes. Gift of the artist and Three River Films

368. Sigmar Polke
The Goat Wagon. 1992. Synthetic polymer paint on printed fabric, 7 ft. 2 in. x 9 ft. 10 in. (218.4 x 299.7 cm). Gift of Werner and Elaine Dannheisser

369. Philip-Lorca diCorcia
Marilyn; 28 years old. Las Vegas, Nevada; $30. 1990–92. Chromogenic color print (Ektacolor), 25³⁄₁₆ x 37¹⁵⁄₁₆ in. (64 x 96.5 cm). E. T. Harmax Foundation Fund

370. Juan Sánchez
For don Pedro. 1992. Lithograph and photolithograph, with oilstick additions and collage, comp.: 22³⁄₁₆ x 30 in. (56.4 x 76.2 cm), sheet: 22³⁄₁₆ x 30 in. (56.4 x 76.2 cm). Publisher and printer: Tamarind Institute, Albuquerque. Edition: 22. The Ralph E. Shikes Fund

371. Raymond Pettibon
No Title (The Sketch Is). 1992. Pen and ink on paper, 11⅜ x 7½ in. (28.9 x 19 cm). Gift of the Friends of Contemporary Drawing

372. Rosemarie Trockel
Untitled. 1992. Ink on paper, 13¾ x 13¾ in. (35 x 35 cm). Purchased with funds given by Agnes Gund

373. Mark Steinmetz
Knoxville. 1992. Gelatin silver print, 11¹⁵⁄₁₆ x 17⅛ in. (30.3 x 43.5 cm). Anonymous Purchase Fund

374. Gabriel Orozco
Maria, Maria, Maria. 1992. Erased telephone-book page, 11 x 9⅛ in. (27.9 x 23.2 cm). Gift of Patricia Phelps de Cisneros and the David Rockefeller Latin American Fund

375. Donald T. Chadwick and William Stumpf
Aeron Office Chair. 1992. Glass-reinforced polyester and die-cast aluminum (structure), Hytrel polymer, polyester, and Lycra (pellicle), 43½ x 27 x 19 in. (110.5 x 68.6 x 48.3 cm). Manufacturer: Herman Miller, Inc., Michigan. Gift of the manufacturer

376. Neil M. Denari
Prototype Architecture School, Wilshire Boulevard, Los Angeles, California. Project, 1992. Perspectives: ink, airbrush, and Pantone on Mylar, 24⅛ x 34½ in. (61.3 x 87.6 cm). Rolf Fehlbaum Purchase Fund

377. Simon Patterson
The Great Bear. 1992. Lithograph, comp. (including frame): 52¾ x 42¾ x 2 in. (134 x 108.6 x 5.1 cm). Publisher: the artist. Printer: Poster Print Limited, London. Edition: 50. Frances Keech Fund

378. Chris Burden
Medusa's Head. 1989–92. Plywood, steel, cement, rock, five gauges of model railroad track, seven scale-model trains, diameter 14 ft. (426.7 cm). Purchase

379. Clint Eastwood
Unforgiven. 1992. USA. 35mm film, color, 130 minutes. Gift of the artist and Warner Bros.

380. Clint Eastwood
A Perfect World. 1993. USA. 35mm film, color, 137 minutes. Gift of the artist and Warner Bros.

381. Reiko Sudo
Jellyfish Fabric. 1993. Screenprinted and flash-heated polyester, 34 in. x 20 ft. 11 in. (86.4 x 637.5 cm). Manufacturer: Nuno Corporation, Japan; also Kimura Senko Co., Ltd., Japan. Gift of the manufacturer

382. Helen Chadwick
Number 11 from the series Bad Blooms. 1992–93. Silver dye bleach print (Cibachrome), 35½ in. (90.2 cm) diameter. Gift of Barbara Foshay-Miller and Christie Calder Salomon

383. Chris Marker
The Last Bolshevik (Le Tombeau d'Alexandre). 1993. France. Videotape, black and white and color, sound, 116 minutes. Gift of the artist

384. Zacharias Kunuk
Saputi. 1993. Canada. Videotape, color, sound, 30 minutes 30 seconds. Gift of Margot Ernst

385. Anselm Kiefer
Grane. 1980–93. Woodcut with paint additions on thirteen sheets of paper, mounted on linen, 91¹⁄₁₆ x 82½ in. (227.1 x 250.3 cm) (irreg.). Printer: the artist. Edition: unique. Purchased with funds given in honor of Riva Castleman by the Committee on Painting and Sculpture, the Associates of the Department of Prints and Illustrated Books, Molly and Walter Bareiss, Nelson Blitz, Jr., with Catherine Woodard and Perri and Allie Blitz, Agnes Gund, The Philip and Lynn Straus Foundation, Howard B. Johnson, Mr. and Mrs. Herbert D. Schimmel, and the Riva Castleman Endowment Fund

386. Glenn Ligon
Runaways. 1993. Four from a series of ten lithographs, comp.: each approx. 10¾ x 8¹⁵⁄₁₆ in. (27.3 x 22.7 cm), sheet: each 15¹⁵⁄₁₆ x 11¹⁵⁄₁₆ in. (40.6 x 30.4 cm). Publisher: Max Protetch, New York. Printer: Perry Tymeson, New York. Edition: 45. The Ralph E. Shikes Fund

387. Rosemarie Trockel
What It Is Like to Be What You Are Not. 1993. Portfolio of eight photogravures and one photolithograph and screenprint, photogravure plates: various, sheet: each 22⅝ x 17½ in. (57.5 x 44.5 cm); photolithograph and screenprint, comp.: 19⅝ x 13⁹⁄₁₆ in. (49.9 x 33.8 cm) (irreg.), sheet: 19⅝ x 13¹¹⁄₁₆ in. (49.9 x 34.8 cm). Publisher: Helga Maria Klosterfelde Edition, Hamburg. Printer: photogravure by Niels Borch Jensen, Copenhagen; screenprint by Thomas Sanmann, Hamburg; photolithograph by Ulla Pensolin, Hamburg. Edition: 9. Carol O. Selle Fund

388. Brice Marden
Vine. 1992–93. Oil on linen, 8 ft. x 8 ft. 6½ in. (243.8 x 260.3 cm). Fractional gift of Werner and Elaine Dannheisser

389. Herzog & de Meuron Architects
Facade panel from the Ricola Europe Factory and Storage Building. 1993. Architectural fragment: silkscreen on acrylic, framed in aluminum, 78¾ x 80½ x 1⅝ in. (200 x 203.2 x 4.2 cm). Gift of the architects in honor of Philip Johnson

390. Herzog & de Meuron Architects
Ricola Europe Factory and Storage Building. 1993. Model: wood, plywood, black paint, silkscreen, and polycarbonate, 9¹⁄₁₆ x 53³⁄₁₆ x 53³⁄₁₆ in. (23 x 135.7 x 135.4 cm). Gift of the architects in honor of Philip Johnson

391. Ellsworth Kelly
Red-Orange Panel with Curve. 1993. Oil on canvas, 8 ft. 8 in. x 7 ft. 3½ in. (269.4 x 222.5 cm). Gift of the Committee on Painting and Sculpture in honor of Richard E. Oldenburg

392. Roni Horn
How Dickinson Stayed Home. 1993. Plastic and aluminum, dimensions variable, museum installation, 5 in. x 23 ft. x 16 ft. (12.7 x 701.5 x 488 cm). Gift of Agnes Gund

393. Robert Therrien
No Title. 1993. Painted wood, brass, and steel, 9 ft. 5½ in. x 10 ft. 10 in. x 9 ft. 1½ in. (288.4 x 330.2 x 278.3 cm). Ruth and Seymour Klein Foundation, Inc., Fund and Robert B. and Emilie W. Betts Foundation Fund

394. Derek Jarman
Blue. 1993. Great Britain. 35mm film, color, 79 minutes

395. Fernando Campana and Humberto Campana
Vermelha Chair. 1993. Iron with epoxy coating, aluminum, and cord, 33⅞ x 22⅞ x 29¼ in. (86 x 58 x 74 cm). Manufacturer: Edra Mazzei, Italy. Gift of Patricia Phelps de Cisneros

396. Antonio Citterio and Glen Oliver Löw
Mobil Container System. 1993. Bulk-dyed thermoplastic polymer and chrome- or aluminum-colored steel, two units: 38½ x 19⅜ x ¾ in. (97.8 x 49.2 x 47.6 cm), and 21⅝ x 19½ x 18½ in. (54.9 x 49.5 x 47 cm). Manufacturer: Kartell S.p.A., Italy. Gift of the manufacturer

397. Jean Nouvel
Cartier Foundation for Contemporary Art. 1992–93. Elevation: serigraphed drawings on Plexiglas, 19⅝ x 35½ x 5/6 in. (49.8 x 90.2 x 1.7 cm). Gift of the architect in honor of Philip Johnson

398. Rachel Whiteread
Untitled (Room). 1993. Plaster, 8 ft. 10⅛ in. x 9 ft. 10 in. x 11 ft. 5¾ in. (271.5 x 299.8 x 350 cm). Robert and Meryl Meltzer, Anna Marie and Robert F. Shapiro, Emily and Jerry Spiegel, The Norman and Rosita Winston Foundation, Inc., and Barbara Jakobson funds

399. Ian Hamilton Finlay
Artist's books and cards. 1986–93. *L'Idylle des Cerises.* 1986. Artist's book, lithograph with Michael Harvey, page: 5¹³⁄₁₆ x 8¼ in. (14.8 x 20.6 cm). Gift of Gabriella de Ferrari. *Abraham at Santa Clara.* 1991. Accordion-folded card, lithograph with Gary Hincks, overall: 7⅞ x 11½ in. (20 x 29 cm). Walter Bareiss Fund. *An 18th Century Line on a Watering Can.* 1993. Folded card, lithograph with Michael Harvey, overall: 4¹⁵⁄₁₆ x 16½ in. (12.6 x 41.9 cm). Walter Bareiss Fund. *A Model of Order.* 1993. Card, lithograph with Gary Hincks, sheet: 7⅜ x ³⁄₁₆ in. (18.7 x 8.7 cm), comp. 7¹⁄₁₆ x 3¹⁄₁₆ in. (17.9 x 7.8 cm). Walter Bareiss Fund. Publisher and printer: Wild Hawthorn Press, Little Sparta, Scotland. Editions: approx. 250.

400. Martin Scorsese
The Age of Innocence. USA. 1993. 35mm film, color, 136 minutes. Gift of Columbia Pictures

401. Ximena Cuevas
Bleeding Heart. 1993. Mexico. Videotape, color, sound, 5 minutes. Gift of the Mexican Cultural Institute

402. Charles Ray
Family Romance. 1993. Mixed mediums, 53 in. x 7 ft. 1 in. x 11 in. (134.6 x 215.9 x 27.9 cm). Gift of The Norton Family Foundation

403. Rirkrit Tiravanija
Untitled (apron and Thai pork sausage). 1993. Multiple of brown-paper apron with string, tape, decal, and Xeroxed recipe, apron: 41¼ x 28³⁄₁₆ in. (104.7 x 71.3 cm) (irreg.).

Publisher: Brain Multiples, Santa Monica. Printer: the artist. Edition: 25. Purchased with funds given by Linda Barth Goldstein

404. Cheryl Donegan

Head. 1993. USA. Videotape, color, sound, 2 minutes 49 seconds. Gift of Susan Jacoby

405. Jos van der Meulen

Paper Bags Wastebaskets. 1993. Paper (unused billboard posters), dimensions: 35½ x 27⅛ in. (90 x 70 cm); 20¾ x 13¾ in. (60 x 35 cm); and 15¾ x 10 in. (40 x 25 cm). Manufacturer: Goods, the Netherlands. Gift of the Manufacturer

406. Nam June Paik

Untitled. 1993. Player piano, fifteen televisions, two cameras, two laser-discs and two players, one electric light and light bulb, and wires, overall: approx. 8 ft. 4 in x 8 ft. 9 in. x 48 in. (254 x 266.7 x 121.9 cm). Bernhill Fund, Gerald S. Elliot Fund, gift of Margot Paul Ernst, and purchase

407. Hal Hartley

Amateur. 1994. USA/Great Britain/France. 35mm film, color, 105 minutes. Gift of the artist

408. Quentin Tarantino

Pulp Fiction. 1994. USA. 35mm film, color, 154 minutes. Gift of Miramax Films

409. Lorna Simpson

Wigs (Portfolio). 1994. Portfolio of thirty-eight lithographs on felt, overall: 6 ft. x 13 ft. 6 in. (182.9 x 411.5 cm). Publisher: Rhona Hoffman Gallery, Chicago. Printer: 21 Steps, Albuquerque. Edition: 15. Purchased with funds given by Agnes Gund, Howard B. Johnson, and Emily Fisher Landau

410. Renzo Piano

Kansai International Airport, Osaka, Japan. 1988–94. Passenger terminal, main building: painted brass, 51¾ x 5¼ x 6⅞ in. (132 x 13 x 17.5 cm). Gift of the architect in honor of Philip Johnson

411. Takeshi Ishiguro

Rice Salt-and-Pepper Shakers. 1994. Extruded, slip-cast, and molded rice slurry, dimensions variable, from ½ x ¾ in. to 4 x 1 in. (1.3 x 1.9 cm to 10.2 x 2.6 cm). Gift of the designer

412. Kim Jones

Untitled. 1991–94. Pencil and erasures on paper, 24½ x 37½ in. (62.3 x 95.2 cm). Gift of Sarah-Ann and Werner H. Kramarsky

413. Andreas Gursky

Shatin. 1994. Chromogenic color print, 70⅞ x 7 ft. 8½ in. (180 x 235 cm). Anonymous Purchase Fund

414. Mona Hatoum

Silence. 1994. Glass, 49⅝ x 36⅝ x 23⅛ in. (126.6 x 59.2 x 93.7 cm). Robert B. and Emilie W. Betts Foundation Fund

415. Teiji Furuhashi

Lovers. 1994. Japan. Video installation with five laser discs and players, five projectors, two sound systems, two slide projectors, and two computers, overall: 11 ft. 6 in. x 32 ft. 10 in. x 32 ft. 10 in. (3.5 x 10.8 x 10.8 m). Gift of Canon, Inc.

416. Bill Viola

Stations. 1994. USA. Video installation with five laser discs and players, five projectors, five cloth screens, five granite slabs, and sound system in a 70 x 30 ft. (21.3 x 9.1 m) room. Gift of the Bohen Foundation in honor of Richard E. Oldenburg

417. Jenny Holzer

Truisms projects. 1980–94. *Abuse of Power Comes As No Surprise* and *Raise Boys and Girls the Same Way.* 1980–94. Two cotton T-shirts, from a series of six multiples, screenprinted, various dimensions. Printer: Artisan Silkscreen, New York. *Protect Me from What I Want* from the series *Survival Caps.* 1980. One of three multiples of caps, with embroidered text. Manufacturer: Uniforms to You, Chicago. *Money Creates Taste* and *Torture Is Barbaric* from the series *Truisms Golfballs.* Two of six multiples of colored golfballs, printed in letterpress. Manufacturer: Eastern Golf Corp., Hamlin, Pa. *Action Causes More Trouble Than Thought, At Times Inactivity Is Preferable to Mindless Functioning,* and *Private Property Creates Crime* from the series *Truisms Pencils.* 1994. Three of eight multiples of pencils, printed in letterpress. Publisher: the artist. Editions: unlimited. Gifts of the artist

418. Robert Gober

Untitled. 1993–94. Bronze, wood, brick, aluminum, beeswax, human hair, chrome, pump, and water, 56 x 37½ x 34 in. (142.2 x 95.2 x 86.3 cm). Given anonymously

419. Ann Hamilton

Seam. 1994. Room installation with two entrances on front wall, laser disc and player, projector, rags, wood, plastic, and three panes of glass, room dimensions 11 ft. 5 in. x 24 ft. 5 in. x 16 ft. (347.9 x 744.2 x 487.6 cm). Louis and Bessie Adler Foundation, Inc., Fund, and Peggy and David McCall Fund

420. Ross Bleckner

Memorial II. 1994. Oil on linen, 8 x 10 ft. (244 x 305 cm). Gift of Agnes Gund in memory of Thomas Ammann

421. Michael Schmidt

U-ni-ty (Ein-heit). 1991–94. Thirty-one from a series of 163 gelatin silver prints, each 19¾ x 13½ in. (50.5 x 34.3 cm). Anonymous Purchase Fund and Purchase

422. Thomas Roma

Untitled from the series Come Sunday. 1991–94. Gelatin silver print, 14 x 18¾ in. (35.6 x 47.6 cm). Lois and Bruce Zenkel Fund

423. Richard Artschwager

Five untitled works. 1994. Wood and metal. From left to right: 26½ in. x 7 ft. 6½ in. x 22½ in. (67.4 x 230 x 57.2 cm); 29½ x 32½ x 42 in. (74.9 x 82.6 x 106.6 cm); 13 ft. 2 in. x 50 in. x 36 in. (401.6 x 127 x 91.5 cm); 46 x 13¼ x 16¼ in. (117 x 34.4 x 41.3 cm); 6 ft. 8 in. x 29 in. x 12½ in. (203.2 x 73.8 x 31.6 cm). Gift of Agnes Gund and Anna Marie and Robert F. Shapiro Fund

424. Uta Barth

Ground #35. 1994. Chromogenic color print (Ektacolor), 17⅛ x 20⁵⁄₁₆ in. (44.3 x 53.3 cm). E. T. Harmax Foundation Fund

425. Cy Twombly

The Four Seasons: Autumn, Winter, Spring, and *Summer.* 1993–94. Synthetic polymer paint, oil, pencil, and crayon on canvas: *Autumn,* 10 ft. 3½ in. x 6 ft. 2¾ in. (313.7 x 189 cm); *Winter,* 10 ft. 3¼ in. x 6 ft. 2½ in. (313 x 190.1 cm); *Spring,* 10 ft. 3⅛ in. x 6 ft. 2⅞ in. (312.5 x 190 cm); and *Summer* (1994): 10 ft. 3¾ in. x 6 ft. 7⅛ in. (314.5 x 201 cm). Gift of the artist

426. Philippe Starck

Jim Nature Portable Television. 1994. High-density wood and plastic, 15³⁄₁₆ x 4⅞ x 14¾ in. (38.5 x 37 x 37.5 cm). Manufacturer: Thomson Consumer Electronics, France. Gift of the manufacturer

427. Rineke Dijkstra

Tia, Amsterdam, the Netherlands, 14 November 1994. Tia, Amsterdam, the Netherlands, 23 June 1994. 1994. Two chromogenic color prints, each 15¾ x 11¹³⁄₁₆ in. (40 x 30 cm). Gift of Agnes Gund

428. Marlene Dumas

Chlorosis. 1994. Ink, gouache, and synthetic polymer paint on paper, twenty-four sheets, 26 x 19¼ in. (66.2 x 49.5 cm) each. The Herbert and Nannette Rothschild Memorial Fund in memory of Judith Rothschild

429. Hella Jongerius

Soft Vase. 1994. Polyurethane, 10¾ in. (27 cm) high x 6 in. (15 cm) diameter. Manufacturer: DMD, the Netherlands, for Droog Design. Frederieke Taylor Purchase Fund

430. James Turrell

A Frontal Passage. 1994. Fluorescent light installation, dimensions variable, museum installation, 12 ft. 10 in. x 22 ft. 6 in. x 34 ft. (391.2 x 685.8 x 1036.3 cm). Douglas S. Cramer, David Geffen, Robert and Meryl Meltzer, Michael and Judy Ovitz, and Mr. and Mrs. Gifford Phillips funds

431. Jeff Scher

Garden of Regrets. 1994. USA. 16mm film, color, 8 minutes. Gift of the artist

432. Barbara Kruger

Public projects and illustrated book. 1986–94. Covers for *Esquire, MS,* and *Newsweek* magazines. 1992. Three photolithographs, each approx. 10¾ x 9 in. (27.3 x 22.9 cm). Editions: unlimited. Purchase. Untitled, compact disc insert for the rock band Consolidated. 1994. Comp. and sheet, 4¹¹⁄₁₆ x 4¾ in. (11.9 x 12.1 cm). Publisher: London Records, New York. Purchase. *I Shop Therefore I Am.* 1990. Multiple of paper bag, with photolithograph and letterpress, 17¼ x 10¾ x 4³⁄₁₆ in. (43.9 27.3 x 10.7 cm). Publisher: Kölnischer Kunstverein, Cologne. Edition: 9,000. Gift of Kölnischer Kunstverein. Untitled (matchbooks). 1986. Set of seven multiples of matchbooks, various dimensions. Publisher: Rhona Hoffman Gallery and David Meitus, Chicago. Editions: each approx. 1,000. *My Pretty Pony* by Stephen King. 1988. Illustrated book with nine lithographs, eight screenprints, page 20 x 13½ in. 50.9 x 34.3 cm). Publisher: Library Fellows of the Whitney Museum of American Art, New York. Edition: 250. The Associates Fund in honor of Riva Castleman

433. Louise Bourgeois

Fenelon. 1994. Spray paint, blue ballpoint pen, and pencil on jigsaw puzzle, 8¾ x 11¾ in. (22.2 x 29.8 cm). Gift of Sarah-Ann and Werner H. Kramarsky and an anonymous donor

434. Bob Evans

Tan Delta Force Fin. 1994. Liquid-cast rubber-cured Uniroyal flexible polyurethane, 17 x 11¼ x 4¼ in. (43.2 x 28.6 x 10.8 cm). Manufacturer: Bob Evans Designs, Inc., California. Gift of the manufacturer

435. Roni Horn

Island-Pooling Waters. Vol. IV from the series *To Place.* Cologne, 1994. Two-vol. artist's book, page: 10³⁄₁₆ x 8⅛ in. (25.9 x 20.7 cm). Publisher: Verlag der Buchhandlung Walther König, Cologne. Edition: 1,000. The Museum of Modern Art Library

436. Jean Nouvel

Less Table. 1994. Steel, 28¼ x 83¼ x 27¼ in. (71.7 x 211.4 x 69.2 cm). Manufacturer: Unifor S.p.A., Italy. Gift of the manufacturer

437. Alberto Meda

Long Frame Chaise Longue. 1994. Extruded and die-cast aluminum and PVC-coated polyester, 34½ x 21½ x 58 in. (87.7 x 54.6 x 147.3 cm). Manufacturer: Alias S.r.l., Italy. Gift of the manufacturer

438. Glenn Ligon

White #19. 1994. Oilstick on canvas mounted on wood panel, 7 ft. x 60 in. (213.3 x 152.4 cm). Committee on Painting and Sculpture Funds

439. Carrie Mae Weems

You Became a Scientific Profile from the series From Here I Saw What Happened and I Cried. 1995. Chromogenic color prints and etched glass, 26⅝ x 22¾ in. (67.6 x 57.8 cm). Gift on behalf of The Friends of Education of The Museum of Modern Art

440. Louise Bourgeois

Ode à ma mère. 1995. Illustrated book, four (frontispiece and three plates) of nine drypoints, one with roulette, plates: various dimensions, page: 11⅞ x 11⅞ in. (30.2 x 30.2 cm). Publisher: Editions du Solstice, Paris. Printers: plates by Harlan & Weaver Intaglio, New York; text by PIUF, Paris. Edition: 125. Gift of the artist

441. Marcel Wanders

Knotted Chair. 1995. Carbon and aramid fibers, epoxy, 29½ x 19¾ x 25½ in. (75 x 50 x 65 cm). Manufacturer: Marcel Wanders for Droog Design, the Netherlands. Gift of the Peter Norton Family Foundation

442. Tom Friedman

Untitled. 1995. Plastic, hair, fuzz, Play-doh, wire, paint, and wood, 24¼ x 24 x 24 in. (61.5 x 61 x 61 cm). An anonymous fund

443. Peter Halley

Exploding Cell Wallpaper. 1995. Series of nine screenprints on newsprint, printed from digital files, sheet, each 45¼ x 45⅛ (92.1 x 116.5 cm). Printer: Fine Art Printing, New York. Edition: unlimited. John B. Turner Fund and Howard B. Johnson Fund

444. Toba Khedoori

Untitled (Doors). 1995. Oil and wax on three sheets of paper, overall: 11 ft. x 19 ft. 6 in. (335.3 x 594.4 cm). Gift of Lenore S. and Bernard Greenberg

445. Ellen Gallagher

Oh! Susanna. 1995. Oil and pencil on paper collage on canvas, 10 x 8 ft. (304.8 x 243.8 cm). Fractional and promised gift of Michael and Judy Ovitz

446. Toyo Ito

Mediathèque Project, Sendai, Japan. 1995. Model: acrylic, 10⅝ x 31½ x 29¼ in. (27 x 80 x 74.3 cm). Gift of the architect in honor of Philip Johnson

447. KCHO (Alexis Leyva Machado)

In the Eyes of History. 1992–95. Watercolor and charcoal on paper, 60 x 49¼ in. (152.4 x 125.1 cm). Purchased with funds given by Patricia and Morris Orden

448. Doris Salcedo

Untitled. 1995. Wood, cement, steel, cloth, and leather, 7 ft. 9 in. x 41 in. x 19 in. (236.2 x 104.1 x 48.2 cm). The Norman and Rosita Winston Foundation, Inc., Fund, and purchase

449. Laurie Anderson

Puppet Motel. 1995. CD-ROM. Designer: Hsin-Chien Huang. Publisher: Voyager, New York. Purchase

450. Joel Sanders

Kyle Residence, Houston, Texas. Project, 1991–95. Model: wood, Plexiglas, resin, and aluminum, 7⅞ x 33¾ x 29½ in. (20 x 85.7 x 75 cm). Peter Norton Purchase Fund

451. Herzog & de Meuron Architects
Signal Box, Basel, Switzerland. 1988–95. Model: copper and painted wood, 41⅜ x 19⅛ x 12⅛ in. (105.7 x 48.6 x 30.8 cm). Purchase

452. Sigmar Polke
Bulletproof Vacation magazine. 1995. Two of seventeen photolithographs, page: 11¹¹⁄₁₆ x 8¹³⁄₁₆ in. (29.6 x 22.4 cm). Publisher and printer: Süddeutsch Zeitung magazine, Munich. Edition: mass-produced. Gift of Haus der Kunst

453. Chuck Close
Dorothea. 1995. Oil on canvas, 8 ft. 6 in. x 7 ft. ⅛ in. (259 x 213.6 cm) Promised gift of Anna Marie and Robert F. Shapiro, Enid A. Haupt Fund, Vassilis. Cromwell Voglis Bequest, and The Lauder Foundation Fund

454. Matthew Barney
Cremaster 4. 1994–95. Plastic, satin, fabric, and silkscreened video laser disc in silkscreened onionskin sleeve, 5 x 33¼ x 23¾ in. (12.7 x 84.4 x 60.3 cm). Blanchette Hooker Rockefeller Fund Bequest

455. cyan (Sophie Alex, Wilhelm Ebentreich, Detlef Fiedler, Daniela Haufe, Siegfried Jablonsky)
Foundation Bauhaus Dessau, Events, July–August 1995 (*Event Stiftung Bauhaus Dessau, Jul–Aug 1995*). 1995. Poster: offset lithograph, 33 x 23⅜ in. (83.8 x 59.3 cm). Gift of the designers

456. Sheron Rupp
Untitled (Bayside, Ontario, Canada). 1995. Chromogenic color print, 25⅝ x 32 in. (65.8 x 81.3 cm). E. T. Harmax Foundation Fund

457. Stan Douglas
Historic set for "Der Sandman" at DOKFILM Studios, Potsdam, Babelsburg, December 1994. 1995. Silver dye bleach print (Cibachrome), 30 x 40 in. (76.2 x 101.6 cm). Nina W. Werblow Charitable Trust

458. Jasper Johns
Untitled. 1992–95. Oil on canvas, 6 ft. 6 in. x 9 ft. 10 in. (198.1 x 299.7 cm). Promised gift of Agnes Gund

459. Inoue Pleats Co., Ltd.
Wrinkle P. 1995. Polyester. Hand pleated and heat set, 59 in. (149.9 cm) wide. Manufactured: Inoue Pleats Co., Ltd., Fukui

460. Luc Tuymans
A Flemish Intellectual. 1995. Gouache on paper, 11½ x 8¼ in. (29.2 x 20.9 cm). Gift of the Friends of Contemporary Drawing

461. Luc Tuymans
The Heritage IV. 1996. Oil on canvas, 6 ft. 6¼ in. x 49⅜ in. (200 x 125.5 cm). Committee on Painting and Sculpture Funds

462. Joel Coen
Fargo. 1996. USA. 35mm film, color, 98 minutes. Gift of Joel Coen and Ethan Coen

463. John Sayles
Lone Star. 1996. USA. 35mm film, color, 135 minutes. Acquired from the artist and Maggie Renzi

464. José María Sicilia
Two volumes of *Le Livre des mille nuits et une nuit*. 1996. Two from a series of six illustrated books with twenty-seven lithographs and linoleum cuts, page, 12⁹⁄₁₆ x 9¹³⁄₁₆ in. (32 x 25 cm). Publisher: Michael Woolworth Publications, Paris. Printer: Michael Woolworth Lithographie, Paris. Editions: 20. Mary Ellen Meehan Fund

465. Flex Development B.V.
Cable Turtle. 1996. Thermoplastic elastomer, 1⅜ in. (3.5 cm) high x 2⁹⁄₁₆ in. (6.5 cm) diameter. Manufacturer: Cleverline, the Netherlands. Gift of the manufacturer

466. Mona Hatoum
Rubber Mat. 1996. Multiple of rubber mat, 1⅛ x 30¼ x 21⅞ in. (3 x 78.3 x 58.1 cm). Publishers: Printed Matter and The New Museum of Contemporary Art, New York. Fabricator: Gheorge Adam, Red Hill, Pa. Edition: 35. Purchased with proceeds from the 1998 Clue event, sponsored by The Junior Associates of The Museum of Modern Art

467. John Armleder
Gog. 1996. Four from a portfolio of thirteen screenprints, each 19¹¹⁄₁₆ x 19¹¹⁄₁₆ in. (50 x 50 cm). Publisher: Editions Sollertis, Toulouse. Printer: Atelier à Paris, Paris. Edition: 25. Gift of The Junior Associates of The Museum of Modern Art

468. David Hammons
Out of Bounds. 1995–96. Dirt on paper, framed, with basketball, 53¼ x 41½ x 11½ in. (131.2 x 105.4 x 29.2 cm). Gift of the Friends of Contemporary Drawing, the Friends of Education, and Peter and Eileen Norton

469. KCHO (Alexis Leyva Machado)
The Infinite Column I. 1996. Wood and metal, 12 ft. 10 in. x 12 ft. 7 in. x 11 ft. 1 in. (391.1 x 383.5 x 337.8 cm). Committee on Painting and Sculpture Funds

470. Gary Simmons
boom. 1996. Chalk on blackboard paint on wall, 28 x 11½ in. (711 x 292 cm). Gift of the Friends of Contemporary Drawing and of the Friends of Education

471. Gabriel Orozco
Light Through Leaves. 1996. Iris print, comp: 20¹⁵⁄₁₆ x 30⅛ in. (53.2 x 76.5 cm), sheet: 22¼ x 32³⁄₁₆ in. (56.2 x 81.8 cm). Publisher: Parkett, Zurich and New York. Printer: Cone-Laumont Editions, New York. Edition: 60. Frances Keech Fund

472. Chris Ofili
North Wales. 1996. Three from a portfolio of ten etchings, plate: each 9¾ x 7⅞ in. (24.9 x 19.9 cm), sheet: each 15 x 11¼ in. (38 x 28.7 cm).

Publisher: The Paragon Press, London. Printer: Hope Sufference Studio, London. Edition: 35. Gift of The Young Print Collectors of the Department of Prints and Illustrated Books

473. Jeanne Dunning
Untitled. 1996. Silver dye bleach print (Cibachrome), 42¼ x 28¼ in. (107.3 x 71.8 cm). Gift of Barbara Lee

474. Thomas Demand
Room. 1996. Chromogenic color print, 67¾ x 91⅜ in. (172 x 232.1 cm). Gift of the Nina W. Werblow Charitable Trust

475. Andrea Zittel
A-Z Escape Vehicle: Customized by Andrea Zittel. 1996. Exterior: steel, insulation, wood, and glass; interior: colored lights, water, fiberglass, wood, papier-mâché, pebbles, and paint; 62 in. x 7 ft. x 40 in. (157.5 x 213.3 x 101.6 cm). The Norman and Rosita Winston Foundation, Inc., Fund and an anonymous fund

476. Werner Aisslinger
Juli Armchair. 1996. Polyurethane integral foam and metal, 29½ x 24¾ x 21⅝ in. (75 x 63 x 55 cm). Manufacturer: Cappellini S.p.A., Italy. Gift of the manufacturer

477. Franz West
Spoonerism. 1996. Suitcases, cardboard, plaster, paint, and gauze, in three parts: 6 ft. 6 in. x 39 in. x 40 in. (198.1 x 99 x 101.6 cm), 69 in. x 6 ft. 6 in. x 22 in. (175.2 x 198.1 x 55.9 cm), 6 ft. 6 in. x 21 in. x 21 in. (198.1 x 53.3 x 53.3 cm); overall dimensions variable. An anonymous fund, and Emily Fisher Landau, Frances R. Dittmer, and Patricia Phelps de Cisneros funds

478. Al Pacino
Looking for Richard. 1996. USA. 35mm film, color, 109 minutes. Acquired from the artist and Fox Searchlight Films

479. Toray Industries, Inc.
Encircling Fishing Net. 1996. Teteron polyester. Knotless mesh net, variable width (1½ in. contracted / 132 in. expanded) x 278 in. (3.8 / 335.3 x 706.1 cm) Manufacturer: Toray Industries, Inc., Tokyo; also Nitto Seimo Co., Ltd., Tokyo. Gift of Toray Industries, Inc.

480. Ken Jacobs
Disorient Express. 1996. USA. 35mm film, black and white, silent, 30 minutes. Acquired from the artist

481. Igor Moukhin
Moscow, May 9, 1996. 1996. Gelatin silver print, 13¹⁵⁄₁₆ x 20½ in. (35.5 x 52 cm). Gift of The Junior Associates of The Museum of Modern Art

482. Kiki Smith
Constellations. 1996. Lithograph with flocking, sheet: 57¼ x 31³⁄₁₆ in. (145.5 x 79.8 cm) (irreg.). Publisher

and printer: Universal Limited Art Editions, West Islip, N.Y. Edition: 42. Gift of Emily Fisher Landau

483. Raymond Pettibon
Untitled (Justly Felt and Brilliantly Said). 1996. Accordion-folded illustrated book with screenprint, with manuscript additions and pressed flower, produced for the journal *Parkett 47*, page: 9⅝ x 7⅝ in. (24.5 x 19.4 cm), overall: 9⅝ x 76¾ in. (24.5 x 195 cm). Publisher: Parkett, Zurich and New York. Printer: Lorenz Boegli, Zurich. Edition: 60. Monroe Wheeler Fund

484. Kara Walker
Freedom: A Fable or *A Curious Interpretation of the Wit of a Negress in Troubled Times*. 1997. Artist's book with pop-up silhouettes, page: 9⁷⁄₁₆ x 7¹⁄₁₆ in. (23 x 19.5 cm). Publisher: The Peter Norton Family, Santa Monica. Printers: text by Timothy Silverlake, Valencia, and Typecraft, Pasadena; pop-up by Eisen Architects, Boston, and Lasercraft, Santa Rosa. Edition: 4,000. Given anonymously

485. Arthur Omar
The Last Mermaid. 1997. Brazil. Videotape, color, 11 minutes

486. Kristin Lucas
Host. 1997. USA. Videotape, color, sound, 7 minutes 36 seconds. Gift of Susan Jacoby

487. Vik Muniz
Mass from the series Pictures of Chocolate. 1997. Two silver dye bleach prints (Cibachrome), each 60 x 48 in. (152.4 x 122 cm). The Fellows of Photography Fund and Anonymous Purchase Fund

488. Fred Tomaselli
Bird Blast. 1997. Pills, leaves, collage, synthetic polymer paint, and resin on wood panel, 60 x 60 in. (152.4 x 152.4 cm). Gift of Douglas S. Cramer

489. Chuck Close
Self-Portrait. 1997. Oil on canvas, 8 ft. 6 in. x 7 ft. (259.1 x 213.4 cm). Gift of Agnes Gund, Jo Carole and Ronald S. Lauder, Donald L. Bryant, Jr., Michael and Judy Ovitz, Anna Marie and Robert F. Shapiro, and Leila and Melville Straus, and purchase

490. Arnulf Rainer
Blue Barn. 1997. Etching and drypoint, plate: 11⅝ x 9½ in. (29.5 x 24.2 cm), sheet: 19⅝ x 25½ in. (50 x 65 cm). Publisher: the artist and Maximilian Verlag/Sabine Knust, Munich. Printer: Kurt Zein, Vienna. Edition: 35. Gilbert Kaplan Fund and purchase

491. Arnulf Rainer
Greens. 1997. Etching and drypoint, plate: 13 x 9¾ in. (33 x 24.8 cm), sheet: 19⅝ x 25½ in. (50 x 65 cm). Publisher: the artist and Maximilian Verlag/Sabine Knust, Munich. Printer: Kurt Zein, Vienna. Edition: 35. Gilbert Kaplan Fund and purchase

492. Arnulf Rainer
Blue Nest. 1997. Etching and dry-

point, plate: 13 x 9¾ in. (33 x 24.8 cm), sheet: 19⅝ x 25½ in. (50 x 65 cm). Publisher: the artist and Maximilian Verlag/Sabine Knust, Munich. Printer: Kurt Zein, Vienna. Edition: 35. Gilbert Kaplan Fund and purchase

493. Arnulf Rainer
Red Man. 1997. Etching and drypoint, plate: 12¹³⁄₁₆ x 9¾ in. (32.5 x 24.8 cm), sheet: 19⅝ x 25½ in. (50 x 65 cm). Publisher: the artist and Maximilian Verlag/Sabine Knust, Munich. Printer: Kurt Zein, Vienna. Edition: 35. Gilbert Kaplan Fund and purchase

494. Martin Puryear
Untitled. 1997. Cedar and pine, 68 x 57 x 51 in. (172.7 x 144.7 x 129.5 cm). Promised gift of Agnes Gund and Daniel Shapiro

495. Stan Brakhage
Commingled Containers. 1997. USA. 16mm film, color, 5 minutes. Acquired from the artist

496. Reiko Sudo
Origami Pleat Scarf. 1997. Hand-pleated and heat-transfer-printed polyester, 17⁵⁄₁₆ x 59¼ in. (43.9 x 150 cm). Manufacturer: Nuno Corporation, Japan; also Takekura Co., Ltd., Japan. Gift of the designer

497. Reiko Sudo
Shutter. 1997. Nylon stitched onto soluble base-fabric (base dissolved), 32⅜ in. (82.2 cm) wide. Manufacturer: Nuno Corporation, Japan. Gift of the manufacturer

498. Daniel Libeskind
Berlin Museum with Jewish Museum, Berlin, 1989–97 (projected completion, 2001, date of the model, 1997). Model: wood on paper, 66 x 11½ in. (167.7 x 29.2 cm) each side of diamond. Gift of the architect in honor of Philip Johnson

499. Willie Cole
Stowage. 1997. Woodcut, comp.: 49⁹⁄₁₆ in. x 7 ft. 11¹⁄₁₆ in. (125.9 x 241.5 cm), sheet: 56¼ x 104¾ in. (142.9 x 266 cm). Publisher: Alexander and Bonin Publishing, New York. Printer: Derrière L'Étoile Studios, New York. Edition: 16. Jacqueline Brody Fund and The Friends of Education Fund

500. Kiki Smith
Endocrinology. 1997. Two spreads from an illustrated book with twenty lithographs with collage, page: 20½ x 19½ in. (52.1 x 49.6 cm) (irreg.). Publisher and printer: Universal Limited Art Editions, West Islip, N.Y. Edition: 40. Gift of Emily Fisher Landau

501. William Kentridge
Ubu Tells the Truth. 1996–97. Four from a series of eight etching, aquatint, and drypoints, plate: 9¹³⁄₁₆ x 11¹³⁄₁₆ in. (25 x 30 cm), sheet: 13¾ x 19⅝ in. (35 x 49.8 cm). Publisher: the artist and Caversham Press, Balgowan, South Africa. Printer: Caversham Press, Balgowan, South

Africa. Edition: 50. Acquired through the generosity of Agnes Gund

502. John Baldessari
Goya Series: And. 1997. Ink jet and synthetic polymer paint on canvas, 6 ft. 3 in. x 60 in. (190.5 x 152.3 cm). Mr. and Mrs. Thomas H. Lee Fund

503. Rachel Whiteread
Untitled (Paperbacks). 1997. Room installation, containing plaster and steel, dimensions variable. Gift of Agnes Gund; Thomas W. Weisel, Patricia Phelps de Cisneros, Frances R. Dittmer, John Kaldor, Emily Rauh Pulitzer, and Leon Black funds; and an anonymous fund

504. Franz West
Hangarounds. 1997. Synthetic polymer paint, gouache, dry pigment, watercolor pan, tape, and cut-and-pasted printed paper on paper (two-sided), 39 x 44 in. (100 x 112 cm). Gift of the Friends of Contemporary Drawing

505. Lewis Klahr
Pony Glass. 1997. USA. Animation cel from 16mm film, color, 15 minutes. Acquired from the artist

506. Sue Williams
Mom's Foot Blue and Orange. 1997. Oil and synthetic polymer paint on canvas, 8 ft. 2 in. x 9 ft. (248.9 x 274.3 cm). Carlos and Alison Spear Gómez Fund, Marcia Rilkis Fund, and an anonymous fund

507. Yukinori Yanagi
Wandering Position. 1997. Four from a portfolio of five etchings, sheet: 24¹⁄₁₆ x 20¹⁄₁₆ in. (61.2 x 50.9 cm). Publisher: Peter Blum Edition, New York. Printer: Harlan & Weaver Intaglio, New York. Edition: 35. Frances Keech Fund

508. Zhang Peili
Eating. 1997. China. Video installation with three laser discs and players, and three matching stacked monitors, sound, dimensions variable. Gift of The Junior Associates of the Museum of Modern Art

509. David Williams
Thirteen. 1997. USA. 16mm film, color, 87 minutes

510. Pipilotti Rist
Ever Is Over All. 1997. Video installation with laser discs and players, two projectors, and sound, dimensions variable. Fractional and promised gift of Donald L. Bryant. Jr.

511. Fiona Banner
Break Point. 1998. Screenprint, comp.: 69⁷⁄₁₆ x 7 ft. 11¾ in. (176.4 x 243.3 cm), sheet: 71⅝ x 8 ft. 1⅛ in. (182 x 246.7 cm). Publisher: Frith Street Gallery, London. Printer: Wallis Screenprint, Kent. Edition: 10. Linda Barth Goldstein Fund

512. Konstantin Greic
May Day Lamp. 1998. Plastic and polycarbonate, 21 in. (53.3 cm) high x 8½ in. (21.7 cm) diameter. Manufacturer: Flos S.p.A, Italy. Gift of the manufacturer

513. Julia Loktev
Moment of Impact. 1998. USA. Videotape transferred to 16mm film, black and white, 116 minutes. Acquired from the artist

514. Paul Winkler
Rotation. 1998. Australia. 16mm film, color, 17 minutes

515. Charles Long
Internalized Page Project. 1997–98. Two from a portfolio of seven Iris prints and seven folders, housed in archival box, comp. and sheet: each 11 x 8½ in. (28 x 21.6 cm), folder: 11¾ x 9¹⁄₁₆ in. (29.8 x 23 cm) (irreg.), box: 10½ x 12½ x 2½ in. (26.7 x 31.6 x 6.4 cm). Publisher and printer: Muse X Editions, Los Angeles. Edition: 15. Acquired through the generosity of Agnes Gund

516. Aleksei German
Khroustaliov, My Car! 1998. France/Russia. 35mm film, black and white, 137 minutes. Acquired from Sodaperaga

517. Richard Serra
Torqued Ellipse IV. 1998. Weatherproof steel, 12 ft. 3 in. x 26 ft. 6 in. x 32 ft. 6 in. (373.4 x 807.7 x 990.6 cm). Fractional and promised gift of Leon and Debra Black

518. Anish Kapoor
Wounds and Absent Objects. 1998. Two from a portfolio of nine pigment-transfer prints, comp.: 17⅝ x 21¹⁄₁₆ in. (44.7 x 53.5 cm), sheet: 20½ x 24¼ in. (52 x 61.5 cm). Publisher: The Paragon Press, London. Printer: Permaprint, London. Edition: 12. Jacqueline Brody Fund and Harry Kahn Fund

519. Terry Winters
Graphic Primitives. 1998. Two from a portfolio of nine woodcuts, comp.: each 17¹³⁄₁₆ x 24 in. (45.6 x 60.9 cm), sheet: 20½ x 26⅜ in. (52 x 66.5 cm). Publisher: Two Palms Press and the artist, New York. Printer: Two Palms Press, New York. Edition: 35. John B. Turner Fund

520. Gerhard Richter
128 Details from a Picture (Halifax 1978). 1998. Two from a portfolio of eight photolithographs, comp.: 24⅜ x 38⅜ in. (62.4 x 98.7 cm), sheet: 25¼ x 39⁹⁄₁₆ in. (64.2 x 100.4 cm). Publisher: Kaiser Wilhelm Museum, Krefeld. Printer: Plitt Druck and Verlag GmbH, Oberhauen. Edition: 60. Lee and Ann Fensterstock Fund and the Howard Johnson Fund

521. Gabriel Orozco
I Love My Job. 1998. Silver dye bleach print (Ilfochrome), 12½ x 18½ in. (31.7 x 47 cm). The Family of Man Fund

522. Christian Boltanski
Favorite Objects. 1998. Nine from a portfolio of 264 color Xeroxes, comp.: each approx. 10¾ x 8⁵⁄₁₆ in. (27.4 x 21.1 cm), sheet: each 11 x 8⁹⁄₁₆ in. (28 x 21.7 cm). Publisher: Lycée Française, Chicago. Printer: Lab One and CD Color, Chicago. Edition: 264. Gift of Lee and Ann Fensterstock, in honor of their daughters, Kate and Jane

523. Jia Zhang Ke
Xiao Wu. 1998. China. 35mm film,

color, 108 minutes. Acquired from Kit-Ming Li, with funds provided by The Junior Associates of The Museum of Modern Art

524. Matthew Barney
C5: Elbocsatas. 1998. Graphite, synthetic polymer paint, and petroleum jelly on paper in acrylic and Vivak frame, 14 x 12 x 1¼ in. (35.6 x 30.5 x 3.2 cm). Gift of the Friends of Contemporary Drawing

525. Kara Walker
African/American. 1998. Linoleum cut, comp.: 60½ x 46¾ in. (153.8 x 117.3 cm), sheet: 60½ x 46¾ in. (153.8 x 117.3 cm). Publisher and printer: Landfall Press, Chicago. Edition: 40. Ralph E. Shikes Fund

526. Luc Tuymans
The Blue Oak. 1998. Cut-and-pasted paper, gouache, and pencil on paper, 15½ x 11¾ in. (39.4 x 30.1 cm). Gift of Linda and Howard Karshan

527. John Madden
Shakespeare in Love. 1998. USA/Great Britain. 35mm film, color, 122 minutes. Gift of Miramax Films

528. Robert Rauschenberg
Bookworms Harvest. 1998. Vegetable-dye transfer on paper on metal, 8 ft. 1½ in. x 61 in. (247.6 x 154.9 cm). Fractional and promised gift of Jerry I. Speyer

529. Chris Ofili
Untitled. 1998. Watercolor and pencil on paper, three of eight sheets, each 9½ x 6⅓ in. (24 x 16 cm). Gift of Martin and Rebecca Eisenberg

530. Enrique Chagoya
The Return of the Macrobiotic Cannibal. 1998. Accordion-folded illustrated book with lithograph, woodcut, and chine collé, page: 7½ x 11½ in. (19.2 x 27.9 cm), overall: 7½ x 7 ft. 8 in. (19.2 x 232.8 cm). Publisher and printer: Shark's, Lyons, Colo. Edition: 30. The Ralph E. Shikes Fund

531. Lisa Yuskavage
Asspicker and Socialclimber from the series *The Bad Habits.* 1996–98. Two of five etchings, plate: each 6 x 5 in. (15.2 x 12.7 cm), sheet: each 15¹⁄₁₆ x 11 in. (38.2 x 28.1 cm). Publisher: Marianne Boesky Gallery, New York. Printer: Burnet Editions, New York. Edition: 25. John B. Turner Fund

532. Elizabeth Peyton
Bosie. 1998. Lithograph, comp. and sheet: 29½ x 22½ in. (74.9 x 57.2 cm). Publisher: Gavin Brown, the artist, and Derrière L'Étoile Studios, New York. Printer: Derrière L'Étoile Studios, New York. Edition: 45. Gift of Anna Marie Shapiro

533. Philippe Starck
La Marie Folding Chair. 1998. Polycarbonate, 34½ x 18⅝ x 20½ in. (87.7 x 47.3 x 521 cm). Manufacturer: Kartell S.p.A., Italy. Gift of the manufacturer

534. Ralph Schmerberg
"Los Toros," a commercial for Nike. 1998. USA. 35mm film transferred to videotape, color, 1 minute. Gift of

the Association of Independent Commercial Producers

535. Mariko Mori
Star Doll. 1998. Multiple of doll, produced for the journal *Parkett 54,* 10¼ x 3¼ x 1⁹⁄₁₆ in. (26 x 8 x 4 cm) (irreg.) Publisher: Parkett, Zurich and New York. Fabricator: Marmitte, Tokyo. Edition: 99. Linda Barth Goldstein Fund

536. Cai Guo-Qiang
Borrowing Your Enemy's Arrows. 1998. Wood boat, canvas sail, arrows, metal, rope, Chinese flag, and electric fan; boat approx. 60 in. x 23 ft. 7 in. x 7 ft. 6 in. (150 x 720 x 230 cm), arrows approx. 24 in. (62 cm) long . Gift of Patricia Phelps de Cisneros in honor of Glenn D. Lowry

537. Rachel Whiteread
Water Tower. 1998. Translucent resin, 12 ft. 2 in. (370.8 cm) high x 9 ft. (274.3 cm) diameter. Given anonymously

538. William Kentridge
Seated Couple (Back to Back). 1998. Charcoal on printed book pages pasted on paper, 42 x 6 ft. 3¼ in. (106.7 x 191.1 cm). Gift of the Friends of Contemporary Drawing

539. William Kentridge
Untitled (drawing for *Stereoscope*). 1998–99. Charcoal and pastel on paper, 47¼ x 63 in. (120 x 160 cm). Gift of The Junior Associates of The Museum of Modern Art with special contributions from anonymous donors, Scott J. Lorinsky, Yasufumi Nakamura, and The Wider Foundation

540. Phil Solomon
Twilight Psalm II: Walking Distance. 1999. USA. 16mm film, color, 23 minutes. Acquired from the artist

541. Julian Opie
Imagine You Are Driving; Cars?; Imagine You Are Walking; Cityscape?; Gary, Popstar; Landscape? 1998–99. Six screenprints, various dimensions, from 24 x 20⅞ in. (61 x 53 cm) to 24 x 57⅛ in. (61 x 145 cm). Publisher: Alan Cristea Gallery, London. Printer: Advanced Graphics, London. Edition: 40. Acquired through the generosity of Andrew Shapiro, in honor of his mother, Anna Marie Shapiro

542. Andreas Gursky
Toys "Я" Us. 1999. Chromogenic color print, 6 ft. 9½ in. x 11 ft. ⅝ in. (207 x 337 cm). Gift of Jo Carole and Ronald S. Lauder

543. Barbara Bloom
A Birthday Party for Everything. 1999. Multiple of pinwheel, paper fan, noisemakers, jelly beans, plastic bottle, pencils, candles, wooden tops, kaleidoscope, Frisbee, paper plates, plastic straws, paper horns, streamers, ribbon, balloons, plastic paddle with rubber ball, puzzle, paper napkins, paper cups, paper

place mats, and paper tablecloth, housed in cardboard box, various dimensions. Publisher: I. C. Editions, New York. Edition: unlimited. Gift of Anna Marie Shapiro

544. Jean-Marie Straub and Danièle Huillet
Sicilia! 1999. France/Italy. 35mm film, black and white, 66 minutes

545. Carroll Dunham
Ship. 1997–99. Mixed mediums on linen, 10 ft. ⅛ in. x 13 ft. ½ in. (305.1 x 396.5 cm). Paula Cooper, Donald L. Bryant, Jr., and Andreas C. Dracopoulos funds

546. Damien Hirst
The Last Supper. 1999. Eight from a portfolio of thirteen screenprints, comp: various dimensions, sheet: each approx. 60¼ x 40 in. (153.2 x 101.6 cm). Publisher: The Paragon Press, London. Printer: Coriander Press, London. Edition: 150. Monroe Wheeler Memorial Fund, Roxanne H. Frank Fund, and partial gift of Charles Booth-Clibborn

547. E. V. Day
Anatomy of Hugh Hefner's Private Jet (1–5): Cross-section of Hugh Hefner's Digestive System; Three-Mile-High-Club Proliferation–Stage II; Three-Mile-High-Club Proliferation–Stage III; Three-Mile-High-Club Metastasis; Metastatic Rupture. 1999. Five blueprints, comp.: each 23¼ x 17 in. (58.8 x 43.1 cm), sheet: each 24¹⁄₁₆ x 18⅛ in. (61.1 x 45.9 cm). Publisher: the artist. Printer: Everyday Blueprint, New York. Edition: 8. Roxanne H. Frank Fund

548. Chris Ofili
Prince amongst Thieves. 1999. Synthetic polymer paint, collage, glitter, resin, map pins, and elephant dung on canvas, 8 x 6 ft. (243.8 x 182.9 cm). Mimi and Peter Haas Fund

549. Richard Serra
Out of Round XII. 1999. Oilstick on paper, 6 ft. 7¼ in. x 6 ft. 7¼ in. (201.3 x 201.3 cm). Fractional gift of Leon Black

550. Richard Serra
Switch. 1999. Steel, six plates, each 13 ft. 6 in. x 52 ft. (411.5 x 1585 cm). Fractional and promised gift of Emily Carroll and Thomas W. Weisel

551. Shahzia Sikander
Anchor. 1999. Screenprint, comp: 25⅝ x 32¹¹⁄₁₆ in. (62.5 x 83 cm), sheet: 28¼ x 35 in. (71.7 x 88.9 cm) (irreg.). Publisher: Deitch Steinberg Editions, New York. Printer: Michael Steinberg, New York. Edition: 60. Lee and Ann Fensterstock Fund

552. Jean-Luc Godard
The Old Place. 2000. Switzerland. Videotape, color, 50 minutes. Purchase

553. Faith Hubley
Witch Madness. 2000. USA. 35mm film, color, 9 minutes

554. Matthew Barney
The Cabinet of Baby Fay La Foe. 2000. Nylon, polycarbonate honeycomb, cast stainless steel, cast solar salt, epoxy resin, top hat and beeswax, 4 ft. 11 in. x 7 ft. 11½ in. x 3 ft. 2¼ in. (149.8 x 242 x 96.5 cm). Purchase

Acknowledgments

This publication was produced under unusually severe pressures, and we are therefore doubly grateful to all of those who gave extra quotients of their time, energy, and expertise. Harriet Schoenholz Bee, Managing Editor in the Department of Publications, deserves special thanks for her extraordinarily fine work editing all of the texts under extreme constraints of time. She was ably assisted in the editing and coordination of the various parts of the book by intern Inés Katzenstein. One of the most crucial and challenging aspects of the publication was its design, and in particular the chronological layout of so many diverse images. This task was brilliantly and sensitively accomplished by Steven Schoenfelder, whose calm good-spiritedness made him a great pleasure to work with. At least as challenging, however, was the task of producing such a complex book from an array of photographs that varied widely in format and quality. For his superb execution of this task, and constant attention to quality, we gratefully thank Production Manager Marc Sapir. We also thank Cara Maniaci and Cassandra Heliczer for their expert proofreading. The Museum's Publisher Michael Maegraith provided unstinting support of this endeavor from its inception, and Michael Margitich, Deputy Director, External Affairs, secured the funding that made this publication possible.

The daunting task of gathering and trafficking the photography for this book was overseen by Jeffrey Ryan, with invaluable assistance, especially in compiling the photograph credits, by intern Suzanne Perling. Meticulous caption research and timely corrections were carried out, under urgent pressure, by members of each curatorial department, and we are grateful to Pierre Adler, Sally Berger, Mary Corliss, Kathy Curry, Fereshteh Daftari, Terry Geeskin, Judith Hecker, Sarah Hermanson, Susan Kismaric, Barbara London, Matilda McQuaid, Elaine Mehalakes, Peter Reed, Laura Rosenstock, and Sarah Suzuki for their essential contributions. We are also indebted to Chief Fine Art Photographer Kate Keller for her expert coordination and execution, as well as to photographers Kelly Benjamin, John Cross, Thomas Griesel, Paige Knight, Erik Landsberg, Kimberly Pancoast, Erica Stanton, and John Wronn. We thank Mikki Carpenter, Director of the Department of Photographic Services and Permissions, for her always swift and dependable work in meeting great demands, as well as her staff, Charleen Alcid, Jennifer Bott, Rosa Laster, and Eden Schulz. Thanks also go to Nancy Adelson for advising on reproduction permissions and issues of copyright.

In addition to the individuals already mentioned, we thank each of the curators who have written insightful essays that help to synthesize the rich diversity of images in this volume. We would also like to acknowledge two key members of our core team, Amy Horschak and Fereshteh Daftari, who contributed their insights and prudent advice along the way. Madeleine Hensler provided priceless and exacting administrative assistance for this project, and continually propelled us in the right direction. The project was also supported by a group of dedicated interns including Benjamin Lima, Alice Moscoso, David Rodriguez Caballero, Sarah Burton, and Emily Capper. And finally, a debt of gratitude goes to Judith Hecker who, with her unflagging attention to every detail and her tireless dedication to this project, helped guide the publication to completion.

Kirk Varnedoe
Paola Antonelli
Joshua Siegel

Photograph Credits

© 1980 Vito Acconci: 22; 1977–81: 23; 1990–91: 303.

Courtesy Peggy Ahwesh: 242.

Courtesy Alexander and Bonin: 450–451.

Dave Allison, The Museum of Modern Art: 89; 163; 204; 252; 335.

© 1989 Ida Appelbroog: 241.

Courtesy Dieter Appelt: 301.

© 1996 John Armleder: 425.

© 2000 Artists Rights Society (ARS), New York/ADAGP, Paris: 116; 189; 475; 292.

© 2000 Artists Rights Society (ARS), New York: 267, 315, 351; 74, 92, 163, 204, 231; 329, 468–469, 470, 496, 497; 132, 133; 196, 384; 47, 125; 90; 355.

© 2000 Artists Rights Society (ARS), New York/VG Bild-Kunst, Bonn: 127; 52; 205.

© 2000 Artists Rights Society (ARS)/Pro Litteris, Zurich: 25, 143.

at radical.media: 483 top.

© 1986 John Baldessari: 147; 1997: 454.

Ballo: 170.

© 1995 Matthew Barney: 414; 1998: 477.

© 2000 Georg Baselitz: 42.

© 1988 Bernd and Hilla Becher: 186.

Peter Bellemy, New York: 148–149.

© 1987–88 Ashley Bickerton: 193.

Courtesy Kathryn Bigelow: 76–77.

© 1982 The Blade Runner Partnership. All rights reserved: 62.

© 1994 Ross Bleckner: 381.

Courtesy Tanya Bonakdar Gallery: 466.

© 1983 Jonathan Borofsky: 89.

Courtesy Stan Brakhage and Anthology Film Archives: 446.

Courtesy Robert Breer: 153.

© 1992 Chris Burden: 343.

© 1980–81 Scott Burton: 43.

Canon ARTLAB: 375.

© 1998 Enrique Chagoya: 480.

Courtesy Cheim & Read, New York: 148–149, 332, 395, 400.

Linda Chen, Miramax Films: 367 bottom.

Courtesy Abigail Child: 165 top.

Courtesy Cinematheque Ontario: 33 bottom; 35 bottom right; 167; 220; 240 bottom; 490 top.

© 1983 Francesco Clemente: 83; 1986: 144–145.

Geoffrey Clements, courtesy Robert Gober: 317 top.

© Chuck Close: 443; 1995: 413.

Courtesy Joel and Ethan Coen: 422 top.

Theo Columbe, courtesy 303 Gallery: 458.

© 1990 Bruce Conner: 283.

Courtesy Crown Point Press: 23.

Courtesy Terence Davies: 334 bottom.

James Dee, courtesy Ronald Feldman Fine Arts, New York: 205.

Courtesy Carlos Diegues: 35 top.

Digital Design Collection Project: Jon Cross and Erica Stanton, Luna Imaging, © 2000 The Museum of Modern Art, New York: 29; 40; 101; 118 top; 195; 230 bottom; 256; 328; 341.

Courtesy Nathaniel Dorsky: 178.

© 1994 Marlene Dumas: 390–391.

© 1989 Carroll Dunham: 228; 1999: 491.

Courtesy Electonic Arts Intermix: 87 bottom; 95 top; 165 bottom; 209 top; 248; 321; 347 top; 364 bottom; 439 bottom; 499.

© 1984 Embassy International Pictures. All rights reserved: 93.

© Rainer Werner Fassbinder: 28 top.

© Rainer Werner Fassbinder Foundation: 38.

Courtesy Janice Findley: 157.

© 1987 Eric Fischl: 170–171.

© 1988 Gunther Forg: 208.

Frameline: 222.

© 1985 Robert Frank: 112–113.

Courtesy John Frankenheimer: 146 bottom.

© 1994 Teiji Furuhashi: 375.

Courtesy Gagosian Gallery, New York: 96; 343; 406.

Courtesy Ernie Gehr: 298.

© 1989 Gilbert and George, courtesy the artists: 232–233.

Courtesy Barbara Gladstone Gallery: 155; 393; 414.

© 1986 Robert Gober: 136; 1989: 252; 1991, courtesy the artist: 316; 1992: 317; 1992: 317; 1993–94: 379.

Paula Goldman: 385.

© 1990 Estate of Felix Gonzalez-Torres, courtesy Andrea Rosen Gallery: 285; 1991: 305; 1991: 306, 304.

Courtesy Marian Goodman Gallery: 202; 474.

Courtesy Jay Gorney Modern Art: 190.